Family Tree of the Nemanjić Dynasty
Fresco, 1350
Dečani, Serbi—Monastery Church

Art and Architecture in the Balkans

an annotated bibliography

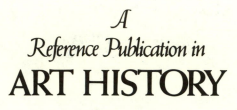

A
Reference Publication in

ART HISTORY

Herbert L. Kessler, Editor
Medieval Art and Architecture

Art and Architecture in the Balkans
an annotated bibliography

SLOBODAN ĆURČIĆ

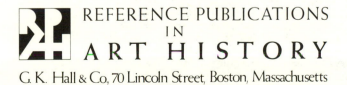

REFERENCE PUBLICATIONS
IN
ART HISTORY

G. K. Hall & Co, 70 Lincoln Street, Boston, Massachusetts

Library of Congress Cataloging in Publication Data

Ćurčić, Slobodan.
 Art and architecture in the Balkans.

 (Reference publications in art history)
 Bibliography: p.
 Includes index.
 1. Art—Balkan Peninsula—Bibliography. 2. Art,
Medieval—Balkan Peninsula—Bibliography. 3. Art,
Byzantine—Balkan Peninsula—Bibliography. 4. Archi-
tecture—Balkan Peninsula—Bibliography. 5. Archi-
tecture, Medieval—Balkan Peninusla—Bibliography.
6. Architecture, Byzantine—Balkan Peninsula—Bibliog-
raphy. I. Title. II. Series: Reference publication
in art history.
Z5961.B28C87 1984 [N7175] 016.7'09496 83-18392
ISBN 0-8161-8326-0

This publication is printed on permanent/durable acid-free paper
MANUFACTURED IN THE UNITED STATES OF AMERICA

To my students

Contents

The Author

Slobodan Ćurčić has been an associate professor in the Department of
Art and Archaeology at Princeton University since 1982. Previously
he taught for eleven years in the School of Architecture, University
of Illinois, Urbana-Champaign (1971-1982). A native of Sarajevo,
Yugoslavia, Professor Ćurčić acquired his elementary and secondary
education in Belgrade, received his B. Arch. and M. Arch. from the
University of Illinois, Urbana-Champaign, and his Ph.D. in art his-
tory at the Institute of Fine Arts, New York University (1975).

Professor Ćurčić has published a book, Gračanica: King Milutin's
Church and Its Place in Late Byzantine Architecture (University Park
and London: Pennsylvania State University Press, 1979), and numerous
articles on various aspects of Byzantine architecture and art. He
was twice a fellow at the Dumbarton Oaks Center for Byzantine Studies
in Washington, D.C. (1975-76 and 1981), received the Millard Meiss
Fund Grant from the C.A.A. (1977), and the prize for the best disser-
tation on an art historical subject on Eastern Europe, awarded jointly
by the A.C.L.S. and the Social Studies Research Council (1977). In
1983 Professor Ćurčić was appointed a member of the Senior Fellows
Committee at the Dumbarton Oaks Center for Byzantine Studies.

Professor Ćurčić has participated in archaeological field work in
Sicily, Yugoslavia, and Greece.

Preface

This volume on art and architecture in the Balkans differs from most other volumes in this series in that its focus, rather than being topical, chronological, or stylistic, is strictly geographical. The material included reveals such great diversity that it defies classification in accordance with established systems in art historical scholarship. Yet it is precisely this complexity that makes the Balkans an area of prime interest for study, particularly of East-West relations. Coexistance, juxtaposition, fusion, and rejection of various artistic modes and styles over the centuries mirror a turbulent pattern of political history in an area that to this day straddles the political and cultural divide between the East and the West.

The present volume constitutes the first comprehensive bibliographical compilation of literature on medieval art and architecture of the Balkan Peninsula as a whole; it is also the first on any part of the medieval Balkans to appear with annotations in English. As such, it is intended to introduce much important material to a wider audience than has been possible in the past. Although this bibliography was never envisioned as being exhaustive, its coverage is thorough, taking into account all of the visual arts in all their aspects.

Geographic and cultural scope. At the outset, it is necessary to define the use of the name Balkans in the title of this book. The geographic territory considered for our purposes is the area covered by the modern states of Albania, Bulgaria, and Yugoslavia (with its six federated republics: Serbia, Croatia, Slovenia, Bosnia and Herzegovina, Macedonia, and Montenegro). The obvious major exclusions are the state of Greece and the European portion of Turkey, with the city of Istanbul (Constantinople). Because the medieval material in these areas is predominantly Byzantine, it will be included in later volumes on Byzantine art and architecture due to appear in this series. From some points of view Rumania may also be considered an exclusion. It should be noted, however, that Rumania is not, strictly speaking, a Balkan country in the geographic sense; and although strong cultural ties bound Wallachia and Moldavia (medieval states on the

territory of modern Rumania) and the Balkan states at times, equally strong ties linked them with other parts of eastern and central Europe. For these reasons it was decided to exclude Rumania from consideration here.

The diversity of medieval material concerning Albania, Bulgaria, and Yugoslavia is a result of complex religious and political circumstances during the Middle Ages. It should be kept in mind, however, that these circumstances were not specifically a product of the Middle Ages. Indeed, they were the legacy of late Antiquity, and they continue into our own times. A major East-West cultural divide has run through this area at least since the partition of the Roman Empire into two administrative halves by Emperor Diocletian. This line of poltiical division coincided, in fact, with an older frontier separating the Greek-speaking from the Latin-speaking world. The quest for ecclesiastical predominance that ensued in the early centuries of Christianity caused continuous conflicts over the question of jurisdiction between Roman popes and Constantinopolitan patriarchs, finally leading to the break between the Roman Catholic and Greek Orthodox churches in 1054. Thus in dealing with art and architecture in this area, the term medieval has, of necessity, extremely broad connotations. It applies at the same time to Byzantine, pre-Romanesque, Romanesque, and Gothic styles as well as all of the local variants, including the mixtures of two or more of these styles in the same work of art or in the same edifice.

Although modern political borders do not necessarily coincide with those of the medieval states, the selection and organization of the material has followed the modern alignments. This has induced a potential problem, which I have attempted to remedy in the following manner. Monuments located on the territory of a modern state but in reality belonging to the medieval cultural heritage of another nation are listed by their modern location, the problem being pointed out in the specific annotations (e.g., Spasovica--a church built by the Serbian King Stefan Dečanski--is found under Bulgaria; Sites; Spasovitsa, while Dolna Kamenitsa--a church built during the reign of the Bulgarian Emperor Michael Shishman--appears under Yugoslavia; Sites; Donja Kamenica).

Chronological scope. The chronological scope of the "Middle Ages" for the purposes of this work has been equally difficult to define. In general, the beginning of the Middle Ages should be understood to coincide with the invasion of the Byzantine Empire by Slavs during the late sixth and early seventh centuries. Early Byzantine material (sixth through eighth centuries), however, has not been considered. Archaeological finds relative to the early history of the Slavs in the Balkan Peninsula are considered only insofar as scarce art objects are considered. A greater concentration of material begins only with the religious and cultural conversion of the South Slavs in the ninth century. Thus for all practical purposes the ninth

century may be assumed to be the general starting point of the Middle Ages in this context. A major exception has been made for early Byzantine material found in Albania, which has been included to give the highly limited information on medieval art and architecture in that country as broad a coverage as possible, even at the risk of duplication of some material in another volume in this series.

Middle and late Byzantine material found on the territories of Albania, Bulgaria, and Yugoslavia is also included, again with a full understanding that some of this material may also appear in other volumes of this series. The reason for such a decision is the difficulty of drawing a clear line of distinction between Byzantine and local patronage, Byzantine and local stylistic qualities, Byzantine and local artists, builders, etc. Thus, for example, the church of the Virgin Peribleptos (present St. Clement) in Ohrid, Yugoslavia, built in 1295, was painted by two Byzantine Greek painters, Michael and Eutichios, hired by a local patron named Progon Zgur. Clearly, such a monument could receive two classifications--either as a Byzantine or as a local monument. All such examples are included in this study.

The terminal point of the "Middle Ages" in the Balkans is also elusive. Historically, the fall of various Balkan states to the Turks in the course of the second half of the fifteenth century is generally considered to mark the end of the medieval era. Yet the artistic and architectural production sponsored by the Orthodox Church under the Turkish yoke reveals a different picture. This material bespeaks a highly conservative, almost fossilized survival of medieval styles of art and architecture well into sixteenth, seventeenth, and even eighteenth centuries. Characterized in scholarship as "Byzance après Byzance," this material can only be meaningfully considered as "medieval," notwithstanding its late date. On the other hand, in the western parts of the Balkans, unaffected by Turkish conquest and under the influence of Italy, a more familiar transition between the Middle Ages and the Renaissance took place. One should note at this point that the term Renaissance is used with entirely different connotations in conjunction with Bulgarian art and architecture under the Turkish domination. Finally, Turkish art and architecture in the area under consideration, although contemporaneous with "Byzance après Byzance," are excluded because they constitute a body of material belonging to another large cultural framework--that of Islam.

Manner of compilation. The task of compiling material for this study was at times frustrating. Although bibliographical works dealing with medieval art and architecture do exist in Bulgaria and Yugoslavia, they cover only the respective countries, employ different organizational principles, and are often not comprehensive. Among the more thorough modern bibliographical tools are such periodical bibliographies as the one appearing annually in Starinar (Belgrade).

Initiated only in 1958 its usefulness is limited to keeping abreast
of current publications. In the category of bibliographical surveys,
I consulted several in preparing the general guidelines for the orga-
nization of this work. The principal among these were: Jelisaveta
S. Allen, ed., Literature on Byzantine Art, 1892-1967, 2 vols.
(Washington, D.C., 1973 and 1976); Sonfa Georgieva and Velizar Veklov,
Bibliografiĩa na bŭlgarskata arkheologiĩa, 1879-1966 (Sofia, 1974);
and Jelisaveta S. Allen, "A Bibliographic Survey of Publications on
the Subject of History of Art and Archaeology in Yugoslavia, from
Classical Antiquity to the Present Time" (unpublished M.S. Thesis,
The Catholic University of America, Washington, D.C., 1968). On the
basis of these bibliographical works I was able to establish a pre-
liminary list of major books and relevant periodic literature. In
evaluating the significance of periodic literature, I decided to con-
duct an exhaustive survey of a select number of Albanian, Bulgarian,
and Yugoslav periodical runs. The final choice included forty-one
periodicals whose titles appear listed in front of the text. In
addition, a considerable number of periodicals of essentially local
scope was also surveyed, some more comprehensively than others. With
regard to periodic literature published outside Albania, Bulgaria,
and Yugoslavia, I decided to conduct a systematic survey of only a
limited number of particularly relevant periodicals such as Cahiers
archéologiques (Paris), and Corsi di cultura sull'arte ravennate e
bizantina (Ravenna). References have been made to numerous articles
in many other periodicals, but not as a result of systematic surveys
of these periodicals. In general, my aim was to concentrate on the
literature published in the three countries under consideration. In
conducting systematic surveys of periodical runs, I used 1979 as the
concluding year of my investigation. Certain major works published
after 1979 have been included, but this was done on an exceptional
basis.

The following bibliographic criteria were employed in determining
which material should not be included. If a major recent study on a
subject is available, older literature judged to be redundant has
been excluded. This was done only if the recent work is equipped
with the proper documentary apparatus to ensure access to the older
literature. Other exclusions involve works of art and architecture,
or aspects thereof, whose importance was judged to be marginal.
Finally, in a number of instances the same material may have been
published in two or more languages in different periodicals. When
such cases were detected, only the version in one of the Western
languages has usually been cited.

Organization of bibliographical material. The fundamental principle
followed in the organization of this work was to proceed from the
most general to the most specific information. There are four main
sections. The first, entitled "Balkans," includes works that con-
sider the art and architecture of the Balkan Peninsula in the broad-
est regional scope. The three following sections, organized alpha-
betically, are "Albania"; "Bulgaria"; and "Yugoslavia." Within each

of these groupings the bibliographical material is further subdivided
into narrower categories, the number and nature of which depend en-
tirely on the material itself. Thus under the headings "Balkans"
and "Albania" one will find only five subdivisions, whereas under
"Bulgaria" and "Yugoslavia" there are eight. While the content of
most of these categories and subcategories is evident from their
titles, the category entitled "Sites" requires a few words of ex-
planation. In general, the term "site" refers to the name of a
place (town, village, isolated monastery, fortress, or archeological
site), but it can also refer to other geographic entities (rivers,
valleys, mountains, islands, or regions). Because the latter usage
is infrequent, when it occurs it is pointed out in the following man-
ner: "Cetina [river]"; "Hvar [island]"; "Fruška Gora [region]."

Throughout, entries are organized alphabetically by authors'
names. In the cateogry "Sites" the material is first divided by
place names organized alphabetically, and then by authors' names
under each place name. In several instances where a large number of
entries occurs under a single place name, the material is further
divided by individual monuments (e.g., Ohrid--Sv. Bogorodica Bolnička,
Sv. Bogorodica Čelnica, etc.), all alphabetized by the name of the
monument. Within each monument heading, the standard rule of alpha-
betical organization by authors' names recurs.

Citations, transliteration rules, place names, and annotations. In
citing a work, the name of the author is always listed in the form
in which it appears in the original publication. Where different
spellings of the last and/or first name occur (e.g., Deroko,
Aleksandar as well as Derocco, Alexandre), they are cross-referenced
in the author index.

In titles of works, the exact wording and spelling is used with
no attempt at correction of grammatical errors. Only an occasional
spelling mistake has been corrected, primarily to avoid potential
problems with the indexing of names. Where the title of a work is in
one of the main Western languages (English, French, German, or
Italian), it is cited without translation. Where the title of a work
is in a non-Western language but the work includes a summary in one
of these four languages, the title of the summary is given; where
there is no summary, I have supplied an English translation of the
title in brackets.

The user of this bibliography will find that thirteen different
languages appear in the citations. Some of these (e.g., Greek,
Russian, Serbian, Bulgarian) use alphabets other than Latin. All
citations appearing in such languages have been transliterated into
the Latin alphabet. The Library of Congress rules on transliteration
have been uniformly employed. In cases where a work appeared in
transliterated form following rules other than those of the Library
of Congress, however, it is cited in its original form.

Names of places are given in their modern form. Where applicable, older names are appended in parentheses following the current form: Durrës (Drač, Durazzo, Durrachion, Durrachium). Cross-references for older names are given in the text as well as in the general index.

The annotations generally consist of two to three sentences describing the essential contribution of the work in question. While on the whole I avoided making critical judgement of individual works, I have attempted to point out major controversial issues on specific subjects.

Indexes. An author index and a general index appear at the end of this volume. The general index lists all personal names (other than those of authors), names of saints, geographic names, names of manuscripts, and iconographic concepts.

Index letter-codes and numbers. For purposes of indexing and cross-referencing, an abbreviation consisting of the first two letters of each main geographic heading is used before the entry numbers: BA for Balkans, AL for Albania, BU for Bulgaria, and YU for Yugoslavia. Within each of these four groupings all entries are numbered consecutively, beginning with "1." There are approximately 32 entries under "Balkans," 96 under "Albania," 488 under "Bulgaria," and 1,318 under "Yugoslavia."

Abbreviations. A list of abbreviations for major periodicals is given alongside the list of periodicals preceding the text.

Acknowledgments

I am grateful to the Research Board of the Graduate College of the University of Illinois, Urbana-Champaign for the generous support of this project from its inception to its virtual completion. Without this aid the realization of this book would have taken considerably longer if, indeed, it could have been accomplished at all.

My work began under optimum circumstances at the University of Illinois, Urbana-Champaign where I was teaching at the time. The Library of the University of Illinois has one of the outstanding collections of books and periodicals on Eastern Europe, which made the initial stages of my work not only efficient but also remarkably convenient.

During the final stages of compilation of bibliographical material I was awarded a Fellowship at the Dumbarton Oaks Center for Byzantine Studies in Washington, D.C. The excellent library of Dumbarton Oaks, along with an occasional visit to the Library of Congress, enabled me to bring to a successful conclusion the bulk of my work. To the numerous staff members of these institutions and libraries I offer sincere thanks.

Among the many individuals who have helped in different ways with this project, I would like to single out a few who deserve my special thanks. To Professor Herbert Kessler, the editor of this series, I owe the honor of having been selected as one of the authors. His initial encouragement and continued support are much appreciated.

The realization of this book owes a great deal to two graduate students at the University of Illinois, Urbana-Champaign. Ann B. Terry, a graduate student of art history, was appointed my research assistant during the summer of 1979, when the project had just begun. Her hard work and unfailing enthusiasm contributed in no small way to the success of this crucial stage. Vesna Radanović-Kocić, a graduate student of Slavic languages and literatures, saw the project through to its completion. She transcribed over 2,000 handwritten cards into a coherent typescript. Her background provided her with ideal skills for dealing with challenges posed by this project. She also made

major contributions to the compilation of the indexes and, in general, displayed a positive attitude even in the most trying moments of her work.

This book owes a special debt to Mrs. Jelisaveta S. Allen. Her major bibliographical work, <u>Literature on Byzantine Art, 1892-1967</u>, is well known and justly acclaimed in scholarly circles. The beginning of my own work on this book would have been very difficult without it and her unpublished thesis on art and archeology in Yugoslavia, which she unselfishly put at my disposal. My particular thanks to Mrs. Allen for her continued support and professional advice.

Different endeavors, of necessity, bring together different people whose paths cross briefly in a collaborative effort. Close friends and members of one's family, however, are destined to witness more than one such undertaking. Passively or actively they become drawn into a process that often spans a number of years. Their collective support forms the foundation of this work. My wife, Susanne, as on many previous occasions, has stood at my side. Her help, particularly in the proofreading stage, is greatly appreciated, as is her constant patience and understanding.

This book is dedicated to my students, whose work and friendship were a major source of inspiration for me during my first decade as a teacher.

Princeton, N.J.
May 29, 1983

Principal Bibliographic Works

Allen, Jelisaveta S., ed. Literature on Byzantine Art, 1892-1967. 2 vols. Dumbarton Oaks Bibliographies Based on Byzantinische Zeitschrift, 1st ser. London: Mansell. Vol. 1, pt. 1 (1973), 499 pp.; pt. 2 (1973), 518 pp.; vol. 2 (1976), 586 pp.
 Considers the literature on all aspects of Byzantine art, architecture, and archeology in all parts of Europe, Asia, and Africa, where such art may be found. It includes the most comprehensive coverage to date of medieval art in Albania, Bulgaria, and Yugoslavia. Annotations are in German, in the same form as they appeared in the original entries in the Byzantinische Zeitschrift.

Georgieva, Sonia, and Velkov, Velizar. Bibliografiia na bŭlgarskata arkheologiia (1879-1966). 2d ed. Sofia: Bŭlgarska akademiia na naukite, 1974, pp. 160-200 (Medieval art).
 The most comprehensive bibliographical coverage of literature on Medieval art in Bulgaria to date.

Hamann-MacLean, Richard. Die Monumentalmalerei in Serbien und Makedonien vom 11. bis zum frühen 14. Jahrhundert: Grundlegung zu einer Geschichte der mittelalterlichen Monumentalmalerei in Serbien und Makedonien. Osteuropastudien der Hochschulen des Landes Hessen, 2d ser., vol. 4. Giessen: Wilhelm Schmitz, 1976. 351 pp., 66 appendix pp.
 The appendix includes, among other useful bibliographical data, an invaluable listing of all periodical and serial publications published in Yugoslavia (pp. 17-41). The material is presented by city and by publishing institution.

Principal Periodicals

Monumentet. Ministria e arësimit dhe e kulturës. Instituti i monu-
 menteve të kulturës (Tirana) 1 (1971-).

Studia albanica. Université d'État. Institut d'histoire et de lin-
 guistique (Tirana) 1 (1964-).

Studime Historike. Universiteti shtetëror i Tiranes. Instituti i
 historisë dhe i gjuhësisë (Tirana) 1 (1964-).

Arkh--Arkheologiîa. Bŭlgarska akademiîa na naukite. Arkheologi-
 cheski institut i muzei (Sofia) 1 (1959-).

Byzantino-Bulgarica. Académie bulgare des sciences. Institut
 d'histoire. Université de Sofia. Faculté de philosophie et
 d'histoire (Sofia) 1 (1962-).

GNAM--Godishnik na narodniîa arkheologicheski muzei. See GNM

GNM--Godishnik na narodniîa muzei. Naroden arkheologicheski muzei
 (Sofia) 1 (1919-). Superseded by Godishnik na narodniîa arkheo-
 logicheski muzei (Sofia) v.?, 19?-).

Izkustvo. Komitet za izkustvo i kultura. Sŭiuz na bŭlgarskite
 chudozhnitsi (Sofia) 1 (1945-).

IBAI--Izvestiîa na bŭlgarskiîa arkheologicheski institut. Bŭlgarska
 akademiîa na naukite. Arkheologicheski institut (Sofia) 1 (1910-
 1919/20), n.s. 1 (1921/22-).

Izvestiîa na institut za izobrazitelni izkustva. See IzvII

IzvII--Izvestiia na institut za izkustvoznanie. Bŭlgarska akademiia
 na naukite. Institut za izkustvoznanie (Sofia) 1 (1956-). From
 1-12, Izvestiia na institut za izobrazitelni izkustva.

MPK--Muzei i pametnitsi na kulturata. Komitet po kultura i izkustvo
 (Sofia) 1 (1961-).

PNI--Problemi na izkustvoto. Bŭlgarska akademiia na naukite.
 Institut za izkustvoznanie (Sofia) 1 (1968-).

Vekove. Nauka i izkustvo (Sofia) 1 (1972-).

<div align="center">YUGOSLAVIA</div>

AI--Archaeologia Iugoslavica. Societas archaeologica Iugoslaviae
 (Belgrade) 1 (1954-).

GSND--Glasnik skopskog naučnog društva. Skopsko naučno društvo
 (Skopje) 1-21 (1926-1940).

GZMS--Glasnik zemaljskog muzeja u Sarajevu. Zemaljski muzej u
 Sarajevu (Sarajevo) 1-55 (1889-1943); n.s. 1 (1945-). From 50-52
 (1938-1940), Glasnik zemaljskog muzeja Kraljevine Jugoslavije;
 from 52-55 (1940-1943), Glasnik hrvatskih zemaljskih muzeja u
 Sarajevu; n.s. 1 (1946), Glasnik državnog muzeja u Sarajevu;
 n.s. 2 (1947), Glasnik zemaljskog muzeja u Sarajevu.

Godišen zbornik. Filozofski fakultet (Skopje) 1 (1948-).

KN--Kulturno nasledstvo. Zavod za zaštita na kulturnite spomenici i
 prirodni retkosti vo N.R. (S.R.) Makedonija (Skopje) 1 (1959-).

NS--Naše starine. Zemaljski zavod za zaštitu spomenika kulture i
 prirodnih rijetkosti N.R. (S.R.) Bosne i Hercegovine (Sarajevo)
 1-13 (1953-1972).

Peristil. Zbornik radova za historiju umjetnosti i arheologiju
 (Zagreb) 1 (1954-).

PPUD--Prilozi povijesti umjetnosti u Dalmaciji. Konzervatorski zavod
 Dalmacije (Split) 1 (1947-).

RVM--Rad vojvodjanskih muzeja. Vojvodjanski muzej (Novi Sad) 1
 (1952-).

Saopštenja--Saopštenja zavoda za zaštitu i naučno proučavanje
 spomenika kulture N.R. (S.R.) Srbije. Republički zavod za
 zaštitu spomenika kulture (Belgrade) 1 (1956-).

Starinar. Srpsko arheološko društvo (Belgrade), 1st ser. 1-12 (1884-
 1895); 2d ser. 1-6 (1906-1911); 3d ser. 1-15 (1921-1940).

Principal Periodicals

Srpska akademija nauka. Arheološki institut (Belgrade) n.s. 1
(1950-).

Starine Crne Gore. Zavod za zaštitu spomenika kulture S.R. Crne Gore
(Cetinje) 1 (1963-).

SKM--Starine Kosova i Metohije. Pokrajinski zavod za zaštitu spo-
menika kulture Kosova i Metohije (Priština) 1 (1961-). From 6-7
(1972-1973), Starine Kosova.

SP--Starohrvatska prosvjeta. Hrvatsko starinarsko društvo (Knin)
1-13 (1895-1904); n.s. 1-2 (1927-1928). Jugoslavenska akademija
znanosti i umjetnosti. Muzej hrvatskih starina (Zagreb) 3d ser.
1 (1949-).

UP--Umetnički pregled. Muzej Kneza Pavla (Belgrade) 1, no. 1-4,
no. 2 (October 1937-February 1941).

Zbornik. Arheološki muzej na Makedonija. Arheološki muzej na
Makedonija (Skopje) 1 (1955/56-).

ZFF--Zbornik filozofskog fakulteta. Beogradski univerzitet. Filo-
zofski fakultet (Belgrade) 1 (1948-).

ZNM--Zbornik radova Narodnog muzeja. Narodni muzej (Belgrade) 1
(1958-). From 4 (1964), Zbornik Narodnog muzeja.

ZRVI--Zbornik radova vizantološkog instituta. Vizantološki institut
(until 1960 arm of Srpska akademija nauka) (Belgrade) 1 (1952-).

ZLU--Zbornik za likovne umetnosti. Matica srpska. Odeljenje za
umetnost (Novi Sad) 1 (1965-).

ZUZ--Zbornik za umetnostno zgodovino. Umetnostno-zgodovinsko društvo
(Ljubljana) 1-20 (1921-1944); Državna založba Slovenije
(Ljubljana) n.s. 1 (1951-).

ZZSK--Zbornik Zaštite spomenika kulture. Savezni (Jugoslovenski)
institut za zaštitu spomenika kulture (Belgrade) 1 (1950-). From
22-23 (1972-1973) published by Republički zavod za zaštitu spo-
menika kulture, Belgrade.

Zograf. Galerija fresaka (Belgrade) 1 (1966-). From 5 (1974) pub-
lished by Beogradski univerzitet. Filozofski fakultet. Institut
za istoriju umetnosti, Belgrade.

Balkans

GENERAL

1 Grabar, A[ndré]. <u>Recherches sur les influences orientales
 dans l'art balkanique</u>. Paris, 1928. 136 pp., 16 pls.
 A major study considering Islamic influences in the devel-
 opment of art during the Middle Ages in the Balkans. These in-
 fluences are detected in decorative ceramic titles, architectural
 sculpture and ornament of manuscript illumination. Particular
 prominence is given to the material excavated at Patleina,
 Bulgaria.

2 Grabar, André. <u>Die Mittelalterliche Kunst Osteuropas</u>. Kunst
 der Welt. Baden-Baden: Holle Verlag, 1968. 234 pp., 28 line
 drawings, 53 col. illus., 15 b&w pls.
 A general study which discusses the history of art and
 architecture of Eastern Europe, but focusing on the lands cul-
 turally bound to the Byzantine Empire--Bulgaria, Serbia,
 Macedonia, Rumania and Russia.

3 Korošec, J. "Arheološki sledovi slovanske naselitve na
 Balkanu" (Eng. sum.: "Archaeological Vestiges of Slav
 Settlement in Balkan"). <u>Zgodovinski časopis</u> 8 (1954):7-26
 (Eng. sum.: 25-26).
 In Slovenian. Discusses the problem of archeological dat-
 ing of early Slavic bronzes found on the territory of Yugoslavia
 and cautions against basing judgments on analogous material found
 elsewhere.

4 Millet, Gabriel, ed. <u>L'art byzantin chez les Slaves: Les
 Balkans</u>. 2 vols. Paris: Paul Geuthner, 1930. 415 pp.,
 illus.
 A major work including articles by several distinguished
 authors on various aspects of history, culture, language, art
 history, architectural history, etc. of the Slavic peoples in the
 Balkans. Also important are an Appendix (pp. 417-54) giving an
 art historical bibliography and a listing of major museums,

1

collections, and libraries in Yugoslavia, Bulgaria, and Rumania
as of 1930.

5 Molè, Vojeslav. Umetnost južnih Slovanov (Fr. sum.: "L'art
 des Slaves Méridionaux"). Translated from Polish by F. Vodnik.
 Ljubljana: Slovenska Matica, 1965. 587 pp., (Fr. sum.:
 555-84), 412 figs. in text.
 In Slovenian. A general history of art and architecture
 among the Balkan Slavs. A large section of the book (pp. 33-352)
 discusses the Middle Ages. Well-documented and illustrated, this
 book is a unique achievement in terms of its scope.

6 _____. "Zapadni Balkan v razvoju umetnosti srednjega veka"
 [Western Balkans in the development of medieval art]. ZUZ 5,
 nos. 1-2 (1925):30-43 (Fr. sum.: 30-31).
 In Slovenian. A general introduction to the contribution
 of the Western Balkans to the development of medieval art.

7 Okunev, N.L. "Niekotoriia cherti vostochnikh vliianii v
 sredneviekovom iskusstvie iuzhnikh Slavian" [Some aspects of
 Eastern influence in medieval art of South Slavs]. Sbornik v
 chest na Vasil N. Zlatarski (Sofia) (1925):229-51.
 In Russian. Identifies certain features in architecture,
 architectural decoration, and in painting of medieval Balkans
 which are attributed to Eastern influence in the region.

8a Strzygowski, J. "Balkankunst: Das Ende von Byzanz und der
 Anfang des Neuhellenismus in Europa." Revue internationale
 des études bakaniques 1, no. 2 (1935):348-59.
 An article by the controversial historian who portrays the
 Balkans as a cultural bridge between the East and the West.

8 Wessel, Klaus, ed. Kunst und Geschichte in Südosteuropa.
 Südosteuropa-Jahrbuch: Im Namen der Südosteuropa Gesell-
 schaft, 10. Recklinghausen: Aurel Bongers, 1973. 174 pp.
 150 b & w and color illus. in text.
 A series of independent essays written by different schol-
 ars on various aspects of medieval history and art of South-
 Eastern Europe. Illustrated with excellent photographs.

ARCHITECTURE

9 Bošković, Djurdje. "L'architecture de la basse antiquité et
 du moyen âge dans les régions centrales des Balkans." Actes
 du XIIe Congrès international d'études byzantines (Belgrade) 1
 (1963):155-63.
 A brief general survey of major monuments and problems.

10 Ćurčić, S[lobodan]. "The Twin-domed Narthex in Paleologan
 Architecture." ZRVI 13 (1971):333-44.
 The twin-domed narthex is identified as a distinctive form
 of Late Byzantine church architecture while its geographic

spread is found to be limited to the Balkan peninsula (Mt. Athos, Thessaloniki, Nikopol, and Spasovica).

11 Dechevska, Neli Chaneva. "Po vŭprosa za srednovekovnite tri-konkhalni tsŭrkvi ot manastirski tip na Balkanite" [Medieval trefoil churches of the monastic type in the Balkans]. MPK 11, no. 1 (1971):10-15 (Fr. sum.: 75-76).
 In Bulgarian. Distinguishes two larger families of monastic trefoil churches in the Balkans--the earlier found in Bulgaria and Greece and the later in Serbia and Rumania.

12 Grabar, A[ndré]. "L'architecture balkanique avant et après les invasions à la lumière des découvertes récentes." Comptes rendus. Académie des inscriptions et belles-lettres, (April-June 1945):270-87.
 Considers certain unique monuments of Balkan architecture from the early Christian era to the beginning of the Middle Ages in the light of the recent archeological discoveries at the time (Caričin grad--Episcopal Basilica with a martyrium [?], Hissar Banja--basilica with a cruciform crypt, and the church of S. Nikon at Sparta with a martyrium).

13 Mijatev, Krsto. "L'architecture de la basse antiquité et du haut moyen âge dans les Balkans." Actes du XII^e Congrès international d'études byzantines (Belgrade) 1 (1963):387-407.
 Refutes the ideas of Bošković, Stričević, and Nikolajević presented in the main papers at the same Congress. Argues for the existence of an early Christian architectural revival during the reign of the Bulgarian Emperor Symeon.

14 Stojković, Ivanka Nikolajević. "L'ornament architectural de la basse antiquité et du moyen âge dans les régions centrales et orientales de la Péninsule Balkanique." Actes du XII^e Congrès international d'études byzantines (Belgrade) 1 (1963): 241-47.
 An examination of certain revival phenomena in medieval architectural sculpture of the central and eastern Balkans, with an attempt to re-date some of the material (e.g., the Round Church at Preslav) to the sixth century.

15 Stričević, Djordje. "I monumenti dell'arte paleobizantina in rapporto con la tradizione antica ed all'arte medioevale nelle regioni centrali dei Balcani." ZRVI 8, pt. 2 (1964):399-415.
 Certain phenomena in church architecture of the ninth and tenth centuries (e.g., appearance of basilicas and triconch churches) are viewed as deliberate revivals of certain early Christian types. Such conscious revivals are linked to specific political circumstances and politico-religious ideologies.

16 _____. "La rénovation du type basilical dans l'architecture
ecclésiastique des pays centrales des Balkans au IX^e-XI^e
siècles." Actes du XII^e Congrès international d'études
byzantines (Belgrade) 1 (1963):165-211.

A major study considering the problem of the revival of the
basilica as a church type in the central Balkans between the
ninth and the eleventh centuries. The earliest phase of this
revival, according to the author, coincides with the period of
the conversion of the Slavs and the foundation of the First
Bulgarian Empire under Boris. The basilica in that context
performed a role comparable to that in the fourth century after
Christianity had become the official religion in the Empire under
Constantine the Great. In later times, after the Byzantine re-
conquest of the central Balkans in the eleventh century, the
basilica became an archaizing church type whose life continued in
the following two centuries.

PAINTING

17 Bakalova, E[lka]. "La vie de Sainte Parasceve de Tirnovo dans
l'art Balkanique du bas Moyen Age." Byzantino-Bulgarica 5
(1978):175-209.

Considers the wide popularity of the life of St. Parasceve
(text written by Bulgarian Patriarch Euthemius) in late medieval
painting of the Balkans (Bulgaria, Serbia, Rumania) in the light
of its religious and "popular" connotations.

18 Chatzidakis, Manolis. "Classicisme et tendances populaires au
XIV^e siècle: Les recherches sur l'évolution du style." Actes
du XIV^e Congrès international des études byzantines (Bucharest)
1 (1971):153-88.

A "state-of-the-scholarship" article which assesses Byzan-
tine fourteenth-century painting by period (1300-1330; 1330-1360;
1360-1400) and by region, and identifies classicizing versus
popular tendencies in artistic expression.

19 Harisijadis, Mara. "Raskošni vizantijski stil u ornamentici
južnoslovenskih rukopisa iz XIV i XV veka" (Fr. sum.: "Le
style somptueux de Byzance dans l'ornamentation des Slaves
Méridionaux"). In Moravska škola i njeno doba. Belgrade:
Filozofski fakultet, Odeljenje za istoriju umetnosti, 1972,
pp. 211-27 (Fr. sum.: 227).

In Serbo-Croatian. Considers stylistic characteristics of
ornamental decorations in fourteenth- and fifteenth-century
Serbian and Bulgarian manuscripts. The source of this sumptuous
decorative style is considered to have been Constantinople.

20 Ilina, Tatiana. "Za grafichnata ukrasa v bŭlgarskite,
 sŭrbskite i ruskite rŭkopisi v sbirkite na Leningrad i
 Moskva" (Fr. sum.: "Sur l'ornamentation graphique des manu-
 scrits bulgares, serbes et russes des collections de Leningrad
 et de Moscou"). IzvII 5 (1962):89–107 (Fr. sum.: 109–10).
 In Bulgarian. Discusses the fact that manuscript orna-
 mentation of Novgorod and Pskov between the twelfth and fourteenth
 centuries is characterized by interlace inhabited by beasts. Such
 ornamentation flourishes also in the Balkans during the twelfth
 and thirteenth centuries, but while it reaches its apogee in
 Russia during the fourteenth century, it virtually disappears in
 the Balkans at that time.

21 Krestev, Cyrille. "Sur la Renaissance balkanique aux XIIIe et
 XIVe siècles." Actes du XIIe Congrès international d'études
 byzantines (Belgrade) 3 (1964):205–11.
 Argues that a "Renaissance in the Balkans" in the thir-
 teenth and fourteenth centuries produced three types of art:
 monuments of Paleologan type, monuments characterized by local
 classicism, and monuments of popular painting.

22 Millet, Gabriel. "L'art des Balkans et l'Italie au XIIIe
 siècle." Studi bizantini e neoellenici (Rome) 6 (1940):
 272–97. Atti del V Congresso internazionale di studi
 bizantini.
 An important pioneering endeavor attempting to establish
 links between the Byzantine painting tradition in the central
 Balkans and Italian painting in the course of the thirteenth
 century.

23 Mošin, Vladimir. "Ornamentika neovizantiskog i 'balkanskog'
 stila" [Neo-Byzantine and "Balkan"-style ornament]. Godišnjak.
 Naučno društvo Bosne i Hercegovine. Balkanološki institut 1
 (1956):295–351.
 In Serbo-Croatian. A major article discussing the ornament
 in Balkan manuscript illumination from the thirteenth to the
 eighteenth centuries.

24 Radojčić, S[vetozar]. "Der Klassizismus und ihm entgegenge-
 setzte Tendenzen in der Malerei des 14. Jahrhunderts bei den
 Ortodoxen Balkanslaven und der Rumänen." Actes du XIVe Con-
 grès international des études byzantines (Bucharest) 1 (1974):
 189–205.
 Discusses classicizing and related tendencies in fourteenth-
 century Byzantine painting of Serbia, Bulgaria, and Rumania.
 Regional distinctions are identified and related to particular
 historical circumstances which caused their creation.

MINOR ARTS

25 Fekher, Geza ml. "Prinos kŭm izuchvaneto na zlatarstvoto na
 balkanite ot XVI-XVII v." (Fr. sum.: Contribution a l'etude
 de l'orfevrerie dans les Balkans pendant le XVIe- XVIIe s.").
 IBAI 32 (1970):5-53 (Fr. sum.: 52-53).
 In Bulgarian. A broad analysis of Balkan silverwork after
 the Turkish conquest. Considers sources of this art from the
 point of view of its forms, decorative motives, and the tech-
 niques used.

26 Miatev, Krsto. "Dekorative Keramik in Byzanz." Studi
 Byzantini e Neoellenici (Rome) 6 (1940):266-71. Atti del
 V Congresso internazionale di studi bizantini 2.
 Discusses links between decorative ceramic tiles found in
 Bulgaria and Constantinople, and suggests links with the Near
 East.

27 Stojanovic, Dobrila. "Les elements orientaux sur les brode-
 ries religieuses des pays Balkaniques jusqu'a la fin du XVIIe
 siecle." Actes du XIVe Congres international des etudes
 byzantines, 1971 (Bucharest) 3 (1976):434-44.
 A brief general consideration of oriental aspects in the
 religious embroideries in the Balkans during the Middle Ages.
 Provides up-to-date literature on the subject.

ICONOGRAPHY

28 Beljaev, Nicolas. "Le 'Tabernacle du Temoignage' dans la
 peinture balkanique du XIVe siecle." L'art byzantin chez les
 Slaves: Les Balkans 1, pt. 2, Paris: Paul Geuthner, 1930,
 pp. 315-24.
 The Old Testament Tabernacle as a prefiguration of the New
 Testament and its iconography is discussed in relationship to the
 medieval painting in the Balkans. The central example is the
 Tabernacle fresco at Curtea de Argeş in Rumania.

29 Iliopoulou, Rogan Dora. "Peinture murale de la periode des
 Paleologues representant d'une maniere originale la partie
 majeure de l'office liturgique." Actes du XIVe Congres inter-
 national des etudes byzantines, 1971 (Bucharest) 3 (1976):
 419-26.
 An analysis of the iconography of the representation of the
 Holy Liturgy in Byzantine painting of Paleologan era.

30 Ljubinkovic, Mirjana Corovic. "Odraz kulta Cirila i Metodija
 u balkanskoj srednjevekovnoj umetnosti" (Eng. sum.: "Reflex
 of Cyril's and Methodius' cult in Balkan Medieval Art"). In
 Simpozium 1100-godišnina od smrtta na Kiril Solunski 1. Ed-
 ited by H. Polenakovic et al. Skopje: Makedonska akademija
 na naukite i umetnostite (1970):123-30 (Eng. sum.: 130).

In Serbo-Croatian. Rarity of representations of SS. Cyril
and Methodius and the limited extent of their cult are seen as
the result of the suppression of their cult by the Patriarchate
in Constantinople. The cult was supported, on the other hand, by
Rome, and was occasionally used as a means of combating Constan-
tinopolitan influence.

31 Ştefănescu, J.D. "L'illustration des liturgies dans l'art de
 Byzance et de l'Orient." Annuaire de l'institut de philologie
 et d'histoire orientales (Université libre de Bruxelles) 1
 (1932):21-77.
 An extensive study of the iconography of liturgy in the art
 of Byzantium and the Christian East. The study is of the broadest
 geographical and cultural scope and includes all art forms. Much
 of the material discussed is from the Balkans.

32 _____. "L'illustration des liturgies dans l'art de Byzance et
 de l'Orient." Annuaire de l'institut de philologie et
 d'histoire orientales (Université libre de Bruxelles) 3
 (1935):403-508.
 The continuation of the extensive study of the iconography
 of liturgy in the art of Byzantium and the Christian East. See
 entry BA 31.

Albania

GENERAL

1 Adhami, S. Monumente të kultures në Shqiperi [Cultural monu-
 ments in Albania]. Tirana: Ministria e arësimit dhe kulturës,
 1958. 177 pp., 143 illus.
 In Albanian. A guide book organized in two parts:
 archeological monuments and architectural monuments (medieval
 and Turkish). The book is profusely illustrated but most photo-
 graphs are of poor quality.

2 Albania. Guida d'Italia della Consociazione Turistica
 Italiana. Milan: Consociazione Turistica Italiana, 1940.
 221 pp., 7 maps, 6 city plans, 2 building plans.
 A useful though outdated guidebook. The material is well
 organized and indexed. Excellent regional maps and city plans
 fill the gap created by the lack of such information in more re-
 cent times.

3 Anamali, Skënder. "Genesis of the Albanians and Archaeologi-
 cal Data." New Albania 25, no. 3 (1971):32-33.
 A brief summary of a noted Albanian archeologist-historian's
 thesis that Albanians are direct ethnic descendants of ancient
 Illyrians. Much of Anamali's field work and writing has been
 devoted to the problem of the genesis of modern Albanians.

4 ____. "Les nouvelles découvertes archéologiques sur les
 rapports des albanais avec Byzance dans le haut moyen âge."
 Studia albanica 9, no. 1 (1972):135-141. Also in Bulletin
 d'archéologie sud-est européene 2 (1971):11-35.
 Discusses the "relations" between Byzantium and Albania in
 the sixth and seventh centuries. Most of the archeological ma-
 terial confirms Byzantine presence in this area at the time.

5 _____. "Mbi kulturën e hershme shqiptare" (Fr. sum.: "Sur la civilisation haute-médiévale albanaise"). <u>Studime Historike</u> 23 (6), no. 2 (1969):155-169 (Fr. sum.: 166-69).
 In Albanian. Considers two fundamental issues: 1) the question of presence of Slavic antiquities in the excavated necropolis at the Fortress Dalmace (Koman) and 2) new opinions regarding early-medieval civilization of Albania.

6 Buda, Aleks, et al. <u>L'art albanais à travers les siècles</u>. Exhibition catalog. Paris: Petit Palais, [1974?], not paginated.
 Catalog of an exhibition of Albanian art from prehistoric times through the twentieth century. A section on the Middle Ages, written by D. Dhamo, discusses and illustrates a number of icons, wood carvings, and metal objects.

7 Ceka, Hasan, and Jubani, B. "Fouilles archéologiques 1970-71 en Albanie." <u>Bulletin d'archéologie sud-est européenne</u> 3 (1975):11-25.
 Section 3 (pp. 21-25) discusses late Antiquity and the early Middle Ages. Of particular interest is the early Christian basilica et Elbasan (Scampinus) (p. 22). Other entries discuss limited excavations within known sites.

8 Degrand, A. <u>Souvenirs de la Haute-Albanie</u>. Paris: H. Welter, 1901. 329 pp., 81 figs.
 A general study of Northern Albania, largely focusing on folklore, customs, etc. Parts of the book are devoted to buildings, many of which are illustrated by photographs of rare documentary value (e.g., SS. Sergius and Bacchus).

9 Ducellier, A. "Observations sur quelques monuments de 1'Albanie." <u>Revue archéologique</u> 2 (1965):153-207.
 A thorough survey of major monuments and archeological sites in Albania from ancient to Turkish times. Particular attention is given to the Byzantine monuments at Butrinti, Mesopotami, Berat, Voskopojë, and Mborjë.

10 Ippen, Theodor. "Alte Kirchen und Kirchenruinen in Albanien." <u>Wissenschaftliche Mitteilungen aus Bosnien und der Herzegovina</u> 7 (1900):231-41.
 Ruins of the church of SS. Sergius and Bacchus at Schirigi (near Shkodër), the church at Schass (Šas), the church at Rubig, and the church at Lači (Danj) are discussed. The article is illustrated with photographs which have a documentary value.

11 _____. "Alte Kirchen und Kirchenruinen in Albanien." <u>Wissenschaftliche Mitteilungen aus Bosnien und der Herzegovina</u> 8 (1902):131-44.
 A discussion of the remains of the church of St. Nicholas at Schati, the ruins of the tower of Schurza, the church ruins

in Ostrosch, and the ruins of the church of St. John at Raschi.
The work is basically an archeological-topographical study and is
illustrated with photographs which have a documentary value.

12 . "Historički gradovi u Albaniji" [Historic towns in
 Albania]. Glasnik Zemaljskog muzeja u Bosni i Hercegovini 14
 (1902):177-99.
 In Serbo-Croatian. Considers four medieval fortified
 towns: 1) Skadar (Shkodër), 2) Leši (Alessio Lesh), 3) Kroja
 (Krujë, and 4) Petreila (Petrelë).

13 . "Još nešto o starim crkvama u Šasu i Rubigu u
 Albaniji" [Further remarks regarding the churches of Šas and
 Rubig in Albania]. Glasnik Zemaljskog muzeja u Bosni i
 Hercegovini 14 (1902):552-57.
 In Serbo-Croatian. Discusses ruined churches at Svacia
 (Šas, now in Yugoslavia) and Rubig.

14 . "Stare crkve i crkvene ruševine u Albaniji" [Old
 churches and church ruins in Albania]. Glasnik Zemaljskog
 muzeja u Bosni i Hercegovini 13 (1901):577-88.
 In Serbo-Croatian. Considers the monastic complex with the
 church of St. Anthony on Kapi-i-Rodonit (Rodoni, Cape Rodoni) and
 the ruins of the church of St. Elijah in the valley of the Ishm
 river near Krujë.

15 . "Stare crkvene ruševine u Albaniji" [Old church ruins
 in Albania]. Glasnik Zemaljskog muzeja u Bosni i Hercegovini
 12 (1900):83-98.
 In Serbo-Croatian. Discusses the ruins of the church of
 St. Nicholas at Shati; the fortification and church ruins at
 Shurdhah (Šurce); the church ruins at Ostroš, now in Yugoslavia
 (church known as Bogorodica Krajinska, and believed to have been
 the burial church of Prince Vladimir of Zeta); and the church of
 St. John in Raši.

16 . "Starine iz Albanije" [Antiquities from Albania].
 Glasnik Zemaljskog muzeja u Bosni i Hercegovini 13 (1901):
 117-20.
 In Serbo-Croatian. Considers a church (?) ruin at
 Çafkishë, north of Shkodër (Scutari, Skadar), as well as two
 medieval stone sculpture fragments: a squatting lion and a bird
 (a pigeon?) in Shkodër, but brought there from other locations.

17 . "Stari spomenici u Albaniji" [Old monuments in
 Albania]. Glasnik Zemaljskog muzeja u Bosni i Hercegovini 12
 (1900):511-31.
 In Serbo-Croatian. Discusses the following medieval items:
 a Byzantine medallion discovered in the vicinity of Shkodër de-
 picting three military saints (Theodore, George and Demetrius);
 a small church ruin in the village of Skjä; the church of the

Virgin in the village Še Mri near Krujë (one of the largest and
finest medieval monuments in Albania); the church ruin of St.
Michael between the villages of Delbinisht and Milot; the monas-
tery church of St. Anthony near Lesh (Alessio); the fortified
town of Drisht (Drivastum); and an interesting trefoil chapel.

18 Koder, J., and Trapp, E. "Bericht über eine Reise nach Süd-
 albanien." Jahrbuch der Österreichischen byzantinischen
 Gesellschaft 15 (1966):391-94.
 This brief report is based on a two-month visit to Albania
 in 1965 during which the authors were permitted to visit several
 Byzantine and post-Byzantine monuments, and to record the sur-
 viving Greek manuscripts preserved in the state archives in
 Tirana. In addition to listing the monuments, the authors give
 dates and record frescos, icons, wood carvings, and other works
 of art found in the respective monasteries and churches.

19 Korkuti, Muzafer. "Fouilles archéologiques 1967-1969 en
 Albanie." Studia Albanica 8, no. 1 (1971):129-59 [pp. 153-59
 discuss the Middle Ages]. Also in Bulletin d'archéologie sud-
 est européenne 2 (1971):11-35.
 A summary report of archeological excavations in 1967-1969.
 Sites discussed are Shurdhah, Lin on Lake Ohrid (esp. three-
 aisled basilica with floor mosaics dated around 500), and
 Pogradec.

20 _____. Shqiperia Arkeologjike. Tirana: Universiteti
 shteteror i Tiranes, Instituti i Historise dhe i Gjuhesise
 sektori i Arkeologijise, 1971. xi pp., 139 illus.
 In Albanian. A popular publication with parallel texts in
 Albanian, French, and English, and with 139 fine black-and-white
 and color photographs. An excellent guide for quick appreciation
 of major archeological monuments of Albania.

21 Mustilli, Domenico. "Viaggiatori e archeologi italiani in
 Albania." Romana 3, no. 9 (1939):535-41.
 Briefly surveys major Italian travelers and archeologists
 whose work was related to Albania. The survey opens with the
 fifteenth-century Ciriaco dei Pizzicolli di Ancona, and concludes
 with the extensive contemporary archeological undertakings of
 Luigi M. Ugolini during the Italian occupation of Albania in the
 1930s.

22 Nopcsa, Franz Baron. Albanien: Bauten, Trachten und Geräte
 Nordalbaniens. Berlin and Leipzig: W. de Gruyter and Co.,
 1925. 238 pp., illus.
 A study of a basically ethnographical character. A large
 section (pt. 1, pp. 3-93) is devoted to vernacular domestic
 buildings with an analysis of planning, construction and various
 details (e.g., hearths, wood details, etc.). The book includes
 extensive bibliography on domestic buildings (pp. 240-243).

23 Pace, B. "Gli scavi archeologici i Albania (1924-43)." <u>Atti</u>
 <u>dell'Accademia nazionale dei Lincei. Classe di scienze morali,</u>
 <u>storiche e filologiche. Rendiconti</u> 348 [8.F. Vol. 6] (1951):
 325-37.
 Discusses the main accomplishments of the Italian archeo-
 logical mission in Albania (during the period of Italian occupa-
 tion of Albania), and provides a useful bibliography of Italian
 literature on the subject between 1927 and 1950.

24 Pallas, D.I. "Epiros." In <u>Reallexikon der byzantinischen</u>
 <u>kunst</u>. Vol. 2. Edited by K. Wessel and M. Restle. Stuttgart:
 Anton Hiersemann, 1970, pp. 207-334.
 An exhaustive article which discusses monuments of early
 Christian and Byzantine Epirus (at present divided between Greece
 and Albania). The article takes into account all relevant liter-
 ature (important bibliography appended) and illustrates most of
 the monuments.

25 Patsch, Carl. <u>Das Sandschak Berat in Albanien</u>. Schriften der
 Balkankommission, Antiquarische Abteilung, 3. Vienna:
 Hölder, 1904. 200 pp., 180 illus., map.
 Considers various cultural aspects of the region, from
 ancient to modern times. Greek and Roman antiquities are given
 the greatest amount of space, though passing references are made
 to medieval and post-medieval monuments.

26 Praschniker, Camillo. "Muzakhia und Malakastra:
 Archäologishe Untersuchungen in Mittelalbanien." <u>Jahreshefte</u>
 <u>des österreichischen archäologischen Instituts</u> 21-22 (1920):
 6-224.
 An exhaustive topographical-archeological survey of the
 central region of Albania. Offers valuable information on
 geography and history of the region. Especially relevant is the
 material on Apollonia, Byllis, and Kljoš.

27 Praschniker, C., and Schober, A. <u>Archäologische Forschungen</u>
 <u>in Albanien und Montenegro</u>. Schriften der Balkan Kommission.
 Antiquarische Abteilung, Heft 8. Vienna: Akademie der Wis-
 senschaften, 1919. 101 pp., 116 figs.
 An archeological survey of the coastal region of Albania
 and Montenegro. Sketchy plans of several fortifications (e.g.,
 Vigu, Lissos, Elbassan, etc.) are of interest. Other illustra-
 tions include photographs of walls, architectural and sculptural
 fragments.

28 Sestieri, P.C. "Esplorazioni archeologiche in Albania nel
 1941-42." <u>Rivista d'Albania</u> 3 (1942):151-61.
 A brief survey of Italian archeological achievements in
 Albania during 1941-42. The material is presented by regions:
 vicinity of Tirana, district of Sulova, district of Dumree, and
 district of Malakastra.

29 Šufflay, Milan V. Städte und Burgen Albaniens hauptsächlich
 während des Mittelalters. Denkschriften. Akademie der
 Wissenschaften in Wien, Phil.-hist. Kl., Vol. 63, no. 1,
 1927. 82 pp.
 The major historical study of Albanian towns and fortifica-
 tions during the Middle Ages. The book considers Albanian cities
 in the context of the Mediterranean civilizations. Medieval
 cities are considered both as survivals of Antiquity and as new
 foundations.

ARCHITECTURE

30 Baçe, A. "Fortifikimet e antikitetit të vonë në vendin tonë"
 (Fr. sum.: "Fortifications de la basse antiquité en Albanie").
 Monumentet 11 (1976):45-74 (Fr. sum.: 69-74).
 In Albanian. An extensive study of the 118 known fortifi-
 cations of the late Antiquity on the territory of Albania. Con-
 siders the layout and function as well as the technical aspects
 of construction. The fortifications are also considered in the
 context of a large defensive network created and maintained from
 the fourth to the sixth centuries in Epirus.

31 Baçe, Apollon. "Kështjellat e Kardhiqit dhe Delvinës" (Fr.
 sum.: "Les forteresses de Kardhiq et de Delvine"). Monu-
 mentet 13 (1977):55-69 (Fr. sum.: 67-69).
 In Albanian. An analysis of two important medieval
 fortresses, which also provides a general picture of medieval
 (eleventh to fourteenth centuries) fortification architecture in
 the area.

32 Karaiskaj, G. "Mbi fortifikimet e vona antike të vendit tonë"
 (Fr. sum.: "À propos des fortifications de la basse antiquité
 de notre pays"). Monumentet 12 (1976):221-28 (Fr. sum.:
 226-28).
 In Albanian. A discussion of fortresses and types of
 towers between the fourth and sixth centuries.

33 Meksi, Aleksandër, and Thomo, P. "Arkitektura pasbizantine në
 Shqipëri" (Fr. sum.: "L'architecture postbyzantine en
 Albanie"). Monumentet 11 (1976):127-45 (Fr. sum.: 142-45).
 In Albanian. Surveys post-Byzantine church architecture in
 Albania. Churches are grouped by types. Plans of churches are
 illustrated; some sections are also included.

34 Meksi, Aleksandër. "Dy bazilika mesjetare të panjohura" (Fr.
 sum.: "Deux basiliques inconnues"). Monumentet 13 (1977):
 71-84 (Fr. sum.: 81-84).
 In Albanian. Considers two Byzantine churches--at Perhondi
 and at Sulove--and discusses them as "basilicas," although their
 architecture suggests other characteristics. The buildings are
 dated toward the end of the thirteenth century.

35 Mušič, Marijan. "Gradivo za proučavanje srbske srednjeveške
 arhitekture v okolici Skadra" (Fr. sum.: "Contribution à
 l'étude de l'architecture médiévale serbe des environs de
 Scutari"). Zbornik zaštite spomenika kulture 2 (1952):177-86
 (Fr. sum.: 186).
 In Slovenian. Discusses the churches of the Virgin at Danj
 (Vaudjns) and SS. Sergius and Bacchus in the vicinity of Shkodër,
 both Serbian foundations from the late thirteenth or early four-
 teenth century. The Romanesque-Gothic style of this architecture
 reveals strong influence of South Italy (esp. Apulia). Measured
 drawings of both churches are presented.

36 Strazimiri, Burham; Nallbani, H.; and Ceka, N. Monumente të
 arkitekturës në Shqipëri [Architectural monuments in Albania].
 Tirana: Instituti i monumenteve të kulturës, 1973. 27 pp.,
 162 pls.
 Brief parallel texts in Albanian, French, and English. A
 pictorial survey of the architectural heritage of Albania. Il-
 lustrations (color and black-and-white) are excellent. A large
 proportion of photographs is devoted to Early Christian, Byzan-
 tine and post-Medieval (Islamic and vernacular) monuments, many
 of which have not been adequately illustrated in older publica-
 tions.

37 Thomo, Pirro. "Arkitekture e banesave fshatare në Has" (Fr.
 sum.: "L'architecture des habitations rurales dans la région
 de Has"). Studime Historike 29 (12), no. 1 (1975):111-40 (Fr.
 sum.: 139-40).
 In Albanian. Discusses a regional development in vernacu-
 lar architecture. Considers several building types, including
 their planning, structural and constructional principles and
 methods, and materials used in construction. Drawings provide
 excellent documentation of relevant material.

38 _____. "L'architecture rurale albanaise: Ses types et leur
 diffusion." Studia Albanica 11, no. 1 (1974):103-18.
 Discusses vernacular architecture, its types and their
 distribution. Material is organized into two large categories:
 open dwellings and enclosed dwellings. The material is relevant
 for study of vernacular architecture in other parts of the
 Balkans.

39 _____. "Banesa popullore e tipit kullë në Mat dhe në Mirditë"
 (Fr. sum.: "L'habitation populaire de type kulle Moti et dans
 la Mirdite"). Studime Historike 24 (7), no. 1 (1970):127-42
 (Fr. sum.: 140-42).
 In Albanian. Discusses a residential building type charac-
 terized by the presence of fortification elements, and argues that
 the type evolved out of local conditions and was not a result of
 external influence.

40 _____. "Mbi dy monumente të arkitekturës sonë mesjetare në
 shek. XI-XIV" (Fr. sum.: "Deux monuments de notre architec-
 ture médiévale des XI-XIV siècles"). Studime Historike 26
 (9), no. 4 (1972):51-62 (Fr. sum.: 60-62).
 In Albanian. Considers the church of the Virgin at the
 village of Kosinë (not later than twelfth century) and the church
 of the Trinity at Berat (second half of the thirteenth or first
 half of the fourteenth century). The churches show clear affini-
 ties with church architecture of Kastoria and Ohrid respectively.

41 Urban, Martin. Die Siedlungen Südalbaniens. Tübingen geo-
 graphische und geologische Abhandlungen, 2d ser. 4. Öhringen:
 1938. 186 pp., 65 illus., 6 maps.
 Part 1 (pp. 29-122) discusses rural architecture of South
 Albania and its setting. It analyzes house forms in considerable
 detail, treats construction of building materials, and finally
 considers material in its social setting. A separate section is
 devoted to farmsteads (Gehöfte), and others to the form of vil-
 lages, towns, and markets.

42 Versakēs, Fr. "Byzantiakoi naoi tēs voreion Epeiron"
 [Byzantine Churches of Northern Epirus]. Archaiologikē
 ephēmeris, 3d ser. (1916):108-17.
 In Greek. Considers two important Middle-Byzantine monu-
 ments in North Epirus, now part of Albania--the Koimesis at
 Labove (Ano Labovo) and the Episkopi at Dropolis. The churches
 (dated to the twelfth century by the author) feature conservative
 plans recalling solutions of the seventh and eighth centuries.
 The church at Labove is further characterized by exceptionally
 fine decorative use of tile work on the exterior.

43 Vokotopoulos, Panagiotis L. Hē ekklesiastikē architektonikē
 eis tēn dutikēn sterean Hellada kai tēn Epeiron apo tou telous
 tou 7ou mechri tou telous 10ou aiōnos [Church architecture of
 mainland Greece and Epirus from the middle of the seventh to
 the middle of the tenth century]. Byzantina mnēmeia, 2.
 Thessalonica: Kentron byzantinōn eregnōn, 1975. 213 pp.,
 59 pls.
 In Greek. A detailed study of Byzantine church architec-
 ture in western Greece and Epirus. Includes two major monuments
 in Albania--the Koimēsis at Labove (pp. 86-92 and 193-96) and the
 Episkopi at Dropolis (pp. 74-80 and 188-89). The author redates
 the two monuments to the tenth century, from the twelfth century
 dating proposed by Versakes (see AL 42).

PAINTING

44 Ago, Saide. "Tri ikona të tipit 'Hodigitria'" (Fr. sum.:
 "Trois icones du type Hodigitria"). <u>Studime Historike</u> 20
 (3), no. 1 (1966):133-40.
 In Albanian. Considers three icons related by iconographic
type: the Virgin of Maliq (fourteenth century?), the Virgin of
Maligrad (fourteenth century), and the Virgin of Floq (eighteenth
century). The author attempts to identify distinctive national
reasons for the more humanistic expression of the type which
evolved over a span of three centuries.

45 Dhamo, Dhorka. "Piktura e Onufër Qipriotit në kishën e
 Vllaho-Goranxise" (Fr. sum.: "Les peintures d'Onufre le
 Chypriote à l'église de Vlahi-Goranxi"). <u>Studime Historike</u> 32
 (15), no. 1 (1978):229-42 (Fr. sum.: 240-42).
 In Albanian. The post-Byzantine church of the Dormition of
the Virgin at Vlaho-Goranxi preserves paintings of the painter
Onofrios the Cypriot and a painter Alivisos (his aide?). The
work is dated to the year 1622. The work of Onofrios the Cypriot
contrasts with that of the better known Onofrios of Neokastra in
its calmness and greater restraint.

46 Djurić, Vojislav J. "Mali Grad--Sv. Atanasije u Kosturu--
 Borje" (Fr. sum.: "Mali Grad--Saint Athanse à Kastoria--
 Borje"). <u>Zograf</u> 6 (1975):31-50 (Fr. sum.: 49-50).
 In Serbo-Croatian. Reconstructs a workshop active in the
western part of Macedonia during the declining period of the
Serbian Empire in the 1360s. The painters are believed to have
received their formal training in Thessaloniki. Their patrons
were Serbian, Albanian and Greek aristocrats and clergymen.

47 Nallbani, Hasan. "Të dhëna të reja për veprimtarinë e piktor
 Onufrit të përftuara gjatë restaurimit" (Fr. sum.: "Données
 nouvelles sur l'activité du peintre Onufri recueillies pendant
 les travaux de restauration"). <u>Monumentet</u> 13 (1977):83-93
 (Fr. sum.: 92-93).
 In Albanian. The activity of the painter Onofrios is dis-
cussed in the light of recent findings. His career is seen as
extending the "Paleologan Renaissance" into the sixteenth cen-
tury.

48 "Onufri: A Noted Painter of the XVIth Century." <u>New Albania</u>
 16, no. 6 (1972):26-27.
 A brief notice of the painter Onofrios, illustrated with
four fine color reproductions of three of his icons (Raising of
Lazarus, Nativity, and Baptism) and a detail of a fresco showing
St. Basil.

49 Popa, Theofan. "L'École de Korçe et sa tradition dans la
 peinture ëcclesiale." Deuxième conférence des études albano-
 logiques (12-18 Jan. 1968). Vol. 2. Edited by A. Kostallari
 et al. Tirana: Université d'état de Tirana, Institut
 d'histoire et de linguistique, 1970, pp. 121-149.
 Discusses the influence of late Byzantine frescoes on the
 "painting school" of Korçe which flourished in the eighteenth and
 nineteenth centuries.

50 _____. "Elemente laike dhe realiste në pikturën tonë
 mesjetare" (Fr. sum.: "Éléments laïques et réalistes dans
 notre peinture médiévale"). Studime Historike 26 (9), no. 1
 (1972):129-56 (Fr. sum.: 153-55).
 In Albanian. Treats a wide range of "popular" motifs over
 a long time span from the tenth (possibly sixth or seventh cen-
 tury) to the late eighteenth century.

51 _____. "Onufre, une figure éminente de la peinture médiévale
 albanaise." Studia Albanica 3, no. 1 (1966):291-309.
 The author sees Onofrios as a painter rooted in the best
 of the Byzantine painting tradition, but also strongly influenced
 by the Italian Renaissance.

52 Popa, Th[eofan]. Piktorët mesjetarë shqiptarë [Medieval
 Albanian painters]. Tirana: Ministria e arësimit dhe
 kulturës, 1961. 124 pp., 80 illus.
 In Albanian. A survey of documented works, as well as
 works attributed to known painters or workshops, with an intro-
 ductory chapter providing a politico-social background. Most
 illustrations are of poor quality.

53 Popa, Theofan. "Të dhana të reja preth piktor Onufrit" (Fr.
 sum.: "À propos d'Onufre de Neokastra"). Studime Historike
 20 (3), no. 1 (1966):141-45.
 In Albanian. Supports the identification by Orlandos and
 Pelekanides of the painter Onofrios with a painter by the same
 name who was active in Kastoria around the middle of the six-
 teenth century. He rejects Orlandos' idea that Onofrios came to
 the southern Balkans from Venice, but ties him to the Albanian
 Orthodox community established in southern Italy in the wake of
 the Turkish conquest of Albania.

54 Puzanova, Viktori. "Paraqitje të skënës së lindjes së
 Krishtit në pikturën mesjetare të Shqipërisë" (Fr. sum.:
 "Trois représentations de la Nativité dans notre peinture
 médiévale"). Studime Historike 20 (3), no. 1 (1966):121-31.
 In Albanian. Discusses three Nativity icons--one dating
 from the fourteenth century, the other two from the fifteenth or
 sixteenth century. The three are grouped together because of
 their thematic relationship and high artistic quality.

55 Puzanova, Viktoriia, and Dhamo, D. "Nekotorie pamiatniki
 monumental'noĭ zhivopisi 13-14 vekov v Albanii" [Several
 monuments of thirteenth- to fourteenth-century monumental
 painting in Albania]. Studia Albanica 2, no. 2 (1965):149-63.
 In Russian. Discusses frescoes of an ancient monastery
 near Rubig (rebuilt 1267), the church of the Virgin at Van Deies
 (thirteenth to fourteenth centuries), the church and the refectory
 of the monastery of the Virgin at Apollonia near Pojan, and the
 church of the Nativity at Maligrad.

56 _____. "O tvorchestve albanskogo srednevekovogo khudozhnika
 Onufriia" [Creative achievement of the medieval Albanian
 painter Onofrios]. Studia Albanica 3, no. 1 (1966):281-90.
 In Russian. Considers the work of Onofrios, one of the
 major sixteenth-century painters in Albania.

MINOR ARTS

57 Anamali, Skendër, and Spahiu, H. "Varreza e herëshme
 mesjetare e Krujës" (Fr. sum.: "Une nécropole du haut moyen
 âge à Kruje"). Buletin i universitetit shtetëror të Tiranës
 17, no. 2 (1963):3-85 (Fr. sum.: 67-85).
 In Albanian. An extensive archeological study of the early
 medieval necropolis at Kruje (material related to the necropolis
 at the fortress of Dalmace). Particularly rich are bronze and
 silver finds--rings, earrings, bracelets, fibulae, broaches, pen-
 dents, buckles, etc.

58 "The Berat Codices." New Albania 28, no. 1 (1974):26-27.
 A brief article dealing with two Byzantine manuscripts of
 exceptional importance which are preserved in Berat--the sixth-
 century "Codex Purpureus Beràtinus O," and the ninth-century
 "Codex aureus Anthimi." The two were buried at the outbreak of
 World War II and rediscovered twenty years later in damaged con-
 dition. The article makes no mention of fine metal book covers
 of a later date (post-Byzantine?) which evidently belong to the
 two codices and which are illustrated here with fine color
 photographs.

SITES

ADRIANOUPOLIS. See DROPOLIS
ANO LABOVO. See LABOVE

APOLLONIA

59 Buschhausen, Heide and Helmut. Die Marienkirche von Apollonia
 in Albanien. Byzantina Vindobonensia, 8. Vienna: Öster-
 reichische Akademie der Wissenschaften, 1976. 241 pp.,
 44 figs., 2 col. pls., 32 b&w pls.
 A thorough monograph on an important medieval monastic com-
 plex that includes the main church, lateral chapels, exonarthex

and the refectory, all built at different times during the Middle
Ages. The book includes an important chapter on the history of
the area (Chapter I) with a useful survey of relevant literature.
Other chapters discuss the architecture (Chapter I), the ex-
onarthex (Chapter II), the Imperial family portrait of Byzantine
Emperor Michael VIII Paleologos (Chapter IV), and the refectory
(Chapter V). The book is well documented and provides a helpful
introduction to many problems of medieval art and architecture in
Albania. Particularly important are the various aspects of
juxtaposition of Eastern and Western elements.

60 Kahn, Arthur. "Apollonia, City of Statues." Archaeology 14,
 no. 3 (1961):161-65.
 Reports briefly on the extensive archeological excavations
carried out in this major ancient city after World War II.

61 _____. "Archaeology Behind the Iron Curtain: A Report on
 Large-scale Albanian Excavations at 'The Greatest of the
 Apollonias'." Illustrated London News 1 (July 1961):20-23.
 A brief, popular report on extensive archeological excava-
tions conducted at Apollonia. Profusely illustrated with fine
photographs.

62 Meksi, Aleksandër. "Arkitektura dhe datimi i kishës së mana-
 stirit të Apollonisë" (Fr. sum.: "L'église du monastère
 d'Apollonie, son architecture et le problème de sa datation").
 Monumentet 1 (1971):103-17 (Fr. sum.: 116-17).
 In Albanian. An analysis of architecture and the struc-
tural history of the building. The main part of the building is
dated to the first half of the thirteenth century. Architectural
drawings (plans, sections, elevations) are included.

63 Meksi, A[leksandër]. "Mbi disa probleme të kishës së mana-
 stirit te Apollonisë" (Fr. sum.: "A propos de quelques pro-
 blèmes relatifs à l'église du monastère d'Apollonie").
 Monumentet 12 (1976):233-36 (Fr. sum.: 235-36).
 In Albanian. A discussion of the architectural history of
the church which the author dates into the first half of the
thirteenth century in contrast to the date ca. 1080 proposed by
H. and H. Buschhausen (see AL 59).

64 Nallbani, Hasan. "Të dhëna të reja preth pikturës së kishës
 së manastirit të Apollonisë" (Fr. sum.: "A propos de cer-
 taines données nouvelles sur la peinture rurale de l'église du
 monastère d'Apollonie"). Monumentet 11 (1976):97-106 (Fr.
 sum.: 105-6).
 In Albanian. The church built before 1275 received its
fresco decoration between 1275 and 1282. The exonarthex was
added ca. 1350 (inscription bearing that date appears to be
contemporary).

BALLSH

65 Anamali, Skënder. "The Basilica at Ballsh." New Albania 6
 (1976):34-35.
 Discusses briefly the 1976 excavation of the sixth-century
 basilica. The church, of sizable dimensions, is one of the
 finest monuments believed to belong to the Justinianic era. The
 church was characterized by use of monolithic square piers with
 relief carving on all four sides. The interior walls of the
 building were covered with fresco decoration, only small frag-
 ments of which survive.

BERAT

66 Baçe, Apollon. "Oborri i fortifiquar i qytetit mesjetar në
 Berat" (Fr. sum.: "La barbacane de la ville forte de Berat").
 Monumentet 12 (1976):243-51.(Fr. sum.: 250-51).
 In Albanian. A Byzantine fortification with a building
 phase belonging to the period of Manuel Komnenos (Comnenus),
 dated before 1214 by an inscription.

67 _____. "Qyteti i fortifiquar i Beratit" (Fr. sum.: "La ville
 fortifiée de Berat"). Monumentet 2 (1971):42-62 (Fr. sum.:
 59-62).
 In Albanian. Discusses the history and the growth of the
 fortified town of Berat from Illyrian through Byzantine and
 Ottoman times. Besides changes in the plan and configuration
 of the fortification system, the author analyzes different build-
 ing techniques.

68 Meksi, Aleksandër. "Tri kisha Bizantine të Beratit" (Fr. sum.:
 "Les trois églises byzantines de Berat"). Monumentet 4 (1972):
 59-75 (Fr. sum.: 96-102).
 In Albanian. Considers the churches of the Virgin of
 Blaherna, the Holy Trinity, and St. Michael, belonging to the
 thirteenth or fourteenth centuries. In plan, building technique,
 and decorative vocabulary the churches belong to the architec-
 tural tradition of Epirus.

69 Strazimiri, Gani. "Disa tipare të arkitekturës qytetit të
 Beratit." In Konferenca e parë e studimeve Albanologjike
 (1962) (Tirana). Edited by A. Kostallari et al. (1965):
 555-61.
 In Albanian. Discusses urban growth and architectural
 heritage of Berat from the late Antique period to the nineteenth
 century.

Thomo, Pirro. See entry AL 40
BUTHROTUM. See BUTRINTI

BUTRINTI (BUTHROTUM)

70 Mustilli, D. "Relazione preliminare degli scavi archeologici
 in Albania 1937-40." Atti della reale Accademia d'Italia.
 Rendiconti della classe di scienze morali e storiche,
 8th ser., 2 (1942):677-704.
 Discusses Italian archeological excavations in Butrinti
 (esp. pp. 685-704) dealing with the acropolis, the sea gate, a
 building near the baptistery, Roman baths, the theater, and the
 necropolis. The article is well illustrated, and includes
 measured plans of most buildings.

71 Ugolini, Luigi M. "Il battistero di Butrinto." Rivista di
 archeologia christiana 11, nos. 3-4 (1934):265-83.
 Reports the discovery of one of the most impressive early
 Christian buildings in Albania. The baptistery of Butrinti was
 a circular building (13.5 m in diameter inscribed in a square)
 with two rows of eight columns, each subdividing the interior
 into the central space with a centrally situated round font and
 two circumventing "aisles." A superbly preserved mosaic floor
 consists of seven concentric zones of decorative patterns which
 circumvent the central font. Abstract geometric patterns, ab-
 stract vine scrolls, and friezes consisting of round discs con-
 taining animal and plant images alternate.

DELVINO. See MESOPOTAM
DRAČ. See DURRËS

DROPOLIS (ADRIANOUPOLIS)

Versakēs, Fr. See entry AL 42
Vokotopoulos, Panagiotis L. See entry AL 43
DURAZZO. See DURRËS

DURRËS (DYRRACHIUM, DRAČ, DURAZZO)

72 Karaiskaj, Gjerak. "Kalaja e Durrësit në mesjetë" (Fr. sum.:
 "La forteresse de Durrës au Moyen Âge"). Monumentet 13
 (1977):29-53 (Fr. sum.: 49-53).
 In Albanian. The medieval fortress of Durrës features
 several distinctive phases of construction, each identified,
 described, and analyzed by the author.

73 Schober, Arnold. "Zur Topographie von Dyrrhachion." Jahres-
 hefte Österreichisches Archäologishes Institut 23 (1926):
 241-46.
 Argues that the location of the ancient Dyrrachium was not
 on the spot of the modern town, but some distance away, and that
 the present town came into being in the thirteenth century when
 the population had significantly shrunken and, for defensive pur-
 poses, the town was relocated on a small peninsula which it now

occupies. Archeological and chance finds substantiate the au-
thor's hypothesis.

74 Thierry, Nicole. "Une mosaïque à Dyrrachium." <u>Cahiers</u>
 <u>archéologiques</u> 18 (1968):227-29.
 A brief discussion of mosaic discovered in a chapel made
 under the ramping vaults of the abandoned ancient amphitheater of
 Dyrrachium. The mosaic depicts the Virgin flanked by two arch-
 angels and St. Stephen and also accompanied by two miniature
 figures at her feet--the two donors. The mosaic is believed to
 date between the sixth and seventh centuries and to show Byzan-
 tine as well as Roman influence, characteristic of the area in
 general.

75 Zheku, Koço. "Découvertes épigraphiques sur les murs de
 ceinture du chateau fort de Durrës." <u>Studia Albanica</u> 9, no. 1
 (1972).
 Newly discovered brick stamps with monograms of Emperor
 Anastasius I lead the author to the conclusion that the fort of
 Durrës represents an example of border fortifications whose con-
 struction began under Anastasius and continued under Justin I and
 Justinian I.

DYRRACHIUM. See DURRËS

ELBASAN

76 Karaiskaj, Gjerak. "Kalaja e Elbasanit" (Fr. sum.: "La cita-
 delle d'Elbasan"). <u>Monumentet</u> 1 (1971):61-77 (Fr. sum.:
 75-77).
 In Albanian. Discusses one of the major late Antique (late
 third- or early fourth-century) fortifications in Albania. The
 huge castrum (348 x 308 m) has a regular layout typical of castrum
 architecture. The fortress was repaired and used in Byzantine
 and Turkish times.

GJIROKASTRA

77 Meksi, Aleksandër. "Dy kisha Bizantine në rreth të
 Gjirokastrës" (Fr. sum.: "Deux églises byzantines du district
 de Gjirokastra"). <u>Monumentet</u> 9 (1975):77-105 (Fr. sum.:
 103-5).
 In Albanian. Discusses the churches of the Virgin of
 Peshkopi at Sipërme and the Virgin of Labove at Kryqit. The
 former church is believed to date from the end of eleventh to
 the middle of the twelfth century. It has a lateral "aisle"
 along its south flank which appears to date from the thirteenth
 or fourteenth century. The second church is dated by the author
 to the second half of the thirteenth century on the basis of its
 plan and building technique.

78 Strazimiri, Gani. "Gjirokastra dhe vlerat e saj kulturale"
 (Fr. sum.: Gjirokastër et ses valeurs culturelles"). Monu-
 mentet 2 (1971):87-102 (Fr. sum.: 100-102).
 In Albanian. An anlysis of one of the most picturesque
 towns in Albania and its cultural monuments. The history and the
 growth of the town is traced from medieval to modern times.

KEPI I RODONIT (RODONI)

79 Thomo, Pirro. "La forteresse de Skanderbeg au cap de Rodon."
 In Deuxième conférence des études albanologiques (12-18 Jan.
 1968) (Tirana) 1. Edited by A. Kostallari et al. (1969):
 323-47.
 The article discusses a stronghold of the fifteenth-century
 Albanian hero, George Kastriote--Skanderbeg, situated on the
 picturesque Cape Rodon. Ruins of the small single-aisled church
 featuring external and internal blind arcades with parabolic
 arches and the remains of fortifications are presented.

KOSINË (near Përmet)

Thomo, Pirro. See entry AL 40

KRUJE

80 Adhami, Stilian. "Gjurmime rreth themelimit dhe rindërtimeve
 kryesore të kalasë së Krujës" (Fr. sum.: La fondation de la
 citadelle de Kruje et ses principales reconstructions").
 Monumentet 1 (1971):87-101 (Fr. sum.: 99-101).
 In Albanian. The large fortress of Kruje on a commanding,
 600-meter-high hill was founded in the twelfth century, and re-
 stored after 1271, in the fourteenth century, and again in the
 fifteenth century when it became a major stronghold of Skanderbeg.
 The fortress was severely damaged in an earthquake of 1617.

LABOVE (ANO LABOVO)

Meksi, Alexsandër. See entry AL 77
Versakēs, Fr. See entry AL 42
Vokotopoulos, Panagiotis L. See entry AL 43

LEZHA (LISSUS)

81 Prendi, F. "The City of Eleven Gates." New Albania 15, no. 6
 (1971):22-23.
 The short article gives a brief history of the city--
 founded, according to modern Albanian scholars, by the Illyrians
 in the fourth century B.C. The fortifications were repaired in
 medieval times. A "Theodosian" capital and an eleventh-century
 gate are illustrated.

LIN (POGRADEC)

82 Anamali, Skënder. "Les mosaïques de la basilique paléochré-
 tienne de Lin (Pogradec)." Iliria 3 (1975):339-53.
 Fine mosaics featuring meanders, vases, birds, etc. Also
 found is a Greek inscription with a Psalm citation. The mosaics
 expand the notion regarding the artistic activity around the
 Ohrid Lake in early Byzantine times.

LISSUS. See LEZHA

MALIGRAD

83 Dhamo, Dhorka. "Kisha e shën mërisë në Maligrad" (Fr. sum.:
 "Notre-Dame de Maligrad"). Buletin i universitetit shtetëror
 të Tiranës 17, no. 2 (1963):154-98 (Fr. sum.: 193-98).
 In Albanian. The article represents a monographic study of
 the church of the Virgin at Maligrad. It discusses the history,
 architecture and painting of this small but important monument of
 late Byzantine art.

84 _____. "Piktura murale e kishës së Shën Mërisë në Maligrad"
 [Mural painting in the Church of the Virgin at Maligrad].
 Konferenca e parë e studimeve Albanologjike (1962), edited by
 A. Kostallari et al. Tirana, 1965, pp. 562-66, 13·illus.
 Identifies two phases of decoration (in 1345 and 1369) in
 this small single-aisled church. The cycle includes twelve
 Great Festival scenes. The frescoes are in a fine state of
 preservation.

Djurić, Vojislav J. See entry AL 46
Stransky. See entry BU 130

MARMIRO

85 Meksi, Aleksandër. "Restaurimi i kishës së Marmiroit" (Fr.
 sum.: "La restauration de l'église de Marmiro"). Monumentet
 2 (1971):73-83 (Fr. sum.: 83).
 In Albanian. An architectural analysis of the small
 ruined cruciform church at Marmiro. The church is compared to a
 number of similar churches in Yugoslavia and Bulgaria, and is be-
 lieved not to be later than the thirteenth century.

MBORJE

86 Meksi, Aleksandër. "Të dhëna mbi rindërtimin e kupolës së
 kishës së Ristozit në Mborje" (Fr. sum.: "Données concernant
 la reconstruction de l'église de Ristoz à Mborje"). Monu-
 mentet 4 (1972):199-204 (Fr. sum.: 203-4).
 In Albanian. The church of Ristoz at Mborje has frescoes
 dated by an inscription to 1389. The author agrees with

Pirro Thomo, who calls for a twelfth century date for the archi-
tecture. The date of 1389 is taken to refer to a reconstruction
of the church.

MESOPOTAM (DELVINO)

87 Kosta, Sotir. "Restaurimi i mozaikëve të Mesopotamit dhe
 Bylisit" (Fr. sum.: "Restauration des mosaïques de Mesopotam
 et de Bylis"). Monumentet 17 (1979):59-70 (Fr. sum.: 68-70).
 In Albanian. Discusses two floor mosaic panels (one de-
 picting two pairs of confronted roosters and the other a griphon)
 situated in an open portico flanking the church at Mesopotamit
 along its north flank. The mosaics were done crudely with uneven
 cubes and are probably Western (Italian) medieval, but the author
 considers them earlier Byzantine works.

88 Meksi, Aleksandër. "Arkitektura e kishës së Mesopotamit" (Fr.
 sum.: "L'architecture de l'église de Mosopotame"). Monu-
 mentet 3 (1972):47-94 (Fr. sum.: 88-94).
 In Albanian. A detailed study of the structural history of
 the curious double church of St. Nicholas. Reports the results
 of excavations which revealed the original form of the sanctuary
 as well as an open portico which originally enveloped the build-
 ing.

89 Versakēs, Frederikos. "Byzantiakos naos en Delvinō."
 Archaiologikon deltion 1 (1916):28-44.
 In Greek. Considers the curious late Byzantine church of
 St. Nicholas. The church (once a double church with two naves
 side-by-side) is now preceded by a common narthex and has a
 single sanctuary at the east end. The building is dated by the
 author to the second half of the twelfth or early thirteenth
 century.

ONHESMOS. See SARANDA

PESHKOPI (SIPËRME)

Meksi, Aleksandër. See entry AL 77

POGRADEC [See also LIN]

90 A., S. "Fouilles archéologiques 1973, Pogradec." Iliria 3
 (1975):481-96.
 Reports on a late fourth-century fortification, restored in
 the sixth century. The phenomenon is of broader interest for
 Balkan archeology of this period.

POJAN. See APOLLONIA
RODONI. See KEPI I RODONIT

SARANDA (ONHESMOS)

91 Budina, Dhimosten, and Korkuti, B. "Mozaikë të rinj të
 zbulnar në Onhezmin e Lashtë (Sarandë)" (Fr. sum.: "Mosaïques
 venues au jour à Onchesme"). Studime Historike 25 (8), no. 1
 (1971):208-25 (Fr. sum.: 222-25).
 In Albanian. The article treats a series of Roman mosaics,
 mostly of geometric designs, which were uncovered between 1958
 and 1969. The mosaics appear to date from the beginning of the
 third century A.D.

SARDA. See SHUEDHAH
SCUTARI. See SHKODËR

SHKODËR (SCUTARI; SKADAR)

92 Deroko, Aleksandar. "U Bodinovoj prestonici: Putopisne
 arhitektonske zabeleške iz Skadra--grada Rosafa--i okoline"
 [In Bodin's capital: Architectural travel notes from Skadar
 and vicinity]. Starinar, 3d ser. 5 (1930):128-51.
 In Serbo-Croatian. A valuable collection of observations,
 sketches, photographs, etc. of a large number of monuments in the
 region of Skadar (Shkodër) which are important for the history of
 Serbian medieval architecture

93 Ippen, Theodor A. Skutari und die nordalbanische Küstenebene.
 Zur Kunde der Balkanhalbinsel. Reisen und Beobachtungen, 5.
 Sarajevo: Verlag von Daniel A. Kajon, 1907. 83 pp.,
 24 illus.
 A topographical survey of Shkodër and its environs with the
 focus on architectural monuments. Particularly noteworthy are
 photographs of the ruins of the church SS. Sergius and Bacchus
 which has since been completely destroyed.

Mušič, Marijan. See entry AL 35

SS. SERGIUS AND BACCHUS [Monastery on Buenë (Bojana) river, near
Shkodër (Skadar)]

94 Korać, Vojislav. "Sv. Sergije (Srdj) i Vakh na Bojani" (Fr.
 sum.: "Monastère des Saints Serge et Blaise sur la Bojana").
 Starinar, n.s. 12 (1961):35-44 (Fr. sum.: 44).
 In Serbo-Croatian. A study of history, historiography, and
 architecture of this important monastery patronized by the medi-
 eval Serbian royal dynasty. The monastery itself has been vir-
 tually destroyed by the shifting course of the Buënë (Bojana)
 river.

95 Smirnov⁻⁻, S.N. "Monast⁻ir⁻ Svv.Sergiĩa i Vakha na riekie
 Boĩanie, bliz⁻⁻ goroda Skadra v⁻⁻ Albanii." Sbornik russkago
 arkheologicheskago obshchestva (Belgrade) 1 (1927):119-47.
 In Russian. A major study on the important church built by
 the Serbian Queen Jelena and her son King Stefan Uroš II Milutin.
 The foundation of the church is documented by two Latin inscrip-
 tions on the jamb and the lintel of the west portal. The large,
 three-aisled church has since been destroyed by the changing
 course of the Buenë (Bojana) river, so that much of the informa-
 tion (including poor photographs) in this article has major docu-
 mentary value.

SHURDHAH (SARDA)

96 Spahiu, Hëna. "La ville haute-médiévale albanaise du Shurdhah
 (Sarda)." Studia Albanica 10, no. 1 (1973):207-13.
 Shurdhah (Sarda) is an example of a new city built between
 the sixth and seventh centuries. It illustrates the survival of
 the urban tradition of late Antiquity in this area.

SIPËRME. See PESHKOPI
SKADAR. See SHKODËR

VAUDJNS (DANJ)

Mušič, Marijan. See entry AL 35

VLLAHO-GORANXI

Dhamo, Dhorka. See entry AL 45

Bulgaria

1 Angelov, Dimiter et al. <u>Medieval Bulgarian Culture</u>. Trans-
 lated from Bulgarian by M. Alexieva, N. Geliazkova, and
 L. Dimitrova. Sofia: Foreign Languages Press, 1964. 140 pp.,
 numerous b&w illus.
 A series of essays on individual topics written by a number
 of distinguished scholars. Illustrations are of reasonably good
 quality.

2 Bakalova, Elka. "La société et l'art en Bulgarie au XIV^e
 siècle: L'influence de l'hésychasme sur l'art." <u>Actes du</u>
 <u>XIV^e Congrès international des études byzantines</u> (Bucharest)
 2 (1975):33-38.
 A general discussion of Bulgarian society and art in the
 light of the Hesychast movement in the fourteenth century. Con-
 siders similar developments in contemporary Byzantium and Serbia.

3 Beševliev, Veselin, and Irmscher, J., eds. <u>Antike und Mittel-</u>
 <u>alter in Bulgarien</u>. Berliner byzantinische Arbeiten, 21.
 Berlin: Akademie-Verlag, 1960. 344 pp., 87 pls.
 A comprehensive survey of the state of scholarship on
 Bulgaria in Antiquity and in the Middle Ages. Despite the empha-
 sis on Antiquity, several medieval sites are discussed (Pliska,
 Preslav, Tŭrnovo, Nesebŭr, etc.). The book is divided into four
 sections: general, Sofia, Danube Bulgaria, and South Bulgaria
 and the Black Sea Coast. Each section contains several chapters
 on specific topics related to the region in question.

4 Bičev, Milko, and Bossilkov, S. "Bulgarien." In <u>Byzanz und</u>
 <u>der Christliche Osten</u>. Edited by Volbach, Wolfgang Fritz, and
 J. Lafontaine-Dosogne. Propyläen Kunstgeschichte, 3. Berlin:
 Propyläen Verlag, 1968, pp. 241-57, 19 plans, 23 b&w pls., and
 4 col. pls.
 A general essay on medieval Bulgarian art and architecture
 with a basic bibliography (pp. 390-91).

5 Bozhkov, Atanas. "Kŭm vŭprosa za vzaimnite vrŭzki mezhdu
 bŭlgarskoto i rumŭnskoto izkustvo prez XIV-XVII v." (Fr.
 sum.: "Sur les relations entre l'art bulgare et l'art roumain
 aux XIV-XVII siècles"). IzvII 7 (1964):41-94 (Fr. sum.:
 97-99).
 In Bulgarian. A major study of relations between Bulgarian
 and Rumanian art of the late Middle Ages. Primary attention is
 given to fresco painting, although other media are also consid-
 ered.

6 _____. "Za niakoi ikonografski i stilovi otliki na bŭlgar-
 skoto srednovekovno izkustvo" [Some iconographic and stylistic
 distinctions of Bulgarian medieval art]. Izkustvo 27, no. 9
 (1977):10-21.
 In Bulgarian. A selection of icons, minor sculpture and
 metalwork dating between the ninth and fourteenth centuries is
 analyzed with the aim of determining those local traits which
 distinguish this art from the more general, Byzantine framework
 to which it is intimately related.

7 Browning, Robert. Byzantium and Bulgaria: A Comparative
 Study Across the Early Medieval Frontier. Berkeley and Los
 Angeles: University of California Press, 1975. 232 pp.
 An important study of the political and cultural relations
 between Bulgaria and Byzantium from the end of Antiquity until
 the collapse of the First Bulgarian Empire. Particularly rele-
 vant is chapter 9 on culture (pp. 170-86).

8 Dimitrov, Dimiter P. Bulgarien: ein Land alter Kulturen.
 Sofia: Fremdsprachenverlag, 1961. 59 pp., 89 b&w illus.
 A short text aimed at acquainting a nonspecialist with the
 cultural contribution of both Bulgarians and earlier settlers of
 the territory presently inhabited by Bulgarians. The reproduc-
 tions are of reasonable quality and give a fair coverage of the
 material.

9 Draganov, Kŭncho; Raĭchev, M.; and Stanchev, S. Muzei i
 pametnitsi v Narodna Republika Bŭlgariia [Museums and monu-
 ments in the People's Republic of Bulgaria]. Sofia: Nauka i
 izkustvo, 1959. 655 pp.
 In Bulgarian. A guide to museums and monuments of
 Bulgaria organized by region. Provides a wealth of information
 and is amply illustrated by photographs of good quality.

10 Duĭchev, Ivan. Bŭlgarsko srednovekovie [Bulgarian Middle
 Ages]. Sofia: Nauka i izkustvo, 1972. 590 pp., 40 illus.
 In Bulgarian. The major study of Bulgarian political and
 cultural history during the Middle Ages (from the sixth through
 the fourteenth centuries). Portrays Bulgarian political and cul-
 tural history in the broader context of the Balkans during the
 same period.

11 Dzhambazov, Nikolaĭ et al. Arkheologicheski otkritiĭa v
 Bŭlgariĭa. Sbornik [Archaeological discoveries in Bulgaria.
 Collected essays]. Sofia: Nauka i izkustvo, 1957. 240 pp.,
 illus.
 In Bulgarian. An illustrated collection of essays by dif-
 ferent authors which consider major archeological discoveries
 from prehistoric to medieval times. Of particular interest are
 articles on Pliska (pp. 137-59), Preslav (pp. 163-95), and Sofia
 (pp. 199-216).

12 Faurel, Jean-Jacques. Bulgarie. Les guides bleus. Paris:
 Libraire Hachette, 1969. 357 pp., maps, city plans.
 A good general guidebook on Bulgaria.

13 Filov, B[ogdan Dimitrov]. Geschichte der bulgarischen Kunst
 unter der türkischen Herrschaft und in der neueren Zeit.
 Grundriss der slavischen Philologie und Kulturgeschichte.
 Edited by R. Trautmann and M. Vasmer. Berlin and Leipzig:
 Walter de Gruyter & Co., 1933. 94 pp., 64 pls.
 A general discussion on Bulgarian art from the period of
 the Turkish occupation to modern times. The most relevant mate-
 rial for the medievalist is part I (1393-1878) (pp. 1-55), in
 which various phenomena characteristic of conservative post-
 Byzantine art are considered (architecture, monumental painting,
 icon painting, manuscript illumination, wood carving, and minor
 arts).

14 Filov, Bogdan Dimitrov. Geschichte der altbulgarischen Kunst
 bis zur Eroberung der altbulgarischen Reiches durch die Türken.
 Grundriss der slavischen Philologie und Kulturgeschichte.
 Berlin and Leipzig: Walter de Gruyter & Co., 1932. 100 pp.,
 48 pls.
 A general history of the early period of Bulgarian medieval
 art (679-1393). Romantically inclined, the book considers the
 Bulgarian material in the broadest possible context, at times
 expropriating the works of art and architecture which do not be-
 long to Bulgarian culture either by virtue of the artist's or
 the patron's origins (e.g., churches of Peribleptos and the
 church of SS. Constantine and Helena at Ohrid). Essentially the
 same text also appears in French (L'ancien art bulgare [Paris:
 Cassirer, 1922] and Bulgarian (Starobŭlgarskoto izkustvo [Sofia,
 1924] editions.

15 Filov, Bogdan D[imitrov]. Early Bulgarian Art. Berne: Paul
 Haupt, 1919. 86 pp., 58 b&w pls., 72 figs. in text.
 A useful early survey of Bulgarian art and architecture
 with excellent black-and-white photographs, some of documentary
 value.

16 Frova, Antonio. "Bulgaria." Encyclopedia of World Art 2.
 New York: McGraw-Hill Book Co., 1960, pp. 723-31.
 A rather skimpy treatment of the material, identifying
 major sites and principal literature.

17 Georgiev, Emil et al. Bulgaria's Share in Human Culture.
 Introduction by Ivan Duĭchev. Sofia: Sofia Press, 1968.
 130 pp., 7 col. pls.
 A collection of essays by four authors. Attempts to assess
 the general contribution of Bulgarian culture for the English-
 speaking reader. One of the more interesting essays is Kiril
 Krustev's "An Unknown Forerunner of Renaissance Art" (pp. 89-109),
 a brief though somewhat romanticized introduction to the fresco
 paintings of Boĭana--an important monument of thirteenth-century
 painting. The language is awkward and the illustrations few and
 of mediocre quality.

18 Georgieva, Sonĭa. "Materialnata kultura na Vtorata bŭlgarska
 . dŭrzhava (razkopki 1964-1974)" (Fr. sum.: "La culture maté-
 rielle pendant le second royaume bulgare [fouilles de 1964 ā
 1974]"). Arkh 16, no. 3 (1974):61-72 (Fr. sum.: 72).
 In Bulgarian. A useful survey of the material culture of
 the Second Bulgarian Empire in the light of excavations conducted
 between 1964 and 1974. Extensive literature on the subject is
 given in the footnotes.

19 Gjuzelev, Vasil. La Bulgarie médiévale: Art et civilisation.
 Catalog of exhibit, June 13-Aug. 18, 1980. Paris: Ministère
 des Affaires Etrangères, 1980. 223 pp., illus.
 A fine catalog of a major exhibit of Bulgarian medieval
 art. All media are represented and illustrated with excellent
 photographs.

20 Grabar, A[ndré]. "Niakolko srednovekovni pametnitsi iz za-
 padna Bŭlgariĭa" [Several medieval monuments from western
 Bulgaria]. GNM 1921 (1922):286-96.
 In Bulgarian. A brief survey of the following medieval
 monuments: Church of the Monastery of the Archangel at Trŭn,
 Monastery of Mislovishtitsa, Monastery of Bilintsi, Monastery of
 Gigen, Monastery of Peshter, Kĭustendil (note the discussion of
 Kolushkata tsŭrkva), and Razhdavitsa.

21 Grabar, André. "La place des monuments paléochrétiens et
 médiévaux bulgares dans l'histoire des arts de l'Europe
 orientale." Corsi di Cultura sull'Arte Ravennate e Bizantina
 15 (1968):175-78.
 A general overview of the place of early Christian and *
 medieval architecture in Bulgaria in the history of Eastern
 Europe.

22 Ivanov, Ĭordan. **Bŭlgarski starini iz Makedoniĩa** [Bulgarian
 antiquities from Macedonia]. Sofia: Bŭlgarskoto knizhovno
 druzhestvo, 1908. 310 pp., illus.
 In Bulgarian. A basic source for cultural history of
 Bulgaria and Macedonia. The work includes manuscripts and in-
 scriptions relevant to the history of individual monuments and
 the region as a whole. The author brings the texts in the origi-
 nal Church Slavonic. The material is organized chronologically
 from the tenth to the nineteenth century.

23 ____. "Starinski tsŭrkvi vŭ ĩugo-zapadna Bŭlgariĩa" (Fr.
 sum.: "Anciennes églises de la Bulgarie du sud-ouest").
 IBAI 3 (1913):53-73 (Fr. sum.L 72-73).
 In Bulgarian. Considers three churches--the church near
 the village of Berenda (1218-1241), Spasovitsa (1330), and
 Bĩelovskiĩat monastir (better known as Zemen) near Struma. Par-
 ticularly important is the information on Spasovitsa because the
 church was completely destroyed during World War II.

24 Ivanov, Jordan. "Le costume des anciens Bulgares." **L'art
 byzantin chez les Slaves: Les Balkans** 1, pt. 2. Paris:
 Paul Geuthner, 1930, pp. 325-33.
 The existence of the national costume of the seventh- to
 eleventh-century Bulgarians is documented by medieval texts,
 sculptures, and Byzantine manuscript illuminations.

25 Ivanova, Vĩera. "Stari tsŭrkvi i monastiri v bŭlgarskitĩe
 zemi (IV-XII v.)" (Fr. sum.: "Églises et monastères en pays
 bulgare [IVe-XIIe s.]"). GNM 4 (1926):428-558 (Fr. sum.:
 558-77).
 In Bulgarian. A major corpus of Bulgarian churches and
 monasteries. Bulgarian territory is understood as being that of
 the greatest expansion. Consequently, many Byzantine and Serbian
 monuments are also included in the survey.

26 Ivanova, Vŭra. "Neizdadeni tsŭrkvi v' ĩugozapadna Bŭlgariĩa"
 (Fr. sum.: "Églises inédites de la Bulgarie du sud-ouest").
 GNM 5 (1933):261-84 (Fr. sum.: 281-84).
 In Bulgarian. Presents the following monuments: a ruined
 small church at R'zhdavitsa with frescoes from 1600, the church
 of the Archangel Michael at Goranovtsi (a single-aisled church
 with large inner pilasters supporting deep blind arcades, and
 with seventeenth-century frescoes), the church Mekhomia (a
 trefoil), a chapel of St. Catherine, and the remains of a ruined
 trefoil church near Mekhomia-Bansko.

27 Kanitz, F[elix]. **Donau--Bulgarien und der Balkan.** 3 vols.
 2d ed. Leipzig: Hermann Fries, vol. 1, 1879, vols. 2-3
 1880. Illus.
 A major pioneering study of history, geography and ethnog-
 raphy of Bulgaria based on a journey in the region undertaken by

Kanitz between 1860 and 1880. Interspersed throughout the text
is a wealth of information of interest to art and architectural
historians.

28 _____. "Reise in Süd-Serbien und Nord-Bulgarien, Ausgefürt im
Jahre 1864." Denkschriften der Kaiserlichen Akademie der
Wissenschaften. Philosophisch-historische Classe 17, pt. 2
(1868):1-65.
 A travel report which includes much information on little-
known (in some cases lost) monuments. Information, though ele-
mentary in nature, is often invaluable. Illustrations (not
dependable for details) range from late Antique capitals and
stele to church plans (Vratarnitsa, Kamenitsa, Sv. Arandjel) to
fortresses.

29 Kuzev, Aleksandǔr. "Prinosi kǔm istoriiata na srednovekovnite
kreposti po dolniia Dunav: 1. Tutrkan i Ruse" (Fr. sum.:
"Contribution à l'histoire des forteresses médiévales le long
du bas-Danube: 1. Tütrakan et Rousse"). Izvestiia na
Naroden muzeĭ - Varna 2 (17) (1966):23-50 (Fr. sum.: 48-50).
 In Bulgarian. A historical and archeological study of the
medieval fortresses of Tutrakan and Ruse.

30 _____. "Prinosi kǔm istoriiata na srednovekovnite kreposti po
dolniia Dunav: 2. Pirgos, Novgrad, Svishtov i Nikopol" (Fr.
sum.: "Contribution à l'histoire des forteresses médiévales
sur le bas-Danube: 2. Pirgos, Novgrad, Svichtov et
Nicopole"). Izvestiia na Naroden muzeĭ -Varna 3 (18) (1967):
41-48 (Fr. sum.: 69-70).
 In Bulgarian. A historical and archeological study of
medieval fortresses of Pirgos, Novgrad, Svishtov and Nikopol.

31 _____. "Prinosi kǔm istoriiata na srednovekovnite kreposti po
dolniia Dunav: 3. Gigen, Oriakhovo, Lom, Vidin i Florentin"
(Fr. sum.: "Contribution à l'histoire des forteresses médié-
vales sur le bas-Danube: 3. Guiguene, Oriahovo, Lom, Vidin
et Florentine"). Izvestiia na Naroden muzeĭ - Varna 4 (19)
(1968):27-55 (Fr. sum.: 53-55).
 In Bulgarian. A historical and archeological study of
medieval fortifications at Gigen, Oriakhovo, Lom, Vidin and
Florentin.

32 _____. "Prinosi kǔm istoriiata na srednovekovnite kreposti po
dolniia Dunav. 4. Silistra i Khǔrsovo" (Fr. sum.: "Contri-
bution à l'histoire des forteresses médiévales sur le bas-
Danube: 4. Silistra et Harsovo"). Izvestiia na Naroden
muzeĭ -Varna 5 (20) (1969):137-57 (Fr. sum.: 156-57).
 In Bulgarian. A study of history and archeology of
fortresses at Silistra and Khursovo.

33 Lang, David Marshall. The Bulgarians, from Pagan Times to the
 Ottoman Conquest. Ancient Peoples and Places. Thames and
 Hudson, 1976. 208 pp., 62 photographs, 36 drawings, 5 maps.
 A useful book presenting a brief overview of Bulgarian
 political and cultural history from Antiquity to the Ottoman
 conquest. The book also provides a useful general bibliography
 (pp. 147-59).

34 Mavrodinov, N[ikola]. "Tsŭrkvi i monastiri v' Melnik' i
 Rozhen'" (Fr. sum.: "Églises et monastères à Melnik et
 Rožene"). GNM 5 (1933):285-306 (Fr. sum.: 304-6).
 In Bulgarian. A basic publication about a number of small
 churches and their treasures. Included is the metropolitan
 church of St. Nicholas at Melnik with a Greek fresco inscription,
 dating from the end of the twelfth or the early thirteenth cen-
 tury.

35 Mavrodinov, Nikola. Starobŭlgarskoto izkustvo XI-XIII v
 [Old Bulgarian art, XI-XIII centuries]. Sofia: Bŭlgarski
 khudozhnik, 1966. 158 pp., 104 figs.
 In Bulgarian. A controversial study on many accounts, the
 book discusses Bulgarian art under Byzantine domination and from
 the end of the twelfth through the thirteenth centuries. The
 book is characterized by highly unconventional dating of monu-
 ments, some of which are dated a century or more earlier than
 generally accepted. Good illustrations. Architectural drawings
 are almost exclusively plans.

36 Miiatev, Kr[ŭst̂o]. "Prinosi kŭm srednovekovnata arkheologiia
 na bŭlgarskite zemi" [Contributions to medieval archeology in
 Bulgarian lands]. GNM 1921 (1922):242-85.
 In Bulgarian. A report of major new archeological finds
 (through excavation or inspection). Major sites reported on are:
 the Khisar Fortress, Kniazhevo, Ikhtiman and Novi Khan (near
 Sofia; an Islamic mosque and karavan-saray), Vidin, Krŭnska
 Khora, Trŭn, (monastery church of the Holy Archangel, 3 km north
 of the town), and Breznik.

37 _____. "Starinni tsŭrkvi v Zapadna Bŭlgariia" (Ger. sum.:
 "Alte Kirchen in Westbulgarien"). IBAI 13 (1941):228-45
 (Ger. sum.: 245).
 In Bulgarian. Three small churches from west Bulgaria are
 presented (architecture and fresco paintings): St. Petka
 (Paraskeve) in the village of Balsha, the church in the monastery
 of St. Nicholas near the village of Malo Malovo, and St. George
 in the village of Cheprlentsi.

38 Miiatev, Kr[ŭst̂o], and Mikov, V., eds. Izsledovaniia v pamet
 na Karel Shkorpil (Studia in Memoriam Karel Shkorpil). Sofia:
 Arkheologicheski institut s muzei, Bŭlgarska akademiia na
 naukite, 1961. 435 pp., illus.

In Bulgarian. Essays by many Bulgarian scholars collected
and published in memory of Karel Shkorpil, a prominent Czech
archeologist much of whose career was devoted to the study or
the Bulgarian material. The introductory essay by Miiatev
(pp. 5-14) and the complete bibliography prepared by V. Velkov
(pp. 73-85) reveal the scope of Shkorpil's achievement and the
importance of his contribution for further development of
Bulgarian studies.

39 Mutafchiev, Petŭr. Iz⁻⁻ nashitie staroplaninski monastiri
 [Our monasteries in the Stara Planina]. Sbornik na Bŭlgar-
 skata akademiia na naukitie, no. 27. Sofia:. Bŭlgarska
 akademiia na naukite, 1931. 121 pp., 15 pls., 23 figs. in
 text.
 In Bulgarian. A survey of twenty-two monasteries and
 churches in the region of Stara Planina. History, architecture
 and art of each monastery and church is briefly discussed. Il-
 lustrations include plans and a limited number of photographs of
 mediocre quality.

40 _____. Izabrani proizvedeniia [Selected works]. Edited by
 D. Angelov. 2 vols. Sofia: Nauka i izkustvo, 1973. Vol. 1
 682 pp., vol. 2 750 pp., illus.
 In Bulgarian. Collected essays of one of the most dis-
 tinguished and most prolific writers on Bulgarian history and
 culture. This work is particularly significant because it re-
 produces some of the key early works of Mutafchiev published in
 various periodicals--many of which are not easily accessible.
 Each volume also includes a very useful brief commentary by the
 editor with an up-to-date bibliography on each of the subjects
 discussed by Mutafchiev. Among the works included are: "Stari
 gradishta i drumove iz dolinite na Striama i Topolnitsa" [Old
 forts and roads from the valleys of Struma and Topolnitsa]
 (1:286-396); "Elenskata tsŭrkva pri Pirdop" [Stag's basilica at
 Pirdop] (2:397-454); "Krŭstovidnata tsŭrkva v s. Klisek⁻oĭ"
 [Cruciform church in the village of Klisek⁻oĭ] (1:455-85); and
 "Iz nashite staroplaninski monastiri" [From our monasteries in
 the Stara Planina] (2:257-440).

41 Nesheva, Violeta. "Prinosi kŭm prouchvaneto na oblekloto prez
 Vtorata bŭlgarska dŭrzhava" (Fr. sum.: "Sur le vêtement pen-
 dant le Second état bulgare"). Arkh 18, no. 2 (1976):23-39
 (Fr. sum.: 38-39).
 In Bulgarian. Attempts to combine information from physi-
 cal evidence with pictorial evidence on frescoes in reconstruct-
 ing vestments associated with the Second Bulgarian Empire.

42 Obretenov, Aleksandŭr et al. Istoriia na bŭlgarskoto izo-
 bratelno izkustvo [History of Bulgarian fine arts]. Sofia:
 Bŭlgarska akademiia na naukite, 1976. 327 pp., 367 illus.

 In Bulgarian. A major general work on Bulgarian art and architecture from Antiquity through the Middle Ages. Up to date, it includes numerous recent finds illustrated with good black-and-white and color photographs.

43 Pandurski, V[asil] I. "Tsenni pametnitsi za naukata i iz-kustvoto ni v Tsŭrkovniia istoriko-arkheologicheski muzeĭ v Sofiia" [Unique objects in the Church Historical-Archeological Museum of Sofia]. MPK 9, no. 4 (1969):48-54 (Fr. & Ger. sum.: 54).
 In Bulgarian. Considers the Gospel Book from Slepcha (fifteenth century), the icon of SS. George and Demetrius (tenth-eleventh centuries), the icon of Christ the Pantocrator (thir-teenth century), the icon of the Old Testament Holy Trinity (sixteenth century) and metal covers for evangelia, dating from the fourteenth to seventeenth centuries.

44 Pandurski, Vasil. Pametnitsi na izkustvoto v tsŭrkovniia istoriko-arkheologicheski muzeĭ, Sofia (Eng. sum.: "Art treasures in the Ecclesiastical Museum of History and Archae-ology, Sofia"). Sofia: Bŭlgarski khudozhnik, 1977. 439 pp., 267 b&w illus., 66 col. illus.
 In Bulgarian. An important work on a major collection of Bulgarian medieval and post-medieval art.

45 Pontiers, Jean-Christian. "À propos des forteresses antiques et médiévales de la plaine danubienne." Études balkaniques 11, no. 2 (1975):60-73.
 Considers the continuity of fortresses and fortified sites in the region between the rivers Iskăr and Ogosta over a period of more than a thousand years. The investigation suggests the perpetuation by medieval Bulgarian rulers of a fortification system established in late Roman and in early Byzantine times.

46 Protič, A[ndreĭ]. "Les origines sassanides et byzantines de l'art bulgare." In Mélanges Charles Diehl: Études sur l'histoire et sur l'art. Vol. 2. Paris: Librairie Ernest Leroux, 1930, pp. 137-59.
 A broad discussion of Bulgarian medieval art and its possi-ble sources of influence, most notably Sassanian and Byzantine.

47 Protich, A[ndreĭ]. "Sasanidskata khudozhestvena traditsiia u prabŭlgaritie" (Fr. sum.: "La tradition d'art sassanide chez les anciens Bulgares"). IBAI 4 (1927):211-35 (Fr. sum.: 233-35).
 In Bulgarian. An early sweeping attempt to link the be-ginnings of Bulgarian art with the art of Sassanid Persia. Most of these ideas have been superseded in recent years.

48 Protich, Andreĭ. "Sveta Gora i bŭlgarskoto izkustvo" [Mount
 Athos and Bulgarian art]. Bŭlgarski pregled 1, no. 2 (1929):
 249-76.
 In Bulgarian. An important historical framework for the
 study of relationship of Bulgarian art and Mount Athos.

49 Stancheva, Magdalina. "Postizheniĭa i problemi na arkheolo-
 gicheskoto prouchvane na Kŭsnoto srednovekovie (XV-XVII v.)"
 (Fr. sum.: "Réalisations et problèmes des études archéolo-
 giques du bas moyen âge [XVe-XVIIe s.]"). Arkh 16, no. 3
 (1974):73-81 (Fr. sum.: 80-81).
 In Bulgarian. A brief survey of major achievements and
 problems pertaining to the archeological study of the Late Middle
 Ages (XV-XVII centuries) in Bulgaria. A useful literature on the
 subject appears in the footnotes.

50 Tschilingirov, Assen. Die Kunst des christlichen Mittelalters
 in Bulgarien 4. bis 18. Jahrhundert. Berlin: Union Verlag,
 1978. 394 pp., 404 illus., numerous plans in text.
 A major up-to-date survey of Bulgarian architecture, paint-
 ing, sculpture and minor arts. Illustrated with excellent black-
 and-white and color photographs.

51 Tsonchev, Dimitŭr. "Starinite po severnite sklonove na
 Elenskiĭa i Slivenskiĭa Balkan" (Fr. sum.: "Les antiquités
 sur les pentes septentrionales du Balkan d'Eléna et de
 Sliven"). Godishnik na Narodniĭa arkheologicheski muzeĭ
 Plovdiv 1 (1948):113-52 (Fr. sum.: 150-52).
 In Bulgarian. A survey of monuments and material finds in
 the northern Balkan mountain region near Elena and Sliven.

52 Vaklinov, Stancho. Formirane na staro-bŭlgarskata kultura
 VI-XI vek (Eng. sum.: "Formation of the Old-Bulgarian cul-
 ture"). Sofia: Nauka i izkustvo, 1977. 293 pp. (Eng. sum.:
 286-93).
 In Bulgarian. A study on the origins of old Bulgarian cul-
 ture, suggesting that it derived its unique characteristics from
 the blend of Slavic and Bulgarian traits which occurred during
 the first centuries of their coexistence.

53 Vaklinov, Stančo Stančev. "L'orient et l'occident dans
 l'ancien art bulgare du VIIe au Xe siècle." Corsi di Cultura
 sull'Arte Ravennate e Bizantina 15 (1968):241-85.
 A lengthy discourse on the place of Bulgarian art. No
 documentary apparatus or bibliography.

54 Vasilev, Asen. "Prouchvaniĭa na izobrazitelnite izkustva iz
 niakoi selishta po dolinita na Struma" (Fr. sum.: "Étude sur
 l'art figuratif de certains sites de la vallée de la Strouma").
 IzvII 7 (1964):151-92 (Fr. sum.: 192).

In Bulgarian. A survey of monuments in the valley of the
Struma river. Works considered range from architecture to wall
painting to stone and wood carving. Most of the material is of
sixteenth- and seventeenth-century date, although some earlier
monuments are also considered.

55 ____. "Tsŭrkvi i monastiri iz zapadna Bŭlgariia" (Fr. sum.:
 "Églises et monastères de la Bulgarie occidentale"). Razkopki
 i prouchvaniia 4 (1949):49-114 (Fr. sum.: 113-14).
 In Bulgarian. A corpus of 69 churches and monasteries in
 western Bulgaria. An important basic research work with plans of
 churches and a select number of photographs.

56 Velkov, I. "Stari selishta i gradishta iuzhno ot Sakar
 Planina--Materiali za arkheologicheskata karta na Bŭlgariia"
 [Old settlements and towns south of the Sakar Mountain--
 Materials for the archaeological map of Bulgaria]. GNM 5
 (1933):169-87.
 In Bulgarian. Material published includes a rock-cut
 trefoil church near Mikhalich and remains of a late Roman [?]
 fort of Fikel on the Bulgarian-Turkish border.

57 Vŭlov, Vŭlo. "Vodosnabdiavaneto na srednovekovnite bŭlgarski
 gradove i kreposti (VII-XIV v.)" (Fr. sum.: "La canalisation
 d'eau des villes et des forteresses médiévales bulgares [VIIe-
 XIVe s.]). Arkh 19, no. 1 (1977):14-30 (Fr. sum.: 29-30).
 In Bulgarian. Discusses the question of water supply in
 medieval Bulgarian towns and fortifications. Unlike the cities
 and forts of the Romans which frequently depended on aquaducts,
 medieval towns and fortifications depended on wells and cisterns.
 The author discusses different types of internal supply systems
 and illustrates them by specific examples.

58 Vŭzharova, Zhivka. Slaviani i prabŭlgari (po danni na ne-
 kropolite ot VI-XI v. na teritoriiata na Bŭlgariia) (Ger.
 sum.: "Slawen und Protobulgaren (nach Angeben aus den Gräber-
 feldern aus dem 6. bis 11. Jahrhundert in Landesgebiet Bul-
 gariens). Sofia: Bŭlgarska akademiia na naukite, 1976.
 448 pp., 243 figs.
 In Bulgarian. An archeological study of early Slavic and
 Protobulgarian cultures in the light of finds excavated in ceme-
 teries dating from the sixth to the eleventh centuries. Objects
 include pottery, jewelry, and metal objects.

59 Wyjarova, Jivka. "Les investigations archéologiques dans les
 villes du haut moyen âge en Bulgare." Slavia antiqua 7 (1960):
 444-52.
 A convenient brief summary of the most important early
 medieval archeological sites in Bulgaria, accompanied by notes
 citing the up-to-date literature on each subject.

60 Zheliazkova, Vessa. <u>Medieval Bulgarian Culture</u>. Sofia:
 Foreign Languages Press, 1964. 140 pp., illus.
 A profusely illustrated semi-popular collection of essays
 by noted Bulgarian and non-Bulgarian scholars.

ARCHITECTURE

61 Aladzhov, Dimcho. "Dve skalni tsŭrkvi v Khaskovski okrŭg"
 [Two rock-cut churches in the region of Khaskovo]. <u>MPK</u> 11,
 no. 2 (1971):9-11 (Fr. sum.: 63).
 In Bulgarian. Considers two small rock-cut churches at
 Mikhalich (a triconoch) and at Matochina (Fikel), and on the
 basis of general affinities to the Cappadocian monuments proposes
 a date around the tenth century.

62 Angelova, Stefka. "Za proizvodstvoto na stroitelna keramika v
 severoiztochna Bŭlgariia prez rannoto srednovekovie" (Fr.
 sum.: "Sur la production de la céramique destinée aux con-
 structions en Bulgarie du nord-est pendant le haut moyen âge").
 <u>Arkh</u> 13, no. 3 (1971):3-24 (Fr. sum.: 24).
 In Bulgarian. An exhaustive study of brick and tile pro-
 duction in early medieval Bulgaria. Different types of tiles are
 carefully analyzed and systematically presented.

63 Balş, Georges. "Contribution à la question des églises
 superposées dans le domaine Byzantin." <u>IBAI</u> 10 (1936):
 156-67. (<u>Actes du IV^e Congres international des études
 byzantines</u>.)
 Bulgarian two-storied churches at Bachkovo, Boiana, and
 Asenovgrad are related to the general Byzantine development of
 the type.

64 Bichev, Milko. "L'architecture bulgare au XIII^e et XIV^e
 siècle." <u>Corsi di cultura sull'arte ravennate e bizantine</u> 15
 (1968):59-79.
 A brief chronological survey of major monuments. The au-
 thor sees the architecture of this period as having become the
 leading art in Bulgaria. Architecture displayed lesser depen-
 dence on Byzantium and a greater degree of originality than did
 painting.

65 _____. <u>Architecture in Bulgaria from Ancient Times to the
 Late 19th Century</u>. Sofia: Foreign Languages Press, 1961.
 80 pp., 45 figs. in text, 105 pls.
 A short history of Bulgarian architecture. The book is
 organized in the conventional chronological manner--architecture
 before the establishment of the national state; architecture of
 the First Bulgarian Empire; architecture of the Second Bulgarian
 Empire; architecture under the Ottoman rule; architecture of the
 period of national rebirth. Architectural drawings include only
 plans.

66 Bošković, Georges. "Note sur les analogies entre l'architec-
 ture serbe et l'architecture bulgare au Moyen-Âge." IBAI 10
 (1936):57-74. (Actes du IV^e Congrès international des études
 byzantines.)
 Considers the problem of the tower above the narthex which
 occurs in church architecture of Serbia and Bulgaria.

67 Brunov, N. "K voprosu o bolgarskikh dvukhetazhnikh tserk-
 vakh-grobnitsakh" [The question of Bulgarian two-storied
 mausoleum churches]. IBAI 4 (1927):135-44.
 In Russian. Although stemming from the same common root,
 Bulgarian two-storied mausoleum churches are found to be charac-
 terized by regional aspects not found in Constantinople or else-
 where.

68 _____. "K voprosu ob arkhitekturnom stile epokhi Paleologov v
 Konstantinopole" (Ger. sum.: "Zur Frage nach dem Baustil des
 Paleologenzeitalters in Konstantinopel"). IBAI 5 (1929):
 187-224 (Ger. sum.: 222-24).
 In Russian. A fundamental work for the study of late
 Byzantine architecture. The architecture of Nesebŭr figures
 prominently in this study.

69 Dechevska, Neli Chaneva. "Edin paralel mezhdu bŭlgarskata i
 gruzinskata srednovekovna tsŭrkovna arkhitektura" (Eng. sum.:
 "A parallel between the Bulgarian and Georgian medieval eccle-
 siastical architecture"). PNI 12, no. 4 (1979):36-40 (Eng.
 sum.: 64).
 In Bulgarian. Considers the relationship between the
 churches of Holy Archangels at Bachkovo monastery in Bulgaria and
 St. Nicholas at Gelati monastery in Georgia. The similarity be-
 tween the two architectural solutions is attributed to the fact
 that Bachkovo monastery was founded by a Georgian.

70 _____. "Po vŭprosa za srednovekovnite trikonkhalni tsŭrkvi ot
 monastirski tip na Balkanite" [On the question of medieval
 trefoil churches of the monastic type in the Balkans]. MPK
 11, no. 1 (1971):10-15 (Fr. sum.: 75-77).
 In Bulgarian. Distinguishes two larger families of monas-
 tic trefoil churches in the Balkans--the earlier found in
 Bulgaria and Greece, and the later in Serbia and Rumania.

71 _____. "Trikonkhalnite tsŭrkvi ot IX-XIV v. po bŭlgarskite
 zemi" (Fr. sum.: "Les églises à trois conques du IX-XIV^e s.
 des terres bulgares"). Arkh 12, no. 4 (1970):8-21 (Fr. sum.:
 21).
 In Bulgarian. The material is divided into six basic cate-
 gories: churches with three adjacent apses; single-aisled
 churches; churches with enclosed apses; churches in the form of
 the free cross; churches with four columns and an inscribed
 cross; churches with transitional forms.

72 Diulov, Liuben Iordanov. Prinos kŭm metrichnoto izsledvane
 na srednovekovnata kultova arkhitektura v Bŭlgariia (Ger.
 sum.: "Beitrag zur metrischen Untersuchung der mittelalter-
 lichen Kirchenbaukunst in Bulgarien"). Sofia: Tekhnika,
 1962. 188 pp., 156 figs.
 In Bulgarian. A study of proportions in the planning of
 Bulgarian medieval churches, with an attempt to define the
 medieval design module.

73 Filov, B[ogdan Dimitrov]. Starobŭlgarskata tsŭrkovna arkhi-
 tektura [Old Bulgarian church architecture]. Spisanie na
 Bŭlgarskata akademiia na naukitie, no. 43. Sofia: Bŭlgarska
 akademiia na naukite, 1930. 59 pp., 40 figs. in text, 20 pls.
 In Bulgarian. A brief survey of Bulgarian church architec-
 ture.

74 Filov, Bogdan [Dimitrov]. "Les palais vieux-Bulgares et les
 palais Sassanides." L'art byzantin chez les Slaves: Les
 Balkans. Vol. 1, pt. 1. Paris: Paul Geuthner, 1930,
 pp. 80-86.
 Two Bulgarian palaces at Aboba-Pliska are linked hypo-
 thetically with the Sassanian tradition of palace architecture.

75 Grabar, A[ndré]. "Bolgarskiia tserkvi-grobnitsi" (Fr. sum:
 "Les églises sepulcrales bulgares"). IBAI 1, no. 1 (1922):
 103-35 (Fr. sum.: 132-5).
 In Russian. A study of two-storied Bulgarian mausoleum
 churches and their relationship to the broader Byzantine archi-
 tectural sphere (e.g., Syria and Armenia).

76 Iakobson, A.L. "K izucheniiu rannesrednevekovoi bolgarskoi
 arkhitekturi" [A contribution to the study of early medieval
 Bulgarian architecture]. Vizantiiskii vremennik 28 (1968):
 195-206.
 In Russian. A study of Bulgarian architecture during the
 first Bulgarian Empire and its relationship to Armenian proto-
 types.

77 Ignatov, Boris. "Kŭm vŭprosa za bŭlgarska arkhitekturna shkola
 vŭv vizantiiskiia stil" [Toward the question of a Bulgarian
 architectural 'school' within Byzantine style]. Arkh 5,
 no. 3 (1963):55-64.
 In Bulgarian. Strives to define distinctive national fea-
 tures in Bulgarian medieval architecture which distinguish it
 from contemporaneous Byzantine achievements. The 'Round Church'
 at Preslav, the church of the Forty Martyrs at Tŭrnovo, and the
 Pantokrator Church at Nesebŭr are considered.

78 Karasimeonov, Petŭr. Nachalo na slavi͡anobŭlgarskata arkhi-
 tektura i istori͡ia [Beginnings of Slavo-Bulgarian architecture
 and history]. Sofia, 1943. 56 pp., 24 figs. in text.
 In Bulgarian. A short essay attempting to define the
 Slavo-Bulgarian elements in early Bulgarian church architecture.
 Reveals a very narrow point of view.

79 Koeva, Margarita. "Poi͡ava i kompozitsionno razvitie na ikono-
 stasa IV-XVIII v." (Eng. sum.: "The Origin and the Develop-
 ment of the Iconostasis Composition IV-XVIII"). PNI 12,
 no. 2 (1979):46-52 (Eng. sum.: 63).
 In Bulgarian. Considers the development of Bulgarian
 iconostasis screens from the fourth to the eighteenth centuries
 within a broader, Byzantine framework.

79a Kozhukharov, Georgi, ed. Arkhitekturata na p͞rvata i vtorata
 Bŭlgarska dŭrzhava. Materijali (Fr. sum.: "L'architecture du
 premier et du deuxi͡eme royaume Bulgare. Materiaux."). Sofia:
 Bŭlgarska akademii͡a na naukite, 1975. 419 pp., numerous b&w
 illus.
 In Bulgarian. A series of essays written by different au-
 thors on various subjects pertaining to Bulgarian medieval archi-
 tecture. Some of the essays are accompanied by brief summaries
 in French.

79b Krandžalov, Dimitr. "Sur le probl͡eme des influences orien-
 tales dans l'art ancien bulgare." Starinar, n.s. 19 (1969):
 141-64.
 A reassessment of the question of oriental influence versus
 the survival of the Romano-Byzantine tradition in the formation
 of Bulgarian architecture during the First Empire. The focus of
 the discussion is on Pliska, Preslav, and the problem of large-
 scale planning in general.

80 Mavrodinov, N[ikola]. Ednokorabnata i krŭstovidnata tsŭrkva
 po bŭlgarskiti͡e zemi do krai͡a na XIV v. (Fr. sum.: "L'église
 ͣ nef unique et l'église cruciforme en pays Bulgare jusqu'ͣ la
 fin du XIVᵉ s."). Sofia: Narodnii͡a arkheologicheski muzei͡,
 1931. 186 pp., 170 figs. in text.
 In Bulgarian. A major study of Bulgarian church architec-
 ture. Considers the question of single-aisled, cruciform, and
 cross-in-square churches in the broadest context of Byzantine
 architecture.

81 Mavrodinov, Nikola. "Vŭnshnata ukrasa na starobŭlgarskiti͡e
 tsŭrkvi" (Fr. sum.: "La décoration extérieure des anciennes
 églises bulgares"). IBAI 8 (1935):262-330 (Fr. sum.: 322-30).
 In Bulgarian. An exhaustive study of exterior decoration
 in Bulgarian medieval church architecture, particularly in rela-
 tionship to Byzantium. The material is divided into decoration
 of west façades, lateral façades, east façades, and domes. The

author considers individual decorative motifs. An appendix con-
siders the place of Tekfur Saray in Istanbul in the context of
early fourteenth-century Byzantine architecture.

82 Miiatev, K[rŭst͡o]. "Arkhitektura Bolgarii" [Architecture of
 Bulgaria]. Arkhitektura vostochnoĭ Evrop͡i srednie veka.
 Vseobshchaia istoriia arkhitektur͡i v 12 tomakh, 3. Leningrad
 and Moscow: Izdatel͡stvo literatury po stroitel͡stvu, 1966,
 pp. 376-417.
 In Russian. A brief general history of Bulgarian medieval
 architecture. Summarizes the main themes of Bulgarian church
 architecture.

83 Miiatev, Krŭsti͡u. Arkhitektura v srednovekovna Bŭlgarii͡a
 [Architecture in Medieval Bulgaria]. Sofia: Bŭlgarskata
 akademii͡a na naukite, 1965. 243 pp., 265 figs.
 In Bulgarian. A standard work on Bulgarian medieval archi-
 tecture. Begins with a short introductory chapter on architec-
 ture on the territory of Bulgaria before the formation of the
 First Bulgarian Empire. The first chapter discusses the archi-
 tecture of the First Bulgarian Empire, the second the architec-
 ture under Byzantine domination and during the Second Bulgarian
 State, while the third considers church architecture under the
 Turkish yoke. The author uses a strictly typological approach
 in his analysis of buildings. The book is amply illustrated, but
 architectural drawings of buildings are exclusively plans.

84 Miiatev, Krŭst͡o. "Zhilishchnata arkhitektura v Bŭlgarii͡a
 prez IX i X v." (Ger. sum.: "Die Wohnungsarchitektur in
 Bulgarien vom 9. ind 10. Jahrhundert"). IBAI 23 (1960):1-21
 (Ger. sum.: 20-21).
 In Bulgarian. A study of residential architecture which
 considers a wide range of building types from wooden huts to
 palaces.

85 Mijatev, Krăstju. Die mittelalterliche Baukunst in Bulgarien.
 Translated by M. Matliev. Sofia: Bulgarische Akademie der
 Wissenschaften, 1974. 243 pp., 265 figs.
 See entry BU 83.

86 Mikhailov, Stamen. "Srednovekovni tsŭrkvi v Rodopite" (Fr.
 sum.: "Églises médiévales des Rhodopes"). Rodopski sbornik 2
 (1969):147-80 (Fr. sum.: 178-80).
 In Bulgarian. Discusses six churches in the area of
 Rodopi: five are medieval buildings ranging in date from the
 thirteenth to the sixteenth centuries; one is an Early Christian-
 Byzantine church, probably of sixth century date. The architec-
 ture of all of the churches discussed is modest.

87 Mi[k]hailov, Stamen. "Sur l'origine de l'architecture monu-
 mentale du premier royaume Bulgare." Starinar 20 (1969):
 213-22.
 An analysis of secular architecture (palaces) of the First
 Bulgarian Empire in relationship to the architecture of Armenia
 and Georgia.

88 Panaĭotova, Dora. "Niakoi problemi na bŭlgarskata arkhitek-
 tura prez XII-XIV vek" (Fr. sum.: "Certains problèmes de
 l'architecture bulgare aux XIIe-XIVe siècles"). PNI 6, no. 1
 (1973):50-57 (Fr. sum.: 64).
 In Bulgarian. Considers national characteristics which
 distinguish Bulgarian architecture from the mainstream of Byzan-
 tine architectural development. Fortified urban character of
 church architecture is considered to be one of the chief distinc-
 tions. Other distinctions are: use of decorative ceramic tiles,
 characteristic use of wooden sculptural decoration of iconostasis
 screens, and external painting of church facades.

89 Popov, Khrabŭr Khristov. Tektonika i konstruktsii na arkhi-
 tekturnoto nasledstvo v Bŭlgariĭa [Tectonics and construction
 in architectural heritage of Bulgaria]. Sofia: Dŭrzhavno
 izdatelstvo "Tekhnika," 1972. 182 pp., 274 figs. (Eng. sum.:
 175-78).
 In Bulgarian. Discusses the tradition of tectonics and
 construction in Bulgarian architecture. The author argues that
 the constant rapport between structural conception and form re-
 flected sound architectural practice. He calls for the applica-
 tion of these principles to modern design and technology. The
 book is printed on poor paper and the illustrations are of poor
 quality with the exception of drawings, which are fair.

90 Protich, Andreĭ. "Arbanashata kŭshta" (Fr. sum.: "La maison
 d'Arbanassi"). GNM 1921 (1922):29-58 (Fr. sum.: 57-58).
 In Bulgarian. An exhaustive study of the town house of
 Arbanassi (near Tŭrnovo). Examines all aspects of this archi-
 tecture from planning to decorative details. The article is well
 illustrated with photographs and drawings.

91 _____. "Sushtnost i razvitie na bŭlgarskata tsŭrkovna arkhi-
 tektura" (Fr. sum.: "L'architecture religieuse bulgare").
 IBAI 1, no. 2 (1924):186-205 (Fr. sum.: 203-205).
 In Bulgarian. An early survey of Bulgarian church archi-
 tecture. Distinguishes three general types: great basilica
 (ninth-twelfth centuries), small domed church (end of ninth-
 fourteenth centuries), and the "basilican" type of Mt. Athos
 (fourteenth-nineteenth centuries). The conclusions reached have
 been largely superseded.

92 Protitch, André. L'architecture religieuse bulgare. Sofia,
 1924. 71 pp., 65 figs. in text.
 A short essay on Bulgarian architecture and some aspects of
 art. The ideas presented are largely outdated. Some of the il-
 lustrations have documentary value.

93 Raschenov, A. "Das bulgarisch-byzantinische Architektur-
 system." Studi Byzantini e Neoellenici (Rome) 6 (1940):
 352-56. (Atti del V Congresso internazionale di studi
 bizantini, 2.)
 A study of proportional and decorative systems employed in
 Bulgarian-Byzantine architecture, and their possible sources.

94 Rashenov, Al. "Bŭlgarska shkola v vizantiiskiia stil" (Fr.
 sum.: "L'école bulgare dans l'architecture byzantine").
 IBAI 6 (1932):206-220 (Fr. sum.: 218-20).
 In Bulgarian. Stilted argumentation aimed at identifying a
 "national" architectural style during the late Middle Ages
 while downplaying the Byzantine influence.

95 Săsălov, Dimităr. "Problèmes sur l'origine de la décoration
 de façade ceramoplastique." IBAI 35 (1979) [Special issue:
 Culture et art en Bulgarie médiévale (VIIIe-XIVe siècle)]:
 92-110.
 A broad, well-documented discussion of the origins and
 development of ceramic tile façade decoration in medieval
 Bulgaria.

96 Silianovska-Novikova, Tatiana. "Sur le problème du style
 byzantin et des tendances romanes dans le décor architectural
 des écoles nationales médiévales." Actes du XIVe Congrès
 international des études byzantines, 1971 (Bucharest) 3
 (1976):399-403.
 Examines Romanesque aspects of architectural decoration of
 Bulgarian churches and sees this trend as paralleling the "in-
 filtration" of Byzantine influence taking place at the same time.

97 Smjadovski, Teodosiĭ. "Za proizkhoda na preslavskite nishi"
 (Fr. sum.: "Sur l'origine des niches de Preslav"). Arkh 18,
 no. 4 (1976):33-47 (Fr. sum.: 47).
 In Bulgarian. Argues that the form of altar apses evident
 at Preslav and Pliska reveals an archaic Eastern practice, not
 related to the practice in ninth-century Constantinople. Links
 with Western, Carolingian architecture are sought with refer-
 ence to lateral niches in some Bulgarian churches, while Western
 apses are referred to as a Frankish element of design. The arti-
 cle is characterized by sweeping, erroneous conclusions.

98 Stamov, S. et al. The Architectural Heritage of Bulgaria.
 Sofia: State Publishing House "Tekhnika," 1972. 327 pp.,
 illus.
 A popular book on Bulgarian architecture with abundant
 illustrations and brief accompanying descriptions. The black-
 and-white photographs are largely good, the color photographs are
 of very inconsistent quality, while the architectural drawings of
 the buildings (white line and black background) are exclusively
 plans.

99 Stančev, Stančo. "L'architecture militaire et civile de
 Pliska et de Preslav à la lumière de nouvelles données."
 Actes du XIIe Congrès international d'études byzantines
 (Belgrade) 3 (1964):345-52.
 A discussion of military (city walls and city gates) and
 secular architecture (palaces, baths) at Pliska and Preslav in
 the light of recent excavations.

100 Stoĭanov, Borislav Ĭ. Starata rodopska arkhitektura [Old
 architecture of Rhodope]. Sofia: Tekhnika, 1964. 115 pp.,
 135 figs.
 In Bulgarian. A thorough study dealing with old (mostly
 vernacular) architecture in the region of the Rhodope mountains.
 The text is subdivided into two parts: a historical-ethnographic
 introduction and a technical analysis of buildings and their com-
 ponents. The study is amply illustrated with good photographs
 and excellent drawings.

101 Stoĭkov, Georgi. "Kultovi i obshchestveni zgradi v severoza-
 padna Bŭlgariĭa" (Fr. sum.: "Édifices culturels et publics").
 Kompleksna nauchna ekspeditsiĭa v severozapadna Bŭlgariĭa prez
 1956 godina. Sofia: Bŭlgarskata akademiĭa na naukite, 1958,
 pp. 113-71.
 In Bulgarian. Material pertaining to secular and religious
 architecture of northwest Bulgaria. Most of the buildings are
 from the eighteenth and nineteenth centuries, though a number of
 strictly medieval churches are also included.

102 Tonev, Liuben et al. Kratkaĭa istoriĭa bolgarskoĭ arkhitek-
 tury [Short history of Bulgarian architecture]. Sofia:
 Bolgarskaĭa akademiĭa nauk, 1969. 645 pp., 641 figs.
 In Russian. A comprehensive survey of history of Bulgarian
 architecture from prehistoric times to 1944. Part 2 (pp. 62-128)
 is devoted to medieval architecture. Part 3 (pp. 129-202) dis-
 cusses Bulgarian architecture under Turkish rule (end of four-
 teenth-second half of the eighteenth century). This period is
 characterized by conservative persistence of medieval types (par-
 ticularly true of church architecture) as well as by importation
 of Ottoman architecture (residential architecture, public baths,
 sarays, mosques and fortifications). Much of this architecture
 persists through the second half of the nineteenth century (the

period of national revival), discussed in part 4 (pp. 203-448),
which witnessed a flourishing of urban architecture--some of
which is of exceptionally fine quality. The book is printed on
good paper and contains good illustrations.

103 Tsapenko, M.P. Arkhitektura Bolgarii [Architecture of
 Bulgaria]. Moscow: Gosudarstvennoe izdatel⁻stvo literatury
 po stroitel⁻stve i arkhitekture, 1953. 279 pp., illus.
 In Russian. A study of Bulgarian architecture in its his-
 torical and geographic setting, from the ancient beginnings to
 modern times. The emphasis is on medieval architecture. Illus-
 trations are fair, mostly reproduced from earlier publications.

104 Zlatev, Todor. Bŭlgarskite gradove po r. Dunav prez epokhata
 na vŭzrazhdaneto [Bulgarian towns on the Danube before the
 period of national rebirth]. Bŭlgarska natsionalna arkhitek-
 tura 4. Sofia: Dŭrzhavno izdatelstvo Tekhnika, 1962.
 In Bulgarian. A study of Bulgarian towns along the Danube.
 The author investigates briefly their history, urban form, and
 architectural heritage. Most of the material is post-medieval,
 but medieval monuments are included. Printed on poor paper, the
 reproductions in this book are of substandard quality.

PAINTING

GENERAL

105 Bakalova, Elka. "Sur la peinture bulgare de la second moitié
 du XIVᵉ siècle (1331-1393)." In Moravska škola i njeno doba.
 Edited by Vojislav J. Djurić. Belgrade: Filozofski fakultet,
 Odeljenje za istoriju umetnosti, 1972, pp. 61-75.
 A general study of the last phase of Bulgarian medieval
 painting. The study considers the frescoes in Hrelja's Tower at
 Rila, at Zemen, Asenovgrad, Sofia (St. George), Berende, and
 Ivanovo, as well as icons and manuscript illuminations (e.g.,
 chronicle of Manasses, Tomić Psalter, and the Gospels of Tsar
 Ivan Alexander).

106 Boschkov, Atanas. La peinture bulgare des origines au XIXᵉ
 siècle. Translated from the Bulgarian by K. Todorov.
 Recklinghausen: Verlag Aurel Bongers, 1974. 394 pp.,
 257 illus. [Also available in German: Die bulgarische
 Malerei, 1969.]
 A major up-to-date survey of Bulgarian painting from
 Antiquity to the eighteenth century. Emphasis is on the medieval
 material. The book is illustrated with high-quality black-and-
 white and color photographs.

107 Bozhkov, Atanas. "Sotsialnata i tvorcheskata priroda na
 bŭlgarskiia zograf ot Srednovekovito" [The social and artistic
 character of the Bulgarian medieval painter]. Izkustvo 26,
 no. 5 (1976):10-17.
 In Bulgarian. Considers the limited amount of information
 about medieval painters (mostly post-medieval) and attempts to
 portray their artistic character.

108 Bozhkov, Athanas. "The Cutting Short of the Bulgarian
 Quattrocento." Contacts, special issue (1967):83-122.
 Discusses the problem of Bulgarian painting during the
 second half of the fifteenth century, emphasizing the need to
 consider the most representative monuments--Poganovo and
 Kremikovtsi--in the broader context of fresco painting in the
 Balkans from Greece to Romania.

109 Duichev, Ivan. "Istoricheskite predpostavki na Paleologov-
 skiia renesans" [Historical assumptions regarding the Paleolo-
 gan Renaissance]. Izkustvo 28, no. 10 (1978):8-15.
 In Bulgarian. Considers the historical factors which ruled
 the formation of the so-called Paleologan Renaissance, and ex-
 amines the Bulgarian component of this development in which
 humanism is a pronounced theme.

110 Manova, Ek[aterina]. "Les armes défensives au moyen âge
 d'après les peintures murales de la Bulgarie du sud-ouest au
 XIIIe, XIVe et XVe s." Byzantino-Bulgarica 3 (1969):187-223.
 This study of armor and weapons in Bulgaria from the thir-
 teenth to the fifteenth centuries is largely based on visual evi-
 dence provided by frescoes.

111 Tsoncheva, Mara. "Za niakoi problemi na bŭlgarskoto vŭzrozh-
 densko izkustvo" (Fr. sum.: "Sur certains problèmes de l'art
 de la renaissance bulgare"). PNI 12, no. 1 (1979):3-14 (Fr.
 sum.: 62).
 In Bulgarian. Considers the Bulgarian Renaissance (to be
 distinguished from the Renaissance in the West) from the view-
 point of specific social and national conditions. The art forms
 are discussed in the light of national, traditional character-
 istics, and folk art is considered as an important intermediary.

112 Vasilev, Vasil P. "Prouchvaniia vŭrkhu teknologiiata na
 starobŭlgarskita zhivopis" [Technological research on old Bul-
 garian wall painting]. Arkh 5, no. 2 (1963):41-68.
 In Bulgarian. A technical report on different mineral
 pigments used by medieval Bulgarian painters.

FRESCOES

113 Bakalova, Elka. "Ivanovskite stenopisi i ideĭte na isikhazma"
 (Fr. sum.: "Les fresques d'Ivanovo et les idées des
 Hesychastes"). <u>Izkustvo</u> 26, no. 9 (1976):14-21 (Fr. sum.:
 24).
 In Bulgarian. Revives the frequently entertained idea of
 links between the Hesychast monastic movement and Byzantine
 fourteenth-century art. The relationship is proposed on three
 accounts: the significance attached to the monastic community as
 was evident by the royal patronage of this small cave church; the
 increased emotional component in artistic expression; and the
 preference for certain subjects (e.g., life of St. Gerassim)
 which were not common before the fourteenth century, but which
 were known in Eastern monastic communities of this period.

114 Boschkov, Atanas. <u>Monumentale Wandmalerei Bulgariens</u>. Mainz:
 Florian Kupferberg Verlag, 1969. 154 pp., b&w illus. in text.
 A general history of medieval Bulgarian fresco painting
 from its beginnings to the eighteenth century. The book is orga-
 nized in three chapters: 1) Beginnings, 2) The flowering of
 Bulgarian art during the Second Bulgarian Empire (1186-1396), and
 3) Bulgarian monumental painting from the fifteenth to the
 eighteenth centuries. The book is illustrated with excellent
 black-and-white photographs.

115 Bozhkov, Atanas. "Dva tsenni pametnika na bŭlgarskata monu-
 mentalna zhivopis ot XVI i XVII vek" [Two important monuments
 of Bulgarian monumental painting from the sixteenth and seven-
 teenth centuries]. <u>Izkustvo</u> 15, no. 9 (1965):2-12.
 In Bulgarian. Discusses the fresco decoration of the
 church of Sv. Ivan Rilski at village Kurilovo and the church of
 Sv. Nikola in the village Maritsa.

116 _____. "Stenopisite v Dobŭrsko i v Alinskiĭa monastir ot
 XVII vek" [Seventeenth-century wall painting at Dobŭrsko and
 Alinski monastery]. <u>Izkustvo</u> 16, no. 5 (1966):18-29.
 In Bulgarian. Considers seventeenth-century frescoes,
 their history, style, and iconography.

117 Filov, B[ogdan]. "Portretŭt' na Iv. Aleksandra" [Portrait of
 Ivan Alexander]. <u>Sbornik v chest na Vasil N. Zlatarski</u>
 (Sofia) (1925):499-504.
 In Bulgarian. Analyzes the known portraits of the Bul-
 garian Emperor Ivan Alexander, focusing on the main portrait in
 the Chronicle of Manasses.

118 Grabar, A[ndré]. "Do-istoriia bolgarskoĭ zhivopisi" [Pre-
 history of Bulgarian wall painting]. Sbornik v chest na Vasil
 Zlatarski. (Sofia) (1925):555-73.
 In Russian. Hypothesizes the existence of two parallel
 trends in the development of Bulgarian painting. The first of
 these draws from the art of pre-Christian Bulgaria, whence the
 distinctive, native style emerges.

Grabar, André. See entry BU 298

119 _____. "Un reflet du monde latin dans une peinture balkanique
 du XIIIᵉ siècle." Byzantion 1 (1924):229-43.
 Points out Western elements in the frescoes of Boiana
 (1259), suggesting that the artist was receptive to Western ideas
 while remaining faithful to the basically Byzantine general
 framework. These notions, expressed at this early date, have
 since been confirmed by research in Byzantine art of the thir-
 teenth century.

120 _____. La peinture religieuse en Bulgarie. Orient et
 Byzance 1. Paris: Libraire orientaliste Paul Geuthner, 1928.
 390 pp., 44 figs. in text, separate album with 64 b&w pls.
 A fundamental study of medieval Bulgarian painting. This
 was a pioneering work with important insights. Remains an essen-
 tial work in the field notwithstanding the results of subsequent
 research.

121 Grabar, André, and Mijatev, Krsto. Bulgaria. Medieval Wall
 Paintings. UNESCO World Art Series. New York: New York
 Graphic Society, 1961. 26 pp., 4 b&w figs., 32 color pls.
 A publication in the series noted for its high-quality
 reproductions of a select number of monuments. Frescoes repro-
 duced here are from the following monuments: Ossuary of Bachkovo
 monastery (2), Boyana (16), Ivanovo (3), Zemen (2), Tŭrnovo (3),
 Monastery of Kremikovtsi (6).

122 Krŭstev, Kiril, and Zakhariev, Vasil. Stara bŭlgarska zhi-
 vopis (Eng. sum.: "Bulgarian medieval painting"). Sofia:
 Bŭlgarski khudozhnik, 1961. 222 pp., 95 pls.
 In Bulgarian. A general survey of old Bulgarian painting
 covering the medieval period as well as the periods of Turkish
 domination and national renaissance.

123 Mavrodinov, Nikola. Staro-bŭlgarskata zhivopis [Old Bulgarian
 wall painting]. Sofia: Bŭlgarsko istorichesko druzhestvo,
 1946. 195 pp., 66 figs.
 In Bulgarian. The book opens with a brief chapter on
 "expressionism" in Eastern medieval art. The remaining nine
 chapters are organized in chronological sequence. The book
 reveals a highly nationalistic viewpoint since it treats Byzan-
 tine monuments (e.g., H. Sophia in Ohrid and Nerezi) and monu-

ments built and decorated under the patronage of Serbian rulers
(Staro Nagorčino, Gračanica) as part of the general development
of Bulgarian art. Printed on poor paper, the illustrations are
substandard.

124 Mavrodinova, Liliana. "Kŭm vŭprosa za sŭshtestvuvaneto na
 tŭrnovskata zhivopisna shkola: Stenopisite na Trapezitsa"
 (Fr. sum.: "Sur le problème de l'existence de l'école de
 peinture de Tărnovo: Les peintures murales de Trapezitza").
 IzvII 14 (1970):85-116 (Fr. sum.: 116).
 In Bulgarian. On the basis of fragmentary remains of
 frescoes, the author argues for the existence of a local "school"
 of painting at Tŭrnovo in the fourteenth century. The conclu-
 sions are largely based on the decoration of the dado zone (imi-
 tation of marble incrustations) and on the lower section of
 draperies (surviving fragments of standing figures of saints).

125 _____. "Prostranstvoto i arkhitekturniiat dekor v iztochno
 khristiianskata srednovekovna zhivopis" [Space and architec-
 tural decoration in Eastern Christian medieval painting].
 Izkustvo 23, no. 2 (1973):29-34.
 In Bulgarian. A brief discussion of spatial conceptions
 and pseudo-perspective in middle and late Byzantine painting.

126 Miiatev, Kr[ŭst̄o]. "Dekorativna sistema na bŭlgarskitie
 stenopsi" [Decorative system in Bulgarian wall painting].
 Sbornik v chest na Vasil N. Zlatarski (Sofia) (1925):135-49.
 In Bulgarian. Attempts to identify the national traits in
 Bulgarian painting which are seen as distinct from the general
 Byzantine painting tradition. Claims that these traits began
 around the middle of the thirteenth century as a Balkan phenome-
 non, but that by the fourteenth century distinctive Bulgarian
 traits became apparent.

127 Panayotova, Dora. Bulgarian Mural Paintings of the 14th
 Century. Translated by M. Alexieva and T. Athanassova.
 Sofia: Foreign Languages Press, 1966. 222 pp., b&w figs.,
 col. pls.
 A detailed study of all known fourteenth-century painting
 cycles in Bulgaria. Examines each individually. In the conclu-
 sion the author attempts some general remarks by grouping the
 paintings into three categories: paintings of "pure" Byzantine
 style of Paleologan Byzantium; paintings in an archaic style
 (presumably revealing pre-Iconoclastic traits which found their
 home in Bulgaria during the earliest stages of Christianization
 and remained alive until the fourteenth century); and paintings
 which reveal a blend of the above trends.

128 Protič, André. "Le style de l'école de peinture murale de
 Tirnovo au XIIIe et XIVe siècles." L'art byzantin chez les
 Slaves: Les Balkans. Vol. 1, pt. 1. Paris: Paul Geuthner,
 1930, pp. 92-101.
 Iconographic and stylistic features of the Tŭrnovo school
 of painting are discussed in relationship to contemporaneous
 painting from other Bulgarian centers.

129 Protich, A[ndre]. "Iugozapadnata shkola v bŭlgarskata
 stenopis prez XIII i XIV v" [Southwestern school in Bulgarian
 painting of the thirteenth and fourteenth centuries]. Sbornik
 v chest na Vasil N. Zlatarski (Sofia) (1925):291-342.
 In Bulgarian. Discusses one of two painting schools active
 in Bulgaria during the period of the Second Bulgarian Empire
 (1187-1393).

130 Stransky, Antoine. "Remarques sur la peinture du moyen Âge
 en Bulgarie, et en Grèce et en Albanie." IBAI 10 (1936):
 37-47. (Actes du IVe Congrès international des études byzan-
 tines.)
 Focuses on the churches of St. Nicholas at Melnik and the
 Virgin at Maligrad. Particularly important are historical re-
 marks on the patrons.

131 Tsoncheva, Mara. "Po vŭprosa za poiavata na monumentalna
 zhivopis v Bŭlgariia (VIII-XI v.)" (Fr. sum.: "Sur l'appari-
 tion de la peinture monumentale en Bulgarie [VIII-XIe ss.]").
 IzvII 11 (1968):5-46 (Fr. sum.: 48-49).
 In Bulgarian. Attempts to assess the process of genesis of
 Bulgarian medieval painting. A large section of the text is de-
 voted to the discussion of wall painting in western Bulgaria
 where such Byzantine monuments as St. Sophia at Ohrid and the
 church at Vodoča are discussed as representative works of Bul-
 garian art.

132 Velmans, Tania. "Deux courants artistiques dans les églises
 Bulgares du XIVe siècle: Les fresques de la chapelle rupestre
 d'Ivanovo (vers 1330) et celles de l'église de Zemen
 (XIVe s.)." Corsi di cultura sull'arte ravennate e bizantina
 15 (1968):291-93.
 A brief discussion of two examples of the "popular" trend
 in Bulgarian fourteenth-century painting, in contrast to what the
 author considers to be "grand art" of Constantinople.

133 _____. "Les peintures murales de Bačkovo et de Boiana (XIIe-
 XIIIe s.)." Corsi di cultura sull'arte ravennate e bizantina
 15 (1968):287-89.
 A summary statement of the main concepts regarding the
 distinctive nature of Byzantine painting in Bulgaria vis-à-vis
 the long-established Byzantine tradition.

134 Voeǐkova, Irina N. "Kŭm problema za izpolzuvane na antichnite
 traditsii v starobŭlgarskata monumentalna zhivopis" (Eng.
 sum.: "On the problem of using antique traditions in the old
 Bulgarian monumental paintings"). PNI 5, no. 2 (1972):42-47,
 64 (Eng. sum.: 63).
 In Bulgarian. An attempt to establish a proportional sys-
 tem for horizontal zones of frescoes in medieval Bulgarian
 churches and to link this system to the ancient architectural
 canons on proportions.

ICONS

135 Akrabova-Jandova, Iv. "Reflets de l'orient musulman dans la
 peinture des icônes post-byzantines en Bulgarie." Actes du
 XIV^e Congrès international des études byzantines (Bucharest) 3
 (1976):263-67.
 Considers twenty-two post-Byzantine Bulgarian icons and
 examines the Islamic element in this painting tradition.

136 Akrabova-Zhandova, Iv., Gerasimov, T.D., and Vasilev, V.P.
 Ikoni v sofiǐskiia arkheologicheski muzeǐ. Datirani ikoni
 [Icons in the archeological Museum of Sofia. Dated icons].
 Sofia: Bŭlgarska akademiia na naukite, 1965. 135 pp., illus.
 In Bulgarian. A catalog of dated icons in the Archeologi-
 cal Museum of Sofia with an introductory text and two special
 articles on inscriptions on dated icons (by T.D. Gerasimov) and
 the study of materials and techniques (by V.P. Vasilev). The
 book is amply illustrated with fairly good detailed photographs.

137 Atanasov, Atanas. "Restavratsiia i konservatsiia na ikona ot
 Melnik" (Fr. sum.: "Restauration et conservation d'une icône
 de Melnik"). MPK 17, no. 3 (1977):41-50 (Fr. sum.: 79).
 In Bulgarian. A detailed technical report on the restora-
 tion of the sixteenth- seventeenth-century icon of St. Athanasius,
 unfortunately illustrated by poor photographs.

138 Bossilkov, Svetlin. 12 Icons of Bulgaria. Sofia: Bŭlgarski
 khudozhnik, 1966. 16 pp., 12 col. pls.
 An album of twelve outstanding Bulgarian icons ranging in
 date from the ninth- or tenth-century St. Theodore to the
 eighteenth-century Nativity.

139 Bozhkov, Atanas. "Estetikata na bŭlgarskata ikona" (Fr. sum.:
 "Esthétique de l'icône bulgare"). PNI 9, no. 4 (1976):15-27
 (Fr. sum.: 62).
 In Bulgarian. A pioneering study attempting to analyze the
 aesthetics of icon paintings with special reference to Bulgarian
 icon painting.

140 _____. "Estetikata na bŭlgarskata ikona" (Fr. sum.:
"L'esthétique de l'icône bulgare"). PNI 10, no. 1 (1977):
11-24 (Fr. sum.: 63).
 Continuation of the study in entry BU 139.

141 _____. "Za siuzheta na bilateralnata ikona ot Poganovskiia
manastir" (Fr. sum.: "Le sujet de l'icône à deux faces du
monastère de Poganovo"). Izkustvo 26, no. 9 (1976):2-6 (Fr.
sum.: 47).
 In Bulgarian. Considers troublesome iconographic relation-
ship between the subjects depicted on the two faces of the icon.
Suggests that the theme of the Apocalypse relates the two sub-
jects, and that the icon reflects the troubled times in the
Balkans during the late fourteenth century.

142 Gerasimov, T[odor D.]. "L'icône bilatérale de Poganovo au
Musée archéologique de Sofia." Cahiers archéologiques 10
(1959):279-88.
 Discusses a fine double icon from Poganovo monastery, now
in the Archeological Museum of Sofia. The front depicts the
Vision of Prophets Ezechiel and Habacuc; the reverse depicts the
Virgin Mary and St. John the Theologian. The author believes
that the icon was painted in Constantinople at the end of the
fourteenth century along with five Deesis icons, now in Vysotski
monastery in Russia.

143 Grabar, André. "À propos d'une icône byzantine du XIVᵉ siècle
au Musée de Sofia." Cahiers archéologiques 10 (1959):289-304.
 Challenges some of Gerasimov's findings (see entry BU 142)
related to the double icon from Poganovo and proposes a more
careful study of late Byzantine artists' sources and methods.

144 Iordanova, Tania. "Bŭlgarskata ikona ot IX do XII v." (Fr.
sum.: "L'icône bulgare du IXᵉ au XIIᵉ s."). PNI 10, no. 3
(1977):32-38 (Fr. sum.: 64).
 In Bulgarian. Identifies Bulgarian characteristics in icon
paintings dated between the ninth and twelfth centuries and con-
siders these a result of Syro-Palestinian influences on contempo-
raneous artistic production in Byzantium.

145 Lafontaine-Dosogne, Jacqueline; Velmans, Tania et al. Icônes
bulgares du IXᵉ au XIXᵉ siècle. Exhibition catalog,
26 Nov. 1977-12 Feb. 1978. Brussels: Musées royaux d'art
et d'histoire, 1977. Not paginated; illus.
 Catalog with two short texts by T. Velmans (Bulgarian
icons; Byzantine-Slav cultural community), and one by Lj.
Prashkov (Evolution and development of Bulgarian icons from the
ninth to the nineteenth centuries).

146 Miiatev, Krŭstiu. "Edna bŭlgarska ikona vuv Frantsiia" [A
 Bulgarian icon in France]. Arkh 7, no. 3 (1965):32-38.
 In Bulgarian. Stylistic and decorative aspects of the
 famous Laon icon are examined in the context of Bulgarian paint-
 ing of the thirteenth century. Historical circumstances under
 which the painting was created and transported to France are also
 discussed.

147 Mijatev, Krsto. "Über den Ursprung der Ikone 'La Sainte Face
 de Laon'." ZNM 4 (1964):231-38.
 The mandylion icon, now in the cathedral treasury of Laon,
 is analyzed stylistically. Links with the twelfth-century art of
 Bulgaria and the broader Byzantine sphere are analyzed. The au-
 thor concludes that the icon was a work of a Bulgarian artist who
 used a Constantinopolitan twelfth-century model, and that the
 painting was done sometime after 1186. Between 1200 and 1257 the
 work was brought to Rome as a miracle-working icon.

148 Panaiotova, Dora. "Dve Bogoroditsi ot Sozopol" (Fr. sum.:
 "Deux Vierges de Sozopol"). IzvII 5 (1962):111-21 (Fr. sum.:
 121).
 In Bulgarian. The icon of the Virgin Pantovasilissa
 (sixteenth century) and the icon of the Virgin Phaneroméni
 (1541) reveal the same basic image of the Virgin adapted to two
 types--the Hodegitria and the Virgin of Cyprus.

149 _____. "Ikona Odigitriia ot XVI vek" [Sixteenth-century icon
 of Virgin Hodegetria]. Arkh 6, no. 1 (1964):15-18.
 In Bulgarian. A fine example of sixteenth-century Greek
 art (inscription at the base in Greek, dated 1566), this icon of
 Virgin Hodegetria is now in the Archeological Museum of Sofia.
 The Virgin with Christ is surrounded by the standing figures of
 Old Testament Kings and Prophets and a bust of St. John the
 Baptist, all appearing on the frame of the icon.

150 _____. "Ikona sv. Georgi na tron" [Icon of an enthroned St.
 George]. Arkh 8, no. 3 (1966):14-17.
 In Bulgarian. Discusses earlier attempts to attribute this
 icon to the thirteenth century and establishes it as a local work
 of the sixteenth century.

151 _____. "Tri ikoni ot Tsŭrkovniia muzei v Sofiia" [Three icons
 from the Church Museum in Sofia]. Arkh 5, no. 1 (1963):43-46.
 In Bulgarian. An icon of the Virgin Hodegetria (late thir-
 teenth or early fourteenth century), Christ Sotir and Zoodotis
 (fourteenth century), and Crucifixion (fifteenth century) are
 discussed. Bulgarian nuances distinguishing these paintings
 from strictly Byzantine works are detected.

152 Paskaleva, Kostadinka. "Dve ikoni ot Rilskiĭa manastir" (Fr.
 sum.: "Deux icônes du monastère de Rila"). IzvII 14 (1970):
 211-32 (Fr. sum.: 231-32).
 In Bulgarian. The icons of the Dormition of the Virgin and
 the Presentation are seen as iconographically and compositionally
 related to the tenth- to twelfth-century Byzantine art, while
 their style betrays post-Byzantine characteristics.

153 Paskaleva, Kostadinka, and Prashkov, Liuben. Icone bulgare
 dei secoli IX-XIX. Exhibition catalog, 15 May-15 June 1979.
 Rome: De Luca Editore, 1979, 59 pp., 100 illus.
 Each item included in the catalog is illustrated. Despite
 the predominance of painted icons, other media are represented,
 e.g., ceramic, bronze, and alabaster.

154 Sokolova, Doroteĭa. "Pet neseburski ikoni ot XVI-XVII vek"
 [Five Nesebur icons from the sixteenth to seventeenth cen-
 turies]. Izkustvo 28, no. 8 (1978):38-45.
 In Bulgarian. Five icons representing the Dormition of the
 Virgin, Ascension, Pentecost, the Marriage of Cana, and the
 Doubting Thomas are discussed. The crisp style characterized by
 a vibrant palette is considered the hallmark of a local workshop.

155 Xyngopoulos, André. "Sur l'icône bilatérale de Poganovo."
 Cahiers archéologiques 12 (1962):341-50.
 Argues that the double-sided icon from Poganovo monastery
 was painted in two stages. The scene depicting the Vision of
 Ezekiel was painted first, around the end of the thirteenth cen-
 tury. At that time the icon is believed to have belonged to the
 Monastery of the Virgin Katafigē in Thessaloniki from where it
 may have been taken to Poganovo. There, the reverse image of the
 Virgin and St. John might have been painted toward the end of the
 fourteenth century.

MANUSCRIPT ILLUMINATION

156 Bozhkov, Atanas. "Miniatiurite na damaskina ot XVII vek v
 Rilskiĭa manastir" [Miniatures in the seventeenth-century
 "Damascine" at Rila monastery]. Izkustvo 18, no. 8 (1968):
 18-22.
 In Bulgarian. Discusses the illuminations of this manu-
 script from the point of view of their iconography and style.

157 _____. "Miniatiurite ot madridskiĭa rukopis na Skilitsa:
 Biseri ot sukrovishtnitsata na svetovnoto izkustvo" [Miniatures
 of the Madrid Skilitzes Manuscript: A treasury of secular
 art]. Izkustvo 19, no. 3 (1969):8-29.
 In Bulgarian. An extensive article which considers the
 miniatures in the light of "secular" art. Provides a description
 of the miniatures with a fine set of illustrations.

158 _____. "Prostranstveni i koloritni problemi v miniatiûrite na
Manasievata letopis" [Spatial and coloristic problems in
miniatures of the Chronicle of Manasses]. Izkustvo 28, no. 10
(1978):2-7.
 In Bulgarian. Concludes that the manuscript illustrations
represent one of the richest repertoires of medieval historical
scenes in the eastern Christian world. As such, the manuscript
sheds light on the lost Byzantine prototypes which later also
served as models for Russian historical illuminations.

159 Dujčev, Ivan. "Le miniature bulgare medioevali." Corsi di
cultura sull'arte ravennate e bizantina 15 (1968):113-30.
 A general survey of the subject with the main literature
given in the footnotes.

160 _____. Miniatures of the Chronicle of Manasses. Sofia:
Bŭlgarski khudezhnik, 1963. 137 pp., illus.
 A study of one of the most important preserved Bulgarian
medieval manuscripts, The Chronicle of Manasses (Codex Vaticanus
slav. II), written and illuminated in 1356 for the Bulgarian
Emperor Ivan Alexander. A facsimile of all miniatures in the
Vatican manuscript. Each illumination is accompanied by a com-
mentary of historical and art-historical nature. The text in-
cludes discussions of Bulgarian culture in the first half of the
fourteenth century, of the Chronicle of Constantine Manasses (a
Byzantine writer of the twelfth century), and of the Vatican copy
of the Chronicle of Manasses. The book is available in several
languages besides English, including German, Bulgarian, and
Serbo-Croatian.

161 Dzhurova, Aksiniia. "Miastoto na Tomichoviia psaltir sred
ukrasenite s miniatiuri bŭlgarski rŭkopisi ot XIV v." [The
place of the Tomich Psalter in the decorative illuminations of
Bulgarian fourteenth-century manuscripts]. Izkustvo 23,
nos. 9-10 (1973):21-27.
 In Bulgarian. Dates the manuscript on historical basis to
after 1360, and attributes the miniatures to an accomplished
Byzantine illuminator who was commissioned, as was common at the
time, to illuminate a non-Greek manuscript.

162 _____. "Tomichoviiat psaltir" [The Tomich Psalter]. Vekove
4, no. 6 (1975):5-14.
 In Bulgarian. Considers the iconographic and stylistic
aspect of the illuminations in the Tomich Psalter, the work of a
workshop at Tŭrnovo dating from ca. 1360.

163 _____. "Za ornamenta v bŭlgarskite rŭkopisi ot XIII-XIV vek"
(Fr. sum.: "De l'ornament dans les manuscrits bulgares au
XIIIe-XIVe s."). Izkustvo 26, no. 9 (1976):22-29 (Fr. sum.:
47-48).

In Bulgarian. Recognizes three distinctive "styles" of
ornamentation in manuscripts: "neo-Byzantine style" (apparent in
the fourteenth century), "teratological style" (evident in
thirteenth-century manuscripts), and "Balkan style" (appeared at
the outset of the thirteenth century and endured as late as the
fifteenth and sixteenth centuries). The article is accompanied
by extensive footnotes listing a considerable bibliography on the
problems of Bulgarian manuscript painting.

164 Filov, Bogdan D. Miniatiurite na londonskoto evangelie na
 tsar Ivan Aleksandra (Parallel text in French: "Les minia-
 tures de l'évangile du roi Jean Alexandre à Londres"). Monu-
 menta artis Bulgariae, 3. Sofia: Dǔrzhavna pechatnitsa,
 1934. 56 pp., 134 b&w pls., 5 col. pls.
 In Bulgarian. The first comprehensive edition of the
Tetraevangelium (Gospels) of the Emperor Ivan Alexander, dated
1356. The black-and-white plates reproduce all miniatures in the
text and are of varying quality.

165 Ivanova, Vera. "Ktitorskiiat obraz v Ipolitoviia sbornik na
 istoricheskiia muzeĭ v Moskva" [A donor portrait in the
 Hypolitus Codex in the Historical Museum, Moscow]. Arkh 1,
 no. 3-4 (1959):13-23.
 In Bulgarian. Argues that the badly damaged donor portrait
represents Bulgarian Tsar Simeon. The idea is supported by
iconographic and stylistic arguments. Relationship between
decorative motifs on the donor portrait and ceramic tiles ex-
cavated at Tuzlalǔka is brought out.

166 Kirov, Maksimiliian. "Miniatiurite v Chetveroevangelieto ot
 1356 i epokhata na tsar Ivan Aleksandǔr" [Miniatures in the
 Tetraevangelium of 1356 and the epoch of Emperor Ivan
 Alexander]. PNI 11, no. 1 (1978):40-44.
 In Bulgarian. Basically an evaluation of Shivkova's book
on the subject. See entry BU 173.

167 Kotseva, Elena. "Za khudozhestvenoto oformiavane na starata
 bǔlgarska kniga" [Artistic evolution of old Bulgarian book].
 PNI 3, no. 2 (1970):52-57.
 In Bulgarian. Considers the seventeenth-century Cherpishko
evangeliary. Its illumination reveals strong adherence to tra-
ditional norms, but with a strong admixture of Western influence.

168 Miletich, L. Bǔlgarski khudozhestveni starini [Bulgarian art
 antiquities]. Vol. 2. Sofia: Arkheologicheskata komisiia,
 1911. 8 pp., 10 col. pls.
 In Bulgarian. An album reproducing frontispieces, initials,
and one full-page Evangelist portrait. The material is repro-
duced from several Bulgarian medieval manuscripts (fifteenth and
sixteenth centuries). A short introductory text (in Bulgarian

and French) provides a brief commentary on each of the items illustrated. Illustrations (all hand-colored) are of varying quality and usefulness.

169 Nichols, B. "Aspects of the Medieval Bulgarian Way of Life (According to Illustrations in the London Bible of Ivan Alexander)." Byzantino-Bulgarica 3 (1969):226-29.
 A brief study attempting to illustrate a relationship between the miniatures in the London Bible of Tsar Ivan Alexander and contemporaneous Bulgarian society. The article is illustrated by rather poor hand-colored copies of the originals, useful only for iconographic purposes.

170 Ruysschaert, J., and Dujčev, Ivan, eds. Manoscritti slavi documenti e carte riguadanti la storia Bulgara della Biblioteca Apostolica Vaticana e dell'Archivio Segreto Vaticano (IX-XVII secolo). Sofia: Nauka i izkustvo, 1979. 149 pp., 73 pls., some in color.
 A catalog prepared for an exhibition of Slavic manuscripts, documents, and maps, related to Bulgarian history from the Vatican collections. The material ranges in date from the ninth to the seventeenth centuries. Several of the manuscripts are illuminated and a number of these illuminations are satisfactorily reproduced.

171 Shchepkina, M.V. Bolgarskaia miniatiura 14 v. Issledovanie psaltyri Tomicha. Moscow: Gosudarstvennnyĭ istoricheskiĭ muzeĭ, 1963. 246 pp., 39 figs. in text, 68 pls., some in color.
 In Russian. Largely a monographic study of one of the most important Bulgarian medieval illuminated manuscripts--the Tomich Psalter now in Gosudarstvennyĭ istoricheskiĭ muzeĭ, Moscow (no. 2752). The author considers the miniatures a work of an accomplished Byzantine artist of the fourteenth century. Miniatures are inscribed in Greek while the text itself is in Bulgarian.

172 _____. "Istoriiata na edin bŭlgarski iliustriran psaltir ot chetirnadeseti vek" [History of a Bulgarian illuminated psalter from the fourteenth century]. Izkustvo 16, no. 6 (1966):27-31.
 In Bulgarian. Created in the wake of Bulgarian military defeat by the Serbs in 1330, the Tomich Psalter and its illuminations are of special importance for the history of the art of both nations.

173 Shivkova, Ljudmila. Das Tetraevangeliar des Zaren Ivan Alexandar. Recklinghausen: Verlag Aurel Bongers, 1977. 229 pp., 64 facsimile pls., 275 figs.
 A luxurious volume on the Tetraevangelium of the Bulgarian Emperor Ivan Alexander. Considers the manuscript in the

political and cultural context of Bulgaria in the fourteenth cen-
tury, as well as in the light of the patron as an individual and
his court. The miniatures are discussed in stylistic and icono-
graphic terms, as well as from the point of view of the influence
of the patron. A convenient b&w photo-layout of the entire manu-
script is provided.

174 Stoianov, Man'o. Ukrasa na slavianskite rŭkopisi v Bŭlgariia
 (Eng. sum.: "The ornamentation of Slavic manuscripts in
 Bulgaria"). Sofia: Bŭlgarski khudozhnik, 1973. 250 pp.,
 436 b&w illus., 115 col. illus.
 In Bulgarian. An exhaustive study of illuminations from
 the Slavic manuscripts in major Bulgarian collections. The book
 consists of a 46-page text, a catalog with 491 entries, a bibli-
 ography, summaries in German, Russian, French, and English. The
 book is amply illustrated with good reproductions.

SCULPTURE

175 Angelov, Valentin. "Proizhod i razvitie na niakoi simvoli pri
 vŭzrozhdenskata dŭrvorezba" (Eng. sum.: "The origin and the
 development of the symbols in the woodcarving of the Bulgarian
 revival art"). PNI 12, no. 2 (1979):53-57 (Eng. sum.: 63).
 In Bulgarian. Considers changes from traditional folk-
 mythological symbols to new, conceptual symbols characteristic of
 the art of woodcarving in eighteenth- and nineteenth-century
 Bulgaria.

176 _____. "Sravnitelen analiz na niakoi motivi ot vŭzrozhdenskata
 rezba" (Eng. sum.: "Comparative analysis of some motifs of the
 Bulgarian national revival carving"). PNI 12, no. 4 (1979):
 26-35 (Eng. sum.: 63).
 In Bulgarian. Points out the links with the medieval
 artistic tradition, particularly from the twelfth to the fif-
 teenth centuries. Borrowing from manuscript illumination is
 believed to have been the means for the transmittal of certain
 motifs into the woodcarving art of the eighteenth and nineteenth
 centuries.

177 Bozhkov, Atanas. "Srednovekovni relefni ikoni v Bŭlgariia"
 [Medieval relief icons in Bulgaria]. Izkustvo 29, no. 2
 (1979):10-18.
 In Bulgarian. A brief survey of medieval relief icons in
 Bulgaria with extensive notes and good photographs.

178 Drangov, Boris, and Kvinto, Lidiia. "Novo tŭlkuvane na
 kamenite skulpturni glavi ot Veliko Turnovo" (Fr. sum.:
 "Une nouvelle interprétation des têtes sculptées à Veliko
 Tarnovo"). MPK 17, no. 2 (1977):5-10 (Fr. sum.: 77).
 In Bulgarian. Hypothesizes that the two fragmented heads
 (male and female) belong to a sculptural composition depicting

either a Crucifixion or a Descent from the Cross, and that the
work reveals the influence of the Italian proto-Renaissance,
presumably received through Dalmatia.

179 Filov, B[ogdan]. "Chapiteaux de marbre avec décorations de
 feuilles de vigne en Bulgarie." In Mélanges Charles Diehl.
 Vol. 2. Paris: Libraire Ernest Leroux, 1930, pp. 11-18.
 Considers several capitals featuring vine scrolls excavated
 at Preslav, and dated from the second half of the ninth to the
 beginning of the tenth century.

180 Manova, Ekaterina. "Srednovekovna relefna ikona ot Nikopol"
 [Medieval relief icon from Nikopol]. MPK 11, no. 3 (1971):
 15-16 (Fr. sum.: 79).
 In Bulgarian. Excavated in 1970, this fragment of a Virgin
 Hodegitria is believed to be from the fourteenth century.

181 Miiatev, Krŭstiu. "Edna nadgrobna skulptura ot dvoretsa v
 Tŭrnovo" (Fr. sum.: "Une sculpture funéraire du palais de
 Tărnovo"). IBAI 19 (1955):339-58 (Fr. sum.: 356-58).
 In Bulgarian. Discusses a fragment of a tomb slab dis-
 covered in the Church of St. Paraskeve in the Palace at Tŭrnovo.
 The slab fragment features feet of a gisant figure--a form of
 funerary sculpture common in the West, but virtually unknown in
 the Byzantine world. The shoes of the unknown person were
 decorated with double-headed eagles indicating the highest social
 rank. All indications point to a royal burial from the four-
 teenth century, probably from the time of Ivan Alexander.

182 Mitov‾, A. Bŭlgarski khudozhestveni starini [Bulgarian art
 antiquities]. Vol. 1. Sofia: Arkheograficheskata komisiia,
 1907. 8 pp., 10 col. pls.
 In Bulgarian. An album of photographs with brief descrip-
 tions (in Bulgarian and French) of major examples of Bulgarian
 medieval and post-medieval woodcarving. Among the works illus-
 trated are the fourteenth-century doors from Rila monastery and
 the so-called Throne of Khreliia, a fourteenth-century patriar-
 chal throne. The remaining works are all iconostasis screens
 ranging in date from the seventeenth to the nineteenth centuries.

183 Novikova, Tatiana Silianovska. "Novi danni za razvitieto na
 skulpturata v Bŭlgariia prez epokhata na feudalizma (XII-
 XIV v.)" (Fr. sum.: "Nouvelles données sur le développement
 de la sculpture en Bulgarie sous le féudalisme"). IzvII 6
 (1963):67-94 (Fr. sum.: 96-98).
 In Bulgarian. A useful survey of Bulgarian medieval sculp-
 ture between the twelfth and fourteenth centuries.

184 Slavov, Atanas. "Kŭm vŭprosa za otnoshenieto tema-
 kompozitsiia v Bŭlgarskata tsŭrkovna dŭrvorezba" [Study of
 the relationship between the theme and the composition in
 Bulgarian church woodcarving]. PNI 1, no. 3 (1968):32-39.
 In Bulgarian. Contrasts certain "natural" compositional
 arrangements with those which reinforce the abstract decorative
 pattern of the background.

185 Vasiliev, Asen. Kameni relefi [Stone reliefs]. Sofia:
 Bŭlgarska akademiia na naukite, 1959. 370 pp., 321 figs.
 In Bulgarian. A history of Bulgarian relief sculpture.
 The material is presented topically, organized in such categories
 as the human figure, figures of saints and angels, animal fig-
 ures, figures of mythological animals, plant motifs, geometric
 and architectural motifs, etc.

186 Vasiliev, Asen et al. Kamenna plastika (Eng. sum.: "Stone
 sculptures"). Bŭlgarsko khudozhestveno nasledstvo. Sofia:
 Bŭlgarska akademiia na naukite, 1973. 529 pp., 337 pls.
 In Bulgarian. The most important work on Bulgarian sculp-
 ture from Antiquity to the nineteenth century. The book consti-
 tutes the first volume of a series on the National Art Heritage,
 published by the Institute of Art of the Bulgarian Academy of
 Sciences.

 MINOR ARTS

187 Aladzhov, Zhivko. "Nov bronzov krŭst-enkolpion ot Veliki
 Preslav" [A new bronze cross-encolpion from Great Preslav].
 Vekove 8, no. 2 (1979):73-75.
 In Bulgarian. A bronze cross, found at Preslav during the
 excavations between 1975 and 1978, has been dated prior to the
 late tenth or early eleventh century on the basis of coin finds
 in the same strata. The cross features the crucified Christ on
 one side and an orant Virgin on the other. The iconography of
 both is quite archaic, leading the author to conclude that the
 cross probably dates from the early or mid-tenth century, while
 explaining the iconography as a Byzantine product under Syrian
 influence.

188 Antonova, Vera. "Srednovekovni nakiti v Okrŭzhniia naroden
 muzeĭ v Kolarovgrad" [Medieval jewelry in the Regional People's
 Museum at Kolarovgrad]. Arkh 6, no. 2 (1964):45-52.
 In Bulgarian. A brief catalog of medieval jewelry in the
 Regional Museum of Kolarovgrad. Necklaces, pendants, crosses,
 earrings, and bracelets described date roughly from the tenth to
 the thirteenth centuries.

189 Atanasova, Ĭordanka. "Srednovekoven pozlaten sŭd ot s.
 Druzhba, Vidinsko" [Medieval gold-plated dish from the village
 of Druzhba, region of Vidin]. MPK 14, no. 2-3 (1974):70-74
 (Fr. sum.: 140).
 In Bulgarian. An accidental discovery (1957), the dish is
 characterized by extraordinary design. The bottom of the dish
 bears an inscription difficult to decipher, but datable to the
 end of the fourteenth century.

190 Changova, Ĭordanka. "Kŭm prouchvaneto na sgrafito keramika v
 Bŭlgariia ot XII-XIV v." [A contribution to the study of
 sgrafitto-pottery in Bulgaria between the twelfth and four-
 teenth centuries]. Arkh 4, no. 2 (1962):25-33.
 In Bulgarian. A well-illustrated brief survey of
 sgrafitto-pottery revealing characteristic pot shapes, motifs,
 patterns and color schemes.

191 Chilingirov, Asen. "Bŭlgarskata miniatiurna dŭrvorezba"
 [Bulgarian miniature woodcarving]. Izkustvo 16, no. 10
 (1966):36-41.
 In Bulgarian. Discusses several miniature crosses and
 icons dating from the seventeenth and eighteenth centuries.

192 Dermendzhiev, Khristo P. "Obkovi i riznitsi vŭrkhu ikonite ot
 epokhata na bŭlgarskoto vŭzrazhdane" [Metal icon covers from
 the period of the Bulgarian renaissance]. Izkustvo 28, no. 6
 (1978):28-36.
 In Bulgarian. A detailed analysis of several icon covers
 illustrated with good photographs.

193 _____. "Za estetikata i tvorcheskata priroda na maĭstorite
 zlatari ot epokhata na bŭlgarskoto vŭzrazhdane" (Ger. sum.:
 "Über die ästhetische und schöpferische Eigenart der Gold-
 schmiedemaister im Zeitalter der Bulgarischen Wiedergeburt").
 PNI 12, no. 2 (1979):40-45 (Ger. sum.: 64).
 In Bulgarian. Considers a variety of secular and religious
 objects to demonstrate aesthetic values in Bulgarian renaissance
 metal work.

194 Drumev, Dimitŭr. "Za niakoi zlatarski pametnitsi ot
 Chiprovtsi" (Fr. sum.: "Sur quelques monuments d'orfèvrerie
 de Čiprovci"). IzvII 5 (1962):73-87 (Fr. sum.: 87).
 In Bulgarian. Analyzes the iconography and style of sev-
 eral metal objects produced by a workshop at Chiprovtsi, active
 during the seventeenth century.

195 _____. Zlatarsko izkustvo (Fr. sum.: "Orfevrèrie"). Bŭl-
 garsko khudozhestveno nasledstvo, vol. 4. Sofia: Institut za
 izkustvoznanie pri BAN, 1976. 644 pp., 546 illus., some in
 color.

In Bulgarian. A major comprehensive work on Bulgarian metal work. Although the majority of the material presented is post-medieval in date, it is basically conservative in style and iconography and is best considered in the medieval context.

196 Dzhambov, Chr. "Novootkriti bronzovi plochi s relefi na
 Konstantin i Elena" (Fr. sum.: "Plaques d'airain nouvellement
 découvertes portant les figures en relief de Constantin et
 Hélène"). Godishnik na Narodniia arkheologicheski muzei
 Plovdiv 4 (1960):185-87.
 In Bulgarian. A small bronze plaque depicting SS. Constan-
 tine and Helena was discovered together with a coin horde includ-
 ing Byzantine eleventh- and twelfth-century coins. The plaque is
 of iconographic interest and is compared with two earlier chance
 finds of similar plaques.

197 Gatev, Peiu. "Nakiti ot pogrebeniia ot XI-XII v." (Fr. sum.:
 "Parures de sépultures des XIe-XIIe s."). Arkh 19, no. 1
 (1977):30-46 (Fr. sum.: 46).
 In Bulgarian. Discusses a vast amount of medieval jewelry
 excavated in some forty medieval necropoles in Bulgaria. The
 dating and the classification of the material is based on the
 securely dated necropoles excavated in the village of Kovachevo
 near Pazardzhik. The material shows affinities with Byzantine
 and older Bulgarian jewelry.

198 Georgieva, Sonia. "Kolanni ukrasi ot dvoretsa na Tsarevets
 v Tŭrnovo" [Metal decoration from the Tsarevets Palace in
 Tŭrnovo]. Arkh 6, no. 2 (1964):38-41.
 In Bulgarian. Discusses several decorated pieces of metal
 jewelry from Tŭrnovo belonging to the period of the Second Bul-
 garian Empire. Figurative as well as abstract decoration occurs.

199 Gerasimov, Todor D. Antichni i srednovekovni moneti v
 Bulgariia (Ger. sum.: "Antike und mittelalterliche Münzen in
 Bulgarien"). Sofia: Bulgarski khudozhnik, 1975. 159 pp.,
 117 illus., some in color.
 In Bulgarian. A useful historical and visual survey of
 Bulgarian coins with descriptions in Bulgarian, German, and
 Russian. Illustrations depict the obverse and reverse of each
 coin.

200 Ivanov, Iordan. "Starobŭlgarski i vizantiiski prŭsteni" (Fr.
 sum.: "Anneaux vieux bulgares et byzantins"). Izvestiia
 na bŭlgarskoto arkheologichesko druzhestvo 2, no. 1 (1911):
 1-14 (Fr. sum.: 13-14).
 In Bulgarian. An account of ten Bulgarian and Byzantine
 rings with linguistic and historical analyses of their inscrip-
 tions.

201 Jandova, Ivanka Akrabova. "La ceramica dipinta i smalto e
 l'arte di Preslav." Corsi di cultura sull'arte ravennate e
 bizantina 15 (1968):21-30.
 A discussion of painted pottery found at Preslav and its
 relationship to other minor arts. The article provides a good
 background on problems of minor arts in Bulgaria during the First
 Empire. Links with other cultures are also examined.

202 _____. "La decorazione ceramica nell' architettura bulgara
 dei secoli IX e X." Corsi di cultura sull'arte ravennate e
 bizantina 15 (1968):7-19.
 A discussion of ceramic material in architectural uses.
 Considers decorative ceramic revetment tiles, painted ceramic
 cornices, a decorative rosette, pavements, and colonnettes with
 ceramic inlay.

203 Koĭchev, P. "Riezbarskoto izkustvo v Bŭlgariĭa" [Art of wood
 carving in Bulgaria]. Izvestiĭa na bŭlgarskoto arkheologi-
 chesko druzhestvo 1 (1910):81-104.
 In Bulgarian. A survey of Bulgarian woodcarving art mostly
 from the period of Turkish rule. In addition to iconostasis
 screens, includes other types of church furniture and some
 secular works.

204 Kuzev, Aleksandŭr. "Srednovekovna sgrafito keramika s mono-
 grami ot Varna" (Ger. sum.: "Monogramme auf mittelalterlicher
 sgraffito Keramik aus Varna"). Izvestiĭa na Naroden muzeĭ -
 Varna 10 (25) (1974):155-70 (Ger. sum.: 170).
 In Bulgarian. A study of medieval sgrafitto pottery fea-
 turing monograms. The study is followed by a catalog with forty-
 eight entries of pottery examples. The monograms are interpreted
 as belonging to various members of the Paleologan dynasty. The
 material is compared to that of other centers and is judged to
 belong to the period of Byzantine rule in the fourteenth century.

205 Kuzmanov, Georgi. "Vizantiĭska ikona-medalion s riadŭk obraz
 na Sv. Sofiĭa" (Fr. sum.: "Icône-médaillone byzantine avec
 une représentation rare de Ste. Sophie"). Arkh 17, no. 3
 (1975):51-54 (Fr. sum.: 54).
 In Bulgarian. A small medallion made of glass paste (ex-
 cavated in 1974 in the medieval fortress of Kaliakra) is at-
 tributed by the author to a twelfth-century workshop in Con-
 stantinople. The author emphasizes the unusual nature of its
 iconography--the depiction of the Holy Wisdom in the guise of a
 young saint.

206 Lukanovska, Mariia Dolmova. "Za proizvodstvoto na srednovek-
 ovni nakiti v Tsarevgrad Tŭrnov" (Fr. sum.: "Sur la produc-
 tion de parures médiévales à Carevgrad Tărnov"). Arkh 21,
 no. 4 (1979):45-52 (Fr. sum.: 52).

In Bulgarian. Discusses a number of thirteenth- and
fourteenth-century jewelry molds excavated at Tsarevgrad,
Tŭrnovo.

207 Manova, Ekaterina. "Oblekla i tŭkani v zhivopista na
 Zemenskata tsŭrkva" [Garbs and fabrics on frescoes in the
 church at Zemen]. Arkh 3, no. 2 (1961):1-7.
 In Bulgarian. Considers garbs and fabrics represented on
the Zemen frescoes and attempts to relate the material to the
broader Byzantine sphere by means of visual comparisons and lit-
erary descriptions.

208 Mashov, Spas. "Ranosrednovekovni fibuli ot Avgusta pri s.
 Khŭrlets, Vrachanski okrŭg" (Fr. sum.: "Fibules du haut moyen
 âge d'Augusta près du village Hărlec, dép. de Vraca"). Arkh
 18, no. 1 (1976):35-39 (Fr. sum.: 39).
 In Bulgarian. Presents a pair of fibulas dated to the
sixth or seventh centuries. Both are decorated with abstract
animal and plant motifs.

209 Migeon, Gaston. "Orfèvrerie d'argent de style oriental
 trouvée en Bulgarie." Syria 3 (1922):141-44.
 A study of three silver plates and silver bracelets from
the Schlumberger collection. The material, dated roughly in the
tenth-eleventh centuries, shows strong affinities with Islamic
production.

210 Miiatev, Kr[ŭsto͞o]. "Palestinski krŭstove v Bŭlgariia" (Fr.
 sum.: "Les crois palestiniennes en Bulgarie"). GNM 1921
 (1922):59-89 (Fr. sum.: 87-89).
 In Bulgarian. Discusses a number of Palestinian pilgrimage
crosses of seventh- and eighth-century date with conventional
iconography.

211 _____. "Bronzovii rel͞ef s izobrazheniem͞ Bogomateri
 iz͞ Plovdivskago muzeia" (Fr. sum.: "Relief en bronze de la
 Vierge du Musée de Plovdiv"). Seminarium Kondakovianum 5
 (1932):39-45 (Fr. sum.: 45).
 In Russian. A study of a bronze icon depicting a standing
figure of Virgin with the Child. A stylistic and iconographic
analysis leads the author to conclude that the icon dates from
the twelfth or the thirteenth century.

212 Mikhailov, Stamen. "Za zlatnata ikonka-enkolpion ot Arkheo-
 logicheskiia muzei v Sofiia" [The golden icon-encolpion in the
 Archaeological museum in Sofia]. Izkustvo 23, no. 6 (1973):
 34-37.
 In Bulgarian. Challenges the conclusion of Vaklinova (see
entry BU 229) that it represents a Byzantine work, and proposes
that the possibility of a Bulgarian workshop during the thir-
teenth and fourteenth centuries should not be dismissed.

213 Milchev, Atanas. "Rannosrednovekovni bŭlgarski nakiti i
 krŭstove enkolpioni ot Severozapadna Bŭlgariia" [Early medie-
 val Bulgarian jewelry and reliquary crosses from Northwestern
 Bulgaria]. Arkh 5, no. 3 (1963):22-37.
 In Bulgarian. A rich selection of earrings, necklaces,
 rings, bronze appliques, and reliquary crosses is discussed.

214 _____. "Die frühmittelalterlichen bulgarischen Schmucksachen
 und Kreuze-Enkolpien aus Nordwestbulgarien." Slavia Antiqua
 13 (1966):326-57.
 Considers early medieval jewelry and metalwork from north-
 west Bulgaria, as well as techniques used in production of these
 objects.

215 Mushmov, N.S. "Bŭlgarskitie moneti s¨ dvuglav¨ orel¨"
 (Fr. sum.: "Monnaies bulgares avec l'aigle bicéphale").
 IBAI 3 (1913):81-87 (Fr. sum.: 87).
 In Bulgarian. An important contribution to the understand-
 ing of the symbolism of the double-headed eagle in the Byzantine
 world.

216 Peev, Khristo D. "Ikonostasŭt na tsŭrkvata 'Sv. Marina' v
 Plovdiv" (Fr. sum.: "L'iconostase de l'église 'Sainte
 Marina' de Plovdiv"). IzvII 4 (1961):97-148 (Fr. sum.:
 146-48).
 In Bulgarian. The large, elaborate, and well-preserved
 iconostasis of the church of St. Marina at Plovdiv was made,
 according to the author, between 1820 and 1830, and adapted for
 this church in 1856 by artists from Metsova in central Greece.
 In its structural solution and its iconographic details the
 iconostasis represents a conservative solution, harking back to
 Byzantine prototypes.

217 Petkova, Liudmila Doncheva. "Bronzov krŭst ot Vratsa" (Fr.
 sum.: "Croix en bronze de Vraca"). Arkh 17, no. 2 (1975):
 60-65 (Fr. sum.: 65).
 In Bulgarian. The bronze cross from Vratsa (Sofia,
 Archaeological Museum, inv. no. 3956 of the medieval collection)
 represents a Virgin Nikopeia, and is executed in niello tech-
 nique. Basing her judgment on analogies, the author dates the
 cross to the tenth century.

218 Petkova, Ljudmila Dončeva. "Croix d'or: Reliquaire de
 Pliska." IBAI 35 (1979) (special issue: Culture et art en
 Bulgarie médiévale):74-91.
 The golden reliquary cross from Pliska consists of three
 crosses encased each within another. The second cross, decorated
 with christological scenes executed in niello technique, is
 dated to the second half of the ninth or to the tenth century.
 The cross is compared to a large number of related crosses on
 the basis of iconography, style, and technique of execution.

219 Petrov, Petŭr P. "Dŭrvorezben krŭst ot Rilskiia manastir"
 [A carved wood cross from Rila monastery]. <u>MPK</u> 9, no. 4
 (1969):32-39.
 In Bulgarian. A piece interesting from the point of view
 of both style and iconography, it is dated to the first half of
 the eighteenth century on comparative basis.

220 Pisarev, Atanas. "Olovna ampula ot khŭlma 'Tsarevets' vŭv
 Veliko Tŭrnovo" (Fr. sum.: "Ampoule en plomb de la colline de
 Caravec à Veliko Tărnovo"). <u>Arkh</u> 18, no. 1 (1976):46-50 (Fr.
 sum.: 49-50).
 In Bulgarian. Identifies the small lead ampoule with busts
 of SS. Theodora and Demetrius excavated in 1974 at Tsarevets
 (Veliko Tŭrnovo) as an example of the Monza type. Basing his
 judgment on the archeological context of the find, the author
 dates the ampoule between the eleventh and twelfth centuries.
 Because this is a unique example of such work found thus far in
 Bulgaria, it is considered a Byzantine import, brought at the
 time of Byzantine domination of Bulgaria.

221 Shulekova, Iuliana. "Sŭkrovishche-moneti i nakiti ot s.
 Dŭbene, Plovdivsko (XIII-XIV vek)" [A jewelry and coin find in
 the village of Dŭbene in the region of Plovdiv]. <u>Vekove</u> 3,
 no. 6 (1974):57-62.
 In Bulgarian. Discusses a chance find of a thirteenth- to
 fourteenth-century jewelry and coin "hoard." The coins include
 five golden coins of Andronicus II and Michael IX (1295-1320) and
 sixty silver coins of Todor Svetoslav (1300-1322). The article
 considers six gold objects (five earrings and one pin) and four
 gold coins. The gold jewelry is of exceptionally fine quality
 and is in well preserved condition.

222 Slavchev, Petŭr. "Ikona na svetec-voin ot Tsarevets (XII-
 XIII v.)" (Fr. sum.: "Icône de saint-guerrier de Carevec
 [XIIe-XIIIe s.]"). <u>Arkh</u> 19, no. 3 (1977):60-65 (Fr. sum.:
 65).
 In Bulgarian. The fragmented steatite icon of a military
 saint (St. Theodore Stratilate or St. Theodore Tiron) was exca-
 vated at Tsarevets, Veliko Tŭrnovo, in 1975. The author argues
 for the local production of the work, but it clearly belongs to
 the larger body of Byzantine steatites of this period. The frag-
 ment is of interest, for the traces of original paint suggest
 that the entire icon may have been painted.

223 Slavchev, Petŭr, and Iordanov, Ivan. "Zlatni medal͡oni na
 khan Omurtag (814-931)" (Fr. sum.: "Médaillons d'or du Khan
 Omurtag [814-831]"). <u>Arkh</u> 21, no. 2 (1979):25-32 (Fr. sum.:
 31-32).
 In Bulgarian. Discusses two known medallions of Khan
 Omurtag--the first excavated at the turn of the century, the
 second during the 1973 excavations at Tsarevets, Veliko Tŭrnovo.

Omurtag is shown in the guise of a Byzantine Emperor as a Chris-
tian ruler with a cross in his hand despite his known opposition
to the spreading of Christianity in Bulgaria.

224 Sotirov, Ivan. "Zlatarskoto izkustvo v Chiprovtsi prez XVI i
 XVII v." (Fr. sum.: "L'orfèvrerie à Čiprovci aux XVI^e et
 XVII^e s."). Arkh 19, no. 3 (1977):42-55 (Fr. sum.: 54-55).
 In Bulgarian. Identifies Chiprovtsi as an important center
 in sixteenth- and seventeenth-century Bulgaria, and a local metal
 workshop as one of the finest in the Balkans at the time. Sty-
 listic analysis of documented works permits attribution of numer-
 ous other uninscribed works to the same workshop.

225 Totev, Totiu. "Icônes de céramique peintes et en relief nou-
 vellement découvertes à Preslav." Actes du XIV^e Congrès
 international des études byzantines, 1971 (Bucharest) 3,
 1976:465-68.
 A brief discussion of painted ceramic and relief icons
 found at Preslav. No illustrations.

226 _____. "Srebŭrna chasha s nadpis ot Preslav" (Fr. sum.: "La
 coupe en argent de Preslav"). IBAI 27 (1964):5-15 (Fr. sum.:
 14-15).
 In Bulgarian. The well-preserved silver cup with abstract
 decoration in relief is dated, on the basis of its style, to the
 end of the ninth century. The inscription records the name of
 GRAND ZHUPAN SIVIN, but the historical meaning of this name is
 not clear.

227 _____. "Za edin paralel na chashata na Sivin Zhupan ot
 Preslav" [Toward a parallel for the cup of Zhupan Sivin from
 Preslav]. Arkh 8, no. 1 (1966):31-37.
 In Bulgarian. Compares the Preslav cup (ninth-tenth cen-
 turies) with a cup from Gotland (dated ca. eleventh century; now
 in the Stockholm National Museum, inv. no. 6849.5) and attempts
 to find an historical basis for the existence of two similar ob-
 jects in such distant locations.

227a Tsvetkov, Boris. Khudozhestvena keramika ot Melnik (Ger.
 sum.: "Keramische Gebrauchskunst"). Sofia: Septemvri, 1979.
 19 pp. (Ger. sum.: 15-19), 27 col. pls.
 In Bulgarian. A survey of ceramic work from Melnik. Most
 of the material is medieval (thirteenth and fourteenth centuries).

228 Vaklinova, Margarita. "Pametnik na srednovekovnata drebna
 plastika" (Fr. sum.: "Une pièce de la petite plastique mé-
 diévale"). Arkh 12, no. 2 (1970):44-51 (Fr. sum.: 51).
 In Bulgarian. The small pendant discovered in
 Chernomasnitsa, northwestern Bulgaria, represents a small
 steatite icon of St. Demetrius encased in a silver frame (cf.
 silver icon of SS. Constantine and Hellena). The work is not

artistically distinguished and is dated to the end of the
eleventh or to the early twelfth century.

229 _____. "Vizantiĭska zlatna ikona-relikviar" (Fr. sum.:
 "Icône-reliquaire en or byzantine"). <u>Arkh</u> 14, no. 3 (1972):
 13-19 (Fr. sum.: 19).
 In Bulgarian. Found in the vicinity of Tŭrnovo, this gold
 reliquary with an image of the interceding Virgin on the cover
 and an ornamented cross on the back is considered to be a
 Constantinopolitan work dating from the second half of the
 eleventh or the twelfth century.

ICONOGRAPHY

230 Angelov, Bonʹo St. "Obrazi na Kiril i Metodiĭ do osvobozh-
 denieto" (Fr. sum.: "Les effiges de Cyrille et Méthode avant
 la libération de la Bulgarie"). <u>IzvII</u> 1 (1956):346-50 (Fr.
 sum.: 352).
 In Bulgarian. Representations of SS. Cyril and Methodius
 on frescoes and icons of the medieval period and the period of
 national renaissance, held particularly important place in Bul-
 garian society. The choice of examples is limited and the dating
 of some works of art questionable.

231 Angelov, Valentin. "Mitologichni motivi v bŭlgarskata vŭz-
 rozhdenska dŭrvorezba" (Eng. sum.: "Mythological motifs in
 the woodcarving of the Bulgarian national revival"). <u>PNI</u> 11,
 no. 4 (1978):42-47 (Eng. sum.: 64).
 In Bulgarian. Analyzes links between ancient mythology and
 woodcarving art and finds that the folklore tradition was respon-
 sible for the transmission of certain motifs.

232 Babikova, Velda Mardi. "Kŭm vŭprosa za obraza na Konstantin-
 Kiril Filosof" (Fr. sum.: "Sur le problème de la figure de
 Constantin-Cyrille Philosophe"). <u>PNI</u> 9, no. 1 (1976):32-37
 (Fr. sum.: 64).
 In Bulgarian. Identifies figures of St. Cyril "the
 Philosopher" whose images appear in Bulgarian painting as
 Constantine-Cyril, who with his brother Methodius brought liter-
 acy to the Bulgarians.

233 Bozhkov, Atanas. "Ikonografskite tipove na Bogoroditsa i
 tekhniiat razvoĭ v lonoto na bŭlgarskata zhivopis prez veko-
 vote" (Fr. sum.: "Les types iconographiques de la Vierge et
 leur développement au sein de la peinture Bulgare à travers
 les siècles"). <u>PNI</u> 12, no. 4 (1979):13-26 (Fr. sum.: 62).
 In Bulgarian. Considers several problems of the iconog-
 raphy of the Virgin in Bulgarian art. Some of these (the Virgin
 as a Symbol of Prophets and as the Fountain of Life) had not been
 discussed previously in Bulgarian scholarship.

234 _____. "Obrazite na antichni filosofi v starata bŭlgarska
zhivopis" [Portraits of ancient philosophers in old Bulgarian
frescoes]. Izkustvo 17, no. 10 (1967):14-19.
 In Bulgarian. Considers seventeenth-century frescoes at
Bachkovo and at Arbanasi, in which figures of ancient philoso-
phers appear robed as Late Byzantine noblemen.

235 Drangov, Boris, and Kvinto, Lidiia. "Otnovo za srednovekov-
noto Tŭrnovo v ikonografiiata na Sv. Sava" (Fr. sum.: "Ā
nouveau sur le Tărnovo médiéval dans l'iconographie de St.
Sava"). Arkh 18, no. 4 (1976):48-57 (Fr. sum.: 57).
 In Bulgarian. Examines frescoes in the refectory of
Hilandar monastery on Mt. Athos, painted in 1621, and an icon
depicting the lives of SS. Simeon and Sava (dated 1645) in the
Morača monastery. Concludes correctly that the architectural
backgrounds in certain scenes from the life of St. Sava cannot
be interpreted as realistic depictions of Tŭrnovo, but rather as
architectural clichés typical for scenes of certain iconographic
content.

236 Dujčev, Ivan. "Heidenische Philosophen und Schriftsteller in
der alten bulgarischen Wandmalerei." Rheinische-Westfälische
Akademie der Wissenschaften Vorträge G214 (1976):7-22.
 Discusses the phenomenon of representation of pagan phi-
losophers and quotations from their writings in the fresco cycle
of the refectory of Bachkovo monastery, painted in 1623. The
phenomenon is analyzed in the cultural context of the struggle
for survival of the orthodox churches under Turkish yoke.

237 Goschew, I. "Zur Frage der Krönungszeremonien und die zere-
monielle Gewandung der Byzantinischen und der Bulgarischen
Herrscher im Mittelalter." Byzantino-Bulgarica 2 (1966):
146-79.
 Discusses the coronation ceremony of Byzantine and Bul-
garian rulers in the Middle Ages. Much of the documentation
depends on the visual material, preserved in the form of ruler
portraits on frescoes and in manuscripts.

238 Manova, Ekaterina. "Bitŭt v kompozitsiiata 'Deizis' ot
manastirskata tsŭrkva 'Sv. Dimitŭr' do s. Boboshevo" [Life as-
pects in the Deësis composition in the monastery church of St.
Demetrius at Boboshevo]. Arkh 4, no. 1 (1962):6-11.
 In Bulgarian. Analyzes the unusual iconography of the
Deesis fresco in which Christ appears in the guise of a Byzantine
emperor sitting upon a throne. While the idea appears to have
been adopted from the Byzantine court ceremonial, the character
of the throne is closely linked to actual woodcarving tradition
of fifteenth-century Balkans.

239 _____. "Ikonographische Züge der Soldatenheiligen Georgios
und Demetrios in der bulgarischen mittelalterlichen Wand-
malerei vom Ende des 16. Jahrhunderts." Actes du XIV^e Congrès
international des études byzantines, 1971 (Bucharest) 3
(1976):353-55.
 A brief analysis of the iconography of the warrior saints
George and Demetrius in Bulgarian painting of the late sixteenth
century.

240 _____. "Vŭrkhu niakoi ikonografski cherti na Sv. Georgi v
bŭlgarski stenopisi ot XV vek" [Some iconographic aspects of
St. George in Bulgarian wall painting of the fifteenth cen-
tury]. Arkh 4, no. 3 (1962):6-10.
 In Bulgarian. Attempts to identify certain iconographic
aspects of St. George in fifteenth-century Bulgarian painting as
being unique to this particular period, but the conclusions are
too sweeping.

241 Mavrodinova, Liliana. "Sv. Teodor: Razvitie i osobenosti na
ikonografskiia mu tip v srednovekovnata zhivopis" (Fr. sum.:
"St. Theodore: Évolution et particularités de son type icono-
graphique dans la peinture médiévale"). IzvII 13 (1969):
33-52 (Fr. sum.: 51-52).
 In Bulgarian. Although general Byzantine iconography of
St. Theodore is discussed, the greatest attention is paid to the
Bulgarian examples.

242 Petkova, Liudmila Doncheva. "Grifonŭt v izkustvoto na sredno-
vekovna Bŭlgariia" (Fr. sum.: "Le griffon dans l'art de la
Bulgarie médiévale"). Arkh 21, no. 4 (1979):22-40 (Fr. sum.:
40).
 In Bulgarian. Uses a number of Bulgarian medieval images
of griffins in different media to analyze the evolution of the
type. Derived from Byzantine sources, griffin representations
were popular in Bulgarian art until the Turkish conquest, when
the motif disappeared.

243 _____. "Izobrazheniia na ednorog v rannosrednovekovni
bŭlgarski pametnitsi" [Representations of the unicorn in early
medieval Bulgarian monuments]. Vekove 7, no. 3 (1978):38-41.
 In Bulgarian. Considers several representations of the
unicorn in early medieval art of Bulgaria and speculates that the
animal might have had an apotropaic meaning.

244 Protich, Andrei. "Edin portret-model za bŭlgarskitie maistori
prez XV i XVI v." (Fr. sum.: "Un modèle des maîtres bulgares
du XV^e et du XVI^e siècle"). GNM 4 (1926):218-36 (Fr. sum.:
233-36).
 In Bulgarian. Attempts to define the national element in
Bulgarian medieval painting. A portrait of one Radu Voda Negru
at Arzhesh in Rumania is considered of crucial importance in the

development of distinctive iconography of SS. Theodore. The
fifteenth-century and later Bulgarian SS. Theodore are different,
iconographically, from the standard Byzantine types.

245 Zhandova, Ivanka Akrabova. "Videnieto na sv. Petŭr
 Aleksandriĭski v Bŭlgariia" (Fr. sum.: "La vision de saint
 Alexandrie en Bulgarie"). IBAI 15 (1946):24-36 (Fr. sum.:
 35-36).
 In Bulgarian. Discusses an iconographic theme that appears
 in Bulgarian medieval frescoes. An appendix contains a list of
 Byzantine monuments from the tenth to the seventeenth centuries
 at which this theme may be found.

BUILDERS, ARTISTS, AND PATRONS

246 Bozhkov, A[tanas]. "Tvorcheskiiat metod na bŭlgarskiia khu-
 dozhnik ot epokhata na turskoto robstvo do vŭzrazhdaneto" (Fr.
 sum.: "La méthode de créer des peintres bulgares de la époque
 de la domination Ottomane jusqu'à la renaissance"). IzvII 10
 (1967):5-30 (Fr. sum.: 31-32).
 In Bulgarian. A general discussion of the creative process
 in Bulgarian art under Turkish domination.

247 Bozhkova, Svetlana. "Za ktitorskite izobrazheniia v sredno-
 vekovnoto bŭlgarsko izkustvo" [Patron portraiture in medieval
 Bulgarian painting]. Izkustvo 29, no. 6 (1979):26-31.
 In Bulgarian. Considers the problem of portraiture in
 medieval Bulgaria in the broader context of the Byzantine Empire
 and other culturally related areas.

Stransky, A[ntoine]. See entry BU 130

248 Svintila, Vladimir. "Sotsiologicheski pogled vŭrkhu izkust-
 voto na ktitorskite portreti" (Fr. sum.: "Observations
 d'ordre sociologique sur l'art des portraits des donateurs").
 MPK 17, no. 2 (1977):11-18 (Fr. sum.: 77).
 In Bulgarian. A sociological investigation of medieval
 Bulgarian portraits. The majority of the examples referred to
 are of a late date.

249 Vasiliev, Asen. Ktitorski portreti [Donor portraits]. Sofia:
 Bŭlgarska akademiia na naukite, 1960. 270 pp., 151 illus.
 In Bulgarian. A study of donor portraits in Bulgarian art
 from the thirteenth to the nineteenth centuries. Medieval Bul-
 garian donor portraits, particularly the royal ones, are also
 important for a better understanding of Byzantine portraiture--
 much of which has been lost. The text discusses the historical
 and art-historical aspects of each of the examples considered,
 and gives special attention to the inscriptions (where these have
 been preserved). Illustrations are fair.

SITES

ABOBA. See PLISKA

ARBANASI

250 Bozhkov, Atanas. "Bitovi elementi v stenopisite ot
 arbanashkite tsŭrkvi (XVII-XVIII v.)" (Fr. sum.: "Éléments
 spécifiques des moeurs des peintures murales des églises
 d'Arbanassé [XVIIe-XVIIIe siècles]"). IzvII 6 (1963):99-129
 (Fr. sum.: 131-32).
 In Bulgarian. The late paintings at Arbanasi are examined
 for their iconographic idiosyncracies, and are found to have a
 significance beyond the local development. They are an important
 component of an underground art which flourished under the Turks
 in Bulgaria and Serbia. Emanating from Athos, the effects of
 this art were felt also in Rumania and Russia.

251 Prashkov, Liuben. "Novootkriti stenopisi v tsŭrkvata
 'Rozhdestvo Khristovo' v Arbanasi" [Newly discovered wall
 paintings in the Church of Nativity at Arbanasi]. Izkustvo
 24, no. 9 (1974):31-35.
 In Bulgarian. Considers a fresco uncovered under a layer
 dated to the first half of the seventeenth century. The scene
 represents the Last Judgment and is dated to the fifteenth cen-
 tury. It is considered one of the finest artistic achievements
 of the period between the flowering of Bulgarian art during the
 Second Empire and the art of the seventeenth century.

252 Teofilov, Teofil. "Arkhitekturno izsledvane na cherkvata
 'Sv. Georgi' v s. Arbanasi" (Fr. sum.: "Étude architecturale
 de l'église Saint Georges du village Arbanasi près de Veliko
 Tărnovo"). MPK 27, no. 3 (1977):18-27 (Fr. sum.: 78).
 In Bulgarian. Two building phases are identified: first
 half of the seventeenth century, and first decade of the eight-
 eenth century.

ASENOVGRAD. See STANIMAKA

BACHKOVO

253 Bakalova, Elka. Bachkovskata kostnitsa (Eng. sum.: "The
 ossuary-church of the Bachkovo monastery"). Sofia: Bŭlgarski
 khudozhnik, 1977. 246 pp., 152 illus. (line-drawings, b&w and
 col. photographs).
 In Bulgarian. The most important monograph to date on this
 outstanding eleventh- to twelfth-century monument of Bulgarian
 and Byzantine architecture and art. All aspects of the building
 are examined thoroughly and the monument placed in historical
 perspective. Greatest emphasis is on frescoes, which are

examined from the point of view of the decorative program, icon-
ography, and style. The quality of illustrations is generally
very good.

254 _____. "Izobrazheniia na gruzinski svettsi v Bachkovskata
kostnitsa" (Fr. sum.: "Images de saints géorgiens dans
l'église-ossuaire de Bačkovo"). IzvII 16 (1973):87-105 (Fr.
sum.: 107-8).
 In Bulgarian. The lowest zone of frescoes at the ossuary-
chapel of Bachkovo includes several standing figures of Georgian
saints. These are linked to the donor of the chapel and reveal
Georgian influence in the development of Bulgarian art in the
eleventh century.

255 Bakalova, E[lka], and Siradze, R. "Novootkrit starogruzinski
nadpis v Bachkovskata kostnitsa" (Fr. sum.: "Ancienne in-
scription géorgienne récemment découverte au monastère de
Batchkovo"). MPK 15, no. 3 (1975):7-10 (Fr. sum.: 47).
 In Bulgarian. The newly discovered Georgian inscription
probably dates from around 1344, and sheds new light on
Bulgarian-Georgian contacts during the Middle Ages.

256 Bobchev, Sava, and Dinolov, Liuben. Bachkovskata kostnitsa.
Istoriko-arkhitekturno i metrichno izsledvane (Fr. sum.:
"L'ossuaire de Bačovo"). Sofia: Tekhnika, 1960. 98 pp.,
88 illus.
 In Bulgarian. A study of the architecture of the monument
with particular emphasis on the proportional system used in the
design and a theoretical reconstruction of a domed tower over the
western bays of the chapel.

257 Boiadzhiev, St. "Kŭm vŭprosa za datirovkata na dvete tsŭrkvi
v Bachkovskiia manastir" (Fr. sum.: "Sur la datation des deux
églises du monastère de Bačkovo"). Rodopski sbornik 3 (197?):
79-103 (Fr. sum.: 103).
 In Bulgarian. Argues that the two-storied chapel of the
Holy Archangels at Bachkovo does not date from the twelfth cen-
tury, as commonly believed. Insists that it postdates the main
church which was rebuilt completely in 1603.

Dechevska, N[eli] C[haneva]. See entry BU 69

258 Grabar, A[ndré] N. "Rospis tserkvi-kostnitsi Bachkovskago
monastiria" (Fr. sum.: "Une décoration murale byzantine au
monastère de Batchkovo en Bulgarie"). IBAI 2 (1924):1-68
(Fr. sum.: 59-68).
 In Russian. A fundamental study of the important twelfth-
century fresco cycle. A detailed description of the program is
followed by an analysis of iconographic problems, historical
subjects, and style.

Ivanonv, Ĭor[dan]. See entry BU 438

259 Kostova, Alla, and Kostov, Konstantin. <u>Bachkovski manastir</u>.
 [Bachkovo monastery]. Sofia: Nauka i izkustvo, 1963. 5 pp.,
 70 pls. (some col.).
 In Bulgarian. A picture monograph on the second-largest
 monastery in Bulgaria--Bachkovo. The monastery (founded in 1083)
 preserves art treasures from different periods of the Middle
 Ages. From the end of the eleventh century are the ossuary and
 chapel (with important late eleventh-century frescoes), and the
 two-storied chapel in front of the main church. The main church
 and the refectory represent reconstruction efforts of the seven-
 teenth century, while the church of St. Nicholas was built only
 in the nineteenth century. The illustrations are, on the whole,
 of good quality.

260 Prashkov, Liuben. "Tekhnika i materiali na stennata zhivopis
 ot XI v. v kostnitsata pri Bachkovskiia manastir" [Technique
 and materials used for eleventh-century wall paintings in the
 ossuary of Bachkovo monastery]. <u>Izkustvo</u> 15, no. 5 (1965):
 24-32.
 In Bulgarian. The technique and the materials used for the
 wall paintings in the ossuary of Bachkovo are found to be con-
 sistent with general Byzantine practice in the eleventh and
 twelfth centuries. The article is a useful contribution to the
 knowledge of Byzantine painting techniques in general.

261 Vasiliev, Asen. <u>Bachkovskata kostnitsa</u> [The ossuary church of
 Bachkovo]. Sofia: Bŭlgarski khudozhnik, 1965. 22 pp.,
 44 illus.
 In Bulgarian. A brief monograph on the church with a good
 selection of black-and-white photographs.

BASHOVITSA

262 Kozhukharov, G. "Bashovichkata tsŭrkva" (Fr. sum.: "L'église
 de Bašovica"). <u>IBAI</u> 17 (1950):84-104 (Fr. sum.: 104).
 In Bulgarian. A report on the architectural and fresco
 remains of a small single-aisled church. On the basis of style
 of fresco fragments the church can be dated to the end of the
 twelfth or early thirteenth century.

BATOSHEVO

263 Khristov, Khristo Iv. "Batoshevskiiat manastir" [Batoshevo
 monastery]. <u>Vekove</u> 5, no. 5 (1976):55-62.
 In Bulgarian. The history of the monastery may be traced
 back to the thirteenth century on the basis of inscription frag-
 ments found in the complex. The present church of the Dormition
 of the Virgin was built in 1836 and subsequently restored.

BERENDE

264 Bakalova, E[lka]. "Za niakoi tipologichni osobenosti na
 stenopisite v Berende" (Fr. sum.: "Certaines particularités
 typologiques des peintures murales de Berende"). IzvII 8
 (1965):193-216 (Fr. sum.: 218-20).
 In Bulgarian. An important iconographic study of the
 fourteenth century fresco cycle of Berende which sets it against
 the background of contemporaneous fresco painting in Greece and
 Serbia.

265 Bakalova, Elka. Stenopisite na tsŭrkvata pri selo Berende
 [The mural paintings in the church at village of Berende].
 Sofia: Bŭlgarski khudozhnik, 1976. 142 pp., 71 figs. in
 text, some in color (Eng. sum.: 138-40).
 In Bulgarian. A monograph on the small fourteenth-century
 church in the village of Berende. Discusses the history, archi-
 tecture, and primarily fresco paintings. Frescoes are well pre-
 served and offer numerous insights into Byzantine painting of the
 fourteenth century.

Ivanov, Iordan. See entry BU 23

BOBOSHEVO

Manova, Ekaterina. See entry BU 238

266 Panaiotova, Dora. "Tsŭrkvata 'Sv. Todor' pri Boboshevo" (Fr.
 sum.: "L'Église St. Théodore près de Boboshevo"). IzvII 7
 (1964):101-38 (Fr. sum.: 140).
 In Bulgarian. A detailed study of the architecture
 (eleventh century) and frescoes (eleventh-twelfth centuries) of
 a small cruciform church near Boboshevo.

BOIANA

267 Barov, Zdravko. "Problemi na konservatsiiata i restavratsiiata
 na stenopisite v Boianskata tsŭrkva" [Problems of conservation
 and restoration of frescoes in the Boiana church]. MPK 11,
 no. 3 (1971):41-44 (Fr. sum.: 79).
 In Bulgarian. Considers the problems of conservation and
 restoration in the light of an international symposium convened
 to discuss the preservation of Boiana frescoes.

268 Boev, Petŭr et al. "Biologichni i meditsinski elementi v
 stenopisite na Boianskata tsŭrkva" (Fr. sum.: "Éléments de
 médicine biologique des peintures murales de l'église de
 Boiana"). IzvII 6 (1963):47-62 (Fr. sum.: 64-65).
 In Bulgarian. In a manner characterized by exaggeration,
 the authors focus on Boiana frescoes as containing unique "medi-
 cal" and "biological" subjects: medical saints (SS. Panteleimon,

Cosmas, Damian, and the Bulgarian St. John of Rila); knowledge of
human anatomy; conceptions of general hygiene; and representa-
tions of birth and death. Boiana frescoes are seen as a crucial
link between the Comnenian painting tradition and the "realism"
of the Paleologan era.

269 Duĭchev, Ivan. "Boĭanskata tsŭrkva v nauchnata literatura"
 (Fr. sum.: "L'église de Boĭana dans la littérature"). IzvII
 6 (1963):23-46 (Fr. sum.: 46).
 In Bulgarian. An invaluable survey of Boiana historiogra-
 phy dealing with all aspects of the monument: history, inscrip-
 tions, architecture, and art.

270 Genova, Ĭokhana. "Naĭ-starata snimka na Boĭanskata cherkva"
 (Fr. sum.: "La plus ancienne photographie de l'église de
 Boyana"). MPK 17, no. 3 (1977):13-15 (Fr. sum.: 78).
 In Bulgarian. The discovery of this photograph illuminates
 a phase in the history of the monument.

271 Grabar, Andreĭ. Boĭanskata tsŭrkva (parallel French text:
 "L'église de Boĭana"). Khudozhestveni pametnitsi na Bŭlgariia,
 1. Sofia: Bŭlgarski arkheologicheski institut, 1924.
 86 pp., 39 pls., 9 figs. in text.
 In Bulgarian. An important early monograph on one of the
 most significant of all medieval Bulgarian monuments. Discusses
 architecture and wall painting, with a detailed analysis of the
 latter.

Grabar, A[ndré]. See entry BU 119

272 Gŭlŭbov, Ivan. Nadpisite kŭm Boĭanskite stenopisi (Ger. sum.:
 "Die Inschriften an den Wandmalereien der Kirche in Bojana").
 Sofia: Bŭlgarska akademiia na naukite, 1963. 110 pp.,
 119 illus.
 In Bulgarian. An important linguistic study of the in-
 scriptions on the frescoes of Boiana.

273 Kozhucharov, Georgi. "Belezhki kŭm stroitelnata istoriia na
 Boĭanskata tsŭrkva" [Notes on the structural history of the
 Boiana church]. Arkh 5, no. 2 (1963):28-34.
 In Bulgarian. Technical aspects of the first two of the
 three main building phases--eleventh or twelfth century, thir-
 teenth century, and nineteenth century--are closely scrutinized
 and proportional characteristics compared to other churches.

274 Mavrodinov, Nikola. Boĭanskata tsŭrkva i neinit̂ stenopisi
 [Boiana Church and its wall paintings]. Sofia: Bŭlgarska
 kniga, 1943. 58 pp., 24 pls. (2 col.).
 In Bulgarian. A brief monograph on the church and its
 frescoes.

275 Mikhaĭlov, Stamen. "Boĭanskata tsŭrkva: Belezhit pametnik na
 srednovekovnoto bŭlgarsko izkustvo" [Boiana: An outstanding
 monument of Bulgarian medieval art]. Arkh 2, no. 2 (1960):
 1-13.
 In Bulgarian. A general discussion on Boiana frescoes.

276 Mikhalcheva, Irina. "Portretuiĭat kharakter na izobrazheniĭata
 v Boĭana" (Fr. sum.: "Le charactère imagier des peintures
 murales de Boïana"). IzvII 4 (1961):149-77 (Fr. sum.:
 176-77).
 In Bulgarian. Discusses the actual portraits at Boiana and
 observes that other representations are imbued with similar
 spirituality and were painted with great artistic skill. The
 artist is seen as an innovator cherishing humanist values.

277 Miyatev, Krustyu. The Boyana Murals. Dresden: VEB Verlag
 der Kunst; Sofia: Bŭlgarski khudozhnik, 1961. 25 pp.,
 60 b&w and col. pls.
 The brief text accompanied by mostly fine plates. In
 general, probably the best available reproductions of the Boiana
 frescoes.

278 Moskova, Ema. "Problemi na arkhitekturnata konservatsiĭa na
 Boĭanskata tsŭrkva" [Problems of architectural conservation of
 the Boiana church]. MPK 11, no. 3 (1971):46-53 (Fr. sum.:
 79).
 In Bulgarian. The author's text is followed by the trans-
 cription of a discussion conducted by a number of Bulgarian and
 international experts concerned with the problems.

279 Obretenov, Aleksandŭr. "Boĭanskite stenopisi" (Fr. sum.:
 "Les peintures murales de Boïana"). IzvII 6 (1963):5-22
 (Fr. sum.: 22).
 In Bulgarian. A highly generalized praise of the Boiana
 frescoes, in which the author finds a unique expression of life
 and man for the period in question.

280 Schweinfurth, Philipp. Die Fresken von Bojana. Ein Meister-
 werk der Monumentalkunst des 13. Jahrhunderts. Mainz and
 Berlin: Florian Kupferberg, 1965. 76 pp., 50 figs. in text.
 A short, well-illustrated monograph on the Boiana church.

281 Stoĭkov, Georgi. Arkhitekturni problemi na Boĭanskata tsŭrkva
 (Ger. sum.: "Architektur-Probleme der Kirche in Bojana").
 Sofia: Bŭlgarskata akademiĭa na naukite, 1965. 147 pp.,
 85 figs. in text.
 In Bulgarian. A detailed study of the structural history
 of the Boiana church, and a comparative analysis of various fea-
 tures against a broad range of architectural comparanda.

282 _____. Boîanskata tsŭrkva [Boyana church]. Materiali ot
bŭlgarskoto arkhitekturno nasledstvo, 4. Sofia: Bŭlgarska
akademiâ na naukite, 1954. 8 pp., 19 b&w pls. (architec-
ture), 11 line drawings, 22 col. pls. (frescoes). [Also
available in English.]
 In Bulgarian. Basically an album which includes a valuable
architectural survey of the building. Photographs are generally
of poor quality.

283 Zhandova, Iv[anka] Akrabova. Boîanskata tsŭrkva [The Boiana
church]. Sofia: Nauka i izkustvo, 1960. 56 pp., 45 pls.
 In Bulgarian. A guide to Boiana church illustrated with
diagrams showing the distribution of the decorative program, and
with good black-and-white photographs.

284 Zonev, Kyrill. Die Wandmalerein in der Kirche von Bojana.
Sofia: Bŭlgarski khudozhnik, 1956 [?]. 17 pp., 48 b&w pls.
 Basically an album containing a good selection of fresco
details--particularly faces. Especially helpful for the appre-
ciation of the style of painting.

CHATALAR. See TSAR KRUM

CHERVEN

285 Dimova, Violeta. "Model na tsŭrkva v Cherven" [Model of a
church in Cherven]. MPK 12, no. 1 (1972):21-22 (Fr. sum.:
74).
 In Bulgarian. Discusses the stone model of a church dis-
covered in the excavated remains of the church no. 5 in 1971.
The model, though simple, reveals certain architectural charac-
teristics typical of middle Byzantine architecture. The author
doubts that the model represents the fourteenth-century church
no. 5.

286 Dimova, Violeta, and Georgieva, Soniâ. "Tsŭrkva No. 1 v
srednovekovniîa grad Cherven" [Church no. 1 in the medieval
town of Cherven]. Arkh 9, no. 1 (1967):5-11.
 In Bulgarian. Discovered in 1910, this church was examined
more thoroughly in the 1960s. The church is interpreted as the
episcopal church (cf. simple synthronon) of the cross-in-square
type (as distinguished from the single-aisled arrangement en-
visioned by Miîatev). The church is dated to the period of the
Second Bulgarian Empire. The excavations revealed interesting
fragments of architectural sculpture, figural reliefs, a fragment
of an inscription, and decorative ceramic elements (crosses)
which were used in the external decoration of the church. The
building technique and decoration elements show affinities with
the thirteenth- to fourteenth-century architecture of Nesebŭr.

287 Georgieva, Sonia. "Srednovekovniĭat grad Cherven: Problemi
 i prouchvaniia" (Ger. sum.: "Die mittelalterliche Stadt
 Červen: Probleme und Untersuchungen"). IBAI 33 (1972):
 305-14 (Ger. sum.: 314).
 In Bulgarian. Clarifies certain aspects of the history of
 Cherven based on archeological information. The late medieval
 fortress, it was determined, was built upon Thracian, Roman, and
 Byzantine remains. After the Turkish conquest the fortress
 underwent two major destructions before the life in it ceased.

288 Georgieva, Sonia, and Dimova, Violeta. "Tsŭrkva no. 2 v
 srednovekovniia grad Cherven" (Ger. sum.: "Kirche no. 2 in
 der mittelalterlichen Stadt Červen"). IBAI 26 (1963):71-85
 (Ger. sum.: 84-85).
 In Bulgarian. A study of the architectural remains of this
 interesting small church, dated by the authors to the thirteenth
 or fourteenth centuries.

289 _____. "Zamŭkŭt v srednovekovniia grad Cherven" (Fr. sum.:
 "Le château fort de la ville médiévale Červen"). IBAI 30
 (1967):5-26 (Fr. sum.: 25-26).
 In Bulgarian. Cherven was an important Bulgarian center
 between the twelfth and fourteenth centuries. From this period
 dates the fortified palace discussed in this article. It is
 important for its architectural remains, as well as its movable
 finds--a complete catalog of which is presented as an appendix.

290 Panaĭotova, Dora. "Skalni stenopisi pri Cherven" [Cave paint-
 ings near Cherven]. Arkh 7, no. 1 (1965):8-13.
 In Bulgarian. Fresco fragments reveal painting of high
 quality whose style shows close affinities with the mature
 Paleologan style of Constantinople (e.g., frescoes at the Kariye
 Camii).

DOBŬRSKO

291 Mikhaĭlov, Stamen. "Tsŭrkvata Sv. Teodor Tiron i Teodor
 Stratilat v s. Dobŭrsko" (Fr. sum.: "L'église St. Théodore
 Tyron et Théodore Stratilate du village Dobarsko"). IBAI 29
 (1966):5-40 (Fr. sum.: 40).
 In Bulgarian. A comprehensive survey of history, archi-
 tecture, fresco program, iconography, and painting style of this
 church dated by an inscription to 1614.

DOLNA KAMENITSA. See DONJA KAMENICA, Yugoslavia, Sites

DRAGALEVTSI

292 Dimitrova, Elena Floreva. Starata tsŭrkva na Dragalevskiĭa
 manastir (Ger. sum.: "Die alte Kirche des Dragalevzi-
 Klosters"). Sofia: Bŭlgarski khudozhnik, 1968. 103 pp.,
 47 pls.
 In Bulgarian. A monograph on a small, single-aisled
 fifteenth-century church and its frescoes.

293 Kovachev, Mikhail. Dragalevskiĭat manastir Sv. Bogoroditsa
 Vitoshka i negovitie starini [The monastery of Dragalevtsi
 Holy Virgin of Vitosha and its treasures]. Materiali za
 istoriiata na Sofiĭa, 11. Sofia: Dŭrzhavna pechatnitsa,
 1940. 251 pp., 24 pls. (some col.), 212 figs. in text.
 In Bulgarian. An exhaustive monograph on the Dragalevtsi
 monastery in the vicinity of Sofia. The author discusses its
 history, architecture, paintings, and the treasury.

GERMAN

294 Stancheva, Magdalina. "Srednevekovna tsŭrkva pri s. German,
 Sofiĭsko" [A medieval church in the village of German, region
 of Sofia]. Arkh 8, no. 3 (1966):21-28.
 In Bulgarian. A brief archeological report on the remains
 of a small single-aisled church of negligible architectural sig-
 nificance. The material finds include fresco fragments, pottery
 fragments, and hollow pottery tubes with cross-shaped pinched
 necks, used in external decoration of walls.

GIGEN

295 Genova, Evelina. "Srednovekovna tsŭrkva v selo Gigen,
 Plevensko" [Medieval church in the village Gigen in the region
 of Pleven]. MPK 14, no. 1 (1974):14-16 (Fr. sum.: 92).
 In Bulgarian. A report of the archeological excavation of
 a cross-in-square church, believed to be of tenth-century date
 and situated on the remains of the ancient Temple of Fortuna.
 Around the church were excavated thirty-seven graves.

HISAR. See KHISAR
ILIENSKI MANASTIR. See SOFIA

IVANOVO

Bakalova, Elka. See entry BU 113

296 Bichev, Milko. Stenopisite v Ivanovo (Eng. sum.: "The murals
 of Ivanovo). Pametnitsi na starata bŭlgarska zhivopis, 2.
 Sofia: Bŭlgarski khudozhnik, 1965. 142 pp., 51 b&w illus.,
 13 col. illus. (Eng. sum.: 135-42).

In Bulgarian. A monograph on the important late Byzantine
cycle of frescoes in the cave church near the village of Ivanovo.
Argues for links of this fresco cycle with the court workshop at
Tŭrnovo (the capital of the Second Bulgarian Empire), and pro-
poses the date in the early part of the fourteenth century. The
author emphasizes, however, the distinctive Bulgarian element in
these paintings which he distinguishes from the contemporaneous
Byzantine achievements. The quality of plates is inconsistent.

297 _____. "Stenopisite v 'tsŭrkvata' kraĭ selo Ivanovo"
 [Frescoes in a church near the village of Ivanovo]. Izkustvo
 14, no. 6 (1964):23-34.
 In Bulgarian. A discussion of fourteenth-century painting
 in the cave church near Ivanovo.

298 Grabar, A[ndré]. "Les fresques d'Ivanovo et l'art des Paléo-
 logues." Byzantion 25-27, no. 2 (1957) (Mélanges Ejnar
 Dyggve):581-90.
 Presents the thesis that Byzantine art of the first half of
 the fourteenth century had its roots in the art of Constantinople
 as can be demonstrated by the same painting "canon" followed by
 artists working at such distant centers as Novgorod in Russia,
 Mistra in Greece, and Ivanovo.

299 Mavrodinova, Liliana. "Stenopisi ot vremeto na tsar Ivan
 Asen II pri Ivanovo" (Fr. sum.: "Peintures murales du regne
 du roi Ivan Assen II près d'Ivanovo"). Izkustvo 26, no. 9
 (1976):7-13 (Fr. sum.: 47).
 In Bulgarian. Considers several fragments of fresco deco-
 ration from a rock chapel at Ivanovo. The recurrence of the
 archangels on these fragments leads the author to identify the
 church as the main church of the monastery of Archangel Michael,
 known to have been built by Ivan Assen II.

300 Vasiliev, Asen. Ivanovskite stenopisi (Fr. sum.: "Les
 fresques dans la vallée de la rivière Roussenski Lom").
 Materiali za istoriiata na gr. Ruse i Rusenskiia okrŭg 1.
 Sofia: 1953. 48 pp., 20 line drawings, 58 b&w pls., 4 col.
 pls.
 In Bulgarian. A thorough monograph discussing the disposi-
 tion of the cave chapel, the layout of the decorative program,
 and the iconography of each of the surviving scenes.

301 Velmans, Tania. "Les fresques d'Ivanovo et la peinture
 Byzantine à la fin du moyen âge." Journal des Savants
 (Jan.-March 1965):358-404.
 A study of the important late Byzantine cycle of frescoes
 in a cave church near the village of Ivanovo in northwest
 Bulgaria. The style of the frescoes is related to the principal
 monuments of Paleologan Byzantium. The presence of the portrait

of the Bulgarian emperor Ivan-Alexander (1331-71) does not help narrow down the dates of the paintings.

KALIAKRA

302 Dzhingov, Georgi. "Srednovekovna tsŭrkva v Kaliakra" (Fr. sum.: "Une église du Moyen Âge à Kaliakra"). IBAI 32 (1972): 315-24 (Fr. sum.: 324).
 In Bulgarian. Report of the 1966-67 archeological excavations of the foundations of a small thirteenth- to fourteenth-century church. The remains indicate that the church was related to contemporaneous architecture of Nesebŭr.

KARLUKOVO

303 Mavrodinova, Liliana. "Stenopisite na tsŭrkvata Sv. Marina pri Karlukovo" (Fr. sum.: "L'église Ste. Marina près de Karlukovo"). PNI 11, no. 1 (1978):49-56 (Fr. sum.: 63).
 In Bulgarian. The wall paintings of this cave church are analyzed from the standpoint of style and iconography. Hands of two painters are recognized and the dating to the second half of the fourteenth century by Miiatev is confirmed.

304 Panaiotova, Dora. "Stenopisi ot peshchernata tsŭrkva 'Gligora' pri Karlukovo" [Wall paintings in the cave church "Gligora" near Karlukovo]. Izkustvo 15, no. 1 (1965):12-15.
 In Bulgarian. Remaining portions of fresco decoration are dated to the late fourteenth and to the fifteenth and sixteenth centuries. The author points out stylistic and iconographic aspects of broader significance.

305 _____. "Sv. Marina" (Fr. sum.: "Sainte Marina"). IzvII 6 (1963):133-54 (Fr. sum.: 153-54).
 In Bulgarian. The small church of St. Marina in the monastery of Karlukovo features fragmentary remains of fourteenth-century frescoes. The church was painted inside and outside. The high quality of the paintings leads the author to the conclusion that they were painted by an artist from the Tŭrnovo school which was under the strong influence of Constantinople.

KHISAR (HISAR)

306 Madzharov, Konstantin. "Bazilika no. 9 v Khisar" (Fr. sum.: "Basilique no. 9 à Hisar"). Arkh 12, no. 3 (1971):34-39 (Fr. sum.: 38-39).
 In Bulgarian. The basilica with an unusual plan, excavated in 1961, is discussed as an important building, probably of sixth-century date.

KOLOVGRAD

307 Maslev, Stoĭan. "Neizsledvani skalni tsŭrkvi v kolarov-
 gradsko" (Fr. sum.: "Églises rupestres non étudiées de la
 région de Kolarovgrad"). IBAI 26 (1963):95-102 (Fr. sum.:
 102).
 In Bulgarian. The text considers three small cave churches
 that can be attributed to the period between the thirteenth and
 the fifteenth centuries.

KREMIKOVTSI

308 Mikhailov, Stamen. "Ktitorskiĭat portret v Kremikovskata
 manastirska tsŭrkva v svetlinata na bŭlgaro-rumŭnskite
 kulturni vrŭzki prez XV v." [The donor portrait in the
 Kremikovo Monastery Church in the light of Bulgaro-Rumanian
 cultural relations in the fifteenth century]. Arkh 2, no. 3
 (1960):23-29.
 In Bulgarian. Argues against the idea proposed by Rumanian
 scholars that an inscription at Kremikovo refers to the children
 of Radu the Great, a Rumanian ruler who annexed this area in
 1494. At the same time, cultural links with Rumanian lands are
 not denied, but influences are seen as flowing from Bulgaria to
 the north.

309 Paskaleva, K[ostadinka]. "Stseni ot zhitieto na Sv. Georgi v
 Kremikovskata tsŭrkva (XV v.)" (Fr. sum.: "Scènes de la vie
 de Saint Georges de l'église de Kremikovci [XV^e s.]"). IzvII
 10 (1967):33-62 (Fr. sum.: 62).
 In Bulgarian. A discussion of iconography of the St.
 George fresco cycle in the fifteenth-century church of St. George
 at Kremikovtsi.

310 Paskaleva-Kabadaieva, Kostadinka. "Nouvelles données sur
 l'église Saint Georges du Monastère de Kremikovtzi." Actes
 du XIV^e Congrès international des études byzantines, 1971
 (Bucharest) 3 (1976):345-47.
 The relative prosperity of the monastery during the six-
 teenth and seventeenth centuries is examined against the his-
 torical background. The monastery is seen as continuing (in a
 limited sense) the artistic production of the major medieval
 centers of the Bulgarian state, at the time under Turkish
 domination.

KRUPNIK

311 Stanchev, Stancho. "Trikonkhalna tsŭrkva v s. Krupnik,
 Blagoevgradsko" [A triconch church in the village of Krupnik].
 Arkh 2, no. 3 (1960):43-49.
 In Bulgarian. A large triconch church, discovered in 1947,
 is dated to the fourteenth century. It features an unusual plan

in which cruciform and triconch features are combined. A large
square narthex contained two tomb-niches--arcosolia.

KULATA

312 Milčev, Ath[anas]. "Neuendeckte mittelalterliche kreuzkup-
 pelartige dreikonchale Kirche in der Umgebung vom Dorfe Kulata
 in Tale von mittleren Struma." Actes du XII^e Congrès inter-
 national d'études byzantines (Belgrade) 3 (1964):289-306.
 A thorough archeological report on the excavations of a
 trefoil church with four corner chapels. Analyzes the plan, the
 building technique, pottery, glass, and metal finds. Concludes
 that the church should be dated to the tenth century.

KŬRDZHALI

313 Manova, Ekaterina. "Razkopki na srednovekovna tsŭrkva v
 Kŭrdzhali" [Excavations of the medieval church at Kŭrdzhali].
 Arkh 5, no. 3 (1963):75-83.
 In Bulgarian. Report of the excavations of a large trefoil
 church which was constructed on the ruins of a smaller church.
 The new church was subsequently enlarged by the addition of an
 annex with a trefoil chapel on the north side of the church, and
 an exonarthex. Rich material finds (bronze crosses, jewelry,
 pottery, and coins) indicate an active life at the site between
 the tenth and the fifteenth centuries.

314 _____. "Tsŭrkvata v Kŭrdzhali" (Fr. sum.: "L'église de
 Kărdžali"). Rodopski sbornik 1 (1965):196-214 (Fr. sum.:
 217-18).
 In Bulgarian. An archeological report of the excavations
 of a large trichonch church (possibly of eleventh-century date)
 with later additions (narthex, and lateral annex with a trefoil
 chapel). The report analyzes all finds--metal objects, coins,
 glass, and pottery.

KURILOVO

Bozhkov, Atanas. See entry BU 115

LOVECH

315 Changova, Ĭordanka. "Bazilikata v Lovechkata krepost" (Fr.
 sum.: "La basilique de la forteresse de Loveč"). Arkh 10,
 no. 2 (1968):36-43 (Fr. sum.: 43).
 In Bulgarian. New excavations conducted between 1964 and
 1966 facilitate corrections in the plan originally published in
 1921. The building (which the author erroneously describes as a
 basilica) is related to Constantinopolitan monuments.

MADARA

316 Miĭatev, Kr[ŭst⁻o]. "Madarskiĭat konnik" (Fr. sum.: "Le
Cavalier de Madara"). IBAI 5 (1929):90-124 (Fr. sum.:
123-24).
 In Bulgarian. A publication of the early ninth-century
horseman relief. The monument is considered in all of its as-
pects--historical, paleographical, and artistic.

317 Popov, R. et al. Madara: Razkopki i prouchvaniĭa. Izdaniĭa
na narodniĭa arkheologicheski muzeĭ, 27. Sofia: Narodniĭa
arkheologicheski muzeĭ, 1934. 447 pp., 296 figs. in text,
4 col. pls., 1 foldout plan.
 In Bulgarian. A series of articles by a number of distin-
guished scholars on subjects ranging from archeological stratig-
raphy to architecture, glazed ceramic work, sculpture, etc.

318 Velkov, Velizar et al. Madarskiĭat konnik: Prouchvaniĭa
vŭrkhu natpisite i relefa [The Madara Horseman: Studies of
the inscriptions and of the relief]. Arkheologicheski
institut. Epigrafska poreditsa, no. 3. Sofia: Bŭlgarska
akademiĭa na naukite, 1956. 233 pp., illus.
 In Bulgarian. A series of essays by distinguished Bul-
garian scholars on a number of subjects ranging from historiog-
raphy of the subject to the technical aspects of the relief.
Each essay is followed by a brief summary in German.

MALA TSŬRKVA

319 Zakhariev, Vasil. "Stenopisite v Starata tsŭrkva v s. Mala
tsŭrkva, Samokovsko" (Fr. sum.: "Peintures murales de la
vielle église du village Mala Carkva, arr. de Samokov").
IzvII 7 (1964):141-44 (Fr. sum.: 150).
 In Bulgarian. Partially preserved seventeenth-century
frescoes in a small village church at Mala tsŭrkva are discussed.
Several iconographic aspects are of interest.

MARITSA

Bozhkov, Atanas. See entry BU 115

320 Panaĭotova, Dora. "Starata tsŭrkva v s. Maritsa" [An old
church in the village of Maritsa]. Arkh 7, no. 4 (1965):
20-30.
 In Bulgarian. The frescoes of this village church dating
from the sixteenth or seventeenth centuries are discussed. The
material is related to a group of other fresco cycles which are
identified as products of a local workshop.

MATOCHINA

321 Boiadzhiev, Stefan. "Krepostta pri selo Matochina" [Fortress
 near the village of Matochina]. Arkh 7, no. 1 (1965):1-8.
 In Bulgarian. A massive fort of a peculiar plan preserved
 to a height of two stories (probably had three) is dated to the
 fourteenth century and linked with Manuel Apokaukos. The build-
 ing technique reveals an irregular alternation of brick bands
 (each of five brick courses) with stone bands of varying widths.

MELNIK

322 Georgieva, Sonia. "Arkhelogicheski prouchvaniia na kŭsno-
 srednovekovnata tsŭrkva 'Sv. Nikola' v Melnik" (Fr. sum.:
 "Études archéologiques de l'église 'St. Nicholas' de Melnik
 du bas moyen âge"). Arkh 16, no. 2 (1974):28-37 (Fr. sum.:
 36-37).
 In Bulgarian. Destroyed in the nineteenth century, the
 cathedral church of St. Nicholas at Melnik underwent archeologi-
 cal investigation in 1971--the results of which are reported
 here. The church is a small three-aisled basilica with a broad
 apse, still preserved. It contains a synthronon with a throne
 for the bishop in the center. The church dates from the end of
 the twelfth or the beginning of the thirteenth century.

Mavrodinov, N[ikola]. See entry BU 34

323 Mavrodinova, Liliana. Tsŭrkvata "Sveti Nikola" pri Melnik
 (Fr. sum.: "Les peintures murales de l'église de Saint
 Nicholas près de Melnik"). Sofia: Bŭlgarski khudozhnik,
 1975. 64 pp., 32 illus.
 In Bulgarian. The basilican church of St. Nicholas is an
 unusual and important monument of Byzantine architecture. Por-
 tions of impressive fresco decoration are still preserved, al-
 though the church is now in ruins.

324 Stransky, Antoine. "Les ruines de l'église de St. Nicholas à
 Melnik." Studi byzantini e neoellenici 6 (1940):422-27.
 (Atti del V Congresso internazionale di studi bizantini 2.)
 An article on architectural and fresco remains of the
 church of St. Nicholas at Melnik. Photographs of some of the
 frescoes have documentary value.

MESEMVRIIA. See NESEBŬR

MEZEK

325 Rachenov, Al. "Krepost‾ta pri Mezek" (Ger. sum.: "Die
 Festung von Mezek"). IBAI 11, no. 1 (1937):171-89 (Ger. sum.:
 188-89).

In Bulgarian. The small (ca. 7000 m^2), irregularly planned fortress is considered to be a Byzantine work dating from the early eleventh century.

MIRKOVO

326 Miĩatev, Kr[ŭst⁀o]. "Stara tsŭrkva pri Mirkovo" [An old church near Mirkovo]. <u>IBAI</u> 8 (1935):442-44.
 In Bulgarian. A brief archeological report of a small single-aisled church excavated in 1930. The church is dated to the late thirteenth or to the fourteenth century. In the region of Pirdop, the church is an exceptional example of such architecture from this period.

NESEBŬR (MESEMVRIĨA)

327 Bojadžijev, Stefan. "L'ancienne église métropole de Nesebăr." <u>Byzantino-Bulgarica</u> 1 (1962):321-46.
 A revised structural history of the oldest of the Nesebŭr churches, based on partial archeological investigation of the monument. Proposes that the original church (probably built in the fifth century) had aisles separated from the nave by colonnades, with arcaded galleries above these resembling the Studios basilica in Constantinople. During the sixth century it was evidently enlarged by the addition of an atrium. The church presumably underwent substantial remodeling in the seventh or eighth centuries following an invasion of either Avars or Slavs. During the Bulgarian sack of Mesemvria under Krum, the church suffered only minor damage, and maintained its status as the metropolitan church.

328 Ivanov, T., ed. <u>Nessebre</u>. Vol. 1. Sofia: Académie bulgare des sciences, 1969. 234 pp., 176 figs. in text.
 The first volume of specialized studies on Nesebŭr. This volume contains articles which primarily discuss ancient Nesebŭr. Articles consider the topography, history, and fortifications of this site, and are of importance for medieval studies.

329 Maillard, Elisa. "Étude géométrique de l'église Saint Jean à Messembrie." <u>IBAI</u> 11 (1938):243-47.
 A study of proportions of the plan and sections of the church of St. John at Nesebŭr.

330 Mutafchiev, P[etŭr]. "Kŭm istoriĩata na mesembriĩskitĩe monastiri" [Toward a history of Mesembria monasteries]. <u>Sbornik v chest na Vasil N. Zlatarski</u> (Sofia) (1925):163-83.
 In Bulgarian. An important contribution to the history of monasteries at Nesebŭr (Mesemvria), largely based on three Greek texts in the metochion of the Jerusalem Patriarchate in Constantinople.

331 Petrov, Toma. "Prezviteriiat na tsŭrkvata Sv. Kliment v
 Mesemvriia" (Fr. sum.: "Le presbytère de l'église St. Clément
 de Mesembria"). <u>Arkh</u> 11, no. 3 (1969):59–62 (Fr. sum.: 62).
 In Bulgarian. The first report of the excavated remains of
 a tripartite sanctuary belonging to the small church of St.
 Clement. All three apses are semicircular inside and outside.
 On the basis of the building technique, comparable to the
 churches of Sv. Ivan and Sv. Stefan, the church may be dated to
 the twelfth century.

332 _____. "Vŭzstanovitelni raboti po tsŭrkvata 'Pantokrator' v
 Nesebŭr" [Restoration work on the Pantokrator church at
 Nesebŭr]. <u>Arkh</u> 2, no. 1 (1960):51–56.
 In Bulgarian. The article has documentary significance.
 Through a series of comparative photographs it shows various
 parts of the church before and after restoration.

333 Rachenov, Al. <u>Mesemvriĭski tsŭrkvi</u> [parallel text in French:
 <u>Églises de Mésembria</u>]. Khudozhestveni pametnitsi na Bŭlgariia,
 2. Sofia: Bŭlgarski arkheologicheski institut, 1932.
 110 pp., 45 pls., 61 figs. in text.
 In Bulgarian. The major monograph on medieval church
 architecture of Nesebŭr. Each building is treated in consider-
 able depth, and illustrated with excellent drawings and photo-
 graphs of inconsistent quality. Many of the photographs, how-
 ever, have documentary value because they show the churches
 before their drastic restoration.

334 Zimmermann, Max. <u>Beiträge zur Kenntnis christlicher Baudenk-
 mäler in Bulgarien</u>. Berlin: Verlag von Ernst Wasmuth, 1913.
 27 pp., 15 pls.
 An early short essay on the Nesebŭr churches. The work has
 largely been superseded, but remains of interest for some of its
 details.

OVECH

335 Kuzmanov, Georgi. "Srednovekovna tsŭrkva ot krepostta Ovech"
 [A medieval church in the fortress of Ovech]. <u>Vekove</u> 2, no. 3
 (1973):66–69.
 In Bulgarian. A brief archeological report on this small
 single-aisled church. Partially preserved outer walls reveal a
 building technique consisting of alternating bands of several
 courses of brick and several courses of stone ashlars, employed
 extensively in the architecture of Nesebŭr.

PATALENITSA

336 Bozhkov, Atanas. "Nova stranitsa na istoriia na bŭlgarskoto
 srednovekovie" [A new page in the history of the Bulgarian
 Middle Ages]. Izkustvo 25, no. 1 (1975):19-25.
 In Bulgarian. Dates the newly revealed frescoes to the
 thirteenth century. The paintings, though damaged, are of very
 high quality.

PATLEĬNA

337 Gospodinov, Ĭur. S. "Razkopki v͞ Patleĭna" (Fr. sum.:
 "Fouilles de Patlēina"). IBAI 4 (1915):113-28 (Fr. sum.:
 127-28).
 In Bulgarian. An archeological report of the first exca-
 vations at this important site. The church, preserved in ruins,
 displays an unusual plan, a partially preserved marble floor, and
 fragments of architectural sculpture and glazed ceramic tiles.

PCHELINTSI

338 Mikhailov, Stamen. "Kŭsnosrednovekovna tsŭrkva pri s.
 Pchelintsi" (Fr. sum.: "Église du bas moyen âge près du
 village Pčelinci"). Arkh 15, no. 2 (1973):59-65 (Fr. sum.:
 65).
 In Bulgarian. A sixteenth-century trefoil church with
 partially preserved frescoes dating from the first half of the
 seventeenth and the second half of the eighteenth century.

PERNIK

339 Changova, Ĭordanka. "Prouchvaniia v krepostta Pernik"
 [Investigations of the fortress of Pernik]. Arkh 5, no. 3
 (1963):65-73.
 In Bulgarian. Reports the first systematic archeological
 excavations of the Pernik fortress. Physical remains of the
 walls and material finds (pottery) are discussed.

340 _____. "Srednovekoven Pernik" [Medieval Pernik]. Vekove 5,
 no. 4 (1976):5-12.
 In Bulgarian. Discusses the archeological and historical
 evidence of the medieval fortification of Pernik. Mentioned in
 the documents at the end of the tenth or early eleventh century,
 the fort was destroyed at the end of the twelfth century. The
 archeological material presented includes fortification walls and
 utilitarian objects.

PERUSHTITSA

341 Frolow, Anatole. "Les peintures de l'Église Rouge de
 Peruštica en Bulgarie." Corsi di cultura sull'arte ravennate
 e bizantina 15 (1968):169-72.
 A reassessment of late Byzantine paintings in the Early
 Byzantine church. The author dates the frescoes in the thir-
 teenth or fourteenth century. A brief bibliography with a com-
 mentary follows the text.

PIRDOP

342 Vassileva, D. "La basilique du Cerf." Byzantino-Bulgarica 4
 (1973):253-73.
 Attempts to propose a new reconstruction of this basilica
 in contrast to the original reconstruction proposed by Mutafchiev
 in 1915. The new reconstruction proposes an unrealistic system
 of bays covered by elongated groin vaults, separated by deep
 transversal arches. The author seeks comparative examples in
 Syria, but the exclusive use of brick places this basilica more
 directly in the Byzantine tradition of the period of Justinian--
 where comparative examples are to be found.

PLISKA (ABOBA)

343 Aklinov, Stancho. "Pliska za trideset godini" (Fr. sum.:
 "Pliska au cours des trente dernières années"). Arkh 16,
 no. 3 (1974):28-39 (Fr. sum.: 39).
 In Bulgarian. A brief review of thirty years of research
 and excavations at Pliska, with an extensive listing of litera-
 ture on the subject.

344 Krandžalov, D[imitr]. "Is the Fortress at Aboba Identical
 with Pliska, the Oldest Capital of Bulgaria?" Slavia Antiqua
 13 (1966):429-49.
 A sharply worded rejection of the Aboba-Pliska theory
 formulated by Shkorpil and Uspenski (see entry BU 355) and pro-
 moted by the majority of Bulgarian scholars.

345 Krandžalov, Dimitr. "Sur la théorie erronée de l'origine
 protobulgare de la cité près d'Aboba (Pliska)." Actes du
 XIIe Congrès international d'études byzantines (Belgrade) 3
 (1964):193-203.
 A rejection of the theory which identifies the fortified
 city near Aboba as Pliska, the capital of the First Bulgarian
 Empire.

346 Mavrodinov, Nikola. "Razkopki i prouchvaniia v Pliska" (Fr.
 sum.: "Fouilles et recherches à Pliska"). Razkopki i
 prouchvaniia 3 (1948):159-70 (Fr. sum.: 169-70).
 In Bulgarian. The first section of the article (pp. 159-62)
 discusses the excavation of a small three-aisled, piered
 basilica. The church is related to a group of four other
 basilicas of identical plan discovered by Mikhailov, who pub-
 lished his findings (see entry BU 350). This basilica is dated
 to the end of the tenth century, after the reconquest of Pliska
 by the Bulgarians in 976.

347 Miiatev, Kr[ŭst⁀o]. "Krumoviiat dvorets i drugi novootkriti
 postroiki v Pliska" (Ger. sum.: Der Palast von Krum und
 weitere neuentdeckte Bauten in Pliska"). IBAI 14 (1943):
 73-135 (Ger. sum.: 131-35).
 In Bulgarian. A major archeological report of excavations
 conducted between 1930 and 1937 by the author, as well as an in-
 terpretation of the architectural material. The principal build-
 ings discussed are the Great Basilica and the Palace of Khan
 Krum.

348 Mikhaĭlov, Stamen. "Arkheologicheski materiali ot Pliska
 (1948-1951 g.)" (Fr. sum.: "Matériaux archéologiques prove-
 nant des fouilles de Pliska [1948-1951]"). IBAI 20 (1955):
 49-181 (Fr. sum.: 176-81).
 In Bulgarian. An exhaustive archeological report of the
 1948-1951 excavations. Finds discussed include architecture,
 inscriptions, metalwork, and pottery.

349 _____. "Razkopki na zapadnata porta v Pliska" (Fr. sum.:
 "Les fouilles de la porte ouest à Pliska"). IBAI 34 (1974):
 204-50 (Fr. sum.: 248-50).
 In Bulgarian. Report of the excavations conducted between
 1965 and 1967. Considers a hypothetical reconstruction and of-
 fers a chronological sequence of construction phases between the
 eighth to ninth, and the tenth to eleventh, centuries.

350 _____. "Razkopki v Pliska prez 1945-1947 godina" (Fr. sum.:
 "Fouilles à Pliska 1945-1947"). Razkopki i prouchvaniia 3
 (1948):171-225 (Fr. sum.: 223-25).
 In Bulgarian. Major archeological report on extensive ex-
 cavations carried out at Pliska in 1945-1947. Plans of several
 excavated churches and photographs of material finds are included.

351 _____. "Stroitelnite periodi v Pliska i proizkhodŭt na
 starobŭlgarskata arkhitektura" [The building phases at Pliska
 and the origins of old Bulgarian monumental architecture].
 Arkh 6, no. 2 (1964):13-23.
 In Bulgarian. Attempts to defend the identification of
 Pliska as an early Bulgarian capital, arguing that the early
 Bulgarians adapted themselves quickly and assimilated the high-
 level culture of the late Antiquity.

352 Milčev, A[tanas]. "Prouchvaniia na rannoslavianskata kultura
 v Bŭlgariia i na Pliska prez poslednite dvadeset godini"
 [Investigation of early Slavic culture in Bulgaria and of
 Pliska during the last twenty years]. Arkh 6, no. 3 (1964):
 23-35.
 In Bulgarian. Considers material finds of the early Slavs
 as well as further excavations at Pliska--a commercial complex
 and small three-aisled basilica of the early Byzantine type.

353 Milchev, Atanas. "Razkopki v Pliska (1945-1970)" (Fr. sum.:
 "Fouilles à Pliska [1945-1970]"). Arkh 16, no. 3 (1974):
 39-48 (Fr. sum.: 47).
 In Bulgarian. A brief account of archeological excavations
 conducted at Pliska between 1945 and 1970. The main literature
 on the subject is listed in the notes.

354 Stanchev, Stancho. "Razkopki i novootkriti materiali v Pliska
 prez 1948 g." (Fr. sum.: "Fouilles et matériaux nouvellement
 découverts à Pliska au cours de 1948"). IBAI 20 (1955):
 183-227 (Fr. sum.: 225-27).
 In Bulgarian. An archeological report of the 1948 excava-
 tions focusing largely on the excavation of a residential area
 of Pliska.

355 Uspenskĭ, Th. I.; Shkorpil, K.V. et al. "Material i dlia
 Bolgarskikh drevnosteĭ: Aboba Pliska" [Material for Bul-
 garian antiquities: Aboba Pliska]. Izvestiia russkago
 arkheologicheskago instituta v Konstantinopolie 10 (1905).
 569 pp., 58 figs., and a separate album with 117 pls.
 In Russian. The fundamental work on early archeological
 excavations of Pliska. Consists of a series of articles by
 various authors.

Great Basilica

356 Ivanova, Vera. "La grande basilique de Pliska." IBAI 12,
 no. 2 (1939):365-74.
 Some general remarks on the great basilica which the author
 dates between 864 (conversion of the Bulgarians to Christianity)
 and 893 (Simeon's elevation to the throne).

357 Mavrodinov, Nikola. "Bazilikata v Pliska i bulgarskiiat
 dvortsov tseremonial" (Fr. sum.: "La grande basilique de
 Pliska et le cérémonial de la cour bulgare"). IBAI 13
 (1941):246-52 (Fr. sum.: 252).
 In Bulgarian. On the basis of comparison with H. Sophia
 in Constantinople and the imperial ceremonial recorded in the
 Book of Ceremonies of Emperor Constantine VII, the author con-
 cludes that the two chambers flanking the bema of the Great

Basilica at Pliska were in fact mitatoria of the Emperor (Boris) on the south and the archbishop of Pliska on the north. Likewise, the author postulates that the throne of the ruler was in the south gallery and that of his consort in the north gallery.

358 Mikhailov, Stamen. "Nouvelles fouilles à la grande basilique de Pliska." Actes du XIV^e Congrès international des études byzantines (Bucharest) 3 (1976):367-71.
 A brief report of excavations at the Great Basilica at Pliska which have revealed different phases of construction. An important contribution to the knowledge of Bulgarian architecture over the course of ninth and tenth centuries.

Palace

Filov, Bogdan [Dimitrov]. See entry BU 74

359 Karasimeonoff, Peter. "Neue Ausgrabungen in der Residenz von Pliska." IBAI 14 (1943):136-38.
 Major archeological report of the excavations in the palace complex to the south of the Great Basilica. The finds permit clarification of many points which had previously been unclear, but larger issues are left open.

360 Maslev, Stoĭan. "Popravki i dobavki kŭm plana na 'tronnata palata' v Pliska" (Ger. sum.: "Berichtungen und Ergänzungen des Plans des 'Tronpalastes' in Pliska"). IBAI 20 (1955): 265-75 (Ger. sum.: 75).
 Additions and corrections of the earlier plan of the so-called "throne room" at Pliska are discussed.

361 Miĭatev, Krsto. "Der grosse Palast in Pliska und die Magnaura von Konstantinopel." IBAI 10 (1936):136-44. (Actes du IV^e Congrès international des études byzantines.)
 The great palace at Pliska is related to the Magnaura at the palace in Constantinople and the Sassanian palaces at Firuzabad and Servistan.

362 Mikhailov, Stamen. "Dvortsovata tsŭrkva v Pliska" (Fr. sum.: "L'église palatine de Pliska"). IBAI 20 (1955):229-64 (Fr. sum.: 61-64).
 In Bulgarian. Reconsiders the four periods of construction and analyzes the building techniques, architectural sculpture, tombs, and pottery.

PLOVDIV

363 Dzhambov, Ivan Khr. "Srednovekovniĭat grad na trikhŭlmieto v Plovdiv" [Medieval town of Trikhŭlmieto in Plovdiv]. Vekove 7, no. 4 (1978):68-72.
 In Bulgarian. A brief account of archeological investiga-

tions of a medieval (Second Bulgarian Empire; twelfth-fourteenth centuries) fortified town at Plovdiv (an important center from the period of the First Bulgarian Empire). Finds include medieval fortification walls, a cistern, pottery, and a small alabaster icon of St. George.

POGANOVO. See POGANOVO, Yugoslavia, Sites

PRESLAV

364 Bojadžiev, St. "Une église cruciforme à cinq nefs à Preslav." Byzantino-Bulgarica 4 (1973):53-73.
 A reconsideration of three successive churches within the citadel of Preslav, excavated between 1949 and 1952. Offers hypothetical reconstructions of the three plans. The first church is reconstructed and referred to somewhat erroneously as a five-aisled church; the second is reconstructed as a compact cross-in-square church; while the third displays a fully developed cross-in-square plan with all the characteristics of Constantinopolitan architecture. The dating of these three churches is assumed to be very early. The first is believed to date some time after 869. The third church is alleged to have been destroyed during the sack of Preslav by John I Tzimisces in 972.

365 Dzhingov, Georgi. "Kŭm prouchvaneto na ukrepitelnata sistema okolo srednovekoven Preslav" [A contribution to the study of the fortification system around medieval Preslav]. Arkh 4, no. 4 (1962):16-20.
 In Bulgarian. The brief survey of the fortifications of Preslav focuses on two forts--at Dolni Stradini and at Gorni Stradini. The Dolni Stradini fort was determined, on archeological grounds, to be from the period of Preslav's greatest prosperity (ninth-tenth centuries). The fort at Gorni Stradini is believed to belong to the same period.

366 Gospodinov, Iordan. "Grobnichni tsŭrkvi na Tuzlalŭka v Preslav" (Fr. sum.: "Chapelles funéraires de Touzlalak à Preslav"). Razkopki i prouchvaniia 3 (1948):97-100 (Fr. sum.: 100).
 In Bulgarian. An archeological report on the excavation of funerary chapels dated to the first quarter of the tenth century.

367 Gospodinov, Iu. S. "Novi nakhodki v Preslav" [New finds in Preslav]. IBAI 15 (1946):82-85.
 In Bulgarian. Reports the finding of a ceramic workshop in the vicinity of the Round Church at Preslav and fragments of ceramic tiles with images and inscriptions. The workshop is related to a similar one found at Pliska.

368 _____. "Razkopki v Preslav" (Ger. sum.: "Ausgrabungen in
 Preslav"). IBAI 6 (1932):183-93 (Ger. sum.: 193).
 In Bulgarian. Preliminary report of the 1928 archeologi-
 cal excavations focusing on the palace and the Round Church.

369 Ignatov, Boris. "Iuzhnata porta na vŭtreshnata krepost v
 Preslav kato obekt za konservatsiia i restavratsiia" (Fr.
 sum.: "La porte sud de la forteresse intérieure de Preslav et
 sa conservation et restauration"). IBAI 22 (1959):173-209
 (Fr. sum.: 207-208).
 In Bulgarian. A proposal for the reconstruction of the
 south gate of the inner city wall at Preslav is based on a study
 of the surviving evidence and, to an even greater degree, on
 comparative examples.

370 Ivanova, Vera. "Dvete tsŭrkvi pri chupkata na iztochnata
 stena na vŭtreshniia grad v Preslav" (Fr. sum.: "Les deux
 églises à l'angle du mur est de l'enceinte intérieure à
 Preslav"). IBAI 20 (1955):463-86 (Fr. sum.: 485-86).
 In Bulgarian. Discusses two churches built on the same
 site. The older one is believed to date from the late ninth or
 early tenth century and to have burnt around the middle of the
 tenth century. The second church, built subsequently, was
 destroyed in the eleventh century. The site was then leveled and
 used as a cemetery.

371 _____. "Iuzhnata porta na vŭtreshniia grad v Preslav, neiniat
 gradezh i arkhitekturen tip" (Fr. sum.: "La porte sud de
 l'enceinte intérieure de Preslav"). IBAI 22 (1959):133-71
 (Fr. sum.: 170-71).
 In Bulgarian. The archeological report of the excavation
 of the south gate of the inner city wall at Preslav. Also dis-
 cusses the architectural typology and proposes a hypothetical
 reconstruction.

372 Mavrodinova, V[era] Ivanova. Preslav: Vodach za starinite i
 muzeia [Preslav: A guide to the antiquities and the museum].
 Sofia: Bŭlgarskata akademiia na naukite, 1963. 110 pp.,
 49 figs. in text.
 In Bulgarian. A brief but useful guidebook to the anti-
 quities of Preslav. Main monuments are illustrated with plans
 and photographs of reasonable quality.

373 Mavrodinova, Vera Ivanova. "La civilisation de Preslav."
 Actes du XIIe Congrès international d'études byzantines
 (Belgrade) 3 (1964):141-49.
 A brief general survey of architecture and art of Preslav
 in a historical context.

374 Miiatev, Krŭstiu. Preslavskata keramika (Ger. sum.: "Die
 Keramik von Preslav"). Monumenta artis Bulgariae, 4. Sofia:
 1963. 154 pp., 18 b&w and 10 col. pls., 86 figs. in text.
 In Bulgarian. An important study of the painted decorative
 ceramic tiles discovered in large quantities at Preslav. Con-
 cludes that the decorative system originated in the Near East and
 was brought to Preslav via Constantinople.

375 Moss, Linda Mary. "The Art of Preslav: Its Sources of In-
 spiration and Influence." 2 vols. Ph.D. dissertation,
 Darwin College, University of Cambridge, 1976. 244 pp.,
 85 pls.
 Considers the art of Preslav and Bulgarian art of the tenth
 century as part of a broader development of Byzantine art, with
 certain individual characteristics. In so doing, it refutes the
 traditional nationalistic approach of many Bulgarian scholars.
 The differences detected are considered not a result of the
 creativity of the "local genius," but rather the reflection of a
 different social and economic structure and a different purpose
 of art.

376 Ognenova, Liuba, and Georgieva, Sonia. "Razkopkite na
 manastira pod Vŭlkashina v Preslav prez 1948-1949 g." (Fr.
 sum.: "Fouilles du monastère au pied de 'Valkachina' à
 Preslav"). IBAI 20 (1955):373-417 (Fr. sum.: 415-17).
 In Bulgarian. An exaustive archeological report incorpo-
 rating a discussion of architecture, architectural sculpture,
 metalwork, glazed tiles, glazed ware and other types of ceramic
 finds. The life of this monastery is linked with the First
 Bulgarian Empire.

377 Shkorpil, K. "Belezhki za starata bŭlgarska stolica Preslav"
 (Fr. sum.: "Notes sur l'ancienne capitale bulgare Préslave").
 Izvestiia na bŭlgarskoto arkheologichesko druzhestvo 4 (1915):
 129-47 (Fr. sum.: 147).
 In Bulgarian. Discusses topographical problems of Preslav,
 as well as the scattered architectural fragments in the vicinity.
 Considers some important pieces of architectural sculpture (good
 illustrations).

378 Stanchev, Stancho. "Dvadeset godini razkopki v Preslav"
 [Twenty years of excavations in Preslav]. Arkh 6, no. 3
 (1964):18-23.
 In Bulgarian. Focuses on the excavation of two palaces--
 the Large Palace and the Small Palace.

379 _____. "Razkopki po desniia briag na r. Ticha v Preslav prez
 1951-1952 g." (Fr. sum.: "Fouilles le long de la rive droite
 de la rivière Ticha à Preslav"). IBAI 20 (1955):419-28 (Fr.
 sum.: 428).
 In Bulgarian. A report of the excavations of a small
 cruciform church with a sepulchral lateral annex.

380 ____. "Tri novorazkriti tsŭrkvi v Preslav" (Fr. sum.:
"Trois églises récemment découvertes à Preslav"). Razkopki i
prouchvaniia 3 (1948):79-95 (Fr. sum.: 94-95).
 In Bulgarian. Excavation report on three churches dis-
covered at Preslav--no. 3, no. 4, and the church at Dŭlgata
Poliana. The first church is of the two-column type, the second
is a miniature basilica, and the third a regular cross-in-square
church. All of them are dated, on the basis of material finds,
to the second half of the tenth century.

381 Totev, Totiu. Arkheologicheski muzei, Preslav [Archeological
Museum, Preslav]. Biblioteka Nashite muzei. Sofia:
Bŭlgarski khudozhnik, 1969. 183 pp., 109 illus.
 In Bulgarian. A short but useful catalog of archeological
material at the Preslav museum. The material presented is from
the extensive excavations at Preslav and ranges from inscrip-
tions to architectural sculpture, decorative ceramic tiles,
ceramic bowls, pottery, decorative metalwork, seals, jewelry,
and coins. Illustrated with useful photographs accompanied by
catalog entries. A relevant bibliography is included.

382 ____. "Trideset godini arkheologicheski razkopki v Preslav"
(Fr. sum.: "Les fouilles archéologiques à Preslav au cours
des trente dernières années"). Arkh 16, no. 3 (1974):48-61
(Fr. sum.: 61).
 In Bulgarian. A brief account of archeological excavations
conducted at Preslav between 1944 and 1974. The main literature
appears in the notes.

383 ____. "Za novootkritite risuvani keramichni ikoni ot Preslav"
[Newly discovered painted ceramic icons from Preslav].
Izkustvo 26, no. 2 (1976):25-28.
 In Bulgarian. The four ceramic icons (apostles Peter,
James, and Philip, and the Evangelist Mark), excavated at the
monastery called "Tuzlalŭka" near Preslav, represent a major
addition to the understanding of this medium which evidently
flourished at Preslav during the ninth and tenth centuries.

384 Vŭzharova, Zhivka, ed. Pliska - Preslav: Prouchvaniia i
materiali (Fr. sum.: "Pliska - Preslav: Études et maté-
riaux"), vol. 1. Sofia: Bŭlgarska akademiia na naukite,
1979. 212 pp., illus.
 In Bulgarian. A series of articles written by different
authors which discuss Pliska and Preslav. Two articles are par-
ticularly relevant: the first by Totev and Georgiev on the
cruciform churches of Preslav (pp. 7-17); the second by Dechevska
on architectural compositional distinctions of monastic complexes
of Veliki Preslav (pp. 32-43).

Avradaka

385 Ivanova, Vera. "Razkopki na Avradaka v Preslav" (Fr. sum.:
 "Fouilles sur l'Avradak à Preslav"). Razkopki i prouchvaniia
 3 (1948):13-64 (Fr. sum.: 62-64).
 In Bulgarian. An exhaustive archeological report on two
 very important cross-in-square churches of the Middle Byzantine
 type. Attempts to identify local characteristics of planning,
 but the churches actually reflect planning principles typical
 of Middle-Byzantine Constantinople.

Bial briag

386 Gospodinov, Iordan. "Razkopki iz dolinata Bial briag v
 Preslav" (Fr. sum.: "Fouilles dans la vallée Bial-briag à
 Preslav"). Razkopki i prouchvaniia 3 (1948):73-77 (Fr. sum.:
 77).
 In Bulgarian. Archeological report on excavations of re-
 mains of secular buildings at Bial briag.

387 Ivanova, Vera. "Dve tsurkvi na Bial briag v Preslav" (Fr.
 sum.: "Deux églises de Bial-briag à Preslav"). Razkopki i
 prouchvaniia 3 (1948):149-56 (Fr. sum.: 197).
 In Bulgarian. Discusses the remains of two excavated
 churches--the second built on the remains of the first. The
 first church was of the cross-in-square type with a system of
 external pilasters and engaged half columns. Links with Armenian
 architecture are suggested. The second, smaller, church is of
 the compact cross-domed type, with a narthex.

Deli-Dushka

388 Ivanova, Vera. "Bazilika na Deli-Dushka v Preslav" (Fr. sum.:
 "Basilique de Deli-Douchka à Preslav"). Razkopki i prouch-
 vaniia 3 (1948):65-72 (Fr. sum.: 71-72).
 In Bulgarian. An archeological report of the excavations
 of a fifth-century basilica, many decorative aspects of which are
 seen as the forerunners of Bulgarian decorative arts of the tenth
 century.

Gebe-Klise

389 Ivanova, Viera. "Prouchvane na tsurkvata Gebe-klise"
 [Investigation of the church Gebe-Klise]. GNM 5 (1933):
 229-32.
 In Bulgarian. Reconsiders the church excavated in 1905 by
 Shkorpil and concludes that the church was a three-aisled
 basilica without a dome, and that it should be dated to the
 ninth century.

Round Church (Krŭglata tsŭrkva)

390 Karaman, Lj[ubo]. "O okrugloj crkvi u Preslavu" (Ger. sum.:
 "Die Rotunde in Preslav"). Bulletin Zavoda za likovne
 umjetnosti Jugoslavenske akademije znanosti i umjetnosti 10,
 nos. 1-2 (1962):1-21 (Ger. sum.: 18-21).
 In Serbo-Croatian. Surveys the previous literature on the
 subject and views the building as part of the pre-Romanesque tra-
 dition, linking it directly with ninth- to tenth-century church
 architecture of Dalmatia where the appearance of centralized
 churches during the same period is quite common.

391 Khodinot, R.F. "Zapadni vliianiia vŭrkhu Krŭglata tsŭrkva v
 Preslav" (Fr. sum.: "Influences occidentales dans l'Église
 Ronde de Preslav"). Arkh 10, no. 1 (1968):20-32 (Fr. sum.:
 32).
 In Bulgarian. Relates the layout of the Round Church at
 Preslav to a number of Carolingian and post-Carolingian cen-
 tralized churches in the West. Especially emphasized is the
 presence of the westwerk. The relationship between the palatine
 chapel at Aachen and the Round Church at Preslav figures
 prominently.

392 Miiatev, Kr[ŭstiu]. Krŭglata tsŭrkva v Preslav (Fr. sum.:
 "L'église ronde de Preslav"). Izdaniia na narodniia arkheo-
 logicheski muzeĭ, 25. Sofia: Narodniia arkheologicheski
 muzeĭ, 1932. 281 pp., 3 pls., 285 figs. in text.
 In Bulgarian. The main monograph on the Round Church.
 Also includes the report of archeological excavation of the site.
 Each aspect of the church (e.g., plan, materials and construction
 technique, column bases, capitals, carved cornices, etc.) is
 carefully examined in detail.

393 _____. "Miestni traditsii i natsionalni elementi v krŭglata
 preslavska tsŭrkva" (Fr. sum.: "Traditions locales et élé-
 ments nationaux dans l'église ronde de Preslav"). IBAI 6
 (1932):194-205 (Fr. sum.: 204-205).
 In Bulgarian. An attempt at portraying the Round Church as
 a result of an early Christian revival brought about by the Bul-
 garian conversion to Christianity in 865. Miiatev's ideas have
 since been challenged on a number of occasions.

394 _____. "Razkopkit v Preslav prez 1930 g." [Excavations
 at Preslav in 1930]. GNM 5 (1933):189-221.
 In Bulgarian. The article is subdivided into three sec-
 tions: investigations of the environs of the Round church;
 clearing of the palace in the inner city; and re-checking of the
 plans made during some of the earlier excavations. Much new
 archeological material is presented (architectural sculpture,
 decorated ceramic ware, bronze objects).

395 _____. "Simeonovata tsŭrkva v Preslav i neĭniiat epigrafichen
 material" [Simeon's church at Preslav and its epigraphic ma-
 terial]. Bŭlgarski pregled 1, no. 1 (1929):100-124.
 In Bulgarian. A report of archeological excavation of the
 Round Church with emphasis on the epigraphic material (mostly
 graffiti and fragmented inscriptions from ceramic tiles which
 evidently decorated upper parts of church walls). This reveals
 that both Bulgarian and Greek were used, but the significance of
 Greek inscriptions is dismissed as an iconographic aspect as-
 similated into Bulgarian art.

396 Raschenov, Alexander. "Die Rekonstruktion der Rundkirche von
 Preslav." IBAI 10 (1936):216-20. (Actes du IVe Congrès
 international des études byzantines.)
 A hypothetical reconstruction of the Round Church featuring
 a massive dome and vaulting system.

397 Stričević, Djordje. "L'église ronde de Preslav et le problème
 des traditions paléobyzantines dans l'architecture balkanique
 du moyen âge." Actes du XIIe Congrès international d'études
 byzantines (Belgrade) 1 (1963):212-23.
 An examination of the Round Church at Preslav in light of
 the architectural tradition of late Antiquity in the Balkans
 leads the author to conclude that it actually belongs to that
 tradition, and that it was only restored around 900.

398 Zhandova, Ivanka Akrabova. "Rabotilnitsa za risuvana keramika
 na iug ot Krŭglata tsŭrkva v Preslav" (Fr. sum.: "Un atelier
 de céramique peinte au sud de l'église ronde à Preslav").
 IBAI 20 (1955):487-510 (Fr. sum.: 510).
 In Bulgarian. Discusses the excavated remains of a painted
 ceramic workshop and its products. Especially interesting are
 ceramic tiles with geometric designs clearly produced for decora-
 tion of building interiors. Other finds include fragments of a
 painted ceramic icon and bowls.

Tuzlalŭka

399 Akrabova, Ivanka. "Dekorativnata keramika ot Tuzlalŭka v
 Preslav" (Fr. sum.: "La céramique décorative de Touzlalak à
 Preslav"). Razkopki i prouchvaniia 3 (1948):101-28 (Fr. sum.:
 126-28).
 In Bulgarian. A discussion of decorative ceramic floor
 tiles featuring simple geometric patterns, and revealing strong
 ties with the middle Byzantine tradition of floor designs in
 spite of the change in medium (from stone to tiles). Argues for
 a distinctive regional quality of the Preslav material.

Gospodinov, Iordan. See entry BU 366

400 Totev, Totíu. "Icônes peintes en céramique de 'Tuzlalǎka' à
 Preslav." IBAI 35 (Special issue: Culture et art en Bulgarie
 médiévale [VIIIe-XIVe s.]) (1979):65-73.
 A series of seven painted ceramic tiles is illustrated
 (four in color) depicting seven apostles (all shown frontally).
 The works reflect local ceramic production during the ninth and
 tenth centuries.

401 _____. "Manastirǔt v 'Tuzlalǔka': Centǔr na risuvana
 keramika v Preslav prez IX-X v." (Fr. sum.: "Le monastère
 de Tuzlalǎka: Un centre de céramique peinte à Preslav au
 IXe-Xe s."). Arkh 18, no. 1 (1976):8-15 (Fr. sum.: 15).
 In Bulgarian. Identifies a workshop of ceramic decorations
 within the monastery known as Tuzlalǔka at Preslav. This work-
 shop was active in the ninth to tenth centuries, and its products
 (icons of saints) are related to the material excavated at
 Patleina.

RILA

402 Babikova, Velda Mardi. "Ktitorski portret na feodala Khrel̄o"
 [The donor portrait of the feudal lord Khrel̄o]. MPK 11,
 no. 2 (1971):12-18 (Fr. sum.: 63).
 In Bulgarian. Reconsiders the frescoes in the chapel of
 Transfiguration on the top of the so-called Tower of Khrel̄o. In
 one of the compositions occupying the usual position of donor
 portraits, the author identifies the portrait [?] of Khrel̄o.
 On the basis of historical circumstances, the fresco is dated to
 1342, the year when Khrel̄o became a monk.

403 Khristov, Kh.; Stoikov, G.; and Miiatev, Kr. Rilskiiat
 manastir [Rila monastery]. Materiali ot bǔlgarskoto arkhi-
 tekturno nasledstvo, 6. Institut za gradoustroĭstvo i arkhi-
 tektura. Sofia: Bǔlgarska akademiia na naukite, 1957.
 316 pp., 68 drawings, 206 b&w illus., 8 col. illus.
 In Bulgarian. A major monograph on the most important
 medieval monastery in Bulgaria. The relatively brief text dis-
 cusses the history, architecture, painting, and wood carving.
 The book is printed on good paper and is abundantly illustrated,
 capturing the spirit of the entire monastic complex, notwith-
 standing the fact that much of the architecture and painting at
 Rila is post-medieval.

404 Kotseva, Elena. "Nadpisi kǔm stenopisite ot paraklisa na
 Khrel̄ovata kula v Rilskiia manastir" [Inscriptions on the
 frescoes of the chapel in the Tower of Khrel̄o in the monas-
 tery of Rila]. MPK 9, no. 4 (1969):18-25 (Fr. and Ger. sum.:
 25).
 In Bulgarian. The inscriptions on the frescoes (painted
 ca. 1340) reveal both interesting local dialects of the thir-
 teenth and fourteenth centuries, and links between Rila and
 Tǔrnovo.

405 Krŭstev, Ķiril. "Srednovekovni stenopisi v Khrel-ovata kula
 na Rilskiĩa manastir" (Fr. sum.: "Peintures murales mēdiē-
 vales dans la tour de Khrelio du monastēre de Rila"). IzvII
 1 (1956):181-202 (Fr. sum.: 206-8).
 In Bulgarian. The partially preserved frescoes in the
 chapel of the Khrelio (Chrelyo) Tower at Rila monastery (built in
 1335) are of great interest iconographically. They illustrate
 Psalms 149 and 150. The author hypothesizes that the painter
 came from the western part of Bulgaria and that he was profoundly
 influenced by the School of Tŭrnovo.

406 Miĩatev, Kr[ustiũ]. "Sŭkrovishtnitsata na Rilski monastir"
 (Fr. sum.: "Le trēsor du monastēre de Rila"). GNM [4]
 (1926):314-61 (Fr. sum.: 358-61).
 In Bulgarian. A major article on the treasury of Rila
 monastery which includes manuscripts, metal objects, and
 embroideries.

407 Panayotova, Dora. "Le Christ verbe, sagesse et lumiēre sur
 les fresques de la tour de Chrelju au monastēre de Rila."
 Actes du XIV[e] Congrēs international des ētudes byzantines
 (Bucharest) 3 (1976):405-10.
 An iconographic analysis of the frescoes in the small
 chapel atop the Tower of Khrelio at Rila monastery reveals an
 underlying theme of the Divine Wisdom in its different mani-
 festations.

407a Piquet, Dora Panayotova. "La chapelle dans la tour de Khrelju
 au monastēre de Rila." Byzantion 49 (1979):363-84.
 A detailed discussion of the fresco program in the chapel
 situated atop Khrel⁻o's (Hrelja's) Tower at Rila Monastery.
 Funerary and commemorative functions are deemed the basis for
 the choice of the program scenes. Written sources and archeo-
 logical information suggest that the chapel was associated with
 the tomb of its patron--Khrel⁻o (Hrelja)--once situated between
 the tower and the church.

408 Prachkov, Luben. "Peintures murales rēcemment dēcouvertes
 dans la chapelle de la tour de Hrēlijo au monastēre de Rila en
 Bulgarie." Actes du XIV[e] Congrēs international des ētudes
 byzantines 1971 (Bucharest) 3 (1976):415-18.
 A brief discussion of the frescoes discovered and cleaned
 in the Tower of Khrelio at Rila monastery.

409 Prashkov, Liuben. Khrel⁻ovata kula (Eng. sum.: "Hrelyo's
 Tower"). Sofia: Bŭlgarski khudozhnik, 1973. 150 pp.,
 90 figs. in text, 22 line drawings in appendix. (Eng. sum.:
 146-50).
 In Bulgarian. A detailed study of the history, architec-
 ture and painting of Khrel⁻o's Tower at Rila. Built in 1335, the
 tower resembles a group of such monastic towers on Mt. Athos built

during the early part of the fourteenth century. The chapel at
the top of the tower contains important frescoes from the period
in question.

410 _____. "Novootkritite freski v Khrel⁻ovata kula na Rilskiĭa
manastir" [Newly discovered frescoes in Khrel⁻o's Tower at
Rila monastery]. Izkustvo 18, no. 2 (1968):34-40.
 In Bulgarian. Discusses the iconography and style of the
1334-35 frescoes discovered in the chapel atop Khrel⁻o's Tower.

411 Vlakhova, Lidiĭa. "Stenopisite ot tsŭrkvata 'Uspenie
bogorodichno' pri metokha 'Pchelina,' Rilski manastir" [Wall
paintings in the Church of the Dormition of the Virgin in the
"Pchelina" Metochion of Rila monastery]. Izkustvo 29, no. 10
(1979):32-37.
 In Bulgarian. Discusses the wall paintings dating from the
end of the eighteenth or early nineteenth century, which reveal
strong Western influence within the basic Byzantine painting
tradition.

ROZHEN

412 Arnandova, Lozinka Koĭnova. "Novootkriti stenopisi ot
Rozhenskata trapezariĭa" [Newly discovered wall paintings in
the refectory of Rozhen]. MPK 13, no. 3 (1973):46-58 (Fr.
sum.: 88).
 In Bulgarian. The fresco remains uncovered in 1970 are
dated 1728 by a note of a priest Isaia.

RUEN

413 Dzhambov, Khristo, and Moreva, Rositsa. "Srednovekovna
tsŭrkva pri s. Ruen" (Fr. sum.: "Église du moyen âge à côté
du village de Rouen"). Godishnik na Narodniĭa muzeĭ Plovdiv
7 (1971):115-33 (Fr. sum.: 132-33).
 In Bulgarian. An archeological report of excavations of a
cross-in-square piered church, which has a narthex dating from
the twelfth century with a later exonarthex. Interesting tech-
nical features include remains of wooden reinforcing beams within
church walls and remains of fresco decoration.

SESLAVTSI

414 Kamenova, Dora. Seslavskata tsŭrkva [The church of Seslavtsi].
Sofia: Bŭlgarski khudozhnik, 1977. 149 pp., 68 figs. in
text (some in color). (Eng. sum.: 145-47).
 In Bulgarian. A monograph (history, architecture, and
frescoes) of the small seventeenth-century church of St.
Nicholas. The well-preserved frescoes are of high artistic
quality and display iconographic and stylistic ties with the
medieval prototypes.

415 _____. "Stenopisite ot Seslavskata tsŭrkva" [Wall paintings
 in the church of Seslavtsi]. Izkustvo 19, no. 9 (1969):31-34.
 In Bulgarian. Considers the seventeenth-century frescoes
 whose importance lies in their iconography--which reveals some
 distinctive local characteristics.

SHUMEN

416 Antonova, Vera. "Grad Shumen do XI vek (V svetlinata na
 arkheologicheskite prouchvaniia)" [The town of Shumen to
 the eleventh century in the light of archeological investiga-
 tions]. Vekove 4, no. 6 (1975):22-30.
 In Bulgarian. The town of Shumen is a rare example of a
 fortified urban center in the Balkans in which the continuity of
 habitation can be followed from the first century A.D. to the
 fourteenth century. The principal phases identified are: the
 late Roman period (first-fourth centuries); the early Byzantine
 period (fifth-sixth centuries); the First Bulgarian Empire
 (ninth-tenth centuries); and the Second Bulgarian Empire
 (twelfth-fourteenth centuries).

417 _____. "Tsŭrkva no. 5 v Shumneskata krepost" (Fr. sum.:
 "L'église no. 5 de la forteresse de Šumen"). Arkh 14, no. 1
 (1973):42-53 (Fr. sum.: 53).
 In Bulgarian. A contribution to the archeology of the late
 period of medieval Bulgaria (twelfth-fourteenth centuries). The
 article discusses architectural ceramic and other material re-
 mains.

418 Petrova, Marta. "Arkhitektonikata i prostranstvenite obrazi
 na tri tsŭrkvi v Shumenskata krepost" (Fr. sum.: "L'architec-
 tonique et les figures spatiales de trois églises dans la
 forteresse de Šumen"). Arkh 19, no. 2 (1977):60-65 (Fr. sum.:
 65).
 In Bulgarian. A proposed reconstruction of the three
 churches excavated within the fortress of Shumen. Hypothetical
 reconstructions of plans are based on proportional relationships
 of dimensions.

SKITŬT "GLIGORA"

419 Velenis, Georgios. "Skitŭt 'Gligora" (Fr. sum.: "Le skite
 'Gligora"). MPK 16, no. 3 (1976):15-26 (Fr. sum.: 78).
 In Bulgarian. A detailed study of the architecture and
 fresco remnants of this medieval monastic skete. The author
 distinguishes three phases of fresco decoration, of which the
 oldest dates from the late thirteenth or early fourteenth century.

SOFIA (SREDETS)

420 Stancheva, M[agdalina]. "Sofia au moyen âge à la lumière de
 nouvelles études archéologiques." Byzantino-Bulgarica 5
 (1978):211-28.
 A useful survey of recent archeological works in medieval
 Sofia and the relevant literature on the subject.

421 Stancheva, Magdalina. "Srednovekovniĭat Sredets spored novi
 arkheologicheski danni" [Medieval Sredets in the light of new
 archeological information]. Vekove 2, no. 3 (1973):51-61.
 In Bulgarian. A brief attempt to define the medieval
 boundaries of Sredets on the basis of archeological material.
 Pottery, metal objects, and jewelry are considered. Of some
 interest are decorative hollow ceramic tubes with cross-shaped
 pinched necks for external decoration of churches, found at the
 village of German, near Sofia.

422 Vasileva, Dafina. "Shest srednovekovni tsŭrkvi v raĭona na
 Sofiia" [Six medieval churches in the region of Sofia]. MPK
 12, no. 4 (1972):17-25 (Fr. sum.: 77).
 In Bulgarian. Considers a group of simple, single-aisled
 barrel-vaulted churches, all dating not later than the end of the
 fourteenth century. Information about two of these, "Monastiro"
 and Sv. Todor, is published for the first time.

Ilienskii manastir

423 Pandurski, Vasil Iv. "Stenopisite v Ilienskiĭa manastir kraĭ
 Sofiia" (Fr. sum.: "Les peintures murales dans le monastère
 d'Ilenci près de Sofia"). IzvII 13 (1969):5-28 (Fr. sum.:
 30-31).
 In Bulgarian. Three phases of fresco decoration in the
 church of Ilienski monastery are discussed: the fourteenth- or
 fifteenth-century phase; the sixteenth- or seventeenth-century
 phase; and the nineteenth-century phase. The earliest phase
 reveals some high-quality paintings.

Sv. Georgi

424 Filov, B[ogdan]. "Razkopki v tsŭrkvata Sv. Georgi v Sofiia"
 (Fr. sum.: "Les fouilles dans l'église St. Georges à Sofia").
 GNM 1921 (1922):183-97 (Fr. sum.: 196-97).
 In Bulgarian. A report on the excavations in St. George,
 a niched rotunda of a Roman bath converted into a Christian
 church. The dome preserves two distinct layers of frescoes (the
 first with Greek, the second with Bulgarian inscriptions).

425 Filov, Bogdan. <u>Sofiĭskata tsŭrkva Sv. Georgi</u> (Ger. sum.:
 "Die Georgskirche in Sofia"). Materiali za istoriiata na
 Sofia, 7. Sofia: Sofiĭskoto arkheologichesko druzhestvo,
 1933. 80 pp., 12 pls., 40 figs. in text.
 In Bulgarian. A major study on the monument, discussing
 the history, architecture, and art of the building from Roman to
 modern times. The medieval history of the building and its con-
 version into a church are treated prominently.

426 Ĭanev, Stoĭan. "Novi danni za tsŭrkvata Sv. Georgi v Sofiĭa"
 [New work on the church of St. George in Sofia]. <u>MPK</u> 13,
 no. 1 (1973):42-46 (Fr. sum.: 76).
 In Bulgarian. Reports the results of collective efforts on
 the study and preservation of the monument. The exact drawings
 which were made at that time are unfortunately poorly reproduced.
 Also reports on the evidence for the original, much larger,
 windows in the drum of the dome.

427 Karasimeonov˘, Petŭr˘. "Tsŭrkvata Sv. Georgi v˘ Sofiĭa"
 (Ger. sum.: "Die Georgskirche in Sofia"). <u>GNAM</u> 7 (1943):
 185-231.
 In Bulgarian. A detailed report on the structural history
 of the monument. It was built as a Roman bath, converted into a
 church in early Byzantine times, subsequently damaged, restored,
 and re-decorated in middle and late Byzantine times.

428 Krŭstev, Kiril. "Stenopisite v sofiĭskata tsŭrkva 'Sv.
 Georgi'" [Frescoes in the church of St. George in Sofia].
 <u>Izkustvo</u> 14, no. 7 (1964):26-33.
 In Bulgarian. A discussion of the various phases of fresco
 decoration, ranging in date from the tenth to the fifteenth cen-
 turies. Considers the inscriptions and the style of the frescoes.

429 Prashkov, Liuben. "Novi danni za stenopisite v tsŭrkvata Sv.
 Georgi v Sofia" [New work on wall paintings in the church of
 St. George in Sofia]. <u>Izkustvo</u> 16, no. 10 (1966):32-55.
 In Bulgarian. Considers the discovery of three layers of
 frescoes in the church of St. George--dated from the tenth-
 eleventh, twelfth, and fourteenth centuries on the basis of
 their style.

430 _____. "Za srednovekovnata zhivopis v tsŭrkvata 'Sv. Georgi'
 v Sofiĭa" [Medieval frescoes in the church of St. George in
 Sofia]. <u>Izkustvo</u> 21, no. 10 (1971):12-13.
 In Bulgarian. As a result of 1969 fresco conservation,
 substantial fragments of frescoes representing angles have come
 to light. These may be dated on stylistic basis to the second
 half of the tenth or the early eleventh century.

431 Raĭnova, Liuba Krasovska. "Naĭ-rannata stenopis v rotondata
 Sv. Georgi v Sofiĭa" [The oldest wall paintings in the rotunda
 of St. George in Sofia]. MPK 13, no. 4 (1973):17-18 (Fr.
 sum.: 70).
 In Bulgarian. Reports on the discovery of a fresco de-
 picting a plant ornament which the author dates to the fourth
 century.

432 Tsoncheva, Mara. "Niakolkoplastova srednovekovna zhivopis v
 tsŭrkvata 'Sv. Georgi' v Sofiĭa (kraĭa IX-kraĭa XIV v.) i
 vizantiĭskata khudozhestvena traditsiĭa" (Fr. sum.: "Peinture
 médiévale à plusieurs couches dans l'église 'St. Georgi' à
 Sofia [fin IXe-fin XIVe s.] et la tradition artistique byzan-
 tine"). PNI 11, no. 3 (1978):47-55 (Fr. sum.: 63).
 In Bulgarian. Considers the remaining fresco fragments
 found in several layers (dating from the end of the ninth to the
 end of the fourteenth century) in the general context of Byzan-
 tine painting.

433 _____. Tsŭrkvata 'Sveti Georgi' v Sofiĭa [The church of Saint
 George in Sofia]. Sofia: Bŭlgarski khudozhnik, 1979.
 273 pp., 136 figs. (some in color).
 In Bulgarian. An exhaustive monograph on the church of St.
 George. Analyzes the building history, and focuses on the his-
 tory, iconography, and style of its frescoes. A separate chapter
 (written by I. Duĭchev) is devoted to the study of inscriptions
 and the dating of the monument in its various phases.

Sv. Petka Samardzhiĭska

434 Mikhaĭlov, Stamen. "Stenopisite na tsŭrkvata Sv. Petka
 Samardzhiĭska v Sofiĭa" (Fr. sum.: "Les peintures murales de
 l'église Ste. Petka Samardjiska de Sofia"). IBAI 22 (1959):
 291-327 (Fr. sum.: 326-27).
 In Bulgarian. An analysis of frescoes dated to the fif-
 teenth or sixteenth centuries which represent a unique preserved
 cycle from this period in Sofia.

Sv. Sofiĭa

435 Boĭadzhiev, Stefan. Sofiĭskata tsŭrkva Sv. Sofiĭa (Fr. sum.:
 "L'église Sainte Sophie à Sofia"). Sofia: Bŭlgarski khudozh-
 nik, 1967. 54 pp., 35 pls., 13 figs. in text.
 In Bulgarian. A short monograph on this important church
 outlining its entire architectural history and relating it to
 contemporaneous developments. The author also expounds a far-
 fetched theory whereby the church of St. Sophia at Sofia should
 be seen as a forerunner of Romanesque basilicas with a transept
 and a lantern over the crossing.

436 Rashenov, Al. "Zazdraviavane i restavrirane na tsŭrkvata Sv.
 Sofiia v Sofiia" [Consolidation and restauration of the church
 of St. Sophia in Sofia]. GNM 5 (1933):307-16.
 In Bulgarian. A discussion of the conservation undertak-
 ings on the church of St. Sophia. Explanation of various options
 and decisions made in the process.

SOZOPOL

437 Velkov, Velizar. "Prinos kŭm materialnata kultura na sredno-
 vekovniia Sozopol" (Ger. sum.: "Beitrag zur materiellen Kul-
 tur des mittelalterlichen Sozopol"). IBAI 27 (1964):43-54
 (Ger. sum.: 54).
 In Bulgarian. Report of the 1949 excavations which re-
 vealed remains of a fifth- or sixth-century basilica and an
 eighth- or ninth-century church next to and below the present
 eighteenth-century church of St. George. Particularly note-
 worthy are architectural fragments belonging to both of the
 earlier churches.

SPASOVITSA (SPASOVICA)

437a Nenadović, Slobodan M. "Arhitektura Spasovice" (Fr. sum.:
 "L'architecture de Spasovica"). ZZSK 19 (1968):33-42 (Fr.
 sum.: 41-42).
 In Serbo-Croatian. An architectural study of the now
 destroyed monument. The church was built after 1330 by the
 Serbian king Stefan Dečanski. The author offers a hypothetical
 reconstruction based on older photographs made prior to the final
 destruction of the building.

STANIMAKA (ASENOVGRAD)

438 Ivanov, Ior[dan]. "Asenovata krepost⁻ nad⁻ Stanimaka i
 Bachkovskiiat monastir⁻" (Fr. sum.: "La forteresse d'Assène
 près de Stanimaca et le monastère de Batchkovo"). Izvestiia
 na bŭlgarskoto arkheologichesko druzhestvo 2, no. 2 (1911):
 191-230 (Fr. sum.: 229-30).
 In Bulgarian. A fundamental historical and archeological
 study, which discusses architecture, fresco decoration, and
 portable works of art.

439 Mavrodinova, L[iliana]. "Ostanki ot stenopisi v tsŭrkvata
 pri Asenova krepost" (Fr. sum.: "Vestiges des peintures
 murales dans l'église de la forteresse d'Asen"). IzvII 10
 (1967):63-74 (Fr. sum.: 80).
 In Bulgarian. Earlier discussions of the Stanimaka church
 centered on the question of the building date, ranging between
 the eleventh and thirteenth centuries. The author finds the
 fresco vestiges to be datable to the fourteenth century.

STRANDZHA

440 Aĭanov, Georgi. "Stari monastiri v⁻ Strandzha. Prinos kŭmŭ
vŭprosa za miestonakhozhdenieto na Sinaitoviĭa monastir" (Fr.
sum.: "Les anciens monastères du Strandža-Planina"). IBAI
13 (1941):253-64 (Fr. sum.: 263-64).
 In Bulgarian. The study attempts to pinpoint the monastery
of Gregory the Sinaite as an important center in the development
of Hesychasm in Bulgaria. Historical sources as well as lin-
guistic and physical evidence are considered in identifying the
Strandzha mountain at the Bulgarian-Turkish border just north of
Vize. Remains of a number of churches in this general area are
recorded.

STUDENA

441 Vasiliev, Asen. "Edna starinna tsŭrkva pri s. Studena" [An
old church near the village of Studena]. GNAM 7 (1943):
165-84.
 In Bulgarian. The church of St. George is a small single-
aisled vaulted church with two lateral apses. The poorly pre-
served frescoes are dated by the author to ca. 1300.

SVISHTOV

442 Vŭlov, Vŭlo. "Razkopki na Kaleto v gr. Svishtov" [Excavations
in the Kale at Svishtov]. Arkh 4, no. 4 (1962):7-15.
 In Bulgarian. A brief excavation account. The fortress
had two main building phases: one during the thirteenth-
fourteenth centuries, and the other during Turkish rule. An
earlier attempt to associate the first phase with the Byzantine
emperor Manuel I Comnenus is strongly rejected. Building tech-
niques and glazed pottery (sgrafitto) are discussed.

TETEVEN

443 Ignatov, Boris. "Manstirŭt 'Sv. Iliĭa' pri gr. Teteven"
[Monastery of St. Elijah near Teteven]. Arkh 7, no. 2 (1965):
4-15.
 In Bulgarian. A small monastery complex with an unusual
church (a five-apsed plan and two domes) is discussed. On the
basis of planning characteristics of the original portion of the
church, which was a trefoil, the building is dated (somewhat
rashly) to the end of the fourteenth century.

TSAR KRUM (CHATALAR)

444 Antonova, Vera. "Anlŭt na Omurtag pri s. Tsar Krum" [Palace
of Omurtag near the village of Tsar Krum]. Arkh 5, no. 2
(1963):49-56.

In Bulgarian. Report of 1960-61 archeological excavations
of the site. The complex consists of a vast, highly regular,
nearly square enclosure fortified by a massive wall and a single
gate. A building accommodating the living quarters with a bath,
the barracks, and a prison are discussed. The complex is be-
lieved to have been founded in 822.

TSEPINA

445 Conchev, D. "La forteresse Tsepaina-Cepina." Byzantino-
 slavica 20, no. 2 (1959):285-304.
 An exhaustive historical, topographical, and archeological
 study of the Tsepina fortress. Literary (Byzantine) and physical
 evidence is discussed in detail.

446 Georgieva, Sonia. "Tsŭrkva v rodopskata krepost Tsepina" [A
 church in the fortress of Tsepina]. Arkh 5, no. 3 (1963):
 47-54.
 In Bulgarian. Meager architectural remains (the east end
 of the church was completely destroyed) are in stark contrast to
 the elaborate remains of church furniture. Fragments of a stun-
 ning iconostasis screen (including relief icons of St. Peter and
 St. Paul within arched frames) were recovered. The two icons are
 dated on stylistic grounds to the thirteenth or fourteenth cen-
 turies, while the other fragments are said to lack sufficiently
 distinguishable stylistic characteristics to allow for precise
 dating.

447 Georgieva, Sonia, and Gizdova, Nedialka. "Srednovekovnata
 krepost Tsepina" (Fr. sum.: "La forteresse médiévale Cepina").
 IBAI 29 (1966):41-56 (Fr. sum.: 56).
 In Bulgarian. A report of archeological investigations
 conducted between 1961 and 1964 on this thirteenth- to fourteenth-
 century fortress. The architecture includes fortification walls,
 cistern, and two small churches.

448 Tsonchev, Dimitŭr. "Opisanie na vŭnshnite steni na krepostta
 Tsepina" (Fr. sum.: "Sur les murs d'enceinte extérieure de
 la forteresse Cepina"). IBAI 29 (1966):57-60 (Fr. sum.: 60).
 In Bulgarian. Discusses the building techniques used in
 the construction of the late medieval fortification wall at
 Tsepina.

TŬRNOVO

449 Aleksiev, Ĭordan. "Tsŭrkva no. 21 na khŭlma 'Tsarevets' vŭr
 Veliko Tŭrnovo" (Fr. sum.: L'église no. 21 sur la colline
 'Carevec' ā Veliko Tărnovo"). Arkh 18, no. 2 (1976):53-62
 (Fr. sum.: 62).
 In Bulgarian. An archeological report on the excavated
 remains of a small single-aisled church situated on a prominent

outcropping adjacent to the city wall. The author proposes the
late thirteenth or early fourteenth centuries as probable dates
of construction.

450 Angelov, Nikola. "Spasitelni razkopki na Tsarevets prez
 1961 g." [Rescue excavations at Tsarevets in 1961]. Arkh 4,
 no. 4 (1962):20-29.
 In Bulgarian. A large complex to the north of the palace,
 and a smaller one to the south of it, belong to the period of the
 Second Bulgarian Empire (1187-1393). The northern complex in-
 cludes a church and a cruciform building, whose facades were
 unified by means of a colonnaded porch featuring reused Late
 Roman architectural elements. The excavation yielded rich
 pottery finds.

451 Bosilkov, Svetlin. Tŭrnovo: Its History and Art Heritage.
 Sofia: Bŭlgarski khudozhnik, 1960. 182 pp., 130 pls.,
 12 figs. in text (some color).
 Basically a picture album of Tŭrnovo and its art. Most
 black-and-white photographs are generally of very good quality.

452 Dimov, V. "Razkopkite na Trapezitsa v⌣ Tŭrnovo" (Ger. sum.:
 "Die Ausgrabungen auf Trapezitza in Tirnovo"). Izvestiia
 na bŭlgarskoto arkheologichesko druzhestvo 5 (1915):112-76
 (Ger. sum.: 175-76).
 In Bulgarian. The fundamental archeological report of the
 earliest systematic excavations on the Trapezitsa Hill. Con-
 siders the location and the origins of Trapezitsa, the numerous
 excavated churches (including their architecture and their
 painted decoration), the architectural types of churches, and the
 system and technique of church decoration.

453 Dragomirov, Zhivko. "Srednovekovna bŭlgarska arkada na
 Tsarevets" [A Bulgarian medieval arcade at Tsarevets,
 Tŭrnovo]. Arkh 3, no. 1 (1961):27-32.
 In Bulgarian. Fragments of columns, column capitals, and
 cornices excavated in the ruins in the mosque at Tsarevets are
 interpreted as having belonged to a medieval arcade featuring a
 system of freestanding columns, round wall pilasters, and groin
 vaults.

Drangov, Boris, and Kvinto, Lidiia. See entry BU 235

454 Duĭchev, Ivan. "Tŭrnovo kato politicheski i duhoven tsentŭr
 prez kŭsnoto srednovekovie" [Tŭrnovo as a political and
 spiritual center during the late Middle Ages]. Arkh 8, no. 3
 (1966):1-8.
 In Bulgarian. Discusses the role of Tŭrnovo in Bulgarian
 culture of the late Middle Ages. The emphasis is placed on
 political and literary history.

455 F[ilov], B[ogdan]. "Arkheologicheski viesti--Tŭrnovskitie
 starini i zemletresenieto" [The antiquities of Tŭrnovo and the
 earthquake]. IBAI 3, no. 2 (1913):305-8.
 In Bulgarian. An account of the disastrous effect of the
 June 1, 1913 earthquake on the monuments of Tŭrnovo. Photographs
 of the church of the Forty Martyrs, St. Demetrius, and SS. Peter
 and Paul have considerable documentary significance. All three
 churches have since undergone extensive reconstruction.

456 Gerasimov, Todor. "Novo tŭlkuvane na risunkata na Veliko
 Tŭrnovo ot Brashovskiia rŭkopis" (Fr. sum.: "Une nouvelle
 interprétation d'un dessin de Tărnovo du manuscit de Braşov").
 Arkh 10, no. 1 (1968):32-42 (Fr. sum.: 42).
 In Bulgarian. A reinterpretation of a miniature published
 by Maslev (see entry BU 457). Argues that the miniature illus-
 trates an idealized image of Tŭrnovo. The argument is based on
 comparisons with similar "idealized" townscapes in Byzantine
 frescoes and illuminations.

457 Maslev, Stoian. "Edno neizvestno u nas izobrazhenie na
 Tsarevets vŭv Veliko Tŭrnovo ot XIV v." [An unknown represen-
 tation of Tsarevets at Veliko Tŭrnovo dating from the four-
 teenth century]. Arkh 9, no. 2 (1967):1-15.
 In Bulgarian. First publication of a drawing from a lec-
 tionary at Braşov, Rumania (inv. no. 34). The drawing is be-
 lieved to be a fourteenth-century depiction of the fortified
 palace of Tsarevets at Tŭrnovo. The book is believed to have
 been brought by Bulgarians, who colonized this area of Rumania
 in 1392 in the wake of the Turkish conquest of Bulgaria.

Miiatev, Krŭstiu. See entry BU 181

458 Miiatev, Kr[ŭstiu]. "Mozaiki ot Trapezitsa" (Fr. sum.:
 "Mosaïques de Trapesitza [Tirnovo]"). IBAI 1, no. 2 (1924):
 163-76 (Fr. sum.: 175-76).
 In Bulgarian. Discusses a number of meager fragments ex-
 cavated in church no. 5 in 1900. The fragments allow only for
 technical comparisons with Byzantine works. A general similarity
 with eleventh-, twelfth-, and thirteenth-century Byzantine
 mosaics is noted, but the dating is narrowed down to the late
 eleventh or early twelfth century.

459 Miiatev, Kr[ŭstiu] et al. Tsarevgrad Tŭrnov (Fr. sum.:
 "Carevgrad Tărnov"). Vol. 1, Istoriia na prouchvaniiata,
 arkhitektura i nadpisi, moneti kulturni plastove predi
 izgrazhdaneto na dvoretsa. Sofia: Bŭlgarskata akademiia na
 naukite, Arkheologicheski institut i muzei, 1973. 354 pp.,
 illus.
 In Bulgarian. The major study on Tsarevgrad at Tŭrnovo. A
 detailed archeological report of the extensive excavations with
 interpretation of the material.

460 _____. Tsarevgrad Tŭrnov (Fr. sum.: "Carevgrad Tărnov").
 Vol. 2, Keramika, bitovi predmeti, vŭorzhenie, nakit i tŭkani.
 Sofia: Bulgarskata akademiĭa na naukite, Arkheologicheski
 institut i muzeĭ, 1974. 416 pp.
 See entry BU 459.

461 Miĭatev, Krŭstiu. "Tsarevgrad Tŭrnov" [The imperial city of
 Tŭrnovo]. Arkh 6, no. 3 (1964):7-17.
 In Bulgarian. A general essay on the culture of Tŭrnovo
 during the Second Bulgarian Empire. Basing his conclusions
 largely on recent archeological finds, the author portrays the
 style and elegance of the art of Tŭrnovo. Architecture, sculp-
 ture (architectural and tomb sculpture), frescoes, metal work,
 and pottery are all considered.

462 _____. "Vizantiĭska sgrafito keramika v tsarskiĭa dvorets v
 Tŭrnovo" [Byzantine sgrafitto-pottery in the imperial palace
 at Tŭrnovo]. Arkh 9, no. 3 (1967):6-9.
 In Bulgarian. Large pottery finds in the palace at Tŭrnovo
 are interpreted as evidence of a declined standard of living at
 the Bulgarian court during the troubled times prior to the Turk-
 ish conquest.

463 Nikolova, Ĭanka. "Novi danni za plana na srednovekovniĭa grad
 Veliko Tŭrnovo" [New contributions toward the plan of medieval
 town of Veliko Tŭrnovo]. Arkh 6, no. 1 (1964):10-15.
 In Bulgarian. New archeological finds and their contribu-
 tion to the topography of Tŭrnovo.

464 Pisarev, Atanas. "Novi danni za gradoustroĭstvoto na khŭlma
 Tsarevets" [New discoveries regarding the town planning of
 Tsarevets]. Vekove 7, no. 5 (1978):44-54.
 In Bulgarian. A brief report of archeological finds at the
 top of Tsarevets--a fortified section of the Bulgarian capital of
 Tŭrnovo. Finds include architectural remains (mostly foundation
 walls and street pavements), pottery and carved bone, and iron
 weapons.

465 Popov, Atanas. "Noviĭat grad' v srednovekovnata stolitsa
 Turnovo" ["The New City" in the medieval capital of Tŭrnovo].
 Vekove 7, no. 2 (1978):5-13.
 In Bulgarian. An assessment of sources and newest archeo-
 logical finds pertaining to "the new city," a new section of
 Tŭrnovo built by Asen I. The archeological excavations of the
 Church of the Forty Martyrs and its exonarthex-mausoleum are
 given particular prominence in the discussion.

466 Shkorpil, K. "Plan na starata bŭlgarska stolitsa Veliko
 Tŭrnovo" [The plan of the old Bulgarian capital Veliko
 Tŭrnovo]. Izvestiia na bŭlgarskoto arkheologichesko druzhestvo
 1 (1910):121-54.
 In Bulgarian. A fundamental assessment of earliest studies
 of Tŭrnovo. Discusses topographical and other problems of the
 medieval town and its vicinity on the basis of sources and
 archeological finds.

Forty Martyrs (Sv. chetirideset mŭchenitsi)

467 Barov, Zdravko. "Razkrivane na stenopisni fragmenti v
 tsŭrkvata Sv. 40 mŭchenitsi, Veliko Tŭrnovo" [The uncovering
 of wall painting fragments in the church of the Forty Martyrs
 at Veliko Tŭnovo]. MPK 14, no. 2-3 (1974):93-101.
 In Bulgarian. Discusses thirteenth-century fresco frag-
 ments uncovered during the restoration of the church. The
 frescoes were found behind later walls which had to be removed
 to free the frescoes.

468 Bojadžiev, Stefan. "L'église dans Quarante Martyrs à
 Tărnovo." Études balkaniques 7, no. 3 (1971):143-58.
 Analyzes various aspects of the exonarthex-mausoleum at the
 church of the Forty Martyrs at Tŭrnovo in the light of the recent
 archeological investigation and restoration of the church. En-
 visions the exonarthex as being an addition from around 1280, and
 dates the mausoleum to the second half of the fourteenth century.
 Reconstructs the mausoleum as being two-storied with an upper
 gallery, accessible by a stair within a wall and surmounted by an
 axially placed belfry [Serbian, and hence Western, influence?].

469 Dermendzhiev, Khristo P. "Po niakoi vuprosi otnosno inter-
 pretatsiata na materialite ustanoveni v pogrebenie no. 39 i
 negovata datirovka" (Fr. sum.: "De certains problèmes rele-
 vant de l'interprétation des matériaux mis au jour dans la
 tombe no. 39 et de sa datation"). Izkustvo 26, no. 9 (1976):
 38-45 (Fr. sum.: 48).
 In Bulgarian. Examines the rich finds in the tomb no. 39
 in the church of the Forty Martyrs, excavated in 1972. A gold
 ring with an inscription reading "Kaloianov pr'sten" is inter-
 preted as having belonged to the Bulgarian Emperor Kaloian (1197-
 1207). Refers to various scientific evidence to support the
 hypothesis that the tomb no. 39 was actually Kaloian's grave.

470 Grabar, A[ndré]. "Stenopisŭt v tsŭrkvata Sv. Chetirideset
 mŭchenitsi v V.-Tŭrnovo" (Fr. sum.: "Les peintures murales de
 l'église des Quarante Martyrs à Tirnovo"). GNM 1921 (1922):
 90-112 (Fr. sum.: 111-12).
 In Bulgarian. The church of the Forty Martyrs at Tŭrnovo
 preserves the oldest known cycle of frescoes (in the narthex)
 with Bulgarian inscriptions (dated 1230). The discussion focuses

largely on iconographic problems, though questions regarding the
style are also touched upon. The Menologion cycle was the most
important feature of preserved decoration.

471 Ignatov, Boris. "Sto godini ot pŭrvoto prouchvane na tsŭrk-
 vata 'Sv. Chetirideset mŭchenitsi' v Tŭrnovo" [One hundred
 years since the first investigations of the church of the
 Forty Martyrs at Tŭrnovo]. Arkh 4, no. 2 (1962):56-63.
 In Bulgarian. A brief account of the first scientific in-
 vestigation of the church of the Forty Martyrs at Tŭrnovo.

472 Vŭlov, Vŭlo. "Novite razkopki na tsŭrkvata 'Sv. chetirideset
 mŭchenitsi' vŭv Veliko Tŭrnovo" (Fr. sum.: "Nouvelles fouilles
 de l'église des Quarante Martyrs de Tărnovo"). Arkh 16, no. 2
 (1974):37-54 (Fr. sum.: 54).
 In Bulgarian. A preliminary report of extensive excava-
 tions carried out from 1970 to 1973 at the church of the Forty
 Martyrs at Tŭrnovo. The church was built initially by King Ivan
 Assen II in 1230. It was expanded by the addition of the narthex
 during the second half of the thirteenth century, and open gal-
 leries-porches along the north and south flanks during the later
 thirteenth or the first half of the fourteenth century. The
 church was used for burials, 39 of which were uncovered during
 the excavation. Only ten of these contained objects which had
 been deposited with the deceased. Three of these are rings with
 inscriptions.

Sv. Petka

473 Georgieva, Sonia. "Novi danni za tsŭrkvata Sv. Petka i za
 dzhamiiata na Tsarevets vŭv Veliko Tŭrnovo" [New information
 about the church of St. Paraskeve and about the mosque on
 Tsarevets in Veliko Tŭrnovo]. Arkh 9, no. 2 (1967):27-31.
 In Bulgarian. A fragmentary inscription with the word
 "Paraskeva" discovered in conjunction with a small single-aisled
 church has been interpreted as part of a dedicatory inscription
 with the name of the saint actually preserved. Also discusses a
 mosque built in 1453, in whose rubble was found an inscription-
 contract incised on a brick, binding one Kosta to produce 10,000
 bricks for the construction of the mosque.

TŬRZHISHKIIA MANASTIR

474 Vodenicharski, Tseno, and Mladenov, Liudmil. "Stenopisite v
 tsŭrkvata na Tŭrzhishkiia manastir Prorok Iliia" [Wall paint-
 ings in the church of Prophet Elijah at Tŭrzhishki monastery].
 MPK 8, no. 3 (1968):29-34.
 In Bulgarian. A study of frescoes in a small church dated
 with reservation to the first half of the fifteenth century.

TUZLALŬKA. See PRESLAV

VARNA

475 Dimitrov, Dimitŭr Il. et al. Arkheologicheski muzeĭ Varna
 [The archeological museum of Varna]. Biblioteka nashite muzei.
 Sofia: Bŭlgarski khudozhnik, 1965. 155 pp., 108 illus.
 In Bulgarian. A useful though limited guide to the
 Archeological Museum at Varna. Material ranges chronologically
 from prehistoric through Turkish times.

476 Kuzev, Aleksandŭr. "Srednovekovnata krepost na grad Varna"
 (Fr. sum.: "La forteresse médiévale de la ville de Varna").
 Izvestiia na varnenskoto arkheologichesko druzhestvo 13
 (1962):111-26 (Fr. sum.: 125-26).
 In Bulgarian. A historical, archeological, topographical,
 and architectural study of the medieval fortress of Varna.

VIDIN

477 Mikhailov, St[amen]. "Edin mnim nadpis ot krepostta 'Baba
 Vida' vŭv Vidin" [An imaginary inscription on the "Baba Vida"
 fortress at Vidin]. Arkh 1, no. 1-2 (1959):17-19.
 In Bulgarian. A convincing rejection of Velkov's inter-
 pretation of an ornamental brick pattern on the "Baba Vida"
 fortress as an inscription containing the name Shishman (see
 entry BU 479).

478 Mikhailov, Stamen. "Arkheologicheski prouchvaniia na kreposta
 Baba Vida vŭv Vidin" [Archeological investigations of the Baba
 Vida fortress at Vidin]. Arkh 3, no. 3 (1961):1-8.
 In Bulgarian. The history of the Baba Vida fortress is
 enveloped in legends, and the archeological work undertaken aimed
 at unravelling the mystery. The report reveals the existence of
 several major building phases going back to Roman times. The
 major medieval phase is dated between the twelfth and fourteenth
 centuries.

479 Velkov, Ivan. "Edin tukhlen nadpis na Babini Vidini kuli"
 (Fr. sum.: "Une inscription dans la forteresse dite 'Babini
 Vidini kuli'"). IBAI 17 (1950):116-20 (Fr. sum.: 120).
 In Bulgarian. Attempts to interpret a standard late-
 Byzantine brick ornament as an inscription in brick which should
 be read as "Shishman"--a local despot (1290-1313). On the basis
 of this inscription, the author proposes that Shishman may have
 been responsible for the construction or the restoration of the
 fortress.

VINITSA

480 Bojadžiev, St[efan]. "L'église du village Vinica à la lumière
 de nouvelles données." Byzantino-Bulgarica 2 (1966):241-65.
 A reconsideration of the structural history of the church
 at Vinitsa (originally excavated and published by Stanchev) based
 on new excavations carried out in 1963. Argues that the church
 was originally of the contracted cross-in-square plan and that in
 the second phase it underwent substantial remodelling, which gave
 the church its characteristic interior with shallow niches carved
 out of the lateral walls. In the third phase the church acquired
 an exonarthex which the author reconstructs with a small axially
 situated belfry.

481 Stanchev, St[ancho]. "Tsŭrkvata do s. Vinitsa" [Church near
 the village of Vinitsa]. IBAI 18 (1952):305-28.
 In Bulgarian. A major report of the 1948 excavations con-
 ducted in the church. Also attempts to establish a relationship
 between the Vinitsa church and the architecture of Georgia and
 Armenia.

VUKOVO

482 Bozhkov, Atanas. "Za niakoi 'zabraveni' pametnitsi na
 bŭlgarskata monumentalna zhivopis ot XVI v.: Stenopisite vŭv
 Vukovo" [Some forgotten monuments of Bulgarian monumental
 painting of the sixteenth century: Wall paintings at Vukovo].
 Izkustvo 14, no. 9-10 (1964):47-57.
 In Bulgarian. Considers sixteenth-century frescoes in three
 churches at Vukovo. History, style and iconography are discussed.

483 Panaiotova, D[ora]. "Tsŭrkvata Sv. Petka pri Vukovo" (Eng.
 sum.: "The Saint Petka Church at Voukovo"). IzvII 8 (1965):
 221-56 (Eng. sum.: 255-56).
 In Bulgarian. A discussion of a fresco cycle, dated by an
 inscription to 1598, and its relationship to national painting
 during the Turkish occupation.

ZEMEN

484 Babikova, Velda Mardi. "Novootkrite stenopisi v tsŭrkvata pri
 zemenskiia manastir" [Newly discovered wall paintings in the
 church of the Zemen monastery]. MPK 13, no. 3 (1973):16-25
 (Fr. sum.: 87).
 In Bulgarian. Fragments of frescoes uncovered in the
 prothesis and the diaconicon belong to the eleventh or twelfth
 century.

485 Babikova, Velda Mardi, and Ilieva, Bonka. "Novootkrite
 stenopisi v tsŭrkvata pri Zemenskiia manastir" [Newly un-
 covered frescoes in the church of Zemen monastery]. Izkustvo
 22, no. 10 (1972):12-14.
 In Bulgarian. Considers newly discovered fragments of
 frescoes stylistically datable to the eleventh or twelfth
 century.

486 Dujčev, Ivan. "Traits de polémique dans la peinture murale de
 Zemen." ZLU 8 (1972):119-27.
 Certain aspects of the frescoes at Zemen are seen as mani-
 festations of anti-Jewish sentiments fueled by the marriage of
 the Emperor Ivan Alexander to a Jewish convert Theodora. The
 paintings are dated on historical grounds to between 1344-45 and
 1355-56.

Ivanov, Iordan. See entry BU 23
Manova, Ekaterina. See entry BU 207

487 Mavrodinova, L[iliana]. "Stenopisite na Zemenskata tsŭrkva"
 (Fr. sum.: "Les peintures murales de l'église de Zemen").
 IzvII 8 (1965):257-80 (Fr. sum.: 280).
 In Bulgarian. The remains of Zemen frescoes are dated to
 the late thirteenth or early fourteenth century. Unique quali-
 ties of the painting style are discussed.

488 Mavrodinova, Liliana. "Le courant artistique représenté par
 Zémène et sa place dans la peinture balkanique et byzantine."
 Actes du XIVe Congrès international des études byzantines,
 1971 (Bucharest) 2 (1975):207-10.
 The fourteenth-century frescoes of Zemen are seen as occu-
 pying a position between the works of the monastic style of the
 thirteenth century and the emerging Paleologan style. As such,
 they are considered to represent a local Macedonian variant of
 Paleologan art.

Yugoslavia

GENERAL

1 Abramič, Michele. "L'arte bizantina in Dalmazia." Corsi di cultura sull'arte ravennate e bizantina 1, pt. 2 (1955):5-8.
 A brief overview of main artistic developments in Dalmatia during the Middle Ages. Discusses the dependence of these developments on the arts of Byzantium.

2 Andjelić, Pavao. "Periodi u kulturnoj historiji Bosne i Hercegovine u Srednjem vijeku" [Periods in the cultural history of Bosnia and Herzegovina in the Middle Ages]. GZMS, n.s. 25 (Arheologija) (1970):199-212.
 In Serbo-Croatian. Proposes a new "periodization" which is broken down as follows: First centuries (seventh and eighth centuries); Frankish influx (ninth century); First signs of "national achievement" (900-1150); Century of cultural flowering (1150-1250); Cultural depression (1250-1322); Cultural renewal (1322-1377); Royal period (1377-1463); and Decline of medieval culture (1463-1528).

3 Benac, A. et al. Kulturna istorija Bosne i Hercegovine od najstarijih vremena do početka turske vladavine [Cultural history of Bosnia and Herzegovina from the earliest times until the beginning of the Turkish rule]. Biblioteka kulturno nasljedje. Sarajevo: Veselin Masleša, 1966. 541 pp., figs. in text.
 In Serbo-Croatian. Only the last two chapters--"Early Slavic period" (pp. 379-402) and "Period of the medieval Bosnian state" (pp. 405-536)--are relevant. A broad cultural framework is adequately presented.

4 Bihalji-Merin, Oto. Umetničko blago Jugoslavije [Art treasures of Yugoslavia]. Belgrade: Jugoslavija, 1969. 438 pp., 77 col. pls., 393 figs., 115 drawings, 10 maps.
 In Serbo-Croatian. A useful survey of art treasures of Yugoslavia from prehistoric to modern times. Chapters 8-13 (pp. 163-298) treat medieval material. The book is well illustrated.

123

5 Boskovič, Djurdje, ed. Arheološki spomenici i nalazišta u
 Srbiji [Archeological monuments and sites in Serbia]. Vol. 1,
 Zapadna Srbija [Western Serbia]. Srpska akademija nauka.
 Gradja 9. Belgrade: Naučna knjiga, 1953. 200 pp., 322 figs.
 in text.
 In Serbo-Croatian. An extensive survey of archeological
 (mostly medieval) material and sites in western Serbia. Brief
 French summaries accompany the introductory text.

6 _____. Arheološki spomenici i nalazišta u Srbiji [Archeologi-
 cal monuments and sites in Serbia]. Vol. 2, Centralna Srbija
 [Central Serbia]. Srpska akademija nauka. Gradja 10.
 Belgrade: Naučna knjiga, 1956. 270 pp., 292 figs. in text.
 In Serbo-Croatian. See entry YU 5.

7 _____. "L'art entre l'antiquité et l'époque romane sur le
 litoral de l'ancienne Zeta." Starinar, n.s. 27 (1977):71-82.
 A study examining the question of continuity between the
 art of the late Antiquity and that of the Middle Ages along the
 litoral of Zeta. The study focuses on the architecture and
 sculpture of the so-called pre-Romanesque phase which show formal
 and spatial, as well as technical affinities with late Antiquity.

8 _____. Medieval Art in Serbia and Macedonia: Church Archi-
 tecture and Sculpture. Belgrade: Jugoslovenska knjiga, n.d.
 19 pp., 96 pls.
 A short but useful survey of medieval church architecture
 and its decoration in Serbia and Macedonia. Many illustrations
 have a documentary value.

9 _____. "Nouvelles byzantines de Yugoslavie." Studi bizantini
 e neoellenici (Rome) 8 (1953):86-95. (Atti dello VIII Con-
 gresso internazionale di studi bizantini 2.)
 A discussion of recent discoveries in Byzantine painting
 and architecture in Yugoslavia. Particularly important is the
 discussion of the discovery of painters' signatures at several
 churches (figs. 6-9).

10 _____. "Orient--Byzance--Macédoine--Serbie--Occident. Archi-
 tecture et arts plastiques." AI 2 (1956):145-59.
 A general consideration of the problem of transmission of
 influences from the East to the West as reflected in the archi-
 tecture and sculpture of Macedonia and Serbia of the thirteenth
 and fourteenth centuries.

11 _____. "Srednjovekovni spomenici istočne Srbije" (Fr. sum.:
 "Monuments médiévaux de la Serbie de l'est"). Starinar,
 n.s. 2 (1951):221-44 (Fr. sum.: 244).
 In Serbo-Croatian. A brief survey of architectural monu-
 ments in eastern Serbia including fortifications, monasteries and

churches. Good architectural drawings (plans, sections, and de-
tails), as well as photographs accompany the study.

12 _____. "Srednjevekovni spomenici severoistočne Srbije" (Fr.
 sum.: "Monuments médiévaux de la Serbie du Nord-Est").
 Starinar, n.s. 1 (1950):185-218.
 In Serbo-Croatian. A general survey of medieval monuments
 in northeastern Serbia. Provides the basic historical and archi-
 tectural (plans and sections) information on a large number of
 medieval monuments.

12a Ćirković, Sima, ed. Istorija srpskog naroda. I. Od
 najstarijih vremena do Maričke bitke (1371) [History of the
 Serbian People. I. From the oldest times until the battle
 of Marica (1371)]. Belgrade: Srpska književna zadruga, 1981.
 698 pp., 104 b&w pls., 48 col. pls., additional b&w figs. and
 drawings in text.
 In Serbo-Croatian. A major political and cultural history
 of the Serbian people. Particularly relevant are the following
 sections on art and architecture, written by Vojislav J. Djurić:
 "Beginnings of art among the Serbs" (pp. 230-47); "Reorientation
 in art under Nemanja" (pp. 273-96); "Building in Raška and
 Primorje" (pp. 389-407); and "Serbian painting at its apogee"
 (pp. 408-33). Also relevant are the following chapters, written
 by Gordana Babić-Djordjević: "Paleologan classicism in Serbian
 art" (pp. 476-95); and "Branching out of artistic production and
 the emergence of stylistic diversity" (pp. 641-63).

13 Djurić, Vojislav J. "L'art des Paléologues et l'état serbe:
 Rôle de la cour et de l'église serbes dans la première moitié
 du XIV^e siècle." In Art et société à Byzance sous les Paléo-
 logues. Bibliothèque de l'Institut Hellénique d'études byzan-
 tines et post-byzantines de Venise, no. 4. Venice: Institut
 Hellenique d'Études Byzantines et Post-byzantines de Venise,
 1971, pp. 179-91.
 A general consideration of the role of the Serbian court
 and the imperial ambitions of Milutin and Dušan in the develop-
 ment of Serbian art and architecture during the first half of the
 fourteenth century.

14 _____, ed. Moravska škola i njeno doba (Fr. sum.: "L'école
 de la Morava et son temps"). Symposium de Resava, 1968.
 Belgrade: Filozofski fakultet, Odeljenje za istoriju umet-
 nosti, 1972. 339 pp., many b&w illus.
 In Serbo-Croatian. Collected essays by different authors
 presented at the symposium about the Morava school, the last
 phase of artistic development in medieval Serbia. For descrip-
 tions of individual articles, see entries BA 19, YU 22, 123, 170,
 236, 241, 389, 432, 478, 608, 639, 902-3, 909, 922, 969.

15 Djurović, Milinko, ed., et al. Istorija Crne Gore [History of
 Montenegro]. Vol. 1, Od najstarijih vremena do kraja XII
 vijeka [From Prehistory to the end of the twelfth century].
 Titograd: Redakcija za istoriju Crne Gore, 1967. 508 pp.,
 45 figs. in text, 23 pls.
 In Serbo-Croatian. An important comprehensive coverage of
 history, architecture, sculpture, painting, and the minor arts on
 the territory of Montenegro (medieval Duklja). Of particular
 interest is the chapter by Jovan Kovačević, "From the arrival of
 the Slavs to the end of the twelfth century" (pp. 281-444).

16 _____. Istorija Crne Gore [History of Montenegro]. Vol. 2,
 pt. 1, Crna Gora u doba Nemanjića [Montenegro under the
 Nemanjićs]. Titograd: Redakcija za istoriju Crne Gore, 1970.
 350 pp., 132 pls., 51 figs. in text.
 In Serbo-Croatian. Of particular interest are chapters by
 Vojislav Korać ("Architecture," pp. 117-201); Jovanka Maksimović
 ("Sculpture," pp. 201-23); and Pavle Mijović ("Painting,"
 pp. 223-305). These chapters provide comprehensive coverage of
 the visual arts in Montenegro at the time when this area was an
 integral part of the Serbian medieval state.

17 _____. Istorija Crne Gore [History of Montenegro]. Vol. 2,
 pt. 2, Crna Gora u doba oblasnih vladara [Montenegro under
 regional rulers]. Titograd: Redakcija za istoriju Crne Gore,
 1970. 592 pp., 107 pls., 41 figs. in text.
 In Serbo Croatian. A chapter by Vojislav [J.] Djurić
 ("Art," pp. 411-53) gives comprehensive coverage of the visual
 arts on the territory of Montenegro during the second half of the
 fourteenth and the fifteenth centuries.

18 Dudan, Alessandro. La Dalmazia nell'arte Italiana. Vol. 1,
 Dalla preistoria all'anno 1450. Milan: Fratelli Treres,
 1921. 208 pp., 134 pls.
 A detailed, well-documented study of art and architecture
 in Dalmatia with great emphasis on the medieval period.

19 Garašanin, M., and Kovačević, J. Pregled materijalne kulture
 Južnih Slovena u ranom srednjem veku [A survey of the material
 culture of the South Slavs during the early Middle Ages].
 Muzejski priručnik, 3-5. Belgrade: Prosveta, 1950. 239 pp.,
 51 figs.
 In Serbo-Croatian. A general survey of South Slav material
 culture and archeology. Includes a useful bibliographic section
 listing 232 relevant works with a brief critical commentary on
 each.

20 Gunjača, Stipe. "Nécessité d'une révision des fouilles
 d'époque croate ancienne." AI 1 (1954):97-107.
 A detailed methodological reassessment of the results of
 archeological excavations of old Croatian sites. Particular
 attention is given to a church on the land of Bukorović family
 at Biskupija near Knin.

21 Jelovina, Dušan. "Die Forschungstätigkeit an mittelalter-
 lichen Fundstätten Kroatiens 1945-1959." AI 5 (1964):97-111.
 A state-of-the-art research study on old Croatian sites
 excavated between 1945-59. Architecture, sculpture, and minor
 arts (jewelry) are discussed.

22 Kajmaković, Zdravko. "Odsjaji moravske umetnosti u Bosni"
 (Fr. sum.: "Reflets de l'art moravien en Bosnie"). In
 Moravska škola i njeno doba. Edited by Vojislav J. Djurić.
 Belgrade: Filozofski fakultet, Odeljenje za istoriju umet-
 nosti, 1972, pp. 293-307 (Fr. sum.: 307).
 In Serbo-Coratian. An examination of architectural,
 sculptural and fresco reflections of the Morava school in Bosnia.

23 Karaman, Ljubo. Iz kolijevke hrvatske prošlosti.
 Historijsko-umjetničke crtice o starohrvatskim spomenicima
 [From the cradle of the Croatian past. Art-historical ob-
 servations on old Croatian monuments]. Zagreb: Matica
 hrvatska, 1930. 229 pp., 132 pls., 2 foldout pls., some
 drawings in text.
 In Serbo-Croatian. A general study of old Croatian art in
 its historical context. The book is organized in several chap-
 ters, each representing a distinctive art-historical theme.
 Documentary and archeological evidence is used extensively.

24 _____. "Notes sur l'art byzantin et les Slaves catholiques de
 Dalmatie." L'art byzantin chez les Slaves: L'ancienne
 Russie, les Slaves catholiques. Vol. 2, pt. 2. Paris:
 P. Geuthner, 1932, pp. 332-80.
 Architecture, painting, and icons of Dalmatia over a wide
 chronological range are considered in the light of Byzantine
 influence.

25 _____. O djelovanju domaće sredine u umjetnosti hrvatskih
 krajeva (Ger. sum.: "Über die Einwirkung des einheimischen
 Milieus auf die Entwicklung der Kunst in der Kroatischen
 Ländern"). Društvo historičara umjetnosti N. R. H., no. 8.
 Zagreb: n.p., 1963. 95 pp., 104 figs. (Ger. sum.: 99-131).
 In Serbo-Croatian. An attempt to define the influence of
 the local ambient on the development of a regional artistic tra-
 dition. The problems are investigated from early Middle Ages
 through Renaissance times.

26 ____. "O putovima bizantskih crta u umjetnosti istočnog
Jadrana" [Paths of Byzantine influence in the art of the
eastern Adriatic region]. SP, 3d ser. 6 (1958):61-76 (Eng.
sum.: 74-76).
 In Serbo-Croatian. An examination of the Byzantine element
in the art of Dalmatia and Istria. Recognizes two main ways by
which Byzantine influence reached this region--indirectly, from
the West; and directly, from Byzantium itself or through the
Balkan lands. The broadest chronological span is considered.

27 ____. "Osvrti na neka pitanja iz arheologije i povijesti
umjetnosti" (Fr. sum.: "Remarques sur quelques problèmes
d'archéologie et d'histoire d'art"). SP, 3d ser. 2 (1952):
81-104 (Fr. sum.: 102-4).
 In Serbo-Croatian. A discussion of several highly diversi-
fied issues in archeology and art history. Most relevant in this
context are the questions of regional instead of national sig-
nificance of sculptural decoration; and the appearance of human
images in old Croatian braided sculpture.

28 ____. Pregled umjetnosti u Dalmaciji (od doseljenja Hrvata
do pada pod Mletke) [A survey of art in Dalmatia from the
settlement of Croatians to the fall of Venice]. Zagreb:
Matica hrvatska, 1952. 80 pp., 185 pls.
 In Serbo-Croatian. A general survey of arts in Dalmatia
from the early Middle Ages to the fall of Venice at the end of
the eighteenth century. Most of the book is devoted to the
medieval period. Considers architecture, sculpture, painting,
and minor arts.

29 ____. "Razgovori o nekim problemima domaće historije,
arheologije i historije umjetnosti" (Ger. sum.: "Gespräch
über Probleme der Archäologie, Geschichte und Kunstgeschichte
Dalmatiens"). Peristil 5 (1962):126-34 (Ger. sum.: 134).
 In Serbo-Croatian. A critical survey of several art-
historical and archeological problems in which the author ex-
amines the arguments and methodology of other authors. Subjects
include early medieval architecture, art, and archeology of
Dalmatia and its hinterlands.

30 ____. Umjetnost u Dalmaciji, XV i XVI vijek [Art in Dalmatia
in the fifteenth and sixteenth centuries]. Zagreb: Matica
hrvatska, 1933. 188 pp., 101 figs.
 In Serbo-Croatian. A general analysis of art and archi-
tecture in Dalmatia in the fifteenth and sixteenth centuries.

31 Kašanin, Milan. L'art yugoslave des origines à nos jours.
Belgrade: Musée du Prince Paul, 1939. 89 pp., 8 col. pls.,
160 b&w pls.
 A general survey of Yugoslav art from early medieval times
to World War II. A substantial portion of the book is devoted to
the medieval period. Includes some good illustrations.

32 _____. Kamena otkriča: Studije o umetnosti Srbije u srednjem
veku [Stone discoveries: Studies on art of medieval Serbia].
Biblioteka otkriča. Belgrade: Jugoslavija, 1978. 97 pp.,
139 pls.
 In Serbo-Croatian. A selection of essays on architecture,
sculpture, and painting in medieval Serbia.

33 Kolarić, Miodrag et al. Antica arte Serba. Exhibition cata-
log. Palazzo Venezia, Feb.-March 1970. Rome: De Luca
Editore, 1970. 80 pp., 66 pls.
 Exhibition catalog of a major exhibit of Serbian medieval
art (306 items). Works of art include fresco fragments, icons,
stone and bone carving, metal work, cloisonné, embroideries, and
glass jewelry.

34 Kondakov, N[ikodim] P[avlovich]. Makedoniĭa: Arkheologi-
cheskoe puteshestvie [Macedonia: An archeological journey].
St. Petersburg: Otdielenie Russkago ĭazika i slovoṣnasti
Imperatorskoĭ akademii nauk, 1909. 298 pp., 194 figs.,
13 pls.
 In Russian. An important early account of Byzantine archi-
tecture and art in what now constitutes the southern part of
Yugoslavia and the northern part of Greece. Particularly impor-
tant is the account of numerous art objects which have since been
lost or destroyed.

35 Kos, Milko. Zgodovina Slovencev, od naselitve do petnajstego
stoletja [History of Slovenians from the settlement to the
fifteenth century]. Ljubljana: Slovenska matica, 1955.
426 pp., illus.
 In Slovenian. A general history of Slovenia with the cul-
tural history integrally discussed. The book is divided into
three main sections: 1) From the settlement to the ninth cen-
tury; 2) From the tenth to the twelfth centuries; and 3) From
the thirteenth to the fifteenth centuries.

36 Kowalczyk, Georg, and Gurlitt, Cornelius. Denkmaeler der
Kunst Dalmatien. 2 vols. Berlin: Verlag für Kunstwissen-
schaft, 1910. 25 pp., 132 pls.
 A large album of photographs and engravings (reproduced
from Robert Adam) of art and architecture in Dalmatia. Photo-
graphs of high quality have documentary value.

37 Ljubinković, Radivoje. "Quelques observations sur le pro-
blème des rapports artistiques entre Byzance, l'Italie
Méridionale et la Serbie avant le XIII^e siècle." Corsi di
cultura sull'arte ravennate e bizantina 10 (1963):181-205.
 A study examining the influence of Byzantium and Southern
Italy on Serbian art during its formative stage. The main monu-
ments, such as the Gospels of Prince Miroslav, the church SS.
Peter and Paul at Novi Pazar, and the church of St. Michael at

Ston, are examined in the light of complex cross-cultural
influences.

38 Maksimović, Jovanka. "Le naif et l'abstrait dans l'art médié-
val (Á propos d'un groupe de monuments artistiques médiévaux)."
Balconoslavica 5 (1976):79-99.
 A discussion of a group of medieval works of art from the
central Balkans (mostly Bosnia and Herzegovina) characterized by
a high degree of abstraction and naïveté. Parallels between
monumental scuplture and manuscript illumination are drawn.

39 Mandić, Svetislav. Drevnik: Zapisi konzervatora [A Chroni-
cle: Notes by Conservators]. Belgrade: Slovo ljubve, 1975.
175 pp., 14 pls.
 In Serbo-Croatian. A collection of essays written by a
painter and restorer of medieval frescoes. Each of the essays
is a major contribution to scholarship, enhanced by the author's
perceptive observations. The subjects include medieval Serbian
history, architecture, painting, sculpture, and iconography.

40 Medaković, Dejan. "Beleške o srpskoj umetnosti u oblastima
Stare Slavonije i Hrvatske" (Ger. sum.: "Beiträge zur
serbischen Kunst in Altslawonien und Kroatien"). Starinar,
n.s. 5-6 (1956):317-30 (Fr. sum.: 330).
 In Serbo-Croatian. A study of Serbian art on the territory
of old Slavonia and Croatia. Architecture, manuscripts, and
minor arts are discussed.

41 Mesesnel, Franc. "Istoriski spomenici Južne Srbije, pt. 2.
Vizantiski spomenici" [Historical monuments of South Serbia,
pt. 2. Byzantine Monuments]. Spomenica dvadesetpetogod-
išnjice oslobodjenja Južne Srbije 1912-1937 (Skopje) (1937):
345-59.
 In Serbo-Croatian. A brief survey of Byzantine monuments
on the territory of what constitutes present-day Yugoslav
Macedonia. Church architecture and decoration are primarily
considered, although icons and other works of art are mentioned.
The survey includes a number of black-and-white photographs,
some of which have documentary value.

42 _____. "Istoriski spomenici Južne Srbije, 3. Stari srpski
spomenici" [Historical monuments of South Serbia, 3. Old
Serbian monuments]. Spomenica dvadesetpetogodišnjice
oslobodjenja Južne Srbije 1912-1937 (Skopje) (1937):361-85.
 In Serbo-Croatian. A brief survey of medieval monuments
built or restored under the auspices of Serbian rulers and
aristocrats. Church architecture and decoration are considered
almost exclusively. The survey includes a number of black-and-
white photographs, some of which have documentary value.

43 Mijović, Pavle. <u>Monodija u kamenu</u> [Stone monody]. Mala
 biblioteka-Stranice prošlosti. Kruševac: Bagdala, 1967.
 139 pp., 16 pls.
 In Serbo-Croatian. A collection of essays on a variety of
 art historical and archeological monuments and sites in Serbia
 and Montenegro. The essays are written for a popular audience,
 while attempting to take issue with certain established ideas.

44 _____. <u>Tragom drevnih kultura Crne Gore</u> (Fr. sum.: "Sur la
 trace des cultures antiques et medievales du Montenegro").
 Biblioteka studija, kritike i eseja 7. Titograd: Grafički
 zavod, 1970. 218 pp. (Fr. sum.: 215-18), 22 pls., 14 figs.
 in text.
 In Serbo-Croatian. A series of essays on various cultural
 and archeological questions dealing with ancient cultures on the
 territory of present-day Montenegro. Most of the book is devoted
 to the medieval period.

45 Milošević, Desanka. <u>Umetnost u srednjevekovnoj Srbiji od 12.</u>
 <u>do 17. veka</u> (Parallel text in English: "Art in medieval
 Serbia from the twelfth to the seventeenth century").
 Belgrade: Narodni muzej, 1980. 115 pp., 246 pls.
 In Serbo-Croatian. A comprehensive exhibition catalog of
 art in medieval Serbia. Emphasis is placed on minor arts
 (metalwork, glass, ceramic work, jewelry, etc.), though painting
 (frescoes, icons, manuscripts) is also included. The material
 includes some recent finds, as well as some works that are not
 well known.

46 Nikolovski, Antonie; Čornakov, D.; and Balabanov, K. <u>The</u>
 <u>Cultural Monuments of the People's Republic of Macedonia.</u>
 The Historical and Cultural Heritage of the People's Republic
 of Macedonia 8. Skopje: The Institute for the Preservation
 of Cultural Monuments in the People's Republic of Macedonia,
 1961. 279 pp., numerous illus.
 A detailed guide to the cultural monuments of Macedonia.
 The largest percentage of the material presented is medieval.
 The material is organized by region. The book is illustrated
 with good black-and-white photographs.

47 Panić-Surep, Milorad, ed. <u>Yugoslavia: Cultural Monuments of</u>
 <u>Serbia</u>. Belgrade: Turistička štampa, 1965. 208 pp.,
 116 pls.
 A useful guide book for the cultural monuments (mostly
 medieval) of Serbia. The material is organized by region. The
 book is preceded by an introductory chapter discussing the fol-
 lowing topics: archeological wealth of Serbia, medieval Serbian
 art, fortifications, wooden dwellings, and churches.

48 Petković, Vladimir R. Pregled crkvenih spomenika kroz
 povesnicu srpskog naroda (Fr. sum.: "Aperçue des monuments
 religieux à travers l'histoire Serbe"). Srpska akademija
 nauka, Posebna izdanja 157. Belgrade: Naučna knjiga, 1950.
 1258 pp., 1105 figs.
 In Serbo-Croatian. The most exhaustive corpus of Serbian
 churches. Monuments are treated alphabetically by location,
 although some of the monuments are grouped under the name of a
 particularly popular patron saint (e.g., Bogorodica-Virgin).
 The book is printed on very poor paper, hence the illustrations
 are very poor.

49 Popović, D.J., ed. Vojvodina 1. Od najstarijih vremena do
 velike seobe [Vojvodina: From the beginnings to 1699]. Novi
 Sad: Istorisko društvo, 1939. 528 pp., 85 figs. in text,
 38 pls.
 In Serbo-Croatian. A series of essays written by different
 scholars on various aspects of Vojvodina from prehistoric times
 to 1699. A substantial portion of the book (pp. 128-414) dis-
 cusses the art and culture of Vojvodina during the Middle Ages.

50 Prelević, Ljiljana Mišković, and Bogdanović, Sonja. Izlozi
 Srpskog učenog društva. Istraživanja srpske srednjovekovne
 umetnosti, 1871-1884 [Display cases of the Serbian Learned
 Society. Studies of Serbian medieval art, 1871-1884].
 Galerija Srpske akademije nauka i umetnosti 34. Belgrade:
 Srpska akademija nauka i umetnosti, 1978. 146 pp., 8 col.
 and 56 b&w pls., 1 foldout map.
 In Serbo-Croatian. Catalog of an exhibit presenting the
 work of two pioneer investigators of medieval Serbian church
 architecture and art--Mihailo Valtrović and Dragutin Milutinović.
 The catalog is richly illustrated with drawings and watercolors,
 most of which have documentary value.

51 Prelog, Milan et al. L'art en Yugoslavie de la préhistoire à
 nos jours. Exhibition catalog, Grand Palais, March-May 1971.
 Paris, 1971. Numerous figs. in text, 8 col. pls.
 The catalog of a major exhibit of Yugoslavian art. A
 large portion is devoted to medieval art, with essays on:
 Period of great invasion (essay by Z. Vinski); Romanesque art
 (M. Prelog); Byzantine Yugoslavia (S. Radojčić); Gothic art
 (E. Cevc).

52 Radojčić, Svetozar. Geschichte der Serbischen Kunst von
 Anfängen bis zum Ende des Mittelalters. Grundriss der
 Slavischen Philologie und Kulturgeschichte. Berlin: Walter
 de Gruyter & Co., 1969. 116 pp., 21 figs., 65 pls.
 The most comprehensive history of Serbian medieval art and
 architecture in a Western language. The material is organized in
 six chapters discussing the beginnings of Serbian medieval art
 until the end of the twelfth century; the beginnings of monumental

art in Raška; the mature Raška style (1200-1300); the reign of King Milutin; the period 1321-1371; and the art of the Morava and Danube regions (1371-1459).

53 ____. "O vremenima stvaranja srpske monumentalne umetnosti" (Ger. sum.: "Die Entstehungszeit der altserbischen monumentalen Kunst"). ZLU 12 (1976):3-22 (Ger. sum.: 18-22).
 In Serbo-Croatian. A general overview of Serbian medieval art in its cultural and historical setting.

54 ____. "Problem celine u istoriji stare srpske umetnosti" [The problem of entity in the history of old Serbian art]. In Spomenica u čast novoizabranih članova. Belgrade: Srpska akademija nauka i umetnosti, 1964, pp. 169-74.
 In Serbo-Croatian. A general overview of past and present methods and goals in art-historical scholarship dealing with medieval Serbia.

55 ____. Uzori i dela starih srpskih umetnika [Models and achievements of old Serbian artists]. Srpska književna zadruga, no. 457. Belgrade: Srpska književna zadruga, 1975. 288 pp., 32 pls.
 In Serbo-Croatian. A selection of essays by Radojčić written over a period of nearly forty years and originally published in different periodicals. Essays discuss medieval art of Serbia and Byzantine art.

56 Stelè, François. "L'art en Slovénie et le Byzantinisme." L'art byzantin chez les Slaves: L'ancienne Russie. Les Slaves catholiques (Paris) 2, pt. 2 (1932):381-93.
 Byzantine influence on sculpture, wall painting, panel and miniature painting of Slovenia is discussed.

57 Stelè, Francè. Monumenta artis Sloveniae 1. Srednjeveško stensko slikarstvo (Parallel Slovenian and French texts: La peinture murale au moyen âge). Ljubljana: Akademska založba, 1935, 56 pp.
 A general survey of medieval painting in Slovenia. Although the focus is on wall-paintings, panel paintings and manuscript illuminations are also discussed.

58 ____. Umetnost v Primorju (Fr. sum.: "L'art du littoral Slovène"). Ljubljana: Slovenska matica, 1960. 205 pp., 216 figs. in text (Fr. sum.: 216-32).
 In Slovenian. A general survey of the arts in the Slovenian coastal region. A large section of the book discusses the Middle Ages. The book is of particular interest for the understanding of regional tendencies in art.

59 ____, ed. Umjetnost na tlu Jugoslavije od praistorije do
 danas [Art on the territory of Yugoslavia from prehistoric
 times to the present]. Belgrade: Jugoslavija; Sarajevo:
 Sarajevopublic, 1971. 247 pp., 32 col. pls., 322 figs.
 In Serbo-Croatian. A general survey-catalog of art in
 Yugoslavia. Pages 57-140 discuss the medieval material. Good
 illustrations.

60 Stričević, G[eorge]. "Byzantine Archaeology in Yugoslavia,
 1955-1958." Akten des XI. Internationalen Byzantinisten-
 kongresses München, 1958 (Munich) (1960):586-94.
 A brief account of major Byzantine archeological discov-
 eries, one of which--the quatrefoil church at Zanjevac--belongs
 to the middle Byzantine period. The church is compared to the
 eleventh-century church at Veljusa.

61 Strika, Boško. Srpske zadužbine, dalmatinski manastiri
 [Serbian foundations, Dalmatian monasteries]. Zagreb, 1930.
 283 pp., 162 figs. in text, 2 maps.
 In Serbo-Croatian. An exhaustive study of Serbian monas-
 teries along the Dalmatian coast and in the immediate hinterland.
 The study considers their history, architecture, art, and
 treasures.

62 Strzygowski, Joseph. O razvitku starohrvatske umjetnosti:
 Prilog otkriću sjeverno-evropske umjetnosti [Development of
 Old Croatian art: A contribution toward discovery of North-
 European art]. Zagreb: Matica hrvatska, 1927. 223 pp.,
 109 figs. in text.
 In Serbo-Croatian. A controversial book in which Old
 Croatian art is seen as a link between the art of Central Asia
 and Northern Europe--a theory rejected by present-day historians.

63 Subotić, Gojko. Arhitektura i skulptura srednjeg veka u
 Primorju [Architecture and sculpture of the Middle Ages in
 Primorje]. Saznanja 10. Belgrade: Zavod za izdavanje
 udžbenika S.R. Srbije, 1963. 110 pp., 27 figs., 50 pls.
 In Serbo-Croatian. A general study of architecture and
 sculpture in Dalmatia during the Middle Ages. Subdivided into
 three chapters--Pre-Romanesque, Romanesque, and Gothic--the book
 is organized as a group of essays rather than as a handbook.

64 Vasić, Miloje. Arhitektura i skulptura u Dalmaciji od početka
 IX do početka XV veka: Crkve [Architecture and sculpture in
 Dalmatia from the beginning of the ninth to the beginning of
 the fifteenth century: Churches]. Belgrade: Geca Kon, 1922.
 320 pp., 225 figs. in text.
 In Serbo-Croatian. A very useful handbook on the subject,
 notwithstanding the fact that it is outdated in many respects.
 The book considers individual monuments as well as general
 themes.

65 _____. "L'hesichasme dans l'église et l'art des Serbes du
 moyen âge." L'art byzantin chez les Slaves: Les Balkans.
 Vol. 1, pt. 1. Paris: Paul Geuthner, 1930, pp. 110-23.
 A largely superseded theory linking Hesychasm with artistic
 development of art and architecture of medieval Serbia. It was a
 highly influential work for many art historians.

66 The Yugoslav Coast: Guide and Atlas. Zagreb: Jugoslavenski
 leksikografski zavod, 1966. 117 pp., 27 maps, numerous illus.
 in text.
 An excellent up-to-date guide to the Yugoslav Adriatic
 coast. The book is organized alphabetically by location. The
 material is presented in a detailed and accurate manner. An in-
 valuable research tool.

67 Zadnikar, Marijan. Romanska umetnost [Romanesque art]. Ars
 Sloveniae. Ljubljana: Mladinska knjiga, 1970. 77 pp.,
 72 pls., numerous drawings and photographs in text (some in
 color).
 In Slovenian. A general survey of Romanesque art and
 architecture in Slovenia. The book includes studies of religious
 and secular architecture, sculpture, painting, book illumination,
 and coinage. Superbly illustrated.

ARCHITECTURE

68 Andjelić, Pavao. "Srednjevjekovni gradovi u Neretvi" (Fr.
 sum.: "Villes médiévales sur la Neretva"). GZMS, n.s. 13
 (Arheologija) (1958):179-231 (Fr. sum.: 229-31).
 In Serbo-Croatian. A general survey of medieval forts and
 fortresses in the valley of Neretva and its tributaries in the
 region of Konjic. Each site is analyzed individually (historical
 and archeological information), while some general conclusions
 are drawn regarding the system of fortifications in the early and
 late Middle Ages, as well as in Turkish times.

69 Andrejević, Andrej. "Pretvaranje crkava u džamije" (Eng.
 sum.: "On the transformation of churches into mosques").
 ZLU 12 (1976):99-117 (Eng. sum.: 117).
 In Serbo-Croatian. Analyzes the problem of conversion of
 medieval churches into mosques following the Turkish conquest of
 South Slav territories. Architectural implications of such con-
 versions (e.g., addition of minarets) are discussed.

70 Basler, Djuro. Arhitektura kasnoantičkog doba u Bosni i
 Hercegovini (Ger. sum.: "Die Architektur der spätantiken Zeit
 in Bosnien und Herzegowina"). Biblioteka Kulturno nasljedje.
 Sarajevo: Veselin Masleša, 1972. 171 pp., (Ger. sum.:
 163-64), 168 figs., 1 foldout map.
 In Serbo-Croatian. A number of churches here considered
 to be early Christian (pp. 63-143), are believed by other authors
 to belong to the medieval period. The book is well illustrated.

71 Bošković, Dj[urdje]. Beleške sa putovanja" (Fr. sum.: "Notes
 de voyages"). Starinar, 3d ser. 7 (1932):88-132 (Fr. sum.:
 136-38).
 In Serbo-Croatian. Discusses numerous monuments (mostly
 churches). Among the monuments included are Lesnovo; H. Arch-
 angles; St. John and St. Savior at Štip; St. Demetrius and St.
 Nicholas at Veles; Djurdjevi Stupovi, Sopoćani, and St. Peter
 near Novi Pazar; the Patriarchate at Peć; Budisavci; Bogorodica
 Ljeviška, St. Savior, and St. George at Prizren; Nikoljac; Sv.
 Trojica at Pljevlja; and the cemetery church at Rača Kragujevačka.

72 _____. "Izveštaj i kratke beleške sa putovanja" [A report and
 brief travel notes]. Starinar, 3d ser. 6 (1931):140-89 (Fr.
 sum.: 194-96).
 In Serbo-Croatian. Discusses medieval monuments from three
 distinct regions--between Skadar Lake and the sea, South Serbia,
 and North Serbia. Contains much useful information about scores
 of monuments.

73 _____. "Izveštaji o proučavanju Južne Srbije na terenu:
 Arhitektonski izveštaji" [Reports on field research in South
 Serbia. Architectural reports]. GSND 11 (1932):212-23.
 In Serbo-Croatian. An important report on a number of
 conservation undertakings: the exonarthex at Peć; Staro
 Nagorčino (including excavations); churches at Mlado Nagorčino;
 Matejić, and reconstruction of the iconostasis at Nerezi.

74 Bošković, Djurdje. "L'architecture médiévale en Serbie et en
 Macédoine." Corsi di cultura sull'arte ravennate e bizantina
 10 (1963):13-49.
 A general discussion of medieval architecture of Serbia and
 Macedonia. The material is presented in two sections: secular
 architecture (palaces and fortresses) (pp. 13-25), and religious
 architecture and sculpture (pp. 27-49). The article includes a
 basic bibliography on the subject.

75 _____. "Arhitektonski spomenici na Tari i pod Osogovom" (Fr.
 sum.: "Notes sur les monuments de la Tara et d'Osogovo").
 GSND 12 (1933):147-56 (Fr. sum.: 155-56).
 In Serbo-Croatian. A brief study of several churches on
 the Tara river (Dobrilovina, Dovolja, Sv. Arhandjel Mihailo) and
 of the church of Sv. Joakim Osogovski near Kriva Palanka.

76 _____. "Byzance et l'occident dans l'architecture médiévale
 serbe." Corsi di cultura sull'arte ravennate e bizantina 17
 (1970):23-33.
 A summary treatment of the question of interaction of
 Byzantine and Western influences in the architecture of medieval
 Serbia. Includes a basic general bibliography.

77 _____ . "L'église de Sainte-Sophie à Salonique et son reflet
dans deux monuments postérieurs en Macédonie et en Serbie."
AI 1 (1954):109-15.
 The church of St. Sophia at Thessaloniki is seen as the
prototype of two later churches--at Drenovo in Macedonia and at
Stara Pavlica in Serbia. The superficial resemblance of their
plans provides the exclusive basis for such a conclusion.

78 _____ . "O nekim problemima vezanim za istraživanja Hilandara,
sa posebnim osvrtom na odnos izmedju eksonarteksa Hilandarske
crkve i spomenika Moravske škole" (Fr. sum.: "Sur quelques
problèmes concernant les recherches exécutées à Chilandar,
avec un aperçu concernant tout particulièrement l'exonarthex
de son église et les monuments de l'école architecturale de la
Morava"). Starinar, n.s. 28-29 (1979):69-79 (Fr. sum.:
77-79).
 In Serbo-Croatian. A series of topics pertaining to the
study of the architecture of Hilandar monastery on Mount Athos.
The third section (pp. 71-77) considers the exonarthex of the
church and the question of origins of architecture and sculpture
of the so-called Morava school.

79 Bošković, Georges. "Deux églises de Milutin: Staro Nagoričino
et Gračanica." L'art byzantin chex les Slaves: Les Balkans.
Vol. 1, pt. 1. Paris: P. Geunther, 1930, pp. 195-212.
 A major study of two important churches built by the
Serbian King Milutin: Staro Nagoričino and Gračanica. The arti-
cle is illustrated by excellent photographs and extensive archi-
tectural drawings of the two buildings.

80 _____ . "Note sur les analogies entre l'architecture serbe et
l'architecture bulgare au moyen âge." IBAI 10 (1936):57-74.
(Actes du IVe Congrès international des études byzantines.)
 Considers the problem of the tower above the narthex which
occurs in church architecture of Serbia and Bulgaria.

81 Breje, Luj. "Srpske crkve i romanska umetnost" [Serbian
churches and Romanesque art]. Starinar, 3d ser. 1 (1922):
33-46.
 A general study of Serbian church architecture. The views
expressed by the author were very influential in the subsequent
development of scholarship. Especially important was the notion
of the "Serbian national genius."

81a Cevc, Emilijan. "Typologische Kontinuität des altchristlichen
Mausoleums in der Romanischen Zeit und die Anfänge der Doppel-
kapelle auf Mali Grad in Kamnik." Arheološki vestnik 23
(1972):397-406.
 Considers a problem of continuity between the late
Antiquity and the beginnings of the Middle Ages, by focusing on
the two-storied mausoleum type and its "survival" in the form of
two-storied chapels during the early Middle Ages.

82 Ćurčić, Slobodan. "Articulation of Church Façades during the
 First Half of the Fourteenth Century: A Study in the Rela-
 tionship of Byzantine and Serbian Architecture." In <u>Vizan-
 tijska umetnost početkom XIV veka</u>. Edited by S. Petković.
 Belgrade: Filozofski fakultet, Odeljenje za istoriju umet-
 nosti, 1978, pp. 17-27.
 Compares the façade articulation systems in Byzantium and
 in Serbia and concludes that over the course of the first half of
 the fourteenth century Serbian architecture shifted from strictly
 Byzantine to a unique system resulting from a blend of Byzantine
 and Western influences.

83 _____. "Two Examples of Local Building Workshops in
 Fourteenth-Century Serbia." <u>Zograf</u> 7 (1977):45-51.
 The churches of Sv. Spas (Savior) at Prizren and Vavedenje
 (Presentation of the Virgin) at Lipljan, both built around 1330,
 are seen as works of local builders trained by the Greek masters
 responsible for the construction of two major nearby monuments--
 Bogorodica Ljeviška and Gračanica.

84 Derocco, Alexandre. "Les deux églises des environs de Ras."
 <u>L'art byzantin chez les Slaves: Les Balkans</u>. Vol. 1, pt. 1.
 Paris: P. Geuthner, 1930, pp. 130-46.
 An important documentary study on Djurdjevi Stupovi, near
 Ras and Sopoćani. The article is illustrated by numerous photo-
 graphs and drawings (not always accurate) of the two churches
 prior to their modern reconstruction.

85 Deroko, A[leksandar]. <u>Medieval Castles on the Danube</u> [Serbo-
 Croatian original: <u>Srednjevekovni gradovi na Dunavu</u>].
 Belgrade: Turistička štampa, 1964. 27 pp., 82 pls.
 A brief survey of medieval Serbian fortifications and
 fortified towns on the Danube. The majority of the fortifica-
 tions are from the fifteenth century--a period during which the
 Serbian state was fighting for survival.

86 _____. <u>Monumentalna i dekorativna arhitektura u srednje-
 vekovnoj Srbiji</u> (Eng. sum.: "Monumental and decorative
 architecture in medieval Serbia"). 2d ed. Belgrade: Naučna
 knjiga, 1962. 297 pp. (Eng. sum.: 287-97), 455 illus.
 In Serbo-Croatian. A major survey of medieval church
 architecture in Serbia. The book follows the grouping of monu-
 ments established by Gabriel Millet: The Raška stylistic group;
 Monuments of Kosovo and Macedonia at the time of Serbia's terri-
 torial expansion in the fourteenth century; and the Morava sty-
 listic group. Other smaller groups of monuments are also con-
 sidered. The book is richly illustrated with drawings and photo-
 graphs.

87 ____. Spomenici arhitekture IX-XVIII veka u Jugoslaviji
[Architectural monuments of the ninth to the eighteenth cen-
turies in Yugoslavia]. Narodna arhitektura, 1. Belgrade:
Gradjevinska knjiga, 1964. 264 pp., illus.
 In Serbo-Croatian. A general survey of architectural his-
tory on the territory of Yugoslavia from the ninth to the eight-
eenth centuries. Provides a wealth of pictorial information.

88 ____. Srednjevekovni gradovi u Srbiji, Crnoj Gori i
Makedoniji (Fr. sum.: "Les châteaux forts médiévaux sur le
territoire de la Serbie, Crna Gora et Macédoine"). Belgrade:
Prosveta, 1950. 214 pp. (Fr. sum.: 211-12), 210 figs.,
36 pls., 1 foldout map.
 In Serbo-Croatian. A general survey of medieval fortifica-
tion architecture in Serbia, Montenegro, and Macedonia. Richly
illustrated with plans, photographs, and numerous drawings of
technical details.

89 ____. "Sur l'architecture en Serbie médiévale, contempo-
raine des temps des Paléologues." Akten des XI. Inter-
nationalen Byzantinistenkongresses, München 1958 (Munich)
(1960):106-12.
 A study of the relationship between Serbian and Byzantine
architecture during the reign of the Palaeologi. Different means
of borrowing are examined, as well as their ultimate results.

90 Deroko, Aleksandar. Avec les maîtres d'autrefois. Belgrade:
Turistička štampa, 1967. 38 pp., 110 pls.
 A general book on medieval architecture of Serbia,
Macedonia and Montenegro. Illustrated with fine black-and-white
photographs.

91 ____. "Na svetim vodama Lima (Nemanjićke crkve i manastiri u
Polimlju)" (Fr. sum.: "Les églises et monastères de l'époque
des Nemanić à Polimlje"). GSND 11 (1932):121-36 (Fr. sum.:
136).
 In Serbo-Croatian. A brief survey of a number of medieval
monuments in the valley of Lim River. Included are: Zaton,
Palež, Sv. Djordje u Dabru, Budimlja, Šudikova, Mileševa,
Davidovica, Majstorovina, Kumanica, Banja, and Nikoljac.

92 ____. "Nekoliko crkvica primorskoga tipa" [Several churches
of the coastal type]. GSND 14 (1935):213-16.
 In Serbo-Croatian. Identifies several small churches of
the "coastal" type--Monastery Ždrebaonik, Smokovac, and churches
of St. Nicholas at Studenica; and SS. Peter and Paul at Žiča.

93 ____. "Niski transept nemanjićske bazilike" [The low
transept of Nemanjić basilicas]. Srpski književni glasnik,
n.s. 24, no. 8 (16 Aug. 1928):615-18.
 In Serbo-Croatian. Discusses lateral chambers flanking
domed bays of single-aisled churches in Serbian architecture of
the thirteenth century. The author refers to them as "low
transept wings" and believes that they were intended to accom-
modate monastic choirs after the model of Athonite churches.

94 Deroko, A[leksandar], and Zdravković, I. "Stare crkve kod
Lepenca, Melentije i Stalaća" (Fr. sum.: "Les églises de
Lepenac, Melentija et Stalać"). Starinar, n.s. 1 (1950):
223-28 (Fr. sum.: 228).
 In Serbo-Croatian. A brief architectural survey of two
churches in ruins (Lepenac and Melentija) and the small church
at Stalać. The first two feature compact trefoil plan, typical
of Morava school churches.

95 Djurić, Vojislav J. "Mileševa i drinski tip crkve" (Fr. sum.:
"Mileševa et le type des églises de la Drina"). Raška baština
1 (1975):15-27 (Fr. sum.: 26-27).
 In Serbo-Croatian. Identifies a church type characteristic
of the valley of the river Drina which emerged under the influ-
ence of Mileševa monastery. The influence occurred in two waves--
in the fifteenth century to the south, and in the seventeenth
century to the north. In both cases it was inspired by the fact
that Mileševa held the tomb of St. Sava, the first Serbian
Archbishop.

96 ____. "Nastanak graditeljskog stila Moravske škole: fasade,
sistem dekoracije, plastika" (Fr. sum.: "L'école de la
Morava: Origines du decor, parement des façades, système
d'ornamentation plastique"). ZLU 1 (1965):35-65 (Fr. sum.:
64-65).
 In Serbo-Croatian. A controversial study which examines
the remains of painted fresco decoration on the façades of the
churches of the Holy Apostles and the Virgin, and the exonarthex
at Peć, and reattributes them to Archbishop Danilo II (1324-
1337). On the basis of this re-dating the author concludes that
the rich sculptural decoration of the Morava school was derived
from these frescoes and that therefore it was a native, Serbian,
creation. See entry YU 1036.

97 ____. "Srpski državni sabori u Peći i crkveno graditeljstvo"
(Fr. sum.: "Les assemblées d'État serbes à Peć et l'archi-
tecture religieuse"). In O knezu Lazaru. Edited by Ivan
Božić and V.J. Djurić. Belgrade: Filozofski fakultet,
Odeljenje za istoriju umetnosti, 1975, pp. 105-23 (Fr. sum.:
122-23).
 In Serbo-Croatian. Illuminates the known appearance of
certain church types (e.g., triconch plan) during the last phase

of architectural development in medieval Serbia. Arguments focus
on the role of Serbian monks from Mt. Athos in major state coun-
cils in the critical years 1374 and 1375.

98 Findrik, Ranko. "O krovnim pokrivačima od opeke na našim
srednjovekovnim gradjevinama" (Fr. sum.: "Sur les toitures en
tuilles de nos édifices médiévaux"). Starinar, n.s. 24-25
(1975):121-29 (Fr. sum.: 129).
 In Serbo-Croatian. A study of the tile-roof tradition in
medieval architecture of Serbia and Macedonia. Examines the sur-
viving examples as well as the archeologically retrieved material.

99 Fisković, Cvito. "Romaničke kuće u Splitu i u Trogiru" (Fr.
sum.: "Maisons romanes à Split et à Trogir"). SP, 3d ser. 2
(1952):129-78 (Fr. sum.: 177-78).
 In Serbo-Croatian. A major study of Romanesque residential
architecture in Split and Trogir. The profusely illustrated
general study is followed by a useful catalog of 68 surviving
Romanesque residences in Split, and 69 in Trogir.

100 Freudenreich, A[leksandar]. Narod gradi na ogoljenom krasu
(Fr. sum.: "Le peuple construit sur le karst dénudé").
Zagreb-Belgrade: Savezni institut za zaštitu spomenika
kulture, 1962. 254 pp. (Fr. sum.: 251-54), 648 figs.
 In Serbo-Croatian. A general study of vernacular architec-
ture in western part of Yugoslavia (principally Dalmatia).
Richly illustrated with fine drawings and photographs.

101 Freudereich, Aleksandar. Kako narod gradi na području
Hrvatske (Fr. sum.: "Comment le peuple construit sur le
territoire de la Croatie"). Zagreb: Republički zavod za
zaštitu spomenika kulture, 1972. 344 pp. (Fr. sum.: 331-44),
585 figs. in text.
 In Serbo-Croatian. General observations on vernacular
architecture in Croatia. The first six chapters consider regional
architectural characteristics; the following twelve chapters con-
sider general questions about design, aesthetics, function, con-
structional techniques, and conservation methods and practice.

102 Grabar, A[ndré]. "Deux notes sur l'histoire de l'iconostase
d'après des monuments de Yugoslavie." ZRVI 7 (1961):13-22.
 An important study for the history of the development of
the iconostasis screen. The article considers a two-leaf
iconostasis door with an Annunciation relief from the Andrejaš
monastery near Skopje, and two masonry iconostasis screens--at
Staro Nagorčino and at Karan.

103 Gregorič, Jože. "Srednjeveška cerkvena arhitektura v
 Sloveniji do leta 1430" (Fr. sum.: "L'architecture religieuse
 en Slovenie jusqu'à 1430"). ZUZ 1 (1951):1-36 (Fr. sum.:
 35).
 In Slovenian. A general overview of medieval church archi-
 tecture in Slovenia. Includes a basic earlier bibliography on
 the subject.

104 Grujić, Radoslav M. "Arheološke i istoriske beleške iz
 Makedonije" (Fr. sum.: "Notes archéologiques et historiques
 de Macédoine"). Starinar, n.s. 3-4 (1955):203-16 (Fr. sum.:
 215-16).
 In Serbo-Croatian. A series of archeological notes include
 (among others): Konča monastery and its art treasures, and the
 church of St. George at Gornji Kozjak.

105 Gvozdanović, Sena Sekulić. "Medieval and Renaissance Archi-
 tecture in Croatia" in "Proceedings of the Seminar on Archi-
 tecture and Historic Preservation in Central and Eastern
 Europe." Journal of the Society of Architectural Historians
 38, no. 2 (May 1979):133-38.
 A general overview of major architectural monuments and
 trends in Croatia during the Middle Ages and the Renaissance.
 Also examines the main problems and challenges in preservation.
 The preservation laws and the institutions which administer them
 are also discussed.

106 Gvozdanović, Vladimir. "The Beginnings of the Romanesque
 Architecture in Croatia." Journal of Croatian Studies 18-19
 (1977-78):3-72.
 Distinugishes two phases in early medieval architecture of
 Croatia--the pre-Romanesque and early Romanesque phases--spanning
 the late eighth to early twelfth centuries. The pre-Romanesque
 phase is associated with the rise of the Croatian state and is
 characterized by the revival of late Antiquity. The early
 Romanesque (Royal) phase saw greater links between Croatia and
 the West (e.g., appearance of Carolingian and post-Carolingian
 architecture) as well as the continuation of local links to the
 Roman imperial tradition. The builders of the early Romanesque
 phase sought to revise the tradition completely.

107 _____. "Two Early Croatian Royal Mausolea." Peristil 18-19
 (1975-76):5-10.
 Discusses the church at Crkvina at Biskupija near Knin, and
 the church of St. Mary on the island in Solin (Salonae). The two
 churches served as important mausolea with tombs, in both cases,
 accommodated within two-storied westwerks. The two churches are
 linked to the broad pre-Romanesque tradition of Western Europe.

108 Han, Verena. "Prozorsko staklo XV i XVI veka u Srbiji:
 Povodom nalaza stakla u Gornjem gradu beogradske tvrdjave"
 (Fr. sum.: "Verre à vitres du XVe et XVIe siècle en Serbie:
 À l'occasion de la découverte de verre dans la ville haute de
 la forteresse de Belgrad"). ZLU 8 (1972):193-207 (Fr. sum.:
 206-7).
 In Serbo-Croatian. An important contribution to the study
 of medieval glazing. In addition to examining the recent finds
 in the Belgrade fortress, the author examines other known exam-
 ples and places the production of most of the glass used in
 Serbia during the fifteenth and sixteenth centuries in Dubrovnik.

109 Horvat, Zorislav. "Klesarske oznake" (Ger. sum.: "Die Stein-
 metzzeichnen"). Peristil 14-15 (1971-72):109-16 (Ger. sum.:
 116).
 In Serbo-Croatian. A study of Gothic masons' marks in the
 territory of Croatia. The marks are grouped by site, but are
 also analyzed collectively.

110 _____. "Neke profilacije svodnih rebara u srednjevjekovnoj
 arhitekturi kontinentalne Hrvatske" [Some Gothic rib profiles
 in medieval architecture of continental Croatia]. Peristil
 20 (1977):5-12.
 In Serbo-Croatian. An addendum to the study of rib pro-
 files published by the same author in Peristil 12-13. See entry
 YU 111.

111 _____. "Profilacije gotičkih svodnih rebara" [Profiles of
 Gothic ribs]. Peristil 12-13 (1969-70):41-52.
 In Serbo-Croatian. A survey of Gothic ribs found in the
 monuments of Croatia. The study is organized by types, with a
 listing of monuments, a commentary, and a basic bibliography for
 each type.

112 Iveković, C[irillo] M. Die Entwickelung der Mittelalterlichen
 Baukunst in Dalmatien. Vienna: Kunstverlag Anton Schroll &
 Co., 1910. 22 pp., 11 figs., 28 pls.
 A brief account of the beginnings of medieval architecture
 in Dalmatia. Book is of interest for the historigraphy of the
 subject. Some of the illustrations have documentary value.

113 Iveković, Cirillo M. Dalmatiens Architektur und Plastik.
 6 vols. Vienna: Anton Schroll & Co., 1927. 53 pp., 126 figs.
 in text, 320 pls.
 A monumental pictorial survey of Dalmatian architecture and
 sculpture. An invaluable resource of excellent photographs, many
 of documentary value. Bound in volumes as follows: 1. Zadar,
 2. Šibenik, 3. Trogir, 4. Split, 5. Dubrovnik, 6. Islands: Rab,
 Hvar and Korčula.

114 Kajmaković, Zdravko. "Oko problema datacije pravoslavnih
 manastira u sjeveroistočnoj Bosni sa posebnim osvrtom na
 Papraću" (Fr. sum.: "Du problème de la datation des monastères
 orthodoxes dans la Bosnie du nord-est avec regard particulier
 sur Papraća"). NS 13 (1972):149-71 (Fr. sum.: 171).
 In Serbo-Croatian. A reassessment of the problems of dating
 a group of Serbian-Orthodox monasteries in northeastern Bosnia.
 These include: Ozren, Lomnica, Liplje, Moštanica, Vozuće, Tavna,
 and Papraća.

115 Kandić, Olivera M[arković]. "Kule-zvonici uz srpske crkve
 XII-XIV veka" (Fr. sum.: "Les tours de clocher auprès des
 églises serbes du XII^e au XIV^e siècle"). ZLU 14 (1978):3-75
 (Fr. sum.: 72-75).
 In Serbo-Croatian. A major study of church belfries within
 the Eastern orthodox sphere from the twelfth to the fourteenth
 centuries. Examines the textual and physical evidence in an
 attempt to classify the uses and the symbolic meaning of belfries
 in Serbian churches.

116 _____. "Utemeljavanje crkava u srednjem veku" (Fr. sum.: "La
 fondation des églises au moyen âge"). Zograf 9 (1978):12-14
 (Fr. sum.: 14).
 In Serbo-Croatian. Describes the imprint of a large wooden
 cross in the foundation wall of the main apse of Sopoćani as the
 evidence of a custom employed in laying foundations of churches
 in the Byzantine world.

117 Kandić, Olivera Marković. "Odnos kalote i tambura na kupolama
 u Vizantiji i srednjovekovnoj Srbiji" (Fr. sum.: "Rapport de
 la calotte et du tambour des coupoles à Byzance et dans la
 Serbie médiévale"). Zograf 6 (1975):8-10 (Fr. sum.: 10).
 In Serbo-Croatian. Examines design solutions in the ar-
 ticulation of eaves in Middle and Late Byzantine domes, with
 particular attention paid to the Serbian monuments (Stara
 Pavlica, Kalenić, and Ravanica). Formal and structural aspects
 of design solutions are investigated.

118 Karaman, Ljubo. "Dalmatinske katedrale" (Eng. sum.:
 "Dalmatia's cathedrals"). Radovi Instituta Jugoslavenske
 akademije znanosti i umjetnosti u Zadru 10 (1963):29-66
 (Eng. sum.: 58-66).
 In Serbo-Croatian. A general discussion of the major
 Dalmatian cathedrals and their histories: Split, Rab, Kotor,
 Dubrovnik (medieval cathedral), Zadar, Trogir, Šibenik, Korčula,
 Pag, Hvar, and Dubrovnik (Baroque cathedral). The majority of
 the monuments discussed are medieval or predominantly medieval.

119 Katanić, Nadežda, and Gojković, M. Gradja za proučavanje
 starih kamenih mostova i akvadukata u Srbiji, Makedoniji i
 Crnoj Gori (Fr. sum.: "Matériaux servant à l'étude des vieux
 ponts de pierre et aqueducs en Serbie, Macédoine et
 Monténégro"). Belgrade: Savezni institut za zaštitu
 spomenika kulture, 1961. 318 pp., numerous drawings and
 photographs, foldout pls.
 In Serbo-Croatian. A corpus of medieval and post-medieval
 stone bridges and aqueducts. Well documented and illustrated.

120 Kiel, Machiel. "Armenian and Ottoman Influences on a Group of
 Village Churches in the Kumanovo District." ZLU 7 (1971):
 247-55.
 Identifies a group of buildings in the Žegliovo district
 northeast of Kumanovo in which Armenian and Ottoman influence is
 detected (e.g., Mlado Nagoričane, Žegljane, Dobrača, and
 Strezovce). This influence is attributed to the fact that
 Armenians were settled in the Žegliovo district, as recorded in
 a fourteenth-century document.

121 Komelj, Ivan. Gotska arhitektura. Ars Sloveniae. Ljubljana:
 Mladinska knjiga, 1969. 78 pp., 78 pls., drawings in text,
 catalog with numerous illus.
 In Slovenian. A study of Gothic architecture in Slovenia.
 The book is superbly illustrated with fine drawings and photo-
 graphs. Gothic architecture of Slovenia illustrates the dual
 exposure of this region--to central Europe (via Austria) and to
 the Mediterranean (via Italy).

122 _____. "Srednjoveška grajska arhitektura na Dolenjskem" (Fr.
 sum.: "L'architecture médiévale de châteaux en Basse-
 Carniole"). ZUZ 1 (1951):37-85 (Fr. sum.: 84-85).
 In Slovenian. A broad consideration of medieval civic
 architecture in the region of Dolenjsko.

123 Korać, V[ojislav]. "Les origines de l'architecture de l'école
 de la Morava." In Moravska škola i njeno doba. Edited by
 Vojislav J. Djurić. Belgrade: Filozofski fakultet, Odeljenje
 za istoriju umetnosti, 1972, pp. 157-68.
 Considers Mt. Athos and church architecture built under
 Emperor Dušan as critical factors in the development of the so-
 called "Morava school" of church architecture.

124 Korać, Vojislav. "L'architecture du haut moyen âge en Dioclée
 et Zeta programme de repartition des espaces et origine des
 formes." Balcanoslavica 5 (1976):155-72.
 Concludes that the early medieval architecture of Duklja
 (Doclea) and Zeta drew heavily on the late Roman and early
 Christian architecture in the area. The development was also
 characterized by a lack of a coherent architectural style. Over
 time a style evolved, but the influence of Italy and Byzantium

continued to affect the planning and spatial articulation of
these churches.

125 _____. "Les églises à nef unique avec une coupole dans
 l'architecture byzantine des XI^e et XII^e siècles." Zograf 8
 (1977):10-14.
 A considerable section of the article is devoted to the
Serbian group of single-aisled domed churches: St. Nicholas at
Kuršumlija, Djurdjevi Stupovi near Novi Pazar, and Studenica.
The three churches are the oldest monuments of the so-called
Raška school. The type of church is viewed as having been wide-
spread in the Byzantine world of the eleventh and twelfth cen-
turies.

126 _____. Graditeljska škola Pomorja (Fr. sum.: "L'école de
 Pomorje dans l'architecture serbe"). Srpska akademija nauka
 i umetnosti. Posebna izdanja 384. Belgrade: Naučno delo,
 1965. 223 pp. (Fr. sum.: 208-23), 35 drawings, 78 photo-
 graphs.
 In Serbo-Croatian. A comprehensive study of the church
architecture of medieval Serbia's littoral region. Examines the
influence of the Benedictine order on the development of this
architecture, and ultimately its impact on the development of
church architecture in Serbia's Orthodox hinterland.

127 _____. "O prirodi i pravcima razvitka arhitekture u ranom
 srednjem veku u istočnim i zapadnim oblastima Jugoslavije"
 (Fr. sum.: "Sur la nature du renouvellement et les voies de
 développement de l'architecture du haut moyen âge des régions
 orientales et occidentales de la Yougoslavie"). ZRVI 8,
 pt. 2 (1964):209-26 (Fr. sum.: 225-26).
 In Serbo-Croatian. An important overview of development in
architecture during the critical centuries of the early Middle
Ages. Considers eastern parts of Yugoslavia (Macedonia and part
of Serbia) during the ninth and tenth centuries and during the
period of Byzantine restoration (eleventh and twelfth centuries).
Also discusses architecture in Dalmatia and Duklja (Zeta) as well
as the beginnings of the monumental tradition in Raška.

128 _____. "Sur les basiliques médiévales de Macédoine et de
 Serbie." Actes du XII^e Congrès international d'études byzan-
 tines (Belgrade) 3 (1964):173-85.
 Argues that the appearance of basilicas in Middle Byzantine
times on the territory of Serbia and Macedonia was a result of a
"continuous revival."

129 _____. "Sveti Sava i program raškog hrama" (Fr. sum.:
 "Saint Sava et l'origine du plan des églises de Rascie"). In
 Sava Nemanjić - Sveti Sava. Istorija i predanje. Edited by
 Vojislav Djurić. Belgrade: Srpska akademija nauka i umet-
 nosti, 1979, pp. 231-44 (Fr. sum.: 243-44).

In Serbo-Croatian. Considers the influence of St. Sava on the development of the church type characteristic of the so-called Raška school. The role of St. Sava was crucial, particularly in bringing to Serbia certain Byzantine planning concepts which remain an integral part of Serbian architecture throughout the thirteenth century, and beyond.

130 Korać, Vojislav, and Djurić, Vojislav J. "Crkve s prislonjenim lukovima u Staroj Hercegovini i dubrovačko graditeljstvo, XV-XVII vek" (Fr. sum.: "Églises à arcatures aveugles de l'ancienne Herzégovine et architecture ragusaine du XV^e au XVII^e siècle"). ZFF 8, pt. 2 (1964):561-99 (Fr. sum.: 598-99).
 In Serbo-Croatian. Examines a group of small, mostly single-aisled, vaulted churches characterized by internal responds and transversal arches. The group is seen as a survival of the medieval building tradition during the centuries of Turkish domination.

131 Kreševljaković, Hamdija. "Kule i odžaci u Bosni i Hercegovini" (Fr. sum.: "Les châteaux-forts et les manoirs (odžak) de Bosnie and Herzégovine"). NS 2 (1954):71-86 (Fr. sum.: 86).
 In Serbo-Croatian. A corpus of fortified residences from the Turkish period (mostly seventeenth and eighteenth centuries). The buildings show affinities with medieval architectural concepts.

132 _____. "Stari bosanski gradovi" (Fr. sum.: "Vieux bourgs bosniaques"). NS 1 (1953):7-44 (Fr. sum.: 44).
 In Serbo-Croatian. A corpus of medieval Bosnian fortresses and fortified towns. Includes the basic historical data and bibliography on each.

133 Kreševljaković, Hamdija, and Kapidžić, H. "Stari hercegovački gradovi" (Fr. sum.: "Les anciennes villes d'Herzégovine"). NS 2 (1954):9-22 (Fr. sum.: 22).
 In Serbo-Croatian. A corpus of medieval fortresses and fortified towns in Herzegovina. Includes the basic historical data and bibliography on each.

134 Marasović, Tomislav et al. Prilozi istraživanju Staro-hrvatske arhitekture [Contributions to the study of Old Croatian architecture]. Split, 1978. 183 pp., numerous drawings and photographs in text.
 In Serbo-Croatian. A broad survey of pre-Romanesque church architecture in Croatia. Four authors have contributed separate papers which constitute the book: Morphological classification of early medieval architecture in Dalmatia; The importance of old Croatian architecture in the history of pre-Romanesque Europe; A graphic contribution to the typology of pre-Romanesque churches; and Main determinants in old Croatian culture and art.

135 Marasović, Tomislav. "Regionalni južnodalmatinski kupolni tip
 u arhitekturi ranoga srednjeg vijeka (tipološki osvrt)" (Fr.
 sum.: "Type régional à coupole de la Dalmatie méridionale
 dans l'architecture du haut moyen âge"). Beritićev zbornik.
 Edited by Vjekoslav Cvitanović. Dubrovnik: Društvo pri-
 jatelja dubrovačke starine, 1960, pp. 33-47 (Fr. sum.: 47).
 In Serbo-Croatian. An analysis of the single-aisled, domed
 church in Dalmatia during the pre-Romanesque period (ninth-
 eleventh centuries). Churches in Dubrovnik, Koločep, Lopud,
 Ston, and Omiš are considered. The type is considered to be the
 most characteristic of the region during the period in question.

136 Marušić, Branko. "Istarska grupa spomenika sakralne arhitek-
 ture s upisanom apsidom" (Ger. sum.: "Istrische Denkmäler-
 gruppe sakraler Architektur mit eingezeichneter Apsis").
 Histria archaeologica 5, no. 1-2 (1974):7-94 (Ger. sum.:
 83-87).
 In Serbo-Croatian. A typological study of churches with
 inscribed apses reveals their persistence in Istria from the
 fifth to the fourteenth century. The type is identified as a
 local phenomenon which was free of external influences and which
 shows a pattern of development differing from neighboring areas.

136a _____. "Monumenti istriani dell' architettura sacrale alto-
 medioevale con le absidi inscritte." Arheološki vestnik 23
 (1972):266-88.
 A regional study of early medieval churches with inscribed
 apses. The type is analyzed in relationship to the early Chris-
 tian tradition as well as the later medieval developments.

137 Medić, Milka Čanak. "Neki primerci crkvenog kamenog
 nameštaja, amvonskih ploča i prozorskih tranzena" (Fr. sum.:
 "Quelques examples d'ameublement en pierre des églises, de
 pierres d'ambon et de meneaux de fenêtres"). ZNM 9-10 (1979):
 527-41 (Fr. sum.: 540-41).
 In Serbo-Croatian. A study of several pieces of stone
 church furniture, ambo slabs and window transoms executed by
 artisans associated with the Studenica monastery from the end of
 the sixteenth to the end of the seventeenth century.

138 Mijović, Pavle, and Kovačević, M. Gradovi i utvrdjenja u
 Crnoj Gori (Fr. sum.: "Villes fortifiées et forteresses au
 Montenegro"). Arheološki institut. Posebna izdanja 13.
 Belgrade and Ulcinj: Arheološki institut and Muzej Ulcinj,
 1975. 189 pp. (Fr. sum.: 83-86, 173-76), 126 figs. in text,
 71 pls.
 In Serbo-Croatian. An exhaustive study of the fortifica-
 tions of Montenegro. A large section of the book (pp. 89-172)
 is devoted to medieval fortifications. The material is pre-
 sented by site, grouped alphabetically.

139 Miljković-Pepek, P[etar]. "Novootkriveni arhitekturni i
 slikarski spomenici vo Makedonija od XI do XIV vek" (Fr. sum.:
 "Les monuments nouvellement découvertes dans l'architecture et
 dans la peinture en Macédoine du XI^e au XIV^e siècle"). KN 5
 (1974):5-16 (Fr. sum.: 15-16).
 In Macedonian. Considers new architectural discoveries at
 Veljusa (new plan, fig. 1), St. Demetrius at Varoš, and church
 of the Virgin at Dabnište near Kavadarci (thirteenth century).

140 Millet, Gabriel. L'ancien art serbe: Les églises. Paris:
 E. de Boccard, 1919. 208 pp., 249 figs.
 A pioneering survey of Serbian medieval church architec-
 ture. Material is grouped into three large sections: the Raška
 school, the school of Byzantinized Serbia, and the Morava school.
 This classification, with minor modifications, has been in use
 ever since.

141 _____. "Étude sur les églises de Rascia." L'art byzantin
 chez les Slaves: Les Balkans. Vol. 1, pt. 1. Paris:
 P. Geuthner, 1930, pp. 147-94.
 A pioneering work on a group of Serbian churches labeled by
 the author the Raška School. Extremely influential on the fol-
 lowing generation of architectural historians studying this ma-
 terial.

142 Mohorovičić, Andre. "Sjeverozapadna granica teritorijalne
 rasprostranjenosti starohrvatske arhitekture" [Northwest
 border of the territorial spread of Old Croatian architec-
 ture]. Peristil 2 (1957):91-107 (Fr. sum.: 107).
 In Serbo-Croatian. Challenges the earlier view that the
 island of Krk constituted the northernmost extent of territorial
 spread of old Croatian architecture. Western Kvarner and Istria
 are seen as areas in which the same type of creative fervor as
 that in Dalmatia existed during the critical period between the
 ninth and eleventh centuries.

143 Momirović, Petar. "Drvene crkve zapadne Bosne" (Fr. sum.:
 Les églises de bois de la Bosnie occidentale"). NS 3 (1956):
 149-72 (Fr. sum.: 172).
 In Serbo-Croatian. A study of principal post-medieval
 wooden churches of Bosnia, including their history, architecture,
 and art treasures.

144 Nedić, Olivera. "Grafičke pretstave srpskih manastira kao
 izvorni podaci pri konzervatorsko-restuaratorskim radovima"
 (Fr. sum.: "Réproductions graphiques des monastères serbes
 pouvant servir de sources lors de travaux de conservation et
 de restauration"). ZZSK 9 (1958):17-38 (Fr. sum.: 38).
 In Serbo-Croatian. A study of woodcuts and engravings de-
 picting Serbian medieval monasteries as potential sources for
 conservation and restoration work.

145 Nenadović, S[lobodan] M. "Fundiranje spomenika arhitekture
 u srednjovekovnoj Srbiji" (Fr. sum.: "Construction des fonda-
 tions pour les édifices en Serbie médiévale"). ZZSK 8 (1958):
 21-33 (Fr. sum.: 33).
 In Serbo-Croatian. A general survey of building techniques
 used in construction of foundation walls of medieval buildings in
 Serbia. The study is a pioneering effort based on a relatively
 limited number of monuments where foundations were archeologi-
 cally examined.

146 Nenadović, Slobodan [M.]. "Dve rekonstrukcije štukoplastike u
 srpskoj srednjevekovnoj arhitekturi" (Fr. sum.: "Deux recon-
 structions de décoration en stuc dans des monuments d'archi-
 tecture médiévale serbe"). ZZSK 9 (1958):85-92 (Fr. sum.:
 92).
 In Serbo-Croatian. A discussion of two monuments with
 preserved fragments of decorative stucco work: Sopoćani and the
 church of St. Peter near Novi Pazar. The stucco decoration in
 both cases includes string courses and frames for arched door
 openings featuring classical motifs (egg-and-dart, acanthus
 leaves, palmettes, astragal).

147 _____. "Tipovi vrata u narodnoj arhitekturi" (Fr. sum.:
 "Types de portes dans l'architecture populaire"). ZZSK 17
 (1966):25-50 (Fr. sum.: 50).
 In Serbo-Croatian. A study of wooden doors in vernacular
 architecture of Serbia and Macedonia. Several examples discussed
 are from medieval monuments (St. Clement and SS. Constantine and
 Hellena in Ohrid; Treskavac Monastery; St. Nicholas in Peć).

148 Nenadović, Slobodan M. "Osvrt na način zidanja srpskih
 srednjovekovnih spomenika" (Fr. sum.: "Aperçu sur le mode de
 construction des monuments historiques médiévaux serbes").
 ZZSK 15 (1964):43-60 (Fr. sum.: 60).
 In Serbo-Croatian. A general contribution to the study of
 building techniques and methods employed by medieval builders in
 Serbia.

149 _____. "Rezonatori u crkvama srednjovekovne Srbije" (Fr.
 sum.: "Les pots résonnants dans les églises médiévales
 serbes"). Zbornik Arhitektonskog fakulteta 5, no. 5 (1960):
 3-11 (Fr. sum.: 11).
 A discussion of the use of accoustical pots in church
 architecture of medieval Serbia. Investigates the practice which
 has its roots in ancient Roman architecture and examines Serbian
 churches which have such "accoustical provisions."

150 Nikolajević, Ivanka. "Beleške o nekim problemima rano-
 hrišćanske arhitekture u Bosni i Hercegovini" (Fr. sum.:
 "Notes sur quelques problèmes de l'architecture paleo-
 chrétienne en Bosnie et en Herzégovine"). ZRVI 10 (1967):
 95-119 (Fr. sum.: 117-19).
 In Serbo-Croatian. A probing reevaluation of early Chris-
 tian architecture in Bosnia and Herzegovina. Questions conclu-
 sions of scholars who ascribed several of the monuments to the
 Arian sect. Important for its redating to a later period of some
 of the monuments.

151 Pavlović, Dobroslav [St.]. "Prilog proučavanju slikanih
 dekoracija fasada srpskih srednjovekovnih crkava sa područja
 Zapadne Morave" (Fr. sum.: "Contribution à l'étude de la
 décoration peinte des façades des églises médiévales serbes
 dans le bassin de la Morava occidentale"). Raška baština 1
 (1975):199-202 (Fr. sum.: 202).
 In Serbo-Croatian. Discusses a special group of Morava
 school churches which reveal painted exterior decoration in addi-
 tion to the usual architectural and sculptural decoration.
 Ljubostinja and Veluće are the most important churches in which
 remnants of painted exterior decoration have recently come to
 light.

152 Pavlović, Dobroslav St. Crkve brvnare u Srbiji (Fr. sum.:
 "Les vieilles églises serbes construites en bois"). Saopštenja
 5 (1962), 204 pp. (Fr. sum.: 195-99), 151 figs. in text.
 In Serbo-Croatian. A study of wooden churches of Serbia,
 mostly dating from the eighteenth and nineteenth centuries. In-
 cludes historical background, as well as general discussions of
 the architecture, the relationship to other architectural tradi-
 tions in wood, and the typology of churches. Also includes a
 catalog of both known churches now lost and the forty-two sur-
 viving examples.

153 Pokryshkin, P[etr Petrovich]. Pravoslavnaía tserkovnaía
 arkhitektura XII-XVIII stol. v nynieshnem Serbskom koro-
 levstvíe [Orthodox church architecture of the twelfth-eight-
 eenth centuries in the present kingdom of Serbia]. St.
 Petersburg: Imperatorska Akademiía khudozhestv¯, 1906.
 76 pp., 28 figs., 105 pls. in text.
 In Russian. The first attempt at offering an overview of
 medieval architecture of Serbia. Presents Serbian churches in
 three main groups: those revealing Dalmatian influence, those
 revealing Byzantine influence, and those of Byzantine style with
 clear independent characteristics.

154 Popović, Pera J. "Prilog za studiju stare srpske crkvene
 arhitekture" [A contribution toward a study of Old Serbian
 church architecture]. Starinar, 3d ser. 1 (1922):95-119.
 In Serbo-Croatian. A brief, descriptive survey of forty-
 four individual monuments in northern Macedonia. Includes many
 valuable comments and observations.

155 Prelog, Milan. "Izmedju antike i romanike. Prilog analizi
 historijskog položaja 'predromaničke' arhitekture u Dalmaciji"
 [Between Antiquity and Romanesque: A contribution to the
 analysis of the historical place of 'pre-Romanesque' architec-
 ture in Dalmatia]. Peristil 1 (1954):5-14.
 In Serbo-Croatian. A broad consideration of early medieval
 architecture in Dalmatia. Argues against an earlier view that
 early medieval architecture should be seen as a decline of the
 architecture of Antiquity. Instead, it is seen as a viable new
 beginning.

156 Pupin, Michael J., and Jackson, Thomas G. Serbian Orthodox
 Church. South Slav Monuments 1. London: John Murray, 1918.
 64 pp., 54 pls.
 A general study of Serbian art and architecture. Of inter-
 est for the historiography of the subject. Drawings and photo-
 graphs are not of high quality.

157 Radauš, Vanja. Srednjovekovni spomenici Slavonije [Medieval
 monuments of Slavonia]. Jugoslavenska akademija znanosti i
 umjetnosti, 7. Razred za likovne umjetnosti. Zagreb, 1973.
 27 pp., 217 pls.
 In Serbo-Croatian. Basically a picture book of medieval
 monuments of Slavonia. Churches, castles, and fortifications are
 primarily represented, with a few photographs devoted to decora-
 tive details. The brief text includes a catalog of monuments
 with essential bibliography. Black-and-white photographs are
 generally of good quality.

158 Sas-Zaloziecky, Wladimir. Die byzantinische Baukunst in den
 Balkanländern und ihre Differenzierung unter abendländischen
 und islamischen Einwirkungen. Südosteuropäische Arbeiten 46.
 Munich: R. Oldenbourg, 1955. 146 pp., 15 pls., 10 foldout
 plans.
 A study of Byzantine architecture in the Balkans (Serbia,
 Bulgaria, and Rumania) where this architecture became modified
 under Western and Islamic influence. Though perceptive in many
 ways, the book is largely superseded.

158a Šriber, Vinko. "K dataciji zgodnjesrednjeveške crkvene
 arhitekture na slovenskem" (Ger. sum.: "Zur Datierung der
 frühmittelalterlichen Kirchenarchitektur in Slovenien").
 Arheološki vestnik 23 (1972):384-96 (Ger. sum.: 394-96).

In Slovenian. Provides a methodological framework for the
dating of early medieval architecture in Slovenia. The conclud-
ing remarks delineate a program of study, criteria and priorities
for this material.

159 Stelè, France. "Gotske dvoranske cerkve v Sloveniji" [Gothic
 hall churches in Slovenia]. ZUZ 15, nos. 1-4 (1938):1-43
 (Ger. sum.: 1-3).
 In Slovenian. A general survey of Slovenian gothic hall
 churches. The principal churches discussed are at: Kranj (after
 1452), Škofja Loka (1471), Radovljica (1459), St. Rupert na Dol
 (1497), Crngrob (1521-1524), and Krtina (sixteenth century).
 Builders of the churches, whose names are frequently documented,
 are also discussed.

160 Stričević, Djordje. "Dva varijeteta plana crkava moravske
 arhitektonske škole" (Fr. sum.: "Deux variantes du plan de
 l'architecture de l'école de la Morava"). ZRVI 3 (1955):
 213-20 (Fr. sum.: 220).
 In Serbo-Croatian. Identifies two variant church plans
 during the last phase of Serbian medieval architecture--a
 triconch combined with a cross-in-square and a "compact"
 triconch. The former type is associated with monastic estab-
 lishments; the latter with court and private churches and
 chapels.

161 _____. "Églises triconques médiévales en Serbie et en
 Madédoine et la tradition de l'architecture paléobyzantine."
 Actes du XII^e Congrès international d'études byzantines
 (Belgrade) 1 (1963):224-40.
 A major study of ninth- and tenth-century triconch churches
 in Serbia and Macedonia. Rejects the hypotheses which link this
 architecture with sixth-century churches with triconch plans.

162 _____. "Hronologija ranih spomenika moravske škole" (Fr.
 sum.: "Chronologie des premiers monuments d'architecture de
 l'école de la Morava"). Starinar, n.s. 5-6 (1956):115-28
 (Fr. sum.: 128).
 In Serbo-Croatian. An important study which reconsiders
 the relative chronology of the eight oldest churches belonging to
 the so-called Morava school.

163 _____. "Uloga starca Isaije u prenošenju svetogorskih
 tradicija u moravsku arhitektonsku školu" (Fr. sum.: "Le rôle
 de Starac Isaïa dans le transfert des traditions athonites
 dans l'école d'architecture de la Morava"). ZRVI 3 (1955):
 221-32 (Fr. sum.: 231-32).
 In Serbo-Croatian. Discusses the role of one Isaia, an old
 monk and confidant of Serbian rulers as well as a liaison between
 the Serbian court and Mt. Athos. Isaia's activities are linked
 with the appearances of triconch church plans in Serbia around
 the middle of the fourteenth century.

164 Stričević, Giorgio. "I monumenti dell'arte paleobizantina in
 rapporto con la tradizione antica e coll'arte medioevale nelle
 regioni centrali dei Balcani." Corsi di cultura sull'arte
 ravennate e bizantina 10 (1963):327–31.
 A brief analysis of the question of the relationship be-
 tween the traditions of late Antiquity and early medieval archi-
 tecture in the central Balkans. A brief basic bibliography on
 the subject is included.

165 Szabo, Gjuro. Sredovječni gradovi u Hrvatskoj i Slavoniji
 [Medieval fortifications in Croatia and Slavonia]. Zagreb:
 Matica hrvatska, 1920. 225 pp., 233 figs. in text.
 In Serbo-Croatian. A general survey of fortification
 architecture in Croatia and Slavonia, the book also presents a
 history of the development of fortification architecture in this
 area. The greatest part of the book discusses medieval and late
 medieval fortifications, presenting these individually, by re-
 gion. Various components of this architecture are considered
 separately (e.g., curtain walls, moats, gates, windows, vaulting,
 kitchens, water supply, roofs, etc.).

166 Tatić, Žarko M. Tragom velike prošlosti: Svetogorska pisma i
 monografske studije stare srpske arhitekture [In the footsteps
 of the glorious past: Letters from Mt. Athos and monographic
 studies of Old Serbian architecture]. Belgrade, 1929.
 265 pp., 197 figs. in text.
 In Serbo-Croatian. An architect's field notes reveal great
 sensitivity, knowledge and perceptiveness. The book is illus-
 trated with numerous drawings and sketches by the author, as well
 as by his photographs. The first part of the book (pp. 3–95)
 discusses Mount Athos (mostly the Serbian monastery Hilandar).
 The second part considers individual Serbian medieval churches in
 detail (Staro Nagoričino, Ljuboten, Markov Manastir, Sv.
 Arhandjel near Kučevište, Sv. Andreja on the Treska river,
 Kalenić, and Pavlovac).

167 Vasić, Miloje M. Žiča i Lazarica: Studije iz srpske umet-
 nosti srednjeg veka [Žiča and Lazarica: Studies in medieval
 Serbian art]. Belgrade: Geca Kon, 1928. 256 pp., 186 figs.
 In Serbo-Croatian. A major study of medieval Serbian church
 architecture. Presents several controversial ideas which have
 been largely superseded. Many of the observations, however, are
 still valid, and the use of primary sources exemplary.

168 Vasiljević, Slobodan. "Naši stari graditelji i njihova
 stvaralačka kultura" (Eng. sum.: "Our ancient builders and
 their creative culture"). ZZSK 6–7 (1956):1–36 (Eng. sum.:
 34–35).
 In Serbo-Croatian. A general discussion of medieval
 Serbian builders' design methods. Attempts to show that mathe-
 matical principles were employed in the laying out of plans and

elevations, as well as for details. The church of Dečani
monastery is used as the main example of this investigation.

169 Vulović, Branislav. "Konzervatorske beleške sa terena"
 [Conservation field notes]. Zbornik arhitektonskog fakulteta
 4, no. 3 (1958):3-20 (Rus. sum.: 19-20).
 In Serbo-Croatian. Field notes discuss several architec-
 tural monuments (Sisojevac, Sopoćani, Milentija, Lepenac, Church
 of SS. Peter and Paul in Kriva Reka, Monastery of St. Nicholas in
 Banja), fortification remains at Kruševac and Naupara, and the
 problem of Stefan's narthex at Ravanica monastery.

170 _____. "Učešće Hilandara i srpske tradicije u formiranju
 moravskog stila" (Eng. sum.: "The role of Chilandar and of
 the Serbian tradition in the formation of the Morava style").
 In Moravska škola i njeno doba. Edited by Vojislav J. Djurić.
 Belgrade: Filozofski fakultet, Odeljenje za istoriju umet-
 nosti, 1972, pp. 169-80 (Eng. sum.: 179-80).
 In Serbo-Croatian. Investigates the role of the Serbian
 monastery Hilandar on Mt. Athos in the development of Serbian
 church architecture in the second half of the fourteenth and
 early fifteenth century.

171 Zadnikar, Marijan. "Romanesque Architecture in Slovenia."
 Journal of the Society of Architectural Historians 28, no. 2
 (May 1969):99-114.
 A general overview of Romanesque architecture in Slovenia.
 The author first considers the monastic contribution to medieval
 building and then applies his "typological method" in analyzing
 the church types--single-aisled churches, three-aisled basilicas,
 and centralized churches.

172 _____. "Die romanische Baukunst in Slowenien und ihre kunst-
 geographische Stellung." Südost-Forschungen 20 (1961):74-89.
 A general survey of Romanesque architecture in Slovenia and
 its geographic spread. Illustrates the main monuments and dis-
 cusses major trends.

173 _____. "Romanski vzhodni zvoniki na Slovenskem" (Ger. sum.:
 "Die Romanischen Chorturmkirchen in Slowenien"). ZUZ 3
 (1955):55-104 (Ger. sum.: 103-4).
 In Slovenian. Discusses Romanesque churches with single,
 axial bell-towers over the choir area. The type is uncommon and
 is studied in the broadest regional context.

174 Zdravković, Ivan. Srednjovekovni gradovi u Srbiji (Fr. sum.:
 "Les forteresses médiévales de Serbie"). Biblioteka Enciklo-
 pedijska dela, no. 3. Belgrade: Turistička štampa, 1970.
 151 pp., illus.
 In Serbo-Croatian. After a brief introduction, discusses
 twenty-two individual medieval fortifications in Serbia. Each
 discussion is followed by a brief French summary.

175 Zdravković, Ivan M. Srednjovekovni gradovi i dvorci na
 Kosovu (Fr. sum.: "Forteresses et châteaux médiévaux de
 Kosovo"). Belgrade: Turistička štampa, 1975. 129 pp.,
 numerous illus. in text, 1 foldout map.
 In Serbo-Croatian. The book consists of twenty-seven
 essays on individual fortresses. Each essay is followed by a
 bibliography and a French summary.

PAINTING

GENERAL

176 Babić, Gordana. "Chapelles laterales des églises serbes du
 XIII^{ème} siècle et leur décor peint." In L'art byzantin du
 XIII^e siècle. Edited by Vojislav J. Djurić. Belgrade:
 Faculté de philosophie, Département de l'histoire de l'art,
 1967, pp. 179-87.
 A consideration of lateral chapels of Serbian churches
 during the thirteenth century and their fresco decoration. The
 Serbian tradition is seen as a part of a much broader Byzantine
 phenomenon.

177 _____. "Les discussions christologiques et le décor des
 églises byzantines au XII^e siècle: Les évêques officiant
 devant l'Hétimasie et devant l'Amnos." Frühmittelalterliche
 Studien 2 (1968):368-86.
 An important study of the influence of Christological dis-
 putes on the theological articulation of painting iconography in
 the twelfth century. The study focuses on Nerezi and Kurbinovo,
 though other monuments (Veljusa and St. Nicholas at Prilep) are
 also considered.

178 _____. "Nizovi portreta srpskih episkopa, arhiepiskopa i
 patrijarha u zidnom slikarstvu (XIII-XVI v.)" (Fr. sum.:
 "Les séries de portraits des évêques, archevêques et
 patriarches serbes dans la peinture murale [XIII^e-XVI^e s.]").
 Sava Nemanjić - Sveti Sava. Istorija i predanje. Belgrade:
 Srpska akademija nauka i umetnosti, 1979, pp. 319-43 (Fr.
 sum.: 340-42).
 In Serbo-Croatian. The idea of depicting Serbian bishops
 in series is attributed to St. Sava, who is believed to have
 introduced it from Byzantium. The individual examples of such
 series are discussed in detail, and the origins of the concept
 are analyzed in the broadest Byzantine and Western contexts.

179 _____. "O živopisnom ukrasu oltarskih pregrada" (Fr. sum.:
 "La décoration en fresques des clôtures de choeur"). ZLU 11
 (1975):3-49 (Fr. sum.: 41-49).
 In Serbo-Croatian. A major study on medieval frescoed
 altar screens. Although the bulk of presented material comes
 from churches of medieval Serbia, the study is not restricted

regionally and considers Byzantine examples in a broader sense.
The study is exceptionally well documented, and also includes
detailed architectural drawings of the altar partitions dis-
cussed.

180 Bihalji-Merin, Oto. Byzantine Frescoes and Icons in
 Yugoslavia. New York: Harry Abrams, Inc., 1958. 15 pp.,
 81 pls.
 A book with a short introductory text and a good selection
 of fine black-and-white and color photographs illustrating medi-
 eval frescoes and icons of Serbia and Macedonia.

181 Cutler, Anthony. "The Maniera Greca in Italy and Serbia: Art
 and Society in Two Byzantine Spheres of Influence, 1204-1355."
 Ph.D. dissertation, Emory University, 1963. 253 pp., 165 pls.
 Attempts to broaden the term maniera greca to imply an
 "international" style emanating from Byzantium and commissioned
 by Italian and Serbian patrons during the thirteenth and the
 first half of the fourteenth centuries. Beyond this, the author
 sees the emergence of native schools which become independent of
 the original Byzantine source, while remaining related to it.

182 Demus, O[tto]. "Die Entstehung des Paläologenstils in der
 Malerei." Berichte zum XI. Internationalen Byzantinisten-
 Kongress München, 1958, 4, pt. 2. 63 pp., 32 figs.
 A fundamental study of Paleologan painting, much of which
 focuses on fresco cycles of Serbia and Macedonia.

183 Djordjević, Ivan M. "Dve molitve kralja Stefana Dečanskog
 pre bitke na Velbuždu i njihov odjek u umetnosti" (Fr. sum.:
 "Deux prières du Roi Stefan Dečanski à la veille de la
 bataille de Velbužd, et leurs répercussions dans l'art").
 ZLU 15 (1979):135-50 (Fr. sum.: 149-50).
 In Serbo-Croatian. An attempt to relate the content of two
 prayers attributed to the Serbian King Stefan Dečanski before the
 battle of Velbužd (modern Kiustendil in Bulgaria) as recorded in
 literary sources, and their echoes in Serbian art of the time.

184 _____. "O fresko-ikonama kod Srba u srednjem veku" (Ger.
 sum.: "Die Freskoikonen des Mittelalters bei den Serben").
 ZLU 14 (1978):77-98 (Ger. sum.: 96-98).
 In Serbo-Croatian. An examination of the use of icon
 images depicted in frescoes in medieval Serbian churches. The
 formula, established and well known in Byzantium, is best docu-
 mented in the relatively large number of preserved Serbian
 examples.

185 Djurić, Vojislav J. Dubrovačka slikarska škola (Fr. sum.:
 "L'école de peinture de Dubrovnik"). Srpska akademija nauka i
 umetnosti. Posebna izdanja, 363. Belgrade: Naučno delo,
 1963. 396 pp. (Fr. sum.: 279-88), 170 pls.
 In Serbo-Croatian. An exhaustive study of the painting
 school of Dubrovnik from its beginning in the eleventh century
 through its decline in the sixteenth century. The artistic
 links of Dubrovnik with Italy, Dalmatia, Istra, Kotor, and the
 Balkan hinterlands are examined systematically.

186 _____. "Istorijske kompozicije u srpskom slikarstvu
 srednjega veka i njihove književne paralele" [Historical com-
 positions in Serbian medieval painting and their literary
 parallels]. ZRVI 8, pt. 2 (1964):69-90.
 In Serbo-Croatian. Links of fresco cycles (dedicated to
 Simeon Nemanja) to literary sources are discussed. Cycles in the
 exonarthex chapel of Studenica, at Gradac, and at Sopoćani are
 considered. See entries YU 187, YU 188.

187 _____. "Istorijske kompozicije u srpskom slikarstvu srednjega
 veka i njihove književne paralele" [Historical compositions in
 Serbian medieval painting and their literary parallels]. ZRVI
 10 (1967):121-48.
 In Serbo-Croatian. The fresco cycle dedicated to St. Sava
 at Gradac is linked to four literary texts written before the
 painting of the frescoes. The second part of the article con-
 siders Serbian State councils as depicted on frescoes in King
 Dragutin's chapel at Djurdjevi Stupovi, at Arilje, Peć, and
 Mateić. See entries YU 186, YU 188.

188 _____. "Istorijske kompozicije u srpskom slikarstvu srednjega
 veka i njihove književne paralele" (Fr. sum.: "Compositions
 historiques dans la peinture médiévale serbe et leurs paral-
 lèles littéraires"). ZRVI 11 (1968):99-127 (Fr. sum.:
 119-27).
 In Serbo-Croatian. The third installment of this study
 concludes with a discussion of the fresco cycle dedicated to the
 Archbishop Arsenije I at Peć, and to funerary scenes above the
 tombs of Serbian rulers and high clergy (at Studenica, Sopoćani,
 Peć, Arilje, Gračanica, and Lesnovo). Both subjects are related
 to literary sources. The French summary relates to all three
 installments. See entries YU 186, YU 187.

189 _____. "Portreti na poveljama vizantijskih i srpskih vladara"
 (Fr. sum.: "Portraits des souverains byzantins et serbes sur
 les Chrysobulles"). ZFF 7, pt. 1 (1963):251-72 (Fr. sum.:
 270-72).
 In Serbo-Croatian. An important contribution to the study
 of ruler portraiture in Byzantium and Serbia. Focuses on the
 late Byzantine and Serbian portraits (fourteenth and fifteenth
 centuries). Particular attention is given to the group portrait

of the Serbian Despot Djuradj Branković and his family, preserved
on the elaborate charter which he issued to the Esphigmenou
monastery at Mt. Athos.

190 ____. "Sveti Sava i slikarstvo njegovog doba" (Fr. sum.:
 "Saint Sava et la peinture de son époque"). In Sava Nemanjić-
 Sveti Sava. Istorija i predanje. Edited by Vojislav Djurić.
 Belgrade: Srpska akademija nauka i umetnosti, 1979,
 pp. 245-61 (Fr. sum.: 258-61).
 In Serbo-Croatian. Discusses the double role of St. Sava
 as a patron of art: first as a person striving to adapt Byzan-
 tine painting to local needs through the fostering of native
 saints' cults, and second through hiring the best available
 talent at the time.

191 ____. "Sveti Sava Srpski: Novi Ignjatije Bogonosac i drugi
 Kiril" (Fr. sum.: "Saint Sava de Serbie: Un nouveau Ignace
 Théophore et un autre Cyrille d'Alexandrie"). ZLU 15 (1979):
 93-102 (Fr. sum.: 101-2).
 In Serbo-Croatian. The link which was established between
 St. Sava and SS. Cyril and Ignatius Theophores by Domantian was
 faithfully reflected in Serbian frescoes of the thirteenth cen-
 tury. This tradition came to an end in the fourteenth century
 when a new theological and artistic conception of the place of
 St. Sava within the general church hierarchy came into being.

192 ____. "Tri dogadjaja u srpskoj državi XIV veka i njihov
 odjek u slikarstvu" (Fr. sum.: "Trois événements dans l'état
 serbe du XIVe siècle et leur incidence sur la peinture de
 l'époque"). ZLU 4 (1968):67-100 (Fr. sum.: 97-100).
 In Serbo-Croatian. An important contribution to the
 understanding of links between political events and church art
 of medieval Serbia. Examines the impact of: the defeat of the
 Turks by King Milutin and its reflection at Staro Nagoričino; the
 reconciliation between the Archbishop of Ohrid, the Serbian
 church and the Serbian royal dynasty; and King Marko's ascent to
 the throne.

193 Grozdanov, Cvetan. "O portretima Klimenta Ohridskog u
 ohridskom živopisu XIV veka" (Fr. sum.: "Les portraits de
 Clément d'Ohrid dans la peinture d'Ohrid du XIVe siècle").
 ZLU 4 (1968):103-18 (Fr. sum.: 117-18).
 In Serbo-Croatian. A study of portraiture of St. Clement
 in the frescoes and icons of Ohrid from the fourteenth century.

194 ____. "Odnosot medju portretite na Kliment Ohridski i
 Kliment Rimski vo živopisot od prvata polovina na XIV vek"
 (Eng. sum.: "The relation of the portraits of Ohrid's Clement
 and Roman Clement in painting of the first half of the XIVth
 century"). Simpozium 1100-godišnina od smrtta na Kiril
 Solunski. Edited by H. Polenaković et al. Vol. 1. Skopje:

Makedonska akademija na naukite i umetnostite, 1970, 99-107
(Eng. sum.: 107).
 In Macedonian. The portraits of St. Clement of Ohrid are
found to be consistent in Ohrid itself, but outside of Ohrid they
are confused with St. Clement of Rome. Special attention is
given to a group of portraits produced by a painting workshop of
Michael and Eutichios.

195 _____. "Pojava i prodor portreta Klimenta Ohridskog u
 srednjovekovnoj umetnosti" (Fr. sum.: "Apparition et intro-
 duction des portraits de Clément d'Ohrid dans l'art médiéval").
 ZLU 3 (1967):49-72 (Fr. sum.: 70-72).
 In Serbo-Croatian. Examines the growth of the cult of St.
Clement and its reflection in the proliferation of his portraits
during the Middle Ages. Ecclesiastical and political factors
which influenced the development are examined.

196 Karaman, Ljubo, and Prijatelj, K. "O mjesnim grupama dal-
 matinske slikarske škole u XV st." (Fr. sum.: "Sur les
 groupes locaux de la peinture de l'école dalmate du XVe
 siècle"). PPUD 9 (1955):170-80 (Fr. sum.: 313-14).
 In Serbo-Croatian. An attempt to present some of the
methodological problems and challenges facing the students of
local painting schools in Dalmatia during the fifteenth century.

197 Ljubinković, R[adivoje], and Ljubinković, M. Ćorović. "La
 peinture médiévale à Ohrid." In Zbornik na trudovi. Ohrid:
 Naroden muzej vo Ohrid, 1961, pp. 101-48.
 A brief survey of medieval painting in Ohrid. Provides a
general historical background, as well as information on churches,
their frescoes, and individual icons.

198 Mandić, Svetislav. Portraits from the Frescoes. Medieval Art
 in Yugoslavia. Belgrade: Jugoslavija, 1966. 11 pp., 48 pls.
 A brief account of medieval portraiture in Serbia. The
book includes some fine black-and-white reproductions of por-
traits.

199 Miljković-Pepek, P[etar]. "Novootkrieni arhitekturni i
 slikarski spomenici vo Makedonija od XI do XIV vek" (Fr. sum.:
 "Les monuments nouvellement découverts dans l'architecture et
 dans la peinture en Macédoine du XIe au XIVe siècle"). KN 5
 (1974):5-16 (Fr. sum.: 15-16).
 In Macedonian. Considers newly cleaned frescoes at
Veljusa, St. Demetrius at Varoš, church of the Virgin at Dabnište
(thirteenth century), a cave church on Lake Prespa (fourteenth-
nineteenth centuries), and fragmentary remains of the charter of
Emperor Andronicus II Palaeologus at Manastir-Mariovo.

200 _____. "Un courant stylistique dans la peinture du XIII^e
 siècle en Macédoine." KN 4 (1972):21-24.
 Considers a number of twelfth-century frescoes discovered
 in Macedonia (St. Demetrius at Varoš, St. Sophia at Ohrid), and
 a number of icons, in the broader stylistic context of Byzantine
 painting of the period.

201 Petković, Sreten. "Kult kneza Lazara i srpsko slikarstvo
 XVII veka" (Eng. sum.: "The cult of Prince Lazar and the
 Serbian painting of the seventeenth century"). ZLU 7 (1971):
 85-102 (Eng. sum.: 101-2).
 In Serbo-Croatian. The relatively small number of repre-
 sentations of Serbian Prince Lazar (canonized shortly after his
 death in 1389) in the churches decorated in the sixteenth and
 seventeenth centuries is attributed to the attitude of the
 Patriarchs--who saw themselves as the successors of St. Sava,
 and therefore of the Nemanjić Dynasty to which Prince Lazar did
 not belong.

202 _____. "Ruski uticaj na srpsko slikarstvo XVI i XVII veka"
 (Fr. sum.: "L'influence russe sur la peinture Serbe du XVI^e
 et du XVII^e siècles"). Starinar, n.s. 12 (1961):91-109 (Fr.
 sum.: 109).
 In Serbo-Croatian. A study of Russian influence on the
 development of Serbian painting during the sixteenth and seven-
 teenth centuries (while Serbia was under Turkish domination).
 This influence is primarily noticeable in iconographic details,
 and is completely absent in style, suggesting that Serbian art-
 ists were using older icons or manuscript illuminations as models.

203 _____. "Uticaj ilustracija iz srpskih štampanih knjiga na
 zidno slikarstvo XVI i XVII veka" (Eng. sum.: "The influence
 of the illustrations from Serbian printed books on wall paint-
 ing of the sixteenth and the seventeenth centuries").
 Starinar, n.s. 17 (1967):91-96 (Eng. sum.: 96).
 In Serbo-Croatian. Investigates the limited impact of
 printed book illustrations on Serbian fresco painting of the
 seventeenth century. Though basically conservative iconography
 characterizes this development, a degree of Western influence is
 detected.

204 Prijatelj, Kruno. Dubrovačko slikarstvo XV-XVI stoljeća
 [Painting in Dubrovnik: fifteenth-sixteenth centuries].
 Umjetnički spomenici Jugoslavije. Zagreb: Zora, 1968.
 41 pp., 78 col. pls., 8 b&w pls.
 In Serbo-Croatian. A general overview of painting in
 Dubrovnik during the fifteenth and sixteenth centuries. Examines
 major artistic trends, workshops and painters (e.g., Nikola
 Božidarević). Painting of this period reveals a transition from
 Gothic to Renaissance painting, with an admixture of lingering
 Byzantine influence.

205 _____. "Prilog poznavanju zadarskog i šibenskog slikarstva
 XV stoljeća" (Fr. sum.: "Contribution à l'étude de la pein-
 ture du XV^e siècle à Zadar et à Šibenik"). PPUD 8 (1954):
 67-86 (Fr. sum.: 118).
 In Serbo-Croatian. Observations on several major works of
 painting workshops in Zadar and Šibenik during the fifteenth cen-
 tury. The appendix of the article includes full texts of four
 previously unpublished documents.

206 Radojčić, S[vetozar]. "Korreferat zu O. Demus, 'Die Ent-
 stehung des Paläologenstils in der Malerei.'" Berichte zum
 XI. Internationalen Byzantinisten-Kongress München, 1958
 (Munich) 7 (1958):29-32. Korreferate.
 Examines the relationship between texts and painting.
 Serbian and Macedonian monuments are included in the discussion.

207 Radojčić, Svetozar. "Odjek pesme nad pesmama u srpskoj umet-
 nosti XIII veka" (Fr. sum.: "Les échos du Cantique des Can-
 tiques dans l'art serbe du XIII^e· siècle"). Raška baština 1
 (1975):29-32 (Fr. sum.: 32).
 In Serbo-Croatian. A brief account of the concept of
 beauty in the Psalm of Psalms as reflected in Byzantine and
 Serbian painting of the late twelfth and early thirteenth
 centuries.

208 _____. "La pittura in Serbia e in Macedonia dall'inizio del
 secolo XII fino alla metà del secolo XV." Corsi di cultura
 sull'arte ravennate e bizantina 10 (1963):293-325.
 A general discussion of Serbian painting from the beginning
 of the twelfth to the middle of the fifteenth century. A useful
 survey in which some known themes are explored. Basic literature
 is provided through the notes.

209 _____. Portreti srpskih vladara u srednjem veku [Serbian
 ruler portraits in the Middle Ages]. Muzej Južne Srbije,
 Posebna izdanja, 1. Skopje: Muzej Južne Srbije, 1934.
 102 pp. (Fr. sum.: 99-102), figs. in text, 24 pls.
 In Serbo-Croatian. An important study of medieval ruler-
 portraiture in Serbia. Considers the material in the context of
 Byzantine, as well as Western, medieval traditions.

210 _____. Staro srpsko slikarstvo [Old Serbian painting].
 Biblioteka sinteze. Belgrade: Nolit, 1966. 222 pp.,
 22 figs., 49 b&w and 13 col. pls. in text, 112 pls. following
 text.
 In Serbo-Croatian. A major work on painting in medieval
 Serbia. The material is organized into four chapters: the be-
 ginnings of painting; monumental style (1170-1300); narrative
 style (1300-1370); and decorative style (1370-1459). Discusses
 all aspects of painting, from monumental frescoes to icons and
 manuscript illuminations. The book is well documented and
 illustrated.

211 _____. Tekstovi i freske [Texts and frescoes]. Mozaik,
no. 25. Novi Sad: Matica srpska, 1965. 157 pp., 12 pls.
 In Serbo-Croatian. A series of essays examining a number
of medieval frescoes and texts, and suggesting a direct depen-
dence of the images on the texts.

212 _____. "Zografi: O teoriji slike i slikarskog stvaranja u
našoj staroj umetnosti" [Zographs: Regarding the theory of
image and creativity in old Serbian art]. Zograf 1 (1966):
4-15.
 In Serbo-Croatian. A discussion of the practices of the
last fresco painters (zographs), with an attempt to relate their
work habits to those of the medieval masters.

213 Stelè, France. "Slovanska gotska podružnica in njen ikono-
grafski kanon" (Fr. sum.: "L'église paysanne slovène et le
problème de son canon iconographique"). ZNM 4 (1964):315-28
(Fr. sum.: 328).
 In Slovenian. Gothic village churches in Slovenia display
certain iconographic idiosyncracies which distinguish them from
their counterparts in western Europe. The emphasis in decoration
of presbyteries is on Christological themes.

214 _____. "Spomeniki starejšega portretnega slikarstva na
Slovenskem" [The oldest monuments of portrait painting in
Slovenia]. ZUZ 5, no. 4 (1925):142-61 (Fr. sum.: 142).
 In Slovenian. A brief survey of medieval portraiture (on
manuscript illuminations and frescoes) in Slovenia. An important
contribution to the general knowledge of medieval portrait paint-
ing in the Balkans.

215 Stojaković, Anka. Arhitektonski prostor u slikarstvu srednjo-
vekovne Srbije (Fr. sum.: "L'espace architectural dans la
peinture de la Serbie médiévale"). Studije za istoriju srpske
umetnosti 4. Novi Sad: Matica srpska. Odeljenje za likovne
umetnosti, 1970. 230 pp. (Fr. sum.: 213-30).
 In Serbo-Croatian. A study of pictorial space in medieval
Serbian and Byzantine painting. The author articulates ideas of
inverted perspective and classical influence, and examines the
intrinsic difference between Western and Byzantine conceptions of
pictorial space.

216 _____. "La conception de l'espace defini par l'architecture
peinte dans la peinture murale serbe du XIIIe siècle." L'art
byzantin du XIIIe siècle. Edited by Vojislav J. Djurić.
Belgrade: Faculté de philosophie, Département de l'histoire
de l'art, 1967, pp. 169-78.
 Examines the conception and representation of space in
thirteenth-century painting of Serbia, arguing in favor of a
consistently employed theory of "inverted perspective"--a system
which places the vanishing point in front of the picture plane.

217 _____. "Svetlost u moravskom slikarstvu" (Fr. sum.: "La
lumière dans la peinture de l'école de la Morava"). In
O knezu Lazaru. Edited by Ivan Božić and Vojislav J. Djurić.
Belgrade: Filozofski fakultet, Odeljenje za istoriju umet-
nosti, 1975, pp. 289-301 (Fr. sum.: 300-301).
In Serbo-Croatian. Examines the manner of depicting light
in Serbian painting of the fourteenth and fifteenth centuries.
Symbolic and formal aspects are analyzed. The subject is related
to literary sources in which the meaning of light is discussed.

218 _____. "Une contribution à l'iconographie de l'architecture
peinte dans la peinture médiévale serbe." Actes du XIIe Con-
grès international d'études byzantines (Belgrade) 3 (1964):
353-62.
The iconography of a number of Miracles of Christ scenes is
examined from the point of view of background architecture. The
author links representations of free-standing arcades with a
portico at the pool of Bethesda, whose remains have been inves-
tigated archeologically.

219 Tadić, Jorjo. Gradja o slikarskoj školi u Dubrovniku XIII-
XVI v. [Documents of the painting school of Dubrovnik, 13th-
16th centuries]. Vol. 1 (1284-1499). Srpska adademija nauka,
Gradja 4. Belgrade: Naučna knjiga, 1952. 359 pp.
In Serbo-Croatian. A collection of 749 documents in Latin
from the archives of Dubrovnik which pertain to the activities
of Dubrovnik painters during the Middle Ages.

FRESCOES

220 Blažić, Zdravko. Tehnika i konzervacija naše freske (Fr.
sum.: "Technique et conservation de nos fresques").
Kulturno-istorisko nasledstvo vo N.R. Makedonija, no. 4.
Skopje: Centralen zavod za zaštita na kulturno-istoriskite
spomenici na N.R. Makedonija, 1958. 89 pp. (Fr. sum.:
79-89), many figs. in text.
A detailed analysis of painting techniques and conserva-
tion methods.

221 Djurić, Vojislav J. Byzantinische Fresken in Jugoslawien.
Munich: Hirmer Verlag, 1976. 289 pp., 39 col. pls., 119 b&w
pls.
A major up-to-date history of Byzantine painting in
Yugoslavia. The book is beautifully illustrated and well docu-
mented. Each monument is given a single note (all are grouped
on pp. 227-89), and the entire bibliography for that particular
monument is critically assessed.

222 ____. "Markov manastir-Ohrid" (Fr. sum.: "Le monastère de Marko-Ohrid"). ZLU 8 (1972):131-62 (Fr. sum.: 160-62).
 In Serbo-Croatian. A study of artistic links between Markov Manastir and Ohrid. Iconographic and stylistic parallels substantiate the hypothesis. The entire phenomenon is related to the general trends in Byzantine painting of the second half of the fourteenth century.

223 ____. "Nepoznati spomenici srpskog srednjevekovnog slikarstva u Metohiji, 1" (Fr. sum.: "Monuments inconnus de la peinture serbe médiévale à Metohija, 1"). SKM 2-3 (1963): 61-89 (Fr. sum.: 88-89).
 In Serbo-Croatian. Frescoes from the churches of the Virgin at Mušutište (ca. 1315) and St. George at Rečani (ca. 1360-70) are discussed in detail. The place of these cycles in the development of Serbian fourteenth-century painting is analyzed.

224 ____. "La peinture murale serbe au XIIIe siècle." In L'art byzantin du XIIIe siècle. Edited by Vojislav J. Djuric. Belgrade: Faculté de philosophie, Departement de l'histoire de l'art, 1967, pp. 145-67.
 A general overview of Serbian painting in the thirteenth century. Examines the problem against the broad background of Byzantine and Romanesque art, taking into account literary sources as well as the recently uncovered frescoes.

225 ____. "Solunsko poreklo resavskog živopisa" (Fr. sum.: "Origine thessalonicienne des fresques du monastère de Resava"). ZRVI 6 (1960):111-28 (Fr. sum.: 127-28).
 In Serbo-Croatian. Earlier attempts to link Serbian painting of the late fourteenth and fifteenth centuries with the painting of Mistra are rejected in favor of links with contemporaneous developments in Thessaloniki. Paintings in the church of Prophet Elijah, originally the Katholikon of the monastery of Nea Moni (built around 1360-80), are seen as being most closely related to the paintings of Manasija (Resava).

226 Fiskovic, Cvito. Dalmatinske freske [Dalmatian frescoes]. Umjetnički spomenici Jugoslavije. Zagreb: Zora, 1965. 27 pp., 56 col. pls.
 In Serbo-Croatian. A general discussion of medieval painting in Dalmatia. The book is illustrated with a fine selection of color photographs. No attempt was made to give a complete coverage of individual monuments although some did receive greater attention than others (e.g., St. Michael at Ston, and St. Crisogono [Krševan] at Zadar).

227 Fučić, Branko. <u>Istarske freske</u> [Istrian frescoes]. Umjet-
 nički spomenici Jugoslavije. Zagreb: Zora, 1963. 38 pp.,
 82 col. pls., 26 b&w pls.
 In Serbo-Croatian. A general survey of medieval frescoes
 of Istria from pre-Romanesque to late Gothic times. The book is
 illustrated with a fine selection of black-and-white and color
 plates which include photos and drawings of churches and their
 fresco programs.

228 _____. "Romaničko zidno slikarstvo istarskog Ladanja" (It.
 sum.: "La pittura murale romanica della Campagna Istriana").
 <u>Bulletin Zavoda za likovne umjetnosti Jugslavenske akademije</u>
 <u>znanosti i umjetnosti</u> 12, no. 3 (1964):50-85 (It. sum.:
 84-85).
 In Serbo-Croatian. Discusses the Romanesque fresco cycles
 at Bazgalji and at Draguć. Analyzes their iconography and style,
 and concludes that these reveal certain local characteristics.

229 Hamann-MacLean, Richard. <u>Die Monumentalmalerei in Serbien und</u>
 <u>Makedonien vom 11. bis zum frühen 14. Jahrhundert: Grund-</u>
 <u>legung zu einer Geschichte der mittelalterlichen Monumental-</u>
 <u>malerei in Serbien und Makedonien.</u> Osteuropastiudien der
 Hochschulen des Landes Hessen, 2d ser., vol. 4. Giessen:
 Wilhelm Schmitz, 1976. 351 pp., 66 appendix pp., 48 pls.,
 numerous drawings in text.
 An exhaustive study of medieval painting in Serbia and
 Macedonia set in the cultural contexts. Numerous problems,
 iconographic and stylistic, are discussed in great detail. An
 invaluable source of information (specialized literature, peri-
 odical literature, etc.).

230 Hamann-MacLean, Richard, and Hallensleben, Horst. <u>Die Monu-</u>
 <u>mentalmalerei in Serbien und Makedonien vom 11. bis zum</u>
 <u>frühen 14. Jahrhundert.</u> Osteuropastudien der Hochschulen des
 Landes Hessen, 2d ser., vol. 3. Giessen: Wilhelm Schmitz,
 1963. 39 pp., 354 pls., 36 foldout pls.
 Although this is one of the richest corpuses of photographs
 of medieval frescoes in Serbia and Macedonia, it is far from
 being comprehensive. Foldout plans contain useful diagrams show-
 ing the layout of the decorative programs.

231 Höfler, Janez. "K stilni podobi stenskega slikarstva 15.
 stoletja na slovenskem" (Ger. sum.: "Zu den stilistischen
 Erscheinungsformen der Wandmalerei des 15. Jahrhunderts in
 Slowenien"). <u>ZLU</u> 14 (1978):131-51 (Ger. sum.: 150-51).
 In Slovenian. This study of stylistic trends in Slovenian
 painting of the fifteenth century considers the contribution of
 such native painters as Master John from Ljubljana and Master
 Bolfgangus von Crngrob. In addition to the work of these native
 artists, the work and influence of visiting foreign artists is
 investigated.

232 Janc, Zagorka. <u>Ornamenti fresaka iz Srbije i Makedonije od</u>
<u>XII do sredine XV veka</u> (Eng. sum.: "Ornaments in the Serbian
and Macedonian frescoes from the XIIth to the middle of the
XVth century"). Belgrade: Muzej primenjene umetnosti, 1961.
40 pp. (Eng. sum.: 33-40), 76 pls, 12 figs.
In Serbo-Croatian. An exhibition catalog with an extensive
selection of fresco ornaments illustrated with fine drawings, and
with an informative introductory text.

233 _____. "Romanski ornament u srpskom monumentalnom slikarstvu
XIII veka" (Fr. sum.: "Ornements romans dans la peinture
monumentale serbe du XIIIe siecle"). <u>ZLU</u> 7 (1971):53-60 (Fr.
sum.: 60).
In Serbo-Croatian. Certain decorative fresco ornaments
(particularly border-motifs) in Serbian painting of the thirteenth
century are seen as evidence of Western influence in Serbia at
the time. Western parallels which are cited are from different
periods or in different media.

234 Kajmakovic, Zdravko. <u>Zidno slikarstvo u Bosni i Hercegovini</u>
[Wall painting in Bosnia and Herzegovina]. Biblioteka Kul-
turno nasljedje. Sarajevo: Veselin Masleša, 1971. 382 pp.
(Fr. sum.: 377-82), 263 figs., 32 schematic drawings in text.
In Serbo-Croatian. A comprehensive study of medieval
painting in Bosnia and Herzegovina. The book considers all
aspects of medieval Bosnian painting--Eastern and Western in
orientation--as well as all the monuments. The Appendix includes
a convenient description of all frescoes discussed, accompanied
by diagrams illustrating their precise location on walls.

235 Lazarev, V.N. "Zhivopis XI-XII vekov v Makedonii" [Wall
painting of the eleventh and twelfth centuries in Macedonia].
<u>Actes du XIIe Congres international d'etudes byzantines</u>
(Belgrade) 1 (1963):105-34.
In Russian. A major study of fresco painting in Macedonia
during the eleventh and twelfth centuries. The Macedonian mate-
rial is examined in the broadest context of contemporaneous
Byzantine painting (from Sicily to Russia).

236 Lepage, Claude. "Remarques sur l'ornementation peint a
l'intérieur des églises de la Morava." In <u>Moravska škola i</u>
<u>njeno doba</u>. Edited by Vojislav J. Djuric. Belgrade:
Filozofski fakultet, odeljenje za istoriju umetnosti, 1972,
pp. 229-37.
Discusses the stylistic unity of painted interior ornamen-
tation in Serbian churches of the Morava school and finds that
certain major monuments dictated the taste of the time.

237 Ljubinković, Radivoje. "La peinture murale en Serbie et en
 Macédoine aux XI^e et XII^e siècles." Corsi di cultura sull'
 arte ravennate e bizantina 9 (1962):405-41.
 A survey of eleventh- and twelfth-century monuments with an
 overview of relevant, up-to-date literature and scholarship.

238 Miljković-Pepek, Petar. "Contribution aux recherches sur
 l'évolution de la peinture en Macédoine au XIII^e siècle." In
 L'art byzantin du XIII^e siècle. Edited by Vojislav J. Djurić.
 Belgrade: Faculté de philosophie, Département de l'histoire
 d'art, 1967, pp. 189-96.
 Examines the question of monumental painting in thirteenth-
 century Macedonia. The discussion is based on numerous new dis-
 coveries (e.g., in the monastery of the Archangels at Prilep, in
 the church of the Virgin at Dabnište, in the church of St.
 Constantine at Svečani, in the church of St. Nicholas at
 Manastir).

239 _____. "Jedna realistička osobenost na freskama Nereza i
 Studenice" (Fr. sum.: "Une particularité réaliste sur les
 fresques de Nerezi et de Studenica"). Zograf 2 (1967):4-5
 (Fr. sum.: 59).
 In Serbo-Croatian. Identifies certain realistic details
 on the Crucifixion composition at Studenica and argues that these
 are Byzantine in origin. Cites parallels at Nerezi, painted by
 the previous generation of Byzantine painters, to prove the
 point.

240 Okunev, N[ikolai L'vovich]. Monumenta artis serbicae.
 4 vols. Zagreb-Prague: Dr. J. Stern, 1928-1932. Folios
 containing pls. (some color).
 One of the first attempts at producing a corpus of photo-
 graphs of Serbian medieval frescoes. Each folio contains approx-
 imately 15 plates. Plates are not organized either chronologi-
 cally or by location.

241 Petković, Sreten. "Slikarstvo Moravske škole i srpski spo-
 menici iz doba turske vladavine" (Eng. sum.: "Painting of
 the Morava School and Serbian monuments dating from the
 period of Turkish rule"). In Moravska škola i njeno doba.
 Edited by Vojislav J. Djurić. Belgrade: Filozofski fakultet,
 Odeljenje za istoriju umetnosti, 1972, pp. 309-21.
 In Serbo-Croatian. The influence of the Morava school of
 painting on the Serbian painting tradition under the Turkish rule
 is shown to have been very restricted. Only on Fruška Gora was
 this influence significant. The survival of dynastic ambitions
 of the Branković family in the area helps explain this phenomenon.

242 _____. Zidno slikarstvo na području Pećke Patrijaršije,
 1557-1614 (Eng. sum.: "Wall painting on the territory of the
 Patriarchate of Peć, 1557-1614"). Studije za istoriju srpske
 umetnosti, 1. Novi Sad: Matica srpska, 1965. 254 pp. (Eng.
 sum.: 215-27), 118 pls., 10 figs., drawings and maps in text.
 In Serbo-Croatian. The major study of Serbian wall paint-
 ing during the revived patronage of the Serbian church under the
 Turkish domination. Examines the subject thoroughly: its his-
 toriography, the history of the period, artistic conditions,
 themes and iconography, and stylistic characteristics of differ-
 ent workshops and masters. The book ends with a catalog of all
 monuments, describing the frescoes and providing bibliography for
 each.

243 Petković, Vlad[imir] R. "Jedna srpska slikarska škola XIV
 veka" (Fr. sum.: "Une école de peinture serbe du XIV siècle").
 GSND 3 (1928):51-66 (Fr. sum.: 62-66).
 In Serbo-Croatian. Aesthetically of high quality and
 iconographically unusual, the fresco program of the church of
 St. Andrew on the Treska river (Andreaš), near Skopje, is a work
 of two painters who signed their names: Metropolitan Jovan and
 monk Grigorije. Another inscription at Zrze monastery identifies
 the two as brothers and as painters, supporting the notion that
 they headed a painting workshop during the last quarter of the
 fourteenth century.

244 _____. La peinture serbe du moyen âge. Musée d'histoire de
 l'art. Monuments Serbes, 6-7. 2 vols. Belgrade: Kraljevski
 srpski narodni muzej, 1930 and 1934. Vol. 1, album, 160 pls.;
 vol. 2, 64 pp., 53 figs., album with 208 pls.
 A corpus of black-and-white photographs--one of the largest
 undertaken, but far from comprehensive.

245 Radojčić, Svetozar. "Jedna slikarska škola iz druge polovine
 XV veka: Prilog istoriji hrišćanske umetnosti pod Turcima"
 (Fr. sum.: "Une école de peinture de la deuxième moitié du
 XVe siècle. Contribution à l'histoire de l'art chrétien des
 Balkans sous la domination des Turcs"). ZLU 1 (1965):69-104
 (Fr. sum.: 103-4).
 In Serbo-Croatian. A major study on the work of a painting
 workshop active between 1483 and 1499. The work of this group is
 noted at Treskavac monastery, at St. Nikita near Skopje, and at
 Poganovo monastery, as well as at the monastery of Transfigura-
 tion at Meteora and the church of St. Nicholas at Kastoria, both
 in Greece.

246 Skovran, Anika. "Novootkrivene freske u crkvi sv. Luke u
 Kotoru" [Newly discovered frescoes in the church of St. Luke
 in Kotor]. Zograf 4 (1972):76-7.
 In Serbo-Croatian. A major discovery made in 1971 brought
 to light this late twelfth-century fresco depicting St. Basil,

St. Helena and an unknown female saint. The fresco is of major
significance for the understanding of East-West currents in the
development of monumental painting in Serbia around 1200.

247 Stelē, F[rance]. "Le byzantinisme dans la peinture murale
 Yougoslave." Studi bizantini e neoellenici 8:253-59. Atti
 dello VIII Congresso internazionale di studi bizantini 2.
 A brief essay on the Byzantine influence on medieval paint-
 ing in Yugoslavia. Of particular interest is the discussion of
 medieval painting in western Yugoslavia.

248 Stelē, Francē. "Slikani svodovi gotskih prezbiterija u
 Slovenačkoj" (Ger. sum.: "Bemalte Gewölbe gotisher Presby-
 terien in Slowenien"). Starinar, 3d ser. 5 (1930):70-87
 (Ger. sum.: 87).
 In Slovenian. Discusses the architectural and iconographic
 implications of painted Gothic ceilings in prebyteries of Slo-
 venian Gothic churches.

248a See Addenda

249 Talbot, Rice, and Radojčić, Svetozar. Yugoslavia: Medieval
 Frescoes. Unesco World Art Series, 4. Paris: New York
 Graphic Society and UNESCO, 1955. 29 pp., 32 col. pls.
 A book intended to popularize medieval painting of
 Yugoslavia. The volume is illustrated by a selection of superb
 color plates. Some of the photographs, unfortunately, were made
 before the cleaning of frescoes.

ICONS

250 Balabanov, Kosta. "Dve novootkrieni portabl mozaični ikoni od
 crkvata Sv. Bogorodica Perivleptos (Sv. Kliment) vo Ohrid"
 (Fr. sum.: "Deux icônes portables en mosaïque de l'église de
 la Vierge Péribleptos (Saint Clément) d'Ohrid"). KN 3 (1971):
 127-38 (Fr. sum.: 137-38).
 In Macedonian. Two mosaic icons dating from the end of the
 thirteenth or first half of the fourteenth century--one showing
 Christ enthroned, the other poorly preserved (subject unclear)--
 were discovered in 1960 in the church of St. Clement at Ohrid.
 The icons are related to other relevant examples. The article
 contains a photograph of a mosaic floor at St. Clement dating
 from the fourteenth century (fig. 8).

251 _____. Ikone iz Makedonije [Icons from Macedonia]. Parallel
 texts in Serbo-Croatian, Macedonian, English, and French.
 Belgrade: Jugoslavija; Skopje: Kultura, 1969. 61 pp.,
 80 pls.
 The most comprehensive up-to-date study of Macedonian
 icons, covering the full range of icons from the eleventh to the

eighteenth centuries. Some of the icons appear here for the
first time. Reproductions are generally excellent.

252 Blažič, Zdravko. Konzervacija ohridskih ikona i nove
 konstatacije (Eng. sum.: "Conservation of Ohrid icons and
 some new data"). Kulturno-istorisko nasledstvo vo N.R.
 Makedonija, no. 3. Skopje: Centralen zavod za zaštita na
 kulturno-istoriski spomenici na N.R.Makedonija, 1957. 49 pp.
 (Eng. sum.: 51-54), 38 figs., 8 pls.
 In Serbo-Croatian. A detailed technical account of the
 conservation process employed on several icons from Ohrid. Also
 reports certain discoveries made during the conservation process.

253 Djurić, Mirjana Tatić. "Ikona apostola Petra i Pavla u
 Vatikanu" (Fr. sum.: "L'icône des apôtres Pierre et Paul au
 Vatican"). Zograf 2 (1967):11-16 (Fr. sum.: 59).
 In Serbo-Croatian. A detailed analysis of the icon pre-
 sented to the Papacy by the Serbian Queen Jelena. After examin-
 ing numerous iconographic and stylistic aspects and parallels,
 the author dates the icon between 1282 and 1300.

254 _____. "Ikona Hristovog krštenja. Nova akvizicija iz doba
 druge vizantijske renesanse" (Fr. sum.: "Le baptême de
 Jésus-Christ: Icône datant de l'époque de la Renaissance des
 Paléologues"). ZNM 4 (1964):267-81 (Fr. sum.: 280-81).
 In Serbo-Croatian. An important icon depicting the Baptism
 of Christ is analyzed stylistically and iconographically and
 dated to the first half of the fourteenth century. The icon is
 linked with a major painting center on the basis of numerous
 iconographic details which are not commonly found in the iconog-
 raphy of the Baptism. Frescoes at Hilandar, Peć (St. Demetrius),
 Ljeviška, and Gračanica provide the closest parallels.

255 Djurić, Vojislav J. Icônes de Yugoslavie. XIIe Congrès
 international des études byzantines - Ohrid. Belgrade:
 Naučno delo, 1961. 141 pp., 119 pls.
 A catalog of a major exhibit of Yugoslav icons. Consists
 of a general text (pp. 11-79) and a catalog (pp. 83-141) in which
 each piece is described in detail and followed by bibliographical
 references.

256 _____. "Mozaička ikona Bogorodice Odigitrije iz manastira
 Hilandara" (Fr. sum.: "Icône en mosaïque de la Vierge
 Hodigitria du monastère de Chilandari"). Zograf 1 (1966):
 16-20 (Fr. sum.: 47).
 In Serbo-Croatian. A detailed discussion of the mosaic
 icon of the Virgin Hodegetria from Hilandar monastery. Stylistic
 and iconographic aspects of the icon are considered,as well as
 its uses in last-rite ceremonies for dying monks.

257 Fisković, Cvito. "Neobjavljena romanička Madona u Splitu"
 (Fr. sum.: "Madone romane à Split, non encore publiée").
 PPUD 12 (1960):85-100 (Fr. sum.: 100).
 In Serbo-Croatian. Presents a fine Romanesque panel paint-
 ing of a Madonna with Child discovered after World War II in the
 church of Our Lady of the Belfry in Split. The painting is dated
 to the thirteenth century and is associated with Tuscan or
 Pisan-Sienese school.

258 _____. "Tri ikone u Splitu" (Fr. sum.: "Trois icônes de
 Split"). ZLU 11 (1975):235-52 (Fr. sum.: 252).
 In Serbo-Croatian. A discussion of three icons preserved
 in Split. Two of these (Virgin with Child and St. Dominic) are
 Italo-Cretan works of the late fifteenth or the sixteenth cen-
 tury, while the third (St. Basil the Great) is an eighteenth-
 century Greek work.

259 _____. "Trogirska romanička Gospa" (Fr. sum.: "Une Madone de
 style roman à Trogir"). PPUD 20 (1975):31-38 (Fr. sum.:
 38).
 In Serbo-Croatian. A recently discovered and cleaned panel
 painting represents a Madonna with Child, and is dated to the
 second half of the thirteenth century. Attempts to attribute the
 painting to the later years of a local painter Stojan, whose name
 is recorded in 1308. Distinctions between local workshops are
 stressed as well as the possibility of panel paintings having
 been imported from elsewhere.

260 Gamulin, Grgo. Madonna and Child in Old Art of Croatia.
 Monuments of Croatia, 1. Zagreb: Matica hrvatska and
 Kršćanska sadašnjost, 1971.. 150 pp., 61 b&w figs. in text,
 42 col. pls.
 A general study of Madonna icons in medieval art of
 Croatia. Consists of a general text in which iconographic and
 stylistic problems are considered, and a catalog in which the
 forty-two examples are discussed in detail with a bibliography
 for each of the pieces included. Illustrated with superb color
 photographs.

261 _____. "Trogirsko 'Raspelo sa triumfirajućim Kristom'" (It.
 sum.: "La crocifissione con Cristo Trionfante' da Trogiro").
 Zbornik Svetozara Radojčića. Edited by Vojislav J. Djurić.
 Belgrade: Filozofski fakultet, Odeljenje za istoriju umet-
 nosti, 1969, pp. 35-38 (Fr. sum.: 38).
 In Serbo-Croatian. The recent cleaning of the Crucifix
 from the church of St. Andrew in Trogir has revealed that it was
 painted around the middle of the fourteenth century, and that it
 has strong affinities with Venetian painting of the period (par-
 ticularly with the mosaics of the Baptistery of S. Marco).

262 Ivanović, Milan. "Ljubiždanska dvojna ikona sa predstavama
 susreta Joakima i Ane i Blagovesti" (Fr. sum.: "Le diptique
 de Ljubižde avec la rencontre de Joachim et Anne et l'Annon-
 ciation"). Zograf 4 (1972):19-23 (Fr. sum.: 23).
 In Serbo-Croatian. The double icon from the village
 Ljubižda (now in the National Museum in Belgrade) features the
 Meeting of Joachim and Anna on the one side and the Annunciation
 on the other side. The icon is believed to have been painted
 around the middle of the fourteenth century in a local (Prizren)
 workshop and to have belonged to the monastery of the Archangels.

263 Kajmaković, Zdravko. "Četiri ikone iz radionice majstora
 Kozme" (Fr. sum.: "Quatre icônes de l'atelier du Maître
 Kozma"). ZLU 7 (1971):259-69 (Fr. sum.: 269).
 In Serbo-Croatian. A study of four icons which, along with
 the upper portion of the iconostasis of the church of St.
 Nicholas in Podvrh (near Bijelo Polje), are attributed to the
 seventeenth-century Serbian icon painter Kozma.

264 _____. "Novo delo Georgija Mitrofanovića" (Fr. sum.: "Une
 oeuvre récemment trouvée de Georges Mitrofanović"). ZLU 4
 (1968):263-71 (Fr. sum.: 271).
 In Serbo-Croatian. A Trinity icon from the village church
 at Rijeka (near Čelebići) is attributed to the noted seventeenth-
 century Serbian icon painter Georgije Mitrofanović.

265 _____. "Raičevićeva ikona sa Ošanića" (Fr. sum.: "Une icône
 de Raičević à Ošanići"). ZLU 5 (1969):309-11 (Fr. sum.:
 311).
 In Serbo-Croatian. A small icon of St. Lazarus the Just
 from the church of SS. Peter and Paul at Ošanići (near Stolac)
 is ascribed to the seventeenth-century icon painter Andrija
 Raičević.

266 _____. "Tešanjske ikone" (Eng. sum.: "The icons from
 Tešanj"). NS 10 (1965):165-88 (Eng. sum.: 188).
 In Serbo-Croatian. A study of a local group of icons of
 widely varying dates and quality. An icon depicting six saints
 (sixteenth-seventeenth centuries) and two icons of the Virgin
 with Child (end of sixteenth and seventeenth centuries) may be
 singled out as interesting.

267 Kojić, Ljubinka. "Ikona 'Hristos na prestolu' iz pravoslavne
 crkve u Foči" (Fr. sum.: "L'icône 'Le Christ sur le trône'
 dans l'église orthodoxe à Foča"). ZLU 4 (1968):275-80 (Fr.
 sum.: 279-80).
 In Serbo-Croatian. The icon of "Christ Enthroned" from
 the collection of the Serbian Orthodox church at Foča is attrib-
 uted to the seventeenth-century icon painter Radul.

268 _____. "O ikoni svetog Djordja sa žitijem iz Čajniča" (Fr.
sum.: "À propos de l'icône de 'St. Georges et sa vie' de
Čajniče"). ZLU 7 (1971):239-44 (Fr. sum.: 243-44).
 In Serbo-Croatian. The sixteenth-century icon of St.
George is seen as a local product, although under strong influ-
ence of post-Byzantine iconography.

269 _____. "Tri sarajevske ikone apostola" (Fr. sum.: "Trois
icônes d'apôtres de Sarajevo"). ZLU 5 (1969):315-22 (Fr.
sum.: 320-22).
 In Serbo-Croatian. Considers three icons with representa-
tions of paired apostles: Bartholomew with James, Andrew with
Simon, and Luke with John. The three icons are attributed to the
seventeenth-century icon painter Avesalom Vujičić.

270 Ljubinković, Mirjana Ćorović. "Ikonostas crkve svetog Nikole
u Velikoj Hoči" (Fr. sum.: "L'iconostase de l'église de
Saint Nicolas a Velika Hoča"). Starinar, n.s. 9-10 (1959):
169-79 (Fr. sum.: 179).
 In Serbo-Croatian. The remaining icons of the sixteenth-
century iconostasis of the church of St. Nicholas are analyzed
stylistically and iconographically. Special attention is given
to the iconography as a reflection of the cult of Stefan
Dečanski.

271 _____. "Nekoliko sačuvanih ikona starog gračaničkog ikono-
stasa XIV veka i problem visokog ikonostasa u našem srednjem
veku" (Fr. sum.: "Quelques icônes de la vieille iconostase de
Gračanica datant du XIVème siècle et le problème de icono-
stase haute au moyen âge en Serbie"). ZNM 2 (1958-59):135-52
(Fr. sum.: 150-52).
 In Serbo-Croatian. Four large icons at Gračanica monastery,
representing standing figures of Christ and three apostles, are
dated to the fourteenth century and are seen as having belonged
to an early form of a "high iconostasis" in Serbia.

272 _____. Pećko-dečanska ikonopisna škola od XIV do XIX veka
(Fr. sum.: "Les icônes de l'école du Peć"). Belgrade:
Narodni muzej, 1955. 29 pp. (Fr. sum.: 19-22), 30 pls.
 In Serbo-Croatian. Considers the survival of the tradition
of icon painting in the region of two major monastic centers,
Peć and Dečani, between the fourteenth and nineteenth centuries.

273 Ljubinković, Radivoje. "Dve gračaničke ikone sa portretima
Mitropolita Nikanora i Mitropolita Viktora" (Fr. sum.:
"Deux icônes à portraits de donateur à Gračanica"). Starinar,
n.s. 5-6 (1956):129-38 (Fr. sum.: 138).
 In Serbo-Croatian. A study of two dated icons from
Gračanica monastery--a Christ icon (dated 1567) and an icon of
St. Fevronija (dated 1600). The two icons also preserve minia-
ture portraits of their donors, metropolitans Nikanor and Viktor.

274 Macan, Jelena. "Ohridskite ikoni" (Fr. sum.: "Les icônes
 d'Ohrid"). <u>KN</u> 1 (1959):61-84 (Fr. sum.: 83-84).
 In Macedonian. A catalog-like discussion of the major
 thirteenth- and fourteenth-century icons from Ohrid. Each icon
 is described along with its inscriptions and relevant technical
 information.

275 Mijović, Pavle. "O ikonama s portretima Tome Preljuboviča i
 Marije Paleologove" (Fr. sum.: "Les icônes avec les portraits
 de Toma Preljubovič et de Marie Paléologine"). <u>ZLU</u> 2 (1966):
 185-95 (Fr. sum.: 195).
 In Serbo-Croatian. Relates a diptych from the cathedral of
 Cuenca, Spain with a diptych leaf and an icon depicting the
 Incredulity of Thomas from the monastery of Transfiguration at
 Meteora, Greece. The latter was created under the patronage of
 the Serbian despot Toma Preljubovič and his wife Maria
 Paleologina. All of the works are dated between 1382 and 1384.

276 Miljković-Pepek, P[etar]. "L'icône de Saint Georges de
 Struga." <u>Cahiers archéologiques</u> 19 (1969):213-21.
 Analyzes a fine large icon (146 x 86 cm) of St. George
 from Struga. The icon is dated to 1266, and its painter, John,
 signed his name on the back. The career of this painter is
 linked with other artistic activities at Manastir and at Holy
 Archangels.

277 _____. "L'icône de la Vierge Episkepsis d'Ohrid." <u>KN</u> 3
 (1971):139-44.
 Deals with a fine icon dating from the late thirteenth or
 the first half of the fourteenth century on the basis of its
 style. The icon represents a standing Virgin with Christ Child
 on her right arm. Archangels Michael and Gabriel are depicted in
 two medallions in the upper corners of the panel.

278 _____. "Proučuvanjata na nekolku novootkrieni ikoni koi
 značitelno ja zbogatuvaat makedonskata kolekcija" (Fr. sum.:
 "Recherches sur des icônes nouvellement découvertes de la
 collection Macédonienne"). <u>KN</u> 4 (1972):5-13 (Fr. sum.: 13).
 In Macedonian. Considers the following newly discovered
 icons: SS. Basil and Nicholas (first half of eleventh century);
 Virgin Hodegitria (first half of the thirteenth century); St.
 Barbara (first half of thirteenth century); St. Clement of Ohrid
 (third quarter of thirteenth century); processional double icon
 with Christ Pantocrator on one side (1370-1400); a triptych
 (1370-1400); Virgin Hodegitria from Banjani (1315-1325); and SS.
 Theodore Tyron and Stratilite (fifteenth-sixteenth centuries).

279 _____. "Za najstarata ikona vo makedonskata kolekcija" (Fr.
sum.: "Sur la plus ancienne icône en Macédoine"). Zbornik.
Arheološki muzej na Makedonija (Skopje) 6-7 (1975):133-48
(Fr. sum.: 147-48).
 In Macedonian. An analysis of the icon depicting SS. Basil
and Nicholas. The icon is dated to the first half of the elev-
enth century on the basis of its style and is associated with the
artistic patronage of Leon, the archbishop of Ohrid (1037-1056).

280 Milošević, Desanka. "Dve ikone XIV veka u Narodnom muzeju"
(Fr. sum.: "Deux icônes du XIV^e siècle au Musée National").
ZLU 1 (1965):3-20 (Fr. sum.: 19-20).
 In Serbo-Croatian. Discusses two fragmentary icons,
Nativity and Pentecost, from the iconostasis of the church of
St. Clement in Ohrid. The former is dated to the very beginning
and the latter to the first half of the fourteenth century.

281 _____. "Ikona Rodjenje i Milovanje Bogorodice" (Fr. sum.:
"La nativité de la Vierge et les caresses: Icône du Musée
National de Beograd"). ZLU 8 (1972):179-89 (Fr. sum.:
188-89).
 In Serbo-Croatian. An icon depicting the Nativity and
Tenderness of the Virgin from the National Museum in Belgrade
(Inv. no. 2679) is linked iconographically to the Serbian Munich
Psalter as well as to certain Russian icons of the sixteenth
century. Although previous dating to the end of the fourteenth
century remains probable, the author leaves several crucial
questions regarding the manner of Russian influence unanswered.

282 _____. "Jedna ohridska ikona u Narodnom muzeju" (Fr. sum.:
"Une icône d'Ohrid au Musée National"). ZNM 1 (1956-57):
187-208 (Fr. sum.: 206-8).
 In Serbo-Croatian. A detailed study of the double icon
representing Virgin with Christ on the side and the Annunciation
on the reverse. The icon (originally from the Church of St.
Clement in Ohrid) is dated close to 1300 and is seen as a sty-
listic link between the Paleologan painting in Ohrid and painting
of the first two decades of the fourteenth century in Serbia.

283 Mirković, L[azar]. "Ikona Bogorodice u crkvi Gospe od Zvonika
u Splitu" (Fr. sum.: "Icône de la Vierge à l'église de Notre
Dame du Clocher à Split"). Starinar, n.s. 1 (1950):47-51 (Fr.
sum.: 51).
 In Serbo-Croatian. An analysis of an icon representing a
Virgin with Child believed to be a thirteenth-century work in the
Italo-Byzantine style.

284 _____. "Die Ikonen der griechischen Maler in Jugoslawien und
in den serbischen Kirchen ausserhalb Jugoslawiens." Peprag-
mena tou 9 diethnous byzantinologikon synedriou (Athens) 1
(1955):301-28.
 An extensive, thoroughly documented study of the works of
both Greek icon painters in Yugoslavia and icon painters in
Serbian churches outside the territory of Yugoslavia.

285 _____. "Ikone manastira Dečana" (Fr. sum.: "Icônes du
monastère Dečani"). SKM 2-3 (1963):11-55 (Fr. sum.: 55).
 In Serbo-Croatian. An exhaustive catalog of Dečani icons.
Detailed descriptions of all icons include inscriptions, icono-
graphic content, and technical details. Sixty-six icons are
illustrated with good black-and-white photographs.

286 _____. "Ikone na Rijeci, u Puli i Peroju" (Fr. sum.: "Icônes
à Rijeka, Pula et Peroj"). Starinar, n.s. 13-14 (1965):
293-310 (Fr. sum.: 310).
 In Serbo-Croatian. A survey of orthodox icon collections
of Serbian orthodox churches at Rijeka, Pula, and Peroj. The
icons vary widely in dating, provenance, and quality.

287 Muro, Vukosava Tomić De. "Beleške o ikoni Sv. Nikole u
Bariju, Italija" (Fr. sum.: "Note sur l'icône de Saint
Nicolas à Bari, Italie"). ZLU 6 (1970):223-25 (Fr. sum.:
225).
 In Serbo-Croatian. A postscript to the earlier study of
Serbian icons in Bari (see entry YU 288). Reports that the main
icon of St. Nicholas with Serbian royal portraits was "restored"
incompetently and that the historical and artistic significance
of this icon was, for all practical purposes, completely lost.

288 _____. "Srpske ikone u crkvi Sv. Nikole u Bariju, Italija"
(Fr. sum.: "Les icônes dans l'église Saint Nicolas à Bari en
Italie"). ZLU 2 (1966):107-24 (Fr. sum.: 123-24).
 In Serbo-Croatian. A detailed study of documentation on
several icons presented to the church of St. Nicholas in Bari by
Serbian kings. The most important of these is the large icon of
St. Nicholas with portraits identified by the author as King
Milutin and his wife Simonida. See entry YU 287.

289 Nikolić, Radomir. "Novo datovanje ikone Sv. Save i Sv.
Simeona Nemanje" (Fr. sum.: "Nouvelle manière de dater
l'icône de St. Sava et St. Siméon Nemanja appartenant au
Musée National de Beograd"). Saopštenja 8 (1969):197-202
(Fr. sum.: 202).
 In Serbo-Croatian. Challenges the generally accepted
fifteenth-century date of the icon of SS. Sava and Simeon in the
National Museum in Belgrade and proposes that on the basis of its
stylistic and paleographic characteristics it should be dated to
the sixteenth century.

290 Petricioli, Ivo. "Nepoznata srednjovjekovna slika Bogorodice
 iz zadarske katedrale" (It. sum.: "Una sconosciuta Madonna
 dugentesca a Zara [Zadar]"). Peristil 3 (1960):7-10 (It.
 sum.: 10).
 In Serbo-Croatian. Discusses a well-preserved icon of the
 Madonna with Child from Zadar Cathedral, discovered during clean-
 ing and restoration below later overpainting. On stylistic
 grounds the icon is dated to the second half of the thirteenth
 century.

291 _____. "Novootkrivena ikona Bogorodice u Zadru" (Fr. sum.:
 "Une icône de la Vierge nouvellement découverte à Zadar").
 Zograf 6 (1975):11-13 (Fr. sum.: 13).
 In Serbo-Croatian. A fine icon of the Virgin with Child
 from the sacristy of the church of Sv. Šimun in Zadar was re-
 cently cleaned, and studied by the author. The icon is found to
 belong to the Byzantine-Venetian painting tradition of the
 twelfth and thirteenth centuries, on the basis of comparison with
 other local works (frescoes and icons).

291a _____. "Prinove zadarskom slikarstvu XV st." (Fr. sum.:
 "Quelques notices nouvelles sur la peinture de Zadar du XVe
 siècle"). PPUD 9 (1955):155-69 (Fr. sum.: 313).
 In Serbo-Croatian. Considers several newly discovered or
 cleaned paintings belonging to the local painting school of Zadar
 during the fifteenth century.

292 Prijatelj, Kruno. "Nepoznata ikona Bogorodice s Djetetom iz
 Dalmacije" (It. sum.: "Un icona inedita della Vergine dalla
 Dalmazia"). Peristil 18-19 (1975-76):23-26 (It. sum.: 26).
 In Serbo-Croatian. Publication of a fine unknown icon
 datable on stylistic grounds to the mid- or late fourteenth
 century.

292a _____. "Slikano raspelo iz samostana sv. Klare u Splitu" (It.
 sum.: "Il crocifisso dipinto del convento di S. Chiara a
 Spalato [Split]"). Peristil 4 (1961):8-15 (It. sum.: 15).
 In Serbo-Croatian. The painted wooden crucifix from the
 church of St. Clara in Split is dated to the end of the thir-
 teenth century, and is believed to be the product of a local
 workshop.

292b _____. "Triptih iz splitskog arheološkog muzeja" [A triptich
 from the archeological museum in Split]. Peristil 5 (1962):
 29-35 (It. sum.: 35).
 In Serbo-Croatian. The triptich features a Madonna with
 Child in the central panel, while the flanking wings depict
 standing figures of St. Francis of Assisi (on the left) and St.
 Nicholas (on the right). At the feet of the two saints are de-
 picted small kneeling figures of two donors. The author dates
 the piece to ca. 1325-30.

293 _____. "Za tačnije datiranje krapanjske Bogorodice" (It.
 sum.: "Per una datazione piu precisa della Madonna di
 Krapanj"). ZLU 10 (1974):345-48 (It. sum.: 348).
 In Serbo-Croatian. The panel painting representing the
 Virgin and Child in the Franciscan church in Krapanj is seen as a
 fine piece of a late fifteenth-century Veneto-Cretan workshop--
 works from which are to be found throughout Europe.

294 Putsko, Vasilii. "Serbskaia ikona v Troitse-Sergievom monas-
 tire" [A Serbian icon in the Troitse-Sergiev monastery]. ZNM
 6 (1970):319-25.
 In Russian. An account of the fourteenth-century Serbian
 icon in the collection of the Troitse-Sergiev monastery. The
 icon depicts St. Anne with the Virgin Mary as a child. Examines
 the iconographic type and links it to the known images of the
 Virgin with Child.

295 Radojčić, Svetozar. The Icons of Serbia and Macedonia.
 Belgrade: Jugoslavija, 1963. 16 pp., 103 pls.
 A collection of excellent photographs of some of the finest
 icons in Serbia and Macedonia. Includes an appendix-catalog (by
 S. Petković) which lists all of the icons illustrated, and pro-
 vides the basic information and bibliography for each.

296 Skovran, Anika. "Deizisna ploča Georgija Mitrofanovića u
 Studenici" (Fr. sum.: "La plaque de Deisis à Studenica,
 oeuvre de Grigorije Mitrofanović"). Saopštenja 4 (1961):
 33-38 (Fr. sum.: 38).
 In Serbo-Croatian. A discussion of the Deesis icon origi-
 nally belonging to the iconostasis decoration of the church of
 the Virgin. The icon was painted by Georgije Mitrofanović, a
 noted painter of the first half of the seventeenth century.

297 _____. "Ikonostas crkve Svetog Nikole u Podvrhu i njegov
 tvorac" (Fr. sum.: "L'iconostase de l'église de St. Nicolas
 à Podvrh et maître Cosme"). Zograf 4 (1972):54-62 (Fr. sum.:
 62).
 In Serbo-Croatian. A discussion of the iconostasis screen
 from the church of St. Nicholas at Podvrh, a masterpiece of
 seventeenth-century art. The screen was the work of a master
 Cosma and his apprentice Radul.

298 Stanić, Radomir. "Nepoznate ikone u jugozapadnoj Srbiji"
 (Fr. sum.: "Les icônes inconnues de la Serbie du sud-ouest").
 ZLU 11 (1975):255-72 (Fr. sum.: 272).
 In Serbo-Croatian. A survey of several unknown icons from
 churches and monasteries in southwest Serbia. Most of them are
 post-Byzantine in date (sixteenth-seventeenth centuries).

299 Trivunac, Gordana Tomić. "Ikona sa predstavom srpskih
 svetitelja" (Fr. sum.: "Une icône représentant des saints
 Serbes"). ZNM 4 (1964):345-57 (Fr. sum.: 357).
 In Serbo-Croatian. The seventeenth-century icon depicting
 Deesis with Serbian saints (Sava, Simeon, Stefan Prvovenčani,
 Stefan Dečanski, Emperor Uroš, and Prince Lazar) is attributed to
 Avesalom Vujičić, a noted seventeenth-century icon painter from
 Morača monastery.

MANUSCRIPT ILLUMINATION

300 Babić, Gordana. "O srpskom četverojevandjelju XVII veka iz
 zbirke Fitzwilliam-ovog muzeja u Kembridžu" (Fr. sum.:
 "Tétraévangile serbe du XVIIᵉ siècle à la collection du musée
 Fitzwilliam de Cambridge"). In Zbornik Svetozara Radojčića.
 Edited by Vojislav J. Djurić. Belgrade: Filozofski fakultet,
 Odeljenje za istoriju umetnosti, 1969, pp. 17-23 (Fr. sum.:
 23).
 In Serbo-Croatian. A discussion of the Serbian gospel book
 in the Fitzwilliam Museum in Cambridge, England. The gospel book
 made for Patriarch Gavrilo I (1648-1654), though post-medieval in
 date, reveals a conservative adherence to the artistic mode of
 expression from the thirteenth century. Illuminations are well
 preserved as are the metal book covers.

301 Badurina, Andjelko. "Fragmenti ilumiranog evandjelistara iz
 kraja XI stoljeća u Rabu" (Fr. sum.: "Fragments de l'évangé-
 liare de Rab [XIᵉ siècle]"). Peristil 8-9 (1965-66):5-12
 (Fr. sum.: 12).
 In Serbo-Croatian. A brief analysis of high-quality mar-
 ginal illuminations in a gospel book in the archives of the
 parochial office in Rab. The illuminations include individual
 representations of Christ and the Virgin, as well as standing
 figures of saints. Primarily on the basis of style, the manu-
 script is dated to the late eleventh century and is believed to
 have originated from a circle of Benedictine scriptoria known to
 have existed on the island at that time.

302 Djurić, Jelica, and Ivanišević, Rajka. "Jevandjelje Divoša
 Tihoradića" (Fr. sum.: "L'évangile de Divoš Tihoradić pro-
 venant des premières décades du XIVᵉ siècle"). ZRVI 7 (1961):
 153-60 (Fr. sum.: 160).
 In Serbo-Croatian. This early fourteenth-century illumi-
 nated Bosnian manuscript compels the authors to revise previously
 held views that miniature illumination in Bosnia during the thir-
 teenth and fourteenth centuries had dropped to the level of
 strict provincial conservatism. Better manuscripts (and not
 their copies), such as the gospels of Divoš Tihoradić, illustrate
 the creative impulses and links with such artistic centers as
 Split.

303 Dufrenne, Suzy; Radojčić, S.; Stichel, R.; and Ševčenko, I.
 Der Serbische Psalter. Edited by H. Belting. Wiesbaden:
 Dr. Ludwig Reichert Verlag, 1978. 360 pp., 19 pls.
 The most important publication of the Serbian Psalter in
 Munich (Cod. Slav. 4 der Bayerischen Staatsbibliothek). The book
 was envisioned as a facsimile edition to which this is a commen-
 tary text volume.

304 Harisiadis, Mara. "Les miniatures du tétraévangile du
 Metropolite Jacob de Serrès." Actes du XII^e Congrès inter-
 national d'études byzantines (Belgrade) 3 (1964):121-30.
 A study of illuminations (esp. decorative heading, and a
 donor portrait) in the British Museum (Ms. Add. 39629). The
 manuscript (in Serbian) was made in 1354-1355 for the Serbian
 Metropolitan of Serres, Jakov (James) (1348-1365), who was ap-
 pointed to the post by the Serbian Emperor Stefan Dušan following
 the conquest of Serres.

305 _____. "Slovenski rukopisi u biblioteci Saraja u Carigradu"
 (Fr. sum.: "Manuscrits slaves de la bibliothèque du Sérail à
 Constantinople"). Starinar, n.s. 15-16 (1966):145-61 (Fr.
 sum.: 161).
 In Serbo-Croatian. A detailed discussion of several south-
 Slavic manuscripts preserved in the Seraglio Library in Istanbul.
 These include the original text of the Banjska Chrysobull (ca.
 1318) and the Missal of Hrvoje Vukčić (early fifteenth century).

306 Harisijadis, Mara. "Apostol br. 47 u Vukovoj rukopisnoj
 zbirci u Berlinu" (Fr. sum.: "Les actes des apôtres, manu-
 scrit no. 47 de la collection Vuk Karadžić à Berlin"). ZLU
 12 (1976):225-35 (Fr. sum.: 235).
 In Serbo-Croatian. A study of the Acts of the Apostles
 manuscript in the Vuk Karadžić collection in the Prussian
 National Library in Berlin (ms. no. Wuk, 47). The manuscript
 has lavish decorated and illuminated frontispieces and ornamental
 headpieces. It is dated to the later part of the fourteenth or
 the fifteenth century. Though believed to have been a work of a
 Serbian illuminator, strong influence of Mount Athos is noted.

307 _____. "Četvorojevandjelje patrijarha Pajsija" (Fr. sum.:
 "La tétraévangile du patriarche Pajsije"). ZLU 15 (1979):
 331-42 (Fr. sum.: 341-42).
 In Serbo-Croatian. Examines the gospels of Serbian
 Patriarch Pajsije made in the late sixteenth or early seven-
 teenth century. The manuscript is kept in the Museum of the
 Serbian Patriarchal Library in Belgrade (Ms. no. 263). The
 decorative features are restricted to the elaborate headpieces.

308 _____. "Dva rukopisa popa Nikodima" (Fr. sum.: "Deux manu-
scrits du pope Nicodème"). ZLU 9 (1973):85-96 (Fr. sum.:
96).
 In Serbo-Croatian. A study of two fifteenth-century manu-
scripts. The ornaments of these manuscripts contain unique
motifs, while the gospels in Sofia also contain Evangelist por-
traits of considerable artistic merit.

309 _____. "Dva srpska četverojevandjelja iz XIV veka--u
Lenjingradu i Moskvi" (Fr. sum.: "Deux tétraévangiles serbes
du XIV^e siècle à Leningrad et à Moscou"). Zograf 4 (1972):
35-42 (Fr. sum.: 42).
 In Serbo-Croatian. Considers two illuminated Serbian
gospels from Leningrad and Moscow. The two are believed to have
been made in Macedonia during the second half of the fourteenth
century. The manuscripts are illustrated with full-page evan-
gelist portraits, abstract decorative headings, and initials.

310 _____. "Figuralni inicijali u Radoslavljevoj apokalipsi"
(Fr. sum.: "Les initiales historiées de l'Apocalypse de
Radoslav"). Zograf 9 (1978):50-53 (Fr. sum.: 53).
 In Serbo-Croatian. Considers figurative initials in the
fifteenth-century Apocalypse manuscript copied by one Radoslav
for one Goisav between 1443 and 1461. The manuscript is kept in
the Vatican Library (Fondo Borgiano Illirico 12). The initials
are closely related to a group of Bosnian manuscripts from the
preceding centuries, and may be ultimately linked to the tradi-
tion initiated in the gospels of Prince Miroslav (Miroslavljevo
Jevandjelje).

311 _____. "Frontispis srpskog Paterika Nacionalne biblioteke u
Beču" (Fr. sum.: "Frontispice du Paterikon serbe de la
Bibliothèque Nationale de Vienne"). ZRVI 8, pt. 2 (1964):
169-76 (Fr. sum.: 175-76).
 In Serbo-Croatian. The frontispiece of the Serbian
Paterikon is dated to the second half of the fourteenth century.
It depicts seven standing figures of the Apostles. The author
finds important links between this miniature and earlier monu-
mental tendencies in fresco painting and attributes the illumina-
tion to a Byzantine artist collaborating with a Serbian
calligrapher.

312 _____. "Frontispisi i zastavice u srpskom četverojevandjelju
Bugarske akademije nauka br. 15" (Fr. sum.: "Les frontispices
et les en-têtes du tétraévangile serbe de l'Academie bulgare
des sciences"). ZLU 7 (1971):25-33 (Fr. sum.: 33).
 In Serbo-Croatian. The Serbian gospels (Bulgarian Academy
of Sciences, ms. no. 15) are dated to the second half of the
fifteenth century on the basis of the analysis of the frontis-
pieces and headpieces. Links with the first printed books which
appeared on the territory of Serbia in the course of the fif-
teenth century are examined.

313 _____. "Iluminirani rukopisi stare Narodne biblioteke u
Beogradu" (Fr. sum.: "Les manuscrits enluminés de l'ancienne
Bibliothèque de Belgrade"). Starinar, n.s. 19 (1969):251-61
(Fr. sum.: 261).
 In Serbo-Croatian. A descriptive catalog of twenty illu-
minated manuscripts, dating from the thirteenth to the eighteenth
centuries, which were destroyed in the fire caused by the bombing
of the National Library of Belgrade in April 1941. Thirteen
manuscripts were of the Serbian reduction, while four were
Bulgarian, two Macedonian, and one Slavonic-Walachian.

314 _____. "Jedna nedovoljno objašnjena scena u Minhenskom
psaltiru i njegovoj beogradskoj kopiji" (Fr. sum.: "Une scène
insuffisamment expliquée dans le psautier de Munich et dans la
copie de celui-ci à Belgrade"). ZLU 5 (1969):77-85 (Fr. sum.:
85).
 In Serbo-Croatian. A partially preserved scene depicting
three men in confinement in the Serbian Munich Psalter is com-
pared to the fully preserved scene in the Belgrade Psalter (pre-
sumably a copy), and is related to the monumental fresco tradi-
tion and the earlier uses of the scene in manuscript illuminations.

315 _____. "Karlovačko naprestolno četvorojevandjelje" (Fr. sum.:
"La tétraévangile de l'église inférieure de Sremski Karlovci").
Starinar, n.s. 20 (Mélanges Djurdje Bošković) (1970):143-49
(Fr. sum.: 149).
 In Serbo-Croatian. The sixteenth-century Serbian gospels
manuscript has abstract headpieces and decorated initials which
reveal affinities with artistic production in Rumania. The book
is bound and has a silver cover with the Crucifixion scene exe-
cuted in 1559, according to an inscription.

316 _____. "Minijature i ornamenti Oktoiha R.64 Gradske biblio-
teke u Zagrebu" (Fr. sum.: "Les miniatures et les ornements
de l'octoëchos R.64 de la Bibliothèque municipale de Zagreb").
ZLU 4 (1968):283-96 (Fr. sum.: 296).
 In Serbo-Croatian. The analysis of the sixteenth-century
octoechos leads the author to conclude that it belongs to a group
of works produced in western Macedonia.

317 _____. "Pergamentni rukopisi Državne biblioteke u Berlinu"
(Fr. sum.: "Les manuscrits sur parchemin de la Staatsbiblio-
thek de Berlin"). ZLU 13 (1977):177-93 (Fr. sum.: 193).
 In Serbo-Croatian. A study of eleven parchment manuscripts
in the Prussian National Library in Berlin belonging to the so-
called Vuk Karadžić collection (Mss. nos. Wuk, 3, 4, 5, 6, 7, 27,
37, 47, 48 and 49). Focuses on the analysis of decorative head-
pieces and a few illuminations, although historical marginal
notes are also taken into account.

318 _____. "Psaltir R.29 sa ilustrovanim mesecoslovom patrija-
 šijske biblioteke u Beogradu" (Fr. sum.: "Le psautier R.29
 avec ménologe à la Bibliothèque de la Patriarchie de Béograd").
 ZLU 1 (1965):175-96 (Fr. sum.: 195-96).
 In Serbo-Croatian. A study of an illuminated Serbian
 psalter from 1664. Illuminations include the only known
 menologion cycle in a Serbian manuscript. Links with Russia
 are suggested.

319 _____. "Srpski rukopisi u atinskoj Narodnoj biblioteci" (Fr.
 sum.: "Les manuscrits serbes dans la Bibliothèque Nationale
 d'Athènes"). ZLU 14 (1978):205-12 (Fr. sum.: 212).
 In Serbo-Croatian. A study of three Serbian medieval manu-
 scripts now in the National Library of Athens (Mss. nos. 2159,
 2652, 1797). In addition to their content, the author discusses
 the initials of the fourteenth-century Psalter--which show an
 archaizing persistence of Western tradition in Serbian manuscript
 illumination of the fourteenth century.

319a Janc, Zagorka. "Islamski elementi u minijaturama Karanskog
 jevandjelja" (Fr. sum.: "Éléments islamiques dans les minia-
 tures de l'évangile de Karan"). Godišnjak. Naučno društvo
 Bosne i Hercegovine. Balkanološki institut 2 (1961):159-70
 (Fr. sum.: 170).
 In Serbo-Croatian. A study of a gospel book written and
 partially illuminated by a priest Vuk in 1608 at Bela Crkva in
 Karan. Two hands are distinguished in the illuminations which
 include evangelist portraits--one being that of the priest Vuk,
 and the other of an unknown decorator whose work reveals
 knowledge of Islamic ornament.

320 Kečkemet, Duško. "Romaničke minijature u Splitu" [Romanesque
 illuminations in Split]. Peristil 2 (1957):125-38 (Fr. sum.:
 138).
 In Serbo-Croatian. A study of illuminated eleventh-,
 twelfth-, and thirteenth-century manuscripts in the treasury of
 the cathedral of Split. Various stylistic and paleographic
 traits are analyzed. The illuminations are exclusively elaborate
 initials.

321 Kos, Milko. Srednjeveški rokopisi v Sloveniji [Medieval manu-
 scripts in Slovenia]. Ljubljana: Umetnostno-zgodovinsko
 društvo, 1931. 244 pp., 52 figs. in text.
 In Slovenian. The comprehensive corpus of medieval manu-
 scripts on the territory of Slovenia. The material is organized
 by regions, cities, and libraries. Illustrated manuscripts are
 described by France Stelè.

322 Ljubinkovíc, Mirjana Ćorovíc. "Prizrensko četvorojevandjelje.
 Ka problemu njegovog datovanja" (Fr. sum.: "Quelques objec-
 tions concernant la datation actuelle du tétraévangile de
 Prizren"). Starinar, n.s. 19 (1969):191-202 (Fr. sum.: 202).
 In Serbo-Croatian. An attempt to correlate earlier paleo-
 graphical investigation of the Prizren Tetraevangelion with the
 art-historical analysis of its miniatures, and to provide a dat-
 ing. A date sometime during the first half of the fourteenth
 century appears most plausible.

323 Maksimović, Jovanka. "Četvorojevandjelje Starčeve Gorice"
 (Fr. sum.: "Le tétraévangile de Starčeva Gorica"). ZLU 12
 (1976):59-68 (Fr. sum.: 68).
 In Serbo-Croatian. A study of a Serbian gospels manuscript
 with ornamental headpieces, now in the Marciana Library in
 Venice (Cod.or. - Cod. slav. CCXCV-12380). The manuscript, be-
 lieved to be a fifteenth-century work, is linked to what is be-
 lieved to have been a scriptorium on the island of Starčeva
 Gorica in Skadar Lake, active until its destruction in a flood
 in the second half of the sixteenth century.

324 _____. "Slikarstvo minijatura u srednjovekovnoj Bosni" (Fr.
 sum.: "Les miniatures de la Bosnie médiévale"). ZRVI 17
 (1976):175-88 (Fr. sum.: 186-88).
 In Serbo-Croatian. A general survey of manuscript illumi-
 nation in medieval Bosnia. Various stylistic trends are linked
 to developments in other arts (e.g., sculpture).

325 _____. "Studije o Miroslavljevom jevandjelju" (Fr. sum.:
 "Études sur l'évangéliare du Prince Miroslav"). ZNM 4 (1964):
 201-17 (Fr. sum.: 216-17).
 In Serbo-Croatian. The main goal of this study is to ex-
 amine the Western traits in the miniatures of Prince Miroslav
 Gospels. The strong Western element is seen as a result of
 copying Western books, most likely sent into the area by one of
 the popes during the period when links with the papacy were quite
 frequent. Local artists are seen as instrumental in adopting the
 Western style to the cyrillic alphabet and Orthodox religion.
 See also entries YU 326, 327, and 328.

326 _____. "Studije o Miroslavljevom jevandjelju, 2" (Fr. sum.:
 "Études sur l'évangile de Miroslav, 2"). ZLU 6 (1970):3-11
 (Fr. sum.: 10-11).
 In Serbo-Croatian. Examines two decorated initials from
 the gospels of Prince Miroslav. The initials depicting St. John
 the Baptist and St. Mary Magdalene are seen as belonging to the
 iconographic and stylistic milieu of pre- and early Romanesque
 art. Strong Byzantine influence, which flourished along the
 Adriatic littoral, is noted. See also entries YU 325, 327, and
 328.

327 ____. "Studije o Miroslavljevom jevandjelju, 3" (Fr. sum.:
"Études sur l'évangéliare de Miroslav, 3: Les figures des
évangélistes"). ZLU 8 (1972):41-50 (Fr. sum.: 49-50).
 In Serbo-Croatian. Diversified stylistic and iconographic
characteristics among the figures of the evangelists in the
gospels of Prince Miroslav suggest the complex background of this
art, which has its closest parallels in manuscript illumination
of southern Italy. See also entries YU 325, 326, and 328.

328 ____. "Studije o Miroslavljevom jevandjelju, 4: Vizantijski
elementi u inicijalima Miroslavljevog jevandjelja" (Fr. sum.:
"Études de l'évangéliare de Miroslav, 4: Éléments byzantins
dans les initiales de l'évangéliare de Miroslav"). ZNM 8
(1975):383-93 (Fr. sum.: 392-93).
 In Serbo-Croatian. The fourth installment of studies on
the gospels of Prince Miroslav focuses on the Byzantine sources
of some of the initials. Emphasizes the complex nature of the
illuminations in this manuscript, which show clear affinities
with both Eastern and Western traditions. See also entries
YU 325, 326, and 327.

329 Marinković, Radmila. Srpska Aleksandrida: Istorija osnovnog
teksta (Fr. sum.: "L'Alexandride serbe: L'histoire de texte
initial"). Monografije, vol. 31. Belgrade: Filološki fakul-
tet Beogradskog univerziteta, 1969. 348 pp. (Fr. sum.:
337-46), 66 pls.
 In Serbo-Croatian. An exhaustive study of all Serbian
medieval manuscripts illustrating the novel of Alexander. The
study takes into account highly diversified illuminations which
appear in several manuscripts. The author provides results of
earlier findings on these illuminations and cites older litera-
ture.

330 Milošević, Desanka. Miroslavljevo jevandjelje (Fr. sum.:
"L'évangéliaire de Miroslav"). Belgrade: Narodni muzej,
1972. 25 pp. (Fr. sum.: 17-23), 12 col. pls.
 In Serbo-Croatian. A brief discussion of the oldest major
medieval Serbian illuminated manuscript--the gospels of Prince
Miroslav. Considers the major issues of iconography and style
and provides the basic literature on the subject.

331 Mirković, Lazar. Minijature u antifonarima i gradualima
manastira Sv. Franje Asiskog u Zadru (Fr. sum.: "Les minia-
tures des antiphonaires et des graduelles du monastère de St.
François d'Assise à Zadar"). Posebna izdanja, 501. Mono-
grafije, 5. Belgrade: Srpska akademija nauka i umetnosti and
Filozofski fakultet, Institut za istoriju umetnosti, 1977.
92 pp. (Fr. sum.: 73-85), 88 pls.
 In Serbo-Croatian. A study of eight musical manuscripts
from the treasury of the monastery of St. Francis of Assisi in
Zadar. Analyzes the elaborate initials in these manuscripts and

finds that they display evidence of strong Byzantine influence
(particularly the five antiphonaries) notwithstanding their dis-
tinctly Western origin. In part the material had been related to
the Bolognese school of painting by P. Toesca and C. Cecchelli.
The author broadens their investigation. An appendix includes
the complete bibliography of L. Mirković prepared by J.
Radovanović.

332 _____. Miroslavljevo Evandjelje [The gospels of Prince
 Miroslav]. Posebna izdanja. Srpska akademija nauka, 156.
 Belgrade: Naučna knjiga, 1950. 54 pp. (Fr. sum.: 49-50),
 60 pls.
 In Serbo-Croatian. A study of the gospels of Prince
Miroslav. The author believes that the text of the gospels was
translated from the Greek original in the church of St. Sophia in
Constantinople. The illumination was done separately by an art-
ist trained in the Western tradition. The style of the text and
the style of illuminations are in sharp contrast.

333 Petković, Vladimir R. "Le roman d'Alexandre illustré de la
 Bibliothèque Nationale de Beograd." Studi byzantini e neo-
 ellenici 6 (1940):341-43. (Atti del V Congresso inter-
 nazionale di studi bizantini 2.)
 A brief consideration of a medieval novel about the life of
Alexander the Great and its illuminations.

334 Popović, P., and Smirnov, S. "Minijatura porodice Despota
 Djurdja na povelji svetogorskom manastiru Esfigmenu iz 1429"
 (Fr. sum.: "Une miniature de la famille du despote Djuradj,
 dans la charte du monastère d'Esphigmène [1429]"). GSND 11
 (1932):97-110 (Fr. sum.: 110).
 In Serbo-Croatian. A detailed study of miniatures on the
monastery charter of Esphigmenou (Mt. Athos) depicting the donor,
Serbian Despot Djuradj Branković, and his entire family. The
miniatures are of major historical and artistic significance.

335 Radojčić, Svetozar. "Minhenski srpski psaltir" (Fr. sum.:
 "Le psautier serbe de München"). ZFF 7, pt. 1 (1963):277-85
 (Fr. sum.: 285).
 In Serbo-Croatian. Analyzes the place of the Serbian
Psalter in Munich and finds that though painted toward the end
of the fourteenth century, the psalter is related stylistically
to the earlier developments rather than to the mainstream of
Serbian monumental painting. Nevertheless, it remains the most
important monument of medieval Serbian manuscript illumination.

335a _____. "Minijature u srpskim aleksandridama" [Miniatures in
 Serbian novels about Alexander the Great]. UP 1, no. 5
 (Feb. 1938):138-41.
 In Serbo-Croatian. A study of illuminations in two
"Romance of Alexander the Great" Serbian manuscripts (in Belgrade

and in Sofia), believed to date from the fourteenth and fifteenth
century respectively.

336 _____. "Naslovna zastava hilandarskog šestodneva iz 1263
 godine" (Fr. sum.: "L'en-tête décoré de l'hexaméron de
 Chilandar daté de l'an 1263"). Hilandarski zbornik 2 (1971):
 69-91 (Fr. sum.: 90-91).
 In Serbo-Croatian. The decorative aspects of the hexameron
 manuscript from 1263, produced at Hilandar Monastery and now in
 the Historical Museum in Moscow (Sinod.345), are related to a
 group of thirteenth-century manuscripts--two psalters in Bologna
 and at Zograf Monastery on Mt. Athos, and a tetraevangelion at
 Hilandar monastery.

337 _____. "Srpske minijature XIII veka" [Serbian miniatures of
 the 13th century]. Glas Srpske akademije nauka 234 (1959):
 55-67.
 In Serbo-Croatian. Discusses discrepancies between Serbian
 monumental painting and manuscript illumination during the thir-
 teenth century. While monumental painting constituted the main-
 stream of Byzantine painting, manuscript illumination followed an
 older, Western tradition throughout the thirteenth and into the
 fourteenth century.

338 _____. Stare srpske minijature (Fr. sum.: "Les anciennes
 miniatures serbes"). Biblioteka društva Narodne Republike
 Srbije. Belgrade: Naučna knjiga, 1950. 69 pp. (Fr. sum.:
 61-69), 6 col. pls., 56 b&w pls.
 In Serbo-Croatian. A general study of medieval Serbian
 book illustration from the twelfth to the seventeenth centuries.
 Dual exposure, to the Western (Romanesque) and Eastern (Byzan-
 tine) influences, is examined in detail. The second part of the
 book (pp. 21-59) is a catalog with extensive comments on individ-
 ual manuscripts.

339 Ranković, Dušanka. "Ovčarsko-kablarsko četvorojevandjelje
 iz zbirke prof. Alekse Ivića" (Fr. sum.: "Le tétraévangile
 d'Ovčar-Kablar appartenant au Prof. Aleksa Ivić"). ZLU 1
 (1965):107-16 (Fr. sum.: 116).
 In Serbo-Croatian. A study of the sixteenth-century
 tetraevangelion which focuses on its ornamentation including
 decorative initials. The character of this decoration is found
 to be related to other manuscripts from the scriptoria of
 Lesnovo, Kumanovo, Kratovo, and Novo Brdo, dating from the fif-
 teenth and sixteenth centuries.

340 Šakota, Mirjana. "Ko je autor minijatura Beočinskog
 Jevandjelja" (Fr. sum.: "Quel est l'auteur de la miniature
 de l'Évangile de Beočin"). Saopštenja 8 (1969):203-11 (Fr.
 sum.: 211).

In Serbo-Croatian. A study of the so-called Beočin gospels dated between the sixteenth and seventeenth centuries. An investigation of two inscriptions by scribes illuminates certain historical figures hitherto ignored.

341 Stričević, Djordje. "Majstori minijatura Miroslavljevog jevandjelja" (Eng. sum.: "The painters of the Miroslav gospel miniatures"). ZRVI 1 (1952):181-203 (Eng. sum.: 201-3).
 In Serbo-Croatian. Presents a controversial hypothesis that the initials of the Prince Miroslav gospels were painted by two Bosnian artists belonging to the Bogomil sect. The hypothesis is supported by close links of Bosnia with the Adriatic littoral, and by the survival of this tradition of manuscript illumination in Bosnia during the subsequent centuries.

SCULPTURE

342 Abramić, Michel. "Quelques reliefs d'origine ou d'influence byzantine en Dalmatie." L'art byzantin chez les Slavs: L'ancienne Russie, et Slaves catholiques. Vol. 2, pt. 2. Paris: Paul Geuthner, 1932, pp. 317-31.
 Considers a number of architectural fragments and relief sculpture from Dalmatia which reveal Byzantine influence.

343 Basler, Djuro. "Neke likovne paralele stećcima" (Ger. sum.: "Einige Paralellen zu der bosnischen mittelalterlichen Grabdenkmalkunst"). NS 13 (1972):123-33 (Ger. sum.: 133).
 In Serbo-Croatian. Attempts to explain some aspects of the "mystical" content of pictorial images on medieval Bosnian tombstones by relating them iconographically and stylistically to a select number of Romanesque examples throughout Western Europe.

344 Benac, Alojz. Medieval Primitive Sculpture. Belgrade: Jugoslavija, 1959. 32 pp., illus.
 A popular book on medieval Bosnian tombstones (stećci) with a selection of fine black-and-white photographs.

345 _____. Olovo. Srednjovekovni nadgrobni spomenici B i H, no. 2. Belgrade: Savezni institut za zaštitu spomenika kulture, 1951. 77 pp. (Fr. sum.: 75-77), 40 pls., 1 map, 7 foldout site plans.
 In Serbo-Croatian. A comprehensive discussion of the Bogomil necropolises at Olovo. Monuments are grouped by types. Various ornamental systems are considered, and technical execution is discussed.

346 _____. Radimlja. Srednjevjekovni nadgrobni spomenici B i H, no. 1. Sarajevo: Zemaljski muzej, 1950. 46 pp. (Eng. sum.: 43-46), 40 pls., 1 foldout site plan.
 In Serbo-Croatian. A comprehensive discussion of the Bogomil necropolis at Radimlja. Monuments are grouped by types.

Various ornamental systems are analyzed. Technical execution and
inscriptions (rare) are also discussed.

347 _____. Široki Brijeg. Srednjevjekovni nadgrobni spomenici
 B i H, no. 3. Sarajevo: Zemaljski muzej, 1952. 58 pp. (Fr.
 sum.: 57-58), 37 pls., 1 map, 9 site plans.
 In Serbo-Croatian. A comprehensive discussion of the-
 Bogomil necropolises at Široki Brijeg. Monuments are grouped by
 types. Their form, technique of execution, ornamental systems,
 chronology, orientation, and inscriptions are discussed.

348 Bešlagić, Šefik. "Boljuni: Srednjovjekovni nadgrobni
 spomenici" (Fr. sum.: "Boljuni: Pierres tombales du moyen
 âge"). Starinar, n.s. 12 (1961):175-206 (Fr. sum.: 206).
 In Serbo-Croatian. A study of an important medieval
 necropolis at Boljuni, its 269 tombstones, and their decoration.
 Several are distinguished by inscription, while others are in-
 scribed by artisans who made them. The necropolis dates from the
 second half of the fourteenth to the first decades of the six-
 teenth centuries.

349 _____. Kalinovik. Srednjovjekovni nadgrobni spomenici B i H,
 no. 7. Sarajevo: Zemaljski muzej, 1962. 108 pp. (Fr. sum.:
 106-8), 142 figs. in text.
 In Serbo-Croatian. A comprehensive analysis of the Bogomil
 necropolises at Kalinovik. Monuments are discussed from the
 point of view of their form, ornament, inscriptions, location,
 technique, and chronology.

350 _____. Kupres. Srednjevjekovni nadgrobni spomenici B i H,
 no. 5. Sarajevo: Zemaljski muzej, 1954. 198 pp. (Fr. sum.:
 196-98), 115 figs., 5 pls. in text.
 In Serbo-Croatian. A comprehensive analysis of the Bogomil
 necropolises at Kupres. Monuments are grouped by type. Their
 form, ornament, location, orientation, execution, and dating are
 discussed.

351 _____. "Ljubinje: Srednjovjekovni nadgrobni spomenici" (Eng.
 sum.: "Medieval tombstones"). NS 10 (1965):113-63 (Eng.
 sum.: 163).
 In Serbo-Croatian. A systematic regional study of medieval
 tombstones. Individual cemeteries, as well as general regional
 formal and symbolic characteristics, are discussed. Most tomb-
 stones in the group are dated to the fifteenth century. Some are
 dated to the fourteenth or the first decades of the sixteenth
 century.

352 _____. "Nevesinjski stećci" (Fr. sum.: "Les stećaks de
Nevesinje"). NS 13 (1972):97-122 (Fr. sum.: 122).
 In Serbo-Croatian. A survey of the medieval tombstones in
the region, dated between the end of the thirteenth and the first
decades of the sixteenth century. Individual cemeteries, as well
as general characteristics of the group, are discussed.

353 _____. Stećci centralne Bosne (Fr. sum.: "Stèles médiévales
de la Bosnie centrale"). Srednjovjekovni nadgrobni spomenici
B i H, no. 9. Sarajevo: Zemaljski muzej, 1967. 115 pp. (Fr.
sum.: 113-15), 115 figs. in text.
 In Serbo-Croatian. A comprehensive analysis of the Bogomil
necropolises in central Bosnia. Monuments are discussed from the
point of view of form, ornament, inscriptions, technique, loca-
tion, and dating.

354 _____. "Stećci Duvanjskog Polja" (Fr. sum.: "Les 'Stećak' de
Duvanjsko Polje"). Starinar, n.s. 7-8 (1958):375-96 (Fr.
sum.: 396).
 In Serbo-Croatian. A topographical study of stećci in the
area of Duvanjsko Polje with a general assessment of their types
and iconography.

355 _____. "Les 'Stećci' médiévaux: Recherches et études." AI 5
(1964):113-26.
 A state-of-the-art research study on stećci, discussing
objectives and methods of investigation. Includes a bibliography
listing seventy studies which treat exclusively the problems of
stećci.

356 _____. Stećci na Blidinju (Fr. sum.: "Monuments funéraires
bogomiles de Blidinje"). Zagreb: Jugoslavenska akademija
znanosti i umjetnosti, 1959. 78 pp. (Fr. sum.: 71-78),
81 pls., several plans in text.
 In Serbo-Croatian. A comprehensive discussion of the
Bogomil necropolises at Blidinje. After an analysis of each
necropolis the author considers monument types, organizing the
discussion as follows: form, decoration, technique, orientation,
location, and dating.

357 _____. "Stećci okoline Kladnja" (Fr. sum.: "Stećaks (stećci)
aux environs de Kladanj"). NS 12 (1969):155-76 (Fr. sum.:
176).
 In Serbo-Croatian. A systematic regional study of medieval
tombstones. Individual cemeteries, as well as general regional
formal and symbolic characteristics, are discussed. The material
is dated between the fourteenth and sixteenth centuries.

358 _____. "Stećci u Bitunjoj" (Fr. sum.: "Les stećaks ā
Bitunja"). NS 9 (1964):79-101 (Fr. sum.: 101).
 In Serbo-Croatian. A systematic regional study of medieval
tombstones. Individual cemeteries, the remains of a small church
(first half of the fifteenth century), and general formal and
symbolic regional characteristics are discussed. The material is
believed to date from the fifteenth century.

359 _____. "Stećci u dolini Neretve (s područja Jablaničog
jezera)" (Fr. sum.: "Les 'stetchak' [pierres funéraires] de
la vallée de Narenta [entre Konjic et Rama]"). NS 2 (1954):
181-212 (Fr. sum.: 212).
 In Serbo-Croatian. A survey of medieval tombstones in the
area dating from the fourteenth, fifteenth, and sixteenth cen-
turies. Individual cemeteries as well as general characteristics
of the region as a whole are discussed.

360 _____. "Stećci u Gornjem Hrasnu" (Eng. sum.: "Tombstones of
Gornje Hrasno"). NS 7 (1960):91-112 (Eng. sum.: 112).
 In Serbo-Croatian. A survey of medieval tombstones in the
region, believed to date from the late fourteenth, fifteenth, and
early sixteenth centuries. Individual cemeteries as well as gen-
eral characteristics are discussed.

361 _____. "Stećci u okolini Vlasenice" (Fr. sum.: "'Stećci' des
environs de Vlasenica"). Starinar, n.s. 23 (1974):107-24
(Fr. sum.: 124).
 In Serbo-Croatian. A survey of medieval tombstones in the
vicinity of Vlasenica. The author's investigations suggest that
cemeteries in this group were begun in the fourteenth and were
in use through the sixteenth century. The study includes formal
and iconographic analyses.

362 _____. "Stećci u Ziemlju" (Fr. sum.: "Les 'stećci' de
Ziemlje"). Starinar, n.s. 15-16 (1966):279-92 (Fr. sum.:
292).
 In Serbo-Croatian. A study of medieval tombstones in the
plain of Ziemlje in Hercegovina concludes that they date from
the fourteenth and fifteenth centuries. The study also demon-
strates that they show affinities with other stećci in
Hercegovina, and, to a more limited extent, with those in Bosnia.

363 _____. "Trnovo: Srednjovjekovni nadgrobni spomenici" (Fr.
sum.: "Monuments funéraires médiévaux de Trnovo"). NS 11
(1967):101-35 (Fr. sum.: 135).
 In Serbo-Croatian. A systematic regional study of medieval
tombstones. Individual cemeteries, as well as general formal and
symbolic regional characteristics, are discussed. The group is
dated largely to the fourteenth and fifteenth centuries, though
some may be as early as the end of the thirteenth or as late as
the beginning of the sixteenth century.

364 Bihalji-Merin, Oto, and Benac, A. The Bogomils. London:
 Thames & Hudson, 1962. 34 pp., 80 pls.
 Two essays by the two authors represent widely different
 approaches to the subject of Bogomil sculpture. Bihalji-Merin
 views the problem within the "universal" framework of primitivism,
 while Benac sees the Bogomil creations as being uniquely bound to
 the region and culture which created them.

365 Cevc, Emilijan. Gotska plastika na Slovenskem (Ger. sum.:
 "Gotische Plastik in Slowenien"). Ljubljana: Narodna
 galerija, 1973. 367 pp. (Ger. sum.: 58-72), 171 b&w pls.,
 6 col. pls.
 In Slovenian. An exhibition catalog documenting 157 pieces
 of Gothic sculpture (mostly wood and stone). Each item is dis-
 cussed in detail and is followed by a relevant bibliography. The
 photographs are of outstanding quality.

366 _____. Gotsko kiparstvo [Gothic sculpture]. Ars Sloveniae.
 Ljubljana: Mladinska knjiga, 1967. 59 pp., 103 pls.
 In Slovenian. A general study of Gothic sculpture in
 Slovenia, the book is beautifully illustrated. Examines differ-
 ent trends and regional characteristics, and concludes with a
 catalog of pieces considered.

367 _____. Poznogotska plastika na Slovenskem (Fr. sum.: "La
 sculpture du gothique tardif en Slovénie"). Ljubljana:
 Slovenska matica, 1970. 343 pp., 203 figs. in text.
 In Slovenian. A general survey of late Gothic sculpture in
 Slovenia. The largest portion of the book is devoted to the
 study of late fifteenth- and early sixteenth-century sculpture by
 region. The remainder of the text considers the Renaissance
 trend, and architectural sculpture.

Fiskovič, Cvito. See entry YU 627

368 Fiskovič, Cvito. "Fragments du style roman à Dubrovnik." AI
 1 (1954):117-37.
 A survey of various fragments of relief sculpture, sculp-
 ture in the round, and architectural sculpture belonging to the
 Romanesque period in Dubrovnik.

369 _____. "Prilog dubrovačko-dalmatinskim i apuljskim likovnim
 vezama" (Fr. sum.: "Contribution sur les relations artistiques
 entre Dubrovnik et la Dalmatie d'une part et l'Apulie de
 l'autre"). ZLU 10 (1974):325-31 (Fr. sum.: 331).
 In Serbo-Croatian. A study of late Romanesque sculpture in
 Dubrovnik, Trogir, and Split points to strong connections with
 the sculptural tradition of Apulia.

370 _____. "Stećci u Cavtatu i u Dubrovačkoj Župi" (Fr. sum.:
"Stetchaks du moyen âge à Cavtat et dans Župa de Dubrovnik").
PPUD 13 (1961):147-75 (Fr. sum.: 175).
 In Serbo-Croatian. A discussion of Bogomil tombstones
(stećci) in Cavtat and in Dubrovačka Župa. A survey of decora-
tive and stylistic motifs is analyzed and related to the larger
body of Bosnian material.

371 Fisković, Igor. "Neznani gotički kipar u dubrovačkom kraju"
(Fr. sum.: "Oeuvres d'un sculpteur gothique anonyme à
Dubrovnik et dans śes environs"). Peristil 10-11 (1967-68):
29-40 (Fr. sum.: 40).
 In Serbo-Croatian. Traces the activity of an unknown
sculptor in Dubrovnik and its environs and dates his works on a
stylistic basis to the first half of the fifteenth century.

372 _____. "Uz knjigu W. Woltersa 'La scultura veneziana gotica
1300-1460'" [On the occasion of W. Wolters's "La scultura
veneziana . . .']. Peristil 20 (1977):145-62.
 In Serbo-Croatian. A major critical review which analyzes
extensively the problems of Gothic sculpture in Dalmatia in the
fourteenth and fifteenth centuries.

373 Folnesics, Hans. "Studien zur Entwicklungsgeschichte der
Architektur und Plastik des XV. Jahrhunderts in Dalmatien."
Jahrbuch des Kunsthistorischen Institutes der K.K. Zentral-
Kommission für Denkmalpflege. Vienna: Schroll, 1914,
pp. 27-196.
 A comprehensive, well-documented, well-illustrated study of
fifteenth-century architecture and (primarily) sculpture in
Dalmatia.

374 Gunjača, Stipe. "Atribucija jednog srednjovekovnog splitskog
sarkofaga" [Attribution of a medieval sarcophagus from Split].
ZNM 9-10 (1979):205-19.
 In Serbo-Croatian. A reassessment of arguments regarding
the date of a medieval sarcophagus from Split. Argues in favor
of mid-eleventh century, during the reign of the Archbishop Ivan
(John) IV.

375 _____. "Reconstitution d'une dalle avec représentation du
'dignitaire croate.'" AI 2 (1956):111-17.
 A proposed reconstruction of an old Croatian relief slab
with a representation of a dignitary or a warrior discovered at
Biskupija near Knin. A twelfth-century date is proposed instead
of the earlier view, which placed the piece in the ninth century.

376 Horvat, Andjela. "Dva epitafa u Iloku" (Ger. sum.: "Zwei
 Epitaphien aus Ilok"). ZLU 15 (1979):307-15 (Ger. sum.:
 315).
 In Serbo-Croatian. The article considers two late Gothic
 tomb markers with depictions of armored gisants dated 1477 and
 1524. Only four such tomb markers have survived intact from
 medieval times in continental Croatia. Stylistically they are
 related to Hungarian artistic developments which indicate an
 infusion of Renaissance stylistic elements.

377 Karaman, Ljubo. "O ploči s likom sv. Petra u Stonu" (Ger.
 sum.: "Über das Relief des Hl. Peter in Ston"). ZNM 4
 (1964):219-22 (Ger. sum.: 222).
 In Serbo-Croatian. The curious slab from Ston--represent-
 ing a frontal figure of St. Peter with an ornamental halo and a
 cyrillic inscription--is seen (on stylistic basis), as a work of
 the thirteenth rather than the twelfth century, as previously
 thought.

378 _____. "O porijeklu pregradnih zabata starohrvatskih crkava"
 [Origins of iconostasis gables in old Croatian churches].
 Peristil 3 (1960):97-103 (Ger. sum.: 102-3).
 In Serbo-Croatian. A general consideration of gabled
 iconostasis screens and their dating (roughly eighth-eleventh
 centuries). In addition to the Croatian material, refers to
 German and Italian examples.

379 _____. "O spomenicima VII i VIII stoljeća u Dalmaciji i o
 pokrštenju Hrvata" [Regarding seventh- and eighth-century
 monuments in Dalmatia and the conversion of the Croats].
 Viestnik hrvatskoga arheološkoga društva, n.s. 22-23 (1941-42):
 73-113 (Ger. sum.: 111-13).
 In Serbo-Croatian. A discussion of early Croatian stone
 carving in the context of north Adriatic pre-Romanesque develop-
 ments.

380 _____. "Sarkofag Ivana Ravenjanina u Splitu i ranosredovječna
 pleterna ornamentika u Dalmaciji" [The sarcophagus of John of
 Ravenna in Split and early medieval braided ornament in
 Dalmatia]. Starinar, 3d ser. 3 (1925):43-59.
 In Serbo-Croatian. A discussion of the sarcophagus of the
 Archbishop John (second half of the eighth century). On the
 basis of its style the sarcophagus belongs to the sculptural
 relief development in which three-band braiding had not yet
 appeared.

381 Katić, Lovre. "Stećci u Imotskoj Krajini" [Stećci in Imotska
 Krajina]. SP, 3d ser. 3 (1954):131-67 (Fr. sum.: 168-69).
 In Serbo-Croatian. A detailed study of stećci in the re-
 gion of Imotsko. A descriptive analysis by sites is followed by
 general consideration of the location, typology, source of stone,

ornamentation, iconographic content, symbols, size, and the time
of origin.

382 Korać, Vojislav. "Beleška o načinu rada vizantijskih klesara
 u XI veku" (Fr. sum.: "Note sur les procédés des sculptures
 byzantins du XI^e siècle"). Zograf 7 (1977):11-16 (Fr. sum.:
 16).
 In Serbo-Croatian. Analyzes the remaining fragments of the
 eleventh-century iconostasis screen of St. Sophia at Ohrid and
 attempts to determine geometric principles used in laying out the
 compositions of individual panels. The method is seen as having
 been rooted in general knowledge and application of geometry in
 Byzantine architecture and architectural decoration of the elev-
 enth century.

383 Ljubinković, Mirjana Ćorović. "Estergonski zapadni portal i
 Studenica" (Fr. sum.: "Le portail occidental d'Estergon et
 Studenica"). ZNM 8 (1975):395-407 (Fr. sum.: 406-7).
 In Serbo-Croatian. A study of the lost monumental western
 portal of the cathedral of St. Adalbert at Estergon (Hungary) and
 its links with the main portal of the church of the Virgin at
 Studenica monastery. The two contemporaneous achievements are
 seen as reflections of Eastern and Western influences simulta-
 neously affecting the art of Hungary and Serbia during the reigns
 of Bela III and Stefan Nemanja respectively.

384 Maksimović, Jovanka. "Gotsko-vizantijska skulptura i dva
 primera iz Dubrovnika i Kotora" (Fr. sum.: "La sculpture
 byzantino-gothique et deux examples à Dubrovnik et Kotor").
 ZFF 11, pt. 1 (1970):337-44 (Fr. sum.: 344).
 In Serbo-Croatian. Examines cross-cultural influences in
 certain sculptural pieces found in Dubrovnik and Kotor, which
 reveal Gothic and Byzantine aspects of style. The influences are
 seen as having reached the area through Venice.

385 _____. "Justinijanski modeli u skulpturi od IX do XI veka"
 (Fr. sum.: "Les modèles justiniens dans la sculpture de IX^e
 au XI^e siècle"). Zbornik Svetozara Radojčića. Edited by
 Vojislav J. Djurić. Belgrade: Filozofski fakultet, Odeljenje
 za istoriju umetnosti, 1969, pp. 163-72 (Fr. sum.: 172).
 In Serbo-Croatian. A broad discussion of stylistic and
 iconographic emulations of Justinianic models in the pre-
 Romanesque sculpture of Dalmatia and southern Italy (esp.
 Apulia).

386 _____. "Kamene ikone u Zadru" (Fr. sum.: "Icônes de pierre
 de Zadar"). ZFF 12, pt. 1 (1974):379-91 (Fr. sum.: 390-91).
 In Serbo-Croatian. Analyzes a number of Byzantine relief
 icons in Zadar portraying individual standing figures (Virgin
 with Christ Child, two icons of St. Anastasia, Christ), as well
 as an icon depicting the Nativity of Christ. The material is

related to the Byzantine prototypes, and the question is raised
whether these icons were local products or imports (e.g., from
Venice). Argues in favor of the existence of a local school
under Byzantine influence ("maniera greca") which paralleled the
mainstream Romanesque development, as witnessed in monumental
sculpture of church façades.

387 _____. Kotorski ciborij iz XIV veka i kamena plastika
susednih oblasti (Fr. sum.: "Le ciborium de Kotor du XIVe
siècle et la sculpture des régions voisines"). Srpska
akademija nauka i umetnosti. Posebna izdanja, 345. Belgrade:
Naučno delo, 1961. 115 pp. (Fr. sum.: 105-15), 62 pls.,
1 foldout drawing.
 In Serbo-Croatian. A detailed analysis of the fourteenth-
century ciborium of the Kotor Cathedral. The ciborium is first
considered within the framework of regional art, and then in a
more general context. The cult and the legend of St. Tryphon are
also discussed. The final two chapters consider the questions of
the style and dating of the monument.

388 _____. "Model u slonovači zadarskog kamenog reljefa i neka
pitanja preromanske skulpture" (Fr. sum.: "Le relief de
Zadar, son modèle en ivoire et quelques questions de la
sculpture préromane"). ZRVI 7 (1961):85-96 (Fr. sum.:
95-96).
 In Serbo-Croatian. An ivory relief depicting several
scenes from the life of Christ (now in a private collection in
England) is seen as a model for stone slabs decorated in low re-
lief. The virtually identical iconography of the two works of
art compels the author to support the notion that in general
Byzantine and Eastern influence was affecting the development of
pre-Romanesque and Romanesque sculpture in the West, and that the
minor arts were the means for the dissemination of such influ-
ence.

389 _____. "Moravska skulptura" (Fr. sum.: "La sculpture de
l'école de la Morava"). In Moravska škola i njeno doba.
Edited by Vojislav J. Djurić. Belgrade: Filozofski fakultet,
Odeljenje za istoriju umetnosti, 1972, pp. 181-90 (Fr. sum.:
189-90).
 In Serbo-Croatian. A general discussion of Serbian archi-
tectural sculpture during the fourteenth and fifteenth centuries,
its sources, and its relationship to the minor arts.

390 _____. "Reljef splitskih Blagovesti: Jedna vizantijsko-
latinska simbioza" (Fr. sum.: "Relief de l'Annonciation de
Split, une symbiose Byzanto-Latine"). ZFF 7, pt. 1 (1963):
227-40 (Fr. sum.: 239-40).
 In Serbo-Croatian. Examines the iconographic and stylistic
characteristics of the Annunciation relief from the base of the
campanile of the Cathedral of Split. The piece, dated to the

thirteenth century, is found to have both Gothic and Byzantine
characteristics. It is seen as belonging to the classicistic
trend which characterized European sculpture in the thirteenth
century.

391 _____. "La sculpture romane du XIVe siècle en Espagne, France,
 Italie et Yougoslavie." ZLU 10 (1974):61-70.
 A comparative study of late Romanesque sculpture in south-
 ern Europe. The focus is on a number of iconographic and sty-
 listic aspects which reveal a wide spread. Attempts to clarify
 the character of fourteenth- and fifteenth-century architectural
 sculpture in Serbia.

392 _____. Srpska srednjovekovna skulptura (Fr. sum.: "La
 sculpture médiévale serbe"). Studije za istoriju srpske
 umetnosti 6. Novi Sad: Matica srpska, Odeljenje za likovne
 umetnosti, 1971. 187 pp. (Fr. sum.: 155-76), 278 pls.
 In Serbo-Croatian. A general history of medieval Serbian
 sculpture. The book is organized in three chapters: sculpture
 of Zeta (Montenegro) from the ninth to the end of the twelfth
 centuries; sculpture of Raška from the end of the twelfth to the
 second half of the fourteenth century; and sculpture of Morava
 from the second half of the fourteenth to the middle of the fif-
 teenth century. Exposure to Eastern and Western influence is
 given special attention.

393 _____. "Tradition byzantine et sculpture romane sur le lit-
 toral adriatique." ZRVI 11 (1968):93-98.
 The iconographic and stylistic influence of the Byzantine
 tradition on the development of Romanesque sculpture along the
 two coasts of the Adriatic is seen as the survival of the Byzan-
 tine presence in the area, which lasted until the end of the
 twelfth century along the eastern coast. Dalmatia (and interior
 reflections), Apulia and Venice are considered.

394 _____. "Vizantijski i orijentalni elementi u dekoraciji
 Moravske škole" (Fr. sum.: "Éléments byzantins et orientaux
 dans la décoration de l'école de la Morava"). ZFF 8, pt. 1
 (1964):375-84 (Fr. sum.: 383-84).
 In Serbo-Croatian. A study of the origins of the sculpture
 of the Morava school. Explores the Byzantine and the oriental
 (mostly Islamic) component.

395 Marlot, Marijan. "Celjski nadgrobniki 15. in 16. stoletja"
 (Fr. sum.: "Les pierres tombales du XVme et XVIme siècle, à
 Celje"). ZUZ 8, nos. 3-4 (1928):73-85 (Fr. sum.: 73).
 In Slovenian. The five sculptures, dated between 1421 and
 1572, are rare examples of monumental sculpture in the area.
 They reflect the evolution from Gothic to Renaissance style.

396 Marušić, Branko. "Novi spomenici ranosrednjovekovne skulpture
 u Istri, na Kvarnerskim otocima" [New monuments of early
 medieval sculpture in Istria and the Kvarner Islands].
 Bulletin Instituta za likovne umjetnosti Jugoslavenske
 akademije znanosti i umjetnosti 4, no. 8 (1956):7-13.
 In Serbo-Croatian. A brief survey of new finds of pre- and
 early Romanesque architectural sculpture. Observes links with
 the late Antique traditions and in certain cases concludes that
 it is impossible to determine whether the work is a medieval imi-
 tation or a late Antique original.

397 Mesesnel, Francé. "Mittelalterliche figurale Skulpturen im
 heutigen Südserbien." Studi bizantini e neoellenici 6 (1940):
 257-65. (Atti del V Congresso internazionale di studi bizan-
 tini 2.)
 Considers Romanesque stone sculpture (e.g., from Banjska,
 Dečani), as well as Byzantine wood sculpture (e.g., iconostasis
 doors from Prilep and Andreaš, and the statue of St. Clement from
 Ohrid).

398 Nikolajević, I[vanka]. "Miscellanea o srednjovekovnoj skulp-
 turi u Jugoslaviji" (Eng. sum.: "Some remarks on medieval
 sculpture in Yugoslavia"). ZRVI 18 (1978):227-45 (Eng. sum.:
 245-46).
 In Serbo-Croatian. A geographically broad consideration of
 medieval sculpture in Yugoslavia. Accounts for certain phenomena
 in Bosnia (Predjelo, Dabravina, Breza and Dikovača), Macedonia
 (Drenovo), and Dalmatia (Pridraga) which are related to the
 Western developments. Despite acknowledged links with early
 medieval sculpture of Italy and Greece proposed by André Grabar,
 the author argues against the early dating of this material.

399 _____. "Motiv 'rozeta sa ptičijom glavicom' na pilastriću iz
 Bogdašića (Bosna)" (Fr. sum.: "'Rinceau à tête d'oiseau':
 Ornement d'un pilier de chancel de Bogdašić, en Bosnie").
 ZRVI 17 (1976):165-73 (Fr. sum.: 173).
 In Serbo-Croatian. The iconographic motif of rinceau with
 a head of a bird is analyzed in the context of medieval architec-
 tural sculpture in Bosnia. Argues for its dating between the
 tenth and twelfth centuries, in contrast to the commonly accepted
 dating in the seventh or eighth centuries.

400 _____. "Sculpture médiévale dans les régions centrales de la
 Yougoslavie: Question de chronologie." Balcanoslavica 5
 (1976):69-78.
 A general consideration of medieval sculpture in Bosnia and
 Herzegovina. Questions some of the earlier groupings of the ma-
 terial and their dating in the early medieval period.

401 _____. "La sculpture ornamentale au XII^e siècle en Bosnie et
en Herzégovine." ZRVI 8, pt. 2 (1964):295-309.
 A consideration of the problematic twelfth-century sculp-
tural tradition in Bosnia. Argues for closer ties between Bosnia
and Italy (Sicily, Apulia) and other Western lands.

402 Petricioli, Ivo. "Neobjelodanjene romaničke skulpture u
Zadru" (Fr. sum.: "Sculptures romanes inédites [Zadar]").
PPUD 7 (1953):21-27 (Fr. sum.: 87).
 In Serbo-Croatian. Discusses several unrelated Romanesque
sculptural pieces and fragments from Zadar. The main pieces in-
clude a baptismal font (base), capitals, and relief icons.

403 _____. "Plutej s figuralnim kompozicijama iz zadarske crkve
sv. Lovre" (Fr. sum.: "Le chancel presbytériel à compositions
figurées de l'église de Saint Laurent à Zadar"). In Zbornik
instituta za historijske nauke u Zadru. Edited by Duje
Rondić-Miočević. Zadar: Filozofski fakultet sveučilišta u
Zagrebu, 1955, pp. 59-80 (Fr. sum.: 79-80).
 In Serbo-Croatian. A detailed discussion of relief sculp-
ture on fragmented parapet slabs from the church of Sv. Lovro
(St. Lawrence) in Zadar. Though loosely dated between the tenth
and early twelfth centuries, the reliefs are seen as major works
marking the transition from the purely abstract decoration to
figural compositions of mature Romanesque.

404 Petrov, Konstantin. "Dekorativna plastika na spomenicite od
XIV vek vo Makedonija" (Fr. sum.: "La plastique décorative
des monuments du XIV^e siècle en Macédoine"). Godišen zbornik.
Filozofski fakultet na univerzitetot Skopje 15 (1963):199-286
(Fr. sum.: 282-86).
 In Macedonian. An exhaustive study of fourteenth-century
architectural sculpture in Macedonia. Technical and stylistic
aspects are discussed and compared with contemporaneous examples
elsewhere. Principal monuments considered include: the ambo of
Archbishop Gregorius in St. Sophia in Ohrid, Staro Nagoričino,
St. Athanasius at Lešak, Ljuboten, Lesnovo, Markov Manastir, and
St. Nicholas on Treska River.

405 _____. "Dekorativna plastika vo Makedonija vo XI i XII vek"
(Fr. sum.: "La plastique décorative en Macédoine au XI^e et
XII^e siècle"). Godišen zbornik. Filozofski fakultet na
univerzitetot Skopje 14 (1962):125-85 (Fr. sum.: 183-85).
 In Macedonian. An exhaustive study of architectural
sculpture in Macedonia dating from the eleventh to the twelfth
centuries. Technical and stylistic aspects are discussed and
compared with relevant examples from other parts of the Byzantine
world. Principal monuments discussed are St. Sophia in Ohrid and
the church of St. Panteleimon at Nerezi.

406 _____. "Dva srednovekovni figuralni reljefi od Makedonija" (Fr. sum.: "Deux reliefs figuratifs du moyen âge en Macédoine"). Godišen zbornik. Filozofski fakultet na univerzitetot Skopje 16 (1964)103-30 (Fr. sum.: 128-30).

 In Macedonian. A discussion of two sculptural fragments—a fragmentary "icon" depicting a side view of the bust of St. John the Theologian found at Demir Kapija, and a fragmented relief of Archangel Michael from Ohrid. The former piece is dated to the eleventh century; the latter to the thirteenth-to-fourteenth centuries.

407 _____. "Kapiteli od oltarnata pregrada na neidentificirana ohridska crkva" (Fr. sum.: "Les chapiteaux du parapet de l'autel d'une église non identifiée à Ochrid"). Godišen zbornik. Filozofski fakultet na univerzitetot Skopje 16 (1964):131-38 (Fr. sum.: 138).

 In Macedonian. An analysis of three capitals belonging to an unknown church in Ohrid and believed to date from the eleventh to the twelfth century.

408 Prijatelj, Kruno. "Skulpture s ljudskim likom iz staro-hrvatskog doba" (Fr. sum.: "Sculptures de l'époque vieille croate représentant la figure humaine"). SP, 3d ser. 3 (1954):65-91 (Fr. sum.: 91-91).

 In Serbo-Croatian. An exhaustive article and catalog of pre-Romanesque Croatian sculpture depicting human images. Considers twenty-six known examples.

409 Pušić, Ilija. "Preromanska dekorativna plastika u Kotoru" (Fr. sum.: "Décoration plastique pre-romane à Kotor"). Boka 3 (1971):39-52 (Fr. sum.: 52).

 In Serbo-Croatian. A corpus of fragments of pre-Romanesque architectural sculpture in Kotor. Analyzes twenty-seven pieces which indicate a stylistic development in this area consistent with other parts of the Dalmatian coast during the period between the ninth and eleventh centuries.

410 Sergejevski, D[imitrije]. Ludmer. Srednjevjekovni nadgrobni spomenici B i H, no. 4. Sarajevo: Zemaljski muzej, 1952. 38 pp. (Fr. sum.: 38), 48 pls., 1 map, 3 site plans.

 In Serbo-Croatian. A comprehensive discussion of the Bogomil necropolises at Ludmer. Monuments are grouped by type. Their form, ornament, execution and dating are analyzed.

411 Stojković, Ivanka Nikolajević. "Prilog proučavanju vizantiske skulpture od 10 do 12 veka iz Makedonije i Srbije" (Fr. sum.: "Contribution à l'étude de la sculpture byzantine de la Macédoine et de la Serbie"). ZRVI 4 (1956):157-86 (Fr. sum.: 186).

 In Serbo-Croatian. An important survey of Byzantine sculpture between the tenth and twelfth centuries in the central

Balkans (Serbia and Macedonia). Stylistic and technical aspects
are examined, as are parallels with early Christian and early
Byzantine prototypes and links with Western and Islamic tradi-
tions.

412 ____. "Skulptura srednjevekovnih crkava Bosne i Hercegovine"
 (Eng. sum.: "The sculpture in some churches in Bosnia and
 Hercegovina"). ZRVI 5 (1958):111-23 (Eng. sum.: 123).
 In Serbo-Croatian. A reassessment of sculptural decoration
 of medieval Bosnia. Rejects earlier hypotheses which denied the
 existence of a sculptural tradition in Bosnia between the early
 Christian and late medieval periods. Much new material is exam-
 ined in the light of related examples (e.g., in Dalmatia), and a
 tentative conclusion is reached that a sculptural tradition did
 exist in Bosnia, and that the material (including architecture)
 must be reexamined in this light.

413 Stošić, Josip. "Kiparska radionica opčinske palače u Puli"
 (It. sum.: "Maestranza di scalpellini del Palazzo communale a
 Pola"). Peristil 8-9 (1965-66):25-46 (It. sum.: 45-46).
 In Serbo-Croatian. An exhaustive study of the work of the
 late thirteenth-century sculptural workshop at Pula, whose main
 achievement was the decoration of the Public building at Pula.
 Their work is also noted at Karšete, Buje, Novigrad, Poreč,
 Vodnjan, and Motovun.

414 Šuput, Marica. "Vizantijski plastični ukras u graditeljskim
 delima kralja Milutina" (Ger. sum.: "Byzantinische plastische
 Dekoration an den Bauten des Königs Milutin"). ZLU 12 (1976):
 43-55 (Ger. sum.: 54-55).
 In Serbo-Croatian. A study of low-relief sculptural deco-
 ration in churches built by King Milutin. The monuments dis-
 cussed are: Hilandar, Banjska, King's Church at Studenica, and
 the fourteenth-century remodeling of St. Sophia at Ohrid.

415 Vego, Marko. Ljubuški. Srednjevjekovni nadgrobni spomenici
 B i H, no. 6. Sarajevo: Zemaljski muzej, 1954. 48 pp. (Ger.
 sum.: 46-48), 44 pls., 2 site plans.
 In Serbo-Croatian. A comprehensive analysis of the Bogomil
 necropolises at Ljubuški. Monuments are grouped by type. Their
 form, ornament, execution, and chronology are discussed.

416 ____. "Ploča sa ćirilskim natpisom i likom Sv. Petra iz
 Stona. Revizija čitanja natpisa" (Eng. sum.: "Tablet with
 inscription in the cyrillic alphabet and St. Peter's image
 from Ston"). NS 7 (1960):139-44 (Eng. sum.: 144).
 In Serbo-Croatian. The paleographic and linguistic anal-
 ysis of the inscription provides a date in the second half of the
 twelfth or first two decades of the thirteenth century, which is
 consistent with the stylistic characteristics of the work.

417 Vidović, Drago. "Srednjevjekovni nadgrobni spomenici u
 okolini Zvornika" (Fr. sum.: "Les monuments funéraires
 médiévaux de Zvornik"). NS 3 (1956):221-38 (Fr. sum.: 238).
 In Serbo-Croatian. A survey of medieval tombstones from
 the region, believed to be of late fourteenth- or early fifteenth-
 century date. Groups of monuments as well as certain general
 characteristics are discussed.

418 Wenzel, Marian. Ukrasni motivi na stećcima [Ornamental motifs
 on tombstones from medieval Bosnia and surrounding regions].
 Biblioteka Kulturno nasljedje. Sarajevo: Veselin Masleša,
 1965. 453 pp., 115 pls., numerous maps.
 Parallel Serbo-Croatian and English texts. An exhaustive
 study of ornamental motifs on medieval Bosnian tombstones. Orna-
 ments are grouped by type. Their geographic distribution, icono-
 graphic implications, and sources are analyzed.

MINOR ARTS

419 Ammann, A.M. "Ein wenig bekanntes byzantinoslawisches
 Enkolpion aus dem Domschatz in Hildesheim." Pepragmena tou
 9 Diethnous byzantinologikou synedriou (Athens) 1 (1955):
 126-33.
 Publication of a little-known "Jerusalem cross" from the
 treasury of Hildesheim cathedral, long believed to be an encol-
 pion of Patriarch Joachim V of Jerusalem given to Charlemagne.
 The author shows it to be a later, thirteenth- or fourteenth-
 century work with Old Church Slavonic inscriptions.

420 Andjelić, Pavao. "Grobovi bosanskih kraljeva u Arnautovićima
 kod Visokog" (Fr. sum.: "Tombeaux des rois bosniaques à
 Arnautovići, près de Visoko"). GZMS, n.s. 17, pt. A (1962):
 165-71 (Fr. sum.: 170-71).
 In Serbo-Croatian. A reconsideration of archeological
 material excavated at Arnautovići in 1909-1910. The material
 includes fragments of cloth embroidered with gold and silver
 thread, featuring elements of Bosnian medieval royal insignia.
 On the basis of a detailed analysis the author concludes that
 these fragments may come from the tomb of Tvrtko I.

421 Bach, Ivan. "Emaljne pločice iz XII stoljeća u Rabu" (Ger.
 sum.: "Emailplättchen aus dem XII Jahrhundert in Rab").
 Peristil 14-15 (1971-72):55-60 (Ger. sum.: 60).
 In Serbo-Croatian. A group of fine enamel plaques from
 Rab depicting Apostles is believed to come from Mosan workshops
 and to have once belonged to a portable altar.

422 Bach, Ivan; Radojković, B.; and Comisso, Dj. Le travail
 artistique des métaux des peuples Yugoslaves au cours des
 siècles. Exhibition catalog. (Part 1: Text, bibliography,
 illustrations; Part 2: Catalog). Belgrade: Muzej primenjene
 umetnosti, 1956. Pt. 1: 30 pp., 125 illus.; Pt. 2: 110 pp.
 A catalog of a major exhibit of metalwork on the territory
 of Yugoslavia from the seventh to the twentieth centuries. A
 large portion of the material is medieval.

423 Birtašević, Marija. Srednjovekovna keramika (Eng. sum.:
 "Medieval ceramics"). Zbirke i legati Muzeja grada Beograda.
 Katalog 2. Belgrade: Muzej grada Beograda, 1970. 99 pp.
 (Eng. sum.: 38-48), 26 tables with drawings, 98 pls.
 In Serbo-Croatian. A fine general survey of medieval pot-
 tery found on the territory of Belgrade and kept in the City
 Museum of Belgrade. The collection includes Byzantine, early
 Slavic, Avar, Serbian, Hungarian, and Austrian pottery. The book
 includes a detailed catalog and excellent illustrations.

424 Božanić, Nevenka Bezić. "Doprinos gotičkom zlatarstvu u
 Trogiru" (Fr. sum.: "Contribution à l'étude de l'orfèvrerie
 à Trogir"). ZNM 9-10 (1979):393-97 (Fr. sum.: 397).
 In Serbo-Croatian. Two late Gothic reliquaries with crystal
 containers are discussed in the context of late medieval gold-
 smith works in Dalmatia and in the light of the goldsmiths known
 to have been active in the area from the thirteenth century on.

425 Čremošnik, Irma. "Nalazi nakita u srednjevjekovnoj zbirci
 Zemaljskog muzeja u Sarajevu" (Fr. sum.: "Parure dans la
 collection du moyen âge au Musée National de Sarajevo").
 GZMS, n.s. 6 (1951):241-70 (Fr. sum.: 270).
 In Serbo-Croatian. A broad overview of jewelry in the
 Zemaljski muzej, focusing on the medieval material. The material
 is presented by site: Mogorjelo, Crikvenica (Doboj), Breza,
 Arnautovići, Bihać, Klisa-Ališići (Sanski Most), Vručica (Teslić),
 Mujdžići (Jajce), and Bosanska Rača.

426 Djurić, Mirjana Tatić. "Steatitska ikonica iz Kuršumlije"
 (Fr. sum.: "La petite icône en stéatite de Kuršumlija").
 ZLU 2 (1966):65-85 (Fr. sum.: 84-85).
 In Serbo-Croatian. An important study of the small
 steatite icon of the Virgin of Intercession, discovered in the
 excavations of the church of the Virgin at Kuršumlija. The
 Byzantine iconography of the Virgin of Intercession is examined
 in different art media.

427 Djurić, Vojislav J. "Vizantijske i Italo-vizantijske starine
 u Dalmaciji 1" (Fr. sum.: "Antiquités byzantines et italo-
 byzantines en Dalmatie"). PPUD 12 (1960):123-45 (Fr. sum.:
 145).

In Serbo-Croatian. Considers Venetian miniatures on a
bishop's mitre in Trogir and on a metal book cover from the
Benedictine abbey in Zadar. Also discusses an icon of the en-
throned Virgin and Child and the donor, from Korčula.

428 Dušanić, Svetozar. <u>Muzej srpske pravoslavne crkve</u> [Museum of
the Serbian Orthodox Church]. Mala istorija umetnosti.
Spomenici i zbirke. Belgrade: Jugoslavija, 1969. 20 pp.,
1 col. pl., 48 b&w pls.
In Serbo-Croatian. A general survey of the collection of
the Museum of the Serbian Orthodox Church in Belgrade. The se-
lection of plates includes the finest pieces in different media--
embroidery, metalwork, manuscript illumination, icon painting,
woodcuts, and woodcarving.

429 Gerasimov, T. "La reliure en argent d'un evangéliare du XIVe
siècle à Ochrida." <u>ZRVI</u> 12 (1970):139-42.
The fine silver book cover from Ohrid is dated to the
fourteenth century. In it are seen late reflections of earlier
iconographic themes.

429a See Addenda

430 Gušić, Marijana. "Perizom u raki Sv. Šimuna u Zadru" (Eng.
sum.: "Perizome in the tomb of St. Simon at Zadar").
<u>Balcanica</u> 8 (1977):145-88 (Eng. sum.: 185-86).
In Serbo-Croatian. Considers the shroud of St. Simeon at
Zadar, an embroidered work with pearls dating from the fifteenth
century. The work was commissioned and donated by the Serbian
ruler Georgije Despot, whose name appears on the inscription, and
whom the author interprets to be Stefan the Blind, the Serbian
despot between 1486-1496. Examines thoroughly the technical as-
pects of the shroud, though the historical interpretation of the
workmanship appears to be somewhat tenuous.

431 Hadži-Pešić, Marija Bajalović. "Dekorisana keramika Moravske
Srbije" (Fr. sum.: "La céramique décorée de la Serbie mora-
vienne"). <u>Starinar</u>, n.s. 30 (1980):49-53 (Fr. sum.: 53).
In Serbo-Croatian. A brief general discussion of late
medieval pottery in Serbia. Decorative patterns, forms, and
techniques are examined.

432 Han, Verena. "Duborez Srbije, Makedonije i susednih zemalja
u svetlu ornamentike Moravske škole" (Fr. sum.: "La sculpture
sur bois en Serbie, Macédoine et dans les pays voisins, vue à
partir de l'ornementation de l'école de Morava"). In <u>Moravska
škola i njeno doba</u>. Edited by Vojislav J. Djurić. Belgrade:
Filozofski fakultet, Odeljenje za istoriju umetnosti, 1972,
pp. 323-39 (Fr. sum.: 337-39).
In Serbo-Croatian. Examines links between woodcarving and
architectural sculpture of the so-called Morava School. While

woodcarving may have led the way in the evolution of the Morava style, it was subsequently strongly influenced by the achievements in architectural sculpture.

433 _____. Intarzija na području Pećke Patrijaršije, XVI–XVIII vijek (Eng. sum.: "Intarsia in the Balkan area under the jurisdiction of the patriarchate of Peć, XVI–XVIII c."). Studije za istoriju srpske umetnosti, 2. Novi Sad: Matica srpska, Odeljenje za likovne umetnosti, 1966. 158 pp. (Eng. sum.: 135–48), 92 pls.
 In Serbo-Croatian. The book deals with intarsia works executed in Serbian lands under the Turkish domination. Examines the aspects of medieval survival as well as Islamic influence.

434 _____. "Intarzirani predmeti XVI i XVII stoljeća iz crkava fruškogorskih manastira" (Fr. sum.: "Objets incrustés du XVIe et XVIIe siècles dans les églises des monastères de la Fruška Gora"). ZLU 1 (1965):145–58 (Fr. sum.: 157–58).
 In Serbo-Croatian. Several wooden objects decorated with incrustation from Fruška Gora monasteries are attributed to known artists and are related to their other works.

435 _____. "Marginalije uz nalaze oslikanog srednjovjekovnog stakla iz Kraljeve Sutjeske" (Fr. sum.: "Notes marginales sur les découvertes du verre peint médiéval de la localité de Kraljeva Sutjeska"). Balcanica 8 (1977):137–44 (Fr. sum.: 144).
 In Serbo-Croatian. Considers the find of rare glass fragments with painted decoration which shed new light on glass production in Murano (whence glass was generally imported into this region) during the first half of the fifteenth century.

436 _____. "Une coupe d'argent de la Serbie médiévale." Actes du XIIe Congrès international d'études byzantines (Belgrade) 3 (1964):111–19.
 Discusses a silver cup dating from the second half of the fourteenth century with an enamel medallion depicting a panther at the bottom. The characteristically scalloped cup is compared to other contemporaneous material, including fresco representations.

437 Jelovina, Dušan. Starohrvatske nekropole na području izmedju rijeka Zrmanje i Cetine [Old Croatian necropolises]. Biblioteka znanstvenih djela 2. Split: Čakavski sabor, 1976. 176 pp. (Ger. sum.: 165–76), 91 pls.
 In Serbo-Croatian. A survey of material finds in old Croatian necropolises. Jewelry constitutes a large percentage of the finds, although other metal objects (e.g., buckles, buttons, weapons, etc.) were also decorated.

438 _____. "Statistički tipološko-topografski pregled staro-

hrvatskih naušnica na području S.R.Hrvatske" (Fr. sum.:
"Aperçu topographique, typologique et statistique des boucles
d'oreille vieux-Croates sur le territoire de la République
Populaire de Croatie"). SP, 3d ser. 8-9 (1963):101-19 (Fr.
sum.: 119).
 In Serbo-Croatian. A study of typological and geographical
distribution of old Croatian earrings on the territory of the
present-day Republic of Croatia. Illustrated with photographs of
characteristic types and with foldout maps showing the geographic
distribution of different types.

439 Jelovina, Dušan, and Vrsalović, Dasen. "Die materielle Kultur
 der altkroatischen Gräberfelder auf dem Gebiete des dalmatin-
 ischen Kroatien." AI 7 (1966):85-97.
 A study of old Croatian material culture (mostly minor
arts) based on excavation finds in old Croatian cemeteries of
Dalmatia. Useful charts listing sites, excavation dates, types
of finds, etc. are included.

440 Jevrić, Mirjana. "Panagie du trésor du monastère de Dečani."
 Actes du XIIe Congrès international d'études byzantines
 (Belgrade) 3 (1964):151-57.
 A thorough study of the "Panagia" (liturgical vessels) from
Dečani Monastery. Considers the iconography, style, techniques,
and inscriptions, and dates the piece to the end of the twelfth
century.

441 Jironšek, Željko. "Bjelokosni diptih ranog srednjeg vijeka u
 galeriji Jugoslavenske akademije u Zagrebu" (Fr. sum.: "La
 diptyque médiéval en ivoire de la galerie d l'Académie Yougo-
 slave de Zagreb"). ZUZ 5-6 (1959):105-22 (Fr. sum.: 120-22).
 In Serbo-Croatian. An ivory dyptich representing a stand-
ing figure of Christ under an arcade and an enthroned Virgin with
Child, also under an arcade, finds its closest parallels in early
Ottonian ivory works, and should be dated to the late tenth or
early eleventh century. The work, like the Ottonian works, be-
trays a survival of the Carolingian tradition.

442 Kovačević, Jovan. Srednjovekovna nošnja balkanskih Slovena.
 Studija iz istorije srednjovekovne kulture Balkana. (Ger.
 sum.: "Mittelalterliche Trachten der Balkanslwen"). Srpska
 akademija nauka. Posebna izdanja 215. Belgrade: Naučna
 knjiga, 1953. 361 pp. (Ger. sum.: 315-30), 11 col. pls.,
 73 b&w pls.
 In Serbo-Croatian. An exhaustive survey of medieval
fashion in Serbia. The study is based on a few surviving exam-
ples of medieval fabrics, on written sources, and primarily on
pictorial information. Provides a corpus of fresco depictions of
medieval garbs (imperial, royal, aristocratic, monastic, peasant,
military, etc.). Jewelry is also considered.

443 Lazović, Miroslav. "Une bague serbe à Genève." Zograf 9
 (1978):27.
 Examines the silver ring from a private collection in
 Geneva in relationship to other known examples. The inscription
 on the ring does not indicate its owner. On the basis of
 comparative material and paleography the ring is dated to the
 fourteenth century.

444 Ljubinković, Mirjana Ćorović. "Arhijerejsko odejanije nepoz-
 natog raškog mitropolita" (Fr. sum.: "Le costume liturgique
 d'un métropolite de la Rascie"). ZNM 4 (1964):289-306 (Fr.
 sum.: 305-6).
 In Serbo-Croatian. A detailed analysis of a medieval
 liturgical garb of a bishop discovered in an eighteenth-century
 bishop's tomb in the church of St. Peter at Novi Pazar.

445 _____. "Les arts mineurs de la Serbie du moyen âge et
 Byzance." Corsi di cultura sull'arte ravennate e bizantina
 10 (1963):147-79.
 A major article on the minor arts of medieval Serbia.
 Thoroughly documented, the article presents the material in a
 broad historical context.

446 _____. "Bijoux communs aux Slaves du Sud et leurs variantes
 locales: Boucles et pendants d'oreilles." AI 3 (1959):
 111-19.
 A comparative study of jewelry among the early South Slav
 settlers in Pannonia, Dalmatia, and Slovenia. Identifies common
 themes as well as local variants.

447 _____. "Metalni nakit belobrdskog tipa: Grozdolike mindjuše"
 (Fr. sum.: "La parure en metal chez les Slaves du Sud aux
 IX-XIème siècles: Boucles d'oreilles à appendice en forme de
 grappe"). Starinar, n.s. 2 (1951):21-56 (Fr. sum.: 56).
 In Serbo-Croatian. An important general study of early
 jewelry (earrings with grape-like endings) among South Slavs.
 The study has determined that during the period between the tenth
 and twelfth centuries a high-level indigenous material culture
 developed among the South Slavs in general.

448 _____. "Pretečina desnica i drugo krunisanje Prvovenčanog"
 (Fr. sum.: "Le dextre du Précurseur et le couronnement de
 Stephan Prvovenčani"). Starinar, n.s. 5-6 (1956):105-14
 (Fr. sum.: 114).
 In Serbo-Croatian. A preliminary study of the reliquary
 containing the right forearm of St. John the Baptist, now in the
 treasury of the Cathedral of Siena. The reliquary has a Serbian
 inscription with the name of Sava I, the first Serbian arch-
 bishop, and is believed to have been used during the second
 coronation of the first Serbian king, Stefan Prvovenčani. The
 artistic aspects of the reliquary are discussed summarily.

449 ____ . Srednjevekovni duborez u istočnim oblastima Jugo-
slavije (Fr. sum.: "Les bois sculptés du moyen âge dans les
régions orientales de la Yougoslavie"). Arheološki institut.
Posebna izdanja 5. Belgrade: Naučno delo, 1965. 167 pp.
(Fr. sum.: 141-61), 94 pls., 1 foldout drawing, 15 figs. in
text.
 In Serbo-Croatian. A comprehensive study of medieval and
post-medieval woodcarving in the eastern parts of Yugoslavia.
The material is presented in two major chronological chapters:
the Middle Ages and the period of Turkish rule. Other related
traditions and phenomena (e.g., woodcarving on Mt. Athos) are
also discussed. The final chapter (pp. 134-40)· is devoted to
the known woodcarvers, their lives and practices.

450 Maksimović, Jovanka. "Émaux italo-byzantins en Italie méri-
dionale et à Dubrovnik." Actes du XII^e Congrès international
d'études byzantines (Belgrade) 3 (1964):245-49.
 Discusses the reliquary of St. Blaise in the treasury of
the Cathedral of Dubrovnik, given to the Cathedral in 1694. The
reliquary incorporates older enamel pieces which are considered
to have been made in Italy in the twelfth century, at the time
when enamel work was in a period of decline.

451 Medaković, Dejan. Grafika srpskih štampanih knjiga XV-XVII
veka (Ger. sum.: "Die Graphik der serbischen Drucke vom XV
bis zum XVII Jahrhundert"). Srpska akademija nauka. Posebna
izdanja 309. Belgrade: Naučno delo, 1958. 275 pp. (Ger.
sum.: 249-63), 125 pls.
 In Serbo-Croatian. Although chronologically occurring at
the very end of the Middle Ages, the graphic work of the first
Serbian printed books is closely linked to the medieval artistic
tradition. This richly documented and illustrated book provides
an overview of the material spanning two centuries.

452 Miletić, Nada. "Nakit i oružje IX-XII veka u nekropolama
Bosne i Hercegovine" (Ger. sum.: "Schmuck und Waffen des
IX.-XII. Jahrhunderts in den Nekropolen Bosniens und der
Herzegowina"). GZMS, n.s. 18 (Arheologija) (1963):155-78
(Ger. sum.: 177-78).
 In Serbo-Croatian. A useful overview of early medieval
jewelry and weapons discovered in Bosnia. The material is con-
sidered by site and region. Three distinctive groups are
identified: the Frankish cultural circle; the cultural group of
Bijelo Brdo; and the Dalmatian-Croatian cultural group.

453 ____ . "Slovenska nekropola u Gomjenici kod Prijedora" (Ger.
sum.: "Slawische Nekropole im Gomjenica bei Prijedor").
GZMS, n.s. 21-22 (Arheologija) (1966-67):81-154 (Ger. sum.:
146-54).
 In Serbo-Croatian. Archeological report on the excavations
of a major Slavic necropolis, probably dating from the second

half of the tenth and the early decades of the eleventh century.
Especially important is a large quanity of jewelry, presented
typologically.

454 Milošević, Desanka. "Bronzana ikonica Bogorodice sa Hristom"
 (Fr. sum.: "Une icône en bronze de la Vierge a l'Enfant").
 ZNM 9-10 (1979):373-84 (Fr. sum.: 383-84).
 In Serbo-Croatian. The small bronze icon depicting the
 Virgin with Child is analyzed in stylistic and iconographic
 terms. The piece is compared to the related material from
 Rakovac and Elena (Bulgaria), and dated to ca. 1260--around the
 time when the frescoes of the church of the Holy Apostles at Peć
 were painted.

455 _____. "Bronzana kadionica u Narodnom muzeju" (Fr. sum.:
 "Un encensoir de bronze au Musée National"). ZNM 4 (1964):
 283-88 (Fr. sum.: 288).
 In Serbo-Croatian. A rare example of a medieval bronze
 censor is analyzed from the point of view of its form, iconog-
 raphy of its decoration, and style. A variety of results make
 the dating of the piece impossible. A general medieval date is
 accepted, the archaic elements of its figurative decoration
 notwithstanding.

456 Minić, Dušica. "Prilog datovanju srednjovekovne keramike iz
 Kruševca" (Fr. sum.: "Contribution à la datation de la céra-
 mique médiévale de Kruševac"). Starinar, n.s. 30 (1980):
 43-47 (Fr. sum.: 47).
 In Serbo-Croatian. A study of the excavated pottery from
 medieval Kruševac. A major contribution to the knowledge of late
 medieval pottery in Serbia. Particularly interesting are glazed
 vessels with sgrafitto ornaments.

457 Minić, Dušica, and Tomić, Mirjana. "Ostava srednjovekovnog
 nakita u Narodnom muzeju u Požarevcu" (Fr. sum.: "Dépôt de
 parures médiévales au musée de Požarevac"). Starinar, n.s. 21
 (1972):163-68 (Fr. sum.: 168).
 In Serbo-Croatian. A brief account of a medieval jewelry
 treasury excavated in 1969 in the village of Sibnica. The
 treasury contains various pieces of differing dates. It is
 believed to have been buried toward the end of the fourteenth
 or during the first half of the fifteenth century.

458 Mirković, Lazar. "Die byzantinischen Emails auf den Reli-
 quiaren des Hl.Blasius in Dubrovnik." IBAI 10 (1936):272-76.
 (Actes du IVe Congrès international des études byzantines.)
 Discusses the eleventh- and twelfth-century Byzantine
 enamel plaques on reliquaries of St. Blaise in the treasury of
 Dubrovnik Cathedral.

459 _____. Crkveni umetnički vez [Church art embroidery].
 Posebna izdanja 1. Belgrade: Juzej srpske pravoslavne crkve,
 1940. 48 pp., 27 pls.
 In Serbo-Croatian. A survey of medieval and post-medieval
 Serbian church embroidery. The material is presented by types
 (e.g., curtains, shrouds, liturgical garments, etc.). Each piece
 discussed is described in detail and illustrated.

460 _____. "Dve srpske plaštanice iz XIV stoleća u Hilandaru"
 [Two fourteenth-century Serbian epitaphios-embroideries in
 Hilandar]. GSND 11 (1932):111-20 (Fr. sum.: 120).
 In Serbo-Croatian. Two Serbian fourteenth-century
 epitaphios-embroideries--one from Skopje, the other from Lesnovo--
 are analyzed in detail from liturgical, artistic, and historical
 points of view.

461 _____. "Haljina kneza Lazara" [The garb of Prince Lazar].
 UP 1, no. 3 (Dec. 1937):72-73.
 In Serbo-Croatian. A rare preserved example of the medi-
 eval ceremonial garb of a medieval Serbian ruler. The garb--a
 tunic--is identified on the basis of the heraldic symbol which
 appears on one of the two preserved buttons. The garb is of
 embroidered silk, with silver thread trim. Decorative motifs on
 the material betray Islamic influence, probably imported via
 Byzantium.

462 _____. Starine fruškogorskih manastira [Antiquities in the
 monasteries of Fruška Gora]. Istorisko društvo u Novom Sadu.
 Posebna izdanja 3. Belgrade: Geca Kon, 1931. 78 pp.,
 69 pls.
 In Serbo-Croatian. A catalog of art objects in the collec-
 tion of the monasteries of Fruška Gora. The material is grouped
 by monastery. Each object is described briefly with relevant
 objective information (e.g., inscriptions). The elaborate table
 of contents also gives basic information on each piece in French
 and German.

463 _____. Starine stare crkve u Sarajevu [Antiquities in the Old
 Church in Sarajevo]. Spomenik 83. Belgrade: Srpska kraljev-
 ska akademija, 1936. 34 pp., 53 pls.
 In Serbo-Croatian. A catalog of antiquities of the Old
 Serbian Orthodox Church in Sarajevo. The material includes
 objects in a variety of media: wood panel icons, manuscript
 illumination, woodcarving, and metalwork. The collection is one
 of the richest of its kind.

464 Momirović, Petar. "Carske dveri manastira Žitomislića u
 Hercegovini" (Fr. sum.: "La porte 'impériale' du couvent de
 Žitomislić en Herzégovine"). NS 2 (1954):99-112 (Fr. sum.:
 112).

In Serbo-Croatian. A study of one of the finest examples
of seventeenth-century Serbian woodcarving. Concludes that the
painter Radul may also have been a successful woodcarver.

465 Mošin, Vladimir. "Srednjevekovni srpski pečati" [Serbian
 medieval seals]. UP 2, no. 1 (Jan. 1939):6-11.
 In Serbo-Croatian. A brief survey of Serbian medieval
seals illustrated with a number of excellent photographs. The
material is presented against the broader Byzantine and Western
background.

466 Nikolić, Radomir. "Jedan ranosrednjovekovni bronzani krst"
 (Fr. sum.: "Une croix de bronze paléomédiévale"). Saopštenja
 4 (1961):220-22 (Fr. sum.: 222).
 In Serbo-Croatian. A processional bronze cross with five
engraved images (Christ at the top, and Saints Gerontios, George,
Theodor and Polychronia) with Greek inscriptions was a chance
find. It is believed to belong to the ninth or tenth century,
and to have been made in a local workshop.

467 Ostrogorsky, Georg, and Schweinfurth, Philipp. "Das Reliquiar
 der Despoten von Epirus." Seminarium Kondakovianum 4 (1931):
 165-72.
 A historical and art-historical study of the reliquary (now
in the Cathedral of Cuenca, Spain) of the Despot of Epirus, Toma
(Preljubović), and his wife, Byzantine Princess Maria
Paleologina.

468 Pavlović, Slavenka Ercegoví. "Prilog proučavanju naušnica u
 Srbiji od 9. do 13. stoljeća" (Fr. sum.: "Contribution à
 l'étude des boucles d'oreilles en Serbie du IXe au XIIIe
 siècle"). Starinar, n.s. 21 (1972):41-51 (Fr. sum.: 49-51).
 In Serbo-Croatian. A typological and topographical general
study of earrings on the territory of Serbia from the ninth to
the thirteenth centuries.

469 Pecarski, Branka. "Byzantine Influences on Some Silver Book-
 covers in Dalmatia." Actes du XIIe Congrès international
 d'études byzantines (Belgrade) 3 (1964):315-20.
 A number of silver book covers in Trogir and Split, dating
from the twelfth and thirteenth centuries, display strong Byzan-
tine influence despite clear indications that they were products
of local workshops.

470 Popović, Pera J. "Nekoliko zvona iz XV veka" [Several
 fifteenth-century bells]. Starinar, 3d ser. 4 (1926-27):
 105-10.
 In Serbo-Croatian. Considers several preserved medieval
bells from Serbia (mostly fifteenth century). With the exception
of one, bearing a Greek inscription, all others have Slavic in-
scriptions suggesting that they were cast in Serbia itself.

471 Purković, Miodrag Al. Naše staro posudje [Our ancient ves-
 sels]. UP 3, no. 10 (Dec. 1940):309-12.
 In Serbo-Croatian. Discusses Serbian medieval metal ves-
 sels, their art, and references to them in literary sources. The
 material is presented within a broad cultural context.

472 Radojčić, Djordje Sp. "O jednoj srpskoj inkunabuli" [An
 illustrated Serbian incunabula]. UP 4, no. 1 (Jan. 1941):
 23-26.
 In Serbo-Croatian. Discusses the history and the three
 preserved woodcut illustrations of the first book to be printed
 in Serbian (completed Jan. 4, 1494 in Cetinje).

473 Radojčić, S. "Bronzani krstovi-relikvijari iz ranog srednjeg
 veka u beogradskim zbirkama" (Fr. sum.: "Croix-reliquaires
 en bronze du haut moyen âge dans les collections belgradoises").
 ZUZ 5-6 (1959):123-34 (Fr. sum.: 134).
 In Serbo-Croatian. A number of early medieval bronze reli-
 quaries in the shape of the cross from several collections in
 Belgrade are considered in the context of early medieval minor
 arts in the Balkans.

474 Radojković, Bojana. "Les arts mineurs du XIII^e siècle en
 Serbie." L'art byzantin du XIII^e siècle. Edited by Vojislav
 J. Djurić. Belgrade: Faculté de philosophie, Departement de
 l'histoire de l'art, 1967, pp. 131-34.
 A general study of the minor arts in thirteenth-century
 Serbia. Examines the Byzantine, Romanesque, and Islamic compo-
 nents, as well as the contemporary literary references to the
 minor arts.

475 _____. "Kameja sa Hristom Pantokratorom" (Fr. sum.: "Le
 camée avec le Christ Pantocrator"). Zbornik Svetozara
 Radojčiča. Edited by Vojislav J. Djurić. Belgrade:
 Filozofski fakultet, Odeljenje za istoriju umetnosti, 1969,
 pp. 283-86 (Fr. sum.: 286).
 In Serbo-Croatian. A discussion of a mid-thirteenth cen-
 tury cameo from the Museum of Applied Arts in Belgrade. The dat-
 ing of the cameo is based on a stylistic analysis; its provenance,
 however, is unknown.

476 _____. "Krst iz Ozrena Djordja Gostimirovica" (Fr. sum.: "La
 croix de Djordje Gostimirović exécutée pour le monastère de
 St. Nikola à Ozren"). ZLU 10 (1974):105-13 (Fr. sum.: 113).
 In Serbo-Croatian. A sixteenth-century woodcarved cross
 within a silver frame, now in the Patriarchal Museum in Zagorsk,
 U.S.S.R., bears an inscription with the signature of its maker,
 one Djordje Gostimirović.

477 _____. Nakit kod Srba od XII do kraja XVIII veka (Eng. sum.:
"Jewelry with the Serbs, XII-XVIII century"). Belgrade:
Muzej primenjene umetnosti, 1969. 357 pp. (Eng. sum.: 299-
339), 128 figs. in text, 217 pls.
 In Serbo-Croatian. An exhaustive, well-documented and
well-illustrated study of jewelry among the Serbs. The book is
organized in five chapters: 1) Historiography, 2) Types of
jewelry in the Middle Ages, 3) Jewelry value and workshops in
the Middle Ages, 4) Development of jewelry in medieval Serbia,
and 5) Serbian jewelry under the Turkish domination. The great-
est attention is given to the medieval material.

478 _____. "Primenjena umetnost moravske Srbije" (Fr. sum.: "Les
métiers d'art dans la Serbie moravienne"). In Moravska škola
i njeno doba. Edited by Vojislav J. Djurić. Belgrade:
Filozofski fakultet, Odeljenje za istoriju umetnosti, 1972,
pp. 191-210 (Fr. sum.: 207-10).
 In Serbo-Croatian. A detailed examination of minor arts of
the Morava school (jewelry, embroidery, glass, pottery, metal-
work) with an analysis of stylistic traits and their origins.

479 _____. Sitna plastika u staroj srpskoj umetnosti (Parallel
text in French: "Les objects sculptés d'art mineur en Serbie
ancienne"). Belgrade: Jugoslavija and Muzej primenjene
umetnosti, 1977. 55 pp., 78 pls., 4 col. illus in text.
 In Serbo-Croatian. A general study of minor sculpture in
medieval Serbia. The superbly illustrated book considers mate-
rial from the eleventh to the nineteenth centuries. The post-
medieval works (sixteenth-nineteenth centuries) show the stubborn
survival of certain techniques, iconographic concepts and sty-
listic traits.

480 _____. "Srebrena čaša vlastelina Sanka" (Fr. sum.: "La
timbale d'argent du seigneur Sanko"). ZLU 2 (1966):53-62
(Fr. sum.: 60-62).
 In Serbo-Croatian. Analyzes the Serbian inscription on a
silver cup now in the Metropolitan Museum in New York, and at-
tributes the work either to a Bosnian or a Dubrovnik workshop
from the second half of the fourteenth century.

481 _____. Srpsko zlatarstvo XVI i XVII veka (Fr. sum.:
"L'orfèvrerie serbe du XVIe et XVIIe siècle"). Studije za
istoriju srpske umetnosti 3. Novi Sad: Matica srpska,
Odeljenje za likovne umetnosti, 1966. 187 pp. (Fr. sum.:
157-71), 201 pls.
 In Serbo-Croatian. Discusses precious metal work among the
Serbs during the period of Turkish domination. Establishes that
the material from this period perpetuates the medieval tradition
with links to Byzantine, Western, and Islamic metalwork.

482 _____. "Tursko-persijski uticaj na srpske umetničke zanate
XVI i XVII veka" (Fr. sum.: "Les influences turco-persanes
sur les métiers d'art serbes au XVIe et XVIIe siècles"). ZLU
1 (1965):119-41 (Fr. sum.: 140-41).
 In Serbo-Croatian. An examination of Turkish and Persian
influences on Serbian minor arts (metalwork, textiles, and manu-
script illumination). The principal center through which these
influences were transmitted is believed to have been Constan-
tinople.

483 _____. "Une colombe eucharistique du tésor de Saint Clément
d'Ohrid." Actes du XIIe Congrès international d'études
byzantines (Belgrade) 3 (1964):327-31.
 An eucharistic silver vessel in the form of a dove, used
for storing the eucharistic elements, is discussed in relation-
ship to textual references to such vessels. The author proposes
that it dates from the second half of the thirteenth century, and
that it was used in the church of St. Sophia in Ohrid before be-
ing moved to the church of St. Clement. Both Byzantine and
Western parallels are considered.

484 Radojković, Bojana, ed. Istorija primenjene umetnosti kod
Srba (Eng. sum.: "History of the applied arts with the
Serbs"). Vol. 1, Srednjovekovna Srbija [Serbia in the Middle
Ages]. Belgrade: Muzej primenjene umetnosti, 1977. 413 pp.
(Eng. sum.: 373-99), illus.
 In Serbo-Croatian. The book is divided into a series of
chapters, each written by a different author and devoted to one
of the media as follows: 1) Ceramics, 2) Architectural ornamen-
tation, 3) Metalwork, 4) Arms, 5) Coinage, 6) Bone and horn
carving, 7) Wood, 8) Glass, 9) Stone, 10) Fresco ornaments,
11) Textile, 12) Embroidery, and 13) Books. The book is well
documented and beautifully illustrated with numerous black-and-
white and some color illustrations.

485 Šakota, Mirjana. Riznice manastira u Srbiji [Monastic
treasuries in Serbia]. Biblioteka tragovi prošlosti 5.
Belgrade: Turistička štampa, 1966. 29 pp., 91 pls.
 In Serbo-Croatian. A popular survey of the major monastic
treasuries in Serbia. The material is presented by monastery.
Only the finest pieces (icons, manuscripts, metal work, embroi-
dery, woodcarving) are discussed. Illustrations are of fine
quality and include many useful details not found elsewhere.

486 Stejić, Radmila Polenaković. "Une rare découverte du moyen
âge faite dans le village de Gorno Orizari, près de Kočani en
Macédoine." Actes du XIIe Congrès international d'études
byzantines (Belgrade) 3 (1964):321-25.
 A brief analysis of a major fourteenth-century jewelry
find in the tomb at Gorno Orizari, near Kočani. The find in-
cluded several pairs of earrings, a silver reliquary-diptych,
and a tall silver goblet.

487 Stojanović, Dobrila. Umetnički vez u Srbiji od XIV do XIX
 veka (Fr. sum.: "La broderie artistique du XIVᵉ au XIXᵉ
 siècle"). Belgrade: Muzej primenjene umetnosti, 1959.
 83 pp. (Fr. sum.: 35-38), 81 pls.
 In Serbo-Croatian. A survey of embroidery in Serbia from
 the fourteenth to the nineteenth century. In addition to the
 general essay on the subject (pp. 5-34), the book includes a
 catalog of 105 items. Each piece is discussed briefly, and its
 bibliography cited.

488 Stričević, Djordje. "A Serbian Cross in London." Hilandarski
 zbornik 4 (1978):153-68.
 A detailed historical and art-historical analysis of the
 wooden carved cross and its worked silver frame (bearing the
 inscription dated 1640). On the basis of stylistic parallels and
 historical circumstances the author hypothesizes that it may have
 been brought to Gomionica (its original location) from Hilandar
 monastery.

489 Tasić, Dušan. "Hvostanska plaštanica" (Fr. sum.: "L'épi-
 taphios de Hvosno"). Starinar, n.s. 13-14 (1965):151-61 (Fr.
 sum.: 161).
 In Serbo-Croatian. A study of an important painted epi-
 taphios from Hvosno, now in the Patriarchate at Peć. On the
 bais of iconography and style it is dated to ca. 1300.

490 Tomić, Gordana. "Beleške o dvema duboreznim ikonicama" (Fr.
 sum.: "Notes sur deux petites icônes gravées sur bois"). ZLU
 5 (1969):281-89 (Fr. sum.: 288-89).
 In Serbo-Croatian. Examines the miniature icons carved in
 wood. Discovered in graves at Novo Brdo within dated contexts,
 these icons are believed to date from the fourteenth century,
 though no comparable Serbian material exists.

491 Trivunac, Gordana Tomić. "Epitrahilj Mana Ključara" (Fr.
 sum.: "L'étole de Mane Ključar"). ZNM 2 (1958-59):173-89
 (Fr. sum.: 187-89).
 In Serbo-Croatian. The epitrachelion of one Mane Ključar
 is a Walachian work, dated ca. 1518, and is believed to have been
 given to the monastery of the Dormition at Mušutište. The work
 is examined from historical and iconographic points of view.

492 Vasilić, Angelina. "Jedan prilog klasifikaciji epitrahilja
 XIV-XIX veka" (Fr. sum.: "Essai de classification des
 épitrahilions du XIV-XIX siècle"). ZNM 5 (1967):351-73
 (Fr. sum.: 373).
 In Serbo-Croatian. A proposed classification system for
 medieval and post-medieval epitrachelions of the Eastern Orthodox
 churches. The criteria employed include iconographic content and
 decorative motifs.

493 Vulović, Mila. "Crnorečka bronzana kadionica" (Fr. sum.:
 "Encensoir de bronze de Crna Reka"). ZLU 8 (1972):401-5
 (Fr. sum.: 405).
 In Serbo-Croatian. A study of a medieval censer believed
 to date from the first half of the fourteenth century. The dat-
 ing is based on a limited number of surviving examples and on
 depictions of censers on Serbian frescoes.

494 Werner, Joachim. "Frühkarolingische Gürtelgarnitur aus
 Mogorjelo bei Čaplijina (Hercegovina)." GZMS, n.s. 15-16,
 pt. A (1960-61):242-47.
 An analysis of bronze appliqués from a Carolingian belt
 discovered at Mogorjelo. The material is compared to Carolingian
 decorated pieces from northern Europe, and is believed to belong
 to an aristocratic Slavic burial situated within the remains of
 the ancient villa at Mogorjelo.

ICONOGRAPHY

495 Andjelić, Pavao. "Neka pitanja bosanske heraldike" (Fr. sum.:
 "Certaines questions sur l'héraldique bosniaque"). GZMS,
 n.s. 19 (Arheologija) (1964):157-72 (Fr. sum.: 170-72).
 In Serbo-Croatian. A general discussion of heraldic sys-
 tems employed in medieval Bosnia. Analyzes the coat of arms of
 Stjepan II Kotromanić, the use of the star in Bosnian heraldry,
 and the Bosnian flag.

496 Babić, Gordana. "Ikonografski program živopisa u pripratama
 crkava kralja Milutina" (Fr. sum.: "Le programme iconogra-
 phique des peintures murales décorant les narthex des églises
 fondées par le roi Milutin"). In Vizantijska umetnost počet-
 kom XIV veka. Edited by S. Petković. Belgrade: Filozofski
 fakultet, Odeljenje za istoriju umetnosti, 1978, pp. 105-26
 (Fr. sum.: 126).
 In Serbo-Croatian. Discusses the nature of new icono-
 graphic programs which appear in the decoration of narthexes in
 churches of King Milutin. Among the new themes which appear are:
 prefigurations of the Virgin, the Tree of Jessee, portraits of
 hymnographers, illustrated liturgical chants, personifications,
 illustrations of the menologion, etc. These appear alongside
 certain old themes, while replacing some of the themes which had
 become outmoded. ˋ

497 _____ . "O portretima u Ramaći i jednom vidu investiture
 vladara" (Fr. sum.: "Les portraits de Ramaća et un aspect
 particulier de l'investiture des souverains régnants"). ZLU
 15 (1979):151-77 (Fr. sum.: 176-77).
 In Serbo-Croatian. The juxtaposition of donor portraits
 with the portraits of the young Prince Stefan and his mother
 Milica at Ramaća is investigated in light of the established
 custom of depicting ruler portraits in private churches. The

custom is explained as a visual confirmation of the legal con-
tract established by the issuing of the monastic charter.

498 _____. "O Prepolovljenju praznika" (Fr. sum.: "La mi-
Pentacôte"). Zograf 7 (1977):23-27 (Fr. sum.: 27).
 In Serbo-Croatian. Considers the iconographic theme of
mid-Pentecost in general. Among other examples the author ex-
amines frescoes at St. Nichetas-Čučer and at Dečani.

499 _____. "Vladarske insignije kneza Lazara" (Fr. sum.: "Les
insignes de souverain du Prince Lazar"). In O Knezu Lazaru.
Edited by I. Božić and V.J. Djurić. Belgrade: Filozofski
fakultet, Odeljenje za istoriju umetnosti, 1975, pp. 65-79
(Fr. sum.: 79).
 In Serbo-Croatian. A detailed discussion of royal iconog-
raphy employed by Prince Lazar in monumental painting, on seals,
and on coins. While respecting established hierarchic relation-
ships, Lazar--who emerged as one of the most powerful noblemen in
Serbia after the death of Emperor Uroš--strove to legitimize his
role of leader by stressing his family ties with the Nemanjić
dynasty.

500 Challet, Jean. "Bogumili i simbolika stećaka" (Fr. sum.:
"Les Bogomiles et la symbolique des Stećci"). NS 10 (1965):
19-38 (Fr. sum.: 38).
 In Serbo-Croatian. An iconographic study which attempts to
link motifs which appear on "stećak" tombstones with Romanesque
sculpture of Dalmatia, Italy, and France.

501 Davidović, Nadežda. "Predstava Bogorodice sa Hristom
'Krmiteljem' u Bogorodici Ljeviškoj u Prizrenu" (Ger. sum.:
"Mutter Gottes Bild mit dem Christus 'Krmitelj' in der
Ljeviška Kirche von Prizren"). SKM 1 (1961):85-92 (Ger.
sum.: 91-92).
 In Serbo-Croatian. A study of the fresco representing the
Virgin with Christ the Provider, one of the few surviving fres-
coes in the church from the thirteenth century. The icono-
graphically unusual representation is believed to be a copy of a
lost icon. The type is also illustrated at Sopoćani and at the
church of the Virgin Hodegetria at Peć.

502 Djordjević, Ivan. "Stari i Novi zavet na ulazu u Bogorodicu
Ljevišku" (Fr. sum.: "La représentation de l'Ancien et du
Nouveau Testament à l'entrée de la Vierge Ljeviška"). ZLU 9
(1973):15-26 (Fr. sum.: 26).
 In Serbo-Croatian. An interpretation of two winged female
figures on the entrance arch into the exonarthex of Bogorodica
Ljeviška as the personifications of the Old and the New Testa-
ments.

503 Djurić, Mirjana Tatić. "L'iconographie de la donation dans
 l'ancien art Serbe." Actes du XIV^e Congrès international des
 études byzantines, 1971 (Bucharest) 3 (1976):311-22.
 Conisders the problem of donor iconography in different
 media of Serbian medieval art. The article is thoroughly docu-
 mented and makes numerous comparisons with relevant material from
 other parts of the Byzantine sphere.

504 _____. "Ikona Bogorodice 'Prekrasne,' njeno poreklo i ras-
 prostranjenost" (Fr. sum.: "L'icône de la Vierge Peribleptos:
 Son origine et sa diffusion"). Zbornik Svetozara Radojčiča.
 Edited by Vojislav J. Djurić. Belgrade: Filozofski fakultet,
 Odeljenje za istoriju umetnosti, 1969, pp. 335-54 (Fr. sum.:
 354).
 In Serbo-Croatian. Considers the origins and dissemination
 of the Virgin Peribleptos type. Found in the East and the West
 alike, it is considered a reflection of common interests in the
 classical heritage. The type was especially popular in Serbia
 and Macedonia during the fourteenth century.

505 _____. "Ikona Bogorodice Skopiotise" (Fr. sum.: "L'icône de
 la Vierge Skopiotissa"). Zbornik. Arheološki muzej na
 Makedonija (Skopje) 6-7 (1975):245-56 (Fr. sum.: 255-56).
 In Serbo-Croatian. The Virgin type known as Skopiotissa is
 associated with the hill Skopos near Jerusalem--the legendary
 hill of Christ's passion.

506 _____. "Ikona Bogorodice Znamenja" (Fr. sum.: "L'icône de la
 Vierge du Signe"). ZLU 13 (1977):3-26 (Fr. sum.: 23-26).
 In Serbo-Croatian. An exhaustive study of the "Virgin of
 the Sign" in Byzantine iconography. The majority of the examples
 discussed are from Serbia and Macedonia.

507 _____. "Ikona Jovana Krilatog iz Dečana" (Fr. sum.: "L'icône
 de Jean ailé de Dečani"). ZNM 7 (1973):39-51 (Fr. sum.:
 50-51).
 In Serbo-Croatian. A discussion of the unusual early
 seventeenth-century icon representing a winged St. John the
 Baptist. The type is related to the fourteenth-century prece-
 dents as well as to contemporaneous developments.

508 _____. "Iz naše srednjovekovne mariologije: Ikona Bogorodice
 Evergetide" (Fr. sum.: "De notre mariologie médiévale:
 L'icône de la Mère de Dieu Evergetide"). ZLU 6 (1970):15-36
 (Fr. sum.: 33-36).
 In Serbo-Croatian. An exhaustive study of the iconography
 of the Virgin Evergetis, whose cult was centered in the monastery
 of the Abramites in Constantinople. The focus of the study is on
 the depiction of this type of Virgin in medieval art of Serbia.

509 _____. "Marija-Eva, prilog ikonografiji jednog retkog tipa
 Orante" (Fr. sum.: "Marie-Ève, contribution à l'iconographie
 d'un type rare d'Orante"). ZLU 7 (1971):209-18 (Fr. sum.:
 216-18).
 In Serbo-Croatian. A study of the icon of the Virgin
 Orans, who is characterized by the fact that the palms of her
 hands face the observer. The type of icon is seen as a variant
 in which the commonly emphasized parallelism between Mary and Eve
 is employed.

510 _____. "Pijeta sa Jovanom i Josifom Arimatijskim" (Fr. sum.:
 "Icône de la Pietà avec St. Jean et Joseph d'Arimathie").
 ZNM 9-10 (1979):551-69 (Fr. sum.: 568-69).
 In Serbo-Croatian. The seventeenth-century icon depicting
 the Pietà with St. John and Joseph of Arimathea is compared to
 other related works of the Cretan school of painting from the
 sixteenth and seventeenth centuries. The presence of Joseph of
 Arimathea is seen as a Byzantine elaboration of a Western scene--
 a phenomenon characteristic of the Cretan school of this period.

511 _____. "La Vierge de la Vraie Espérance: Symbole commun aux
 arts byzantin, géorgien et slave." ZLU 15 (1979):79-90.
 A study of the iconography of the "Virgin of True Hope"--a
 common type in the broader sphere of Byzantine influence. The
 type is related to the Virgin of Intercession and occurs in con-
 junction with the depiction of donors at the Virgin's feet.

512 _____. "Vrata slova. Ka liku i značenju Vlahernitise" (Fr.
 sum.: "La porte du verbe: Type et signification de la Vierge
 Blachernes"). ZLU 8 (1972):63-88 (Fr. sum.: 86-88).
 In Serbo-Croatian. Examines the iconography and the mean-
 ing of the Virgin Vlachernitissa in Byzantine art. Refers to
 several later examples from Serbian churches.

513 Djurić, Srdjan. "Predstava Sokrata u Ljubostinji" (Eng. sum.:
 "Socrates represented in a painting at Ljubostinja"). ZLU 13
 (1977):199-204 (Eng. sum.: 203-4).
 In Serbo-Croatian. A bust of a man painted in the lunette
 of painted architecture on the fresco of the Healing of the
 Paralytic is interpreted as a representation of Socrates. The
 choice of Socrates is explained by Byzantine interest in this
 ancient philosopher's work and by a general parallel drawn be-
 tween Socrates the teacher and Christ the teacher.

514 Dragojlović, Dragoljub. "Prilog proučavanju simbolike minija-
 tura srpskog Minhenskog psaltira" (Fr. sum.: "Une contribu-
 tion à l'étude du symbolisme des miniatures du psautier Serbe
 de Munich"). Starinar, n.s. 21 (1972):171-75 (Fr. sum.:
 175).
 In Serbo-Croatian. A brief discussion of certain icono-
 graphic themes in the Serbian Psalter in Munich and their sym-
 bolic implications.

515 Fiskovič, Cvito. "O ikonografiji Radovanova portala" (Fr.
 sum.: "Sur l'iconographie du portail de Radovan"). PPUD 7
 (1953):7-20 (Fr. sum.: 87).
 In Serbo-Croatian. A detailed iconographic study of the
 main portal of Trogir Cathedral, the masterpiece of the sculptor
 Radovan. Dated 1240, the portal displays many innovative aspects
 which look several decades ahead from the point of view of icon-
 ography as well as style.

516 Gabelič, Smiljka. "Četiri freske iz ciklusa arhandjela Mihaila
 u Lesnovu" (Fr. sum.: "Quatre fresques du cycle de l'archange
 saint Michel à Lesnovo"). Zograf 7 (1977):58-64 (Fr. sum.:
 64).
 In Serbo-Croatian. Considers four of the twelve scenes
 from an unusually elaborate cycle dedicated to Archangel Michael
 at Lesnovo. The four scenes, not observed by previous investi-
 gators, represent a valuable contribution to the study of iconog-
 raphy.

517 _____. "Crveni konjanički lik arhandjela Mihaila u Lesnovu"
 (Fr. sum.: "L'Archange Michel de Lesnovo, représenté en
 cavalier rouge"). Zograf 8 (1977):55-58 (Fr. sum.: 58).
 In Serbo-Croatian. Discusses the fresco of patron saint--
 Michael--painted in a shallow niche over the main church door.
 St. Michael is depicted as a military saint with a drawn sword,
 mounted on a red horse. A parallel is drawn between Archangel
 Michael as the leader of the "Heavenly Guard" and the donor of
 the church, Despot Oliver, the leading figure in the Serbian
 state hierarchy under King and later Emperor Dušan.

518 Grabar, André. "Deux images de la Vierge dans un manuscrit
 Serbe." L'art byzantin chez les Slaves: Les Balkans.
 Vol. 1, pt. 2. Paris: Paul Geuthner, 1930, pp. 264-76.
 Considers two images of the Virgin in the Tetraevangelion
 of Belgrade (no. 297) and a twelfth-century manuscript, destroyed
 in 1941.

519 _____. "L'Hodigitria et l'Eléousa." ZLU 10 (1974):3-14.
 A study of two Virgin types of paramount importance in
 Byzantine religious thought and art--the Hodegitria and the
 Eleousa. The investigation focuses on the images of the two
 types depicted at Markov Manastir in their ceremonial use, pre-
 sumably reflecting the Constantinopolitan custom.

520 _____. "Les images de la Vierge de tendresse: Type icono-
 graphique et thème (à propos de deux icônes à Dečani)."
 Zograf 6 (1975):25-30.
 Analyzes an iconographic type of Virgin, as illustrated by
 two icons in the monastery of Dečani. The type and its variants
 are considered in the broadest context of Byzantine art.

521 _____. "Sur les sources des peintres Byzantins des XIIIe et
XIVe siècles." Cahiers archéologiques 12 (1962):351-80.
The first section considers certain iconographic questions
related to late Byzantine painting in the territory of Yugoslavia
(Staro Nagoričino: Righteous Abraham). The second part considers
the function of double icons (in reference to the double icon of
Poganovo, Bulgaria), and theophanies as depicted in church
narthexes (Bachkovo, St. Clement at Ohrid, Markov monastery).

522 Grozdanov, Cvetan. "Ilustracija himni Bogorodičinog akatista
u crkvi Bogorodice Perivlepte u Ohridu" (Fr. sum.: "Illustra-
tions des hymnes de l'Acathiste de la Vierge à l'église de la
Sainte Vierge Peribleptos à Ohrid"). In Zbornik Svetozara
Radojčića. Edited by Vojislav J. Djurić. Belgrade:
Filozafski fakultet, Odeljenje za istoriju umetnosti, 1969,
pp. 39-54 (Fr. sum.: 53-54).
In Serbo-Croatian. A discussion of the Acathist cycle
painted on the north exterior wall of the church of the Virgin
Peribleptos around 1364-1365. Considers the iconographic sources
of each of the illustrated scenes, and places the cycle within
the general context of Paleologan painting.

523 _____. "Kompozicija Opsade Carigrada u crkvi svetog Petra na
Prespi" (Ger. sum.: "Die Komposition 'Belagerung von
Konstantinopel' in der Peterskirche von Prespa"). ZLU 15
(1979):277-87 (Ger. sum.: 286-87).
In Serbo-Croatian. The representation of the "Siege of
Constantinople" in the fourteenth-century church of St. Peter is
analyzed in the context of the cycle of the Acatyst of the
Virgin to which it is directly linked. The scene is a forerunner
of similar scenes commonly depicted in Moldavian churches.

524 _____. "Novootkrivene kompozicije Bogorodičinog akatista u
Markovom manastiru" (Fr. sum.: "Les scènes de l'Acatiste de
la Vierge nouvellement découvertes à Markov manastir").
Zograf 9 (1978):37-42 (Fr. sum.: 42).
In Serbo-Croatian. Discusses six recently cleaned frescoes
from the Acatyst of the Virgin cycle at Markov monastery. The
frescoes are considered in the broadest context of such cycles,
which appear both on frescoes and in manuscript illuminations.
The discovery is an important contribution to the understanding
of such cycles in Paleologan art.

525 Hadermann-Misguich, Lydie. "La grande théophanie de Sainte
Georges de Kurbinovo et le décor du registre des Prophètes."
Zbornik. Arheološki muzej na Makedonija. Skopje 6-7 (1975):
285-95.
Discusses an unusual theophany on the west wall of
Kurbinovo, depicting an enthroned Christ on a round mandorla
surrounded by seraphim and angels, as an adaptation of a program
for a dome which did not exist at Kurbinovo.

526 Karanović, Milan. Grobna crkva grafički izražena na bosanskom
 srednjevekovnom spomeniku (Eng. sum.: "The churchyard chapel
 graphically represented on a Bosnian medieval tomb").
 Novitates Musei Sarajevoensis, no. 11. Sarajevo: Bosansko-
 hercegovački muzej, 1934. 31 pp. (Eng. sum.: 25-31),
 1 foldout chart.
 In Serbo-Croatian. Attempts to decipher abstract patterns
 on a medieval tombstone as having specific meaning and being
 related to a funerary church and its liturgical function.

527 Ljubinković, Mirjana Ćorović. "Dve dečanske ikone Bogorodice
 Umilenija" (Fr. sum.: "Deux icônes de la Vierge du monastère
 de Dečani"). Starinar, n.s. 3-4 (1955):83-91 (Fr. sum.: 91).
 In Serbo-Croatian. Distinctive characteristics of two
 icons depicting the Virgin of Tenderness at Dečani monastery are
 seen as having originated in Serbia. Frescoes from Staro
 Nagoričino (1317) and Bogorodica Ljeviška (1306-1307) are seen
 as monumental forerunners.

528 _____. "Odraz kulta svetog Stefana u srpskoj srednjovekovnoj
 umetnosti" (Fr. sum.: "Reflets du cult de St. Étienne dans
 l'art médiéval Serbe"). Starinar, n.s. 12 (1961):45-62 (Fr.
 sum.: 61-62).
 In Serbo-Croatian. A study of the significance of the cult
 of St. Stephen in religious and political matters of medieval
 Serbia and its reflection in art from the twelfth to the early
 seventeenth centuries.

529 _____. "Predstave grbova na prstenju i drugim predmetima
 materijalne kulture u srednjevekovnoj Srbiji" (Fr. sum.:
 "Les armoiries sur les bagues et les autres objets de la
 culture materielle dans la Serbie médievale"). In O Knezu
 Lazaru. Edited by I. Božić and V.J. Djurić. Belgrade:
 Filozofski fakultet, Odeljenje za istoriju umetnosti, 1975,
 pp. 171-83 (Fr. sum.: 182-83).
 In Serbo-Croatian. Discusses the introduction and spread-
 ing of the family coat of arms in medieval Serbia. The custom,
 accepted from the West, was introduced quite late--in the second
 half of the fourteenth century. Various media (metalwork, stone,
 embroidery, woodcut) are examined. The overwhelming number of
 examples appear on rings.

530 _____. "Uz problem ikonografije srpskih svetitelja Simeona i
 Save" (Fr. sum.: "Sur le problème de l'iconographie de deux
 saints serbes: St. Simeon et St. Sava"). Starinar, n.s. 7-8
 (1958):77-90 (Fr. sum.: 89-90).
 In Serbo-Croatian. The iconographic pairing of SS. Simeon
 and Sava is linked with the appearance of the cult of these two
 saints promoted by the Serbian church and the Nemanjić dynasty.

531 Ljubinković, Radivoje. "Predstava prvog greha u apsidijalnoj
 konhi u crkvi svetog Mihajla kod Stona" (Fr. sum.: "La compo-
 sition de péché originel dans la conque de l'abside de
 l'église Saint Michel près de Ston"). ZNM 4 (1964):223-29
 (Fr. sum.: 229).
 In Serbo-Croatian. The unusual representation of the
 Original Sin in the conch of the main apse of the church of St.
 Michael is interpreted by the author as the evidence of early
 Bogomil influence in Ston where its impact is well documented
 only in the later part of the twelfth and the beginning of the
 thirteenth century.

532 _____. "Sur le symbolisme de l'histoire de Joseph du narthex
 de Sopoćani." L'art Byzantin du XIIIe siècle. Edited by V.J.
 Djurić. Belgrade: Faculté de philosophie, Départment de
 l'histoire de l'art, 1967, pp. 207-37.
 An extensive investigation of symbolism of the Joseph cycle
 in the narthex of Sopoćani. The iconography of all scenes is
 scrutinized closely and against the background of other related
 iconographic themes.

533 Mano-Zisi, Djordje. "Božić u srpskom srednjevekovnom sli-
 karstvu" [Nativity in Serbian medieval painting]. UP 1,
 no. 4 (Jan. 1938):111-14.
 In Serbo-Croatian. A brief general discussion of the por-
 trayal of the Nativity scene in Serbian medieval painting. Il-
 lustrated with scenes from the King's Church at Studenica, Peć,
 Dečani, and Markov monastery.

534 Medaković, Dejan. "Bogorodica 'Živonosni istočnik' u srpskoj
 umetnosti" (Fr. sum.: "Theotocos 'Zōodochos Pēgē' dans l'art
 serbe"). ZRVI 5 (1958):203-18 (Fr. sum.: 217-18).
 In Serbo-Croatian. A survey of the iconographic type of
 the Virgin as the Source of Life in the development of Serbian
 art from medieval times to the eighteenth century.

535 _____. "Pretstave antičkih filosofa i Sivila u živopisu
 Bogorodice Ljeviške" (Ger. sum.: "Darstellungen antiker
 Philosophen und Sibyllen in der Wandmalerei der Kirche
 Bogorodica Ljeviška"). ZRVI 6 (1960):43-57 (Ger. sum.:
 56-57).
 In Serbo-Croatian. The appearance of ancient philosophers
 Plato and Plutarch and the Ethiopian Sybil is seen as a manifes-
 tation both of links between painting and literature, and of
 classical influence on Byzantine painting during the Paleologan
 era.

536 Mijović, Pavle. "Carska ikonografija u srpskoj srednjo-
 vekovnoj umetnosti" (Fr. sum.: "L'iconographie imériale dans
 la peinture serbe médiévale"). Starinar, n.s. 18 (1968):
 103-18 (Fr. sum.: 118).
 In Serbo-Croatian. Analyzes a number of imperial themes
 reflected in the iconography of frescoes at Gračanica, Treskavac,
 Markov monastery, and Lesnovo.

537 _____. "Carska ikonografija u srpskoj srednjovekovnoj umet-
 nosti, 2" (Fr. sum.: "L'iconographie impériale dans l'art
 serbe médiéval 2"). Starinar, n.s. 22 (1974):67-92 (Fr. sum.:
 90-92).
 In Serbo-Croatian. A continuation of a study of imperial
 themes reflected in the iconography of frescoes at Dečani, Relja's
 [Hrelio's] Tower at Rila (Bulgaria), and Markov monastery.

538 _____. "Carska ikonografija u srpskoj srednjovekovnoj umet-
 nosti, 3" (Fr. sum.: "L'iconographie impériale dans l'art
 médiéval serbe 3"). Starinar, n.s. 28-29 (1979):81-120 (Fr.
 sum.: 116-20).
 In Serbo-Croatian. The third installment in a series of
 studies of imperial iconography focuses on certain frescoes of
 Gračanica and examines their iconographic content in the impe-
 rial light.

539 _____. Menolog: Istorijsko-umetnička istraživanja (Fr. sum.:
 "Ménologe: Recherches iconographiques"). Posebna izdanja 10.
 Belgrade. Arheološki institut, 1973. 442 pp. (Fr. sum.:
 395-410), 282 pls., 76 figs. in text.
 In Serbo-Croatian. A major study of menologion cycles in
 Byzantine art. The bulk of the material considered comes from
 churches in Serbia and Macedonia. The book is well illustrated,
 and includes helpful diagrams which illustrate the disposition of
 menologion cycles in individual churches.

540 _____. "Personification des sept péchés mortels dans le
 Jugement dernier à Sopoćani." L'art byzantin du XIIIe
 siècle. Edited by V.J. Djurić. Belgrade: Faculté de
 philosophie, Département de l'histoire de l'art, 1967,
 pp. 239-48.
 Examines the iconography of the seven cardinal sins as
 depicted on the fresco of the Last Judgment at Sopoćani. Clas-
 sical and other ancient works of art are treated as the probable
 iconographical forerunners.

541 _____. "Smrti mučenika u srednjovekovnoj književnosti i
 slikarstvu" (Fr. sum.: "Les morts des martyrs dans la lit-
 térature et la peinture médiévales"). ZLU 4 (1968):3-23
 (Fr. sum.: 23).
 In Serbo-Croatian. A comparative study of martyrdom scenes
 in Byzantine literature and art. A large section of the article

is devoted to the pictorial depictions of martyrdom scenes in
Serbian churches (Gračanica, Dečani, and Peć).

542 _____. "Teofanija u slikarstvu Morače" (Fr. sum.: "La
Théophanie dans la peinture de Morača"). Zbornik Svetozara
Radojčiča. Edited by Vojislav J. Djurić. Belgrade:
Filozofski fakultet, Odeljenje za istoriju umetnosti, 1969,
pp. 179-96 (Fr. sum.: 195-96).
 In Serbo-Croatian. Discusses the cycle of frescoes dedi-
cated to the prophet Elijah in the light of Palestinian influ-
ence on Serbian mid-thirteenth-century art. Explains this
influence as a result of St. Sava's repeated visits to the Holy
Land.

543 Miljković-Pepek, P[etar]. "La fresque de la Vierge avec le
Christ du pilier situé au nord de l'iconostase de Sainte
Sophie à Ohrid." Akten des XI. Internationalen Byzantinisten-
kongresses, 1958 (Munich) (1960):388-91.
 The fresco of the Virgin with a playful Christ child is
contrasted with the one in which the Virgin with Christ is de-
picted frontally and is enthroned, the two forming a symmetric
pair. The author postulates that the two juxtaposed images were
intended to allude to the human and divine natures of Christ.

544 _____. "Umilitelnite motivi vo vizantiskata umetnost na
Balkanot i problemot na Bogorodica Pelagonitisa" (Fr. sum.:
"Les motifs délicats de l'art byzantin des Balkans et le
problème de la Vierge Pelagonitissa"). Zbornik. Arheološki
muzej, Skopje 2 (1958):1-30 (Fr. sum.: 27-30).
 In Macedonian. An exhaustive study of the iconography of
the Virgin and Child in which an intimate relationship is por-
trayed. Focuses on the Virgin Pelagonitissa type.

545 Milošević, Desanka. "Ikonografija Svetoga Save u Srednjem
veku" (Fr. sum.: "Iconographie de Saint Sava au moyen âge").
In Sava Nemanjić--Sveti Sava: Istorija i predanje. Edited
by Vojislav Djurić. Belgrade: Srpska akademija nauka i
umetnosti, 1979, pp. 279-318 (Fr. sum.: 316-18).
 In Serbo-Croatian. An exhaustive study of the iconography
of St. Sava in Serbian medieval painting. Fresco examples are
related to literary sources, and modern literature is considered
fully.

546 _____. "Srbi svetitelji u starom slikarstvu" [Serbian saints
in old Serbian painting]. In O Srbljaku. Edited by
D. Bogdanović et al. Stara srpska književnost. Belgrade:
Srpska književna zadruga, 1970, pp. 143-268.
 In Serbo-Croatian. A major study on the iconography of
Serbian saints. Links between literary sources and paintings
(mostly frescoes) are scrutinized exhaustively. The study is
documented thoroughly.

547 Mirković, Lazar. "Da li se freske Markova Manastira mogu
 tumačiti žitijem Sv.Vasilija Novoga?" (Fr. sum.: "Peut-on
 interpréter les fresques du monastère de Marko par la bio-
 graphie de St. Basile le Nouveau?"). Starinar, n.s. 12
 (1961):77-90 (Fr. sum.: 89-90).
 In Serbo-Croatian. Offers a liturgical interpretation for
 the frescoes in the blind dome in the narthex of Markov monastery
 which depict the Heavenly Liturgy. Refutes S. Radojčić who in-
 terpreted the same frescoes as illustrating the life of St. Basil
 the New (see entry YU 571).

548 _____. "Die Engel und Dämonen auf den Kapitälen der S.
 Demetrius Kirche des Markosklosters bei Skoplje." Actes du
 IIIme Congrès international d'études byzantines (Athens)
 (1932):383-88.
 The unusual occurrence of painted angels and demons on
 column capitals of the church of St. Demetrius is explained by
 citations from liturgical texts.

549 _____. Ikonografske studije (Fr. sum.: "Études iconogra-
 phiques"). Studije za istoriju srpske umetnosti 7. Novi Sad:
 Matica srpska. Odeljenje za likovne umetnosti, 1974. 399 pp.
 (Fr. sum.: 367-99), 122 pls.
 In Serbo-Croatian. A selection of iconographic studies of
 a wide chronological range--from early Christian and Byzantine
 mosaics of Ravenna and Poreč to the post-Byzantine icons of
 Serbia. A large portion of the book is devoted to medieval
 Serbian iconographic problems. One study is devoted to the
 reliquaries of St. Blaise of Dubrovnik.

550 _____. "Die nährende Gottesmutter (Galaktotrophusa)." Studi
 bizantini e neoellenici 6 (1940):297-304. (Atti del V Con-
 gresso internazionale di studi bizantini 2.)
 Considers the iconography of the Virgin breastfeeding the
 infant Christ. A list of eight icons of this rare iconographic
 type--all in Yugoslavia--is included.

551 _____. "Nejasne freske iz ciklusa čuda Sv.Arhandjela Mihaila
 u Lesnovu" (Fr. sum.: "Les fresques obscures du cycle des
 miracles de St. Michel Archange à Lesnovo"). GSND 3 (1928):
 67-70 (Fr. sum.: 70).
 In Serbo-Croatian. Discusses three scenes from the cycle
 of Miracles of Archangel Michael which do not have known
 parallel in standard literary sources. They illustrate local
 miracles which were added to the established list of miracles.

552 _____. "Presveta Bogorodica Milostiva (Jeleusa) u Dečanima"
 (Fr. sum.: "Ste Vierge Miséricordieuse à Dečani"). Starinar,
 3d ser. 7 (1932):3-4 (Fr. sum.: 133).
 In Serbo-Croatian. A brief account of the fresco repre-
 senting the Virgin Eleusa in the diaconion of Dečani. Compara-
 tive material from the Byzantine world is included.

Misguich, L.H. See entry YU 865

553 Momirović, Petar. "Ikonografija duboreznih vrata manastira
 Slepča" (Fr. sum.: "L'iconographie xylographique des portes
 du monastère Slepče). <u>ZLU</u> 6 (1970):55-69 (Fr. sum.: 68-69).
 In Serbo-Croatian. Examines the iconography of sixteenth-
 century wooden doors from Slepča monastery in conjunction with
 similar doors from Treskavac monastery. This art is character-
 ized by a fusion of Romanesque, Byzantine and Islamic elements,
 as is the sculptural decoration of the so-called Morava school.

554 Myslivec, Josef. "Ikonografie Akathistu Panny Marie" (Fr.
 sum.: "L'Acathiste de la Sainte Vierge: Étude iconogra-
 phique"). <u>Seminarium Kondakovianum</u> 5 (1932):97-130 (Fr.
 sum.: 129-30).
 In Czech. A detailed study of the Akathist of the Virgin
 and its reflection in late Byzantine art. A large portion of art
 material considered comes from Serbian medieval churches.

Nikolovska, Z. See entry YU 775
Nikuljska, N. See entry YU 918

555 Pecarski, Branka [Telebaković]. "Antički geniji kao andeli u
 jednom zadarskom rukopisu XIII veka" (Fr. sum.: "Les génies
 antiques devenus anges sur un manuscrit de Zadar du XIIIe
 siècle"). <u>Zbornik Svetozara Radojčića</u>. Edited by Vojislav J.
 Djurić. Belgrade: Filozofski fakultet, Odeljenje za istoriju
 umetnosti, 1969, pp. 271-75 (Fr. sum.: 275).
 In Serbo-Croatian. Compares angel figures in a thirteenth-
 century antiphonary in Zadar with ancient Roman depictions of
 genii, and sees this as evidence of a revived interest in ancient
 forms in the art of the northern Adriatic.

556 Pecarski, Branka Telebraković. "Reljef pranja nogu na portalu
 Trogirske katedrale" (Fr. sum.: "La représentation du
 Lavament des pieds sur le portail de la Cathédrale de
 Trogir"). <u>ZFF</u> 8, pt. 1 (1964):261-78 (Fr. sum.: 276-78).
 In Serbo-Croatian. Analyzes the iconography of the Washing
 of Feet as depicted on the portal of the Cathedral of Trogir.
 While recognizing the general adherence to the Western custom as
 reenacted on Maundy Thursday, the author believes that the
 iconography may also have been subjected to the heretic influence
 of the Patarens. The point cannot be proven because written
 sources contradict each other on some of the crucial issues.

557 Petković, Sreten. "Legenda o svetom Mini u crkvi sela Štave"
 (Eng. sum.: "The legend of St. Menas in a Serbian church of
 the XVIIth century"). <u>Starinar</u>, n.s. 20 (Mélanges Djurdje
 Bošković) (1970):277-88 (Eng. sum.: 288).
 In Serbo-Croatian. The church of St. Menas in the village
 of Štava (near Kuršumlija), painted in 1633-1636, preserves a

rarely depicted cycle of the Miracles of St. Menas, the national
saint of the Copts. The cycle is abridged (only five scenes are
shown), reflecting the strictly conservative religious climate
during which this church was decorated.

558 _____. "Lik cara Uroša u srpskom slikarstvu XVI i XVII veka"
 (Fr. sum.: "La représentation de l'empereur Uroš dans la
 peinture serbe des XVIe et XVIIe siècles"). ZNM 9-10 (1979):
 513-25 (Fr. sum.: 524-25).
 In Serbo-Croatian. An analysis of the iconography of
Emperor Uroš in Serbian painting of the sixteenth and seventeenth
centuries reveals that the type used was based on images of the
Emperor painted in the 1350s, when he was still a child. Such a
choice was consistent with an erroneous legend indicating that
Uroš was murdered as a young man. That legend was the basis of
the Life of Uroš as compiled by patriarch Pajsije in 1642.

559 Petkovic, Vlad[imir] R. "Ciklus slika iz legende Sv. Djordja
 u Dečanima" (Fr. sum.: "Les miracles de Saint Georges dans
 la peinture de l'église de Dečani"). Starinar, 3d ser. 5
 (1930):7-11 (Fr. sum.: 11).
 In Serbo-Croatian. A brief discussion of frescoes illus-
trating the life of St. George. Fifteen fresco compositions are
included.

560 _____. "Die 'Genesis' in der Kirche zu Dečani." IBAI 10
 (1936):48-56. (Actes du IVe Congrès international des études
 byzantines.)
 A study of the iconography of the Genesis cycle of frescoes
at Dečani monastery.

561 _____. "Iz crkvenog kalendara u živopisu Gračanice" [From the
 menologion in the fresco decoration of Gračanica]. GSND 19
 (1938):79-86.
 In Serbo-Croatian. A few scenes from the Menologion cycle
at Gračanica are discussed. This study constitutes a pioneering
effort in the research on monumental Menologion cycles.

562 _____. "Jedan ciklus slika iz Dečana" (Fr. sum.: "Un cycle
 des peintures de l'église de Dečani"). GSND 7-8 (1930):83-88
 (Fr. sum.: 88).
 In Serbo-Croatian. Considers a cycle of frescoes in the
northwest bay of the naos which illustrates twenty-one scenes
from the Acts of the Apostles. Such an extensive cycle of the
Acts is unique in Byzantine monumental painting. The iconography
reveals reliance on the original texts. All of this leads the
author to suspect that the source must have been a now lost
Byzantine manuscript.

563 ____. "Legenda Sv. Save u starom živopisu srpskom" [The
 legend of St. Sava in old Serbian wall painting]. Glas Srpske
 kraljevske akademije 159 (1933):1-76.
 In Serbo-Croatian. The legend of the first Serbian arch-
 bishop, St. Sava, is discussed as a subject of fresco depictions.
 The author also considers the legend of the Serbian martyr-king
 Stefan Dečanski and its portrayal in the works of art.

564 ____. "Priča o 'Prekrasnom Josifu' u Sopoćanima" (Fr. sum.:
 "La légende du 'Beau Joseph' dans la peinture de Sopoćani").
 GSND 1, nos. 1-2 (1926):35-43 (Fr. sum.: 43).
 In Serbo-Croatian. A rare monumental cycle depicting the
 legend of Joseph. Points out the link between manuscript illu-
 mination and monumental painting, but also stresses the reliance
 of this cycle on the iconography derived from the apocryphal
 literature, Arab literature, and Jewish theological texts.

565 Petrović, Petar Ž. "Motiv arkada i stolova na stećcima" (Fr.
 sum.: "Le motif des arcades et des tables sur les 'stećak'").
 Starinar, n.s. 7-8 (1958):195-206 (Fr. sum.: 206).
 In Serbo-Croatian. Argues that the representations of
 tables signify funerary tables derived from the folk beliefs
 about afterlife. Aracdes on the other hand, are seen as a
 strictly decorative motif taken perhaps from funerary tables.

566 Prijatelj, Kruno. "Sv. Dujan i Sv. Staš u likovnoj umjetnosti"
 [St. Domnio and St. Anastasius in figural arts]. Peristil 21
 (1978):25-38.
 In Serbo-Croatian. Part 1 (Medieval period) of a general
 study devoted to the iconography of the two Dalmatian saints. A
 wide variety of media is considered (fresco, mosaics, stone and
 wood carving, manuscript illumination, icon painting, and metal
 work).

567 Radojčić, Ljiljana Manojlović. "Ilustrovani kalendar u
 Markovom manastiru" (Fr. sum.: "Ménologe illustré au
 monastère de Marko"). ZLU 9 (1973):61-81 (Fr. sum.: 80-81).
 In Serbo-Croatian. A detailed iconographic study of the
 menologion cycle at Markov monastery points out the emphasis that
 is placed on scenes which underline suffering and pain as a means
 of dramatizing the heavenly rewards.

568 Radojčić, Svetozar. "'Čin bivajemi na razlučenije duši od
 tela' u monumentalnom slikarstvu XIV veka" (Ger. sum.: "Der
 Kanon der mit dem Tode ringenden in der Malerei des 14. Jahr-
 hunderts"). ZRVI 7 (1961):39-52 (Ger. sum.: 52).
 In Serbo-Croatian. A discussion of the fresco cycle based
 on the text Akolouthia, written by St. Andrew of Crete. This
 cycle illustrating the act of the separation of the soul from the
 body appears in monumental painting of the fourteenth century.
 The principal examples discussed are from the chapel in the tower

of St. George at Hilandar monastery on Mt. Athos, and from the
exonarthex gallery of the church of St. Sophia at Ohrid.

569 _____. "Freska Konstantinove pobede u crkvi Svetog Nikole
 Dabarskog" (Fr. sum.: "La fresque de la victoire de
 Constantin dans l'église Saint Nicolas à Dabar"). GSND 19
 (1938):87-102 (Fr. sum.: 101-2).
 In Serbo-Croatian. A rare example of the portrayal of
 Constantine's victory over Maxentius on a fresco dated ca. 1571.
 The study constitutes a general contribution to the understanding
 of battle scenes and imperial iconography in later Byzantine and
 post-Byzantine painting.

570 _____. "Freska pokajanja Davidovog u ohridskoj Sv. Sofiji"
 (Fr. sum.: "La fresque de la pénitence de David à Sainte
 Sophie d'Ohrid"). Starinar, n.s. 9-10 (1959):133-36 (Fr.
 sum.: 136).
 In Serbo-Croatian. The fourteenth-century fresco of
 David's Penitence in the narthex of St. Sophia at Ohrid is re-
 lated to the concept of Holy Wisdom and is linked with the repre-
 sentation of church councils. Such an interpretation, which
 portrays the subservient role of the ruler vis-à-vis the church,
 is contrasted with similar themes in contemporary Serbian paint-
 ing in which the importance of the ruler is stressed.

571 _____. "Freske Markovog manastira i život sv. Vasilija Novog"
 (Fr. sum.: "Les fresques du monastère de Marko et la vie de
 St. Basile le Nouveau"). ZRVI 4 (1956):215-27 (Fr. sum.:
 226-27).
 In Serbo-Croatian. Describes the link between the iconog-
 raphy of certain frescoes at Markov monastery and the text on
 the life of St. Basil the New. These frescoes illustrate cere-
 monies in New Jerusalem as described in the Life of the Saint
 (see also entry YU 547).

572 _____. "Hilandarska povelja Stefana Prvovenčanog i motiv raja
 u srpskom minijaturnom slikarstvu" (Fr. sum.: "Le charte de
 Chilandar de Stefan Prvovenčani et le motif du paradis dans
 les miniatures serbes"). Hilandarski zbornik 1 (1966):41-50
 (Fr. sum.: 49-50).
 In Serbo-Croatian. Representations of birds of Paradise in
 Serbian manuscript illumination of the fourteenth century are
 linked with similar iconographic details on the portal of
 Studenica and with literary evocations of the same motif.

573 _____. "Ikona 'Hvalite Gospoda' iz Crkvenog muzeja u Skoplju"
 (Fr. sum.: "L'icône 'Laudate Dominum' du Musée d'Église de
 Skoplje"). GSND 21 (1940):109-18 (Fr. sum.: 118).
 In Serbo-Croatian. A study of the iconography of a rarely
 depicted subject illustrating Psalms 148, 149 and 150. Icono-
 graphic details as well as the general conception are linked to

the art of Mt. Athos during the sixteenth and seventeenth cen-
turies.

574 _____. "Jedna scena iz romana o Varlaamu i Joasafu u crkvi
 Bogorodice Ljeviške" (Fr. sum.: "Une scène du roman de
 Barlaam et Josaphat dans l'église de Notre Dame de Ljeviša à
 Prizren"). Starinar, n.s. 3-4 (1955):77-81 (Fr. sum.: 81).
 In Serbo-Croatian. A fresco uncovered in the church of
 Bogorodica Ljeviška is interpreted as a scene from a novel on
 Barlaam and Josaphat in conjunction with Psalm 143. As such, the
 scene would be a rare example of secular content in decoration of
 Serbian medieval churches.

575 _____. "Od Dionisija do liturgijske drame: Beleške o
 pozorištu i predstavama u našim krajevima od Antike do XV
 veka" [From Dionysus to the liturgical drama: Notes on
 theater and performance in our lands from Antiquity to the
 fifteenth century]. Zbornik muzeja pozorišne umetnosti 1
 (1962):5-32.
 In Serbo-Croatian. A discussion of the theater, focusing
 on the depiction of performances in works of art. Emphasizes the
 survival of this practice in the Middle Ages.

576 _____. "Pilatov sud u vizantijskom slikarstvu ranog XIV veka"
 (Fr. sum.: "Le jugement de Pilate dans la peinture byzantine
 du début du XIVe siècle"). ZRVI 13 (1971):293-312 (Fr. sum.:
 311-12).
 In Serbo-Croatian. A general discussion of the iconography
 of Christ before Pilate in Byzantine art of the early fourteenth
 century. The majority of examples are found in Yugoslav monu-
 ments: Staro Nagoričino, Pološko, the church of the Virgin
 Peribleptos at Ohrid, and the church of Joachim and Anna at
 Studenica.

577 _____. "Ruganje Hristu na fresci u Starom Nagoričinu"
 [Mocking of Christ on a fresco in Staro Nagoričino]. Narodna
 starina 14 (1939):3-20 (Ger. sum.: 19-20).
 In Serbo-Croatian. Relates the appearance of liturgical
 drama in Byzantium with the emergence of the iconography of the
 Mocking of Christ. In later times (e.g., fourteenth century)
 when the liturgical drama disappeared, the iconographic motif
 survived.

578 _____. "La table de la Sagesse dans la littérature et l'art
 serbes depuis le début du XIIIe jusqu'au début du XIVe
 siècles." ZRVI 16 (1975):215-24.
 The motif of Wisdom in Serbian literature and art from the
 beginning of the thirteenth to the beginning of the fourteenth
 century is examined in the light of local idosyncracies.

579 ____. "Una poenitentium. Marija Egipatska u srpskoj umet-
 nosti XIV veka" (Fr. sum.: "Sainte Marie l'Égyptienne dans la
 peinture serbe du XIVᵉ siècle"). ZNM 4 (1964):255-65 (Fr.
 sum.: 265).
 In Serbo-Croatian. The appearance of St. Mary the Egyptian
 in fourteenth-century Serbian art is linked with hesychastic in-
 fluence in church matters during the period in question.

580 ____. "Zlato u srpskoj umetnosti XIII veka" (Fr. sum.:
 "L'or dans l'art serbe du XIIIᵉ siècle"). Zograf 7 (1977):
 28-35 (Fr. sum.: 35).
 In Serbo-Croatian. Considers the use of gold in the art of
 medieval Serbia and its symbolic implications, along with liter-
 ary references to such uses. Gold is associated with the "Divine
 Light."

581 Radojković, Bojana. "Bronzana ikonica Jovana Krstitelja" (Fr.
 sum.: "Une petite icône de Jean Baptiste en bronze"). ZNM
 9-10 (1979):491-96 (Fr. sum.: 496).
 In Serbo-Croatian. A small bronze icon depicting a bust of
 winged St. John the Baptist is believed to be a Russian work
 imported into Serbia. The iconographic type is thought to
 have been brought initially to Russia from Serbia.

582 ____. "Tema Otečestva na srpskoj panagiji iz Hilandara"
 (Fr. sum.: "La motif de la Paternité sur la Panaghia serbe de
 Chilandar"). ZLU 15 (1979):103-14 (Fr. sum.: 114).
 In Serbo-Croatian. An analysis of the Trinity dogma and
 the manner of its portrayal on the Serbian late thirteenth- or
 fourteenth-century Panagia in Hilandar monastery in Mount Athos.

583 Radovanović, Janko. "Dva retko predstavljena čuda sv. Nikole
 u starom srpskom slikarstvu" (Fr. sum.: "Deux miracles de
 St. Nicolas rarement représentés dans la vieille peinture
 serbe"). ZLU 11 (1975):275-80 (Fr. sum.: 280).
 In Serbo-Croatian. Discusses two rarely represented
 miracles of St. Nicholas as depicted on seventeenth-century
 Serbian icons and frescoes (an icon from Dečani and frescoes
 from Sv. Nikola Šiševski and the church at Brezova near
 Ivanjica).

584 ____. "Ikona sv. apostola Tome sa njegovom oderanom kožom"
 (Fr. sum.: "Une icône du Saint Apôtre Thomas tenant sa peau
 arrachée"). ZLU 6 (1970):223-38 (Fr. sum.: 238).
 In Serbo-Croatian. A study of an unusual sixteenth-century
 icon depicting the Apostle Thomas holding his own flayed skin in
 . his right hand. This icon is believed to be the sole example of
 this iconographic theme in Serbian medieval art.

585 _____ . "Ikonografija fresaka protezisa crkve svetih Apostola
u Peči" (Fr. sum.: "L'iconographie des fresques dans la
prothèse de l'église des Saints Apôtres à Peč"). ZLU 4
(1968):27-63 (Fr. sum.: 61-63).
 In Serbo-Croatian. A critical reinterpretation of the
iconography of the prothesis frescoes. Revolves around a de-
tailed analysis of the individual scenes and their relationship
to the program as a whole--in which the mission of the Church
militant (on this earth) and Church Triumphant (in heaven) are the

586 _____ . "Ikonografska istraživanja Minhenskog srpskog psaltira"
(Ger. sum.: "Ikonographische Untersuchungen des Münchener
Serbischen Psalters"). ZLU 14 (1978):99-129 (Ger. sum.:
123-29).
 In Serbo-Croatian. A detailed iconographic analysis of the
Serbian Munich Psalter examines the specific relationship of dif-
ferent Psalms with their illustrations as well as with the basic
dogmatic teachings.

587 _____ . "Ikonografske zabeleške iz Dečana" (Fr. sum.:
"Observations iconographiques de Dečani"). Zograf 9 (1978):
20-26 (Fr. sum.: 25-26).
 In Serbo-Croatian. Considers three unusual iconographic
subjects which appear at Dečani: the Tree of Life as a Symbol of
Christ, the Sun and the Moon in the Anastasis scene, and alle-
gories of two sins in the Ascension scene.

588 _____ . "Jedinstvene predstave Vaskrsenja Hristog u srpskom
slikarstvu XIV veka" (Fr. sum.: "Les représentations rares de
la Descente du Christ aux Limbes dans la peinture serbe du
XIVe siècle"). Zograf 8 (1977):34-47 (Fr. sum.: 46-47).
 In Serbo-Croatian. Discusses unusual iconographic depic-
tions of the Anastasis at Gračanica, Peč (the church of the
Virgin), and Bijelo Polje. In addition, considers the depiction
of Christ's soul in Hades in the Serbian Psalter in Munich. The
iconographic idiosyncracies are linked to specific medieval texts.

589 _____ . "Jedno čudo arhandjela Mihaila u Lesnovu" (Fr. sum.:
"Un miracle de l'Archange Michel à Lesnovo"). ZLU 10 (1974):
49-58 (Fr. sum.: 58).
 In Serbo-Croatian. Discusses the surviving portion of a
fresco depicting a miracle of Archangel Michael. This is be-
lieved to be the oldest representation of the event which took
place in Dochiariou Monastery on Mount Athos.

590 _____ . "Nekoliko retko prikazivanih čuda sv. Nikole" (Fr.
sum.: "Quelques miracles de St. Nicolas rarement représentés
dans notre peinture"). ZLU 13 (1977):205-19 (Fr. sum.:
218-19).

In Serbo-Croatian. An analysis of several rarely depicted
miracles of St. Nicholas from the early eighteenth-century church
of St. Nicholas in Pelinovo.

591 _____. "Neveste Hristove u živopisu Bogorodice Ljeviške u
 Prizrenu" (Fr. sum.: "Les 'épouses du Christ' sur les
 fresques de la Vierge de Ljeviša à Prizren"). ZLU 15 (1979):
 115-34 (Fr. sum.: 133-34).
 In Serbo-Croatian. The representation of certain female
saints in Bogorodica Ljeviška is linked to the representations of
Christ and is interpreted as a depiction of Christ's brides,
i.e., female martyrs. The cult of these female martyrs was espe-
cially venerated in Constantinople, whence it may have reached
Serbia.

592 _____. "Prikazi Bogorodice u crkvi Bogorodice Ljeviške u
 Prizrenu" (Fr. sum.: "La présentation de la Vierge à l'église
 de la Mère de Dieu de Ljeviška à Prizren"). SKM 2-3 (1963):
 125-31 (Fr. sum.: 131).
 In Serbo-Croatian. Discusses several different Virgin
types preserved on frescoes at Bogorodice Ljeviška from the point
of view of their iconographic idosyncracies.

593 _____. "Runo Gedeonovo u srpskom srednjovekovnom slikarstvu"
 (Fr. sum.: "La Toison de Gédéon dans la peinture serbe du
 moyen âge"). Zograf 5 (1974):38-43 (Fr. sum: 43).
 In Serbo-Croatian. Gideon's fleece is depicted only four
times on frescoes of medieval Serbia--at Hilandar, Gračanica,
Dečani, and Lesnovo. The rare iconographic subject is analyzed
from the point of view of its general meaning, its location
within the four churches, and specific additional meanings which
it had in each of the four monuments.

594 Radovanović, Nadežda Davidović. "Freska vizije proroka Danila
 u crkvi sv. Apostola u Pečkoj Patrijaršiji" (Ger. sum.:
 "Abhandlung über eine sehr interessanten Freske in der Kirche
 der Heiligen Apostel in Patriarchat in Peć"). SKM 2-3 (1963):
 117-24 (Ger. sum.: 124).
 In Serbo-Croatian. Examines a fresco representing the
Vision of Prophet Daniel in the prothesis of the church of the
Apostles at Peć. The rare scene is studied from the point of
view of its iconographic content. The author is not certain
whether it should be dated to the fourteenth or, with the origi-
nal fresco decoration, to the thirteenth century.

595 _____. "Sibila carica etiopska u živopisu Bogorodice
 Ljeviške" (Fr. sum.: "Le personnage de Sibylle, impératrice
 d'Ethiopie, dans le peinture murale de la Vierge de Ljeviša").
 ZLU 9 (1973):29-42 (Fr. sum.: 42).
 In Serbo-Croatian. Examines the presence of Sibyl, the
Empress of Ethiopia, in the exonarthex of Bogorodica Ljeviška in

relationship to a number of medieval texts which illuminate her
prophesizing the birth of Christ.

596 Schwartz, Ellen C. "The Whirling Disc: A Possible Connection
 between Medieval Balkan Frescoes and Byzantine Icons." Zograf
 8 (1977):24-29.
 The appearance of "whirling discs" in certain iconographic
 contexts of Balkan (mostly Serbian) frescoes is seen as a re-
 flection of a practice employed in Byzantine icon painting of the
 twelfth century.

597 Sergejevski, Dimitije. "Slike pokojnika na našim srednje-
 vjekovnim nadgrobnim spomenicima" (Fr. sum.: "Les représenta-
 tions des morts sur nos monuments funéraires du moyen âge").
 GZMS, n.s. 8 (1953):131-39 (Fr. sum.: 139).
 In Serbo-Croatian. A study of representations of the de-
 ceased on medieval Bosnian tombstones compares the "gisant" mode
 of depiction with the Romanesque tradition of Dalmatia.

598 Soloviev, A.V. "Le symbolisme des monuments funéraires bogo-
 miles et cathares." X. Milletlerarasi bizans tetkikleri
 kongresi tebliğleri (Actes du X. Congrès international des
 études byzantines) (Istanbul) (1957):162-65.
 A brief survey of certain iconographic themes which appear
 on Bogomil and Cathar tombstones.

599 Solovjev, Alexandre. "Les emblèmes héraldiques de Byzance et
 les Slaves." Seminarium Kondakovianum 7 (1935):119-64.
 An exhaustive study on the question of heraldry in
 Byzantium and the Slavic lands. Focuses on the question whether
 the Byzantines actually had a "coat of arms" and reexamines the
 use of the double-headed eagle as a heraldic emblem by the Byzan-
 tines and the Slavs.

600 Steska, Viktor. "Gotske podobe Marijine smrti na Slovenskem"
 [Gothic representations of the Dormition in Slovenia]. ZUZ
 15, nos. 1-4 (1938):59-69.
 In Slovenian. A study of the iconography of the Dormition
 in Gothic painting and sculpture of Slovenia. Eastern and West-
 ern influences are examined.

601 Stojaković, Anka. "Dečansko isceljenje uzetoga" (Fr. sum.:
 "Composition de la guérison du paralytique à Dečani"). SKM
 4-5 (1968-71):203-15 (Fr. sum.: 215).
 In Serbo-Croatian. The iconography of the scene represent-
 ing the healing of the paralytic is shown to have been based on
 Luke (v. 17-26). The architectural setting is related to ancient
 residential architecture of Palestine and to the architecture of
 Capernaum in particular.

602 Subotić, Gojko. "Ikonografija Svetog Save u vreme turske
 vlasti" (Fr. sum.: "Iconographie de Saint Sava ā l'époque de
 la domination turque"). In <u>Sava Nemanjić - Sveti Sava.</u>
 <u>Istorija i predanje</u>. Edited by Vojislav Djurić. Belgrade:
 Srpska akademija nauka i umetnosti, 1979, pp. 343-55 (Fr. sum.:
 354-55).
 In Serbo-Croatian. An exhaustive study of the iconography
 of St. Sava in Serbian painting under Turkish rule. Different
 media (frescoes and icons) are considered in relationship to the
 preceding medieval tradition.

603 Todić, Branislav. "Novootkrivene predstave grešnika na
 Strašnom sudu u Gračanici" (Fr. sum.: "Les figures de pe-
 cheurs nouvellement découvertes dans le Jugement dernier de
 Gračanica"). <u>ZLU</u> 14 (1978):193-204 (Fr. sum.: 204).
 In Serbo-Croatian. A study of newly uncovered and cleaned
 frescoes depicting sinners in the Last Judgment composition. The
 quality of these paintings is found to be very high, featuring
 highly credible representations of nude bodies--rarely depicted
 in Byzantine art. Thematically comparable but artistically in-
 ferior scenes are found at Sopoćani, Bogorodica Ljeviška, and
 Dečani.

604 Velmans, Tania. "Le décor sculptural d'une fenêtre de
 l'église de Kalenić et le thème de la fontaine de vie." <u>ZLU</u>
 5 (1969):89-93.
 The Virgin with Child in the tympanum of a narthex window
 of Kalenić is interpreted as the Fountain of Life theme which is
 used commonly in early Christian and Byzantine art in a variety
 of iconographic manifestations.

605 Vidović, Drago. "Simbolične predstave na stećcima" (Fr. sum.:
 "Les symboles sur les monuments funéraires médiévaux de Bosnie
 et Herzégovina"). <u>NS</u> 2 (1954):119-36 (Fr. sum.: 136).
 In Serbo-Croatian. A study of major symbolic motifs em-
 ployed on medieval stećci: the cross and crucifixion, and the
 crescent and the sun.

606 Walter, Christopher. "The Iconographical Sources for the
 Coronation of Milutin and Simonida at Gračanica." In
 <u>Vizantijska umetnost početkom XIV veka</u>. Edited by S. Petković.
 Belgrade: Filozofski fakultet, Odeljenje za istoriju umet-
 nosti, 1978, pp. 183-200.
 Discusses the double coronation scene showing King Milutin
 and Queen Simonida (Simonis) at Gračanica against the background
 of the Byzantine imperial tradition. The two are linked by King
 Milutin's political aspirations.

607 Wenzel, Marian. "O nekim simbolima na dalmatinskim stećcima"
 (Eng. sum.: "Some symbols found on medieval tombstones in
 Dalmatia"). PPUD 14 (1962):79-94 (Eng. sum.: 94).
 In Serbo-Croatian. Discusses symbols appearing on four
 fourteenth- and fifteenth-century tombs (stećci) in the territory
 of Dalmatia. The material is presented typologically.

BUILDERS, ARTISTS, PATRONS

608 Babić, Gordana. "Društveni položaj ktitora u Despotovini"
 (Fr. sum.: "Le rang social des fondateurs d'églises dans le
 despotat de Serbie"). In Moravska škola i njeno doba. Edited
 by Vojislav J. Djurić. Belgrade: Filozofski fakultet,
 Odeljenje za istoriju umetnosti, 1972, pp. 143-55 (Fr. sum.:
 154-55).
 In Serbo-Croatian. Considers the patrons of art and archi-
 tecture in the Serbian despotate outside the circle of the court.
 The study takes into account surviving monuments, paintings and
 written documents.

609 Baum, Milica. "Poreklo i rad majstora Radula" (Fr. sum.:
 "Les origines et l'oeuvre du maître Radul"). NS 2 (1954):
 245-50 (Fr. sum.: 250).
 In Serbo-Croatian. Presents a hypothesis that the
 seventeenth-century icon painter Radul may have been from
 Sarajevo. The icons from the iconostasis of the Old Serbian
 Orthodox Church are seen as possibly his work.

610 Bezić, Nevenka Božanić. "Majstori od IX do XIX stoljeća u
 Dalmaciji" (Fr. sum.: "Maîtres du IXe au XIXe s. en
 Dalmatie"). PPUD 15 (1963):215-327 (Fr. sum.: 325-27).
 In Serbo-Croatian. The first installment of a major study
 of craftsmen, artisans, builders, and artists active in Dalmatia
 between the ninth and nineteenth centuries. Includes a bibliog-
 raphy and an index. See entries YU 611-613.

611 _____. "Majstori od IX do XIX stoljeća u Dalmaciji, 2" (Fr.
 sum.: "Maîtres du IXe au XIVe s. en Dalmatie, 2"). PPUD 16
 (1966):297-344 (Fr. sum.: 344).
 In Serbo-Croatian. The second installment of a major com-
 prehensive study of craftsmen, artisans, builders and artists in
 Dalmatia. Includes a bibliography and an index. See entries
 YU 610, 612-613.

612 _____. "Majstori od IX do XIX stoljeća u Dalmaciji, 3" (Fr.
 sum.: "Maîtres du IXe au XIXe s. en Dalmatie, 3"). PPUD 17
 (1968):351-77 (Fr. sum.: 377).
 In Serbo-Croatian. The third installment of a major com-
 prehensive study of craftsmen, artisans, builders, and artists in
 Dalmatia. Includes a bibliography and an index. See entries
 YU 610-11, 613.

613 _____. "Majstori od IX do XIX stoljeća u Dalmaciji, 4" (Fr.
 sum.: "Maîtres du IXe au XIXe s. en Dalmatie, 4"). PPUD 20
 (1975):189-250 (Fr. sum.: 250).
 In Serbo-Croatian. The fourth installment of a major study
of artisans and craftsmen in Dalmatia between the ninth and the
nineteenth centuries. Includes a bibliography and an index. See
entries YU 610-612.

614 Bošković, Dj[urdje]. "O nekim našim graditeljima i slikarima
 iz prvih decenija XIV veka" (Fr. sum.: "Sur quelques maîtres-
 maçous et maîtres-peintres des premières décades du XIVe s. en
 Serbie et en Macédoine"). Starinar, n.s. 9-10 (1959):125-31
 (Fr. sum.: 131).
 In Serbo-Croatian. A study which discusses several docu-
mented builders and painters active in fourteenth-century Serbia.
Their names either appear incorporated in the works of art for
which they were responsible, or in formal inscriptions recording
their activities.

615 Djurić, Vojislav J. "Dubrovački graditelji u Srbiji srednjega
 veka" (Fr. sum.: "Architects et maîtres maçons de Dubrovnik
 dans la Serbie médiévale"). ZLU 3 (1967):87-106 (Fr. sum.:
 104-6).
 In Serbo-Croatian. An important contribution to the gen-
eral understanding of the influence of coastal artists and arti-
sans in art and architecture of medieval Serbia. Specific docu-
mented cases are examined: the builder Desina de Risa; a workshop
specializing in construction of lead-sheathed roofs; the partici-
pation of builders and stone-carvers on larger building projects
in Serbia; and negotiations of contracts between Dubrovnik art-
ists and Serbian patrons.

616 _____. "Frano Matijin, dubrovački slikar XVI veka" (Fr. sum.:
 "Frano Matijin, peintre ragusain du XVIe siècle"). Starinar,
 n.s. 5-6 (1956):139-54 (Fr. sum.: 154).
 In Serbo-Croatian. A study of the career and personal
style of the sixteenth-century painter Frano Matijin from
Dubrovnik. The author finds the influence of Frano on two
painters in sixteenth-century Serbia: the painter of the
exonarthex of Banja monastery (ca. 1570); and Kir-Stefan, painter
of a Crucifixion and a Virgin with St. John at Gračanica (1626).

617 _____. "Ime Merkurije iz Psače" (Fr. sum.: "L'inscription
 'Merkuri' à Psača"). ZLU 7 (1971):231-35 (Fr. sum.: 235).
 In Serbo-Croatian. Challenges the idea expressed by
Miljković-Pepek (see entry YU 640) that the name Merkuri on the
sword of St. Merkurios should be interpreted as the name of a
local Slavic painter. Proposes that the name "Merkuri" suggests
a Greek painter, living among the Slavs.

618 _____. "Jedna slikarska radionica u Srbiji XIII veka:
 Bogorodica Ljeviška, Nikoljača, Morača" (Fr. sum.: "Un
 atelier de peinture dans la Serbie du XIIIe siècle").
 Starinar, n.s. 12 (1961):63-76 (Fr. sum.: 76).
 In Serbo-Croatian. Attempts to trace the activities of a
 painting workshop in thirteenth-century Serbia. The study is
 based on the stylistic comparison of fresco remains at Bogorodica
 Ljeviška, at the church of St. Nicholas (Nikoljača) at Studenica
 Monastery, and at Morača. The author detects a "maturing pro-
 cess" leading from Comnenian linearism in the earliest works to
 the plastic fullness evident in later works.

619 _____. "Radionica mitropolita Jovana zografa" (Fr. sum.:
 "Atelier du métropolite Jean le Zographe"). Zograf 3 (1969):
 18-33 (Fr. sum.: 68).
 In Serbo-Croatian. A detailed discussion of the painting
 career and workshop of the metropolitan Jovan, one of the major
 painting figures during the last quarter of the fourteenth cen-
 tury in Macedonia. The principal works of Jovan include frescoes
 at Sv. Andrija (Andreaš) on Treska and at Markov monastery, as
 well as a number of icons.

620 _____. "Slikar Blaž Jurjev" [The painter Blaž Jurjev]. PPUD
 10 (1956):153-67.
 In Serbo-Croatian. Analyzes the artistic achievement of
 the fifteenth-century Dalmatian painter Blaž Jurjev. Born in
 Split, Blaž painted in Trogir and Dubrovnik. The painter is
 shown to have belonged to a group of Dalmatian artists of the
 first half of the fifteenth century which operated under strong
 influence of the Venetian Trecento tradition.

621 _____. "Slikar Radoslav i freske Kalenića" (Fr. sum.: "Le
 peintre Radoslav et les freques de Kalenić"). Zograf 2
 (1967):22-29 (Fr. sum.: 59).
 In Serbo-Croatian. Evangelist portraits from the Serbian
 gospels in the National Library in Leningrad (F.I. 591) are
 linked with frescoes at Kalenić. Because the painter, one
 Radoslav, signed the portrait of the evangelist John in the
 Leningrad gospels, he is identified as one of the major painters
 active in Serbia during the first decades of the fifteenth cen-
 tury.

622 _____. "U potrazi za delom Andrije Raičevića" (Fr. sum.:
 "A la recherche des oeuvres du peintre André Raïtchevich").
 Starine Crne Gore 1 (1963):23-48 (Fr. sum.: 31-32).
 In Serbo-Croatian. An important study reconstructing the
 artistic career of a seventeenth-century icon painter.

623 Fiskovic, Cvito. "Bilješke o Radovanu i njegovim učenicima"
 (Fr. sum.: "Remarques sur Radovan et ses élèves"). PPUD 8
 (1954):10-39 (Fr. sum.: 116).
 In Serbo-Croatian. Discusses in great depth various sty-
 listic and iconographic aspects of the main portal of the Trogir
 Cathedral and attempts to distinguish the work of the master
 sculptor, Radovan, from that of his apprentices.

624 _____. "Dubrovači i primorski graditelji XIII-XVI stoljéa"
 (Fr. sum.: "Constructeurs de Dubrovnik et du littoral, du
 XIII^e au XVI^e s., en Serbie, Bosnie et Herzégovine").
 Peristil 5 (1962):36-44 (Fr. sum.: 44).
 In Serbo-Croatian. An important contribution to the under-
 standing of the extent of the input of Dalmatian builders and
 craftsmen in the Balkan hinterlands. In addition to the general
 discussion of the problem, the author publishes nine relevant
 documents from the Dubrovnik archives.

625 _____. "Dubrovački zlatari od XIII do XVII stoljeća" (Fr.
 sum.: "Les orfèvres de Dubrovnik du XIII^e au XVII^e siècle").
 SP, 3d ser. 1 (1949):143-249 (Fr. sum.: 247-49).
 In Serbo-Croatian. An exhaustive study of Dubrovnik gold-
 smiths from the thirteenth to the seventeenth centuries. The
 study is based on the preserved objects and original documents
 (sixty-one of which are fully published here). Includes a com-
 plete alphabetical list of names of all Dubrovnik goldsmiths.

626 _____. Juraj Dalmatinac. Umjetnički spomenici Jugoslavije.
 Zagreb: Zora, 1963. 35 pp., 73 pls.
 In Serbo-Croatian. A survey of the sculptural opus of the
 fifteenth-century Dalmatian sculptor Juraj Dalmatinac from
 Šibenik (also known in literature as Giorgio da Sebenico). While
 the focus is on his cathedral in Šibenik, his other works, in
 Split, Ancona, and Dubrovnik are also considered. The book is
 illustrated with excellent black-and-white photographs.

627 _____. Naši graditelji i kipari XV. i XVI. stoljeća u
 Dubrovniku [Our builders and sculptors of the fifteenth and
 sixteenth centuries in Dubrovnik]. Zagreb: Matica hrvatska,
 1947. 185 pp., 44 pls.
 In Serbo-Croatian. A well-documented study of the activi-
 ties of builders and sculptors in Dubrovnik during the fifteenth
 and sixteenth centuries. Local traditions are examined in the
 light of foreign influences and local training.

628 _____. "Prilog Jurju Dalmatincu" (Fr. sum.: "Contribution à
 la connaissance de Georges le Dalmate"). PPUD 15 (1963):
 36-45 (Fr. sum.: 45).
 In Serbo-Croatian. Rejects certain earlier attributions to
 Juraj Dalmatinac, at the same time making new ones.

629 _____. Prvi poznati dubrovački graditelji (Fr. sum.: "Les
premiers architects connus de Dubrovnik"). Dubrovnik:
Historijski institut Jugoslavenske akademije znanosti i
umjetnosti, 1955. 137 pp. (Fr. sum.: 139-42), 115 figs.
 In Serbo-Croatian. A well-documented history of earliest
builders in Dubrovnik. Concentrates first on the builders con-
nected with the major churches, public buildings, fortifications,
and finally considers builders of residential architecture. The
works of Dubrovnik builders outside of Dubrovnik, as well as the
works of foreign builders in Dubrovnik, are also considered.

630 _____. Radovan. Umjetnički spomenici Jugoslavije. Zagreb:
Zora, 1965. 24 pp., 98 pls.
 A study of the main work of Radovan, thirteenth-century
Dalmatian master sculptor--the portal of Trogir Cathedral. Con-
siders the work in detail from both iconographic and stylistic
points of view. The book is illustrated with excellent black-
and-white photographs.

631 _____. "Slikar Angelo Bizamano u Dubrovniku" [The painter
Angelo Bizamano in Dubrovnik]. PPUD 11 (1959):72-90.
 In Serbo-Croatian. Discusses the works of Angelo Bizamano,
a sixteenth-century Italo-Cretan painter in Dubrovnik. Several
works are considered, including the altar piece from Komolac (now
in the treasury of the Franciscan monastery in Dubrovnik). Other
works outside of Drubrovnik are also considered and compared.

631a See Addenda

632 Fisković, Igor. "Uz proširenje djelatnosti Jurja Dalmatinca u
Šibeniku" (Fr. sum.: "Sur l'étendue de l'oeuvre de Juraj
Dalmatinac à Šibenik"). ZLU 13 (1977):71-97 (Fr. sum.:
95-97).
 In Serbo-Croatian. Attempts to attribute several undocu-
mented sculptural works in Šibenik to Juraj Dalmatinac, one of
the most distinguished fifteenth-century sculptors and architects
in Dalmatia.

633 Kajmaković, Zdravko. "Kozma-Jovan" (Fr. sum.: "Le peintre
Kozma-Jovan"). ZLU 13 (1977):99-116 (Fr. sum.: 115-16).
 In Serbo-Croatian. A study which aims to deny the existence
of a seventeenth-century Serbian painter by the name of Kozma.
Claims that the works which were mistakenly attributed to him are
actually the works of a painter Jovan--whose opus was therefore
far greater and more significant than hitherto believed.

634 _____. "Uticaj stare srpske grafike na živopis zografa
Vasilija" (Fr. sum.: "L'influence de l'ancienne gravure serbe
sur l'oeuvre du peintre Vasilije"). ZLU 2 (1966):235-42 (Fr.
sum.: 242).
 In Serbo-Croatian. Examines the influence of iconography of

painted woodcuts on the work of a seventeenth-century fresco
painter, one Vasilije. Postulates that the reliance on the
printed book spelled the beginning of the end of the genuine
medieval tradition of fresco painting.

635 Karaman, Ljubo. Andrija Buvina: Vratnice splitske keatedrale
 i drveni kor u splitskoj katedrali (Eng. sum.: "Andrija
 Buvina's doors and the wooden choir bench in the cathedral of
 Split"). Biblioteka likovnih umjetnosti. Zagreb: Zora,
 1960. 49 pp. (Eng. sum.: 43-49), 80 pls., numerous figs.
 in text.
 In Serbo-Croatian. A monographic study of the two master-
 pieces of Andrija Buvina, the oldest known Croatian sculptor.
 The works are dated and are of exceptional artistic and icono-
 graphic interest. The book is richly illustrated with excellent
 photographs including numerous details.

636 Kovijanić, Risto. Vita Kotoranin, neimar Dečana [Vita of
 Kotor: The bulder of Dečani]. Biblioteka Portreti, 2d ser.,
 no. 29. Belgrade: Nolit, 1962. 271 pp., several illus. in
 text.
 In Serbo-Croatian. A historical reconstruction of the per-
 son of Vita, a Franciscan priest from Kotor and the master builder
 of the church of the Savior at Dečani monastery. The study was
 based on extensive investigation of the archival material at
 Kotor.

637 Ljubinković, Radivoje. "Stvaranje zografa Radula: Jedna
 etapa našeg zidnog slikarstva i ikonopisa" (Fr. sum.: "Les
 créations du peintre Radul"). NS 1 (1953):123-31 (Fr. sum.:
 131).
 In Serbo-Croatian. An assessment of the painting career of
 the seventeenth-century Serbian painter Radul. His opus, con-
 sisting of icons and frescoes, was executed in a short period of
 time--between 1671 and 1677.

638 Miljković-Pepek, Petar. Deloto na zografite Mihailo i
 Eutihij (Fr. sum.: "L'oeuvre des peintres Michel et Eutych").
 Kulturno-istorisko nasledstvo vo S.R.Makedonija, no. 10.
 Skopje: Republički zavod za zaštita na spomenicite na kul-
 turata, 1967. 262 pp. (Fr. sum.: 245-63), 143 figs. in text,
 14 diagrams, 195 pls.
 In Macedonian. A major study of the painting workshop of
 Michael and Eutichius, this book is of fundamental importance for
 understanding the style of painting in Byzantine art around 1300.
 Entire programs as well as technical details are analyzed in
 depth.

639 _____. "O slikarima mitropolitu Jovanu i jermonahu Makariju"
 (Fr. sum.: "Sur les peintres le métropolite Jovan et l'hiéro-
 moine Makarije"). In Moravska škola i njeno doba. Edited
 by Vojislav J. Djurić. Belgrade: Filozofski fakultet,

Odeljenje za istoriju umetnosti, 1972, pp. 239-48 (Fr. sum.: 247-48).

In Serbo-Croatian. Discusses the painting oeuvres of two painters active in Macedonia in the last decades of the four-teenth and early decades of the fifteenth century. Several un-published works (especially icons) are attributed to these painters, while their careers are envisioned as having periods of rise, epitome, and decline.

640 _____. "Zograf 'Merkuri': Jedan od autora fresaka crkve sv. Nikole u Psači" (Fr. sum.: "Maître 'Merkuri': L'un des peintres des fresques de l'église St. Nikola à Psača"). ZLU 7 (1971):221-28 (Fr. sum.: 228).

In Serbo-Croatian. A Greek inscription on the sword of St. Mercurios gives the name Merkurios, which is taken to identify one of the painters of the church. The incorrect use of the Greek language leads the author to conclude that the painter was a local Slav who may have received his training in a Greek work-shop. See entry YU 617.

641 Nenadović, Slobodan. "Simboli graditeljskog poziva na spo-menicima u Srbiji" (Fr. sum.: "Les symboles de la profession d'architecte sur les monuments en Serbie"). ZZSK 22-23 (1973): 33-38 (Fr. sum.: 38).

In Serbo-Croatian. This study of mason marks found on medieval monuments of Serbia is the first of this kind to address the issue.

642 Panić, Draga. "O natpisu sa imenima protomajstora u eksonar-teksu Bogorodice Ljeviške" (Fr. sum.: "L'inscription avec les noms des protomaîtres dans l'exonarthex de la Vierge-Ljeviška à Prizren"). Zograf 1 (1966):21-23 (Fr. sum.: 47).

In Serbo-Croatian. A discussion of an important inscription-contract mentioning the names of a builder [?] Nicholas and a painter [?] Astrapas. It is one of the rare instances of such a document having been preserved.

643 Petković, Sreten. "Nektarije Srbin, slikar XVI veka" (Eng. sum.: "Nectarius of Serbia, a sixteenth-century painter"). ZLU 8 (1972):211-26 (Eng. sum.: 225-26).

In Serbo-Croatian. A study of the work of sixteenth-century Serbian painter Nektarije who, in 1557, was commissioned to paint three icons for the church of the Annunciation at Supraslo (in Poland). The remains of the frescoes in the destroyed church suggest that Nektarije may have been responsible for their paint-ing as well.

644 _____. "Zograf Georgije Mitrofanović u Pećkoj Patrijaršiji 1619-1620. godine" (Eng. sum.: "Zograf Georgije Mitrofanović in the Patriarchate of Peć in 1619-1620"). Glasnik muzeja Kosova i Metohije 9 (1964):237-51 (Eng. sum.: 250-51).

In Serbo-Croatian. Considers the painting career of the
monk-painter Georgije Mitrofanović between the years 1615 and
1622. Focuses on his work at the Patriarchate of Peć.

645 Petricioli, Ivo. "Prilog Alešijevoj i Firentinčevoj
 radionici" (Fr. sum.: "Contribution à la connaissance des
 ateliers d'Aleši et de Nicholas le Florentin"). PPUD 15
 (1963):67-74 (Fr. sum.: 74).
 In Serbo-Croatian. Attributes certain new works to the
sculptor Andrija Aleši and attempts to establish links between
his workshop and that of Nikola Firentinac.

646 Prelog, Milan. "Dalmatinski opus Bonina de Milano" (Fr. sum.:
 "L'oeuvre Dalmate de Bonin de Milan"). PPUD 13 (1961):193-
 215 (Fr. sum.: 215).
 In Serbo-Croatian. Traces the architectural and sculptural
activities of Bonino da Milano in Dalmatia during the second and
third decades of the fifteenth century. His major works include
the south portal of the Dominican church and Orlando's Column in
Dubrovnik, the west and the side portals of the Šibenik Cathedral,
and the main portal of the Cathedral of Korčula.

647 Prijatelj, Kruno. "Bibliografski i biografski podaci o
 majstorima dalmatinske slikarske škole" (It. sum.:
 "Contributi bibliografici e biografici sui pittori della
 scuola Dalmata"). PPUD 17 (1968):321-50 (It. sum.: 350).
 In Serbo-Croatian. A study of the lives of painters of the
so-called Dalmatian painting school from the fourteenth to the
sixteenth centuries. The study includes an exhaustive bibliog-
raphy, a catalog of all major painters organized chronologically
together with their brief biographies, and a list of other
lesser-known painters and illuminators in the principal centers.

648 _____. "Novi podaci o zadarskim slikarima XIV-XVI stoljeća"
 (Fr. sum.: "Nouvelles données sur les peintres de Zadar des
 XIVe - XVIe s."). PPUD 13 (1961):96-113 (Fr. sum.: 113).
 In Serbo-Croatian. Discusses archival material discovered
in the Marciana library in Venice pertaining to the lives and
activities of several painters from Zadar from the fourteenth to
the sixteenth centuries.

649 _____. "Prilog trogirskom slikarstvu XV st. O Blažu
 Trogiraninu" (Fr. sum.: "Contribution à la peinture du XVe
 siècle de Trogir"). PPUD 9 (1955):136-54 (Fr. sum.: 312).
 In Serbo-Croatian. Contributes to the study of the local
painting school of Trogir in the fifteenth century. Focuses on
the work of one Blaž Trogiranin.

650 Radojčić, Svetozar. "Archbishop Danilo II and Serbian Archi-
 tecture Dating from the Early 14th Century." Serbian Orthodox
 Church: Its Past and Present 2, no. 2 (1966):11-19.
 An assessment of the major role played by Serbian Arch-
 bishop Danilo II (1324-1337) in the development of Serbian archi-
 tecture during the critical first decades of the fourteenth cen-
 tury. Politics, propaganda, and religious objectives are seen as
 major factors influencing certain key decisions made by Serbian
 kings at the advice of Danilo.

651 _____. Majstori starog srpskog slikarstva (Fr. sum.: "Les
 maîtres de l'ancienne peinture serbe"). Srpska akademija
 nauka. Posebna izdanja, 236. Belgrade: Naučna knjiga, 1955.
 135 pp., 59 figs. in text, 6 col. pls. and 56 b&w pls.
 In Serbo-Croatian. A major study of known painters in
 medieval Serbia. Expands on the knowledge of recorded names, and
 through stylistic and other analyses, attempts to trace the move-
 ment and development of individual painters and their workshops.

652 _____. "Die Meister der altserbischen Malerei vom Ende des
 XII bis zur Mitte des XV Jahrhunderts." Pepragmena tou 9
 dietnous byzantinologikou synedriou (Athens) 1 (1955):433-39.
 A contribution to the study of painters of frescoes in
 medieval Serbia. Discusses a number of painters whose names were
 uncovered, allowing for the identification of personal styles in
 late Byzantine painting.

653 Radojičić, Djordje Sp. "Makarije, živopisac Ljubostinje" (Fr.
 sum.: "Macaire, iconographe de Lioubostinia"). Starinar,
 n.s. 1 (1950):87-90 (Fr. sum.: 90).
 In Serbo-Croatian. Interprets a painted inscription (in
 Old Church Slavonic and Greek) on the lunette over the door be-
 tween the narthex and the naos of Ljubostinja. It was signed by
 one Makarios, who the author links with the one known at Zrze
 monastery near Prilep. The author believes that he migrated
 north following the general migration of patrons and artists into
 Serbian territories controlled by Prince Lazar and his successors.

654 Radojković, Bojana. "Tri zlatara iz Čajniča" (Fr. sum.:
 "Trois orfèvres de Čajniče"). NS 5 (1958):63-67 (Fr. sum.:
 67).
 In Serbo-Croatian. Discusses the work of three eighteenth-
 century goldsmiths from Čajniče: Ivan Milić, Djuro Čajničanin,
 and Pavle Čajničanin, whose names appear on a number of litur-
 gical objects.

655 Šakota, Mirjana Todorović. "Jovan Gramatik: Prepisivač i
 iluminator jedne dečanske knjige" (Fr. sum.: "Jovan Gramatik:
 Copiste et enlumineur d'un livre de Dečani"). Saopštenja 1
 (1956):172-73 (Fr. sum.: 173).

In Serbo-Croatian. Discusses a cryptogram in manuscript
no. 82 of the monastery library of Dečani, on which has been
preserved the name of its illuminator, one Jovan Gramatik. He
was active at the end of the fourteenth and the beginning of the
fifteenth centuries.

656 _____. "Nekoliko Longinovih crteža u Dečanima" (Fr. sum.:
"Quelques dessins de Longin dans le monastēre de Dečani").
SKM 4-5 (1968-71):303-7 (Fr. sum.: 307).
 In Serbo-Croatian. Discusses a badly damaged icon at
Dečani monastery, on which have been preserved several sketches
believed to have been made by the well-known sixteenth-century
icon painter Longin. These are interesting as they represent
free sketches rather than synopia for the icon.

657 _____. "Prilog poznavanju ikonopisca Longina" (Fr. sum.:
"Contribution à l'étude sur le peintre d'icônes Longin").
Saopštenja 1 (1956):156-66 (Fr. sum.: 166).
 In Serbo-Croatian. A manuscript (no. 138) from the monas-
tic library at Dečani was copied in part by the well-known
sixteenth-century icon painter Longin. The text contains some
remarks of value for the study of Longin's life and work.

658 Skovran, Anika. "Longinove ikone i freske u manastiru
Lomnici" (Fr. sum.: "Les icônes et fresques de Longin au
monastère Lomnica"). NS 9 (1964):23-42 (Fr. sum.: 42).
 In Serbo-Croatian. A study of several icons by the painter
Longin and their relationship to the original iconostasis. A
number of frescoes at Lomnica, painted before 1608, are also
ascribed to Longin.

659 Stelē, France. "Slikar Johannes Aquila de Rakespurga" (Ger.
sum.: "Maler Johannes Aquila de Rakespurga"). ZLU 8 (1972):
165-75 (Ger. sum.: 175).
 In Serbo-Croatian. A study of the work of the fourteenth-
century painter Johannes Aquila de Rakespurga in Slovenia. His
paintings at Turnišče and Martjanci are examined in the light of
contemporary artistic developments in Europe.

660 _____. "Slikar Johannes concivis in Laybaco" (Fr. sum.:
"Le peintre Johannes de Laybaco"). ZUZ 1 (1921):1-48 (Fr.
sum.: 1-3).
 In Slovenian. A detailed study of the work of the late
Gothic painter Johannes of Laybaco (Ljubljana). The study con-
siders the documents pertaining to the painter's life and indi-
vidual monuments. Frescoes are analyzed from the point of view
of their style and iconography.

661 Subotić, Gojko. "Ohridski slikar Konstantin i njegov sin
 Jovan" (Fr. sum.: "Le peintre d'Ohrid Constantin et son fils
 Jean"). Zograf 5 (1974):45-47 (Fr. sum.: 47).
 In Serbo-Croatian. Discusses the painting career of one
 Constantine, a painter active in Ohrid in the fourth decade of
 the fourteenth century. His name appears in the chapel of St.
 John the Baptist in the gallery of St. Sophia. The name of his
 son John is also recorded. Constantine is believed to have been
 stationed in Ohrid and was responsible for several fresco cycles.
 His approach to painting (particularly iconography) was conserva-
 tive, unlike that of another contemporaneous painter--John
 Teorianos--who was trained elsewhere and who appears to have only
 visited Ohrid.

SITES

ANDREAŠ

662 Mikhaĭlov, Stamen. "Za arkhitekturata i zhivopisita na
 manastirskata tsŭrkva Sv. Andreĭ na r.Treska" (Fr. sum.:
 "Sur l'architecture et les peintures murales de l'église du
 monastère St. André sur Treska"). Arkh 10, no. 1 (1968):
 7-20 (Fr. sum.: 20).
 In Bulgarian. Offers a new interpretation of the donor
 inscription (reading of the date: 1389), and presents for the
 first time a commemorative inscription mentioning one Kalest
 Cyrille, the first hegumenos and, according to the author, the
 possible founder of the monastery.

Petković, Vlad[imir] R. See entry YU 243

663 Zdravković, Ivan. "Zaštitni radovi na crkvi sv. Andrije--
 Andreašu na Treski. Obezbedjenje od vlage" (Fr. sum.:
 "Travaux de protection de l'église de St. André--Andreaš sur
 le Treska"). ZZSK 13 (1962):57-66 (Fr. sum.: 65-66).
 In Serbo-Croatian. A brief note on the architecture of the
 building and the problems of its conservation. Particular atten-
 tion is given to the problem of moisture seepage.

ARAČA

664 Medić, Milka Čanak. "Srednjovekovna crkva u Arači. Uvod sa
 istoriografijom" (Fr. sum.: "L'église médiévale à Arača").
 ZLU 10 (1974):17-45 (Fr. sum.: 44-45).
 In Serbo-Croatian. A study of the architectural remains of
 the late Romanesque Benedictine church of St. Michael at Arača
 which discusses problems of its hypothetical reconstruction.

ARILJE

665 Medić, Milka Čanak. "Slikani ukras na crkvi sv. Ahilija u
Arilju" (Fr. sum.: "Les façades peintes de Saint Achille à
Arilje"). Zograf 9 (1978):5-11 (Fr. sum.: 11).
 In Serbo-Croatian. Recent conservation of the church of
St. Achilleos at Arilje has revealed the remains of external
painted decoration which aimed at imitating the "cloisonné"
technique, commonly used in Byzantine architecture. The author
considers this example against the broadest background of such
decorative external treatment of building façades in Roman and
Byzantine architecture.

666 Okunev, N. "Aril'e: Pamiatnik serbskago iskusstva XIII věka"
(Fr. sum.: "Arilje: Un monument de l'art serbe du XIIIe s.").
Seminarium Kondakovianum 8 (1936):221-58 (Fr. sum.: 255-58).
 In Russian. A comprehensive study of the monument's his-
tory, architecture, and fresco decoration. Though largely super-
seded, it still contains invaluable information.

667 Petković, Sreten. Arilje. Medieval Art in Yugoslavia.
Belgrade: Jugoslavija, 1965. 10 pp., 16 pls.
 In Serbo-Croatian. A brief account of the church of St.
Achilleos at Arilje, discussing its history, architecture, and
art. Accompanied by a selection of good black-and-white photo-
graphs.

668 Radojčić, Svetozar. "Natpis МАРΠΟΥ na ariljskim freskama"
[Inscription МАРΠΟΥ on frescoes of Arilje]. Glas srpske
akademije nauka 234 (1959):89-94.
 In Serbo-Croatian. Interprets the inscription as an
acrostic containing the prophecy which foretold the rise to power
of Michael VIII Palaeologus. Considering the Thessalonican ori-
gin of this acrostic, the author argues that in all likelihood
the painters of Arilje came from Thessaloniki as well.

669 Todić, Branislav. "O stilskim osobenostima fresaka Arilja iz
1296. godine" (Fr. sum.: "Les particularités du style de la
peinture d'Arilje datant de 1296"). ZLU 13 (1977):27-43 (Fr.
sum.: 43).
 In Serbo-Croatian. Examines the stylistic traits of Arilje
frescoes and discusses the transition between the monumental
style of the thirteenth century and the emerging Paleologan style
of painting.

670 Žiković, Branislav. Arilje: Raspored fresaka [Arilje:
Disposition of frescoes]. Belgrade: B. Žiković and
S. Mandić, 1970. 15 pp., 47 drawings.
 In Serbo-Croatian. An album of diagrams showing in con-
siderable detail the layout of all frescoes in the church of St.
Achilleos at Arilje. Most of the fresco program (finished in
1296) is preserved.

BALJEVAC

671 Deroko, Aleksandar. "Crkva Sv. Nikole kod Baljevca" (Fr.
 sum.: "St. Nicolas de Baljevac"). Starinar, 3d ser. 7
 (1932):36-39 (Fr. sum.: 134).
 In Serbo-Croatian. A brief account of the small single-
 aisled domed church featuring a plan and building technique com-
 mon to the Ibar valley in the twelfth and thirteenth centuries.
 The author suggests links with Sopoćani.

672 Stanić, Radomir. "Freske crkve Sv. Nikole u Baljevcu kod
 Raške"). Saopštenja 10 (1974):53-75 (Fr. sum.: 74-75).
 In Serbo-Croatian. The frescoes, dating from the mid-
 fourteenth century, are found to be without direct parallels in
 contemporaneous art of Serbia and are believed to have been the
 work of Serbian painters from the Adriatic Coast. The article
 gives a detailed stylistic and iconographic analysis of the
 frescoes.

BANJA

673 Jovanović, Vojislav S. "O jednom ktitorskom natpisu u
 manastiru Banji" (Fr. sum.: "À propos d'une inscription dé-
 dicatoire au monastère de Banja"). Zograf 4 (1972):27-34 (Fr.
 sum.: 34).
 In Serbo-Croatian. An analysis of the lengthy donor in-
 scription on a fragmented stone slab from Banja monastery. The
 dated inscription (1328-29) is a major contribution to the under-
 standing of the history of the monastery--the foundation of King
 Stefan Dečanski. His son Stefan Dušan, portrayed on the donor
 portrait with his father, is only identified as the junior king
 and not as the donor.

674 Kostić, Ivan. "Ispitivački radovi na crkvi sv. Nikole
 manastira Banje kod Priboja" (Fr. sum.: "Résultats des tout
 derniers travaux de recherche sur l'église St. Nicolas au
 monastère de Banja près de Priboj"). Saopštenja 8 (1969):
 133-36 (Fr. sum.: 136).
 In Serbo-Croatian. A brief account of the archeological
 investigation of the church of Banja monastery, focusing on the
 discovery of original external fresco decoration. The main apse
 is shown to have been decorated with an imitation of red, black,
 and white blocks in a checkerboard pattern, while the window was
 framed by painted floral ornaments.

675 Šakota, Mirjana. "Prilozi poznavanju manastira Banje kod
 Priboja" (Fr. sum.: "Les données pour connaître le monastère
 Banja près de Priboj"). Saopštenja 9 (1970):19-46 (Fr. sum.:
 46).
 In Serbo-Croatian. An important study of the history of
 the monastery and the tombstones found in its compound. Dis-

cusses the question of patronage and the original date of its foundation.

676 ____. "Prilozi poznavanju manastira Banje kod Priboja. 3. Nepublikovani izveštaj o stanju manastira Banje iz 1857. godine" (Fr. sum.: "Contribution à la connaissance du monastère Banja près de Priboj: Un compte rendu non-publié sur l'état du monastère Banja en 1857"). Saopštenja 10 (1974): 11-36 (Fr. sum.: 36).
 In Serbo-Croatian. An important contribution to the study of the history and architecture of the monastery. The 1857 report on the conditions of the monastery offers valuable general and specific information on the monastery and its buildings.

BANJANI (BANJANE). See ČUČER

BANJSKA

677 Šuput, Marica. "Plastična dekoracija Banjske" (Fr. sum.: "La décoration sculpturale de l'église de Banjska"). ZLU 6 (1970):39-52 (Fr. sum.: 51-52).
 In Serbo-Croatian. Sees the remains of architectural sculpture from Banjska monastery as an intermediate stage in the development from Studenica to Dečani. The style is characterized as basically Romanesque, although Byzantine influence is also noted.

BAR

678 Bošković, Djurdje et al. Stari Bar. Belgrade: Savezni institut za zaštitu spomenika kulture, 1962. 347 pp. (Fr. sum.: 317-42), 322 figs. in text, 109 pls.
 In Serbo-Croatian. A major monograph on an important medieval city. Includes an architectural survey of all important buildings. Discusses the city's history, the urban form, individual buildings, methods of construction, trades and artisans, and the problems of conservation.

BARGALA. See GOREN KOZJAK

BEOGRAD

679 Čubrilović, Vasa et al. Beogradska tvrdjava kroz istoriju (Fr. sum.: "Forteresse de Béograd à travers l'histoire"). Galerija Srpske akademije nauka i umetnosti, 7. Belgrade: Srpska akademija nauka i umetnosti, 1969. 196 pp., illus.
 In Serbo-Croatian. A series of essays on the history of the Belgrade fortress. The essay on the medieval period by Marija Birtašević (pp. 37-78; French text: 63-78) gives a good overview of that stage in the life of the fortress. Particularly relevant are the results of the new archeological finds which are integrated into the general historical framework.

680 Jovanović, Drag[oljub]. "Kula Nebojša i staro pristanište"
 (Fr. sum.: "La tour Nebojša et l'ancien port de Belgrad").
 Starinar, 3d ser. 14 (1939):111-23 (Fr. sum.: 123).
 In Serbo-Croatian. An architectural study of the Nebojša
 Tower which guarded the entrance to the medieval harbor of
 Belgrade.

681 Jovanović, Dragoljub; Garašanin, Draga; and Garašanin,
 Milutin V. "Otkopavanja u Beogradskoj tvrdjavi 1948 godine:
 Prethodni izveštaj" (Fr. sum.: "Fouilles exécutées en 1948
 dans la forteresse haute de Belgrade: Rapport préliminaire").
 Starinar, n.s. 2 (1951):255-66 (Fr. sum.: 266).
 In Serbo-Croatian. An account of the 1948 excavations con-
 ducted in the fortress of Belgrade. Attempts to relate the re-
 sults to old maps and city views which provide a wealth of visual
 information about the no longer extant portions of the fortress.

682 Popović, Marko. "Srednjovekovna crkva Uspenja Bogorodice u
 Beogradu" (Fr. sum.: "L'église médiévale de la Dormition de
 la Vierge à Belgrade"). ZNM 9-10 (1979):497-512 (Fr. sum.:
 511-12).
 In Serbo-Croatian. Examines old engravings and woodcuts
 depicting the fortress of Belgrade on which the church of the
 Dormition is depicted. Combines information from archeological
 finds (including a portion of the dedicatory inscription) in an
 attempt to pinpoint the location of this destroyed church. See
 entry YU 685.

683 _____. "Utvrdjene srednjovekovne kapije na severoistočnom
 bedemu beogradskog grada" (Fr. sum.: "La forteresse de
 Belgrade: Ouvrages de défense des portes médiévales du
 rempart nord-est de la forteresse de Belgrade"). Saopštenja
 Zavoda za zaštitu spomenika kulture grada Beograda 9 (1970):
 3-42 (Fr. sum.: 40-42).
 In Serbo-Croatian. An archeological and architectural
 study of the medieval fortress gates. Different stages in the
 development of individual gate complexes are analyzed in a
 historical context.

684 Popović, Mirjana. "Pregled razvoja beogradske trvdjave kroz
 literaturu i planove" (Fr. sum.: "La citadelle de Belgrade:
 Exposé sommaire du développement des fortifications à travers
 la bibliographie et les plans"). Saopštenja Zavoda za zaštitu
 spomenika kulture grada Beograda 2 (1964):3-24 (Fr. sum.: 24).
 In Serbo-Croatian. Surveys old city plans and views of
 Belgrade, from a fifteenth-century Turkish view to the accurately
 measured and rendered Austrian plans of the eighteenth century.

685 Vujović, Branko. "Natpis despota Stefana Lazarevića" [An
 inscription of despot Stefan Lazarević]. ZLU 4 (1968):
 175-89.
 In Serbo-Croatian. A recently (1967) discovered fragment
 of a large door lintel with a fragmentary inscription is inter-
 preted as having belonged to the Cathedral church of Belgrade,
 built by despot Stefan Lazarević in the early part of the fif-
 teenth century. This important church is known only from liter-
 ary sources and visual documents. The building itself has been
 completely destroyed and its site remains unknown. See entry
 YU 682.

686 Vulović, Mila Vujičić. "Konzervatorsko-restauratorski radovi
 na beogradskoj tvrdjavi u periodu 1961-1968. godine" (Fr.
 sum.: "La forteresse de Belgrade: Travaux de conservation
 et de restauration de la forteresse de Belgrade entre 1961 et
 1968"). Saopštenja Zavoda za zaštitu spomenika kulture grada
 Beograda 8 (1970):3-72 (Fr. sum.: 71-72).
 In Serbo-Croatian. A detailed report of the excavations
 and conservation work conducted on the fortress. Illustrated
 with numerous drawings and photographs not found elsewhere.

BERAM

687 Ivančević, Radovan. Beram. Medieval Monuments in Yugoslavia.
 Belgrade: Jugoslavija, 1965. 12 pp., 50 pls., 5 figs. in
 text.
 A brief monograph on the cemetery church at Beram, discuss-
 ing its history and architecture and focusing on its fifteenth-
 century Gothic frescoes. The extensive fresco cycle is remark-
 ably well preserved. The book is illustrated with a fine
 selection of black-and-white photographs.

BIJELA

688 Šerović, Petar D. "Crkva 'Riza Bogorodice' u Bijeloj, u Boki
 Kotorskoj" [The church 'Riza Bogorodice' in Bijela, Boka
 Kotorska]. GZMS 32, nos. 3-4 (1920):273-94 (Fr. sum.: 294).
 In Serbo-Croatian. A detailed historical account of this
 important medieval church and its art treasures. Scrutinizes all
 inscriptions and historical documents.

BIJELO POLJE

689 Ljubinković, Radivoje. "Humsko eparhisko vlastelinstvo i
 crkva Svetog Petra u Bijelom Polju" (Fr. sum.: "La seigneurie
 épiscopale de Hum et Saint Pierre à Bijelo Polje"). Starinar,
 n.s. 9-10 (1959):97-124 (Fr. sum.: 124).
 In Serbo-Croatian. A major study of the history and archi-
 tecture of the church of St. Peter, based on archeological infor-
 mation and historical sources.

690 Nagorni, Dragan. Die Kirche Sv. Petar in Bijelo Polje
 (Montenegro): Ihre Stellung in der Geschichte der serbischen
 Architektur. Miscellanea Byzantina Monacensia 23. Munich:
 Institut für Byzantinistik, Neugriechische Philologie und
 Byzantinische Kunstgeschichte der Universität, 1978. 346 pp.,
 illus.
 Analyzes the small church of St. Peter at Bijelo Polje in
 great detail, starting with the earlier building on the site
 (probably sixth century) and continuing through the eleventh-
 century [?] building, the expansion of ca. 1170, and various
 subsequent additions and alternations. The building, erected
 for Serbian princes as an orthodox church, displays strong links
 with the architecture of the Adriatic littoral--which are ex-
 haustively scrutinized. Extensive bibliography.

691 Nešković, Jovan. "Konzervatorsko-restauratorski radovi na
 crkvi Sv. Petra u Bijelom Polju" (Fr. sum.: "Des travaux de
 conservation sur l'église de Saint Pierre à Bijelo Polje").
 Starine Crne Gore 1 (1963):97-111 (Fr. sum.: 111).
 In Serbo-Croatian. A report on the conservation and
 restoration work on the church of St. Peter which resolved many
 questions regarding the structural history of the church.

692 _____. "Stari kameni ikonostas crkve sv. Petra u Bijelom
 Polju" (Fr. sum.: "Le vieil iconostase de pierre dans
 l'église Saint Pierre à Bijelo Polje"). ZZSK 19 (1968):
 85-94 (Fr. sum.: 94).
 In Serbo-Croatian. A study of excavated carved stone
 fragments which are believed to belong to the twelfth-century
 phase of the church of St. Peter, stylistically and formally
 related to the pre-Romanesque material found along the Adriatic
 coast.

693 Simić, Pribislav. "Freska Vazensenja Hristovog u Bijelom
 Polju i njena liturgijska podloga" (Fr. sum.: "La fresque de
 l'ascension du Christ à Bijelo Polje et son contenu litur-
 gique"). Zograf 6 (1975):21-24 (Fr. sum.: 23-24).
 In Serbo-Croatian. The iconographically unusual depiction
 of Christ's Ascension in the church of St. Peter at Bijelo Polje
 is shown to have been based on liturgical sermons of St. John
 Chrysostomos and John Presbyteros.

694 Zdravković, Ivan. "Rezultati arhitektonskih ispitivanja na
 crkvi Sv. Apostola Petra u Bijelom Polju" (Fr. sum.: "Résul-
 tats des examens architectoniques sur l'église de Saint
 Pierre-Apôtre à Bijelo Polje"). Starine Crne Gore 1 (1963):
 83-95 (Fr. sum.: 89-90).
 In Serbo-Croatian. A brief survey of the structural his-
 tory of the building, an examination of its present condition,
 and a proposal for its restoration. The article is illustrated
 with a number of useful drawings and photographs.

BILIMIŠĆE [near Zenica]

695 Nikolajević, Ivanka. "Reljefi iz Bilimišća, Zenica" (Fr.
 sum.: "Reliefs de Bilimišće près de Zenica"). In Zbornik
 Svetozara Radojčića. Edited by Vojislav J. Djurić. Belgrade:
 Filozofski fakultet, Odeljenje za istoriju umetnosti, 1969,
 pp. 245-52 (Fr. sum.: 252).
 In Serbo-Croatian. Discusses the style and iconographic
 content of low-relief slabs from a ruined church at Bilimišće
 and dates it to the twelfth century.

BISKUP [near Konjic]

696 Vego, Marko. "Nadgrobni spomenici porodice Sankovića u selu
 Biskupu kod Konjica" (Ger. sum.: "Die Grabdänkmäler der
 Familie Sanković in Dorfe Biskup bei Konjic in der Herze-
 gowina"). GZMS, n.s. 12 (Arheologija) (1957):127-41 (Ger.
 sum.: 139-41).
 In Serbo-Croatian. A detailed archeological study of a
 private family cemetery. The tombs were found to have been
 situated within the remains of a ruined church, and were rich in
 finds including gold-embroidered textiles and glass vessels.

BISKUPIJA. See KNIN

BISTRA

697 Marin, Marko. "Kartuzija Bistra in njen stavbno zgodovinski
 problem" (Fr. sum.: "La chartreuse de Bistra: Le développe-
 ment architectural"). ZUZ, n.s. 8 (1970):45-94 (Fr. sum.:
 94).
 In Slovenian. A detailed analysis of the architectural
 growth of the Carthusian monastery at Bistra from its foundation
 in 1255 until the nineteenth century. The largest amount of
 material is Gothic and is presented against the general develop-
 ment of Gothic architecture in Slovenia.

BOBOVAC [near Kraljeva Sutjeska]

698 Andjelić, Pavao. Bobovac i Kraljeva Sutjeska, stolna mjesta
 bosanskih vladara u XIV i XV stoljeću (Ger. sum.: "Bobovac
 und Kraljeva Sutjeska, Sitze der bosnischen Herrscher im 14.
 und 15. Jh."). Biblioteka Kulturno nasljedje. Sarajevo:
 Veselin Masleša, 1973. 264 pp. (Ger. sum.: 265-67), illus.
 in text.
 In Serbo-Croatian. An exhaustive report of major archeo-
 logical undertakings which brought to light principal residences
 of the Bosnian rulers during the last period of national inde-
 pendence in the Middle Ages. Most important among the numerous
 material finds are the remains of monumental tombs in a funerary
 chapel and three fully-preserved bronze bells with inscriptions.

BODJANI

699 Mikič, Olga. <u>Bodjani</u>. Medieval Art in Yugoslavia. Belgrade:
 Jugoslavija, 1964. 10 pp., 47 pls., 2 illus. in text.
 A brief account of the eighteenth-century monastery of
 Bodjani which considers its history, architecture, and art.
 Illustrated with a selection of fine black-and-white photographs.

700 Mirkovič, Lazar, and Zdravkovič, Ivan. <u>Manastir Bodjani</u> (Fr.
 sum.: "Le monastère de Bodjani"). Srpska akademija nauka.
 Posebna izdanja, 198. Belgrade: Naučna knjiga, 1952. 87 pp.
 (Fr. sum.: 85-87), 64 pls.
 In Serbo-Croatian. An exhaustive study of the eighteenth-
 century monastery church of Bodjani and its frescoes. The monas-
 tery itself has a longer history. During the eighteenth-century
 reconstruction, the older tradition was adhered to in many re-
 spects, although the architectural and artistic dependence on
 the contemporaneous Baroque style is obvious.

BOGDAŠIČ

Nikolajevič, I[vanka]. See entry YU 399

BOGORODICA LJEVIŠKA. See PRIZREN

BORAČ

701 Mazalič, Djoko. "Borač - bosanski dvor srednjeg vieka" (Ger.
 sum.: "Borač, die mittelalterliche bosnische Burg"). <u>GZMS</u> 53
 (1941):31-94 (Ger. sum.: 91-94).
 In Serbo-Croatian. A detailed historical, archeological
 and architectural study of this important medieval fortified
 residence belonging to a Pavlovič family. Because the complex is
 considered in its regional setting, numerous nearby sites are
 examined individually as well as in the context of their relation-
 ship to Borač.

BORILOVCI

702 Balabanov, Kosta. "Crkva vo selo Borilovci" [Church in the
 village of Borilovci]. <u>KN</u> 1 (1959):5-10.
 In Macedonian. A brief account of the late fifteenth- or
 early sixteenth-century single-aisled village church, its
 frescoes, and a partially preserved inscription.

BRAČ [island]

703 Domančič, Davor. "Srednji vijek" [The Middle Ages]. <u>Brački</u>
 <u>zbornik</u> 4 (1960):113-60 (Eng. sum.: 250-57).
 In Serbo-Croatian. A general survey of medieval monuments
 on the island of Brač. Includes primarily small churches, a num-
 ber of sculptural fragments, and a few frescoes.

BRNAZI [near Sinj]

704 Gunjača, Stipe. "Starohrvatska crkva i kasnosrednjovjekovno
 groblje u Brnazima kod Sinja" (Fr. sum.: "L'église vieille-
 croate et le cimetière du bas moyen âge de Brnazi près Sinj").
 SP, 3d ser. 4 (1955):85-134 (Fr. sum.: 133-34).
 In Serbo-Croatian. A detailed report of the archeological
 investigation of the six-foil centralized church dating from the
 ninth or tenth century. Probably destroyed in the thirteenth
 century, the church and the surrounding area were used as a
 burial ground during the later Middle Ages. Finds include fine
 architectural fragments and numerous minor finds from the 109
 graves which were investigated.

BRODAREVO. See DAVIDOVICA

BRVENIK

705 Stanić, Radomir, and Vukadin, Obrenija. "Crkva sv. Nikole u
 Brveniku" (Fr. sum.: "L'église St. Nicolas à Brvenik").
 Saopštenja 8 (1969):145-53 (Fr. sum.: 153).
 In Serbo-Croatian. A report on the history, architecture,
 and remnants of fresco decoration and the problems of their con-
 servation. Sepulchral monuments in and around the church are
 also discussed.

BUDIMLJE

706 Bošković, Djurdje. "O jednom reljefu sa natpisom sa
 Djurdjevih stubova u Budimlju" (Fr. sum.: "Dalle avec relief
 et inscription à Djurdjevi Stubovi de Budimlje"). ZNM 8
 (1975):409-16 (Fr. sum.: 416).
 In Serbo-Croatian. An interpretation of a carved slab with
 an inscription, mentioning one Grdeš, seen as belonging to the
 original phase of construction (attributed to Grdeš) and dated to
 the end of the twelfth or early thirteenth century. The recon-
 struction of the exonarthex with its tower is consequently at-
 tributed to Stefan Prvoslav.

BUDISAVCI

707 Ivanović, Milan. "Crkva Preobraženja u Budisavcima" (Fr.
 sum.: "L'église de la Transfiguration à Budisavci"). SKM
 1 (1961):113-26 (Fr. sum.: 126).
 In Serbo-Croatian. A study of the history, architecture,
 and frescoes of the small church of Transfiguration. Built in
 the fourteenth it was heavily restored in the sixteenth and
 nineteenth centuries. The frescoes are all from the sixteenth
 century and were commissioned by Patriarch Makarije.

BUTONIGA

708 Fučić, Branko. "Butoniga." Bulletin Odjela VII za likovne
 umjetnosti Jugoslavenske akademije znanosti i umjetnosti 8,
 nos. 2-3 (1960):126-39.
 In Serbo-Croatian. The archaizing Romanesque frescoes
 (probably dating from the fourteenth century) in the small vil-
 lage church of Butoniga were discovered accidentally during a
 bombardment in 1942. A sufficient number of fresco remains per-
 mits the reconstruction of the entire cycle, which includes two
 zones of christological scenes along both lateral walls. The
 apse is occupied by Christ enthroned in a mandorla and surrounded
 by evangelist symbols (in the conch), with the twelve apostles in
 the zone below.

709 Perčić, Iva; Nešković, Jovan; and Medić, Milorad. "Konzerva-
 torski radovi na kapeli svetoga Križa u Butonizi" (Fr. sum.:
 "Travaux de conservation éffectués dans la chapelle de la
 Sainte-Croix à Butoniga"). ZZSK 11 (1966):243-310 (Fr. sum.:
 308-10).
 In Serbo-Croatian. An exhaustive report on the examination
 and conservation of the small, single-aisled thirteenth- or
 fourteenth-century church at Butoniga in Istria. The article
 discusses the church's architecture and the remains of its Gothic
 fresco cycle.

CETINA [river]

710 Marun, Fra Luigi. "Starohrvatsko groblje sa crkvom Sv. Spasa
 na Cetini" [An old Croatian cemetery with the Church of St.
 Savior on Cetina river]. SP 1, nos. 3, 4 (1895):183-87,
 224-30, and 2, no. 1 (1896):25-29.
 In Serbo-Croatian. An early detailed account of histori-
 cal, topographical, and archeological material pertaining to this
 important early Croatian church complex.

CRNA REKA

711 Stanić, Radomir. "Ikonostas manastira Crne Reke" (Fr. sum.:
 "L'iconostase du monastère de Crna Reka"). ZLU 14 (1978):
 235-60 (Fr. sum.: 259-60).
 In Serbo-Croatian. Discusses the iconostasis of Crna Reka
 monastery and its individual components, revealing that it con-
 sists of parts made between the sixteenth and eighteenth cen-
 turies.

712 _____. "Zidno slikarstvo crkve manastira Crne Reke" (Fr.
 sum.: "La peinture murale de l'église du monastère Crna
 Reka"). Raška baština 1 (1975):95-129 (Fr. sum.: 129).
 In Serbo-Croatian. An exhaustive study of post-Byzantine
 frescoes in the small church of the Crna Reka Monastery dating

from ca. 1592-1601. The frescoes are the work of a highly com-
petent group of painters active in Serbia after the restoration
of the Patriarchate in 1557.

713 Vulović, Mila. "Manastir sv. Arhandjela u Crnoj Reci" (Fr.
 sum.: "Le monastère des Saints Archanges à Crna Reka"). ZLU
 4 (1968):249-59 (Fr. sum.: 259).
 In Serbo-Croatian. An architectural study of the dramati-
 cally situated monastery which hangs off the cliff in the gorge
 of Crna Reka. The complex appears to date from the late fif-
 teenth or early sixteenth century.

ČUČER (BANJANI)

714 Tatić, Žarko. "Arhitektonski spomenici u skopskoj Crnoj Gori.
 3. Sv. Nikita" (Fr. sum.: "Les monuments architecturaux de
 la Crna Gora de Skoplje. 3. L'église St. Nikita"). GSND 12
 (1933):127-34 (Fr. sum.: 134).
 In Serbo-Croatian. A study of the architecture of the
 church of St. Nikita. The architectural drawings have a docu-
 mentary value, recording a chapel on the south, and an enclosed
 porch on the south and west sides, which have since been removed.

DABRAVINA

715 Nikolajević, Ivanka. "Oltarna pregrada u Dabravini" (Fr.
 sum.: "Chancel sculpté de Dabravina"). ZRVI 12 (1970):91-112
 (Fr. sum.: 110-12).
 In Serbo-Croatian. The altar screen of Dabravina is re-
 dated to the second half of the twelfth century, in opposition to
 the original dating in the early Christian period proposed by the
 excavators. The subject is part of a larger controversy regard-
 ing medieval architectural sculpture in Bosnia.

716 Radimský, Vaclav. "Crkvena razvalina kod Dabravine u Kotaru
 visočkom u Bosni" [Church ruin near Dabravina in Visočki Kotar,
 in Bosnia]. GZMS 4, no. 4 (1892):372-87.
 In Serbo-Croatian. A detailed report of the original exca-
 vations of this important medieval church with rich sculptural
 decoration. Provides excellent photographs of sculptural frag-
 ments. The author maintains that the church is considerably
 older than the nearby medieval cemetery.

717 Sergejevski, D[mitrije]. Bazilika u Dabravini (Ger. sum.:
 "Basilika von Dabravina"). Glasnik zemaljskog muzeja u
 Sarajevu, n.s. 11, Arheologija: posebna izdanja. Sarajevo:
 Zemaljski muzej u Sarajevu, 1956. 49 pp., 22 pls.
 In Serbo-Croatian. A revised interpretation of the 1891
 excavation of the early Christian [?] basilica at Dabravina based
 on the results of the 1954 excavations.

DAVIDOVICA [near Brodarevo]

718 Ćorović, Mirjana. "Crkva u Brodarevu" (Fr. sum.: L'église de
 Brodarevo"). Starinar, 3d ser. 7 (1932):77-80 (Fr. sum.:
 135).
 In Serbo-Croatian. A contribution to the history of the
 church, built in 1281 by a builder from Dubrovnik. Considers the
 contract between the donor, Monk David, and the builder, as well
 as other documents, in an attempt to illuminate the origins of
 the building.

719 Ljubinković, Mirjana [Ćorović]. "Arheološka iskopavanja u
 Davidovici" (Fr. sum.: "Fouilles archéologiques à Davidovica").
 Saopštenja 4 (1961):113-23 (Fr. sum.: 122-23).
 In Serbo-Croatian. This archeological investigation of the
 church focuses on the remains of several tombs in and around the
 building. The most important is the tomb of the monk David, the
 donor of the church. The church was in use until the end of the
 seventeenth century.

720 Ljubinković, Mirjana Ćorović. "Ostaci živopisa u Davidovici"
 (Fr. sum.: "Vestiges de peintures murales à Davidovica").
 Saopštenja 4 (1961):124-36 (Fr. sum.: 136).
 In Serbo-Croatian. A study of the fresco remains in the
 church. These include remains of the dado decoration in the
 north chapel, figures of unknown hermit-saints in the exonarthex,
 the Mandylion, and remains of the Evangelists in the pendentives
 and Prophets in the dome drum. Stylistically, the frescoes are
 related to other works of the late thirteenth century, but they
 are qualitatively inferior.

721 Nešković, Jovan. "Crkva manastira Davidovice na Limu" (Fr.
 sum.: "L'église du monastère Davidovica sur la rivière Lim").
 Saopštenja 4 (1961):89-112 (Fr. sum.: 111-12).
 In Serbo-Croatian. A detailed study of architectural re-
 mains of the church of Davidovica monastery, and its conservation.

DEČANI

722 Bošković, Djurdje. "La sculpture de Dečani et la question du
 développement de quelques cycles iconographiques dans la
 sculpture médiévale de l'Italie Méridionale et de l'Occident."
 Studi Bizantini e Neoellenici 6 (1940):37-47. (Atti del V
 Congresso int. di studi bizantini 2.)
 Investigates the iconography of sculptural decoration at
 Dečani and discusses its sources, revealing both Western and
 Eastern characteristics.

723 Deroko, Aleksandar. "Crkva manastira Dečana" (Fr. sum.:
 "L'église du couvent de Dečani"). GSND 12 (1933):135-46
 (Fr. sum.: 146).
 In Serbo-Croatian. A brief analysis of Dečani architec-
 ture, illustrated with several drawings and photographs of the
 church and its sculptural decoration.

724 Mano-Zisi, Djordje. "Jedan zapis kapitela iz Dečana - ispod
 freskoslike začeća Kaina" (Fr. sum.: "Une signature d'artiste
 à Dečani"). Starinar, 3d ser. 5 (1930):185-93 (Fr. sum.:
 191-93).
 In Serbo-Croatian. Considers the signature of a painter
 (Srdj) painted on the abacus of a capital. The signature repre-
 sents a rare instance of a painter signing his work in Byzantine
 art.

725 Mijović, Pavle. Dečani. Medieval Art in Yugoslavia.
 Belgrade: Jugoslavija, 1963. 8 pp., 59 pls.
 A brief monograph on the church of the Savior at Dečani.
 The short text is illustrated with a selection of fine black-and-
 white photographs, mostly details.

726 Nenadović, S[lobodan]. "Trpezarija protomajstora Djordja u
 Dečanima" (Fr. sum.: "La vieille salle à manger de Detchani").
 SKM 1 (1961):293-98 (Fr. sum.: 298).
 In Serbo-Croatian. The refectory of Dečani monastery was
 built by the master builder Djordje (George) with the help of his
 brothers Dobroslav and Nikola. After the fire of 1949 its re-
 mains were studied. The results, along with a proposal for re-
 construction, are presented here.

727 Petković, Vlad[imir] R., and Bošković, Dj. Manastir Dečani
 [Dečani monastery]. Stari jugoslovenski umetnički spomenici,
 Pt. 1. Stari srpski umetnički spomenici, 2. 2 vols.
 Belgrade: Srpska kraljevska akademija, 1941. Vol. 1,
 242 pp. (Fr. sum.: 197-230), 151 figs., 72 pls.; Vol. 2,
 97 pp. (Ger. sum.: 73-79), 229 pls. (17 col.).
 In Serbo-Croatian. The most comprehensive monograph on
 the monastery of Dečani. Discusses all aspects of this important
 monument in detail. Even considers all of the pieces of church
 furniture, providing the kind of information not available for
 other Serbian monuments. Sculptural decoration and frescoes are
 described in totality and most of the material is illustrated.
 Volume 1 discusses the history and architecture of the monastery,
 while Volume 2 describes its frescoes.

Radojčić, Svetozar. See entry YU 786

DEMIR KAPIJA

728 Aleksova, Blaga. Prosek - Demir Kapija. Slovenska nekropola i
 slovenske nekropole u Makedoniji (Fr. sum.: "Prosek - Demir
 Kapija. Nécropole slave et les nécropoles slaves en
 Macédoine"). Dissertationes, 1. Skopje and Belgrade:
 Arheološko društvo Jugoslavije, 1966. 102 pp. (Fr. sum.:
 95-102), 25 pls., 3 foldout plans.
 In Serbo-Croatian. A study of a Slavic necropolis which
 grew around a modest church between the tenth and fifteenth cen-
 turies. The church, in turn, was built on the remains of a small
 early Christian basilica with its own cemetery.

DIVLJE

729 Balabanov, Kosta. "Crkvata vo selo Divlje" [Church in the
 village of Divlje]. KN 1 (1959):10-14.
 In Macedonian. A brief account of a small, single-aisled
 village church. Extensively restored in the nineteenth century,
 the church was originally built in the fourteenth or fifteenth
 century as attested by the partially preserved frescoes. Note-
 worthy are donor portraits of a nobleman and his wife holding the
 model of the church. No inscriptions survive.

DJURDJEVI STUPOVI. See RAS

DOBOJ

730 Kajmaković, Zdravko. "Stari grad Doboj: Konzervatorski
 radovi 1962. godine" (Eng. sum.: "The old city of Doboj:
 Work on its conservation during 1962"). NS 9 (1964):43-61
 (Eng. sum.: 61).
 In Serbo-Croatian. A study of the fortress of Doboj (first
 mentioned in the sources in 1415). Reports on the results of
 archeological and architectural investigations and offers a
 hypothetical reconstruction of the original fortress.

DOBRIČEVO

731 Kajmaković, Zdravko. "Prenos manastira Dobričeva. Konzerva-
 torski izvještaj" (Eng. sum.: "The moving of the monastery of
 Dobričevo"). NS 11 (1967):67-86 (Eng. sum.: 86).
 In Serbo-Croatian. A detailed report on the moving of the
 monastery complex of Dobričevo to a new location (caused by the
 creation of an artificial lake). The report also discloses the
 discovery of sinopia under the coat of frescoes in the main
 church.

732 Kajmaković, Zdravko, and Nonin, D. "Prenos manastira
 Dobriċeva" (Fr. sum.: "Le transfert du monastère de
 Dobriċevo"). Zograf 1 (1966):35-37 (Fr. sum.: 47).
 In Serbo-Croatian. A brief account of the moving of
 Dobriċevo monastery in Herzegovina to a new location. Certain
 technical aspects of the move as well as certain discoveries
 (e.g., sinopia below frescoes) are reported.

733 Kajmaković, Zdravko, and Tihić, Smail. "Manastir Dorbriċevo:
 Problematika zaštite" (Eng. sum.: "The monastery Dobriċevo:
 The problem of its protection"). NS 6 (1959):143-60 (Eng.
 sum.: 160).
 In Serbo-Croatian. A study of the architecture and frescoes
 of the church of Dobriċevo and a proposal for their preservation.

DOBRUN

734 Kajmaković, Zdravko. "Živopis u Dobrunu" (Fr. sum.: "Peinture
 de Dobrun"). Starinar, n.s. 13-14 (1965):251-60 (Fr. sum.:
 260).
 In Serbo-Croatian. A study of the oldest surviving cycle
 of medieval frescoes in Bosnia (in the church of the Annunciation
 at Dobrun). The iconography and style are examined, and a new
 dating--1353--is proposed.

735 Mazalić, Dj[oko]. "Starine u Dobrunu" [Antiquities in Dobrun].
 GZMS 53 (1941):101-23.
 In Serbo-Croatian. A study of the medieval buildings in
 the area of Dobrun (a fortress; watch towers; a secular, public
 [?] building; and the church). The church is dated to 1383, but
 has decorative elements which suggest that older and younger
 phases also exist.

DOLAC [near Studenica]

736 Djordjević, Slobodan. "Bogorodičina crkva u Docu kod
 Studenice" (Fr. sum.: "Conservation de l'architecture de
 l'église dans le village Dolac, au-dessus de Studenica").
 Saopštenja 9 (1970):55-62 (Fr. sum.: 62).
 In Serbo-Croatian. An architectural study of a small two-
 storied funerary chapel near Studenica monastery. The author
 links the chapel with similar structures along the Adriatic lit-
 toral and dates it to the end of the twelfth or the thirteenth
 century.

DOLAC [near Novigrad]

737 Gunjača, Stipe. "Srednjovjekovni Dolac kod Novigrada" (Fr.
 sum.: "Dolac près de Novigrad au moyen âge"). SP, 3d ser.
 8-9 (1963):7-66 (Fr. sum.: 64-66).
 In Serbo-Croatian. A detailed discussion of early medieval
 Dolac and two of its churches--the trefoil church of St. Martin,
 adapted from an early Christian building; and a monastic estab-
 lishment with a six-foil "oratory." Both buildings are believed
 to date from the tenth or eleventh centuries. Full archeological
 material is presented including architectural and sculptural
 fragments and minor finds (mostly jewelry from graves).

DOMBŌ

738 Sándor, Nagy. "Dombō: Rezultati istraživanja na Gradini u
 Rakovcu" [Dombō: Results of excavations 1963-1966]. RVM 20
 (1971):161-85.
 In Serbo-Croatian. Reports on important discoveries in the
 excavations of this medieval monastery, first mentioned in
 sources in 1237. Finds include a cache of several votive [?]
 bronze icons of fine quality, metal appliqués, and rich archi-
 tectural sculpture of high quality. The material is linked to
 the twelfth-century restoration of the monastery, while the
 presence of Greek icons is seen as part of the Byzantine restora-
 tion under Emperor Manuel Comnenus.

DONJA KAMENICA (DOLNA KAMENITSA)

739 Kiel, Machiel. "The Church of Our Lady of Donja Kamenica
 (Dolna Kamenica) in Eastern Serbia: Some Remarks on the
 Identity of its Founder and the Origin of its Architecture."
 Actes du XIVe Congrès international des études byzantines
 (Bucharest) 2 (1975):159-66.
 Considers the church of Donja Kamenica as belonging with
 architecture of the Second Bulgarian Empire on the basis of its
 type. The church is attributed to the Emperor Michael Šišman and
 his son Michael, a little known figure of Bulgarian history.

740 Ljubinković, Mirjana Ćorović, and Ljubinković, R. "Crkva u
 Donjoj Kamenici" (Fr. sum.: "Donja Kamenica: L'église de la
 Vierge"). Starinar, n.s. 1 (1950):53-86 (Fr. sum.: 86).
 In Serbo-Croatian. An important, exhaustive study of the
 church of the Virgin at Donja Kamenica, made prior to the exten-
 sive restoration of the church. The poorly documented history
 of the church is considered, but the emphasis of the article is
 on frescoes, which are analyzed from the point of view of style
 and iconography. Various stylistic and decorative details are
 carefully examined.

741 Nenadović, Slobodan. "Restauracija donjokameničke crkve.
 Jeden dodir srednjevekovne verske i narodne arhitekture" (Fr.
 sum.: "Restauration de l'église de Donja Kamenica"). ZZSK 10
 (1959):51-68 (Fr. sum.: 68).
 In Serbo-Croatian. A study of the architecture of the
 church and a report on its conservation. The remains of the
 buildings are examined along with older documentary photographs
 and depictions of the church on donor portraits preserved within
 the church. Postulates that the western exterior porch (now com-
 pletely destroyed) was executed in wood, in vernacular style.

742 Panaĭotova, Dora. "Ornamentŭt v stenopisite. ot Dolna
 Kamenitsa" [Ornament in the wall paintings of Dolna Kamenitsa].
 PNI 4, no. 4 (1971):57-62.
 In Bulgarian. A detailed analysis of decorative motifs in
 the wall paintings of Donja Kamenica reveals their conservative
 character, more akin with the preceding Comnenian than with the
 current Paleologan tradition.

742a Panajotova, D[ora]. "Les portraits des donateurs et l'orna-
 ment des fresques de l'église de Dolna Kamenica." Byzantino-
 Bulgarica 4 (1973):275-94.
 A study of donor portraits and fresco ornament in this
 church, known to have been built during the reign of Michael
 Shishman (1323-1330).

743 _____. "Tsŭrkvata v Dolna Kamenitsa (1323-1330) i izkustvoto
 ot tazi epokha" [The church of Dolna Kamenitsa and the art of
 that period]. PNI 3, no. 4 (1970):43-51.
 In Bulgarian. Considers the style of these paintings and
 attempts to relate them to the broadest scope of Paleologan
 painting.

744 _____. "Tsŭrkvata v Dolna Kamenitsa i izkustvoto ot tova
 vreme: Arkhitektura" (Fr. sum.: "L'Église de Dolna Kamenica
 et l'art de cette époque: Architecture"). IzvII 16 (1973):
 25-48 (Fr. sum.: 48).
 In Bulgarian. The architecture of the church of Donja
 Kamenica (ca. 1300) is seen as drawing from the East and West
 alike. Its twin-towered façade is seen as related to those
 Romanesque churches as well to the twin-domed façades of certain
 late Byzantine churches.

745 _____. "Les portraits des donateurs de Dolna Kamenica." ZRVI
 12 (1970):143-56.
 A detailed discussion of the donor portraits in the church
 of Donja Kamenica and their significance for the study of
 fourteenth-century Bulgarian art.

746 Živković, Branislav. "Konzervatorski radovi na freskama
 crkve u Donjoj Kamenici" (Fr. sum.: "Travaux de conservation
 effectués sur les fresques de l'église de Donja Kamenica").
 Saopštenja 4 (1961):189-94 (Fr. sum.: 194).
 In Serbo-Croatian. An account of the surviving frescoes in
 the church and the problems of their conservation. Of the ap-
 proximately 244 m^2 of original frescoes only 109 m^2 are estimated
 to have survived.

DONJI HUMAC [on the island of Brač]

747 Domančić, Davor. "Srednjovječna freska u Donjem Humcu na
 Braču" [A medieval fresco in Donji Humac on Brač]. PPUD 10
 (1956):84-94.
 In Serbo-Croatian. A study of a Deesis fresco in the
 church at Donji Humac. The author analyzes the Byzantine influ-
 ence, and dates the fresco to the end of the thirteenth century
 on archeological grounds.

DONJI STOLIV

748 Nagorni, Dragan. "Die Entstehungszeit der Wandmalerei und
 Identifizierung ihres Malers nach der Fresko-Inschrift in der
 Kirche Sv. Bazilije in Donji Stoliv (Golf von Kotor). Re-
 vision." Zograf 9 (1978):43-49.
 A detailed consideration of surviving fresco inscriptions
 in the church of Sv. Bazilije in Donji Stoliv enables the author
 to identify as the painter one Michael from Kotor (the apprentice
 of one Jovan, painter from Debar) and to date the frescoes to
 1451.

DOVOLJA

749 Ćorović, V[ladimir]. "Manastir Dovolja" (Fr. sum.: "Le
 monastère de Dovolja"). GSND 13 (1934):41-45 (Fr. sum.: 45).
 In Serbo-Croatian. A historical study of the monastery in
 which the author disputes Dj. Bošković's proposed construction
 date of 1545, believing that it was built much earlier. The
 church was dedicated to the Dormition of the Virgin.

DRAGOVOLJIĆI

750 Raičević, Slobodan S. "Crkva u Dragovoljićima kod Nikšića i
 njene zidne slike" (Fr. sum.: "L'église de Dragovoljići près
 de Nikšić et sa peinture murale"). ZLU 12 (1976):139-51 (Fr.
 sum.: 151).
 In Serbo-Croatian. Analyzes the late sixteenth-century
 frescoes of the small single-aisled church of the Savior. The
 work was done before 1592 by the painter Strahinja, who is also
 known to have worked on the church of the Trinity at Pljevlja as
 well as at Piva monastery.

DRENČA

751 Vulović, Branislav. "Problem restauracije manastira Drenče"
 (Fr. sum.: "Les ruines du monastère de Drenča"). ZLU 14
 (1978):213-34 (Fr. sum.: 233-34).
 In Serbo-Croatian. A detailed investigation of the archi-
 tecture of the church of Drenča monastery, near Aleksandrovac.
 Previous attempts at offering a hypothetical reconstruction are
 examined and a new proposal is presented.

752 ____ . "Rezultati radova na konzervaciji ruševina Drenče"
 (Fr. sum.: "Résultats des travaux de conservation exécutés
 sur les ruines du monastère Drenča"). ZZSK 6-7 (1956):227-42
 (Fr. sum.: 242).
 In Serbo-Croatian. A report on the archeological and archi-
 tectural investigation of the monastery church at Drenča and on
 the manner of its conservation.

753 Zdravković, Ivan M. "Manastir Drenča - Dušmanica" (Fr. sum.:
 "Le monastère de Drenča - Dušmanica"). Starinar, n.s. 2
 (1951):245-49 (Fr. sum.: 249).
 In Serbo-Croatian. A study of the architectural remains of
 the church of Drenča monastery. The unusual features of this
 church (built in 1382) are compared to contemporaneous solutions
 in churches of the so-called Morava school.

DUBROVNIK

754 Beritić, Lukša. "Ubikacija nestalih gradjevinskih spomenika
 u Dubrovniku 1" [The location of some lost buildings in
 Dubrovnik]. PPUD 10 (1956):15-83.
 In Serbo-Croatian. A detailed discussion of sixty-six lost
 buildings (fortifications, public buildings, churches, monas-
 teries, and palaces) and their locations in Dubrovnik. The study
 is based on the archival material preserved in Dubrovnik. See
 entry YU 755.

755 ____ . "Ubikacija nestalih gradjevinskih spomenika u
 Dubrovniku 2" (Fr. sum.: "Localisation des monuments archi-
 tecturaux disparus de Dubrovnik, dans les faubourgs de Pile
 et Ploče"). PPUD 12 (1960):61-84 (Fr. sum.: 84).
 In Serbo-Croatian. Additional discussion of the lost monu-
 ments of Dubrovnik and their location within the city. See entry
 YU 754.

756 ____ . Utvrdjenja grada Dubrovnika (Fr. sum.: "Les fortifi-
 cations de la ville de Dubrovnik"). Zagreb: Jugoslavenska
 Akademija znanosti i umjetnosti, 1955. 218 pp. (Fr. sum.:
 219-23), figs. in text, pls., 9 foldout plans.
 In Serbo-Croatian. A comprehensive history of the forti-
 fications of Dubrovnik from the earliest times to the present.

Fiskovič, Cvito. See entry YU 629

757 _____. "O vremenu i jedinstvenosti gradnje dubrovačke Divone"
 (Fr. sum.: "Sur l'époque et l'unité de style de la Douane de
 Dubrovnik"). PPUD 7 (1953):33-57 (Fr. sum.: 88).
 In Serbo-Croatian. Proposes that contrary to what was be-
 lieved by earlier investigators, the Divona should be considered
 a product of a single building campaign and should be dated to
 the early part of the sixteenth century. The conservative fusion
 of late Gothic and Renaissance styles is seen as a local charac-
 teristic, also witnessed on several contemporaneous villas and
 mansions.

758 _____. "Umjetnine stare dubrovačke katedrale" [Art treasures
 of the old cathedral of Dubrovnik]. Bulletin Zavoda za
 likovne umjetnosti Jugoslavenske akademije znanosti i umjet-
 nosti 14, nos. 1-3 (1966):62-75.
 In Serbo-Croatian. Publishes a section of a manuscript
 report entitled "Ragusina Visitatio Apostolica," dated 1573, and
 kept in the Vatican archives. This document provides a detailed
 account of the treasures kept in the old cathedral of Dubrovnik
 prior to its destruction in the earthquake of 1667. Full Latin
 version of this portion of the text is included.

759 _____. "Umjetnine u nekadašnjoj dubrovačkoj crkvi sv. Vlaha"
 (Fr. sum.: "Oeuvres d'art de l'ancienne église St. Blaise
 dans la ville de Dubrovnik"). ZLU 5 (1969):325-35 (Fr. sum.:
 325).
 In Serbo-Croatian. Examines the content of a description
 of the medieval church of St. Blaise by a papal legate during a
 visit to Dubrovnik in 1573. This important description focuses
 on the church treasures largely lost in the fire which destroyed
 the church in 1706.

760 Prelog, Milan. "Dubrovački statut i izgradnja grada (1272-
 1972)" [The Dubrovnik statutes and the growth of the city
 (1272-1972)]. Peristil 14-15 (1971-72):81-94.
 In Serbo-Croatian. An analysis of the continuity of the
 growth of Dubrovnik from medieval times. The phenomenon is
 linked to the laws which carefully controlled and checked the
 growth of the town.

761 Radič, F. "Razvaline crkve S. Stjepana u Dubrovniku" [Ruins
 of the church of St. Stephen in Dubrovnik]. SP 3, no. 1
 (1897):14-27.
 In Serbo-Croatian. An account of the remains of the pre-
 Romanesque church of St. Stephen in Dubrovnik. Particularly
 important are fragments of architectural sculpture and the fully
 preserved west portal (now used in the church of St. Bartul).

762 Skurla, Stjepan. Močnik stolne crkve dubrovačke [Relics in
 the cathedral of Dubrovnik]. Dubrovnik: D. Pretner, 1868.
 177 pp., illus.
 In Serbo-Croatian. A historical guide to the relics of the
 cathedral of Dubrovnik. These include a cross of Queen Margarita,
 a cross of Bishop Boniface, a cross of King Uroš II Milutin,
 threads from Christ's garments, thorns from the Crown of Thorns,
 a piece of sponge, a drop of Christ's blood, and a fragment of
 the Holy Sepulchre.

763 Zdravković, Ivan M. Dubrovački dvorci: Analiza arhitekture i
 karakteristika stila (Eng. sum.: "The mansions of Dubrovnik:
 An analysis of their architecture and the features of their
 style"). Arheološki institut; Gradja, 1. Belgrade: Srpska
 akademija nauka, 1951. 122 pp. (Eng. sum.: 114-22), photos.
 in text, numerous architectural drawings.
 In Serbo-Croatian. A comprehensive survey of fifteenth-
 and sixteenth-century mansions of Dubrovnik. The period of con-
 struction of the mansions coincides with the period of greatest
 economic prosperity of the free republic of Dubrovnik.

FRUŠKA GORA [region]

764 Jović, Olivera Milanović, and Momirović, Petar. Fruškogorski
 manastiri [The monasteries of Fruška Gora]. Spomenici kulture,
 2d ser. 2. Belgrade: Turistička štampa, 1963. 88 pp.,
 numerous illus. in text.
 In Serbo-Croatian. A guide to the monasteries of Fruška
 Gora illuminating their history, architecture, and art. The book
 documents major damage suffered by many of these monasteries dur-
 ing World War II. A select bibliography is included.

765 Manojlović, Aleksandar. Srpski manastiri u Fruškoj Gori
 [Serbian monasteries in Fruška Gora]. Sremski Karlovci:
 1937. 118 pp., many illus.
 In Serbo-Croatian. An illustrated guide to the Serbian
 monasteries of Fruška Gora. While all of the monasteries are
 post-medieval, many of them reflect a survival of medieval archi-
 tectural and artistic traditions.

GLOGOVNICA [near Križevac]

766 Horvat, Andjela. "Prilozi povijesno-umjetničkim problemima u
 nekoć templarskoj Glogovnici kraj Križevca" (Ger. sum.:
 "Beiträge zu den kunsthistorischen Problemen des einstigen
 Templarbesitzes Glogovnica bei Križevci in Nord-Kroatien").
 Peristil 4 (1961):29-45 (Ger. sum.: 45).
 In Serbo-Croatian. A detailed analysis of the Glogovnica
 complex, concluding that the original two-aisled church was begun
 in the late fifteenth or early sixteenth century, but was left

unfinished. Damaged in the sixteenth century, it was repaired in
the eleventh century, when the interior was also decorated.

GOLUBAC

767 Deroko, Aleksandar. "Grad Golubac" (Fr. sum.: "Le château
 fort de Golubac"). Starinar, n.s. 2 (1951):139-49 (Fr. sum.:
 149).
 In Serbo-Croatian. A study of the late medieval fortress
 of Golubac and its subsequent Turkish modifications.

768 Katanić, Nadežda. "Srednjovekovni grad Golubac" (Fr. sum.:
 "La forteresse médiévale de Golubac"). ZZSK 20-21 (1971):
 113-31 (Fr. sum.: 130-31).
 In Serbo-Croatian. A brief study of the history and archi-
 tecture of the medieval fort of Golubac. The article includes a
 short analysis of the excavated coins and proposals for the con-
 servation of the fortress.

GOMIONICA

769 Momirović, Petar. "Da li su manastir Gomionica osnovali
 Mileševci" (Fr. sum.: "Est-ce que le monastère Gomionica
 était fondé par les moines de Mileševa et est-ce que ceux-ci
 y séjournaient?"). NS 12 (1969):127-32 (Fr. sum.: 132).
 In Serbo-Croatian. Disproves earlier suppositions that
 Gomionica monastery in Bosnia was founded by monks from Mileševa
 monastery.

GORAŽDE

770 Mazalić, Djoko. "Hercegova crkva kod Goražda i okolne
 starine" [The church of Herceg Stjepan near Goražde, and the
 antiquities found in the surrounding area]. GZMS 52, no. 1
 (1940):27-43.
 In Serbo-Croatian. A detailed account of the history and
 architecture of the church built by Herceg Stjepan and enlarged
 in the sixteenth century and later. A nearby medieval fortress
 is also discussed.

GOREN KOZJAK (BARGALA)

771 Aleksova, Blaga, and Mango, C. "Bargala: A Preliminary
 Report." Dumbarton Oaks Papers 25 (1971):265-81.
 A preliminary report on the archeological excavations of
 the late Roman-Byzantine episcopal town of Bargala. A section of
 the report is devoted to a detailed account of the middle Byzan-
 tine church of St. George. Three distinctive phases of fresco
 decoration have been observed. Pages 273-77 are of particular
 interest.

Grujić, Radoslav M. See entry YU 104

772 Mikhailov, St[amen]. "Koziak i Bregalnishkata episkopiia"
 (Fr. sum.: "Kozjak et l'évêché de Bregalnica"). <u>IBAI</u> 15
 (1946):1-23 (Fr. sum.: 22-23).
 In Bulgarian. After a historical introduction dealing with
 the bishopric of Bregalnica, the author focuses on an analysis of
 the architecture and frescoes of the church of St. George while
 also considering other churches in the region (Morodviz,
 Zhigiantsi, and Kochani).

773 Nikolovska, Zagorka Rasolkoska. "Arheološkite istražuvanja na
 crkvata Sv. Gorgi vo Gorni Kozjak" (Fr. sum.: "Les recherches
 archéologiques sur l'église Saint Georges à Gorni Kozjak").
 <u>Zbornik na Štipskiot naroden muzej</u> 4-5 (1975):125-39 (Fr.
 sum: 139).
 In Macedonian. An account of the archeological investiga-
 tion of the church which revealed a number of graves around the
 church and a built floor tomb in the south arm of the cross-
 shaped naos.

774 _____. "Crkvata Sv. Djordji vo Goren Kozjak vo svetlinata na
 novite ispituvanja" (Eng. sum.: "The church of St. George at
 Goren Kozjak in the light of new research"). In <u>Simpozium</u>
 <u>1100-godišnina od smrtta na Kiril Solunski</u> 1. Skopje:
 Makedonska akademija na naukite i umetnostite, 1970,
 pp. 219-26 (Eng. sum.: 226).
 In Macedonian. Three phases in the early life of the
 church are reported. The first saw the construction of the main
 part of the church (opinions on the dating vary from the ninth to
 the twelfth centuries). The fresco of Christ Antiphonites be-
 longs to the second phase (thirteenth century), while the addi-
 tion of the two lateral chapels and the majority of the surviving
 frescoes belong to the fourteenth century.

775 _____. "Isus Hristos Antifonitis od crkvata Sv. Gorgi vo
 Goren Kozjak" (Fr. sum.: "Jésus Christ Antiphonitis de
 l'église de Saint Georges de Gorni Kozjak"). <u>Zbornik.</u>
 <u>Arheološki muzej na Makedonija</u> 6-7 (1975):217-30 (Fr. sum.:
 229-30).
 In Macedonian. Discusses a newly discovered fresco of
 Christ Antiphonitis in the church of St. George at Gorni Kozjak.
 The iconography and meaning of this unusual Christ type are ana-
 lyzed in relationship to other known examples.

GRAČANICA

Bošković, Georges. See entry YU 79

776 Ćurčić, Slobodan. Gračanica: King Milutin's Church and Its
 Place in Late Byzantine Architecture. University Park and
 London: The Pennsylvania State University Press, 1979.
 159 pp., 127 illus.
 The major monograph on the history and architecture of
 Gračanica and a major study of Serbian fourteenth-century archi-
 tecture in English. Discusses Gračanica as a work of the best
 Greek builders brought to Serbia by King Milutin as part of his
 general plan to "byzantinize" Serbia. The building is also seen
 as having been initially intended to function as a royal mauso-
 leum. This intention was subsequently abandoned for political
 reasons.

777 _____. "The Original Baptismal Font of Gračanica and Its
 Iconographic Setting." ZNM 9-10 (1979):313-23.
 Fragments of a baptismal font at Gračanica are identified
 as the remains of the church's original font, believed to have
 been situated in the south half of the inner narthex. The font
 is believed to have stood in front of the composition depicting
 the Nemanjić family tree in the manner in which it appears in the
 slightly later churches at Dečani monastery and at Peć.

778 Grguri, Abdula. "Slikarsko-konzervatorski radovi u manastiru
 Gračanici izvedeni 1971 godine" (Fr. sum.: "Les travaux de
 peinture et les travaux conservatoires réalisés au monastère
 de Gračanica en 1971"). SKM 6-7 (1972-73):191-98 (Fr. sum.:
 198).
 In Serbo-Croatian. An account of the 1971 conservation of
 the Gračanica frescoes. Provides many useful details both
 through the description of individual frescoes and through illus-
 trations--the quality of which, unfortunately, is not consistent.

779 Korać, Vojislav. "Gračanica: Prostor i oblici" (Fr. sum.:
 "Gračanica: Espace et formes dans la structure architecto-
 nique"). In Zbornik Svetozara Radojčića. Edited by Vojislav
 J. Djurić. Belgrade: Filozofski fakultet, Odeljenje za
 istoriju umetnosti, 1969, pp. 143-54 (Fr. sum.: 153-54).
 In Serbo-Croatian. An analysis of Gračanica architecture
 from the point of view of the space and exterior building forms.
 Argues for Western origins of elongated proportions and certain
 spatial qualities of the building, and sees it as part of the
 continuing tradition from the thirteenth century.

780 Mijović, Pavle. "O genezi Gračanice" (Fr. sum.: "Genèse de
 Gračanica"). In Vizantijska umetnost početkom XIV veka.
 Edited by S. Petković. Belgrade: Filozofski fakultet,
 Odeljenje za istoriju umetnosti, 1978, pp. 127-63 (Fr. sum.:
 160-63).
 In Serbo-Croatian. A study of Gračanica architecture
 largely based on archeological excavations conducted in and
 around the church between 1957 and 1964. These have revealed

the existence of two older buildings on the site—a Byzantine basilica (sixth-eleventh centuries) and a single-aisled thirteenth-century church. In conjunction with these finds, the author analyzes the centrality of Gračanica's plan and its subsequent modifications and adaptations.

781 ____. "O hronologiji gračaničkih fresaka" (Fr. sum.: "Sur la chronologie des fresques de Gračanica"). SKM 4-5 (1968-71): 179-201 (Fr. sum.: 201).
 In Serbo-Croatian. A study of several frescoes at Gračanica with proposed new interpretations and new datings based largely on investigations carried out during the restoration of the church.

782 ____. "Prilozi proučavanju Gračanice" (Fr. sum.: "Contribution à l'étude du monastère de Gračanica"). ZNM 9-10 (1979): 325-53 (Fr. sum.: 346-47).
 In Serbo-Croatian. Three separate subjects are considered: the funeral of Bishop Theodore and the prayer of Todor Branković in the south chapel; the restoration of the fresco representing Christ Pantokrator and the Virgin in the central portion of the church; and the figures of SS. Marina and Paraskeve in the north ambulatory wing.

783 Nenadović, S[lobodan] M. "Još jedanput o prelomljenim lucima na Gračanici" (Fr. sum.: "Au sujet des arcs brises de l'église Gračanica [Une nouvelle fois]"). SKM 6-7 (1972-73): 13-21 (Fr. sum.: 21).
 In Serbo-Croatian. The appearance of pointed arches at Gračanica and in Serbian medieval architecture in general is seen as a stylistic feature adopted from Gothic architecture, but employed in a different manner. The motif is seen as having been primarily used to emphasize the vertical thrust in building design. As such, it was aesthetically consistent with general design principles of the period.

784 Petković, Sreten. "Slikarstvo spoljašnje priprate Gračanice" (Fr. sum.: "La peinture de l'exonarthex de Gračanica"). In Vizantijska umetnost početkom XIV veka. Edited by S. Petković. Belgrade: Filozofski fakultet, Odeljenje za istoriju umetnosti, 1978, pp. 201-12 (Fr. sum.: 212).
 In Serbo-Croatian. Discusses the sixteenth-century frescoes in the exonarthex of Gračanica and their stylistic relationships to the fourteenth-century frescoes in the main church.

785 Popović, Pera J. "Kralj Milutin kao monah na freski u Gračanici" [King Milutin as a monk on a fresco in Gracaniča]. Starinar, 3d ser. 4 (1926-27):113-14.
 In Serbo-Croatian. A brief account of a fresco depicting King Milutin as a monk with his mother, Queen Jelena (referred to as Saint Jelena). The unusual iconography, the errors of

representing King Milutin as a monk and of referring to Queen
Jelena as <u>Saint</u> Jelena, and the evident subsequent tampering with
the fresco pose many questions which the author leaves open.

786 Radojčić, Svetozar. "Gračanica i Dečani" [Gračanica and
 Dečani]. <u>UP</u> 3, nos. 4-5 (April-May 1940):130-33.
 In Serbo-Croatian. A perceptive discussion of the rela-
 tionship between painted decoration and the architectural system
 in two major fourteenth-century Serbian monuments. Architecture
 of Gračanica, Byzantine in essence, is found to be aptly suited,
 while the system at Dečani, Western in essence, is in conflict
 with the decorative program.

787 _____. "Gračanicke freske" (Fr. sum.: "Les fresques de
 Gračanica"). In <u>Vizantijska umetnost početkom XIV veka</u>.
 Edited by S. Petković. Belgrade: Filozofski fakultet,
 Odeljenje za istoriju umetnosti, 1978, pp. 173-82 (Fr. sum.:
 181-82).
 In Serbo-Croatian. Analyzes the frescoes of Gračanica in
 the context of late Byzantine painting. Stylistic and icono-
 graphic problems are discussed. New qualities of these frescoes
 were revealed as a consequence of their cleaning.

788 Vulović, Branislav. "Manastir Gračanica (Prilozi za istoriju,
 arhitekturu i slikarstvo - I deo)" (Fr. sum.: "Le monastère
 Gračanica"). <u>SKM</u> 4-5 (1968-71):165-78 (Fr. sum.: 177-78).
 In Serbo-Croatian. A detailed report on the findings re-
 sulting from archeological excavations and the restoration of the
 church. These concern the history, architecture, and frescoes.

789 _____. "Nova istraživanja arhitekture Gračanice" (Fr. sum.:
 "Nouvelles recherches sur l'architecture de Gračanica"). In
 <u>Vizantijska umetnost početkom XIV veka</u>. Edited by S. Petković.
 Belgrade: Filozofski fakultet, Odeljenje za istoriju umet-
 nosti, 1978, pp. 165-72 (Fr. sum.: 171-72).
 In Serbo-Croatian. The study is based on extensive in-
 vestigation of the church architecture at the time of its con-
 servation. The author concentrates on the question of the
 exonarthex and its initial appearance.

Walter, Christopher. See entry YU 606

GRADAC

790 Babić, Gordana. "Ciklus Hristovog detinjstva u predelu s
 humkama na fresci u Gracu" (Fr. sum.: "Les scènes de l'en-
 fance du Christ dans le paysage aux collines à Gradac").
 <u>Raška baština</u> 1 (1975):49-57 (Fr. sum.: 56-57).
 In Serbo-Croatian. Draws a parallel between the cycle of
 Christ's infancy at Gradac and a twelfth-century icon from Sinai,
 and suggests that this relationship confirms the dependence of
 thirteenth-century Serbian painting on the Comnenian tradition.

791 Bošković, Djurdje, and Nenadović, S. Gradac [Parallel texts
 in Serbo-Croatian and French]. Beograd: Prosveta, 1951.
 10 pp., 25 pls.
 A monograph on the church and its monastic compound. De-
 tailed drawings and photographs (before restoration) show the
 architecture, sculpture, sculptural decoration, and frescoes.

792 Nenadović, Slobodan. "Problemi restauracije gradačke crkve"
 (Fr. sum.: "Les problèmes de la restauration de l'église de
 Gradac"). ZZSK 18 (1967):27-38 (Fr. sum.: 38).
 In Serbo-Croatian. A study of the ruins of the Gradac
 monastery church. Earlier hypothetical reconstruction proposals
 are examined and a new proposal is presented. Investigates the
 possibility of reconstructing window frames and other sculpted
 details on the basis of surviving fragments.

793 Živković, Branislav. "Konzervatorski radovi na freskama
 manastira Gradca" (Fr. sum.: "Travaux de conservation des
 fresques de l'église de Gradac"). Saopštenja 8 (1969):119-28
 (Fr. sum.: 128).
 In Serbo-Croatian. A brief note on the conservation of the
 Gradac frescoes which includes a series of useful diagrams illus-
 trating the distribution of the program.

794 _____. "Otkrivanje živopisa u crkvi sv. Nikole u Gradcu" (Fr.
 sum.: "Découverte des fresques dans l'église Saint Nicolas à
 Gradac"). Saopštenja 10 (1974):37-41 (Fr. sum.: 41).
 In Serbo-Croatian. A report on the newly uncovered frescoes
 includes drawings which illustrate the distribution of the deco-
 rative program.

795 Zloković, Milan. "Gradačka crkva, zadužbina kraljice Jelene"
 (Fr. sum.: "L'église de Gradac, fondation de la reine
 Hélène"). GSND 15-16 (1936):61-80 (Fr. sum.: 77-79).
 In Serbo-Croatian. This detailed study of the remains of
 the church is of considerable importance, as it documents the
 state of the building before its restoration. Numerous drawings
 and photographs record architectural and sculptural details.

HILANDAR [Mt. Athos]

 [Serbian monastery of Hilandar (Chilandari, in Greek) is situated
 on Mount Athos in Greece, and thus territorially is outside of
 the scope of this bibliography. Because of its vital importance
 in the cultural life of Serbia throughout the Middle Ages it is
 noted here with the citation of a recent comprehensive monograph
 which gives a complete bibliography.]

796 Bogdanović, Dimitrije; Djurić, Vojislav J.; and Medaković,
 Dejan. Hilandar. Belgrade: Republički zavod za zaštitu
 spomenika kulture Srbije, Jugoslovenska revija, and Vuk
 Karadžić, 1978. 220 pp., 164 figs. in text (mostly color).

Published in several languages including English, German, and French. The most comprehensive monograph on the Serbian monastery on Mount Athos. Discusses the history, architecture, painting, and the decorative arts from the monastery's beginning to the eighteenth century. All older literature is systematically presented in an appended bibliography (pp. 206-10). The book is superbly illustrated.

HOPOVO

797 Davidov, Dinko. Hopovo. Medieval Art in Yugoslavia.
 Belgrade: Jugoslavija, 1964. 9 pp., 61 pls.
 A brief account of the sixteenth-century monastery of
 Hopovo considering its history, architecture, and seventeenth-
 century frescoes. The book is illustrated with a selection of
 fine black-and-white photographs.

HUM [in Istria]

798 Fučić, Branko. "Hum: Ciklus romaničko-bizantinskih zidnih
 slikarija" (It. sum.: "Hum: Un ciclo di pitture murali
 romanico-bizantine"). Peristil 6-7 (1963-64):13-22.
 In Serbo-Croatian. A detailed discussion of high-quality
 paintings in the small single-aisled church of St. Jerome in Hum
 (central Istria), believed to date from the twelfth century. The
 frescoes are judged to have been commissioned by the patriarch of
 Aquileia at the time when Hum became his fief (1102), and this is
 seen as an explanation of the extraordinarily high quality of the
 paintings.

HVAR [island]

799 Fisković, Cvito. "Prilog za Romaniku u Hvaru" (Fr. sum.:
 "Au sujet du style roman dans la ville dalmate de Hvar").
 ZNM 9-10 (1979):301-6 (Fr. sum.: 306).
 In Serbo-Croatian. A study of sculptural and architectural
 features from three locations on the island of Hvar. The identi-
 fied pieces are rare examples of Romanesque art on this island.

800 Novak, Grgo. Hvar. Istorijska biblioteka, 2. Belgrade,
 1924. 238 pp., 79 figs.
 In Serbo-Croatian. A general history and cultural history
 of the island of Hvar from Ancient Greek times through the eight-
 eenth century. Chapter 8 (pp. 170-95) considers architectural
 monuments of the island.

HVOSNO [region]

801 Korać, Vojislav. Studenica Hvostanska. Monografije, 4.
 Belgrade: Filozofski fakultet, Institut za istoriju umet-
 nosti, 1976. 172 pp., 172 illus. (Fr. sum.: 145-62).
 In Serbo-Croatian. A detailed study of the destroyed
 medieval monastery of uncertain name. The book includes the
 results of extensive archeological investigations of the site.
 These revealed the extent of the medieval monastery, and the
 remains of an older (fifth-sixth centuries) building complex
 which included a three-aisled basilica, a vaulted tomb chamber,
 and fortification walls. The medieval church shows affinities
 with the architecture of the Adriatic littoral in its architec-
 tural forms and building technique.

802 Smirnov, S., and Bošković, Dj. "L'église de la Mère-de-Dieu
 de Hvosno." Starinar, 3d ser. 10-11 (1935-36):47-81.
 A detailed account of the history and the architecture of
 the church of the Virgin at Hvosno. An important document of the
 first archeological excavations.

JAJCE

803 Basler, Djuro. "Konzervacija južnog zida tvrdjave u Jajcu"
 (Ger. sum.: "Die Südwand der Zitadella in Jajce"). NS 6
 (1959):121-34 (Ger. sum.: 134).
 In Serbo-Croatian. A report on the conservation of the
 south wall of the fortress at Jajce. The wall includes a Gothic
 portal with a royal coat of arms of Stjepan II Tomašević. On the
 basis of the coat of arms, the portal is dated between 1406 and
 1461. Other architectural fragments were discovered, as well as
 a Romanesque two-light window belonging to the thirteenth century.

804 Mazalić, Djoko. "Stari grad Jajce (Novija arheološka istraži-
 vanja)" (Fr. sum.: "Jajce: Un vieux château bosnien").
 GZMS, n.s. 7 (1952):59-100 (Fr. sum.: 99-100).
 In Serbo-Croatian. A detailed historical, archeological
 and architectural study of the fortress of Jajce. Examines the
 structural history of the fortress, as well as the individual
 buildings within it.

805 Nikolajević, Ivanka. "Zvonici crkava u Koluniću i Jajcu" (Fr.
 sum.: "Les clochers orientaux des églises à Kalunić et à
 Jajce"). Starinar, n.s. 20 (Mélanges Djurdje Bošković)
 (1970):249-54 (Fr. sum.: 254).
 In Serbo-Croatian. A study of two medieval belfries in
 Bosnia, characterized by the fact that they rise at the eastern
 ends of churches--over the sanctuary (Kolunić) and adjacent to
 the sanctuary (Jajce). The phenomenon is compared with similar
 arrangements in Slovenia and Italy.

JAŠUNJA

806 Ljubinković, Mirjana Ćorović. "Jašunjski manastiri" (Fr.
 sum.: "Les monastères de Jašunja"). Starinar, n.s. 1
 (1950):229-36 (Fr. sum.: 236).
 In Serbo-Croatian. A brief account of two monastic
 churches, Sv. Jovan Krstitelj and Sv. Bogorodica, built in 1517
 and1499 respectively. The article considers their history,
 architecture, frescoes, and icons.

JELSA [on the island of Hvar]

807 Duboković, Niko. "Gradnja i povjest crkve-tvrdjave u Jelsi"
 (Fr. sum.: "L'église-forteresse de Jelsa"). PPUD 18 (1970):
 101-29 (Fr. sum.: 129).
 In Serbo-Croatian. Discusses the general and structural
 history of the church-fortress at Jelsa. The church dates to the
 fourteenth century, but was thoroughly rebuilt to function as a
 fortress in the sixteenth century to ward off Turkish threats.

JEZERSKO

808 Stelè, Francè. "Gotske freske na Jezerskem" (Fr. sum.: "Les
 fresques gothiques à Jezersko"). ZUZ 1 (1921):109-37 (Fr.
 sum.: 109-10).
 In Slovenian. A detailed study of the upper layer of
 poorly preserved frescoes in the church of St. Oswald at Jezersko
 has revealed that the paintings are from the mid-fifteenth cen-
 tury and that they belong to the tradition of the best fresco
 painting at the time (comparable to the work of Johannes de
 Laybaco).

JEŽEVICA. See STJENIK

JOŠANICA (JOŠANIČKA BANJA)

809 Knežević, Branka. "Stara crkva u Banji Jošanici" (Fr. sum.:
 "La vieille église Jošanica"). ZLU 12 (1976):71-95 (Fr. sum.:
 95).
 In Serbo-Croatian. A study of the history, architecture,
 and frescoes of the small single-aisled seventeenth-century
 church of St. Demetrius.

810 Nikolić, Radomir. "Prilog proučavanju živopisa manastira
 Jošanice" (Fr. sum.: "Apport pour l'étude de la peinture du
 monastère de Jošanica"). Saopštenja 9 (1970):129-43 (Fr.
 sum.: 143).
 In Serbo-Croatian. A study of the style and iconography of
 the preserved frescoes. The author dates the frescoes to the
 middle of the fifteenth century.

811 Prokić, Radoslav. "Konzervatorsko-restauratorski radovi na
 arhitekturi crkve manastira Jošanice" (Fr. sum.: "Travaux de
 conservation et de restauration sur l'architecture du mona-
 stère de Jošanica"). Saopštenja 9 (1970):119-28 (Fr. sum.:
 128).
 In Serbo-Croatian. A study of the architecture and con-
 servation of this small fourteenth-century church. The design of
 the church reveals curious formal and stylistic discrepancies.

JOŠANIČKA BANJA. See JOŠANICA

KALENIĆ

812 Bošković, Dj[urdje]. "Kube nad pripratom Manastira Kalenića"
 (Fr. sum.: "La coupole du narthex du monastère de Kalenić").
 Starinar, 3d ser. 5 (1930):156-74 (Fr. sum.: 173-74).
 In Serbo-Croatian. An important article on the dome on the
 tower of Kalenić. Discusses the subject in great depth, includ-
 ing a detailed architectural and technical account of its
 restauration.

813 Petković, Vlad[imir] R. "Freske iz unutrašnjega narteksa
 crkve u Kaleniću" [Frescoes from the inner narthex of
 Kalenić]. Starinar, n.s. 3 (1908):121-43.
 In Serbo-Croatian. The fresco program is considered to be of
 oriental, Syrian origin--whence it was assimilated into Byzantine
 art. The entire program is analyzed in considerable detail.

814 Petković, Vlad[imir] R., and Tatić, Ž. Manastir Kalenić (Fr.
 sum.: "L'église de Kalenić"). Srpski spomenici, 4. Vršac:
 Narodni muzej u Beogradu, 1926. 90 pp. (Fr. sum.: 11, 52-58,
 88-90), 73 figs.
 In Serbo-Croatian. The most thorough monograph on the sub-
 ject to date. The authors present the material in three chap-
 ters, which discuss the history, architecture, and painting,
 respectively.

Ppopović, Pera J., and Petković, Vlad[imir] R. See entry YU 1202

815 Radojčić, Svetozar. Kalenić. Medieval Art in Yugoslavia.
 Belgrade: Jugoslavija, 1964. 24 pp., 61 figs., map.
 A brief monograph on Kalenić illustrated with a selection
 of fine black-and-white photographs.

816 Živković, Branislav. "Konzervatorski radovi na freskama
 manastira Kalenića" (Fr. sum.: "Travaux de conservation ef-
 fectués sur les fresques du monastère Kalenić"). Saopštenja
 4 (1961):181-88 (Fr. sum.: 188).
 In Serbo-Croatian. This account of the preservation of the
 Kalenić frescoes includes the history of the activity, documen-
 tary evidence, and an estimate of the surviving frescoed area

(ca. 442 m^2) in contrast to the original frescoed area (ca. 742 m^2).

KANFANAR [in Istria]

817 Ekl, Vanda. "Ranogotička propovjedaonica u Kanfanaru" [Early
 Gothic pulpit at Kanfanr]. Bulletin Zavoda za likovne umjet-
 nosti Jugoslavenske akademije znanosti i umjetnosti 9, no. 3
 (1961):158-68.
 In Serbo-Croatian. The fine, well-preserved early Gothic
 pulpit from the church of St. Silvestar at Kanfanar comes from
 the church of St. Sofia in Dvigrad, a prosperous medieval town
 abandoned in the eighteenth century because of malaria and
 plague. The six-sided pulpit is elevated on colonnettes and
 displays high-relief carvings on the parapet panels.

KARAN

818 Babić, Gordana. "Portret kraljeviča Uroša u Beloj Crkvi
 Karanskoj" (Fr. sum.: "La figure du prince Uroš dans l'Église
 Blanche de Karan"). Zograf 2 (1967):17-19 (Fr. sum.: 59).
 In Serbo-Croatian. The group portrait depicting St. Sava,
 King Milutin, and King Dušan at Bela Crkva in Karan is shown to
 have included another member of the Nemanjić family--Dušan's son
 Uroš, depicted as a young boy. The fresco is dated ca. 1341-1342,
 before the final decision regarding Dušan's succession had been
 made.

819 Kašanin, Milan. "Bela Crkva Karanska" [The Bela Crkva at
 Karan]. Starinar, 3d ser. 4 (1926-27):115-21 (Fr. sum.:
 220-21).
 In Serbo-Croatian. A monographic study of Bela Crkva which
 considers the monastery's history, architecture, and frescoes.
 The section on frescoes discusses the distribution of individual
 scenes, the content of individual frescoes, and the technique of
 execution. The church dates from the period of Stefan Dečanski.

820 Mandić, Svetislav. "Jedna ktitorka Bele Crkve Karanske" (Fr.
 sum.: "Une donatrice de Bela Crkva de Karan"). Starinar,
 n.s. 9-10 (1959):223-25 (Fr. sum.: 225).
 In Serbo-Croatian. Discusses a portrait of a kneeling nun
 discovered in 1957. The nun is depicted at the feet of the
 three-handed Virgin and represents the earliest known donor por-
 trait of this type in Serbian medieval painting.

821 Simić, Zorka. "Ikonostas Bele Crkve u selu Karanu i Karanska
 Bogorodica Trojeručica" (Fr. sum.: "Iconostase à Bela Crkva
 de Karan avec la Ste. Vierge Tricheîra"). Starinar, 3d ser. 7
 (1932):15-35 (Fr. sum.: 133-34).
 In Serbo-Croatian. An exhaustive study of the built
 iconostasis in Bela Crkva at Karan focusing on the problem of

built iconostasis screens and their iconographic content. One of
the frescoes on the iconostasis is the full standing figure
representing the Three-Handed Virgin. The second half of the
article considers this type.

KASTALJAN

822 Vujović, Gordana Marjanović. "Manastirski kompleks Kastaljan"
 (Fr. sum.: "Complex monastique Kastaljan"). Starinar,
 n.s. 30 (1980):83-88 (Fr. sum.: 87-88).
 In Serbo-Croatian. A study of the excavated remains of a
 small late-medieval monastery at Kastaljan on the Kosmaj moun-
 tain. The excavated remains include a small single-aisled
 church, a refectory, a kitchen, and a dormitory building.

KMETOVCI

823 Korać, Vojislav. "Crkva sv. Varvare (sv. Dimitrija) u selu
 Kmetovci kod Gnjilana" (Fr. sum.: "L'église de Sainte Barbara
 (Saint Démétrios) au village Kmetovci près de Gnjilane"). SKM
 2-3 (1963):91-99 (Fr. sum.: 99).
 In Serbo-Croatian. A study of the ruins of the small
 church of St. Barbara dated to the second half of the fourteenth
 century. The church is related to a group of churches in which
 Byzantine aspects intermingle with characteristics of the so-
 called Raška school.

KNIN (BISKUPIJA)

824 Abramić, Mich. "Die Wichtigkeit der Denkmäler im Museum von
 Knin für Geschichte und Kunstgeschichte des frühen Mittel-
 alters in Dalmatien." Actes du IIIme Congrès international
 d'études byzantines (Athens) (1932):372-81.
 A discussion of the significance of pre-Romanesque sculp-
 ture from Sopot and Uzdolje, and bronze objects from graves at
 Biskupija (all at the Knin Museum) for the study of early
 Croatian art.

825 Gunjača, Stipe. "Četvrta starohrvatska crkva u Biskupiji kod
 Knina i groblje oko nje" (Fr. sum.: "A propos de la quatrième
 église vieille croate de Biskupija, près de Knin et du cime-
 tière qui l'entoure"). SP, 3d ser. 2 (1952):57-79 (Fr. sum.:
 79).
 In Serbo-Croatian. Archeological report of the discovery
 of the fourth old Croatian church at Biskupija. The church was a
 single-aisled structure of modest dimensions. The finds include
 sculpted architectural fragments as well as small finds (jewelry)
 from the graves excavated around the church.

826 _____. "O položaju Kninske katedrale" (Fr. sum.: "Sur
l'emplacement de la cathédrale de Knin"). SP, 3d ser. 1
(1949):38-86 (Fr. sum.: 84-86).
 In Serbo-Croatian. Analyzes the question of the location
of the old Croatian cathedral of Knin in the light of historical
sources and archeological finds. The problem still remains
largely unresolved, but the options are exhaustively examined.

827 _____. "Ostaci starohrvatske crkve Sv. Cecilije na Stupovima
u Biskupiji kod Knina" (Eng. sum.: "Remains of the old
Croatian church of St. Cecily on Stupovi at Biskupija near
Knin"). SP, 3d ser. 5 (1956):65-127 (Eng. sum.: 125-27).
 In Serbo-Croatian. A major report of supplementary exca-
vations conducted by the author. The report corrects previous
mistaken interpretations and presents a body of new information.
The three-aisled piered basilica, preceded by a tower on axis,
is believed to date from the middle of the eleventh century.

828 _____. "Starohrvatska crkva i groblje na Lopuškoj Glavici u
Biskupiji kod Knina" [Old Croatian church and cemetery on
Lopuška Glavica at Biskupija in Knin]. SP, 3d ser. 3 (1954):
7-29 (Fr. sum.: 29).
 In Serbo-Croatian. An old Croatian church (probably ninth
century) was extensively studied during the secondary excavation.
Previous concepts of the church's architecture were revised, and
much new material presented (architectural sculpture, small
finds, etc.). The church is believed to have been destroyed
around the middle of the thirteenth century (possibly during the
Tartar invasion).

829 _____. "Tinensia archaeologica - historica - topographica 1."
[Archeology, history, and topography of ancient Tininium].
SP, 3d ser. 6 (1958):105-62 (Eng. sum.: 162-64).
 In Serbo-Croatian. Part one of an exhaustive study of old
Croatian culture in the area of Knin (ancient Tenin, Tnin, or
Tininium) considers the archeological finds from four villages:
Padjene, Kninsko Polje, Vrpolje, and Plavno. The material is
considered within the historical context and is well documented.
See entry YU 830.

830 _____. "Tinensia archaeologica - historica - topographica 2"
[Archeology, history, and topography of ancient Tininium, 2].
SP, 3d ser. 7 (1960):7-142 (Eng. sum.: 134-42).
 In Serbo-Croatian. Part two of an exhaustive study of old
Croatian culture in the area of Knin (ancient Tenin, Tnin, or
Tininium) considers primarily the material finds from Knin it-
self. The study is comprehensive in its presentation of mate-
rial, and is well documented. See entry YU 829.

831 Ivekovič, Č.M. "Kapitul kraj Knina" [The "Capitol" near
 Knin]. SP, n.s. 1 (1927):252-71.
 In Serbo-Croatian. Identifies three churches on the
 Capitol--a tenth-century [?] small church, superseded by a larger
 twelfth-century church, to which the third and largest church was
 added ca. 1203.

832 Marun, Fra L[uigi]. "Ruševine Sv. Luke na Uzdolju kod Knina
 sa pisanom uspomenom hrvatskoga kneza Mutimira" [Ruins of the
 church of St. Luke at Uzdolje near Knin with an inscription of
 Croatian Prince Mutimir]. SP, n.s. 1 (1927):1-14, 272-315.
 In Serbo-Croatian. An exhaustive report on the excavated
 remains of the church of St. Luke in Uzdolje. The article pre-
 sents historical, topographical, archeological, and art-historical
 evidence. Important sculptural fragments are presented compre-
 hensively.

833 Radič, Frano. "Hrvatska biskupska crkva sv. Marije u
 Biskupiji i kaptolska crkva sv. Bartula na sadašnjem Kapitulu
 kod Knina" [The Croatian Episcopal Church of St. Mary in
 Biskupija and the Capitol Church of St. Bartul on present-day
 Kapitul near Knin]. SP 1, no. 1 (1895):35-39; no. 2 (1895):
 90-96; no. 3 (1895):150-56.
 In Serbo-Croatian. A detailed early account of the
 eleventh-century Croatian Episcopal center at Biskupija and the
 church of St. Bartul on the Kapitol, both near Knin. Presents
 historical, topographical, and archeological evidence.

834 _____. "Ostanci starohrvatske bazilike na glavici 'Stupovi'
 u Biskupiji kod Knina" [Remains of an old Croatian basilica
 in Biskupija near Knin]. SP 6, nos. 3-4 (1901):63-83.
 In Serbo-Croatian. A detailed discussion of the remains of
 the old Croatian church in Biskupija. Particular attention is
 given to the numerous fragments of architectural sculpture, which
 are scrutinized in minute detail.

835 _____. "Ulomci s jedanaest tegurija oltarskih ciborija i
 jednog vratnog okvira starohrvatske bazilike S. Marije u
 Biskupiji kod Knina" [Fragments of altar ciboria and a door
 frame from the church of St. Mary in Biskupija near Knin].
 SP 3, no. 2 (1897):51-59.
 In Serbo-Croatian. A brief account of assorted fragments
 from different ciboria and a door frame, all beloning to the pre-
 Romanesque church of St. Mary at Biskupija. Factual information
 and brief descriptions are provided.

KOLUNIČ

Nikolajevič, Ivanka. See entry YU 805

KONČE

Grujić, Radoslav M. See entry YU 104

KONJIC. See BISKUP

KONJUH

836 Radojčić, Svetozar. "Crkva u Konjuhu" (Fr. sum.: "L'église
 de Konjuh"). ZRVI 1 (1952):148-67 (Fr. sum.: 166-67).
 In Serbo-Croatian. Discusses an interesting centralized
 church probably dating from the sixth century. The church (par-
 tially excavated) is the only reasonably well known building of
 a major urban area which remains completely unexcavated. The
 church consists of a circular naos surrounded by an ambulatory.
 The naos is preceded by a narthex flanked by two separate
 chambers.

KOPER

837 Murko, Matija. "Palača in patricijska hiša v Kopru od
 Romanike do Baroka" [Palaces and patrician houses in Koper
 from Romanesque to baroque times]. ZUZ, n.s. 9 (1972):23-49
 (It. sum.: 45-49).
 In Slovenian. A study of the general development of palace
 and residential architecture in Koper from the Middle Ages to
 baroque times. A strong link with Venice is noted along with
 distinctive local traits.

KOPORIN

838 Mano-Zisi, Djordje. "Manastir Koporin" [Monastery of Koporin].
 Starinar, 3d ser. 8-9 (1933-34):210-18.
 In Serbo-Croatian. Considers the single-aisled domed
 church and its frescoes in the general context of the building
 and painting activity of the Morava school.

KORIŠKA GORA [region]

839 Bošković, Dj[urdje], and Ljubinković, Radivoje. "Isposnica
 Petra Koriškog" (Fr. sum.: "L'église rupestre de St. Pierre
 de Koriša"). Starinar, n.s. 7-8 (1958):91-112 (Fr. sum.:
 111-12).
 In Serbo-Croatian. A study of the architecture (pp. 91-93)
 and of the history and painting (pp. 93-110) of the cave church
 of St. Peter at Koriša. R. Ljubinković argues that the frescoes
 have no true parallels in Serbian medieval art, and believes that
 they represent an archaizing, monastic phenomenon to be dated to
 the end of the twelfth century.

840 Djurić, V[ojislav J.]. "Najstariji živopis isposnice
 putstinožitelja Petra Koriškog" (Fr. sum.: "Les fresques les
 plus anciennes dans la cellule de l'anachorete serbe Pierre
 de Koriša"). ZRVI 5 (1958):173-202 (Fr. sum.: 201-2).
 In Serbo-Croatian. A study of an important example of
 early thirteenth-century monastic painting in Serbia. The
 character of the cycle of frescoes in a cave church near Prizren
 is seen as being outside of the mainstream of development of
 thirteenth-century painting in Serbia and is related to cave
 painting of Cappadocia and southern Italy.

841 Ivanović, Milan. "Nekoliko srednjovekovnih spomenika Koriške
 Gore kod Prizrena" (Fr. sum.: "Les monuments du territoire de
 Koriša dans la région de Prizren"). SKM 4-5 (1968-71):309-22
 (Fr. sum.: 321-22).
 In Serbo-Croatian. An account of several medieval monu-
 ments (mostly churches) in Koriška Gora. Plans of churches,
 fresco fragments, smaller finds, and other items of relevance
 are reported.

842 Marković, Olivera. "Ostaci manastira Petra Koriškog" (Fr.
 sum.: "Les restes du monastère de Petar Koriški"). SKM 4-5
 (1968-71):409-23 (Fr. sum.: 422-23).
 In Serbo-Croatian. An assessment of the remains of the
 monastery of St. Peter Koriški. The cave monastery was enlarged
 in the early fourteenth century to include a church supported on
 a massive substructure consisting of five piers and four arches.
 The author offers a hypothetical reconstruction of the church and
 the monastery.

KOSTANJEVICA

843 Medić, Milka Čanak. "Cistercitski manastir u Kostanjevici i
 njegova obnova" (Fr. sum.: "Le monastère cistercien à
 Kostanjevica et sa restauration"). ZZSK 22-23 (1973):55-70
 (Fr. sum.: 69-70).
 In Serbo-Croatian. An outline of several alternative pro-
 posals for the restoration of the Cisterian monastery complex at
 Kostanjevica.

844 _____. "Rekonstrukcija crkve cistercitskog samostana u
 Kostanjevici" (Fr. sum.: "Réconstruction de l'église du
 couvent cistercien à Kostanjevica"). ZZSK 16 (1965):183-200
 (Fr. sum.: 200).
 In Serbo-Croatian. A study of architectural remains and
 restoration of the church within the monastery of Kostanjevica.
 Detailed drawings illustrate the main aspects of the mature
 Gothic structural system of the church, and the construction of
 its piers, arches and vaults.

KOTOR

845 Fisković, Cvito. "Stilska zakašnjenja na stolnoj crkvi u
 Kotoru" (Fr. sum.: "Retards de styles de la cathédrale de
 Kotor"). PPUD 16 (1966):219-50 (Fr. sum.: 250).
 In Serbo-Croatian. The cathedral of Kotor, first built in
 the ninth century, was subsequently rebuilt on a number of occa-
 sions. The author points out a number of stylistic details exe-
 cuted in the later centuries (e.g., seventeenth) which reveal a
 conservative adherence to older styles. Awareness of such
 phenomena is important in assessing works of art and architecture
 in such centers as Kotor.

846 Karaman, Ljubo. "O slijedu gradnje katedrale u Kotoru" (Fr.
 sum.: "Sur la succession de la construction de la cathédrale
 de Kotor"). PPUD 9 (1955):5-16 (Fr. sum.: 309).
 In Serbo-Croatian. A systematic study of the major phases
 in the history of the cathedral of Kotor. Disputes some of the
 findings of earlier investigations.

847 Korać, Vojislav. "Prvobitna arhitektonska koncepcija kotorske
 katedrale XII veka: Njeno poreklo i njen značaj za arhitek-
 turu u Zeti i Raškoj" (Fr. sum.: "La conception première de
 la cathédrale de Kotor [XIIᵉ s.]: Ses origines et son impor-
 tance pour l'architecture de la Zeta et de la Rascie"). ZLU 3
 (1967):3-30 (Fr. sum.: 27-30).
 In Serbo-Croatian. An important architectural study of the
 Romanesque cathedral of Kotor. The original form of the building
 (prior to sixteenth and seventeenth-century remodelings) is based
 on the surviving elements, on visual depictions of the cathedral
 before the sixteenth century, and on comparisons.

848 Mijović, Pavle. "Acruvium - Dekatera - Kotor, u svetlu novih
 arheoloških otkrića" (Fr. sum.: "Acruvium - Dekatera - Kotor,
 sous le jour des récentes découvertes archéologiques").
 Starinar, n.s. 13-14 (1965):27-48 (Fr. sum.: 48).
 In Serbo-Croatian. A report on archeological excavations
 in Kotor focusing on the foundations of a curious three-aisled
 basilica at Šuranj (Surana, in medieval Latin sources). The
 author uses these finds to support his hypothesis that the
 ancient Acruvium was located on the same spot as the medieval
 Dekatera and modern Kotor.

849 Mirković, L[azar]. "Fragment kivorija u crkvi svetog Trifuna
 u Kotoru" (Fr. sum.: "Fragments du ciborium de l'église de
 Saint Trophime à Kotor"). Starinar, n.s. 2 (1951):277-80
 (Fr. sum.: 280).
 In Serbo-Croatian. An attempt to reinterpret the meaning
 of the inscription and consequently the date of the ciborium arch
 now in the church of St. Triphon in Kotor. The author believes
 that it should be dated ca. 1026, yet concludes by comparing it

to the fragment of a ciborium from Ulcinj (now in the National
Museum in Belgrade) which is dated to the eighth or ninth
century.

KOVILJ

850 Matić, Vojislav. "Stara crkva manastira Kovilja" (Ger. sum.:
 "Die alte Kirche des Klosters Kovilj"). ZLU 12 (1976):156-77
 (Ger. sum.: 176-77).
 In Serbo-Croatian. A study of the architecture of this
 important late medieval church. Believed to date from the six-
 teenth century, the church was remodeled on numerous occasions.
 Links with earlier medieval architecture of Serbia indicate the
 continuity of this tradition in this area after the fall of
 Serbia to the Turks.

KRALJEVA SUTJESKA. See BOBOVAC
KRIŽEVAC. See GLOGOVNICA

KRIŽNA GORA [near Škofja Loka]

851 Cevc, Emilijan. "Poznogotske freske na Križnoj gori pri
 Škofja Loki" [Late Gothic frescoes at Križna Gora near Škofja
 Loka]. ZUZ 20, nos. 1-2 (1944):32-70 (Ger. sum.: 69-70).
 In Slovenian. A comprehensive discussion of late Gothic
 frescoes in the church of Sv. Urh at Križna Gora. Considers the
 history of the building, provides a detailed description of the
 frescoes (in the vault of the presbytery), and offers an icono-
 graphic and stylistic analysis. The frescoes are dated to some
 time after 1507.

KRK [island]

852 Žic-Rokov, Ivan. "Romanička crkva Majke božje od zdravlja u
 Krku" (It. sum.: "La chiesa romanica della Madonna della
 Salute a Krk"). Bulletin VII odjela za likovne umjetnosti
 Jugoslavenske akademije znanosti i umjetnosti 15-22, nos. 1-3
 (1967?):13-40 (It. sum.: 40).
 In Serbo-Croatian. A comprehensive analysis of regional
 history, the building, its altars, its windows, subsequent
 alterations, and conservation. Concludes that this three-aisled
 basilica with a single apse (originally with three apses) at the
 east end and an axial tower on the west side should be dated to
 the late eleventh or early twelfth century.

KRUŠEDOL

853 Davidov, Dinko. <u>Krušedol</u>. Medieval Art in Yugoslavia.
 Belgrade: Jugoslavija, 1964. 11 pp., 47 pls., 4 illus. in
 text.
 A brief account of Krušedol monastery considering its his-
 tory, architecture, and art. The church was built in the early
 sixteenth century, but its frescoes were probably painted in the
 eighteenth century. The book is illustrated with a selection of
 fine black-and-white photographs.

854 Mirkovič, L[azar]. "Deisis krušedolskog ikonostasa" (Fr.
 sum.: "La Déēsis de l'iconostase de Krušedol"). <u>Starinar</u>,
 n.s. 3-4 (1955):93-106 (Fr. sum.: 105-6).
 In Serbo-Croatian. An analysis of the Krušedol iconostasis
 in which the author considers the so-called expanded Deesis which
 he attributes to Cretan painters, dating it to ca. 1512.

KRUŠEVAC

855 Boškovič, Djurdje. "Mesto Kruševca u sistemu utvrdjenih
 gradova srednjovekovne Srbije" (Fr. sum.: "La ville de
 Kruševac dans le systēme des villes fortifiées de la Serbie
 médiévale"). <u>Starinar</u>, n.s. 30 (1980):7-11 (Fr. sum.: 11).
 In Serbo-Croatian. A brief account of the significance of
 medieval Kruševac and its place in the system of fortified towns
 and fortifications of medieval Serbia.

856 Jordovič, Časlav, and Jurišič, A[leksandra]. "Rezultati
 arheoloških ispitivačkih radova u Kruševcu" (Fr. sum.:
 "Résultats des recherches archéologiques ā Kruševac").
 <u>Saopštenja</u> 9 (1970):289-306 (Fr. sum.: 306).
 In Serbo-Croatian. A preliminary report of the archeologi-
 cal excavations conducted in the medieval center of Kruševac.
 Although material goes back to prehistoric times, the medieval
 phase is the most important. Architectural remains of the palace
 complex, fortifications, and other buildings, as well as movable
 finds are discussed.

857 Kovačevič, Mirko. "Profana arhitektura srednjovekovnog
 Kruševca: Rezultati dosadašnjih istraživanja" (Fr. sum.:
 "L'architecture profane médiévale de Kruševac: Résultats des
 recherches"). <u>Starinar</u>, n.s. 30 (1980):13-29 (Fr. sum.:
 28-29).
 In Serbo-Croatian. A preliminary report of the excavations
 of the fortifications of medieval Kruševac.

858 _____. "Srednjovekovna tvrdjava Kruševac" (Fr. sum.: "La
forteresse médiévale de Kruševac"). Starinar, n.s. 17 (1967):
137-42 (Fr. sum.: 142).
 In Serbo-Croatian. A brief account of the archeological
investigations of the medieval fortress of Kruševac.

859 Popović, Pera J. "Zapadno Kube crkve Cara Lazara u Kruševcu
sa dve neobjavljene slike iz polovine prošloga veka" [The west
dome of Lazarica in Kruševac from two unpublished nineteenth-
century photographs]. Starinar, 3d ser. 4 (1926-1927):229-33.
 In Serbo-Croatian. An important contribution toward under-
standing the original form and use of the axial tower-dome above
the church narthex. The information is based on two nineteenth-
century representations of the monastery.

860 Ristić, Vladislav. "O živopisu crkve Sv. Stefana u Kruševcu"
(Fr. sum.: "La peinture murale de l'église St. Stefan à
Kruševac"). Raška baština 1 (1975):59-64 (Fr. sum.: 64).
 In Serbo-Croatian. Discusses fragments of painted decora-
tion executed in the eighteenth century and suggests that the
church did not receive fresco decoration at all during the Middle
Ages.

861 Vulović, Branislav. "Lazarica: Crkva sv. Stefana u Kruševcu"
(Fr. sum.: "Lazarica: L'église de Saint Étienne à Kruševac").
Starinar, n.s. 30 (1980):31-42 (Fr. sum.: 42).
 In Serbo-Croatian. A brief study of the history, architec-
ture, and architectural sculpture of the church of St. Stephen
(Lazarica), one of the key monuments of the last phase in the
development of Serbian medieval architecture belonging to the
so-called Morava school.

KUČEVIŠTE

862 Tatić, Žarko. "Arhitektonski spomenici u Skopskoj Crnoj Gori"
[Architectural monuments on Skopska Crna Gora]. GSND 1,
nos. 1-2 (1926):351-64 (Fr. sum.: 363-64).
 In Serbo-Croatian. A study of the architecture of the
church of the Holy Archangel near Kučevište. The author rejects
Millet's hypothesis incorporating the church in the Morava school
group of monuments. Instead, the church is seen as a forerunner
of the Morava tradition.

KULAJNA

863 Vulović, Branislav. "Crkva Sv. Bogorodice u srednjovekovnoj
Kulajni. Neobjavljeni rezultati jednog istraživanja" (Fr.
sum.: "L'église de la Vierge dans la Kulajna médiévale").
ZLU 8 (1972):387-98 (Fr. sum.: 398).
 In Serbo-Croatian. A report on the archeological and
architectural excavation of the remains of the church of the

Virgin near Lešje (medieval Kulajna). The older of the two
identified buildings is dated before 1360, while the younger (a
Morava school trichonchos) is dated to ca. 1411.

KURBINOVO

864 Hadermann-Misguich, Lydie. Kurbinovo: Les fresques de Saint
 Georges et la peinture byzantine du XIIᵉ siècle. 2 vols.
 Bibliothèque de Byzantion 6. Brussels: Éditions de Byzantion,
 1975. Vol. 1, 599 pp., 6 col. pls. 75 sketches; vol. 2,
 191 pls.
 The most comprehensive study of Kurbinovo frescoes in the
 context of Byzantine painting of the twelfth century. Icono-
 graphic, stylistic, technical, and other aspects of frescoes are
 considered in great depth.

865 ____. "Quelques particularités de choeur des saints à Saint
 Georges de Kurbinovo." Actes du XIVᵉ Congrès international
 des études byzantines, 1971 (Bucharest) 3 (1976):379-83.
 Considers certain icongraphic aspects of saint figures and
 compositions (e.g., Deesis, St. Marina, SS. Constantine and
 Helen, St. Anne).

865a Ljubinković, Radivoje. "Stara crkva sela Kurbinova" (Ger.
 sum.: "Die alte Kirche in Kurbinovo cum Prespa-See").
 Starinar, 3d ser. 15 (1940):101-23 (Ger. sum.: 123).
 In Serbo-Croatian. The author was the first to analyze the
 Kurbinovo frescoes in detail and to date them in the twelfth cen-
 tury, in contrast to several earlier scholars who had placed them
 in the sixteenth century. Stylistic as well as iconographic
 problems are considered.

866 Nikolovski, Antonie. "Konzervatorski raboti na crkvata sv.
 Gorgi v selo Kurbinovo" [Conservation of the church of St.
 George in the village of Kurbinovo]. KN 1 (1959):37-44.
 In Macedonian. A report of the architectural conservation
 of the single-aisled church of St. George, along with further
 discovery of the original twelfth-century frescoes (particularly
 on the exterior).

867 Nikolovski, Antonije. The Frescoes of Kurbinovo. Medieval
 Art in Yugoslavia. Belgrade: Jugoslavija, 1964. 4 pp.
 A brief account of Kurbinovo frescoes. The book is illus-
 trated with a fine selection of black-and-white photographs show-
 ing mostly details of frescoes.

KURŠUMLIJA

868 Anastasijević, D.N. "Otkopavanje Nemanjine sv. Bogorodice kod
 Kuršumlije" [The excavation of Nemaja's church of the Virgin
 at Kuršumlija]. Starinar, 3d ser. 1 (1922):47-55.
 In Serbo-Croatian. The church of the Virgin at Kuršumlija,
 one of the oldest of Nemanja's monastic foundations, was a re-
 modeling of an early Christian triconch chapel. The excavations
 yielded a large amount of small finds, clearly indicating two
 distinct building phases.

869 Bošković, Djurdje, and Vulović, Branislav. "Caričin grad -
 Kuršumlija - Studenica" (Fr. sum.: "Caričin grad -
 Kuršumlija - Studenica"). Starinar, n.s. 7-8 (1958):173-80
 (Fr. sum.: 180).
 In Serbo-Croatian. An attempt to establish a relationship
 between the triconch church at Caričin grad, the churches of the
 Virgin and St. Nicholas at Kuršumlija, and the church of the
 Virgin at Studenica. Archeological investigations have produced
 identical brick stamps dating from the sixth century at the
 church of the Virgin at Kuršumlija and in the dome of Studenica.

870 Stričević, Djordje. "Srednjovekovna restauracija ranovizanti-
 ske crkve kod Kuršumlije" (Fr. sum.: "La restauration médié-
 vale de l'église paléobyzantine près de Kuršumlija"). ZRVI 4
 (1956):199-213 (Fr. sum.: 212-13).
 In Serbo-Croatian. Argues against dating the reconstruc-
 tion of the church of the Virgin together with the construction
 of the nearby church of St. Nicholas (both of which are tradi-
 tionally attributed to Nemanja). Proposes that the reconstruc-
 tion took place later (fourteenth century) when the trefoil plan
 became commonplace, and the reconstruction of Byzantine ruins
 politically desirable.

871 Vulović, Branislav. "Crkva svetog Nikole kod Kuršumlije"
 (Ger. sum.: "Die Heilige Nikola-Kirche bei Kuršumlija").
 Zbornik Arhitektonskog fakulteta 3, no. 7 (1957):3-22 (Ger.
 sum.: 22).
 In Serbo-Croatian. A detailed discussion of the important
 church of St. Nicholas. Examines the building archeologically
 and architecturally, analyzes the written sources, and offers a
 hypothetical reconstruction. The article is illustrated with a
 series of fine drawings and good photographs.

872 _____. "Konzervacija ruševina Sv. Nikole u Kuršumliji" (Fr.
 sum.: "Les travaux de conservation à l'église St. Nicolas de
 Kuršumlija"). Saopštenja 1 (1956):63-66 (Fr. sum.: 66).
 In Serbo-Croatian. This brief account of the conservation
 of architecture and frescoes includes drawings of the poorly pre-
 served frescoes in the ground floor chapel of the southern tower.

873 _____. "Konzervatorski radovi na spomenicima kulture u
Toplici" (Fr. sum.: "Les monuments historiques de la région
de Toplica et leur conservation"). ZZSK 3, no. 1 (1953):
51-62 (Fr. sum.: 62).
　　　In Serbo-Croatian. A report on the archeological investi-
gation and conservation of the churches of St. Nicholas and of
the Virgin and the remains of a late Antique apsed building
(church?).

LAPUŠNJA

874 Knežević, Branka. "Ktitori Lapušnje" (Fr. sum.: "Les fonda-
teurs de Lapušnja"). ZLU 7 (1971):37-54 (Fr. sum.: 52-54).
　　　In Serbo-Croatian. A historical study of the church of St.
Nicholas, which was built in 1501 by the Valachian ruler Radul
cel Mare (1495-1508) and painted under the auspices of his wife
and children in 1510.

LASTOVO [island]

875 Fiskovic, Cvito. "Lastovski spomenici" (Fr. sum.: "Monuments
de l'île de Lastovo"). PPUD 16 (1966):5-152 (Fr. sum.:
149-52).
　　　In Serbo-Croatian. An exhaustive survey of the architec-
tural and artistic heritage of the island of Lastovo from pre-
history to the nineteenth century. A substantial portion of the
study is devoted to the medieval material.

LAZARICA. See KRUŠEVAC

LEPENAC

876 Kovačević, Mirko. "Konzervatorsko-restauratorski radovi na
crkvi manastira Lepenca u Rasini" (Fr. sum.: "Les travaux de
restauration et conservation de l'église du monastère Lepenac
sur la Rasina"). Raška baština 1 (1975):247-55 (Fr. sum.:
255).
　　　In Serbo-Croatian. Reports the results of recent conserva-
tion and restoration undertakings on Lepenac. The article is
illustrated with detailed architectural drawings and photographs.

877 _____. "Manastir Lepenac na Rasini" (Fr. sum.: "Le monastère
de Lepenac sur la Rasina"). Starinar, n.s. 23 (1974):73-89
(Fr. sum.: 88-89).
　　　In Serbo-Croatian. A study of the Lepenac monastery, its
site, the architecture of the church, archeological investiga-
tions, its relationship to other monuments of the so-called
Morava school, its date, and the problems of its conservation.

LEŠAK

878 Grujić, Rad[oslav] M. "Pološko-tetovska eparhija i manastir
 Lešak" (Fr. sum.: "L'évéché du Polog-Tetovo et le monastère
 de Lešak"). GSND 12 (1933):33-77 (Fr. sum.: 77).
 In Serbo-Croatian. An exhaustive historical and archeo-
 logical study of the monastery and two churches--St. Athanasius
 and the Virgin--both in ruins. The former appears to be a
 fourteenth-century church, cruciform in plan with a large con-
 temporary narthex. Remains of architectural sculpture are
 important.

LESKOVEC

879 Korać, Vojislav. "Arhitektura crkve Voznesenja u Leskovecu"
 (Fr. sum.: "L'architecture de l'église de l'Ascension du
 village de Leskovec"). Starinar, n.s. 2 (1951):217-20 (Fr.
 sum.: 220).
 In Serbo-Croatian. An architectural study of the church of
 the Ascension at Leskovec. The single-aisled church is dated to
 the first half of the fifteenth century while the "envelope"
 spaces and the porch on the west side are believed to be late
 nineteenth-century additions.

880 Ljubinković, Radivoje. "Crkva svetog Vaznesenja u selu
 Leskovecu kod Ohrida" (Fr. sum.: "L'église de l'Ascension du
 village de Leskovec"). Starinar, n.s. 2 (1951):193-216 (Fr.
 sum.: 216).
 In Serbo-Croatian. A detailed study of the history, archi-
 tecture, and fresco decoration of the small single-aisled church
 of the Ascension at Leskovec dating from the first half of the
 fifteenth century. A thorough iconographic and stylistic study
 of frescoes enables the author to place the church within the
 local school of painting.

LESNOVO

881 Okunev, M.N.L. "Lesnovo." L'art byzantin chez les Slaves:
 Les Balkans, vol. 1, pt. 2. Paris: P. Geuthner, 1930,
 pp. 222-59.
 The most important article on the frescoes of the narthex
 added to the original church in 1349. The entire program and the
 iconography of the individual scenes are discussed in detail.

882 Radojčić, Svetozar. Lesnovo. Umetnički spomenici u
 Jugoslaviji. Belgrade: Jugoslavija, 1971. 11 pp., 43 pls.
 In Serbo-Croatian. A short account of the building's his-
 tory, architecture, and frescoes. The book is illustrated with
 a fine selection of black-and-white photographs showing mostly
 details of frescoes.

LIMSKA DRAGA

883 Deanović, Ana. "Ranoromaničke freske u opatiji svetog
 Mihovila nad Limskom Dragom" [Early Romanesque frescoes in the
 abbey of St. Mihovil above Limska Draga]. Bulletin Instituta
 za likovne umjetnosti Jugoslavenske akademije znanosti i
 umjetnosti 4, nos. 9-10 (1956):12-20.
 In Serbo-Croatian. Considers the oldest known medieval
 frescoes discovered on the territory of Croatia. Fragments of
 frescoes were discovered in two small churches belonging to an
 abandoned and partially ruined abbey. Both churches date from
 the first half of the eleventh century. The author hypothesizes
 that the style represents a survival of the late Antiquity.

LIPLJAN

Ćurčić, Slobodan. See entry YU 83

884 Ljubinković, Radivoje; Djokić, D.; Vučenović, S.; and
 Tomašević, A. "Istraživački i konzervatorski radovi na crkvi
 Vavedenja u Lipljanu" (Fr. sum.: "Travaux de recherches et de
 conservation effectués à l'église de la Présentation de la
 Vierge à Lipljan"). ZZSK 10 (1959):69-136 (Fr. sum.:
 135-36).
 In Serbo-Croatian. An exhaustive report on the archeologi-
 cal investigation of the church of the Presentation, its history,
 architecture, frescoes, and its construction. The archeological
 investigations have revealed the foundations of two [?] older
 churches below the present fourteenth-century building.

885 Zdravković, Ivan M. "Stara crkva u Lipljanu" (Fr. sum.:
 "L'ancienne église de Lipljan"). Starinar, n.s. 3-4 (1955):
 186-90 (Fr. sum.: 190).
 In Serbo-Croatian. A brief study of the architecture of
 the church illustrated with basic architectural drawings and
 photographs taken before the restoration of the church was begun.

LISIČIĆI

886 Čremošnik, Irma. "Izvještaj o iskopavanjima na Crkvini u
 Lisičićima kod Konjica" (Fr. sum.: "Compte rendu sur les
 fouilles de Crkvina à Lisičići près de Konjic"). GZMS, n.s. 9
 (Arheologija) (1954):211-26 (Fr. sum.: 224-26).
 In Serbo-Croatian. An archeological report of the excava-
 tions of the small single-aisled church. The plan type is com-
 parable to Dalmatian churches of the eleventh century, but the
 small finds discovered in the tombs inside the church suggest
 that it was used between the thirteenth and fourteenth centuries.

LJUBLJANA

887 Kos, Milko. "Pečat in grb mesta Ljubljane" [The seal and the
 coat of arms of Ljubljana]. ZUZ 19, nos. 1-2 (1943):38-50.
 In Slovenian. A study of the history of the seal and the
 coat of arms of Ljubljana from the thirteenth to the eighteenth
 centuries. Several medieval examples are discussed.

888 _____. Srednjeveška Ljubljana: Topografski opis mesta i
 okolice [Medieval Ljubljana: A topographical description of
 the town and its environs]. Kronike 1. Ljubljana, 1955.
 79 pp., 18 figs., 2 foldout pls.
 In Slovenian. A detailed, well-documented study of medi-
 eval Ljubljana. The material is presented topographically,
 focusing on the city. The last section of the book discusses
 the medieval environs of Ljubljana.

LJUBOSTINJA

889 Pavlović, Dobroslav St. "Ispitavački radovi na arhitekturi
 crkve manastira Ljubostinje i predlog za njen buduči izgled"
 (Fr. sum.: "Travaux de recherche effectués sur l'architec-
 ture de l'église au monastère de Ljubostinja et projet en vue
 de son aspect futur"). Saopštenja 8 (1969):155-86 (Fr. sum.:
 184-86).
 In Serbo-Croatian. A major report on the investigation of
 the church and proposals for its reconstruction. Especially
 important are the discovery of the original painted façades and
 the architectural elements leading to the hypothetical recon-
 struction of the original narthex.

LJUBOTEN

890 Petković, Vlad[imir] R. "Živopis crkve u Ljubotenu" (Fr.
 sum.: "Les peintures murales de l'église de Ljuboten").
 GSND 2, nos. 1-2 (1927):109-24 (Fr. sum.: 124).
 In Serbo-Croatian. A study of the remaining frescoes re-
 veals an iconographic content which has parallels only in Serbian
 churches of the period (Gračanica, Peć, Dečani, and Matejić) as
 well as a certain vernacular flavor.

891 Tatić, Žarko. "Arhitektonski spomenici u Skopskoj Crnoj
 Gori: 2. Ljuboten" (Fr. sum.: "L'église de Ljuboten").
 GSND 2, nos. 1-2 (1927):93-108 (Fr. sum.: 108).
 In Serbo-Croatian. A valuable study of the architecture
 of the building made prior to the drastic restoration of the
 church. Illustrated with a series of excellent drawings and
 photographs.

LOBOR

892 Deanović, Ana. "Gotičke freske u svetištu zavjetne crkve
 Marije Gorske kraj Lobora" [Gothic frescoes in the sanctuary
 of St. Mary near Lobor]. Peristil 12-13 (1969-70):59-78.
 In Serbo-Croatian. A detailed discussion of a Gothic
 fresco cycle dating from the end of the fourteenth or the begin-
 ning of the fifteenth century. Iconography, style, and painting
 technique are all considered.

LOMNICA

893 Petković, Sreten. "Vreme nastanka i majstori zidne dekoracije
 u Lomnici" (Eng. sum.: "The date of the wall paintings in the
 Lomnica monastery and its masters"). ZLU 1 (1965):161-72
 (Eng. sum.: 171-72).
 In Serbo-Croatian. An important study of the fresco deco-
 ration of Lomnica monastery, dated by an inscription to 1608.
 The author shows, on stylistic grounds, that the frescoes belong
 to two distinct phases--one to be dated ca. 1580 and the other
 one to be associated with the inscription dated 1607-1608.

LOPUD [island]

894 Lisičar, Vincenz. Lopud: Eine historische und zeitge-
 nössische Darstellung. Durbrovnik: V. Lisičar, 1932.
 106 pp., 16 pls.
 A useful account of this island's history and monuments,
 many of which are medieval.

MAČVANSKA MITROVICA

895 Popović, Vladislav. "'Metodijev' grob i episkopska crkva u
 Mačvanskoj Mitrovici" (Fr. sum.: "Le tombeau et l'église
 cathédrale de 'Methode' à Mačvanska Mitrovica"). Starinar,
 n.s. 24-25 (1975):265-70 (Fr. sum.: 268-70).
 In Serbo-Croatian. Disputes the hypothesis put forth by
 I. Boba, who identified the remains of an excavated church in
 Mačvanska Mitrovica as the cathedral of Sirmium and a tomb in it
 as the tomb of St. Methodius. According to the author the church
 should be dated after 1018, i.e., after the Byzantine control of
 the region was reestablished.

MAGLAJ

896 Bojanovski, Ivo. "Stari grad Maglaj: Istraživački i konzer-
 vatorski radovi 1962. i 1963. g." (Eng. sum.: "Research and
 work on conservation of the old city of Maglaj"). NS 10
 (1965):61-97 (Eng. sum.: 97).
 In Serbo-Croatian. A detailed report on the archeological
 and architectural investigation of the fortress of Maglaj (built

at the latest in the fourteenth century), its proposed hypotheti-
cal reconstruction and partial restoration.

MAGLIČ

897 Kašanin, Milan. "Grad Maglič" [The Fortress Maglič]. <u>UP</u> 4,
 no. 1 (Jan. 1941):8-14.
 In Serbo-Croatian. A study of the architecture of the
 fortress of Maglič, perched on a rock 120 m above a bend in the
 Ibar valley and controlling a major travel route. The author
 suggests that the fortress also functioned as a royal residence
 and postulates a date in the first or second decade of the thir-
 teenth century.

898 Milićević, Jovan. <u>Maglič: Srednjovekovni grad u klisuri Ibra</u>
 [Maglič: A medieval fortress in the Ibar Gorge]. Srednjo-
 vekovni gradovi u Jugoslaviji, 1. Belgrade: Književne
 novine, 1967. 73 pp., numerous illus. in text.
 In Serbo-Croatian. A monographic study of an important
 medieval fortress in the gorge of the river Ibar. Presents the
 history and the architecture of Maglič and considers the results
 of excavations conducted during the early 1960s.

899 Zdravković, Ivan M. "Istraživački i konzervatorski radovi
 izvršeni na gradu Magliču u Ibarskoj klisuri 1960. i 1961."
 (Fr. sum.: "Travaux de recherches et de conservation ef-
 fectués à la forteresse Maglič dans la défilé de l'Ibar en
 1960 et 1961"). <u>ZZSK</u> 14 (1963):45-56 (Fr. sum.: 55-56).
 In Serbo-Croatian. A report on the partial excavations and
 conservation of the fortress of Maglič. The main buildings un-
 covered include the "palace," a church, and several lesser struc-
 tures--the precise function of which is not clear.

900 _____. "Rezultati konzervatorskih ispitivanja i radova na
 gradu Magliču u Ibarskoj klisuri" (Fr. sum.: "Résultats des
 travaux de recherches et de conservation effectués à la
 forteresse Maglič dans le défilé de l'Ibar"). <u>ZZSK</u> 15
 (1964):61-80 (Fr. sum.: 79-80).
 In Serbo-Croatian. A detailed report on architectural
 remains uncovered within the fortress of Maglič and their con-
 servation. The major structures discussed include the "palace,"
 the church of St. George, the donjon-tower, other towers, and
 gates. Each of these is illustrated by architectural drawings
 and photographs.

MALI IŽ

901 Petricioli, Ivo. "Rotunda u Malom Ižu" (It. sum.: "La
 chiesetta a forma circolare di Mali Iž"). <u>Peristil</u> 4 (1961):
 5-7 (It. sum.: 7).

In Serbo-Croatian. Discussion of the remains of a circular church with a protruding apse believed to belong to the pre-Romanesque period. The church is unique for the period in question in Dalmatia.

MANASIJA (RESAVA)

902 Bošković, Djurdje. "Nekoliko opservacija o Manasiji" (Fr. sum.: "Quelques observations sur Manasija"). In Moravska škola i njeno doba. Edited by Vojislav J. Djurić. Belgrade: Filozofski fakultet, Odeljenje za istoriju umetnosti, 1972, pp. 263-68 (Fr. sum.: 268).
 In Serbo-Croatian. Examines the question of the addition of the narthex to the main church, and concludes that the narthex may have been added by Stefan Lazarević at the time when he re-modeled the main church by facing it with sandstone ashlars.

903 Djurić, Vojislav J. "La peinture murale de Resava: Ses origines et sa place dans la peinture byzantine." In Moravska škola i njeno doba. Edited by Vojislav J. Djurić. Belgrade: Filozofski fakultet, Odeljenje za istoriju umetnosti, 1972, pp. 277-91.
 Manasija frescoes are analyzed from the point of view of their styles and iconography. Thessalonican origins of Morava school painting is evaluated. Good black-and-white illustrations (mostly details).

904 _____. Resava. Medieval Art in Yugoslavia. Belgrade: Jugoslavija, 1963. 17 pp., 53 pls.
 A short account of the history, architecture and frescoes of Manasija (Resava). The book is illustrated with good black-and-white photographs of frescoes (mostly details).

905 Kašanin, Milan. "Resava despota Stefana" (Fr. sum.: "Resava"). Zograf 3 (1969):3-10 (Fr. sum.: 68).
 In Serbo-Croatian. A general discussion of art and of Manasija monastery with emphasis on stylistic and aesthetic qualities of frescoes. The author sees these frescoes as one of the high points in Serbian art. The article is illustrated with some fine details from Manasija frescoes.

906 Nenadović, Slobodan. "Konzervatorska dokumentacija o arhitekturi manastira Resave" (Fr. sum.: "Documentation sur la conservation de l'architecture du monastère de Resava"). ZZSK 12 (1961):51-82 (Fr. sum.: 81-82).
 In Serbo-Croatian. A report on the archeological investigation and conservation of the church of Manasija (Resava) monastery. Details of building technique, architectural forms, architectural sculpture, fenestration, marble floor, and foundations and their construction are discussed.

907 _____. "Konzervatorska dokumentacija o arhitekturi manastira
 Resave. 2. Trpezarija i zgrade za stanovanje" (Fr. sum.:
 "Documentation sur la conservation de l'architecture du mona-
 stère de Resava. 2. Réfectoire et bâtiments d'habitation").
 ZZSK 13 (1962):37-50 (Fr. sum.: 50).
 In Serbo-Croatian. A conservation report considering sev-
 eral major buildings within the monastery compound of Manasija,
 excluding the church. The building ruins included are the re-
 fectory and two dormitory buildings flanking the main fortifica-
 tion tower. The author offers hypothetical reconstructions of
 these structures.

908 Stanojević, St[anoje]; Mirković, L.; and Bošković, Dj.
 Manastir Manasija (Fr. sum.: "Le monastère de Manasija").
 Srpski spomenici 5. Belgrade: Narodni muzej u Beogradu,
 1928. 57 pp. (Fr. sum.: 9-10, 33-35, 57), 33 figs., 23 pls.
 In Serbo-Croatian. A comprehensive monograph which dis-
 cusses the history, architecture, and frescoes of the church.
 The most comprehensive such study to date.

909 Stojaković, Anka. "Ktitorski model Resave" (Fr. sum.:
 "L'effigie de l'église de Resava"). In Moravska škola i njeno
 doba. Edited by Vojislav J. Djurić. Belgrade: Filozofski
 fakultet, Odeljenje za istoriju umetnosti, 1972, pp. 269-76
 (Fr. sum.: 275-76).
 In Serbo-Croatian. Argues that the painted model of
 Manasija (Resava) illustrates the artist's ability to depict
 three-dimensional aspects of architecture. While such ability is
 displayed in painting the model of the church it was not employed
 elsewhere in painted depictions of architecture. This illus-
 trates, according to the author, that aesthetic principles of
 Byzantine painters did not aim toward "realistic" spatial and
 volumetric depictions of architectural forms.

910 Tomić, Stevan, and Nikolić, Radomir, eds. Manasija:
 Istorija - živopis (Fr. sum.: Manasija: L'histoire - la
 peinture). Saopštenja 6 (1964). 107 pp., 128 pls., numerous
 illus. in text.
 In Serbo-Croatian with French summaries following each sec-
 tion of the book. The book is organized in three main parts:
 history of the monastery, the fresco program, conservation of
 frescoes. The material presented stems from the work carried out
 in the church between 1956 and 1962.

MANASTIR

911 Koco, Dimče, and Miljković-Pepek, P. Manastir. Posebni
 izdanija 8. Skopje: Filozofski fakultet. Istorisko-
 filološki odel, 1958. 116 pp. (Fr. sum.: 109-16), 116 figs.,
 43 pls., 3 schematic diagrams of fresco program layout.

In Macedonian. The church of St. Nicholas was decorated
with frescoes in 1271 during the reign of Emperor Michael VIII
Palaeologus, referred to as "New Constantine" in the inscription
in the church. The architecture (basilica) and the frescoes are
distinctly archaic, and are of interest as local phenomena.

MARIBOR

912 Stelè, France. "Mariborska stolnica" [The cathedral of
 Maribor]. ZUZ 19, nos. 1-2 (1943):1-37 (Ger. sum.: 36-37).
 In Slovenian. A detailed analysis of the structural his-
 tory of the cathedral of Maribor from its thirteenth-century
 Romanesque beginnings to its early sixteenth-century late Gothic
 vaulting. Sculptural details and masons' marks are considered in
 this context.

MARKOV MANASTIR

913 Balabanov, Kosta. "Novootkrieni portreti na Kralot Marko i
 Kralot Volkašin vo Markoviot Manastir" (Fr. sum.: "Les por-
 traits nouvellement découverts du roi Marc et du roi Volkašin
 à Markov Manastr"). KN 3 (1971):47-66 (Fr. sum.: 66).
 In Macedonian. The report discusses the removal of a
 medieval chapel built against the south flank of the church of
 St. Demetrius at Markov Manastir. After the removal of the
 chapel, frescoes representing the donors of the original church
 came to light and were cleaned and preserved.

914 _____. "Novootkriveni portreti kralja Marka i kralja Vukašina
 u Markovom Manastiru" (Fr. sum.: "Les portraits des rois
 Vukašin et Marko, récemment découverts dans le monastère de
 Marko (Markov manastir) près de Skopje"). Zograf 1 (1966):
 28-29 (Fr. sum.: 47).
 In Serbo-Croatian. A brief account of two newly discovered
 portraits at Markov Manastir--of Kings Vukašin and Marko, the
 donors of the church. The portraits were uncovered in poor con-
 dition below a layer of plaster. Nevertheless, they represent an
 important contribution to the large gallery of Serbian medieval
 portraits.

915 Mirković, L[azar]. "Još nešto iz Markova manastira kod
 Skoplja" [Further notes on Markov Manastir near Skoplje].
 GSND 1, nos. 1-2 (1926):301-8.
 In Serbo-Croatian. Discusses the baptismal font erected by
 the metropolitan Kir-Matej in 1343, an Old Church Slavonic in-
 scription on the north wall of the church, the iconostasis, and
 the floor of the church of Markov Manastir, as well as the re-
 mains of the church of St. Nicholas in the vicinity of Markov
 Manastir.

916 . "Novootkrivene freske u Markovu Manastiru kod Skoplja"
(Fr. sum.: "Les fresques découvertes au couvent de St. Marko,
près de Skoplje"). GSND 12 (1933):181-91 (Fr. sum.: 191).
 In Serbo-Croatian. Discusses uncovered pieces depicting
standing royal figures in the naos. The north side appears to
portray Old Testament kings, while the south side appears to
illustrate Serbian royal sons and sons of despots.

917 Mirković, Lazar, and Tatić, Ž. Markov Manastir. Srpski
spomenici 3. Novi Sad: Narodni muzej u Beogradu, 1925.
76 pp., 91 figs.
 In Serbo-Croatian. The most comprehensive study of the
monument in existence. The book is organized in three sections--
history, architecture, and frescoes.

918 Nikuljska, Nada Nošpal. "Novonastanatite istoriski uslovi vo
Markedonija izrazeni na edna kompozicija od freskite vo Markov
Manastir - Božjite znamenija prineseni na dar na Sv. Dimitrija"
(Fr. sum.: "Reflet des nouvelles conditions historiques en
Macédoine dans un composition des fresques du monastère du
Marko"). Zbornik: Arheološki muzej na Makedonija (Skopje)
6-7 (1975):171-80 (Fr. sum.: 179-80).
 In Macedonian. Discusses an unusual representation of a
mounted St. George receiving various attributes from six angels
descending from Christ. Attempts to link this rare iconography
with particularly difficult political circumstances at the time.

919 Todorović, Dragomir. "Polijelej u Markovom manastiru" (Fr.
sum.: "Le grand polycandilon de Markov manastir"). Zograf 9
(1978):28-36 (Fr. sum.: 36).
 In Serbo-Croatian. A detailed study of the now fragmented
polycandelon from Markov Manastir. Its fragments (now found in
Belgrade, Istanbul, Skopje, and Sofia) are carefully documented
and the polycandelon meticulously reconstructed.

MARKOVA VAROŠ. See PRILEP

MATEJIČ

920 Okunjev, N. "Gradja za istoriju srpske umetnosti. 2. Crkva
Svete Bogorodice - Matei~" (Fr. sum.: "Matériaux pour servir
à l'histoire de l'art serbe"). GSND 7-8 (1938):89-118 (Fr.
sum.: 114-18).
 In Serbo-Croatian. A thorough descriptive study of the
church of the Virgin and its fresco decoration. All surviving
frescoes are identified in a systematic manner. The study is
illustrated with valuable photographs made before the extensive
restoration of the building.

MESIĆ

921 Zdravković, Ivan M. "Manastir Mesić" (Fr. sum.: "Le mona-
 stère de Mesić"). Starinar, n.s. 5-6 (1956):331-34 (Fr. sum.:
 334).
 In Serbo-Croatian. A brief account of the history and
 architecture of the monastery church, dating, in its present
 form, from the early part of the eighteenth century.

MILENTIJA

922 Tomić, Gordana. "Jedna varijanta u okviru Moravske škole"
 (Fr. sum.: "Une variante dans l'école de la Morava"). In
 Moravska škola i njeno doba. Edited by Vojislav J. Djurić.
 Belgrade: Filozofski fakultet, Odeljenje za istoriju umet-
 nosti, 1972, pp. 249-61 (Fr. sum.: 260-61).
 In Serbo-Croatian. Discusses the architectural suclpture
 of the church of Sv. Stefan (St. Stephen) at Milentija, which is
 seen as a variant of the so-called Morava school. The author's
 undocumented speculation is that the church may have been started
 by Prince Lazar, and finished after his death by his family.

923 _____. "Neka pitanja u vezi sa profanom arhitekturom u
 kompleksu Milentije" (Fr. sum.: "De quelques problèmes con-
 cernant l'architecture profane dans le complexe de Milentija").
 Starinar, n.s. 30 (1980):55-63 (Fr. sum.: 63).
 In Serbo-Croatian. A study of the excavated complex of
 buildings which once surrounded the church of St. Stephen in the
 village of Milentija. While the function of the complex remains
 unclear, the excavated material represents an important contribu-
 tion to the study of late medieval secular architecture in Serbia.

MILEŠEVA

924 Radojčić, Svetozar. Mileševa. Umetnički spomenici Jugo-
 slavije. Belgrade: Srpska književna zadruga and Prosveta,
 1963. 71 pp. (Eng. sum.: 67-71), several figs. in text,
 49 pls., 23 schematic drawings of fresco program layout.
 In Serbo-Croatian. The most comprehensive study of
 Mileševa to date. Considers the history, architecture, and
 frescoes, as well as other works of art which constitute the
 treasures of Mileševa.

925 _____. "Mileševske freske Strašnog suda" [The Last Judgment
 frescoes at Mileševa]. Glas Srpske akademije nauka 234
 (1959):69-79.
 In Serbo-Croatian. The Last Judgment frescoes at Mileševa
 constituted the principal decoration of the ground level space of
 the exonarthex (added to the church shortly after its completion).
 The iconographic and stylistic implications of this decorative
 program in the history of Serbian monumental painting are

examined in detail. The frescoes are dated to the second half of
the thirteenth century, between Morača and St. Nicholas at
Studenica.

926 Stojković, Živorad. <u>Mileševa</u>. Medieval Art in Yugoslavia.
 Belgrade: Jugoslavija, 1963. 6 pp., 61 pls.
 A brief account of Mileševa illustrated with good black-
 and-white photographs of frescoes (mostly details).

MILI

927 Bošković, Dj[urdje]. "Manastir Mili na Limu" [Monastery Mili
 on Lim]. <u>Starinar</u>, 3d ser. 13 (1938):92-95.
 In Serbo-Croatian. A brief account of the remains of Mili
 monastery and its church—a single-aisled (probably domed)
 structure. On the basis of its building technique and the later
 added narthex (sixteenth century?), the church is thought to be-
 long to the thirteenth or fourteenth century.

MISLODJIN

928 Birtašević, Marija. "Manastir sv. Hristofora u Mislodjinu"
 (Fr. sum.: "Le monastère de St. Christophore à Mislodjin").
 <u>Starinar</u>, n.s. 19 (1969):273-75 (Fr. sum.: 275).
 In Serbo-Croatian. A brief account of the excavated re-
 mains, which suggest that the monastery church of Mislodjin dates
 from the first half of the fifteenth century. The church and its
 frescoes were restored in the second half of the sixteenth cen-
 tury.

MLJET [island]

929 Fisković, Cvito. "Samostan i crkva sred Jezera na Mljetu"
 [Monastery and the church in the middle of the lake on the
 island of Mljet]. <u>Bulletin Instituta za likovne umjetnosti</u>
 <u>Jugoslavenske akademije znanosti i umjetnosti</u> 6, no. 1 (1958):
 1-14.
 In Serbo-Croatian. A brief account of the important
 Benedictine monastery and its church. Emphasizes the importance
 of this church for understanding the development of architecture
 in the hinterlands of the Balkans (most notably in Serbia).

930 Korać, Vojislav. "Crkva sv. Marije na Mljetu" (Fr. sum.:
 "L'église Ste. Marie à Mljet"). <u>ZFF</u> 7, pt. 1 (1963):213-26
 (Fr. sum.: 225-36).
 In Serbo-Croatian. A study of the late twelfth- or early
 thirteenth-century Benedictine monastery church of St. Mary on
 Mljet and its relationship to Apulian architecture. The church
 is compared to the church of St. Margherita at Bisceglie.

MODRIŠTE

931 Jovanović, Petar S. "Modrički manastir" [Modrič monastery].
 GSND 3 (1928):277-80.
 In Serbo-Croatian. A brief account of the small ruined
 church in the village of Modrište (believed from sources to be
 the remains of Modrič monastery). Provides documentary photo-
 graphs of surviving frescoes in the church ruins.

MOJSINJE [region]

932 Jovanović, Kosta Jov. "Stare crkve u Mojsinju" [Old churches
 in Mojsinje]. Starinar, 2d ser. 2 (1907):149-65.
 In Serbo-Croatian. Reports on a group of small, diverse
 churches in the region of Mojsinje. The churches vary in type
 and period of construction. The oldest, St. Nicholas at Djunis,
 appears to antedate the twelfth century.

MOKRO

933 Sergejevski, D[imitrije]. "Bazilika u Mokrom" (Ger. sum.:
 "Die Frühchristliche Basilika von Mokro"). GZMS, n.s. 15-16
 (Arheologija) (1960-61):211-28 (Ger. sum.: 227-28).
 In Serbo-Croatian. Excavation report on a small single-
 aisled church with a contiguous baptistery (on the north) and a
 large room to the south. Believed to date from the fifth cen-
 tury, the "basilica" was remodeled. The rich sculptural finds
 pose the problem of dating and the questions of continuity versus
 revival of late Antique art in Bosnia during the early Middle
 Ages.

MORAČA

934 Deroko, Aleksandar. "Morača." Starinar, 3d ser. 7 (1932):
 9-14 (Fr. sum.: 133).
 In Serbo-Croatian. A brief account of the architecture of
 the church of Dormition at Morača monastery.

935 Maksimović, Jovanka. "Kamena dekoracija Morače" (Fr. sum.:
 "La décoration sculpturale de Morača"). ZLU 2 (1966):35-49
 (Fr. sum.: 48-49).
 In Serbo-Croatian. Views the retarded Western-style sculp-
 ture of Morača as an artistic phenomenon comparable to the stag-
 nation also apparent in Serbian manuscript illumination during
 the thirteenth century.

936 Petković, Sreten. "Zidna dekoracija paraklisa sv. Stefana u
 Morači iz 1642. godine" (Eng. sum.: "Wall painting of St.
 Stepen's chapel in the Morača monastery from 1642"). ZLU 3
 (1967):133-57 (Eng. sum.: 156-57).

In Serbo-Croatian. Examines the frescoes in the lateral
chapel of St. Stephen (dated 1642) and relates them to the
frescoes in the small church of St. Nicholas within the monastery
compound. The iconography and the style of frescoes are analyzed
closely. An important contribution to the understanding of
Serbian art during the seventeenth century.

937 Skovran, Anika. "Ispitivanje i konzervacija manastira
 Morače" (Fr. sum.: "Études et conservation du monastère
 Morača"). ZZSK 11 (1960):197-220 (Fr. sum.: 219-20).
 In Serbo-Croatian. A report on the examination of the
 building's history, architecture, painting, and conservation.

938 Stojaković, Anka. "Ktitorski modeli Morače" (Fr. sum.:
 "Effigies de l'église de Morača"). Starinar, n.s. 15-16
 (1966):95-109 (Fr. sum.: 109).
 In Serbo-Croatian. A study of painted models of the main
 church of Morača monastery which appear on sixteenth-century
 frescoes and seventeenth-century icons in the monastery.

939 Vukčević, Anika Skovran. "Freske XIII veka u manastiru
 Morači" (Fr. sum.: "Les fresques du XIIIe siècle au monastère
 de Morača"). ZRVI 5 (1958):149-72 (Fr. sum.: 171-72).
 In Serbo-Croatian. A study of the remaining thirteenth-
 century frescoes at Morača (located in the diaconicon). The
 cycle, consisting of eleven scenes dedicated to Prophet Elijah,
 represents a relatively rare program in Byzantine art. The
 frescoes of Morača are seen as being of exceptional importance
 from the point of view of their iconography and style in the
 development of thirteenth-century art in Serbia.

MOROVIĆ

940 Gvozdanović, Vladimir. "Crkva Majke Božje u Moroviću" [Church
 of the Mother of God in Morović]. Peristil 12-13 (1969-70):
 15-22.
 In Serbo-Croatian. An important example of brick Gothic
 architecture in the southern Panonian region, the church at
 Morović is characterized by a single aisle, a deep sanctuary
 (older than the church?), a chapel flanking the sanctuary on the
 north side, and a massive axially placed tower on the west façade.

MOSTAĆI

941 Miletić, Nada. "Crkva sv. Klimenta u Mostaćima" (Fr. sum.:
 "L'église de St. Clément à Mostaći"). GZMS, n.s. 9 (1954):
 281-97 (Fr. sum.: 296-97).
 In Serbo-Croatian. A study of the architecture of the
 small single-aisled church and its seventeenth-century frescoes.
 Stylistic and iconographic archaisms of the fresco decoration are
 of particular interest.

MOŠTANICA

942 Andrejević, Andrej. "Manastir Moštanica pod Kozarom" (Fr.
 sum.: "Monastère de Moštanica près de Kozara"). Starinar,
 n.s. 13-14 (1965):163-75 (Fr. sum.: 175).
 In Serbo-Croatian. A study of the history and architecture
 of a late medieval Serbian Orthodox monastery in Bosnia. Its
 main church was evidently built ca. 1538. The architecture of
 the building reveals strong Islamic influence in many structural
 and decorative details.

NERADIN

943 Matić, Vojislav. "Crkva svetog Nikole u Neradinu" (Fr. sum.:
 "L'église de St. Nikola à Neradin"). ZLU 10 (1974):117-38
 (Fr. sum.: 138).
 In Serbo-Croatian. The eighteenth-century church of St.
 Nicholas at Neradin is presented as an important example of the
 survival of medieval architectural forms in the area of Fruška
 Gora. Particularly relevant are such details as the corbeled
 table frieze on the façades and the external articulation of the
 dome, both of which show clear links to the architecture of the
 so-called Morava school.

NAUM. See OHRID

NEREZI

944 Akrabova, Ivanka. "Za 'okachenite portreti' v zhivopista na
 edna tsŭrkva ot XII vek" (Fr. sum.: "Portraits 'accrochés'
 dans la peinture d'une église du XIIe siècle"). Razkopi i
 prouchvaniia 4 (1949):5-18 (Fr. sum.: 17-18).
 In Bulgarian. Considers the illusionary "hung portraits"
 which appear at Nerezi (1164) and considers this Comnenian phe-
 nomenon in the light of the ancient Roman wall-painting tradi-
 tion.

945 Bošković, Georges. "La restauration récente de l'iconostase
 à l'église de Nerezi." Seminarium Kondakovianum 6 (1933):
 157-59.
 A brief account of the reconstruction of the original altar
 partition. Illustrates details of the original architectural
 sculpture. See entry YU 949.

946 Mesesnel, Franc. "Najstariji sloj fresaka u Nerezima.
 Stilska studija" (Fr. sum.: "La plus ancienne de fresques à
 Nerez"). GSND 7-8 (1930):119-33 (Fr. sum.: 133).
 In Serbo-Croatian. An early stylistic study of the
 twelfth-century frescoes discovered below the layer of fifteenth-
 and nineteenth-century frescoes.

947 Miljković-Pepek, Petar. Nerezi. Medieval Art in Yugoslavia.
 Belgrade: Jugoslavija, 1966. 7 pp., 48 pls.
 A short account of the building's history, architecture,
 and frescoes. The book is illustrated with a fine selection of
 black-and-white photographs showing mostly details of frescoes.

948 _____. "Prilozi proučavanju crkve manastira Nereza" (Fr.
 sum.: "Contribution à l'étude de l'église monastique de
 Nerezi"). ZLU 10 (1974):313-22 (Fr. sum.: 321-22).
 In Serbo-Croatian. Illuminates certain aspects of the
 history of the church. On the basis of the missing twelfth-
 century fresco decoration, the author reaches certain daring
 conclusions about the extent of past remodelings. Thus, accord-
 ing to him, the dome and the western vault of the naos were com-
 pletely rebuilt after the 1955 earthquake. These conclusions
 remain dubious.

949 Okunev, Nik. "Altarnaia pregrada XII v``ka v Nerez``" (Fr.
 sum.: "L'iconostase du XIIe s. à Nérèz"). Seminarium
 Kondakovianum 3 (1929):5-23 (Fr. sum.: 22-23).
 In Russian. A detailed study of the remains of the origi-
 nal altar screen, including its architectural sculpture and
 fresco decoration. Late fifteenth- or early sixteenth-century
 remodelings are also considered. See entry YU 945.

950 Rajković, Mila. "Iz likovne problematike nereskog živopisa"
 (Fr. sum.: "La peinture de Nerezi"). ZRVI 3 (1955):195-206
 (Fr. sum.: 206).
 In Serbo-Croatian. Considers various stylistic aspects of
 the Nerezi frescoes. The frescoes are compared with those at St.
 Nicholas Kasnitses in Kastoria.

951 Spirovski, Spase. "Konzervatorskite raboti na živopisot vo
 crkvata Sveti Pantelejmon, selo Nerezi - Skopsko" [Conserva-
 tion of frescoes in the church of St. Panteleimon in the vil-
 lage of Nerezi, near Skopje]. KN 2 (1961):107-13.
 In Macedonian. An account of the conservation of frescoes
 with a brief history of the earlier investigations and preserva-
 tion efforts.

NIN

952 Jelić, Luka. Dvorska kapela Sv. Križa u Ninu [The palace
 chapel of the Holy Cross in Nin]. Djela Jugoslavenske
 akademije znanosti i umjetnosti 19. Zagreb: Jugoslavenska
 akademija znanosti i umjetnosti, 1911. 32 pp., 23 pls.
 In Serbo-Croatian. A detailed study of the important old
 Croatian church of the Holy Cross at Nin. Various aspects of
 the church (such as its relationship to the original palace, its
 architectural character, its architectural sculpture, etc.) are
 considered in the light of historical sources and archeological

investigations (1907-1910). The building is defined as belonging
to the "Dalmato-Persian" cross-domed type.

953 Novak, Grga, and Maštrović, V., eds. Povijest grada Nina
 [The history of the town of Nin]. Posebna izdanja. Institut
 Jugoslavenske akademije znanosti i umjetnosti. Zadar:
 Jugoslavenska akademija znanosti i umjetnosti, 1969. 786 pp.,
 illus., foldout pls. in text.
 In Serbo-Croatian. A history of the town of Nin in the
 form of several essays written by different authors. (Each essay
 has a summary in English.) Several articles consider the medi-
 eval art and architecture of Nin.

954 Petricioli, Ivo. "Osvrt na ninske gradjevine i umjetničke
 spomenike sradnjega i novoga vijeka" (Eng. sum.: "Architec-
 tonic and artistic monuments of Nin from the Middle Ages and
 modern times"). Radovi instituta Jugoslavenske akademije
 znanosti i umjetnosti u Zadru 16-17 (1969):299-356 (Eng. sum.:
 355-56).
 In Serbo-Croatian. Discusses primarily the medieval archi-
 tectural and artistic heritage of Nin, providing a basic survey
 with illustrations and references to older literature.

955 Suić, Mate, ed. Nin: Problemi arheoloških istraživanja [Nin:
 Problems of archeological excavations]. Zadar: Arheološki
 muzej, 1968. 67 pp., 44 pls.
 Parallel texts in Serbo-Croatian and English. The last
 section of the book, written by J. Belošević, is devoted to Nin
 in the Middle Ages (pp. 53-63, pls. 34-44). Major monuments of
 architecture and art are discussed and illustrated. Bibliography
 of up-to-date literature is included.

NOVA PAVLICA

956 Mano-Zisi, Djordje. "Nova Pavlica na Ibru" (Fr. sum.: "La
 Nouvelle Pavlica"). Starinar, 3d ser. 8-9 (1933-34):193-206
 (Fr. sum.: 205-6).
 In Serbo-Croatian. A discussion of the church of Nova
 Pavlica, a fourteenth-century three-apsed church preceded by a
 narthex and a large belfry. Devotes considerable attention to
 the fresco cycle, considered one of the finest from the second
 half of the fourteenth century.

957 Mihailović, Milorad. "Zidna dekoracija novopavličke crkve"
 (Fr. sum.: "La décoration murale de l'église Nova Pavlica").
 Raška baština 1 (1975):65-79 (Fr. sum.: 79).
 In Serbo-Croatian. A discussion of the remains of the late
 fourteenth-century frescoes at Nova Pavlica which considers their
 style, iconography, and technique. Concludes that no true paral-
 lels to Nova Pavlica frescoes exist.

958 Nenadović, S[lobodan] M., and Vulović, V. "Konzervatorski
 radovi na Novoj Pavlici" (Fr. sum.: "Les travaux de conser-
 vation à Nova Pavlica"). Saopštenja 1 (1956):47-50 (Fr. sum.:
 50).
 In Serbo-Croatian. This brief account of conservation ef-
 forts at Nova Pavlica includes a discussion of its architecture
 and frescoes. Of the approximately 517 m^2 of original frescoes,
 some 250 m^2 have survived.

NOVI PAZAR. See also RAS

959 Ladjević, Milan. "Rezultati ispitivačkih radova na freskama
 crkve Sv. Petra i Pavla kraj Novog Pazara" (Fr. sum.: "Résul-
 tats des travaux de recherches effectués sur les fresques de
 l'église des saints Pierre et Paul, près de Novi Pazar").
 Saopštenja 4 (1961):149-62 (Fr. sum.: 162).
 In Serbo-Croatian. A study of fresco remains belonging to
 several different phases. The first phase involves plaster low-
 relief work belonging to the original building. While the date
 of the oldest frescoes is in doubt, they are found below a layer
 tentatively ascribed to the late twelfth or early thirteenth
 century.

960 Ljubinković, Mirjana. "Nekropola crkve sv. Petra kod Novog
 Pazara" (Fr. sum.: "La nécropole de l'église Saint Pierre
 près de Novi Pazar"). ZNM 6 (1970):169-233 (Fr. sum.:
 230-33).
 In Serbo-Croatian. A detailed account of the excavations
 in the church of St. Peter at Novi Pazar. The focus of the re-
 port is on the medieval necropolis discovered in and around the
 building, but other significant architectural and sculptural
 finds are discussed as well. Particularly interesting is the
 presence of a baptismal font which appears to have been in use as
 late as the twelfth century.

961 Ljubinković, Mirjana Ćorović. "Živopis crkve svetog Petra
 kod Novog Pazara" (Fr. sum.: "Les peintures murales de
 l'église Saint Pierre près de Novi Pazar"). Starinar, n.s. 20
 (Mélanges Djurdje Bošković) (1970):35-51 (Fr. sum.: 50-51).
 In Serbo-Croatian. A discussion of the fresco remains re-
 veals that they belong to several distinctive phases. The first
 (between the ninth century and 1019-20) is of undetermined ori-
 gin, but is provincial in character. The first and second
 restorations belong to the period when the church was the prin-
 cipal church in Raška (ca. 1054-1219). The paintings from this
 period are of very high quality. The last phase (after 1219),
 when the church became the seat of the local bishop, is charac-
 terized by paintings of varying quality executed by local
 artists.

962 Nešković, Jovan. "Petrova crkva kod Novog Pazara" (Fr. sum.:
 "Église de St. Pierre près de Novi Pazar"). Saopštenja 4
 (1961):137-48 (Fr. sum.: 148).
 In Serbo-Croatian. A study of the architecture of the
 church and its conservation. Different building phases are
 examined.

963 _____. "Petrova crkva kod Novog Pazara" (Fr. sum.: "Église
 de St. Pierre près de Novi Pazar"). Zbornik arhitektonskog
 fakulteta 6, no. 5 (1961):3-33 (Fr. sum.: 33).
 In Serbo-Croatian. A detailed discussion of the church of
 St. Peter (originally the church of the Holy Apostles), consid-
 ered to be the oldest medieval church in Serbia. Provides a
 thorough archeological and architectural assessment of the build-
 ing and proposes the ninth century as the probable date of its
 construction. The article is illustrated with numerous good
 drawings and photographs.

NOVIGRAD. See DOLAC

NOVO BRDO

964 Bošković, Djurdje. "Arheološka istraživanja Novog Brda"
 [Archeological investigations of Novo Brdo]. In Velika
 arheološka nalazišta u Srbiji. Edited by D. Vučenov.
 Belgrade: Kolarčev narodni univerzitet, 1974, pp. 99-116.
 In Serbo-Croatian. A useful survey of archeological inves-
 tigations conducted at Novo Brdo over the years. The site is
 examined as an urban entity, but individual buildings and their
 architectural idiosyncracies are also considered. A selective
 bibliography of the principal literature on Novo Brodo is
 appended.

965 Čerškov, Emil. "'Saška crkva' kod Novog Brda" (Fr. sum.:
 "'Église de Sas' près de Novo Brdo"). Starinar, n.s. 7-8
 (1958):338-40 (Fr. sum.: 340).
 In Serbo-Croatian. A brief account of a major Catholic
 church used by foreign merchants at Novo Brdo. Enumerates major
 archeological finds on the site.

966 Dinić, M[ihailo] et al. "Novo Brdo." Starinar, n.s. 5-6
 (1956):247-94.
 In Serbo-Croatian. A series of contributions on Novo Brdo
 by a number of different authors. These include a short histori-
 cal survey and reports of archeological work carried out in 1952,
 1953, and 1954. Excavations centered on fortification architec-
 ture, although residential architecture and churches (most nota-
 bly the church known as "Jovča" and the complex of the so-called
 Saška crkva) are also included.

967 Jovanović, Vojislav. "Prilog arheološkoj topografiji Novog
 Brda" (Fr. sum.: "Une contribution à la topographie archéo-
 logique de Novo Brdo"). Starinar, n.s. 12 (1961):169-74 (Fr.
 sum.: 174).
 In Serbo-Croatian. A discussion of three small single-
 aisled churches at Nišino Kolo, Boljevice, and Klokoč--all in the
 environs of Novo Brdo.

968 Ljubinković, Mirjana Ćorović. "Arheološka iskopavanja na
 Novom Brdu u toku 1957 godine" (Fr. sum.: "Fouilles archéo-
 logiques à Novo Brdo en 1957"). Starinar, n.s. 9-10 (1959):
 323-32 (Fr. sum.: 332).
 In Serbo-Croatian. Excavation report which primarily dis-
 cusses material finds in the church of St. Nicholas. These in-
 clude sculptural fragments, fresco fragments, ceramic bowls and
 jugs, as well as jewelry, coins, and textiles in the tombs within
 the church.

969 _____. "Značaj Novoga Brda u Srbiji Lazarevića i Brankovića"
 (Fr. sum.: "Le rôle de Novo Brdo dans l'état des familles
 Lazarević et Branković"). In Moravska škola i njeno doba.
 Edited by Vojislav J. Djurić. Belgrade: Filozofski fakultet,
 Odeljenje za istoriju umetnosti, 1972, pp. 123-41 (Fr. sum.:
 138-41).
 In Serbo-Croatian. A general study of Novo Brdo, the most
 important mining and commercial center of medieval Serbia. Con-
 siders the history of the town in the light of recent archeologi-
 cal finds and documentary evidence (primarily in the archives of
 Dubrovnik).

970 Zdraković, Ivan. "Arheološko-konzervatorski radovi na Novom
 Brdu u 1957 godini" (Fr. sum.: "Recherches archéologiques et
 conservation à Novo Brdo en 1957"). Starinar, n.s. 9-10
 (1959):319-22 (Fr. sum.: 322).
 In Serbo-Croatian. This excavation report on the church of
 St. Nicholas includes detailed measured drawings and explains
 conservation methods employed on the remains. Sculptural frag-
 ments show affinities with the monuments of the so-called Morava
 school.

971 _____. "Grad Novo Brdo" [The fortress of Novo Brdo]. UP 2,
 no. 10 (Dec. 1939):300-303.
 In Serbo-Croatian. A brief discussion of Novo Brdo, one of
 the most important fortresses in Serbia during the later Middle
 Ages. The article is illustrated with fine photographs, a plan,
 and four sketches.

972 _____ . "Iskopavanja na Novom Brdu 1955 godine" (Fr. sum.:
"Les fouilles à Novo Brdo 1955"). Starinar, n.s. 7-8 (1958):
341-48 (Fr. sum.: 348).
 In Serbo-Croatian. A report of the excavations and conser-
vation of the fortress of Novo Brdo, of the so-called Saška crkva
(the church of Sas), and a small church near the "Jovča" church.

973 _____ . "Otkopavanje crkve sv. Nikole na Novom Brdu 1956
godine" (Fr. sum.: "Travaux de deblaiment de l'église de St.
Nicolas à Novo Brdo en 1956"). Starinar, n.s. 7-8 (1958):
349-58 (Fr. sum.: 357-58).
 In Serbo-Croatian. Excavation report on the largest
medieval church of Novo Brdo. The church features an unusual
plan, and contains important material for the study of building
techniques and sculptural decoration.

NOVO MESTO

974 Mušič, Marjan. "Kapiteljska cerkev v Novem Mestu: Problem
njene lomljene osi" (Fr. sum.: "L'église capitolienne de Novo
Mesto: Le problème de son axe deviée"). In Zbornik Svetozara
Radojčica. Edited by Vojislav J. Djurić. Belgrade: Filo-
zofski fakultet, Odeljenje za istoriju umetnosti, 1969,
pp. 235-44 (Fr. sum.: 244).
 In Slovenian. Discusses the bend in the axis of the
church on the Capitol of Novo Mesto as a result of the church's
prolonged period of construction, from the mid-fourteenth cen-
tury to ca. 1621. During this time different rules for the
alignment of churches were observed.

OHRID

975 Bošković, Djurdje. "O jednoj zagonetnoj, plitkoreljefno
obradjenoj ploči iz Ohrida" (Fr. sum.: "Sur une dalle
enigmatique sculptée en méplat d'Ohrid"). ZNM 9-10 (1979):
307-11 (Fr. sum.: 311).
 In Serbo-Croatian. The puzzling slab with flat relief
figures (the surface of which was once presumably painted) is
believed to have been brought to the Museum of Ohrid from the
church of the Virgin Peribleptos (now St. Clement). The author
believes that the slab depicts the patron of the church Progon
Zgur in proskynesis before the Virgin with Child.

976 Bošković, Dj[urdje], and Tomovski, K. "L'architecture médié-
vale d'Ohrid." In Zbornik na trudovi. Edited by Dimče Koco.
Ohrid: Naroden muzej vo Ohrid, 1961, pp. 71-100.
 A survey of medieval architectural monuments in Ohrid and
its vicinity. The study provides basic information on all monu-
ments and is illustrated with good architectural plans and sec-
tions of some of the buildings.

977 Grozdanov, Cvetan. "Ohridske beleške" [Ohrid notes]. Zograf
 3 (1969):11-15 (Fr. sum.: 68).
 In Serbo-Croatian. Discusses depictions of SS. Michael and
 Eutichius in the church of the Virgin Peribleptos, the donor com-
 position of Archbishop Nicholas in the narthex of St. Sophia, and
 the portrait of Clement of Ohrid in the church of Virgin
 Hodegitria in Peč. Each of the three phenomena is briefly dis-
 cussed within its particular context.

978 _____. "Prilozi poznavanju srednjovekovne umetnosti Ohrida"
 (Fr. sum.: "Contribution à l'étude de l'art médiéval
 d'Ohrid"). ZLU 2 (1966):199-232 (Fr. sum.: 230-32).
 In Serbo-Croatian. The article discusses a series of spe-
 cific problems of medieval portraiture in Ohrid: the portrait of
 Archbishop Konstantin Kavasila in the church of the Virgin
 Peribleptos (St. Clement); the portrait of Archbishop Nikola; and
 portraits in the exonarthex of the Virgin Peribleptos. The arti-
 cle concludes with a discussion of the Turkish remodeling of
 Ohrid churches.

979 Kuzmanović, Risto, and Šaljić, Draško. Ohrid. Belgrade:
 Turistička štampa, 1966. 62 pp., 49 figs. in text.
 In Serbo-Croatian. A useful general guide to the cultural
 monuments of Ohrid with the focus on the medieval period.

980 Ljubinković, Radivoje. "Les influences de la vie politique
 contemporaine sur la décoration des églises d'Ohrid." Actes
 du XIIᵉ Congrès international d'études byzantines (Belgrade)
 3 (1964):221-25.
 Analyzes the influence of certain political events on the
 art of Ohrid from the eleventh to the fourteenth century.

981 Mesesnel, France. "Srednjevekovni spomenici u Ohridu" (Ger.
 sum.: "Die mittelalterlichen Denkmäler in Ochrida"). GSND
 12 (1933):157-80 (Ger. sum.: 179-80).
 In Serbo-Croatian. An important contribution to the study
 of several Ohrid churches and their art. Frescoes, sculptural
 decoration, woodcarving, and silver work are discussed.

982 Miljković-Pepek, P[etar]. "Materijali za istorijata na
 srednovekovnoto slikarstvo vo Makedonija, 2. Ciklusot
 stradanija apostolski od Sv. Sofija vo Ohrid" (Fr. sum.:
 "Matériaux sur l'art macédonien du moyen âge. Le cycle de la
 passionnée des apôtres--Sainte Sophie d'Ohrid"). Zbornik.
 Arheološki muzej na Makedonija (Skopje) 3 (1961):99-105 (Fr.
 sum.: 105).
 In Macedonian. Discusses a cycle of frescoes in a chapel
 above the diaconicon of St. Sophia in Ohrid. The cycle depicts
 martyrdoms of the Apostles, and is dated to the second half of
 the twelfth century. See entries YU 983 and 984.

983 _____. "Materijali za istorijata na srednovekovnoto
slikarstvo vo Makedonija, 3. Freskite vo naosot i narteksot
na crkvata Sv. Sofija vo Ohrid" (Fr. sum.: "Matériaux sur
l'art macédonien du moyen âge. Les fresques du naos et du
narthex de Sainte Sophie d'Ohrid"). KN 3 (1971):1-25 (Fr.
sum.: 27-28).
 In Macedonian. A detailed study of the fresco cycles in
St. Sophia at Ohrid, with a schematic layout of the positions of
all frescoes, and drawings of some of the compositions and indi-
vidual figures. See entries YU 982 and 984.

984 _____. "Materijali za makedonskata srednovekovna umetnost.
Freskite vo svetilišteto na crkvata Sv. Sofija vo Ohrid" (Fr.
sum.: "Matériaux sur l'art macédonien du moyen âge. Les
fresques du sanctuaire de Sainte Sophie d'Ohrid"). Zbornik.
Arheološki muzej na Makedonija (Skopje) 1 (1956):37-70 (Fr.
sum.: 67-70).
 In Macedonian. A study of the frescoes in the sanctuary of
St. Sophia at Ohrid. Although links with Constantinople and
Thessaloniki are acknowledged, these frescoes are seen as a
product of a local Macedonian school of Byzantine painting. See
entires YU 982 and 983.

985 Radojčić, Svetozar. "Prilozi za istoriju najstarijeg
 ohridskog slikarstva" (Ger. sum.: "Beiträge zur Geschichte
 der ältesten ochrider Malerei"). ZRVI 8, pt. 2 (1964):355-82
 (Ger. sum.: 382).
 In Serbo-Croatian. A major study of the oldest fresco
cycles in the church of St. Sophia in Ohrid. Various iconographic
problems are considered in a historical and theological context.

986 Subotić, Gojko. "Dva spomenika ohridskog zidnog slikarstva
 XV veka. Ktitori i vreme nastanka" (Fr. sum.: "Deux monu-
 ments de la peinture murale du XVe siècle à Ohrid. Les
 ktitors et la datation"). Zbornik Svetozara Radojčića.
 Edited by Vojislav J. Djurić. Belgrade: Filozofski fakultet,
 Odeljenje za istoriju umetnosti, 1969, pp. 315-33 (Fr. sum.:
 331-33).
 In Serbo-Croatian. Considers the patronage and dating of
the church of the Ascension in the village of Leskovec (near
Ohrid) and the church of St. Nicholas Bolnički in Ohrid. Both
churches date from the second half of the fifteenth century and
illustrate the state of fresco painting during the early part of
Turkish rule.

987 Zloković, Milan. "Stare crkve u oblastima Prespe i Ohrida"
 [Old churches in the regions of Prespa and Ohrid]. Starinar,
 3d ser. 3 (1925):115-49.
 In Serbo-Croatian. A survey of medieval churches in the
regions of Prespa and Ohrid Lakes. Brief descriptions and factual
information on individual monuments are accompanied by drawings
and photographs of the buildings.

Sv. Bogorodica Bolnička (Virgin "Bolnička")

988 Tomovski, Krum. "Neue Angaben über die Erbauung der Kirche der Mutter Gottes – Bolnička." Actes du XIIᵉ Congrès international d'études byzantines (Belgrade) 3 (1964):389-91.
A brief account of the new finds illuminating the structural history of Bogorodica Bolnička. The building is considered to have two building phases––in the fourteenth and fifteenth centuries.

Tomovski, Krum. See entry YU 1004

Sv. Bogorodica Čelnica (Virgin "Čelnica")

989 Koco, Dimče. "Bogorodica Čelnica" (Fr. sum.: "L'église de la Vierge 'Čelnica'"). Starinar, n.s. 20 (Mélanges Djurdje Bošković) (1970):171-79 (Fr. sum.: 178-79).
In Macedonian. An archeological and architectural study of this unusual two-aisled church. Argues that the church was built in the ninth century adjacent to a city gate (within the northern tower). The name "Čelnica" appears to refer to the word "čelna," which means "frontal," because the church was associated with the Front Gate.

Sv. Jovan Bogoslov-Kaneo (St. John the Theologian-Kaneo)

990 Miljković-Pepek, P[etar]. "Crkvata Sv. Jovan Bogoslov-Kaneo vo Ohrid" (Fr. sum.: "L'église de Saint Jean le Théologien-Kaneo d'Ohrid"). KN 3 (1971):67-120 (Fr. sum.: 121-24).
In Macedonian. A monographic study of the architecture, architectural sculpture, and frescoes in the church of St. John the Theologian-Kaneo at Ohrid, which the author dates to the seventies or eighties of the thirteenth century on a stylistic basis. The article is illustrated with a number of large black-and-white photographs which cannot be found elsewhere.

Sv. Kliment (St. Clement, formerly Virgin Peribleptos)

991 Čornakov, Dimitar. The Frescoes of the Church of St. Clement at Ohrid. Medieval Art in Yugoslavia. Belgrade: Jugoslavija, 1961. 5 pp., 60 pls.
A brief monograph on the church of St. Clement (Virgin Peribleptos) in Ohrid. The book is illustrated with fine black-and-white photographs, mostly details.

992 _____. "Po konzervatorskite raboti vo crkvata Sv. Bogorodica Perivleptos (sv. Kliment) vo Ohrid" (Fr. sum.: "Après les travaux de conservation effectués dans l'église Notre-Dame Perivleptos (Saint Clément) à Ohrid"). KN 2 (1961):73-94 (Fr. sum.: 94).

In Macedonian. A detailed account of the cleaning of the
frescoes at the church of the Virgin Peribleptos. The report
includes inscriptions found on frescoes.

993 Kiornakov, Dimitar. Clement (St. Bogorodica Peribleptos).
 The Cultural and Historical Heritage of P.R. of Macedonia, 6.
 Skopje: Institute for Preservation of Cultural Monuments,
 1961. 3 pp., 16 pls.
 An album of photographs (mostly details) of the frescoes at
 St. Clement.

994 Hallensleben, Horst. "Die architekturgeschichtliche Stellung
 der Kirche Sv. Bogorodica Peribleptos (Sv. Kliment) in Ohrid."
 Zbornik. Arheološki muzej na Makedonija 6-7 (1975):297-316.
 The architecture of the Virgin Peribleptos at Ohrid is
 linked with the architecture of Epirus. The church of Panagia
 Bellas at Boulgareli is used as a comparison. The two buildings
 are similar in plan as well as in the articulation of their
 exteriors.

995 Xyngopoulos, A. "Au sujet d'une fresque de l'église Saint
 Clément à Ohrid." ZRVI 8, pt. 1 (1963):301-6.
 The fresco depicting the image of the Virgin upon Solomon's
 bier and its symbolic implications are analyzed in the context of
 the narthex fresco program of the church of St. Clement, as well
 as in the broader context of late Byzantine art.

Sv. Kliment - Stari (Old St. Clement)

996 Ljubinković, Mirjana Ćorović. "Crkva Stari sveti Kliment u
 Ohridu" (Ger. sum.: "Die Kirche 'Des alten Hl. Klemens' in
 Ohrid"). Starinar, 3d ser. 15 (1940):92-100 (Ger. sum.:
 100).
 In Serbo-Croatian. Discusses a small single-aisled
 fourteenth-century church. The church represents a type used
 commonly for private foundations. Several original frescoes
 have survived, but these were done by a follower of better
 painters active at the time.

Sv. Konstantin i Jelena (SS. Constantine and Helena)

997 Ljubinković, Mirjana Ćorović. "Crkva Konstantina i Jelene u
 Ohridu. Datum postanka i ktitori crkve" (Fr. sum.: "Sur la
 date de fondation et les donateurs de l'église de Saint
 Constantine et de Sainte Hélène à Ohrid"). Starinar, n.s. 2
 (1951):175-84 (Fr. sum.: 183-84).
 In Serbo-Croatian. A study of the founding of the church
 of SS. Constantine and Helena and its original patrons, whose
 portraits with inscriptions are preserved.

998 Subotić, Gojko. Sveti Konstantin i Jelena u Ohridu (Fr. sum.:
 "L'église des saints Constantin et Helen à Ohrid"). Mono-
 grafije 1. Belgrade: Institut za istoriju umetnosti, 1971.
 135 pp. (Fr. sum.: 113-35), 55 pls., 10 schematic drawings of
 fresco program, several drawings in text.
 In Serbo-Croatian. A comprehensive monograph on the
 church, which was built and decorated in 1365 and 1367. Damaged
 frescoes from this phase were replaced in the fifteenth century.
 Exhaustively considers all questions on architecture, painting
 style and iconography, inscriptions, etc.

Sv. Naum

999 Koco, D. "L'église du monastère de Saint Naoum." Akten des
 XI. Internationalen Byzantinistenkongresses, 1958 (Munich)
 (1960):243-47.
 A brief structural history of this important monastic
 church built in the ninth century on a triconch plan, but subse-
 quently destroyed and rebuilt in the form of a cross-in-square
 plan.

1000 Koco, Dimče. "Proučavanja i arheološki ispituvanja na
 crkvata na manastirot Sv. Naum" (Fr. sum.: "Études et
 fouilles de l'église du monastère de Saint Naum"). Zbornik.
 Arheološki muzej na Makedonija (Skopje) 2 (1958):56-80 (Fr.
 sum.: 80).
 In Macedonian. The main findings stemming from the archeo-
 logical excavations are that the present church is not from the
 time of St. Naum, and that the original church was of the tri-
 conque type. This church was destroyed and completely rebuilt
 during the period of Turkish rule. Two distinctive phases are
 in evidence at that time. The first comprised the naos, narthex,
 and the chapel, while the second saw the construction of domes
 over the narthex and the naos.

Sv. Nikola Bolnički

1001 Balabanov, Kosta. "Novi podatoci za crkvata Sv. Nikola
 Bolnički vo Ohrid" [New information about the church of Sv.
 Nikola Bolnički at Ohrid]. KN 2 (1961):31-44.
 In Macedonian. A detailed discussion of the frescoes
 which, according to the author, date from ca. 1313-14, 1335-45,
 and 1381-82. A new reading of some of the inscriptions has en-
 abled the author to correct some of the previously held opinions.

1002 Miljković-Pepek, Petar. "O datiranju fresaka ohridske crkve
 Sv. Nikole Bolničkog" (Fr. sum.: "Sur la datation des
 fresques dans l'église de Saint Nicolas Hospitalier d'Ohrid").
 In Zbornik Svetozara Radojčiča. Edited by Vojislav J. Djurić.
 Belgrade: Filozofski fakultet, Odeljenje za istoriju umet-
 nosti, 1969, pp. 197-201 (Fr. sum.: 201).

In Serbo-Croatian. Redates the frescoes of St. Nicholas
Bolnički to 1335-36 on the basis of three factors: a new inter-
pretation of dated inscriptions in the church; the activities of
Archbishop Nicholas at the time of the Serbian conquest of Ohrid;
and the establishment of the autocephalous church of Ohrid under
Serbian rule.

1003 Subotić, Gojko. "Vreme nastanka crkve sv. Nikole Bolničkog u
 Ohridu" (Fr. sum.: "Époque de la construction de l'église de
 St. Nicolas ā Ohrid"). Zograf 3 (1969):16-17 (Fr. sum.:
 68).
 In Serbo-Croatian. Offers a new reading of the partially
 preserved date of the church--1345-46, and argues that the bulk
 of fresco decoration was painted at that time and not in two
 phases as earlier believed.

1004 Tomovski, K. "Konzervacija na crkvata Sv. Nikola Bolnički i
 Bogorodica Bolnička vo Ohrid" (Fr. sum.: "Conservation des
 églises de Saint Nicolas et de Sainte Vierge Bolnički ā
 Ohrid"). KN 2 (1961):95-100 (Fr. sum.: 100).
 In Serbo-Croatian. A brief discussion of the conservation
 of two small fourteenth-century Ohrid churches.

Sv. Pantelejmon (St. Panteleimon)

1005 Koco, Dimče. "Klimentoviot manastir 'Sv. Pantelejmon' i
 raskopkata pri 'Imaret' vo Ohrid" (Fr. sum.: "Le monastère de
 St. Pantéleimon fondé par St. Clément et les fouilles d'Imaret'
 ā Ochride"). Godišen zbornik. Filozofski fakultet 1 (1948):
 129-82 (Fr. sum.: 181-82).
 In Macedonian. A detailed account of the excavations under
 the ruined Imaret Camii, which have revealed the remains of the
 ninth-century church of St. Clement and, below it, the remains of
 an early Christian basilica. The article discusses only St.
 Clement. The original trefoil was expanded subsequently by the
 addition of a large narthex and lateral ambulatories. Fragments
 of frescoes, inscriptions, floors, and tombs have been uncovered.

1006 _____. "Klimentoviot manastir 'Sv. Pantelejmon' i raskopkata
 pri 'Imaret' vo Ohrid" [Clement's monastery St. Panteleimon
 and the excavations at Imaret in Ohrid]. Kniga za Kliment
 Ohridski. Edited by B. Koneski et al. Skopje: Kočo Racin,
 1966, pp. 129-71.
 In Macedonian. Essentially a reprint of YU 1003, but with
 higher quality illustrations.

1007 Mikhaĭlov, Stamen. "Belezhki za Klimentovata tsŭrkva 'Sv.
 Panteleĭmon' v Okhrid i neĭniia ktitorski nadpis" (Fr. sum.:
 "Notes sur l'église St. Pantéleimon du monastère St. Clément
 d'Ohrid et son inscription de donateur"). Arkh 17, no. 3
 (1975):11-22.

In Bulgarian. Disputes the conclusions by Koco (see entry
YU 1005) regarding the architecture and the documentary content
of the inscription in the church of St. Panteleimon in Ohrid.

Sv. Sofija (St. Sophia) [cathedral church]

1008 Aleksova, Blaga. "Pokrivni ceramidi od crkvata sv. Sofija vo
 Ohrid" (Eng. sum.: "Some roof tiles from the church of St.
 Sophia in Ohrid"). Zbornik. Arheološki muzej na Makedonija
 (Skopje) 2 (1958):48-55 (Eng. sum.: 55).
 In Macedonian. A study of roof tiles with inscriptions
 uncovered during the restoration of the church. The author be-
 lieves that the tiles, bearing different names, stem from differ-
 ent donors who paid for various repairs at different times. All
 of the tiles were reused by the Turks, who put a new roof on the
 building.

1009 Djuric, Vojislav J. The Church of St. Sophia in Ohrid.
 Medieval Art in Yugoslavia. Belgrade: Jugoslavija, 1963.
 13 pp., 48 pls.
 A brief monograph focusing on the frescoes of the church
 dating from the eleventh to the fourteenth centuries. The book
 is illustrated with a fine selection of black-and-white photo-
 graphs showing mostly details of frescoes.

1010 Forlati, Ferdinando et al. Saint Sophia of Ochrida: Preser-
 vation and Restoration of the Building and Its Frescoes.
 Museums and Monuments 4. Paris: UNESCO, 1953. 27 pp.,
 33 figs. in text.
 A detailed technical account of the restoration and preser-
 vation techniques employed at St. Sophia at Ohrid.

1011 Grozdanov, Cvetan. "Prilozi proučavanju Sv. Sofije ohridske u
 XIV veku" (Fr. sum.: "Contributions à l'étude de la basilique
 Sainte-Sophie d'Ohrid au XIVe siècle"). ZLU 5 (1969):37-56
 (Fr. sum.: 53-56).
 In Serbo-Croatian. Three problems from the history of St.
 Sophia in the fourteenth century are examined: the donor in-
 scription of Archbishop Grigorios on the west façade of the
 exonarthex; the partially preserved frescoes illustrating the
 Canon of St. John Damascene on the Assumption of the Virgin in
 the now destroyed blind dome over the narthex; and the dating of
 the chapel of despot Oliver.

1012 Koco, Dimče. "Crkvata Sv. Sofija vo Ohrid" (Fr. sum.:
 "L'église St. Sophie à Ohrid"). Godišen zbornik. Filozofski
 fakultet 2 (1949):343-58 (Fr. sum.: 357-58).
 In Macedonian. A consideration of the structural history
 of the building based on archeological work carried out by the
 author. The church was originally a three-aisled basilica with-
 out a transept or the dome which it acquired later. The upper

chapels (above the pastophoria) are also later additions, as is
the exonarthex.

1013 ____. "Nouvelles considérations sur l'église de Sainte
 Sophie à Ohrid." AI 2 (1956):139-44.
 Considers several archeological finds concerning the his-
 tory of the building, including a brick stamp with a basilican
 church plan (presumably the original church) and the evidence for
 the existence of a tower [?] over the narthex. Discusses several
 questions pertaining to the original fresco decoration in the
 church.

Korać, Vojislav. See entry YU 382

1014 Ljubinković, Radivoje et al. Konzervatorski radovi na crkvi
 Sv. Sofije u Ohridu [Conservation undertakings on the church
 of St. Sophia in Ohrid]. Belgrade: Savezni institut za
 zaštitu spomenika kulture, 1955. 34 pp., 6 drawings in text,
 pls.
 In Serbo-Croatian. A general discussion of the structural
 history of the building and the conservation of its architecture
 and frescoes.

Miljković-Pepek, Petar. See entries YU 543, 982-84
Radojčić, Svetozar. See entry YU 985

1015 Vasilić, Angelina. "Stilske osobine fresaka XI veka u Svetoj
 Sofiji ohridskoj" (Fr. sum.: "Les particularités du style des
 fresques de l'église de Ste. Sophie d'Ohrid datant du XIe
 siècle"). ZNM 9-10 (1979):233-41 (Fr. sum.: 240-41).
 In Serbo-Croatian. An examination of stylistic traits in
 the eleventh-century frescoes of St. Sophia in Ohrid. They are
 compared with mosaics of Kiev, Hosios Loukas, and Daphni, and
 together with these they are seen as examples of exported Byzan-
 tine art which formed a base from which national artistic devel-
 opments in Russia, Bulgaria, and Serbia would eventually evolve.

OMIŠ

1016 Bezić, Nevenka. "Crkva Sv. Petra na Priku u Omišu" (Fr. sum.:
 "Église St. Pierre de Priko à Omiš"). PPUD 12 (1960):50-60
 (Fr. sum.: 60).
 In Serbo-Croatian. Presents the archeological discovery of
 the remains of the original apse of the church (destroyed in the
 eighteenth century). This discovery provided adquate information
 for a hypothetical reconstruction (subsequently used for rebuild-
 ing of the original apse following the removal of the eighteenth-
 century choir).

1017 _____. "Novi nalaz u crkvi Sv. Petra na Priku u Omišu" (Fr.
 sum.: "Nouvelle trouvaille dans l'église de Sv. Petar (St.
 Pierre) de Priko à Omiš"). PPUD 13 (1961):45-60 (Fr. sum.:
 60).
 In Serbo-Croatian. A report on new archeological discov-
 eries made during the 1962 investigation of the church. Lateral
 niches were discovered in all of the three church bays. Several
 early Christian fragments of architectural sculpture (fifth-
 sixth centuries) have been found and linked with the spoils used
 in the church of St. Peter on the basis of both material and
 style.

1018 Radić, F[rano]. "Crkva S. Petra u Omišu" [The church of St.
 Peter at Omiš]. SP 2, no. 4 (1896):225-31.
 In Serbo-Croatian. An important early account of the
 eleventh-century[?] church of St. Peter at Omiš. Gives a de-
 tailed account of its architecture and relates it to a large
 number of other monuments along the Dalmatian coast.

ORAHOVICA [in Slavonia]

1019 Grujić, Rad. M. "Starine manastira Orahovice u Slavoniji"
 [Antiquities of Orahovica monastery in Slavonija]. Starinar,
 3d ser. 14 (1939):7-62.
 In Serbo-Croatian. An exhaustive study of the Serbian
 Orthodox monastery of Orahovica in Slavonia, dating from the
 sixteenth century. In addition to its conservative architecture
 which emulates the characteristics of the Morava school, the
 monastery is noted for its art treasures (all of post-Byzantine
 date).

OŠLJE

1020 Marsović, Tomislav. "Ranosrednjovekovna crkvica u Ošlju kod
 Stona" [Early medieval church in Ošlje near Ston]. Peristil
 2 (1957):85-89 (Eng. sum.: 89).
 In Serbo-Croatian. A preliminary report of the investiga-
 tions of a centralized early medieval church articulated by eight
 deep niches (semicircular inside and outside).

OVČARSKO-KABLARSKA KLISURA [region]

1021 Bošković, Dj[urdje]; Zdravković, I.; Garašanin, M.; and
 Kovačević, J. "Spomenici kulture u Ovčarsko-Kablarskoj
 klisuri i njenoj najbližoj okolini" (Fr. sum.: "Reconnais-
 sance archéologique dans la région d'Ovčar-Kablar et de celle
 de Požega [Serbie de l'ouest]"). Starinar, n.s. 1 (1950):
 91-108 (Fr. sum.: 108).
 In Serbo-Croatian. A survey of cultural remains in the
 region of the Ovčar-Kablar gorge. A large section of the article
 (pp. 96-107) is devoted to medieval monuments. The most important

monasteries considered are: Jovanje, Blagoveštenje, Sv. Trojica, Sretenje, Vaznesenje, Preobraženje, and Vavedenje.

1022 Dušanić, Svetozar, and Nikolić, Radomir. Ovčarsko-Kablarski manastir [Monasteries of the Ovčar-Kablar gorge]. Spomenici kulture, 2d ser. 1. Belgrade: Turistička štampa, 1963. 74 pp., illus. in text.
 In Serbo-Croatian. A guide to the monasteries of the Ovčar-Kablar gorge illuminating their history, architecture, and art. A basic bibliography is included.

1023 Medić, Milka Čanak. "Blagoveštenje pod Kablarom" (Fr. sum.: "Blagoveštenje sous Kablar"). Saopštenja 9 (1970):199-221 (Fr. sum.: 221).
 In Serbo-Croatian. A study of the architecture and conservation of the complex of Blagoveštenje monastery, with the emphasis on the main church.

1024 _____. "Manastir Trojica pod Ovčarom" (Fr. sum.: "Monastère de la Trinité au pied de l'Ovčar"). Raška baština 1 (1975): 81-94 (Fr. sum.: 94).
 In Serbo-Croatian. A detailed study of the history and architecture of the church of the Trinity monastery dating from ca. 1580-90. The dating is based on comparisons with other monasteries in the area. The architecture of the church reveals similarities with the so-called Raška school as well as with the Morava school.

OZREN

1025 Ruvarac, Ilarion. "O natpisima u Ozrenskoj crkvi i o živopiscu popu Strahinji" [Regarding the inscriptions in the Ozren church and on the painter, priest Strahinja]. GZMS 4 (1892): 293-301.
 In Serbo-Croatian. An important study which corrects earlier misconceptions and errors and dates the church to 1587. Also clarifies the confusion regarding the fresco decoration, executed in 1609 by one priest Strahinja.

1026 Stratimirović, Djordje. "O crkvi Qzrenskoj" [Regarding the Ozren church]. GZMS 4, no. 1 (1892):68-70.
 In Serbo-Croatian. Makes corrections and observations on the history of the church. The belfry is said to have been added in 1878. The author believes that the frescoes should be dated to the thirteenth or the fourteenth century [?].

1027 Vitanović, Timotije. "Manastir Ozren" [Ozren monastery]. GZMS 1, no. 2 (1889):32-38.
 In Serbo-Croatian. A pioneering study of the sixteenth-century monastery, its history, architecture, and decoration.

PALEŽ

1028 Basta, Branka Pavić. "Crkva Sv. Nikole u Paležu" (Fr. sum.:
 "L'église de St. Nicolas à Palež"). Raška baština 1 (1975):
 203-11 (Fr. sum.: 211).
 In Serbo-Croatian. Dates the small single-aisled church of
 St. Nicholas to the fourteenth century on the basis of typologi-
 cal comparisons of its plan with a number of other churches. The
 article also considers the remains of fresco decoration.

PANIK

1029 Popović, Marko. "Novootkrivene freske sa crkvine u Paniku"
 (Fr. sum.: "Fresques nouvellement découvertes de la localité
 de Panik"). Zograf 3 (1969):56-57 (Fr. sum.: 68).
 In Serbo-Croatian. A report of the excavations of a small
 single-aisled church at Panik near Bileća in Herzegovina. The
 finds include fine fresco fragments with Greek of Slavic letters.
 The fresco fragments are dated on stylistic basis to the twelfth
 century and constitute the oldest frescoes found in Bosnia and
 Herzegovina.

PAVLOVAC [on Kosmaj]

1030 Jovanović, Kosta Jov. "Dve stare crkve u Kosmaju" [Two old
 churches on Kosmaj mountain]. Starinar, n.s. 3 (1908):173-83.
 In Serbo-Croatian. An early account of the ruined church
 of Pavlovac. The church dates from the fifteenth century and
 features a characteristic triconch plan. The article includes a
 number of photographs of documentary value. It also considers a
 small single-aisled church of Tresija, which is dated to the
 sixteenth century.

1031 Popović, Marko. "Manastir Pavlovac" (Fr. sum.: "Le monastère
 Pavlovac"). Starinar, n.s. 30 (1980):75-81 (Fr. sum.: 81).
 In Serbo-Croatian. A study of the architectural remains of
 Pavlovac monastery, belonging to the last phase in the develop-
 ment of medieval architecture in Serbia (the so-called Morava
 school).

1032 Tatić, Žarko. "Pavlovac pod Kosmajem" [Pavlovac on Kosmaj].
 Starinar, 3d ser. 3 (1925):3-9.
 In Serbo-Croatian. An early record of this important
 ruined church of the so-called Morava school. The article is
 illustrated with architectural drawings which were not well re-
 produced. The author argues for the Western origin of the
 builders.

PAVLOVAC [on Prača]

1033 Bojanovski, Ivo. "Pavlovac na Prači" (Fr. sum.: "La ville
 médiévale Pavlovac"). NS 13 (1972):71-77 (Fr. sum.: 77).
 In Serbo-Croatian. A brief account of the history and
 architectural features of this medieval fortress characterized by
 the absence of a donjon. A date around 1430 is proposed as the
 probable time of its construction.

PEĆ

1034 Babić, Gordana. "Liturgijski tekstovi ispisani na živopisu
 apside Svetih Apostola u Peći. Mogućnost njihovog restauris-
 anja" (Fr. sum.: "Les textes liturgiques inscrits sur les
 fresques absidales des Saints Apôtres à Peć"). ZZSK 18
 (1967):75-84 (Fr. sum.: 84).
 In Serbo-Croatian. A study of liturgical texts which
 appear on rolls held by church fathers in a procession depicted
 in the apse of the church of Holy Apostles. Written in Old
 Church Slavonic, these texts represent translations from Greek
 originals and constitute an important contribution to the study
 of translations of liturgical books in thirteenth-century Serbia.

1035 _____. "Simbolično značenje živopisa u protezisu Svetih
 Apostola u Peći" (Fr. sum.: "La signification symbolique des
 peintures murales dans la prothésis des Saints Apôtres à
 Peć"). ZZSK 15 (1964):173-82 (Fr. sum.: 182).
 In Serbo-Croatian. The remains of frescoes in the
 prothesis of the church of the Holy Apostles are discussed in
 the light of liturgical symbolism. Old Testament parallels were
 used to explain the eucharist in accordance with church writers
 who commented on this problem.

1036 Bošković, Djurdje. "O slikanoj dekoraciji na fasadama Pećke
 patrijaršije" (Fr. sum.: "Sur la décoration peinte des fa-
 çades au monastère de la Patriarchie de Peć"). Starinar,
 n.s. 18 (1968):91-102 (Fr. sum.: 100-102).
 In Serbo-Croatian. A detailed account of the painted
 façades of the Patriarchal church complex at Peć. Disputes the
 findings of V.J. Djurić and suggests that the painted decoration
 at Peć was a reflection of the decorative system employed on the
 monuments of the so-called Morava school. See entry YU 96.

1037 Ivanović, Milan. "Crkva Bogorodice Odigitrije u Pećkoj
 Patrijaršiji" (Fr. sum.: "L'église de la Vierge Hodigitria
 au Patriarcat de Peć"). SKM 2-3 (1963):133-56 (Fr. sum.:
 156).
 In Serbo-Croatian. A monographic study of the church of
 the Virgin Hodegetria (built between 1324 and 1337) in the
 Patriarchal complex of churches at Peć. The history, architec-
 ture, and fresco decoration are analyzed, with especial emphasis
 on fresco decoration, style, and iconographic characteristics.

1038 _____. The Virgin's Church in the Patriarchate of Peć.
 Medieval Art in Yugoslavia. Belgrade: Jugoslavija, 1972.
 15 pp., 48 pls.
 A brief account of the church of the Virgin within the
 Patriarchal complex of churches at Peć. Considers its history,
 architecture, and art. The book is illustrated with a selection
 of fine black-and-white photographs.

1039 Ljubinković, Radivoje. The Church of the Apostles in the
 Patriarchate of Peć. Medieval Art in Yugoslavia. Belgrade:
 Jugoslavija, 1964. 18 pp., 62 pls., map.
 A brief account of the church of the Apostles including its
 history, architecture, and frescoes. The book is illustrated
 with fine black-and-white photographs (mostly details).

1040 Medić, Milka Čanak. "Prilog proučavanju crkve sv. Apostola u
 Peći" (Fr. sum.: "Contribution ā l'étude de l'église des
 Saints Apôtres ā Peć"). ZZSK 15 (1964):165-72 (Fr. sum.:
 172).
 In Serbo-Croatian. An archeological study contributing to
 the understanding of the form of the original church of the Holy
 Apostles at Peć. The investigation has determined that the church
 was flanked by spaces (chapels?) which roughly occupied the posi-
 tion of the present churches of the Virgin and St. Demetrius,
 built in the fourteenth century.

1041 Nedić, Olivera. "Prilog proučavanju autentičnosti arhitekture
 prikazane na starim gravirama na primeru Pećke patrijaršije"
 (Fr. sum.: "Un apport ā l'étude de l'authenticité de l'archi-
 tecture reproduite sur les vieilles gravures"). ZZSK 11
 (1960):171-80 (Fr. sum.: 180).
 In Serbo-Croatian. Examines the pictorial depictions of
 buildings on old engravings and woodcuts and assesses their po-
 tential use in restoration and conservation work. Old visual
 documents of the Patriarchate of Peć are used as a test case in
 this article.

1042 Petković, V.P. "Živopis crkve Sv. Bogorodice u Patrijaršiji
 Pećskoj" (Fr. sum.: "Les peintures de l'église de la Vierge
 ā Peć"). IBAI 4 (1927):145-71 (Fr. sum.: 170-71).
 In Serbo-Croatian. A basic description of the program and
 iconography of the church of the Virgin within the Patriarchal
 complex of churches at Peć.

1043 Radovanović, Janko. Crkva Sv. Nikole u Pećkoj patrijaršiji
 [The Church of St. Nicholas in the Patriarchate of Peć].
 Belgrade: n.p., 1963. 42 pp., 4 figs.
 In Serbo-Croatian. A study of the smallest of the four
 churches in the Patriarchal complex at Peć--the church of St.
 Nicholas. The emphasis of the study is on its fresco decoration,
 which is an extensive cycle dedicated to the life of St.

Nicholas, painted by a painter Radul during the second half of
the seventeenth century.

1044 Schwartz, Ellen C. "The Original Fresco Decoration in the
 Church of the Holy Apostles in the Patriarchate of Peć."
 Ph.D. dissertation, New York University, 1978, 207 pp.,
 92 figs.
 Attempts to reconstruct the original church of the Holy
 Apostles. Considers the history of the church, its architecture,
 and the extant frescoes from the thirteenth century. Discusses
 the nature of the thirteenth-century program, including its
 iconography and style.

1045 Skovran, Anika. "Freske XVII veka iz crkve Sv. Dimitrija u
 Peći i portret patrijarha Jovana" (Fr. sum.: "Les fresques du
 XVII^e siècle dans l'église de St. Dimitri à Peć et le portrait
 du patriarche Jean"). SKM 4-5 (1968-71):331-50 (Fr. sum.:
 349-50).
 In Serbo-Croatian. The extensive restoration of the church
 of St. Demetrius in 1614 involved replacing a large portion of
 the fourteenth-century fresco cycle. The article analyzes the
 seventeenth-century frescoes; the portrait of the patron,
 patriarch Jovan; and the role of his successor, patriarch
 Pajsije--who sponsored the completion of frescoes.

1046 Subotić, Gojko. The Church of St. Demetrius in the Patriarch-
 ate of Peć. Medieval Art in Yugoslavia. Belgrade:
 Jugoslavija, 1964. 14 pp., 61 pls., map.
 A brief account of the church, including its history,
 architecture, and frescoes. The book is illustrated with fine
 black-and-white photographs (mostly details).

1047 Šuput, Marica. "Arhitektura pećke priprate" (Fr. sum.:
 "L'architecture de l'exonarthex de Peć"). ZLU 13 (1977):
 45-69 (Fr. sum.: 48-49).
 In Serbo-Croatian. A study of the architecture of the
 exonarthex, built in front of the complex of churches at Peć by
 Archbishop Danilo II (ca. 1330). Examines the functional and
 architectural aspects of this addition (including the now lost
 belfry) on the basis of literary sources and archeological evi-
 dence.

1048 Tasić, Dušan. "Živopis pevničkih prostora crkve Sv. Apostola
 u Peći" (Fr. sum.: "Les peintures des choeurs de l'église des
 Sts. Apôtres à Peć"). SKM 4-5 (1968-71):233-69 (Fr. sum.:
 269).
 In Serbo-Croatian. A detailed study of the fourteenth-
 century frescoes in the "low transept" wings (mostly southern)
 of the church of the Holy Apostles. The frescoes represent a
 logical addition (or replacement?) to the twelfth-century fresco
 program, and are dated to the second half of the fourteenth cen-
 tury.

1049 Vasić, Angelina, and Teodorović-Šakota, M. <u>Katalog riznice</u> <u>manastira Pećke Patrijaršije</u> (Fr. text: "Catalogue du trésor du Patriarchat de Peć"). Priština: Zavod za zaštitu spomenika kulture AKMO, 1957. 31 pp., 16 pls.

Parallel texts in Serbo-Croatian and French. The catalog lists eighty-nine principal medieval objects in the treasury of the Patriarchate of Peć, one of the few medieval treasuries that has been partially preserved. Plates illustrate only a section of the collection.

PETKOVICA

1050 Milutinović, D.S. "O starini manastira Petkovice" [Regarding antiquity of Petkovica monastery]. <u>Starinar</u> 2, no. 3 (1885): 73-93.

In Serbo-Croatian. An article about the history and architecture of a basically Romanesque church of Petkovica monastery (near Šabac). Argues for an early date (time of St. Sava).

PIROT

1051 Petrović, Nevenka. "Pirotski grad" (Fr. sum.: "La forteresse de Pirot"). <u>Starinar</u>, n.s. 5-6 (1956):295-304 (Fr. sum.: 304).

In Serbo-Croatian. Discusses a medieval fortress (probably built in the fourteenth century) which is not historically documented. The fortress, including an inner fort with a donjon tower, was evidently remodeled by the Turks in the fifteenth century.

PIVA

1052 Skovran, Anika. <u>Umetničko blago manastira Pive</u> (Eng. text: "Art treasures of Piva monastery"). Cetinje-Beograd: Republički zavod za zaštitu spomenika kulture Crne Gore and Narodni muzej, 1980. 263 pp., 21 col. pls., 36 b&w pls., 3 drawings.

Parallel texts in Serbo-Croatian, English, and French. A major catalog of art treasures of Piva monastery, with an introductory text. The book is illustrated with excellent reproductions.

PLJEVLJA

1053 Petković, Sreten. <u>Manastir Sveta Trojica kod Pljevalja</u> (Eng. sum.: "The monastery of the Holy Trinity near Pljevlja"). Monografije 3. Belgrade: Filozofski fakultet, Institut za istoriju umetnosti, 1974. 163 pp. (Eng. sum.: 137-51), numerous drawings in text, 15 schematic drawings of fresco program layout, 80 pls.

In Serbo-Croatian. A comprehensive monograph on the
monastery of the Holy Trinity near Pljevlja. Considers all
aspects of the monastery--its history, architecture, fresco
program, and the works of art in its treasury.

PODGORICA

1054 Mijović, Pavle. "Alata - Ribnica - Podgorica; Stanica -
 naselje - grad" (Fr. sum.: "Alata - Ribnica - Podgorica;
 station - site d'habitation - forteresse"). Starinar,
 n.s. 15-16 (1966):69-93 (Fr. sum.: 93).
 In Serbo-Croatian. A histor:cal and archoelogical study of
 the medieval and post-medieval city. Attempts to distinguish
 different phases of fortifications which terminated with Turkish
 occupation and partial reconstruction.

PODVRH

1055 Skovran, Anika. "Crkva Sv. Nikole u Podvahu [sic. Podvrhu]
 kod Bijelog Polja" (Fr. sum.: "L'église de St. Nicolas à
 Podrvh de Bijelo Polje"). Starinar, n.s. 9-10 (1959):355-66
 (Fr. sum.: 366).
 In Serbo-Croatian. The small church of St. Nicholas at
 Podvrh was built in 1606. Its architecture, well-preserved
 fresco decoration, and iconostasis screen constitute an important
 contribution to the study of conservative artistic development in
 Serbia during the Turkish occupation.

POGANOVO

1056 Grabar, A[ndré]. "Poganovskiiat monastir" (Fr. sum.: "Le
 monastère de Poganovo"). IBAI 4 (1927):172-210 (Fr. sum.:
 209-10).
 In Bulgarian. A monographic study of Poganovo, which dis-
 cusses architecture and fresco decoration.

1057 Subotić, Gojko. Introduction to Izložba kopija fresaka iz
 manastira Poganova [An exhibit of fresco copies from Poganovo
 monastery]. Edited by Vladimir Koudić. Belgrade: Narodni
 muzej, 1975. 7 pp., 14 pls., 2 drawings.
 In Serbo-Croatian. A catalog of an exhibit of fresco
 copies, the book presents a brief but informative text and is
 illustrated with good photographs and two excellent drawings
 showing the arrangement of frescoes in two lateral apses.

POLJICA. See SITNO

POLOŠKO

1058 Djurić, Vojislav J. "Pološko; hilandarski metoh i Dragušinova
 grobnica" (Fr. sum.: "Pološko; Metoque de Chilandar et mau-
 solée de Dragušin"). ZNM 8 (1975):327-44 (Fr. sum.: 343-44).
 In Serbo-Croatian. An unusual juxtaposition of two fresco
 compositions--the Presentation in the Temple, and the Crucifixion
 on the opposite lateral tympana below the dome of the church of
 St. George at Pološko (ca. 1340)--together with the presence of
 the Deesis below the Crucifixion, are seen as reflections of two
 important factors. First, they reflect the monastery's links
 with the Serbian monastery Hilandar on Mt. Athos; secondly, they
 indicate the presence of the founder's tomb in the church. The
 church was founded by one Dragušin, a close relative of King
 Dušan.

1059 Mano-Zisi, Djordje. "Pološko." Starinar, 3d ser. 6 (1931):
 114-23 (Fr. sum.: 193).
 In Serbo-Croatian. A brief account of frescoes from
 Pološko (ca. 1340), an older Byzantine church restored in
 ca. 1340.

POREČ

1060 Ivančević, Radovan. "Odnos antiknog i srednjovjekovnog
 rastera Poreča" (Fr. sum.: "Le plan de la ville de Poreč
 dans l'Antiquité et celui du moyen âge"). Peristil 6-7
 (1963-64):5-12 (Fr. sum.: 12).
 In Serbo-Croatian. A study of the relationship between
 the ancient grid plan of Poreč and its medieval fabric. The
 author finds a greater degree of linkage between Antiquity and
 the Middle Ages than has generally been assumed.

1061 Ivančević, R., and Kelemen, B. "Fragmenti srednjovjekovne
 skulpture iz Poreča" [Fragments of Medieval Sculpture from
 Poreč]. Peristil 1 (1954):142-46.
 In Serbo-Croatian. A discussion of eleven early medieval
 relief fragments (mostly architectural) from Poreč. Fragments
 of architraves, parapet slabs, ambos [?], and sarcophagi are
 considered.

1062 Prelog, Milan. Poreč: Grad i spomenici [Poreč: The town
 and the monuments]. Belgrade: Savezni institut za zaštitu
 spomenika kulture, 1957. 200 pp. (Fr. sum. as a separate
 appendix), 324 figs.
 In Serbo-Croatian. The most comprehensive study of the
 town of Poreč and its monuments to date. The book is divided
 into four chapters: Poreč in the history of Istria; the growth
 of the town; the monuments; and an analysis of the present state
 of the town. A substantial portion of the book discusses the
 medieval material. Particularly relevant is the discussion of

medieval fortifications and residential buildings in chapter 3.
The book is well illustrated, and contains a particularly useful
selection of architectural drawings.

POREČE [region]

1063 Mesesnel, France. "Izveštaj o proučavanju južne Srbije na
 terenu. Topografske beleške o nekim crkvenim spomenicima u
 Poreču" (Ger. sum.: "Kunsttopographische Aufzeichnungen aus
 Poreče"). GSND 13 (1934):171-83 (Ger. sum.: 183).
 In Serbo-Croatian. A study of several abandoned small
 medieval churches. Includes churches near and at Trebino, at
 Devič, and at Modrište. All churches are single-aisled, and the
 latter two also domed.

PRASKVICA

1064 Mijović, Pavle. "Freske u pevnici Balše III u Praskvici"
 (Fr. sum.: "Les fresques dans le bas transept de l'église de
 Balša III à Praskvica"). Starinar, n.s. 9-10 (1959):345-53
 (Fr. sum.: 353).
 In Serbo-Croatian. A discussion of the frescoes in the
 north transept wing, the only remaining portion of the fifteenth-
 century church of St. Nicholas at Praskvica monastery.

PRČANJ

1065 Korać, Vojislav, and Kovačević, Jovan. "Crkva sv. Tome u
 Prčanju u Boki Kotorskoj" (Fr. sum.: "L'église de Saint
 Thomas à Prčanj, à Boka Kotorska"). ZFF 11, pt. 1 (1970):
 107-17 (Fr. sum.: 114-17).
 In Serbo-Croatian. A study of an important pre-Romanesque
 monument excavated in 1959-60. The church was centralized, fea-
 turing a cross-in-square naos characterized by four free-standing
 columns and three projecting apses (semicircular inside and rec-
 tangular on the exterior). The fourth façade, on the west side,
 accommodated the entrance. The church is related to the pre-
 Romanesque heritage of the Adriatic littoral and to the Carolin-
 gian examples, and is tentatively dated to the ninth century.

PREDJEL

1066 Nikolajević, Ivanka. "Skulpture iz Predjela u Bosni" (Fr.
 sum.: "Sculptures de l'église à Predjel en Bosnie"). ZRVI
 16 (1975):191-202 (Fr. sum.: 202).
 In Serbo-Croatian. Architectural sculpture discovered in
 the ruins of a church at Predjel in eastern Bosnia is seen as
 being linked to the emerging mature Romanesque tradition of the
 twelfth century.

PREKO

1067 Petricioli, Ivo. "Crkvica sc. Ivana Krstitelja u Preku" (Fr. sum.: "La petite église de St. Jean Baptiste sur l'île de Preko"). PPUD 8 (1954):40-47 (Fr. sum.: 117).
 In Serbo-Croatian. Analyzes the architecture and sculpture of the small Romanesque church of St. John the Baptist at Preko and dates it to the thirteenth century.

PRESPA

1068 Knežević, Branka. "Crkva svetog Petra u Prespi" (Fr. sum.: "Église de Saint Pierre à Prespa"). ZLU 2 (1966):245-65 (Fr. sum.: 263-65).
 In Serbo-Croatian. A detailed study of the small, single-aisled church of St. Peter and the remains of its fresco decoration. On the basis of a stylistic and iconographic analysis of the frescoes, the church is dated to the fourteenth century and related to the known monuments of Ohrid.

Zloković, Milan. See entry YU 987

PRIDRAGA

1069 Radić, F. "Župna crkva Sv. Martina u Pridrazi kod Novigrada" [Parish church of St. Martin in Pridraga near Novigrad]. SP 6, nos. 1-2 (1901):42-48.
 In Serbo-Croatian. An account of the old Croatian church at Pridraga, a single-aisled building with a trefoil sanctuary. Also considers the fragments of architectural sculpture.

PRIDVORICA

1070 Korać, Vojislav. "Mesto Pridvorice u raškoj arhitekturi" (Fr. sum.: "La place de Pridvorica au sein de l'architecture serbe"). Raška baština 1 (1975):33-47 (Fr. sum.: 47).
 In Serbo-Croatian. A report of archeological findings at Pridvorica. On the basis of these findings, reassesses the relationship of Pridvorica to other monuments of the so-called Raška school. The church is closely related to Žiča, Mileševa, and the Holy Apostles at Peć, though an absolute chronology of these monuments is still unresolved.

PRIJEDOR

1071 Čremošnik, Irma. "Novi srednjevjekovni nalazi kod Prijedora" (Fr. sum.: "Nouvelles découvertes médiévales près de Prijedor"). GZMS, n.s. 10 (Arheologija) (1955):137-47 (Fr. sum.: 145-47).
 In Serbo-Croatian. An archeological study of the remains of two small medieval churches and the architectural sculpture associated with them.

PRIJEPOLJE

1072 Kašanin, Milan. "Dve crkvine kod Prijepolja" [Two church
 ruins in the vicinity of Prijepolje]. GSND 1, nos. 1-2
 (1926):365-69 (Fr. sum.: 369).
 In Serbo-Croatian. Ruins of two small single-aisled
 churches--in Pustinja monastery and at Ivanje (both near
 Prijepolje)--are examined and the two monuments dated to the
 fourteenth century.

PRILEP (MARKOVA VAROŠ)

1073 Babić, Boško. "Nova saznanja o crkvama srednjovekovnog
 Prilepa" (Fr. sum.: "Données nouvelles sur les églises du
 Prilep médiéval"). Zbornik Svetozara Radojčića. Edited by
 Vojislav J. Djurić. Belgrade: Filozofski fakultet, Odeljenje
 za istoriju umetnosti, 1969, pp. 11-15 (Fr. sum.: 15).
 In Serbo-Croatian. A brief archeological account of some
 newly discovered church remains from medieval Prilep.

1074 _____. "Tri grčka fresko natpisa na zidovima crkava srednjo-
 vekovnog Prilepa iz druge polovine XIII veka" (Fr. sum.:
 "Trois inscriptions à fresque grecques de la deuxième moitié
 du XIII^e siècle sur les parois des églises médiévales de
 Prilep"). ZLU 5 (1969):25-33 (Fr. sum.: 32-33).
 In Serbo-Croatian. Artistic production in medieval Prilep
 (now Varoš) during the second half of the thirteenth century is
 documented by Greek inscriptions. Prilep was of particular im-
 portance for the Byzantine Empire during its final decline, as
 attested to by the invocation of the name of the Emperor
 Andronicus II.

1075 Babić, Boško et al. Kulturno bogatstvo Prilepa od V-XIX veka
 [Cultural treasures of Prilep from the fifth to the nineteenth
 centuries]. Belgrade: Narodni muzej, 1976. 113 pp.,
 b&w pls.
 In Serbo-Croatian. Exhibition catalog with a substantial
 introductory text presenting the history of Prilep. The majority
 of the material (jewelry, metalwork, coins, pottery, fresco frag-
 ments, icons, embroideries, and woodcarvings) is medieval.

1076 Ćornakov, Dimitar. "Konzervatorsko-istraživački radovi na
 arhitekturi i živopisu crkve sv. Arhandjela kod Prilepa" (Fr.
 sum.: "Les travaux de conservation et de restauration sur
 l'architecture et les fresques de l'église de St. Archanges
 près de Prilep"). ZZSK 18 (1967):93-98 (Fr. sum.: 97-98).
 In Serbo-Croatian. A brief account of conservation of
 architecture and paintings reveals the existence of two major
 building phases. Fragments of fine twelfth-century frescoes have
 been uncovered in the original part of the structure. These in-
 clude lower portions of figures believed to be the donors.

1077 Deroko, A[leksandar]. "Markovi kuli-grad Prilep" (Fr. sum.:
 "Le château-fort de Prilep"). Starinar, n.s. 5-6 (1956):
 83-104 (Fr. sum.: 102-4).
 In Serbo-Croatian. A study of the fortress of medieval
 Prilep which considers the layout of the fortress and individual
 architectural features (towers, gates, and houses).

1078 Findrik, Ranko. "Kozervatorski radovi na arhitekturi crkve
 sv. Nikole u selu Varoši kod Prilepa" (Fr. sum.: "Travaux de
 conservation effectués sur l'architecture de l'église Saint
 Nicolas dans le village Varoš près de Prilep"). ZZSK 16
 (1965):200-18 (Fr. sum.: 217-18).
 In Serbo-Croatian. A detailed study of the church of St.
 Nicholas and the conservation of its architecture. The author
 closely examines the condition of the building, its history, and
 earlier attempts at conservation. He then describes his own
 conservation effort.

1079 Mesesnel, France. "Crkva Sv. Nikole u Markovoj Varoši kod
 Prilepa" (Ger. sum.: "Die Nikolauskirche in Markova Varoš
 bei Prilep"). GSND 19 (1938):37-52 (Ger. sum.: 52).
 In Serbo-Croatian. Examines the architecture and frescoes
 of the thirteenth-century church of St. Nicholas. Also analyzes
 a leaf of the iconostasis doors (probably contemporary with the
 church) and a fine icon of the Virgin Eleousa (probably belonging
 to the original altar screen).

1080 Ristić, Vladislav. "Crkva svetog Dimitrija u Prilepu" (Eng.
 sum.: "The church of Saint Demetrius in Prilep"). Sinteza
 10, nos. 3-4 (1979):171-226 (Eng. sum.: 224-26).
 In Serbo-Croatian. A major study of the principal medieval
 church in Prilep. The author identifies six building phases be-
 tween 1143 and the mid-fourteenth century, during which the build-
 ing was expanded and its architectural character substantially
 altered. The phenomenon is linked to the general development of
 architecture in Epirus.

PRIZREN

1081 Bošnjak, Sreto. Prizren ville musée. Belgrade: Mozaik,
 n.d. 36 pp., 1 foldout map, 20 pls.
 A brief illustrated guidebook of Prizren and its monuments.
 Most attention is given to the medieval monuments.

1082 Nenadović, Slobodan M. "Arhitektura crkve mladog kralja
 Marka (?) u Prizrenu" (Fr. sum.: "L'architecture de l'église
 du roi Marko (?) à Prizren"). ZLU 15 (1979):289-305 (Fr.
 sum.: 305).
 In Serbo-Croatian. A detailed analysis of the architec-
 tural remains of the small single-aisled church of King Marko
 excavated in 1968. Archeological finds are systematically

presented and used in a hypothetical reconstruction offered by
the author.

Bogorodica Ljeviška (Virgin of Ljeviša) [cathedral church]

1083 Mandić, Svetislav. "Jedan vladarski lik u Bogorodici
 Ljeviškoj" (Fr. sum.: "Portrait d'un souverain dans l'église
 de la Vierge Ljeviška"). Zograf 1 (1966):24-27 (Fr. sum.:
 47).
 In Serbo-Croatian. Identifies a portrait without an in-
 scription as that of Stefan Dečanski. A number of exhaustive
 arguments are used to prove the point.

1084 Nenadović, Slobodan [M.]. Bogorodica Ljeviška: Njen postanak
 i njeno mesto u arhitekturi Milutinovog vremena [Bogorodica
 Ljeviška: Its origins and its place in the architecture of
 Milutin's time]. Belgrade: Narodna knjiga, 1963. 288 pp.
 (Fr. sum.: 265-77), 131 figs. in text, 42 pls.
 In Serbo-Croatian. A major monograph on the history and
 architecture of Bogorodica Ljeviška. The study includes a com-
 prehensive report on the archeological investigations of the
 building. These have revealed the existence of two earlier
 building phases. The fourteenth-century building phase is almost
 fully preserved and its architecture is scrutinized in consider-
 able detail.

1085 _____. "Šta je kralj Milutin obnovio na crkvi Bogorodice
 Ljeviške u Prizrenu" (Fr. sum.: "Quelles furent les renova-
 tions du roi Milutin dans l'église de Notre-Dame-de-Ljeviša à
 Prizren"). Starinar, n.s. 5-6 (1956):205-26 (Fr. sum.:
 225-26).
 In Serbo-Croatian. A detailed archeological study of the
 church of Bogorodica Ljeviška in Prizren. Identifies different
 building phases and assesses the contribution of King Milutin as
 the last major donor of the church.

1086 Panić, Draga, and Babić, G. Bogorodica Ljeviška. Umetnički
 spomenici Jugoslavije. Belgrade: Srpska književna zadruga,
 1975. 114 pp. (Eng. sum.: 105-14), 22 drawings in text,
 30 figs., 51 col. pls., 31 drawings of decorative program.
 In Serbo-Croatian. The most comprehensive monograph, which
 considers all aspects of the church--its history, architecture,
 frescoes, and sculptural decoration. The book is illustrated
 with excellent black-and-white and color photographs.

1087 Radovanović, Janko. "Portreti Nemanjića u crkvi Bogorodice
 Ljeviške u Prizrenu" (Fr. sum.: "Les portraits des Nemanjići
 dans l'église Sv. Bogorodica Ljeviška [Ste. Vierge de Ljeviša]
 à Prizren"). SKM 4-5 (1968-71):271-301 (Fr. sum.: 301).
 In Serbo-Croatian. A detailed study of the portrait
 "gallery" in the inner narthex of Bogorodica Ljeviška. In

addition to the well known, identified, portraits, the author
attempts to identify the partially preserved portrait of an un-
known member of the royal family as King Dragutin. This inter-
pretation has not been accepted; most scholars now agree that the
figure in question is Stefan Dečanski. See entry YU 1083.

Manastir Sv. Arhandjela (Monastery of the Archangels)

1088 Bošković, Dj[urdje]. "Ruševine Sv. Nikole, u kompleksu
 gradjevina manastira Sv. Arhandjela, kod Prizrena") [Ruins of
 the church of St. Nicholas in the monastery complex of the
 Archangels, near Prizren]. GSND 11 (1932):231-33.
 In Serbo-Croatian. A brief examination of the architecture
 of the church of St. Nicholas, with two hypothetical alternatives
 for the reconstruction of the dome over its narthex.

1089 Grujić, Rad[oslav] M. "Otkopavanje Svetih Arhandjela kod
 Prizrena (preliminarni izveštaj)" [Excavations of the Holy
 Archangels near Prizren: A preliminary report]. GSND 3
 (1928):239-74.
 In Serbo-Croatian. An important report of the somewhat
 hastily conducted excavations of this important monastery com-
 plex. Illustrates numerous details, many of which no longer can
 be observed.

1090 Nenadović, Slobodan. Dušanova zadužbina manastir Svetih
 arhandjela kod Prizrena (Fr. sum.: "Monastère des Saints
 Archanges près de Prizren, fondation de l'empereur Dušan").
 Spomenik, 116. Belgrade: Srpska akademija nauka i umetnosti,
 1967. 120 pp. (Fr. sum.: 113-17), 125 figs. in text, 94 pls.
 In Serbo-Croatian. The monograph on the destroyed monas-
 tery of the Archangels near Prizren. The main church of the
 monastery was built as the mausoleum church of Emperor Dušan.
 The author provides an exhaustive report on archeological in-
 vestigations of the site, presents full documentation of the
 surviving material (sculpture, marble floor fragments, etc.),
 and offers hypothetical reconstructions of the main church and
 other buildings in the monastery compound.

1091 _____. "Konzervacija ruševina manastira svetih Arhandjela kod
 Prizrena" (Fr. sum.: "La conservation des ruines du monastère
 de St. Archange près de Prizren"). SKM 4-5 (1968-71):401-8
 (Fr. sum.: 407-8).
 In Serbo-Croatian. A description of conservation under-
 takings on the monastery of the Archangels near Prizren. An
 important document of the extent of restoration--which was not
 marked on the monuments themselves, making it often difficult to
 discern the original from restored work.

1092 _____. "Nekoliko novih fragmenata iz crkve svetih Arhandjela
 cara Dušana" (Fr. sum.: "Quelques nouveaux fragments de
 l'église Saint Archange ergiée par l'empereur Dušan"). ZLU 5
 (1969):273-77 (Fr. sum.: 277).
 In Serbo-Croatian. An addendum to the architectural study
 of the monastery of the Archangels which examines several subse-
 quent finds of architectural sculpture.

Sv. Spas (Savior)

Čurčić, Slobodan. See entry YU 83

1093 Timotijević, Roksanda. "Crkva sv. Spasa u Prizrenu" (Fr.
 sum.: "L'église de Saint Sauveur à Prizren"). SKM 6-7
 (1972-73):65-80 (Fr. sum.: 80).
 In Serbo-Croatian. A study of the history and art of the
 small church of St. Savior in Prizren. The author dates the
 church to the 1320-30s. Various surviving frescoes are described
 in detail though, unfortunately, their illustrations are excep-
 tionally poor.

PROKUPLJE

1094 Tasić, Dušan. "Živopis srednjovekovne crkve u Prokuplu" (Fr.
 sum.: "Les peintures de l'église médiéval à Prokuplje"). ZLU
 3 (1967):109-30 (Fr. sum.: 128-30).
 In Serbo-Croatian. A detailed study of the frescoes of the
 small single-aisled church. On the basis of the analysis, the
 frescoes are dated ca. 1340-60.

PSAČA

Popović, Pera. See entry YU 1202

1095 Tatić, Žarko. "Bazilika u Psači" (Fr. sum.: "La basilique de
 Psatcha"). GSND 5 (1929):121-30 (Fr. sum.: 130).
 In Serbo-Croatian. A pioneering study of architecture of
 the church of St. Nicholas--which the author erroneously refers
 to as a basilica. Illustrated with valuable drawings and photo-
 graphs.

1096 Tomovski, Krum. "Konzervacija crkve manastira Psače" (Fr.
 sum.: "La conservation de l'église de monastère Psača").
 ZZSK 14 (1963):39-44 (Fr. sum.: 44).
 In Serbo-Croatian. A brief account of the conservation of
 the church of St. Nicholas at Psača. The article considers the
 architecture of the building before conservation as well as the
 original form of the building.

PTUJ

1097 Bošković, Djurdje. "Problem slovenskog hrama u Ptuju" (Fr.
 sum.: "Le problème du sanctuaire Slave à Ptuj"). Srarinar,
 n.s. 1 (1950):39-46 (Fr. sum.: 46).
 In Serbo-Croatian. A reevaluation of the 1947-48 archeo-
 logical excavations, which brought to light the foundations of
 what was believed to have been an early Slavic sanctuary. The
 author points out that no conclusive proof of the building being
 a Slavic sanctuary was unearthed.

1098 Korošec, Josip. Slovansko svetišče na Ptujskem gradu (Eng.
 sum.: "The old Slav sanctuary on the castle-hill of Ptuj").
 Ljubljana: Slovenska akademija znanosti in umetnosti, 1948.
 66 pp. (Eng. sum.: 57-66), 32 pls., 18 drawings.
 In Slovenian. The site, excavated in 1909 and again in
 1946-47, has yielded information about Illirian, Roman, and
 Slavic settlements (the latter in two phases: early seventh-
 ninth centuries; tenth-eleventh centuries). The most important
 find is that of an old Slavic sanctuary. Very few of these have
 been discovered and their remains properly recorded. Therefore,
 the Ptuj find represents a major contribution to early Slavic
 archeology.

1099 Stelè, France. "Stenske slike v minoritski cerkvi vi Ptuju"
 [The wall paintings in the church of the Minorites in Ptuj].
 ZUZ 11, nos. 1-4 (1931):1-30 (Fr. sum.: 1-2).
 In Slovenian. A detailed analysis of the iconography and
 style of wall paintings in the church of the Minorites, on the
 basis of which they are dated to ca. 1260. Iconographically
 interesting are the representations of Christ as a crowned ruler,
 and the scene of the Death of St. Francis of Assisi, one of the
 earliest examples of this scene to have survived.

PTUJSKA GORA

1100 Stelè, France. Ptujska gora. 2d ed. Ljubljana: Zadruga
 katoliških duhovnikov SFRJ, 1966. 134 pp., 56 figs. in text.
 In Slovenian. A comprehensive guide book on Ptujska Gora.
 The author considers the monastic complex and church (late
 Gothic) within its regional setting. Attention is given to
 architecture, sculptural decoration, paintings, and other art
 treasures.

RAMAĆA

1101 Knežević, Branka. "Crkva u selu Ramaći" (Fr. sum.: "L'église
 du village Ramaća"). ZLU 4 (1968):121-71 (Fr. sum.: 166-71).
 In Serbo-Croatian. A monographic study of the small
 single-aisled church which discusses the history, architecture,
 and relatively well-preserved frescoes. Because of certain

unique aspects of the iconography and style, the church is diffi-
cult to date, but the second half of the fourteenth century ap-
pears probable. Links with earlier and later achievements are
discussed.

1102 Mihailović, Draga. "Crkva u Ramaći - novi spomenik slikarstva
 Moravske škole" (Fr. sum.: "Un nouveau monument de le pein-
 ture de l'École de la Morava"). Saopštenja 1 (1956):147-55
 (Fr. sum.: 155).
 In Serbo-Croatian. An account of newly discovered frescoes,
 dated 1395. The frescoes represent an important contribution to
 the study of the so-called Morava school of painting.

RAS

1103 Bošković, Djurdje. "Aperçu des résultats de recherches
 archéologiques à Ras et des problèmes qui s'y rapportent."
 Balcanoslavica 6 (1977):61-78.
 A brief account of archeological findings at Ras. Particu-
 larly interesting are industrial and commercial buildings and a
 single-aisled church with an older, vaulted tomb below it.

Derocco, Alexsandar. See entry YU 84

1104 Mijović, Pavle. "Kupolna arkada Djurdjevih Stubova [sic.
 Stupova]" (Fr. sum.: "L'arcade de coupole de Djurdjevi
 Stubovi"). Starinar, n.s. 20 (Mélanges Djurdje Bošković)
 (1970):223-32 (Fr. sum.: 232).
 In Serbo-Croatian. A hypothesis which attempts to link the
 interior dome arcade of Djurdjevi Stupovi with the architecture
 of the Holy Land, especially Jerusalem, postulating that this was
 a conscious effort on the part of the patron (Stefan Nemanja).
 The author believes that this "real" arcade was subsequently
 imitated in painted architectural frames elsewhere, ignoring the
 fact that this was an established decorative feature in Comnenian
 painting.

1105 Nešković, Jovan. "Djurdjevi Stupovi u Rasu" (Fr. sum.:
 "Djurdjevi Stupovi [Les tours de Georges] à Ras"). Raška
 baština 1 (1975):149-59 (Fr. sum.: 158-59).
 In Serbo-Croatian. An important study of the monastery and
 the church of St. George at Ras. The article includes the re-
 sults of recent archeological excavations and the restoration of
 the church. The full extent of the monastic complex, with changes
 made during the Middle Ages, has come to light. The excavations
 have also revealed fragments of the dedicatory inscription, with
 a preserved date of 1170-1171.

1106 Okunev, Nik. "'Stolpi Sviatogo Georgiia.' Razvalini khrama
 XII v⌣ka okolo Novago Pazara" (Fr. sum.: "'Piliers de Saint-
 Georges.' Les ruines d'une église du XII s. près de Novy
 Pazar"). Seminarium Kondakovianum 1 (1927):225-45 (Fr. sum.:
 246).
 In Russian. Though outdated in some respects, this is
 still a fundamental study of the church and its fresco decora-
 tion. In addition to providing a documentary record of frescoes
 (many of which have since vanished), the author made many impor-
 tant observations and interpretations.

1107 Tasić, Dušan. "Stari Ras" (Fr. sum.: "L'ancien Ras"). ZLU
 5 (1969):259-69 (Fr. sum.: 268-69).
 In Serbo-Croatian. A brief historical study of medieval
 Ras based on the recent archeological undertakings in the area.

RATAC

1108 Bošković, Dj[urdje], and Korać, V[ojislav]. "Ratac" (Fr.
 sum.: "Ratac"). Starinar, n.s. 7-8 (1958):39-75 (Fr. sum.:
 75).
 In Serbo-Croatian. This major architectural study of the
 Benedictine monastery of Ratac discusses the historical develop-
 ment, the site, the complex as a whole, and the individual build-
 ings and their architectural-sculptural decoration.

RAVANICA

1109 Komnenović, Nada Antić. "Ostaci fresaka u kuli Kneza Lazara"
 (Fr. sum.: "Les restes des fresques de la Tour du Prince
 Lazare"). ZNM 8 (1975):417-28 (Fr. sum.: 428).
 In Serbo-Croatian. An analysis of partially preserved
 frescoes in a niche of the destroyed chapel in the "donjon" of
 the Ravanica monastery fortifications. The frescoes (Virgin
 Platitera and Child in a medallion, flanked by an angel; below,
 Agnus Dei, Angels with St. Stephen the Proto-Martyr). The
 frescoes are dated to the last quarter of the fourteenth century,
 and are thus contemporaneous with the frescoes in the church.

1110 Ljubinković, Mirjana. Ravanica. Medieval Art in Yugoslavia.
 Belgrade: Jugoslavija, 1966. 16 pp., 47 pls.
 A brief account of the church, its history, architecture,
 and frescoes. Frescoes are illustrated in fine black-and-white
 photographs (mostly of details).

1111 Madas, Dimitrije. "Arheološki radovi u manastiru Ravanici
 (1967-1971)" (Fr. sum.: "Fouilles archéologiques dans le
 cadre des fortifications du monastère Ravanica"). Saopštenja
 10 (1974):77-85 (Fr. sum.: 85).
 In Serbo-Croatian. A report on archeological investigation
 of the monastery complex, which has yielded significant informa-
 tion about original architecture and medieval pottery.

1112 Nikolić, Radomir. "Prilog za proučavanje živopisa manastira
 Ravanice" (Fr. sum.: "Un apport à l'étude de la peinture
 murale du monastère Ravanica"). Saopštenja 4 (1961):5-32
 (Fr. sum.: 32).
 In Serbo-Croatian. A contribution to the study of Ravanica
 frescoes produced as a result of their recent cleaning. The
 article considers the arrangement of the fresco program, the
 iconography, the style, the present condition of surviving
 frescoes, and the question of dating the frescoes.

1113 Petković, Vlad[imir] R. Manastir Ravanica. Srpski spomenici,
 1. Belgrade: Narodni muzej u Beogradu, 1922. 77 pp.,
 36 figs.
 In Serbo-Croatian. The first monograph on Ravanica. The
 book is divided in three chapters which discuss the history, the
 architecture, and the frescoes. An appendix includes the full
 text of the monastery charter issued by Prince Lazar. The origi-
 nal of this text is preserved in Vrdnik monastery.

1114 Popović, Pierre. "Le mur occidental de l'église de Ravanica."
 L'art byzantin chez les Slaves: Les Balkans. Vol. 1, pt. 1.
 Paris: P. Geuthner, 1930, pp. 213-16.
 Shows that the exonarthex is a later addition and offers a
 reconstruction of the original church façade.

1115 Vulović, Branislav. "Da li je Vuk bio sahranjen pored oca u
 Ravaničkom mauzoleju?" (Fr. sum.: "Vuk fut-il inhumé à côté
 de son père dans le mausolée de Ravanica?"). Starinar,
 n.s. 20 (Mélanges Djurdje Bošković) (1970):405-13 (Fr. sum.:
 413).
 In Serbo-Croatian. A newly discovered tomb in the north-
 west corner of the church contained the remains of a man believed
 to be Vuk (d. 1410), the youngest son of Prince Lazar--whose tomb
 is adjacent.

1116 _____. Ravanica: Njeno mesto i njena uloga u sakralnoj
 arhitekturi Pomoravlja (Fr. sum.: "Ravanica: Son rôle dans
 l'architecture religieuse de Pomoravlje"). Saopštenja 7
 (1966): 214 pp. (Fr. sum.: 210-14), 46 figs., 68 pls.
 In Serbo-Croatian. The most comprehensive monograph on
 Ravanica to date. The material presented is based on an exhaus-
 tive study of the monument during the archeological excavations
 and conservation of the structure. Detailed drawings, photo-
 graphs, and descriptions are included, as well as a general
 assessment of the monument within the last phase of Serbian and
 Byzantine architecture.

1117 _____. "Sistem i kompozicija ravaničke dekorativne plastike"
(Fr. sum.: "Le système et la composition de la plastique
décorative à Ravanica"). Zbornik arhitektonskog fakulteta
8, no. 4 (1967):51-63 (Fr. sum.: 63).
 In Serbo-Croatian. Analyzes different geometric and floral
patterns used in ornamental work at Ravanica and discusses prin-
ciples of their composition. A pattern incised into a brick
discovered in the west wall of the church shows that a compass
was used, revealing the design method of the medieval craftsman.

1118 Živković, Branislav. "Konzervatorski radovi na živopisu
manastira Ravanice" (Fr. sum.: "Travaux de conservation sur
les peintures murales du monastère de Ravanica"). Saopštenja
8 (1969):137-44 (Fr. sum.: 143).
 In Serbo-Croatian. A report on the cleaning and conserva-
tion of frescoes at Ravanica. Approximately 500 m^2 of the origi-
nal 800 m^2 [?] of frescoes have been preserved in the church.

RAVANJSKA

1119 Petricioli, Ivo. "Crkva Sv. Jurja u Ravanjskoj" (Fr. sum.:
"L'église de Saint George à Ravanjska"). SP, 3d ser. 8-9
(1963):177-80 (Fr. sum.: 180).
 In Serbo-Croatian. A brief description of the unusual
old Croatian church of St. George (Sv. Juraj). The church is
single-aisled, rectangular, and covered by a large oval dome
supported on corner squinches and concealed by a tall drum with
a single small window on its south side. No other church of this
type is known in Dalmatia.

RAZIĆI

1120 Vego, Marko. "Crkva u Razićima kod Konjica" (Ger. sum.:
"Die Kirche in Razići bei Konjic"). GZMS, n.s. 13
(Arheologija) (1958):159-67 (Ger. sum.: 166-67).
 In Serbo-Croatian. Excavation report on a small single-
aisled, "rustic Romanesque" church believed to date from the
second half of the twelfth or the first half of the thirteenth
century. Modest sculptural finds are reported, some of which
appear to date from a fifteenth-century remodeling.

REČANE

1120a Vučenović, Sv. "Arhitektura crkve Sv. Djordja u Rečanu i
konzervatorski radovi na njoj" (Fr. sum.: "L'architecture de
l'église de Saint Georges à Rétschan et les travaux de conser-
vation de cet objet"). Glasnik muzeja Kosova i Metohije 1
(1956):347-55 (Fr. sum.: 354-55).
 In Serbo-Croatian. A discussion of the architecture and
conservation of the church of St. George, an important monument
of aristocratic patronage in Serbia at the beginning of the four-
teenth century.

REČANI [near Ajnovci]

1120b Birtašević, Marija. "Crkva Rečani kod Ajnovaca" (Fr. sum.:
 "L'église de Rečani près d'Ajnovci"). Glasnik muzeja Kosova
 i Metohije 3 (1958):209-20 (Fr. sum.: 219-20.
 In Serbo-Croatian. A study of architecture and frescoes of
 the small ruined church dated by the author to the end of the
 fourteenth or early fifteenth century. The building reveals
 several phases of construction which indicate that it may be
 older.

RESAVA. See MANASIJA

RMANJ

1121 Kajmaković, Zdravko. "Manastir Rmanj i njegove freske" (Fr.
 sum.: "Le monastère Rmanj et ses fresques"). Zbornik
 Svetozara Radojčića. Edited by Vojislav J. Djurić. Belgrade:
 Filozofski fakultet, Odeljenje za istoriju umetnosti, 1969,
 pp. 133-42 (Fr. sum.: 142).
 In Serbo-Croatian. A discussion of the destroyed church at
 Rmanj monastery (Bosnia), dating from the middle of the fifteenth
 century. The church represents the westernmost point at which
 Byzantine frescoes in an Orthodox church on the territory of
 modern Yugoslavia have been found.

ROGAČIČI

1122 Čermošnik, Irma. "Izvještaj o iskopinama u Rogačićima kod
 Blažuja" (Fr. sum.: "Compte rendu sur les fouilles à Rogačići
 près de Blažuj"). GZMS, n.s. 8 (1953):303-15 (Fr. sum.:
 314-15).
 In Serbo-Croatian. An archeological report on the excava-
 tion of a six-lobed centralized church, the first of its kind to
 be discovered in Bosnia. The church is related to a type preva-
 lent in pre-Romanesque Croatia. On the basis of finds in and
 around the church, including the stylistic characteristics of its
 architectural sculpture, the author dates the monument to the
 late twelfth or early thirteenth century, during the period of
 close ties between Bosnia and Dubrovnik.

RUDINE

1123 Horvat, Andjela. "Rudine u požeškoj kotlini-ključni problem
 romanike u Slavoniji" [Rudine: The key problem of Romanesque
 art in Slavonia]. Peristil 5 (1962):11-28 (Ger. sum.:
 27-28).
 In Serbo-Croatian. A detailed analysis of the surviving
 Romanesque sculpture from the destroyed Abbey at Rudine. The
 sculpture is characterized by a high degree of abstraction and by
 crude execution. Some of the early Norman sculpture is cited as
 comparable material.

ŠABAC

1124 Pavlović, Dobroslav St. "Šabačka tvrdjava" (Fr. sum.: "La
 forteresse de Šabac"). Starinar, n.s. 5-6 (1956):305-16 (Fr.
 sum.: 316).
 In Serbo-Croatian. A brief account of the now largely
 destroyed fortress of Šabac. Preserved visual records of this
 fortress indicate that it had several major building phases in-
 cluding major Roman and medieval portions. Emergency excavations
 conducted in 1951 confirm continuous habitation in the area from
 neolithic to modern times.

SALONA (SOLIN)

1125 Petricioli, Ivo. "Reliefs de l'église salonitane de St.
 Pierre." Disputationes Salonitanae 1970. Edited by Željko
 Rapanić. Split: Musée Archéologique, 1975, pp. 111-17.
 A discussion of an important ensemble of old Croatian
 relief sculpture belonging to the altar screen of the one-time
 church of St. Peter (Šuplja crkva) at Solin.

SARAJEVO

1126 Čajkanović, Simeon. "Srpsko-pravoslavna crkva svetih
 arhangela u Sarajevu" [Serbian orthodox church of the Holy
 Archangels in Sarajevo]. GZMS 1, no. 4 (1889):1-11.
 In Serbo-Croatian. A pioneering study of the church, its
 history, and its treasures. The church was built shortly after
 1463, while most of its art treasures are of a later date. The
 author provides transcriptions of the most important inscriptions
 found in the church and on the art objects.

1127 Mazalić, Djoko. "Stara crkva u Sarajevu: Razmatranja o
 njezinoj arhitekturi i prošlosti" [The old church in Sarajevo:
 Considerations of its architecture and history]. GZMS 54
 (1942):221-69.
 In Serbo-Croatian. A thorough study of the architecture of
 the building, its furniture, and its treasures. The study in-
 cludes good architectural drawings of the church. Special atten-
 tion is paid to those aspects which indicate that the original
 church was older than the sixteenth century.

Mirković, Lazar. See entry YU 463

SAVINA

1128 Djurić, Vojislav J. Savina. Umetnički spomenici u
 Jugoslaviji. Belgrade: Jugoslavija, 1977. 26 pp., 48 pls.,
 2 figs. in text.
 In Serbo-Croatian. A brief monographic study of Savina
 monastery, its two churches, and the treasury. Particular

attention is given to the reasonably well preserved frescoes in
the Church of the Dormition, painted in 1565. The book is illus-
trated with a fine selection of black-and-white photographs.

1129 Medaković, Dejan. Manastir Savina: Velika crkva, riznica,
 rukopisi (Ger. sum.: "Kloster Savina: Hauptkirche, Schatz-
 kammer, Handschriftensammlung"). Monografije 6. Belgrade:
 Filozofski fakultet, Institut za istoriju umetnosti, 1978.
 104 pp., 17 figs., 109 pls.
 In Serbo-Croatian. The main monograph of the large church
 of Savina monastery. The church, despite its relatively late
 date (1777), reveals the survival of certain traits from the
 Middle Ages. The monastery itself is a medieval foundation.

1130 Moškov, Dušanka Sijerković. "Manastir Savina: Velika crkva;
 arhitektura i ikonostas" (Fr. sum.: "Le monastère Savina:
 La grande église; architecture et iconostase"). Boka 6-7
 (1975):125-54 (Fr. sum.: 153-54)
 In Serbo-Croatian. Although begun in 1777, the main church
 of Savina monastery adheres to the older medieval architectural
 tradition. The article considers its conservative architecture,
 and also discusses its iconostasis.

1131 Petković, O. Jerotej, ed. Spomenica Manastira Savine prigodom
 proslave devetstogodišnjice male savinske crkve, 1030-1930
 [Commemorative issue on Savina monastery on the occasion of
 the nine hundredth anniversary of the small church, 1030-
 1930]. Kotor: Uprava manastira Savine, 1930. 64 pp.
 In Serbo-Croatian. An important selection of articles dis-
 cussing the history of Savina monastery, its churches, its trea-
 sury, and its library--with a detailed account of the principal
 holdings. The book also includes a survey of the sixty-one
 oldest orthodox churches in the bay of Kotor, and a study of the
 two medieval churches in Bijela.

1132 Ružičić, Episkop Nikanor. "Manastir Presvete Bogorodice na
 Savini" [The monastery of the Most Holy Virgin at Savina].
 Starinar 11, nos. 3-4 (1894):100-28.
 In Serbo-Croatian. An early account of the important
 monastery of Savina and its treasures.

SELCA [on the island of Brač]

1133 Radić, F. "Sredovječne crkvice oko Selaca na otoku Braču"
 [Medieval churches in the vicinty of Selca on the island of
 Brač]. SP 6, nos. 1-2 (1901):34-41.
 In Serbo-Croatian. A brief account of four small medieval
 churches near Selca on Brač. The churches are all single-aisled
 featuring three bays in plan, and are internally articulated by
 three blind arches on both sides of the nave.

SELO

1134 Šumi, Nataša Štupar. "Rekonstrukcija romanske rotunde v Selu"
 (Eng. sum.: "Reconstruction of the Romanesque rotunda at
 Selo"). Varstvo spomenikov 22 (1979):173-77 (Eng. sum.:
 173).
 In Slovenian. A brief account of the reconstruction of the
 rotunda at Selo. Illustrated with several useful drawings.

1135 Zadnikar, Marijan. "Romanska rotunda v Selu in njena
 restavracija" (Eng. sum.: "The Romanesque rotunda at Selo
 in Prekomurje and its reconstruction"). Varstvo spomenikov
 22 (1979):167-72 (Eng. sum.: 167).
 In Slovenian. A brief account of the dilemma concerning
 the conservation of the late Romanesque rotunda at Selo. The
 church--with fourteenth- and fifteenth-century frescoes, and
 fragments going back to the thirteenth century--was crudely re-
 modeled in the nineteenth century. The author presents reasons
 for restoring the building to its original form.

1136 _____. Rotunda v Selu [The rotunda in Selo]. Murska Sobota:
 Pomurska založba, 1967. 42 pp., 20 figs. in text.
 In Slovenian. A monograph on the small early Romanesque
 rotunda at Selo. The author examines its architecture, its
 relationship to similar developments in Central Europe (Hungary,
 Czechoslovakia), and also discusses the two layers of Gothic
 frescoes.

ŠIBENIK

1137 Ivanišević, Milan. "Porušena kula-zvonik šibenske stolne
 crkve" (Fr. sum.: "La tour-clocher détruite de la cathédrale
 de Šibenik"). PPUD 15 (1963):84-110 (Fr. sum.: 109-10).
 In Serbo-Croatian. Considers the written and visual docu-
 mentation of the one-time belfry in front of the cathedral of
 Šibenik, which was destroyed in 1889. The tower antedated the
 cathedral. It was originally a private tower in the vicinity of
 the city fortifications, and was subsequently converted into a
 belfry.

SINJ. See BRNAZI

ŠIPAN [island]

1138 Fisković, Igor. "Bilješke o starokršćanskim i ranosrednjo-
 vjekovnim spomenicima na otoku Šipanu" (Fr. sum.: "Sur les
 monuments paléochrétiens de l' île de Šipan"). PPUD 18
 (1970):5-29 (Fr. sum.: 28-29).
 In Serbo-Croatian. A brief survey of early Christian and
 early medieval monuments on the island of Šipan. The material
 primarily includes small churches and fragments of architectural
 sculpture.

1139 Posedel, Josip. "Predromanički spomenici otoka Šipan" (Fr.
 sum.: "Monuments préromaniques de l'île de Šipan"). SP,
 3d ser. 2 (1952):113-28 (Fr. sum.: 128).
 In Serbo-Croatian. Considers the churches of Sv. Petar
 (St. Peter), Sv. Ivan (St. John), and Sv. Mihajlo (St. Michael).
 All are single-aisled simple structures with pronounced arcading
 on the exterior. The churches are related to pre-Romanesque
 churches in other parts of Dalmatia, particularly to those on
 the nearby island of Lopud.

1140 Puhiera, Samuilo. "Srednjevekovne crkve na ostrvu Šipanu kod
 Dubrovnika" (Fr. sum.: "Les églises médiévales dans l'île de
 Šipan près de Dubrovnik [Raguse]"). Starinar, n.s. 5-6
 (1956):227-46 (Fr. sum.: 246).
 In Serbo-Croatian. A general survey of eighteen medieval
 churches on the island of Šipan. Plans of six churches are given.
 Each building is described briefly with the basic factual informa-
 tion included (e.e., dimensions, historical facts, etc.).

ŠIŠEVO

1141 Tomovski, Krum. "Beitrag zur geschichte der Kirche des Hl.
 Nikolaus Šiševski." Actes du XIIe Congrès international
 d'études byzantines (Belgrade) 3 (1964):392-93.
 A brief account of the structural history of the building:
 the one-aisled sanctuary was the original church; the domed unit
 was added in the second half of the fourteenth century.

SITNO (POLJICA)

1142 Radić, F. "Crkva S. Klimenta u Sitnom u bivšoj poljičkoj
 kneževini" [The church of St. Clement in Sitno in the former
 principate of Poljica]. SP 3, nos. 3-4 (1897):138-40.
 A brief account of a curious (early Croatian?) church con-
 sisting of a two-storied, barrel-vaulted western section and an
 octagonal, cloister-vaulted sanctuary.

ŠKOFJA LOKA. See KRIŽNA GORA

SKOPJE (SKOPWE)

1143 Deroko, Aleksandar. "Srednjovekovni grad Skoplje" (Fr. sum.:
 "Le château fort médiéval de Skoplje"). Spomenik 120.
 Belgrade: Srpska akademija nauka i umetnosti, 1971, pp. 3-16
 (Fr. sum.: 15-16).
 In Serbo-Croatian. A brief account of the history and
 architecture of the medieval fortification of Skopje. The study
 includes the finds laid bare by the earthquake of 1963 and exca-
 vated in its aftermath.

SLANKAMEN

1144 Korać, Vojislav. "Stara crkva u Slankamenu i njeno mesto u
 razvitku srpske arhitekture kasnog srednjeg veka" (Fr. sum.:
 "L'ancienne église de Slankamen et sa place dans le développe-
 ment de l'architecture serbe du moyen âge avancé"). ZLU 6
 (1970):293-312 (Fr. sum.: 311-12).
 In Serbo-Croatian. An examination of the extensively re-
 modeled church of St. Nicholas at Slankamen indicates that it was
 probably built toward the end of the fifteenth century, and that
 it possibly represents the earliest example of the triconch church
 plan of the so-called Morava school to have been built north of
 the Sava-Danube line.

1145 Petković, Sreten. "Freska sa likovima Tri jerarha u crkvi
 sv. Nikole u Starom Slankamenu" (Eng. sum.: "The fresco
 representing the three Fathers of the Church at the church of
 St. Nicholas in Stari Slankamen"). ZLU 6 (1970):315-30 (Eng.
 sum.: 329-30).
 In Serbo-Croatian. The fresco of the Three Hierarchs in
 the church of St. Nicholas is dated to the last decades of the
 fifteenth century and is believed to be the oldest Serbian
 fresco painting in Vojvodina. Displays stylistic and icono-
 graphic links with the so-called Morava school.

SLEPČE (SLEPČA)

1146 Ljubinković, Mirjana Ćorović. "Izveštaji o proučavanju južne
 Srbije na terenu: Manastir Slepča" [A report on field re-
 search in south Serbia: Monastery Slepča]. GSND 19 (1938):
 231-37.
 In Serbo-Croatian. A study of the history and the remains
 of fresco decoration.

1147 Momirović, Petar. "Vrata manastira Slepča kod Bitolja" [Door
 of Slepče monastery, near Bitolj]. GSND 15-16 (1936):327-36.
 In Serbo-Croatian. A discussion of a fine two-leaf door
 and a single-leaf door from the monastery church. Believed to
 date from the sixteenth century, the doors display high-quality
 carving and elaborate interlace patterns characteristic of late
 medieval works.

Vasiliev, Asen. See entry YU 1312

SMEDEREVO

1148 Češljar, Katica. "Problem konzervacije živopisa Stare crkve
 u Smederevu" (Fr. sum.: "Le problème de la conservation de
 la peinture dans la vieille église de Smederevo"). Saopštenja
 9 (1970):173-77 (Fr. sum.: 177).

In Serbo-Croatian. A brief account of problems of conser-
vation of the surviving frescoes. The article includes several
illustrations not found elsewhere, in particular, a drawing of
the rare composition "Praise the Lord."

1149 Deroko, Aleksandar. "Smederevski grad. Stanovanje u jednom
 našem srednjevekovnom gradu i još neki drugi nerešeni pro-
 blemi" (Fr. sum.: "Le château fort de Smederevo"). Starinar,
 n.s. 2 (1951):59-98 (Fr. sum.: 97-98).
 In Serbo-Croatian. A detailed study of the architecture of
 the Smederevo fortress with particular emphasis on the so-called
 Mali Grad, i.e., the palace of Djuradj Branković. Numerous tech-
 nical details are examined and theoretical reconstruction of the
 palace is proposed.

1150 Deroko, Aleksandar, and Nenadović, Slobodan. "Smederevski
 grad: Ispitivanja 1956 godine" (Fr. sum.: "Château fort de
 Smederevo: Fouilles de 1956"). Starinar, n.s. 7-8 (1958):
 181-94 (Fr. sum.: 192-94).
 In Serbo-Croatian. Excavation report which discusses the
 excavations of the inner fort and the conservation proposals for
 its outer wall facing the Danube.

1151 Deroko, A[leksandar], and Zdravković, I. "Zaštita ostataka
 dvorca despota Djurdja u Smederevskom gradu" (Fr. sum.:
 "Protection des vestiges du palais médiéval faisant parti du
 château fort de Smederevo"). ZZSK 9 (1958):49-78 (Fr. sum.:
 77-78).
 In Serbo-Croatian. A study of the ruins of the palace of
 despot Djuradj Branković. General layout, structural concerns,
 forms and details of windows, small finds, and the conservation
 of the monument are discussed.

1152 MANO-ZISI, DJORDJE. "Stara crkva u Smederevu" (Fr. sum.:
 "L'ancienne église à Smederevo"). Starinar, n.s. 2 (1951):
 153-74 (Fr. sum.: 174).
 In Serbo-Croatian. A study of the history, architecture,
 and fresco decoration of the late medieval church, whose date is
 uncertain. A detailed stylistic analysis of the architecture and
 the frescoes pinpoints its construction and initial decoration
 to before 1459, with two subsequent restorations of the paintings
 in the sixteenth and eighteenth centuries.

1153 NENADOVIĆ, SLOBODAN. "Razmišljanja o arhitekturi crkve
 Blagoveštenja Despota Djurdja Brankovića u Smederevu" (Fr.
 sum.: "Réflexions sur l'architecture de l'église de l'Annon-
 ciation elevée par le despote Djurdje Branković à Smederevo").
 ZNM 9-10 (1979):403-18 (Fr. sum.: 417-18).
 In Serbo-Croatian. A detailed discussion of the surviving
 architectural fragments believed to have belonged to the church

of Annunciation. The church was built by Despot Djuradj
Brankovic within his fortress at Smederevo.

1154 _____. "Uredjenje smederevskog grada" (Fr. sum.: "L'amé-
nagement de la forteresse de Smederevo"). Saopštenja 1
(1956):75-84 (Fr. sum.: 84).
In Serbo-Croatian. This account of the conservation of the
fortress of Smederevo includes much valuable visual documentation
(photographs and drawings) of architectural and sculptural frag-
ments from Roman (spoils) and medieval times.

1155 Pavlovic, Leontije. Muzej i spomenici kulture Smedereva [The
museum and cultural monuments of Smederevo]. Posebno izdanje,
12. Smederevo: Muzej u Smederevu, 1972. 285 pp., numerous
illus.
In Serbo-Croatian. A detailed account of the principal
holdings of the Museum of Smederevo, and of the most important
monuments in the town and its vicinity. The largest percentage
of the material discussed is medieval.

1156 Popovic, Marko. "Kapije Smederevskog grada" (Fr. sum.: "Les
portes de la forteresse de Smederevo"). Starinar, n.s. 28-29
(1979):213-32 (Fr. sum.: 230-32).
In Serbo-Croatian. A detailed study of the gates of the
Smederevo fortress. Provides extensive archeological and archi-
tectural information for all of the gates. The study is well
illustrated.

1157 Popovic, Pera J., ed. Spomenica petstogodišnjice smederevskog
grada [Memorial volume commemorating the 500th anniversary of
the Smederevo fortress]. Belgrade: Državna štamparija, 1930.
147 pp., numerous photos, drawings, sketches in text.
In Serbo-Croatian. An important selection of articles re-
garding the history and architecture of the Smederevo fortress.
The chapter on architecture is particularly extensive, discuss-
ing not only individual architectural components of the fortress,
but also the building methods and techniques in great detail. A
fundamental work on the history of medieval fortifications in
Serbia.

1158 Tatic, Žarko. "Stara crkva na smederevskom groblju" [The old
church in the cemetery of Smederevo]. Starinar, 3d ser. 5
(1930):55-62.
In Serbo-Croatian. An article on the small fifteenth-
century church. The church features a characteristic trefoil
plan. The article is illustrated with drawings and photographs
which are poorly reproduced.

1159 Zdravković, Ivan. "Smederevo, najveća srpska srednjovekovna
 tvrdjava" (Fr. sum.: "Smederevo, la plus grande citadelle
 médiévale Serbe"). Starinar, n.s. 20 (Mélanges Djurdje
 Bošković) (1970):423-29 (Fr. sum.: 429).
 In Serbo-Croatian. A brief account of the history and
 architecture of the fortress of Smederevo. Provides a convenient
 outline of historical facts and data pertaining to the physical
 aspects of the fortress itself.

1160 Zdravković, I[van], and Deroko, A. "Konzervatorsko-ispitivački
 radovi u Malome gradu Smederevske tvrdjave 1958 godine" (Fr.
 sum.: "Fouilles et travaux de conservation effectués en 1958
 au château fort de Smederevo"). ZZSK 10 (1959):137-48 (Fr.
 sum.: 147-48).
 In Serbo-Croatian. A report on the archeological investi-
 gation of the so-called small fort, i.e., palace, at Smederevo,
 and its conservation.

SOKO

1161 Kovačević, Mirko. "Crkva pod srednjovekovnim gradom Sokolom"
 (Fr. sum.: "L'église sous la forteresse médiévale de Soko").
 Starinar, n.s. 18 (1968):221-24 (Fr. sum.: 224).
 In Serbo-Croatian. The interesting ruined church near the
 fortress of Soko is believed to be the foundation of Herceg
 Stjepan, and to date from the mid-fifteenth century. The church
 reveals a curious juxtaposition of Byzantine, Romanesque, Gothic,
 and Islamic elements.

SOKOL

1162 Bojanovski, Ivo. "Sokol na Plivi" (Fr. sum.: "Le boury Soko
 sur la Pliva"). NS 13 (1972):41-69 (Fr. sum.: 69).
 In Serbo-Croatian. Examines the history, architecture, and
 archeological data of the fortress, believed to have been founded
 in the second half of the thirteenth century. Finds include
 pottery, weapons, tools, and architectural sculpture.

SOLIN

1163 Bulić, Frane. "Krunidbena bazilika kralja Zvonimira usred
 Gradine u Solinu" [Coronation Basilica of King Zvonimir in the
 Gradina in Solin]. Vjesnik za arheologiju i historiju dal-
 matinsku 52-53 (1924-25):Prilog V.
 In Serbo-Croatian. A brief archeological report on the
 excavations at Gradina in Solin. The excavated church displays
 a curious arrangement of eight free-standing columns within a
 large square, with four more columns occupying the corner posi-
 tions. The architectural solution of the building is unique.

1164 Katić, Lovre. "Solin od VII do XX stoljeća" [Solin from the
 seventh to the twentieth centuries]. PPUD 9 (1955):17-91
 (Latin sum.: 309-11).
 In Serbo-Croatian. A large section of this article is
 devoted to the medieval history and monuments of Solin. His-
 torical background, basic descriptions, and relevant bibliography
 for each of the major monuments are provided.

SOPOĆANI

Derocco, Aleksandar. See entry YU 84

1165 Djurić, Vojislav J. Sopoćani. Umetnički spomenici Jugo-
 slavije. Belgrade: Srpska književna zadruga and Prosveta,
 1963. 120 pp. (Eng. sum.: 111-20), figs. in text, 60 col.
 pls., series of drawings showing decorative program layout.
 In Serbo-Croatian. The most comprehensive monograph on
 Sopoćani. Discusses the history and architecture of the monu-
 ment, and then focuses primarily on the frescoes. The book is
 well illustrated with beautiful color plates, most of which show
 details of frescoes.

1166 _____. Sopoćani. Leipzig: Veb E.A. Seemann Verlag, 1967.
 99 pp., figs. in text, 60 col. pls., series of drawings show-
 ing decorative program layout.
 German edition of entry 1165.

1167 Grabar, André, and Velmans, T. Gli affreschi della chiesa di
 Sopoćani. L'arte racconta, 37. Milan and Geneva: Fratelli
 Fabri and Albert Skira, 1965. 8 pp., 1 plan, 40 col. pls.
 A popular booklet illustrated with forty superb large color
 plates which show many aspects of Sopoćani frescoes seldom found
 elsewhere (e.g., the four Evangelists in the pendentives).

Kandić, Olivera M[arković]. See entry YU 116

1168 Korać, Vojislav. "Oltarska pregrada u Sopoćanima" (Fr. sum.:
 "La clôture du bêma à Sopoćani"). Zograf 5 (1974):23-29 (Fr.
 sum.: 29).
 In Serbo-Croatian. Offers a hypothetical reconstruction of
 the original inconostasis screen based on a number of surviving
 fragments. Also analyzes the remains of stucco frames for a pair
 of fresco icons which originally flanked the iconostasis screen.

Ljubinković, R[adivoje]. See entry YU 532

1169 Mandić, S[vetislav]. "Sopoćani na slici Paje Jovanovića" (Fr.
 sum.: "L'église de Sopoćani sur le tableau de Paja
 Jovanović"). Zograf 1 (1966):38-39 (Fr. sum.: 47).
 In Serbo-Croatian. A discussion of an important painting
 by Paja Jovanović depicting the monastery of Sopoćani around

1885. The painting has great documentary value because it shows
the church before its further deterioration recorded on the old-
est photographs.

1170 Markovic, Olivera. "Prilog proučavanju arhitekture manastira
 Sopočana" (Fr. sum.: "Ā l'occasion des travaux de conserva-
 tion de 1966 ā Sopočani"). Saopštenja 8 (1969):93-99 (Fr.
 sum.: 99).
 In Serbo-Croatian. An archeological and architectural
 study of the main church of Sopočani monastery. It considers the
 exonarthex, the belfry, and the reconstruction of the sarcophagus
 of Archbishop Joanikije. A review of older hypotheses regarding
 the reconstruction of the exonarthex is given.

Mijovic, Pavle. See entry YU 540

1171 Nikolic, Radomir. "Beleške o sopočanskom živopisu" (Fr. sum.:
 "Notes sur les fresques de Sopočani"). Saopštenja 8 (1969):
 101-16 (Fr. sum.: 115-16).
 In Serbo-Croatian. Notes on Sopočani frescoes include ob-
 servations on four Serbian church councils in the narthex, on the
 conceptual unity between naos and narthex frescoes, and on simu-
 lated relief sculpture on frescoes.

1172 _____. "O datovanju živopisa u kapelama sv. Nikole i sv.
 Djordja u Sopočanima" (Fr. sum.: "Sur la fixation de la date
 des peintures dans les chapelles de St. Nicolas et de St.
 Georges ā Sopočani"). Saopštenja 9 (1970):63-72 (Fr. sum.:
 75).
 In Serbo-Croatian. Study of fresco decoration in the lat-
 eral chapels of Sopočani leads the author to date them to ca.
 1280. Though artistically inferior to the frescoes in the main
 part of the church, these frescoes are of considerable interest
 and importance.

1173 _____. "Sopočanski medaljoni" (Fr. sum.: "Les médaillons de
 Sopočani"). Saopštenja 9 (1970):73-75 (Fr. sum.: 75).
 In Serbo-Croatian. A brief note on circular medallions
 with saints' busts which appear on the extrados of the main
 arches under the dome. These medallions are iconographically
 interesting. The author also points out exceptional aesthetic
 qualities of the paintings.

1174 Okunev, N[ikolai] L. "Sostav rospisi khrama v Sopochanakh"
 (Fr. sum.: "Les peintures mur-ales ā l'église de Sopočani").
 Byzantinoslavica 1 (1929):119-50 (Fr. sum.: 145-48).
 In Russian. A systematic detailed description of the
 entire decorative program at Sopočani, which is also important
 because it supplies the texts of all inscriptions.

1175 P[anić]-S[urep], M[ilorad]. "Zaštita Sopoćana" (Fr. sum.:
 "La protection du monastère de Sopoćani"). Saopštenja 1
 (1956):15-27 (Fr. sum.: 27).
 In Serbo-Croatian. This brief account of the history of
 the preservation of Sopoćani monastery begins with eighteenth-
 and nineteenth-century documents describing its decline, and then
 focuses on the twentieth-century restoration undertakings. The
 article also discusses the uncovered inscription in the dome, the
 uncovered tombstones with inscriptions, and the origin of the
 name Sopoćani. It concludes with a table indicating, space by
 space, the original area covered by frescoes (ca. 1703 m^2), and
 the total area of frescoes preserved (ca. 741 m^2).

1176 Panić-Surep, M[ilorad] et al. Sedam stotina godina Sopoćana
 [The 700th anniversary of Sopoćani]. Belgrade: Odbor za
 proslavu, 1965. 26 pp., 16 pls.
 In Serbo-Crotian. The book consists of an introduction and
 three essays: on history (By S. Ćirković), on architecture (by
 A. Deroko), and on frescoes (by S. Radojčić). The volume is
 illustrated with a selection of fine black-and-white plates.

1177 Petković, Vladimir R. "La mort de la reine Anne à Sopoćani."
 L'art byzantin chez les Slaves: Les Balkans 1, pt. 2. Paris:
 P. Geuthner, 1930, pp. 217-21.
 The iconography of the scene showing the death of Queen
 Anna is discussed in relation to the genre of funerary scenes
 and to historical circumstances surrounding the event.

1178 Radojčić, Svetozar. "Psaltir br.46 iz Stavronikite i
 sopoćanske freske" [Psalter no. 46 from Stavronikita and the
 frescoes of Sopoćani]. Glas Srpske akademije nauka 234
 (1959):81-87.
 In Serbo-Croatian. Establishes parallels with the
 Stavronikita Psalter no. 46, from Mt. Athos, in an effort to
 determine the source of Sopoćani frescoes. In his conclusion,
 the author remains undecided between Constantinople, Nicaea, and
 Latin Palestine.

1179 _____. "Sopoćani et l'art européen du XIIIe siècle." In
 L'art byzantin du XIIIe siècle. Edited by V.J. Djurić.
 Belgrade: Faculté de philosophie, Département de l'histoire
 de l'art, 1967, pp. 197-206.
 Examines the place of Sopoćani art between Byzantium and
 the West. Comparisons between Sopoćani and miniatures in the
 Wolfenbüttel Gospels are given especially close scrutiny.

1180 Rajković, Mila. Sopoćani. Medieval Art in Yugoslavia.
 Belgrade: Jugoslavija, 1963. 6 pp., 61 pls.
 A short account of the building's history, architecture,
 and frescoes. The book is illustrated with a fine selection of
 black-and-white photographs, most of which show details of
 frescoes.

SPLIT

1181 Domančić, Davor. "Freske Dujma Vuškovića u Splitu" [Frescoes
 by Dujam Vušković in Split]. PPUD 11 (1959):41-58.
 In Serbo-Croatian. Discusses the frescoes by D. Vušković
 discovered in the chapel of Sv. Duje in the cathedral of Split,
 and painted, according to a dated document, in 1429. The
 frescoes, which represent some of the finest works by Vušković,
 are compared to his other known works.

Fiscović, Cvito. See entry YU 99

1182 KARAMAN, LJUBO. "Basreljef u splitskoj krstionici" [The bas
 relief in the baptistry of Split]. Vjesnik za arhitekturu i
 historiju dalmatinsku 52-53 (1924-25):Prilog I.
 In Serbo-Croatian. Identifies the piece as a fragment of
 church furniture originally belonging to the cathedral of Split.
 The relief is believed to represent a coronation of a Croatian
 king, and to have archeological value in determining the form of
 the Croatian royal crown. See entry YU 1191.

1183 _____. "O zvoniku splitske katedrale" [Regarding the belfry
 of the cathedral of Split]. PPUD 11 (1959):5-11.
 In Serbo-Croatian. A brief discussion of the structural
 history of the belfry of the cathedral of Split.

1184 Kečkemet, Duško. "Dekorativna skulptura zvonika splitske
 katedrale" (Fr. sum.: "La sculpture décorative du clocher de
 la cathédrale de Split"). SP, 3d ser. 8-9 (1963):203-16 (Fr.
 sum.: 216).
 In Serbo-Croatian. A detailed discussion of architectural
 sculpture (string courses, capitals, and brackets) of the
 Romanesque belfry of the cathedral of Split, prior to its com-
 plete reconstruction at the turn of this century.

1185 _____. "Figuralna skulptura romaničkog zvonika splitske
 katedrale" (Fr. sum.: "La sculpture figurale du clocher
 roman de la cathédrale de Split"). PPUD 9 (1955):92-135
 (Fr. sum.: 311-12).
 In Serbo-Croatian. An exhaustive study of the sculpture on
 the belfry of Split cathedral. The author uses stylistic dis-
 tinctions to establish building phases of the belfry.

1186 _____. "Restauracija zvonika splitske katedrale" (Fr. sum.:
 "Restauration du clocher de la cathédrale de Split"). ZZSK
 6-7 (1956):37-78 (Fr. sum.: 77-78).
 In Serbo-Croatian. An exhaustive discussion of the history
 and architecture of the belfry of the cathedral of Split. The
 study is illustrated with a complete set of architectural draw-
 ings of the building.

1187 Maksimović, Jovanka. "Orijentalni elementi i datiranje klupa splitske katedrale" (Fr. sum.: "Éléments orientaux et datation des stalles du choeur de la cathédrale de Split"). PPUD 15 (1963):5-16 (Fr. sum.: 15-16).

In Serbo-Croatian. Points out Islamic aspects of wooden choir stalls of the cathedral of Split. Suggests that the stalls should be dated to the twelfth century, and thus indirectly linked to the Siculo-Norman tradition, in contrast to the standard dating to the second half of the thirteenth century.

1188 Marasović, Jerko, and Marasović, T. "Palača kraj Zlatnih vrata u Splitu: Novootkriveni rad Jurja Dalmatinca ili njegove radionice" [A palace near the Golden Gate in Split: A newly discovered work of Juraj Dalmatinac or his workshop]. Peristil 5 (1962):61-70.

In Serbo-Croatian. A fine late Gothic example of urban palace architecture recently restored and adapted for modern use is shown to be the work of Juraj Dalmatinac or his workshop.

1189 Novak, Grga. "Gradski bedemi, javne zgrade i ulice u srednjevjekovnom Splitu" (Fr. sum.: "Les remparts, les édifices publics et les rues du Split médiéval"). SP, 3d ser. 1 (1949):103-14 (Fr. sum.:, 114).

In Serbo-Croatian. Examines the city walls, the city hall, the public spaces, the loggia, the walls, and the building code of medieval Split.

1190 _____. Povijest Splita [History of Split]. Vol. 1. Split: Matica hrvatska, 1957. 534 pp., 100 figs. in text.

In Serbo-Croatian. A general history of Split. Vol. 1 discusses the material from prehistoric times to 1420. Chapter XII of Part 2 (pp. 485-534) considers the appearance of Split during the Middle Ages. The author discusses fortifications, stores, city quarters and streets, communal buildings, squares, walls, towers, churches, etc.

1191 Radojčić, Svetozar. "Ploča s likom vladara u krstionici splitske katedrale" (Fr. sum.: "La figure d'un souverain sur une plaque de pierre au baptistère de la cathédrale de Split"). ZLU 9 (1973):3-12 (Fr. sum.: 12).

In Serbo-Croatian. The traditional interpretation of the relief as depicting a Croatian king is challenged. The author interprets the scene as a depiction of the enthroned Christ. See entry YU 1182.

SREMSKI KARLOVCI

1192 Matić, Vojislav. "Stara crkva svetog Nikole u Sremskim
 Karlovcima" (Fr. sum.: "La vielle église de St. Nicolas à
 Sremski Karlovci"). ZLU 11 (1975):81-95 (Fr. sum.: 95).
 In Serbo-Croatian. A study of the original form of the
 church of St. Nicholas in Sremski Karlovci, believed to have been
 built toward the end of the fifteenth or in the early part of the
 sixteenth century. The church illustrates the survival of the
 medieval architectural tradition to the north of the Danube after
 the Turkish conquest of Serbia in 1459.

SRIMA

1193 Dujmović, Frano, and Fisković, C. "Romaničke freske u Srimi"
 [Romanesque frescoes in Srima]. PPUD 11 (1959):12-40.
 In Serbo-Croatian. A detailed discussion of a small single-
 aisled church at Srima (near Šibenik) and its Romanesque frescoes.
 The frescoes are dated to the twelfth century and links with
 French (rather than Italian) sources are postulated.

STALAĆ

1194 Minić, Dušica; Vukadin, O.; and Djordjević, S. "Srednjo-
 vekovni grad Stalać" (Fr. sum.: "La cité médiévale de
 Stalać"). Raška baština 1 (1975):185-98 (Fr. sum.: 198).
 In Serbo-Croatian. A report on the archeological investi-
 gations in 1971-74 of the entire fortification, and a detailed
 report of the conservation of the principal tower (donjon).

1195 Stanić, Radomir. "Srednjovekovne crkve u Stalaću i okolini"
 (Fr. sum.: "Les églises médiévales à Stalać et dans ses en-
 virons"). Starinar, n.s. 30 (1980):65-73 (Fr. sum.: 73).
 In Serbo-Croatian. A study of several small single-aisled
 churches in Stalać and its vicinity--at Braljina, Jakovac,
 Stalać, and Stevanac.

STARA PAVLICA

1196 Mano-Zisi, Djordje. "Stara Pavlica." Starinar, 3d ser. 8-9
 (1933-34):206-10 (Fr. sum.: 210).
 In Serbo-Croatian. The remains of a Byzantine church are
 considered. Based on various criteria, including the paintings,
 the church is judged to belong to the thirteenth century.

1197 Vukadin, Obrenija. "Arheološka istraživanja u Staroj
 Pavlici" (Fr. sum.: "Les recherches archéologiques de Stara
 Pavlica"). Raška baština 1 (1975):145-48 (Fr. sum.: 148).
 In Serbo-Croatian. A brief account of the archeological
 investigation of Stara Pavlica which revealed continued funerary

use of the church in the second half of the fourteenth and fif-
teenth centuries.

STARI BAR. See BAR

STARI PUSTENIK

1198 Orlov, Dj. "Ruševine crkve u selu Stari Pustenik" [Church
 ruins in the village of Stari Pustenik]. GSND 15-16 (1936):
 324-26.
 In Serbo-Croatian. The small ruined single-aisled church
is dated as early as the tenth or eleventh century and possibly
[most probably] later. The exterior of the main apse and the
lintel over the door on the west façade reveal interesting
details.

STARI TRG

1199 Šuput, Marica. "Crkva u Starom Trgu" (Fr. sum.: "L'église de
 Stari Trg"). ZFF 12, pt. 1 (1974):321-31 (Fr. sum.: 330-31).
 In Serbo-Croatian. A revised assessment of architecture of
the church following an excavation (in 1967) which revealed all
of the remaining foundations. The church, known to have been
used for the Catholic rite, reveals a basilican plan with three
apses at the eastern end and a square bay in the middle of the
nave (possibly domed?). The church is related to the building
tradition of the Adriatic littoral, and is considered an impor-
tant source of influence for the development of Serbian church
architecture in the thirteenth century.

STARO NAGORIČINO

1200 Bošković, Djurdje. "Problem manastira Sv. Djordja--'Gorga' na
 Seravi" (Fr. sum.: "Le problème du monastère de St. Georges--
 'Gorgos' sur la Serava"). Starinar, n.s. 5-6 (1956):73-82
 (Fr. sum.: 82).
 In Serbo-Croatian. Argues that the church of St. George on
Serava river, mentioned in literary sources, is in fact the
church of St. George at Staro Nagoričino. Topographical, archeo-
logical, and literary material is considered.

Bošković, Georges. See entry YU 79.

1201 Okunjev, N. "Gradja za istoriju srpske umetnosti. 1. Crkva
 Svetog Djordja u Starom Nagoričinu" (Fr. sum.: "Éléments pour
 une histoire de l'art serbe. 1. L'église Saint Georges au
 Staro Nagoričino"). GSND 5 (1929):87-120 (Fr. sum.: 120).
 In Serbo-Croatian. A thorough, descriptive study of the
history, architecture, and frescoes. Fresco decoration is
systematically identified by location and by composition, and
the content is described in detail.

1202 Popović, Pera J., and Petković, Vlad[imir] R. Staro
 Nagoričino, Psača, Kalenić. Stari srpski umetnički spo-
 menici, 1. Belgrade: Srpska kraljevska akademija, 1933.
 87 pp. (Fr. sum.: 25-49, 59-65, 77-87), 24 pls.
 In Serbo-Croatian. The most thorough monographic studies
 on Staro Nagoričino and Psača in existence. In all three cases
 the authors consider the history, the architecture, and the
 frescoes of the respective monuments. The illustrations are of
 good quality.

ŠTAVA

Petković, Sreten. See entry YU 557

STIČNA

1203 Zadnikar, Marijan. Stična in zgodnja arhitektura Cistercijanov
 [Stična and early Cistercian architecture]. Ljubljana:
 Državna založba Slovenije, 1977. 285 pp., 141 illus.
 In Slovenian. A monograph on the most important monument
 of Romanesque architecture in Slovenia. While the building il-
 lustrates the beginnings of Cistercian architecture in the re-
 gion, it also appears to reflect influence of the distant monas-
 tery of Cluny II in Burgundy.

ŠTIP

1204 Petković, Sreten. "Crkva Sveti Spas vo Štip" (Fr. sum.:
 "L'église de St. Spas près de Štip"). Zbornik na Štipskiot
 naroden muzej 2 (1961):81-96 (Fr. sum.: 95-96).
 In Macedonian. An account of the history, architecture,
 and painting of the small, single-aisled church of the Savior.
 The church was built in 1388 according to the charter issued in
 that year by Konstantin Dejanović.

1205 Petrov, Jovan. "Istraživački i konzervatorski raboti vo
 crkvata Voznesenia - Sv. Spas vo Štip" (Fr. sum.: "Des
 travaux de recherches et de conservation de l'église Saint
 Saveur à Chtip" [Štip, sic.]). Zbornik na Štipskiot naroden
 muzej 4-5 (1975):155-67 (Fr. sum.: 167).
 In Macedonian. A report on the frescoes following their
 extensive cleaning. Especially important are the fourteenth-
 century scenes uncovered on the vault of the church which depict
 the Ascension, Trinity, Holy Ghost, Christ Emmanuel, and the
 Virgin Orans. This group of frescoes is of considerable icono-
 graphic interest.

STJENIK (JEŽEVICA)

1206 Milovanović, Zora Simić. "Tragovi manastira Stjenika u
 planini Jelici" (Fr. sum.: "Les vestiges du monastère de
 Stjenik dans la montagne Jelica"). Starinar, n.s. 1 (1950):
 237-42 (Fr. sum.: 242).
 In Serbo-Croatian. Fragments of stone church furniture in
 the church of Ježevica are seen as belonging to the medieval
 church of Stjenik monastery, now replaced by a modern church.

STON

1207 Dračevac, Ante. "Da li je već u IX stoljeću postojala crkva
 Bogorodice u Lužinama kod Stona?" (Fr. sum.: "L'église de la
 Vierge à Lužina, près de Ston, existait-elle déjà au IXe s.?").
 PPUD 16 (1966):165-92 (Fr. sum.: 191-92).
 In Serbo-Croatian. A report of the results of an archeo-
 logical investigation of the church of the Virgin at Lužine
 (Ston). The author favors an early date and attempts to show
 that the original building on the site should be dated to the
 ninth century.

1208 _____. "Novi arheološki nalazi kod crkve Gospe Lužina u
 Stonu" (Fr. sum.: "Nouvelles trouvailles archéologiques près
 de l'église de la Vierge a Lužina - Ston"). PPUD 18 (1970):
 31-38 (Fr. sum.: 38).
 In Serbo-Croatian. A number of architectural fragments
 featuring the characteristic braided interlace work were dis-
 covered during the archeological work on the church. These are
 believed to have belonged to the sanctuary closure of the origi-
 nal building, dating, according to the author, to the ninth
 century.

1209 Fisković, Cvito. "Ranoromaničke freske u Stonu" (Fr. sum.:
 "Fresques du début de l'art roman à Ston"). PPUD 12 (1960):
 33-49 (Fr. sum.: 49).
 In Serbo-Croatian. A detailed discussion of the frescoes
 discovered in the church of St. Michael. The frescoes are dated
 to the eleventh century (probably between 1077 and 1081, during
 the reign of King Mihajlo, responsible for the construction of
 the church). Considers the style and the iconography of the
 frescoes as well as the implications of the royal portrait, one
 of the oldest painted royal portraits among the South Slavs.

1210 Karaman, Ljubo. "Crkvica sv. Mihaila kod Stona" [The small
 church of St. Michael near Ston]. Vjesnik Hrvatskog arheo-
 loškog društva 15 (1928):81-116.
 In Serbo-Croatian. A major study of this important pre-
 Romanesque monument of architecture and painting.

1211 Zdravković, Ivan. "Nacrti predromaničke crkvice Sv. Mihajla
 u Stonu" (Fr. sum.: "Petite église St. Michel à Ston").
 PPUD 12 (1960):25-32 (Fr. sum.: 32).
 In Serbo-Croatian. A brief account accompanying the publi-
 cation of several architectural drawings (site, plan, longitudi-
 nal section, and cross-section) of the church of St. Michael at
 Ston.

STRUGA

1212 Subotić, Gojko. "Pećinska crkva Arhandjela Mihaila kod
 Struge" (Fr. sum.: "L'église rupestre de l'Archange Michel
 près de Struga"). ZFF 8, pt. 1 (1964):299-331 (Fr. sum.:
 329-31).
 In Serbo-Croatian. A detailed analysis of the late
 fourteenth-century fresco cycle in a cave church near Struga.
 Discusses various aspects of iconography and style which reveal
 that this small monument belongs to the mainstream of fourteenth-
 century painting. The article is illustrated with drawings show-
 ing the disposition of the fresco cycle, and with good photo-
 graphs.

STRUMICA

1213 Koco, Dimče, and Miljković-Pepek, Petar. "Rezultatite od
 arheološkite iskopuvanja vo 1973 g. vo crkvata 'Sv 15
 Tiveriopolski mačenici' - Strumica" (Fr. sum.: "Résultats
 des fouilles archéologiques effectuées en 1973 à l'endroit de
 l'église 'les 15 Saints Martyres de Tiveriopole' à Strumica").
 Zbornik. Arheološki muzej na Makedonija (Skopje) 8-9 (1978):
 93-97 (Fr. sum.: 96-97).
 In Macedonian. A report on the archeological excavations
 of an important middle Byzantine church probably dating from the
 eleventh century (to be linked with the activities of the
 Archbishop of Ohrid, Theophilact?). The church is of a cross-
 in-square type with four piers instead of columns, a tripartite
 sanctuary, and a narthex. An interesting tomb with a fresco
 depicting the Fifteen Martyrs of Tiveriopolis (whose relics were
 transferred here from Asia Minor) was discovered in the western-
 most bay of the naos.

STUDENICA

1214 Babić, Gordana. "O kompoziciji Uspenja Bogorodice u
 Bogorodičinoj crkvi u Studenici" (Fr. sum.: "Sur la composi-
 tion représentant la Dormition de la Vierge dans l'église de
 la Mère-de-Dieu au monastère de Studenica"). Starinar,
 n.s. 13-14 (1965):261-65 (Fr. sum.: 265).
 In Serbo-Croatian. An examination of the badly damaged
 early thirteenth-century fresco of the Dormition of the Virgin
 in her church at Studenica. The compositional characteristics

and style are found to be consistent with developments in Serbian art of the early thirteenth century.

Bošković, Djurdje, and Vulović, Branislav. See entry YU 869

1215 Burian, Maria Luise. Die Klosterkirche von Studenica. Ein Beispiel für die Begegnung armenischer, byzantinischer und italienischer Formen in der Architektur und Plastik des mittelalterlichen Serbiens. Zeulenroda: Bernhard Sporn, 1934. 61 pp., 16 pls.
 An outdated work noted for its sweeping attempts at establishing Armenian, Byzantine, and Italian sources of Serbian architecture and sculpture during the Middle Ages.

1216 Ćurčić, Slobodan. "The Nemanjić Family Tree in the Light of the Ancestral Cult in the Church of Joachim and Anna at Studenica." ZRVI 14-15 (1973):191-95.
 The juxtaposition of SS. Joachim and Anna with Serbian Saints Simeon and Sava is seen as the iconographic forerunner of the Nemanjić family tree. This family tree is one of the most explicit politico-ideological statements of the reign of Serbian King Milutin, in which his imperial ambitions are revealed.

1217 Djurić, Vojislav J. "Portreti na kapiji Studenice" (Fr. sum.: "Les portraits sur la porte de Studenica"). Zbornik Svetozara Radojčića. Edited by Vojislav J. Djurić. Belgrade: Filozofski fakultet, Odeljenje za istoriju umetnosti, 1969, pp. 105-12 (Fr. sum.: 112).
 In Serbo-Croatian. Discusses the newly uncovered thirteenth-century frescoes on the towers flanking the entrance gate to the Studenica monastery. The frescoes include portraits of the members of the Nemanjić family (Vukan i Stevan), as well as images of the Archangels. The author links the idea of placing ruler portraits at the main gate to Roman triumphal arches.

1218 Jovanović, Ružica. "Likovne predstave kule u Studenici i njeno datovanje" (Fr. sum.: "La tour de Studenica représentée dans la peinture Serbe--date de sa construction"). Saopštenja 8 (1969):81-85 (Fr. sum.: 85).
 In Serbo-Croatian. A study of the visual representations of the main tower of the monastery (a thirteenth-century fresco, and seventeenth- to nineteenth-century engravings and drawings), and of the frescoes in the second-story chapel. On the basis of comparison of the latter with similar frescoes in the tower of Žiča, the thirteenth-century date of the Studenica tower is confirmed.

1219 Jovin, Marija Radan. "Crkva Sv. Nikole i stari konak u Studenici" (Fr. sum.: "L'église St. Nicolas et l'ancien 'Konak' de Studenica"). Saopštenja 8 (1969):75-80 (Fr. sum.: 80).
 In Serbo-Croatian. A brief report on the archeological

investigation of the church of St. Nicholas and the nearby monastic buildings. Fragments of architectural sculpture and lower tiers (dado zone) of frescoes in the church have been uncovered.

1220 _____. "Odnos utvrdjenja i objekata u kompleksu manastira Studenice" (Fr. sum.: "Correlation entre la fortification et les constructions formant le complexe du monastère [de Studenica]"). Saopštenja 8 (1969):63-74 (Fr. sum.: 74).
 In Serbo-Croatian. A study of fortifications of Studenica. Particular attention is given the main western gate originally flanked by two semi-cylindrical towers, but in the thirteenth century superseded by a single axial tower erected directly above the gate. The oldest phase of fortifications is found to antedate Nemanja's construction of the monastery and its church. See entry YU 1223.

1221 _____. Studenica. Saopštenja 12 (1979), 180 pp., 117 figs. in text.
 In Serbo-Croatian (French summaries after each chapter). An extensive report of archeological work conducted in the monastery complex in the late 1960s and 1970s. The book is organized in seven chapters, as follows: the fortification walls and gates, the church of St. Nicholas, the King's church, the refectory, the church of the Virgin, the dormitory buildings from 1912 and 1927, and the so-called Milošev Konak (the dormitory of Prince Miloš).

1222 Kašanin, Milan; Korać, V.; Tasić, D.; and Šakota, M. Studenica. Belgrade: Književne novine, 1968. 153 pp., numerous illus. in text.
 A comprehensive monograph on the monastery of Studenica including all of its churches: the church of the Virgin, the King's church, and the church of St. Nicholas. History, architecture, sculpture, and frescoes are all considered extensively. Other aspects of the monastery complex are also discussed, as is the monastic treasury.

1223 Korać, Vojislav. "Poreklo utvrdjenja manastira Studenice" (Fr. sum.: "Origine des fortifications du monastère de Studenica"). ZLU 12 (1976):25-39 (Fr. sum.: 38-39).
 In Serbo-Croatian. Challenges an earlier viewpoint that the original fortifications of Studenica monastery date from the early Byzantine period. All of the fortifications are believed to be medieval, but Byzantine influence is believed to have reached Serbia on the conceptual level via Thessalonica. See entry YU 1220.

Ljubinković, Mirjana Ćorović. See entry YU 383

1224 Ljubinković, Radivoje. "Sur un exemplaire de vitraux du monastère de Studenica". AI 3 (1959):137-41.
 A discussion of a rare example of stained glass in a

medieval Serbian church. The unusual window, preserved in the
dome of the church of the Virgin, is believed to be of the same
date as the church itself (ca. 1190). The phenomenon is also
known in the Byzantine sphere. The fourteenth-century church of
Archangel Gabriel at Lesnovo monastery is the only comparable
example from medieval Serbia.

1225 Maksimović, Jovanka. "Studije o studeničkoj plastici" (Fr.
 sum.: "Sculptures de Studenica. 1. Iconographie"). ZRVI 5
 (1958):137-48 (Fr. sum.: 148).
 In Serbo-Croatian. A study of iconography of Studenica
 sculpture, which is seen as linked with the Byzantine tradition
 despite its apparent stylistic links with Romanesque sculpture
 of the West.

1226 _____. "Studije o studeničkoj plastici. 2. Stil" (Fr. sum.:
 "Sculptures de Studenica. 2. Le style"). ZRVI 6 (1960):
 95-109 (Fr. sum.: 108-9).
 In Serbo-Croatian. The sculpture of Studenica is seen
 within the framework of twelfth-century Byzantine sculpture, with
 strong Romanesque influence. This peripheral cultural phenomenon
 is compared to southern Italy. Connections between southern
 Italy and Serbia are rejected, and the similarity between the two
 developments is seen as a result of similar cultural developments.

1227 Mandić, Svetislav. "Dva priloga o freskama studeničke spoljne
 priprate. 1. Ana i Radoslav. 2. Slika smrti jednog monaha"
 (Fr. sum.: "Deux contributions à l'étude des fresques de
 l'exonarthex de l'église de la Vierge à Studenica"). ZLU 2
 (1966):89-103 (Fr. sum.: 102-3).
 In Serbo-Croatian. Examines certain remaining frescoes in
 the exonarthex of Studenica and attempts to link them to the spe-
 cific circumstances during the turbulent reign of King Radoslav,
 who is generally considered to have been the builder of the
 exonarthex.

1228 _____. The Virgin's Church at Studenica. Medieval Art in
 Yugoslavia. Belgrade: Jugoslavija, 1966. 13 pp., 48 pls.
 A short account of the monument, its history, architecture
 and frescoes. The book is illustrated with excellent black-and-
 white photographs, most of which show details of frescoes.

1229 M[andić], S[vetislav], and L[adjević], M.L. "Otkrivanje i
 konzervacija fresaka u Studenici" (Fr. sum.: "Studenica").
 Saopštenja 1 (1956):38-41 (Fr. sum.: 41).
 In Serbo-Croatian. A brief account of important discoveries
 made during the cleaning of frescoes in the naos of the church.
 These include an inscription at the base of the dome drum from
 1209, and an inscription mentioning the reconstruction of the
 church in 1569.

1230 De Muro, Vukosava Tomić. "Srednjovekovno shvatanje slike i
 kompozicija Raspeća u Bogorodičinoj crkvi u Studenici" (Fr.
 sum.: "La conception médiévale du tableau et la composition
 de la Crucifixion dans l'église de Notre Dame à Studenica").
 ZZSK 19 (1968):15-32 (Fr. sum.: 30-32).
 In Serbo-Croatian. A study of the Crucifixion fresco in
 the light of medieval pictorial conceptions. Considers the
 composition, iconography, and paleography of the fresco.

1231 Nenadović, S[lobodan] M. "Konzervatorski problemi u
 Studenici" (Fr. sum.: "Travaux de conservation au monastère
 de Studenica"). ZZSK 4-5 (1955):271-86 (Fr. sum.: 286).
 In Serbo-Croatian. A conservation report which discusses
 the church of the Virgin at Studenica. The main aspects of the
 undertaking were the dome, the main portal of the church, and
 the exonarthex.

1232 _____. Studenički problemi (Fr. sum.: "Les problèmes de
 Studenica"). Saopštenja 3 (1957), 100 pp. (Fr. sum.:
 99-100), 120 figs. in text.
 In Serbo-Croatian. An extensive report of archeological
 work conducted in the monastery complex between 1952 and 1956.
 The main topics considered are: the foundations, construction,
 and completion of the church of the Virgin; the refectory and its
 original appearance; the baptismal font in the exonarthex and the
 question of its original position; the question of the original
 appearance of the exonarthex and its frescoes; the chapels of St.
 John the Baptist, St. Demetrius, St. George and the Virgin
 Hodegitria; and the location of the original entrance to the
 monastic complex.

1233 Petković, Vlad[imir] R. Manastir Studenica [Studenica monas-
 tery]. Srpski spomenici, 2. Belgrade: Narodni muzej, 1924.
 81 pp., 114 figs. in text.
 In Serbo-Croatian. An early monograph on the subject, this
 book considers Studenica in a very detailed manner, discussing
 its history and the three main churches, their architecture, and
 their frescoes.

1234 Rajković, Mila. The King's Church in Studenica. Medieval Art
 in Yugoslavia. Belgrade: Jugoslavija, 1964. 7 pp., 61 pls.,
 map.
 A brief account of the small fourteenth-century church of
 SS. Joachim and Anna (King's Church), including its history,
 architecture, and frescoes. The book is illustrated with excel-
 lent black-and-white photographs, most of which show details of
 frescoes.

1235 Stanić, Radomir. "Freske u Donjoj isposnici sv. Save kod
 Studenice" (Fr. sum.: "Les fresques de l'ermitage inférieur
 de St. Sava près de Studenica"). ZLU 9 (1973):113-36 (Fr.
 sum.: 135-36).
 In Serbo-Croatian. Frescoes from the "Lower Hermitage"
 near Studenica are seen as important for the study of sixteenth-
 century painting in Serbia. The painter, whose identity remains
 unknown, is believed to have come from Peć.

1236 Tasić, Dušan. "Freske iz XIII veka u kapeli studeničke
 zvonare" (Fr. sum.: "Fresques du XIIIe siècle dans la
 chapelle du clocher de Studenica"). Zograf 2 (1967):8-10
 (Fr. sum.: 59).
 In Serbo-Croatian. The poorly preserved frescoes in the
 chapel of the entrance tower-belfry of Studenica monastery are
 dated to the fourth decade of the thirteenth century and are
 linked to the patronage of King Radoslav. Frescoes in the
 exonarthex of Studenica and the belfry of Žiča are seen as the
 work of the same workshop, which is believed to have been trained
 by Byzantine painters active in Serbia around 1210.

1237 Vasilić, Angelina. Riznica manastira Studenice (Fr. sum.:
 "Le trésor du monastère de Studenica"). Saopštenja 2 (1957),
 68 pp. (Fr. sum.: 31-32), 5 figs. in text, 43 pls.
 In Serbo-Croatian. A study of the history and the holdings
 of the monastery's treasury. The text is accompanied by a cata-
 log with 78 entries (pp. 41-68). The works of art include
 jewelry, metal book covers, liturgical vessels, reliquaries,
 liturgical vestments, crosses, icons, and manuscripts.

1238 Vojnović, Gorica. "Fotogrametrijsko snimanje Bogorodičine
 crkve u Studenici" (Fr. sum.: "Relevé photogrammétrique de
 l'église de Notre Dame à Studenica"). ZRVI 10 (1967):149-61
 (Fr. sum.: 160-61).
 In Serbo-Croatian. A technical account of the photogram-
 metric survey of the church of the Virgin. Illustrations include
 the north and the west church elevations, the main portal, the
 main apse windows, and several details.

ŠUMNIK

1239 Stanić, Radomir. "Crkva sv. Nikole u Šumniku kod Raške" (Fr.
 sum.: "L'église de St. Nicolas à Šumnik"). Saopštenja 9
 (1970):101-9 (Fr. sum.: 109).
 In Serbo-Croatian. The small single-aisled church consti-
 tutes a characteristic monument of thirteenth-century architec-
 ture in Serbia. It was built of rough stone, was presumably
 plastered externally, and had well-carved window and door frames.

SUŠICA

1240 Babić, Gordana. "Les fresques de Sušica en Madédoine et
 l'iconographie originale de leurs images de la vie de la
 Vierge." Cahiers archéologiques 12 (1962):303-39.
 Describes the fresco program of this small church, its
 date, and the choice of subjects. Also considers the iconography
 of certain subjects, and the questions of style.

SVEČANI

1241 Miljković-Pepek, Petar. "Crkvata Sv. Konstantin od selo
 Svečani" (Eng. sum.: "The church of St. Constantine in the
 village of Svečani"). Simpozium 1100-godišnina od smrtta na
 Kiril Solunski. Edited by H. Polenaković. Vol. 1. Skopje:
 Makedonska akademija na naukite i umetnostite, 1970,
 pp. 149-62 (Eng. sum.: 162).
 In Macedonian. The small church is shown to have had
 three building phases. The first (tenth century?) saw a tri-
 conch church. Partially demolished, the church was restored and
 enlarged during the second (thirteenth century) phase. The final
 phase (fourteenth century?) saw the addition of a lateral chapel.
 Fresco fragments from the first two phases have been preserved.
 The thirteenth-century frescoes are especially important and are
 linked with those from Manastir (dated 1271).

SVETI NAUM [on Lake Ohrid]. See OHRID

TEMSKA

1242 Pavlović, Leontije. Manastir Temska [Monastery Temska].
 Posebno izdanje, 3. Smederevo: Narodni muzej Smederevo,
 1966. 82 pp. (Fr. sum.: 81-82), 96 figs., several drawings
 in text.
 In Serbo-Croatian. A monographic study of the sixteenth-
 century monastery of Temska. The history, architecture, and
 fresco decoration are scrutinized in detail. The frescoes be-
 long to two phases--the first dated 1576 and the second dated
 1654. Because of its well-preserved condition, with numerous
 well-documented details, Temska monastery represents an impor-
 tant monument of Serbian art during the Turkish occupation.

1243 Radović, Aleksandar. "Manastir Temska: Istraživački i
 konservatorsko-restauratorski radovi 1970. godine" (Fr. sum.:
 "Monastère Temska"). Saopštenja 10 (1974):125-39 (Fr. sum.:
 139).
 In Serbo-Croatian. A study of the architecture of the
 monastery of Temska and its main church. Also included is a
 brief report on the conservation of the complex.

TEŠANJ

1244 Mazalić, Dj[oko]. "Tešanj" (Fr. sum.: "Tešanj"). GZMS,
 n.s. 8 (1953):289-302 (Fr. sum.: 302).
 In Serbo-Croatian. A study of a major medieval fortress
 first mentioned in the sources in 1520, but probably older.
 Examines the structural history of the building, which represents
 an important contribution to the general history of medieval
 fortifications in the region.

TIKVEŠ

1245 Babić, Boško. "Pećinska crkva svetog Lazara u Tikvešu" (Fr.
 sum.: "La petite église troglodytique de Saint Lazare à
 Tikveš"). ZLU 3 (1967):161-70 (Fr. sum.: 168-70).
 In Serbo-Croatian. A detailed examination of the remaining
 fragments of the small "cave church" (built within a cave). On
 the basis of their iconographic and stylistic elements, the
 frescoes are dated to the third quarter of the fourteenth
 century.

TITOV VELES (VELES)

1246 Miljković-Pepek, Petar. "Prilog proučavanju crkve sv. Nikole
 u Titovom Velesu" (Fr. sum.: "Contribution à l'étude de
 l'église de St. Nicolas à Titov Veles"). ZLU 15 (1979):
 265-75 (Fr. sum.: 274-75).
 In Serbo-Croatian. A study of the small single-aisled
 church of St. Nicholas at Titov Veles and its partially preserved
 frescoes reveals that it probably dates from 1308-20.

TOPLICA. See KURŠUMLIJA

TOPUSKO

1247 Horvat, Zorislav. "Topusko: Pokušaj rekonstrukcije tlocrta"
 [Topusko: An attempt at the reconstruction of the plan].
 Peristil 10-11 (1967-68):5-16.
 In Serbo-Croatian. The Cistercian abbey church of Topusko,
 founded in 1205, has long been seen as one of the oldest examples
 of Gothic architecture outside France. The church is shown to
 have been built on the remains of an older (Romanesque) church.
 The reconstructed plan reveals a massive sanctuary enclosure with
 a semicircular apse, and a high Gothic system of piers separating
 the nave from two side aisles. Neither feature is characteristic
 of Cistercian architecture. The abbey also included a cloister
 and a number of other buildings normally encountered in a
 Cistercian monastery.

TREBINJE

1248 Ćorović, Vladimir. "Hercegovački manastiri" [Monasteries of
 Hercegovina]. GZMS 23 (1911):505-33.
 In Serbo-Croatian. A detailed study of Tvrdoš monastery in
 Trebinje, including its history, architecture, and treasures.
 Examines thoroughly earlier studies and conclusions and presents
 new interpretations of numerous documents.

1249 Delić, Stevan. "Petrov manastir kod Trebinja" [Peter's
 monastery near Trebinje]. GZMS 24 (1912):275-82.
 In Serbo-Croatian. An account of the architectural remains
 of a medieval monastery with churches of St. Peter and St. Paul.
 Examines historical sources and references as well as archeologi-
 cal information (tombs uncovered in the churches by amateur
 archeologists).

TRESKA

1250 Ljubinković, Mirjana Ćorović. "Crkva Svete Nedelje nad
 klisurom Treske i problem njenog datovanja" (Fr. sum.:
 "L'église de Sainte Nédélia au-dessus des gorges de la Treska
 et le problème de sa date"). ZZSK 2, no. 1 (1952):95-106 (Fr.
 sum.: 105-6).
 In Serbo-Croatian. An account of the small ruined single-
 aisled church of Sv. Nedelja above the entrance to the Treska
 river gorge. Various aspects of the church (many now lost) are
 taken into account to help establish the date in the third quar-
 ter of the fourteenth century.

1251 Ljubinković, Rad[ivoje]. Srpski crkveni spomenici u klisuri
 reke Treske [Serbian church monuments in the gorge of Treska
 river]. Biblioteka "Hrišćanskog dela" 24. Skopje: Hrišćansko
 delo, 1940. 36 pp., 27 figs. in text.
 In Serbo-Croatian. A brief account of several small
 churches in the gorge of the Treska river in the vicinity of
 Skopje. Most of the churches date from around the middle of the
 fourteenth century. The main monuments are Sv. Andreja, Matka,
 and Sv. Nikola Šiševski.

TRESKAVAC (TRESKAVEC)

1252 Babić, Boško. "Na marginama istorije manastira Treskavca"
 (Fr. sum.: "Notes marginales sur l'histoire du monastère
 Treskavac"). ZLU 1 (1965):23-31 (Fr. sum.: 30-31).
 In Serbo-Croatian. A brief but important contribution to
 the study of the main church of Treskavac monastery and its fresco
 decoration. The church was built in stages between 1334-43 and
 1570.

1253 Gligorijević, Mirjana. "Slikarstvo tepčije Gradislava u
 manastiru Treskavcu" (Fr. sum.: "La peinture du tepčija
 Gradislav dans le monastère Treskavac"). <u>Zograf</u> 5 (1974):
 48-51 (Fr. sum.: 51).
 In Serbo-Croatian. Considers the activities of a patron,
one Gradislav--particularly his addition of a lateral chapel
(after 1350) to the church of the Treskavac monastery. The
chapel has since disappeared, but its original form is recorded
on the surviving donor portrait. Gradislav's name also appears
in a number of documents.

1254 Maksimović, Mirjana Gligorijević. "Slikani kalendar u
 Treskavcu i stihovi Hristofora Mitilenskog" (Fr. sum.: "Le
 calendrier peint sur les murs de monastère de Treskavac et les
 vers de Christophore de Mytilène"). <u>Zograf</u> 8 (1977):48-54
 (Fr. sum.: 54).
 In Serbo-Croatian. An analysis of the iconography of the
Calendar frescoes in the narthex of the church at Treskavac
monastery in the light of the poetry of Christophoros
Mitylenaios.

1255 Nikolovska, Zagorka Rasolkoska. "Freski od kalendarot vo
 manastirot Treskavec - Prilep" (Fr. sum.: "Fresques du
 calendrier se trouvant dans le monastère de Treskavac près de
 Prilep"). <u>KN</u> 2 (1961):45-60 (Fr. sum.: 57).
 In Macedonian. A discussion of calendar scenes in the
frescoes of Treskavac monastery, dated to the second decade of
the fourteenth century.

TROGIR

Fisković, Cvito. See entry YU 99

1256 Karaman, Ljubo. "Zapis o Radovanovom portalu u Trogiru" (Fr.
 sum.: "À propos du portail de Radovan à Trogir"). <u>PPUD</u> 8
 (1954):5-9 (Fr. sum.: 116).
 In Serbo-Croatian. Comments on various iconographic
aspects of the main portal of Trogir cathedral, particularly in
reference to an article by Cvito Fisković. See entry YU 515.

1257 Marasović, Tomislav. "Iskapanje ranosrednjovjekovne crkve
 Sv. Marije u Trogiru" (Fr. sum.: "Fouilles à l'église de
 Sainte Marie du haut moyen âge à Trogir"). <u>SP</u>, 3d ser. 8-9
 (1963):83-100 (Fr. sum.: 98-100).
 In Serbo-Croatian. A detailed report of the archeological
excavation and a study of the architectural remains of the
centralized six-lobed church of St. Mary at Trogir. The church
belongs to a type well known in pre-Romanesque architecture of
Dalmatia.

TVRDOŠ. See TREBINJE

UŠČE

1258 Nešković, Jovan. "Obnova crkve sv. Nikole kod Ušča" (Fr.
 sum.: "La restauration de l'église Saint Nicolas près
 d'Ušče"). ZZSK 19 (1968):95-104 (Fr. sum.: 104).
 In Serbo-Croatian. A report on the reconstruction of the
 church of St. Nicholas near Ušče. The small, single-aisled
 church is characterized by its thick stone walls and Romanesque-
 Gothic sculptural decoration (capitals, window archivolts).

VAGANEŠ

1259 Jovanović, Vojislav. "Crkva u Vaganešu" (Fr. sum.: "L'église
 de Vaganeš"). Starinar, n.s. 9-10 (1959):333-43 (Fr. sum.:
 343).
 In Serbo-Croatian. A discussion of the architecture,
 painting, and inscriptions in the ruined church of the Virgin at
 Vaganeš. The church, believed to have been decorated around
 1355, is a small single-aisled structure preceded by a massive
 bell tower--the ground floor of which serves as the narthex. The
 author attempts to determine the identity of the donor of the
 church.

VAROŠ. See PRILEP

VELIKA HOČA

1260 Pajkić, Predrag S. "Crkve u Velikoj Hoči" (Fr. sum.: "Les
 églises à Velika Hoča"). SKM 2-3 (1963):157-96 (Fr. sum.:
 196).
 In Serbo-Croatian. A detailed study of the history of one
 of the oldest villages in Serbia and its medieval churches--St.
 Nicholas, St. John, and a number of other churches of which only
 ruins remain.

VELJUSA

1261 Djurić, V[ojislav] J. "Fresques du monastère de Veljusa."
 Akten des XI. Internationalen Byzantinistenkongresses, 1958
 (Munich) (1960):113-21.
 A comprehensive analysis of the frescoes in the church of
 the Virgin Eleousa in the monastery of Veljusa, and their place
 in Byzantine art of the eleventh century.

Jovanović, Miodrag. See entry YU 1271
Miletich, L. See entry YU 1274

1262 Miljković-Pepek, Petar. "Novi podaci o oltarskoj pregradi
 Veljuse i neke pretpostavke o njenim prvobitnim ikonama" (Fr.
 sum.: "Nouvelles données sur la cloison de l'autel de mona-
 stère de Veljusa et suppositions plausibles sur ses icônes
 primitives"). ZLU 11 (1975):219-31 (Fr. sum.: 230-31).
 In Serbo-Croatian. A hypothetical reconstruction of the
 original altar screen based on the surviving fragments of sculp-
 tural elements. See entry YU 1263.

_____. See entry YU 139

1263 _____. "Oltarna pregrada manastira Bogorodice Milostive u
 selu Veljusi" [The iconostasis of the monastery of the Virgin
 Eleousa in the village of Veljusa]. ZRVI 6 (1960):137-44
 (Eng. sum.: 144).
 In Serbo-Croatian. Fragments of an altar screen are iden-
 tified as belonging to the original, eleventh-century altar
 screen of the church. A drawing of the reconstruction of the
 original screen is provided. See entry YU 1262.

1264 _____. "Za nekoi novo podatoci od proučvanjata na crkvata Sv.
 Bogorodica vo s. Veljusa" (Fr. sum.: "Quelques données nou-
 velles des recherches sur l'église de la Vierge de Veljusa").
 KN 3 (1971):147-60 (Fr. sum.: 159-60).
 In Macedonian. Presents the following important new dis-
 coveries: brick pattern of south façade of the narthex; remains
 of elaborate "cosmatesque" floor in the naos; and fresco remains
 from the eleventh and twelfth centuries. The author dates the
 south ambulatory wing to the second half of the twelfth century.
 The frescoes are compared with Nerezi (1146).

Tatić, Žarko. See entry YU 1277

VELMEJ

1265 Miljković-Pepek, Petar. "Edna neproučena crkva vo s. Velmej
 vo Ohridskiot kraj" (Fr. sum.: "Une église du village Velmei
 de la région d'Ohrid, inconnue dans la littérature scienti-
 fique"). Zbornik. Arheološki muzej na Makedonija (Skopje)
 8-9 (1978):105-31 (Fr. sum.: 121).
 In Macedonian. A detailed study of a small single-aisled
 church now believed to have been built initially in the second
 half of the thirteenth century. Fresco remains on the south
 façade (Virgin Eleousa in the lunette above the south door), St.
 Peter, and the imitation of decorative brickwork on the apse
 suggest such dating. The church contains other works of art
 dating between the sixteenth and nineteenth centuries, thus
 indicating its continuous use.

VELUČE

1266 Petković, Vlad[imir] R., and Bošković, Djurdje. "Manastir
 Veluče" (Fr. sum.: "Le monastère de Veluče"). Starinar,
 n.s. 3-4 (1955):45-76 (Fr. sum.: 75-76).
 In Serbo-Croatian. A study of the monastery's history and
 painting (pp. 45-59), architecture and sculpture (pp. 60-74).
 The material is considered in the context of other monuments be-
 longing to the so-called Morava school. The church is believed
 to have been built between 1390 and 1395 by the nobleman Nikola
 Zojić and his wife Vidosava.

VIS [island]

1267 Fisković, Cvito. "Spomenici otoka Visa od IX do XIX stoljeća"
 (Eng. sum.: "Buildings of architectural significance and
 works of art on the island of Vis dating from 9th to 19th
 centuries"). PPUD 17 (1968):61-264 (Eng. sum.: 261-64).
 In Serbo-Croatian. A comprehensive survey of the architec-
 tural and artistic heritage of the island of Vis. A substantial
 portion of the architectural material belongs to the medieval
 period. The material is presented by building types (e.g.,
 churches, public buildings, fortifications, etc.).

1268 _____. "Spomenici otoka Visa od IX do XIX stoljeća" (Eng.
 sum.: "Buildings of architectural significance and works of
 art on the island of Vis dating from 9th to 19th centuries").
 In Viški spomenici. Split: n.p., 1968, pp. 61-264 (Eng.
 sum.: 261-64).
 In Serbo-Croatian. An exhaustive survey of major architec-
 tural monuments on the island of Vis. A large portion of the
 survey is devoted to the medieval monuments.

VISOKI

1269 Mazalić, Dj[oko]. "Visoki: Bosanski grad srednjeg vijeka"
 (Fr. sum.: "Visoki: Forteresse bosniaque du moyen âge").
 GZMS, n.s. 9(A) (1954):227-53 (Fr. sum.: 252-53).
 In Serbo-Croatian. A historical study of this important
 medieval Bosnian fortress. Also examines the meagre architec-
 tural remains, and proposes a general hypothetical reconstruction.

VODOČA

1270 Bošković, Dj[urdje], and Tomovski, K. "Vodoča: Istražuvački
 raboti i konzervacija" (Fr. sum.: "Vodoča: Investigations et
 conservation"). KN 5 (1974):33-38 (Fr. sum.: 37-38).
 In Macedonian. A brief analysis of the structural history
 of the building, and its historiography. Offers a proposal for
 its conservation.

1271 Jovanović, Miodrag. "O Vodoči i Veljusi posle konzervatorskih
 radova" (Fr. sum.: "De Vodoča et Veljusa après les travaux de
 conservation"). Zbornik na Štipskiot naroden muzej 1 (1959):
 125-35 (Fr. sum.: 135).
 In Macedonian. A report on conservation efforts on two
 important middle Byzantine monuments in southeast Macedonia. In
 addition to giving a basic outline of the building histories of
 Vodoča and Veljusa, the article provides information on the dis-
 covered and cleaned frescoes and on the uncovered sculptural
 fragments.

1272 Miiatev, Kr[ustiu]. "Tsŭrkvata pri S. Vodocha" (Fr. sum.:
 "L'église près du village de Vodotcha"). Makedonski pregled
 2, no. 2 (1926):49-57 (Fr. sum.: 150-51).
 In Bulgarian. A pioneering study of the architecture and
 frescoes of this important but complicated eleventh-century
 monument.

1273 Mijatev, Krsto. "Les 'Quarante martyrs' fragment de fresque
 à Vodoča (Macédoine)." L'art byzantin chez les Slaves: Les
 Balkans. Vol. 1, pt. 1. Paris: Paul Geuthner, 1930,
 pp. 102-9.
 The fragment of the "Forty Martyrs" fresco from Vodoča is
 compared to the scheme of other Byzantine works in different
 media.

1274 Miletich, L. "Strumishkit manastirski cherkvi pri s.
 Vodocha i s. Veliusa" (Fr. sum.: "Les églises des monastères
 de Stroumitza près des villages de Vodotcha et Vélusa").
 Makedonski pregled 2, no. 2 (1926):35-40 (Fr. sum.: 148-49).
 In Bulgarian. A pioneering study of the two very important
 middle Byzantine monuments. The photographs are of good quality
 and have documentary value.

1275 Miljković-Pepek, Petar. Kompleksot crkvi vo Vodoča (Fr. sum.:
 "Le complexe des églises de Vodoča"). Kulturno istorisko
 nasledstvo vo S.R.Makedonija, 13. Skopje: Republički zavod
 za zaštita na spomenicite na kulturata, 1975. 72 pp. (Fr.
 sum.: 69-72), 30 figs. in text, 11 schematic drawings of
 fresco program, 29 pls.
 In Macedonian. A detailed investigation of the ruined com-
 plex of churches at Vodoča, aimed at providing a proposal for the
 conservation of the monument. Identifies several building phases
 between the seventh and fourteenth century. The complex is
 characterized by a peculiar juxtaposition of building forms.
 The study also examines the remians of frescoes.

1276 _____. "Novootkriveni freski vo Vodoča" (Fr. sum.: "Les
fresques récemment découvertes à Vodoča"). Peristil 21
(1978):61-68 (Fr. sum.: 68).
 In Macedonian. Describes important new discoveries of
fresco fragments and fragments of compositions at Vodoča. The
frescoes, dated ca. 1037, are an important contribution to the
study of eleventh-century Byzantine painting.

1277 Tatić, Žarko. "Dva ostatka vizantiske arhitekture u
strumičkom kraju" (Fr. sum.: "Deux monuments de l'architec-
ture byzantine dans la région de Strumica"). GSND 3 (1928):
83-96 (Fr. sum.: 95-96).
 In Serbo-Croatian. A study of the remains of two Byzantine
churches at Vodoča and Veljusa. Especially relevant is the study
of the architecture of Vodoča, because the monument was in a bet-
ter state of preservation than it is at present.

VOLJEVAC (BISTRICA)

1278 Deroko, Aleksandar. "Nemanjina crkva Svete Bogorodice u
Bistrici" [Nemanja's church of the Virgin in Bistrica]. GSND
5 (1929):305-8.
 In Serbo-Croatian. A brief account of the small single-
aisled church, whose architecture is linked to the architectural
tradition flourishing along the Adriatic coast. The church is
believed to have been founded or restored by Stefan Nemanja.

1279 Ilić, Jelica. "Crkva Bogorodice u Bistrici - Voljevac" (Fr.
sum.: "L'église Notre Dame de Bistrica"). ZLU 6 (1970):
203-19 (Fr. sum.: 218-19).
 In Serbo-Croatian. The examination of the remains of the
church of the Virgin and its frescoes suggests that it dates from
the end of the thirteenth or the early part of the fourteenth
century.

VRAČEVŠNICA

1280 Petrović, Petar Ž. Manastir Vračevšnica [Monastery
Vračevšnica]. Kragujevac: Petar Ž. Petrović, 1967. 39 pp.,
9 figs.
 In Serbo-Croatian. A detailed account of the history of
Vračevšnica. The study, though comprehensive, is not always
completely reliable in details.

1281 Ranković, Dušanka, and Vulović, Milovan. Vračevšnica.
Spomenici kulture, 2d ser. 9. Belgrade: Turistička štampa,
1967. 40 pp., numerous illus. in text.
 In Serbo-Croatian. A brief account of the monument's his-
tory, architecture, and fresco decoration. The church, completed
in 1431, was an important and unusual monument of the so-called

Morava school. Its original frescoes have not been preserved. The present frescoes date from 1737.

VRBOSKA [on the island of Hvar]

1282 Dubokovic, Niko. "Crkva-tvrdjava u Vrboskoj" (Fr. sum.: "Église-forteresse de Vrboska"). PPUD 15 (1963):111-25 (Fr. sum.: 125).
 In Serbo-Croatian. Discusses a rare example of a medieval (fourteenth-fifteenth centuries) church-fortress on the island of Hvar. Mentions two other, less well-preserved examples in Dalmatia (at Jelsa, also on Hvar; and at Sudjuradj on the island of Šipan), and suggests that the closest parallels are to be found in medieval France, but that those are considerably older.

VRHLAB

1283 Zdravkovic, Ivan, and Jovanovic, Vojislav. "Vrhlab: letnji dvorac kralja Milutina" (Fr. sum.: "Vrhlab: Palais d'été du roi Milutin"). Starinar, n.s. 15-16 (1966):261-66 (Fr. sum.: 266).
 In Serbo-Croatian. A brief topographical and archeological account of the remains of what is believed to have been the summer residence of the Serbian King Milutin.

ZADAR (ZARA)

1284 Bernardy, Amy A. Zara e i monumenti Italiani della Dalmazia. Monografie illustrate. Serie 1. Italia artistica, no. 93. Bergamo: Istituto Italiano d'arti grafiche, 1928. 166 pp., 170 figs., 1 pl.
 An illustrated guide book to Zadar and other Dalmatian towns. Although the text is outdated, the visual material is very valuable.

1285 Cecchelli, C. Zara. Catalogo delle cose d'arte e di antichità d'Italia. Rome: La libreria dello stato, 1932. 205 pp., numerous illus. in text.
 A detailed catalog of works of art and architecture in Zadar. The book is richly illustrated with small but good photographs. Photographs of some infrequently illustrated objects may be found here. Particularly useful for sculpture and minor arts.

1286 Deanovic, Ana. "Romanicke freske u Sv. Krševanu, Zadar" [Romanesque frescoes in St. Krševan in Zadar]. Peristil 2 (1957):113-23 (It. sum.: 123).
 In Serbo-Croatian. A detailed discussion of the Romanesque fresco remains accidentally discovered during the extensive restoration work on the church between 1911 and 1914. The remaining fragments are dated on stylistic grounds to the last quarter of the twelfth or first quarter of the thirteenth century.

1287 Iveković, Ćiril M. Crkva i samostan Sv. Krševana u Zadru
 [The church and monastery of St. Krševan in Zadar]. Djela
 Jugoslavenske akademije znanosti i umjetnosti, 30. Zagreb:
 Jugoslavenska akademija znanosti i umjetnosti, 1931. 58 pp.,
 38 pls.
 In Serbo-Croatian. The basic study of the monastery com-
 plex of St. Crisogono in Zadar. Considers the general and struc-
 tural history of the monument. Various phases in the development
 of the complex are identified and related to the specific his-
 torical circumstances.

1287a See Addenda

1288 Klaić, Nada, and Petricioli, I. Zadar u srednjem vijeku do
 1409 [Zadar in the Middle Ages until 1409]. Prošlost Zadra,
 2. Zadar: Filozofski fakultet, 1976. 605 pp., 64 pls.,
 col. pls. and drawings in text.
 In Serbo-Croatian. The major political, social, and cul-
 tural history of Zadar during the Middle Ages. Chapters 3
 (pp. 115-46), 6 (pp. 247-88), and 13 (pp. 499-550) are devoted
 to art and architecture of pre-Romanesque, Romanesque, and
 Gothic Zadar, respectively. The chapters are thoroughly docu-
 mented. The book includes an extensive bibliography.

1289 Mirković, L[azar]. "Ikone i drugi predmeti u crkvi Sv. Ilije
 u Zadru" (Fr. sum.: "Icônes et autres objets d'art dans
 l'église de St. Elie à Zadar"). Starinar, n.s. 7-8 (1958):
 359-74 (Fr. sum.: 374).
 In Serbo-Croatian. An account of a collection of icons and
 other art objects with Greek and Old Church Slavonic inscriptions
 in the collection of the church of St. Elijah in Zadar.

1290 Petricioli, Ivo. "Grede s preromaničkim ukrasom iz crkve Sv.
 Donata u Zadru" (It. sum.: "Travi con motivi decorativi pre-
 romanici ritrovati nella chiesa di San Donato a Zara
 [Zadar]"). Peristil 14-15 (1971-72):47-54 (It. sum.: 52-54).
 In Serbo-Croatian. Reports the major find of seven ninth-
 century carved wooden beams in the gallery floor of the church of
 St. Donat at Zadar. The abstract, low-relief carving is compara-
 ble to early medieval works elsewhere and is the basis for the
 dating.

1291 _____. "I piu antichi edifici cristiani à Zadar (Zara)."
 Arheološki vestnik 23 (1972):332-42.
 A brief survey of the oldest medieval monuments of Zadar:
 the cathedral, and the churches of St. Andrew and St. Thomas.
 Presents the results of recent investigations and cites the
 literature to date.

1292 _____. "Neuere Arbeiten an Denkmälern der vor und früh-
romanischen Architektur in Zadar." AI 7 (1966):77-84.
 A study of pre-Romanesque and early Romanesque architecture
in Zadar in the light of recent findings. The episcopal complex
with the church of St. Donat, the churches of St. Peter "the
Old," St. Lawrence, Stomovica (St. Ursula), St. Thomas, St. Mary,
and the early medieval city walls are discussed.

1293 _____. "Ostaci fresaka u zadarskoj katedrali" (Fr. sum.:
"Les vestiges de fresques dans la cathédrale de Zadar").
Zograf 9 (1978):15-19 (Fr. sum.: 19).
 In Serbo-Croatian. Discusses the remnants of medieval
fresco decoration of the cathedral of Zadar. The recently (1976)
discovered fresco of St. Donatus on the west wall of the cathe-
dral is dated ca. 1324 and is linked with the construction of the
main portal from that year. The frescoes in the apses are be-
lieved to be from ca. 1285 or somewhat earlier. The frescoes
are related to the broader circle of Veneto-Byzantine painting
before the beginning of the Gothic painting tradition.

1294 _____. "Ostaci stambene arhitekture romaničkog stila u
Zadru" (Eng. sum.: "Remains of residential architecture in
Romanesque style in Zadar"). Radovi Instituta Jugoslavenske
akademije znanosti i umjetnosti u Zadru 9 (1962):117-61 (Eng.
sum.: 161).
 In Serbo-Croatian. A detailed discussion of the fifty-
eight remaining residential buildings of the Romanesque period
in Zadar. The article is divided into a general discussion and
a catalog (pp. 129-60).

1295 _____. Zadar: Turistički vodič [Zadar: A tourist guide].
Zadar: Turističko društvo Liburnija, 1962. 77 pp., 14 figs.
in text, 1 foldout plan.
 In Serbo-Croatian. A detailed guide to the monuments
(mostly medieval) of Zadar. Plans of major buildings are in-
cluded. The last section of the book (pp. 67-77) discusses the
monuments in the vicinity of the town.

1296 Suić, Mate, ed. Muzeji i zbirke Zadra (Fr. sum.: "Musées et
collections de Zadar"). Zagreb: Zora, 1954. 190 pp.,
146 b&w pls., 6 figs. in text.
 In Serbo-Croatian. A guide to the principal museums and
art collections of Zadar. The medieval material is found mainly
in the cathedral treasury, in the treasury of the Benedictine
monastery of St. Mary, in the treasury of the Franciscans, and in
the Archeological Museum. The book is richly illustrated with
excellent black-and-white photographs.

1297 Suić, Mate, and Petricioli, I. "Starohrvatska crkva Sv.
Stošije kod Zadra" (Fr. sum.: "Église vieille-croate de
Sainte Stošija près Zadar"). SP, 3d ser. 4 (1955):7-22 (Fr.
sum.: 21-22).

In Serbo-Croatian. An archeological investigation of an
important example of the adaptation of an ancient building (a
cistern) into a two-storied pre-Romanesque church. The authors
believe this to be a unique example of such an undertaking during
the period in question.

ZAGREB

1298 Karaman, Ljubo. "Bilješke o staroj katedrali" (Ger. sum.:
 "Bemerkungen über die alte Kathedrale in Zagreb"). Bulletin
 zavoda za likovne umjetnosti Jugoslavenske akademije znanosti
 i umjetnosti 11, nos. 1-2 (1963):1-46 (Ger. sum.: 41-46).
 In Serbo-Croatian. A general discussion of the building
and its history from its Romanesque foundation in 1094 through
its Gothic reconstruction in the thirteenth century to the
nineteenth-century restoration and completion.

ZALOŽJE

1299 Sergejevski, Dimitrije. "Pluteji iz bazilike u Založju" (Ger.
 sum.: "Die Brüstungsplatten der Basilika in Založje"). GZMS,
 n.s. 13 (Arheologija) (1958):137-45 (Ger. sum.: 145).
 In Serbo-Croatian. A formal and stylistic analysis of
fragmented parapet slabs excavated in the church at Založje.
Believed to be of fifth- or sixth-century date, these pieces are
also seen as related to the architectural sculpture of the early
medieval period. The architectural sculpture from Založje fig-
ures prominently in the debate over continuity or revival of
late Antique art in Bosnia during the early Middle Ages.

ZANJEVAC

1300 Stričević, Djordje, and Subotić, Gojko. "Iskopavanje
 Zanjevačke crkve" (Fr. sum.: "Fouilles de l'église de
 Zanjevac"). Starinar, n.s. 9-10 (1959):307-15 (Fr. sum.:
 315).
 In Serbo-Croatian. Excavation report of the quatrefoil
church believed to date from the eleventh century. The church
had a dome elevated on a drum over the naos and a vaulted under-
ground tomb accommodated within the southern lateral apse. Finds
include glazed ceramic bowls, ceramic jars used for decorating
façades, and architectural and fresco fragments.

ZARA. See ZADAR

ZAVALA

1301 Vego, Marko. "Arheološko iskopavanje u Zavali" (Ger. sum.:
 "Archäologische Ausgrabungen in Zavala"). GZMS, n.s. 14
 (Arheologija) (1959):179-201 (Ger. sum.: 199-201).

In Serbo-Croatian. Excavation report on the small single-
aisled church of Sv. Petar (twelfth century), which has a square
apse and rich architectural sculpture characterized by typically
early medieval motifs (e.g., birds and braided geometric pat-
terns).

1302 Zdravković, Ivan, and Skovran, Anika. "Manastir Zavala" (Ger.
 sum.: "Das Kloster Zavala"). NS 6 (1959):37-62 (Ger. sum.:
 62).
 In Serbo-Croatian. A detailed study of the architecture
 and frescoes of the monastery church. First mentioned ca. 1514,
 the church may have been founded in the fourteenth or fifteenth
 century but its frescoes were painted in 1619. Links with
 Dobrićevo are explored. The work is attributed to Djordje
 Mitrofanović and is considered his most important achievement
 after his work at Hilandar.

ZENICA. See BILIMIŠĆE

ŽIČA

1303 Deroko, Aleksandar. "Kosturnica kod manastira Žiče" [Ossuary
 near Žiča monastery]. Starinar, 3d ser. 14 (1939):105-8.
 In Serbo-Croatian. A brief account of the excavations which
 brought to light the foundations of the medieval ossuary of Žiča
 monastery. The building has the form of a single-aisled church,
 with a series of five compartments along each of the longitudinal
 foundation walls for the deposition of bones. The author consid-
 ers a possibly late date of construction.

1304 Kašanin, Milan; Bošković, Dj., and Mijović, P. Žiča:
 Istorija, arhitektura, slikarstvo (Fr. sum.: "Le monastère
 de Žiča: Histoire, architecture, peinture"). Belgrade:
 Književne novine, 1969. 225 pp., illus. in text.
 In Serbo-Croatian. A comprehensive monograph on the
 monastery of Žiča. The history of the complex, its architecture,
 and its painted decoration are discussed in detail. The discus-
 sion of architecture also includes the results of earlier archeo-
 logical investigations.

1305 Nenadović, S[lobodan] M. "Restauratorski radovi na Žiči za
 poslednjih sto godina" (Fr. sum.: "Les travaux de restauration
 à Žiča au cours des cent dernières années"). Saopštenja 1
 (1956):28-37 (Fr. sum.: 37).
 In Serbo Croatian. A brief historical account of preserva-
 tion of Žiča monastery during the past century. Takes into ac-
 count the oldest visual documents of Žiča, including drawings and
 photographs made before modern restorations.

1306 Petković, Vlad[imir] R. Spasova crkva u Žiči: Arhitektura i
 živopis [The church of the Savior at Žiča: Architecture and
 frescoes]. Belgrade: n.p., 1911. 105 pp., figs. in text.
 In Serbo-Croatian. An important early monograph on Žiča.
 Offers certain explanations on liturgical functions of the church
 based on archeological and textual evidence.

1307 ____. "Žiča." Starinar, n.s. 1 (1906):141-87.
 In Serbo-Croatian. An exhaustive study of the church of
 the Savior, including its architecture, building technique, ma-
 terials, and fresco decoration. See entry YU 1308.

1308 ____. "Žiča." Starinar, n.s. 2 (1907):115-48.
 In Serbo-Croatian. Continuation of the discussion of the
 church of the Savior. See entry YU 1307.

1309 ____. "Žiča." Starinar, n.s. 4 (1909):27-106.
 In Serbo-Croatian. An exhaustive study of the Žiča
 frescoes. The most extensive section is devoted to iconographic
 problems, followed by the analysis of style, ornament, and fi-
 nally of architectural decoration (painted).

ŽRNOV

1310 Bošković, Djurdje. "Grad Žrnov" (Ger. sum.: "Die Burg
 Žrnov"). Starinar, 3d ser. 15 (1940):70-91 (Ger. sum.: 91).
 In Serbo-Croatian. Discusses the destroyed medieval
 fortress on top of Avala hill near Belgrade. The fortress,
 probably built in the fifteenth century [?], is discussed in
 detail. Many drawings and photographs have significant docu-
 mentary value.

ZRZE

1311 Čornakov, Dimitar. "Manasteriot Zrze" (Fr. sum.: "Monastère
 de Zrzé"). KN 4 (1972):15-19 (Fr. sum.: 19).
 In Macedonian. The monastery was founded in the mid-
 fourteenth century. The conservation efforts (1963) have re-
 vealed hitherto unknown frescoes dating from 1369. The church
 was expanded and altered in the sixteenth and seventeenth cen-
 turies.

ŽURČE

1312 Vasiliev, Asen. "Dve starinni manastirski tsŭrkvi v
 Makedoniia" [Two old monastic churches in Macedonia]. GNAM
 7 (1943):107-53.
 In Bulgarian. Considers the monastery of St. Athanasius
 of Alexandria, near the village Žurče (region of Kruševo), and
 the church of St. Nicholas in the monastery of St. John the
 Baptist, near the village Slepča (region of Bitola). Both

churches have well-preserved fresco cycles dated by inscriptions
to the first half of the seventeenth century.

ŽUŽEMBERK

1313 Stelè, Franc. "Sv. Nikolaj v Žužemberku: Tragičan primer
 'varstva spomenikov'" [St. Nicholas at Žužemberk: A tragic
 case of the "protection of monuments"]. Starinar, n.s. 20
 (Mélanges Djurdje Bošković) (1970):355-62 (Ger. sum.: 362).
 In Slovenian. Discusses the fourteenth-century Gothic
 frescoes in the church of St. Nicholas and the misguided efforts
 to preserve them.

ZVEČAN

1314 Jovanović, Vojislav. "Srednjevekovni grad Zvečan" (Fr. sum.:
 "Forteresse médiévale de Zvečan"). Starinar, n.s. 13-14
 (1965):137-50 (Fr. sum.: 150).
 In Serbo-Croatian. A historical and archeological study of
 one of the most important fortresses in medieval Serbia.

1315 Zdravković, I[van], and Jovanović, V[ojislav]. "Arheološko-
 konzervatorski radovi na gradu Zvečanu" (Fr. sum.: "Travaux
 archéo-conservateurs sur la forteresse de Zvečan"). SKM 1
 (1961):279-88 (Fr. sum.: 287-88).
 In Serbo-Croatian. A brief account of the archeological
 and conservation undertakings in 1957-1959 on the fortress of
 Zvečan. The main discoveries include the remains of the church
 of St. George (a palace chapel?) and an octagonal tower (donjon?).

1316 _____. "La forteresse de Zvečan, située au moyen âge à la
 frontière entre Byzance et la Serbie." Actes du XIIe Congrès
 international d'études byzantines (Belgrade) 3 (1964):423-28.
 A brief account of Zvečan--an important fortress of medie-
 val Serbia. Several buildings, including the church of St.
 George, were discovered within the fortress.

1317 Zdravković, Ivan. "Istraživački i konzervatorski radovi na
 gradu Zvečanu kraj Kosovske Mitrovice 1957 i 1958 godine"
 (Fr. sum.: "Travaux de recherches et de conservation effec-
 tuées en 1957 et 1958 sur la forteresse de Zvečan, près de
 Kosovska Mitrovica"). ZZSK 10 (1959):173-84 (Fr. sum.: 184).
 In Serbo-Croatian. A preliminary report on the excavations
 conducted within the fortress of Zvečan. The most important
 finds are the foundations of the church of St. George--a domed,
 atrophied cross church with an unusually long and narrow
 narthex (?). Other structures include an octagonal donjon (?),
 and utilitarian buildings (cistern?).

1318 _____. "Rezultati konzervatorskih ispitivanja i radova na
 gradu Zvečanu" (Fr. sum.: "Résultats des recherches scien-
 tifiques et des travaux de conservation sur la forteresse de
 Zvečan"). ZZSK 12 (1961):83-104 (Fr. sum.: 103-4).
 In Serbo-Croatian. A report on the archeological investi-
 gations and conservation of remains within the medieval fortress
 of Zvečan. History and past descriptions of the fort are also
 discussed.

Addenda

[The following four major publications were inadvertently left out of
their respective sections in the chapter "Yugoslavia" of this book.]

248a Stelè, Francè. Slikarstvo v Sloveniji od 12. do srede 16.
 stoletja [Painting in Slovenia from the twelfth to the middle
 of the sixteenth century]. Ljubljana: Slovenska matica,
 1969. 361 pp., 268 b&w illus. in text.
 In Slovenian. A major study of Slovenian medieval painting.
 The main portion of the book is devoted to fresco painting. Icon-
 ographic programs, their idiosyncrasies, regional factors influ-
 encing their choices, and the work of a number of individual
 painters are the principal subjects of Part I. Part II is devoted
 to panel painting. The remaining shorter chapters consider ency-
 clopaedic and secular painting, the beginning of portraiture,
 illuminated manuscripts, and stained glass.

429a Grgić, Marijan. The Gold and Silver of Zadar and Nin.
 Introduction by Miroslav Krleža. Library of Monographs,
 no. 2. Zagreb: Turistkomerc, 1972. 182 pp., 120 b&w and
 col. pls. in text.
 In Serbo-Croatian. A superb publication of two major col-
 lections of metal religious objects (mostly medieval). The book
 includes a detailed catalog, a bibliography, and an analytical
 text. Also available in French, German, and Italian.

631a Fisković, Cvito. Zadarski sredovječni majstori (Fr. sum.:
 "Sur les maîtres médiévaux de la ville de Zadar"). Biblioteka
 suvremenih pisaca, 13. Split: Matica hrvatska, 1959.
 222 pp. (Fr. sum.: 207-12), b&w pls.
 In Serbo-Croatian. A detailed study of medieval artists
 and artisans of Zadar. Builders, sculptors, woodcarvers, paint-
 ers, and metalsmiths are considered.

1287a Hauser, Ludwig, and Bulić, Frane. <u>Die Donatus-Kirche in</u>
 <u>Zadar</u>. Revised by Albert Anton Lehr. Freiburg: Hammer-
 schmied Verlag, 1969. 56 pp., 19 figs., 6 pls., and 3 foldout
 drawings.

 A monograph on the ninth-century church of St. Donatus (Sv.
Donat), one of the most important monuments of early medieval
architecture in Dalmatia. Considers its architecture, the re-
sults of excavations conducted in its vicinity, and the use of
spoils by medieval builders.

Author Index

Abramić, Michele (Michel), YU1,
342, 824
Adam, Robert, YU 36
Adhami, Stilian, AL 1, 80
Ago, Saide, AL 44
Aianov, Georgi, BU 440
Aklinov, Stancho, BU 343
Akrabova, Iv. Zhandova (Jandova),
BU 135-136, 202-203, 245,
283, 398-399; YU 944
Aladzhov, Dimcho, BU 61
Aldzhov, Zhivko, BU 187
Aleksiev, Iordan, BU 449
Aleksova, Blaga, YU 728, 771,
1006
Ammann, A.M., YU 419
Anamali, Skender, AL 3-5, 57,
65, 82
Anastasijević, D.N., YU 868
Andjelić, Pavao, YU 2, 68, 420,
495, 698
Andrejević, Andrej, YU 69, 942
Angelov, Bon'o St., BU 230
Angelov, Dimiter, BU 1
Angelov, Nikola, BU 450
Angelov, Valentin, BU 175-176,
231
Angelova, Stefka, BU 62
Antić, Nada. See Komnenović,
Nada Antić
Antonova, Vera, BU 188, 416-417,
444
Arnandova, L. Koinova, BU 412
Atanasov, Atanas, BU 137
Atanasova, Iordanka, BU 189

Babić, Boško, YU 1073-1075, 1245,
1252
Babić, Gordana, YU 12a, 176-179,
300, 496-499, 608, 790, 818,
1034-1035, 1086, 1214, 1240
Babikova, Velda Mardi, BU 232,
402, 484-485
Baçe, Apollon, AL 30-31, 66-67
Bach, Ivan, YU 421-422
Badurina, Andjelko, YU 301
Bajalović, Marija. See Hadži-
Pešić, M.B.
Bakalova, Elka, BA 17; BU 2, 105,
113, 253-255, 264-265
Balabanov, Kosta, YU 46, 250-251,
702, 729, 913-914, 999
Balş, Georges, BU 63
Barov, Zdravko, BU 267, 467
Basler, Djuro, YU 70, 343, 803
Basta, Branka Pavić, YU 1028
Baum, Milica, YU 609
Beljaev, Nicolas, BA 28
Belošević, J., YU 955
Benac, Alojz, YU 3, 344-347, 364
Beritić, Lukša, YU 754-756
Bernardy, Amy A., YU 1284
Beševliev, Veselin, BU 3
Bešlagić, Šefik, YU 348-363
Bezić, Nevenka. See Božanić,
Nevenka Bezić
Bihalji-Merin, Oto, YU 4, 180,
364
Bichev (Bičev), Milko, BU 4,
64-65, 296-297
Birtašević, Marija, YU 423, 679,
928, 1120b
Blažić, Zdravko, YU 220, 252

Author Index

Vulović, V., YU 958
Vŭzharova, Zhivka, BU 58, 384

Walter, Christopher, YU 606
Wenzel, Marian, YU 415, 607
Werner, Joachim, YU 494
Wessel, Klaus, BA 8a
Wolters, W., YU 372
Wyjarova, Jivka, BU 59

Xyngopoulos, André, BU 155;
 YU 1014

Zadnikar, Marijan, YU 67, 171-
 173, 1135-1136, 1203
Zakhariev, Vasil, BU 319
Zdravkovič, Ivan M., YU 94,
 174-175, 663, 694, 700, 753,
 763, 885, 899-900, 921,
 970-972, 1021, 1159-1160,
 1211, 1283, 1302, 1315-1318
Zhandova-Akrabova, Iv. See
 Akrabova, Iv. Zhandova
Zheku, Koço, AL 75
Zheliakova, Vessa, BU 60
Žic-Rokov, Ivan, YU 852
Zimmermann, Max, BU 334
Živković, Branislav, YU 670,
 746, 793-794, 816, 1118
Zlatev, Todor, BU 104
Zloković, Milan, YU 795, 1015
Zonev, Kyrill, BU 284

395

General Index

Smokovac, YU 92
Socrates, fresco representation
of, YU 513
Sofia, BU 3, 11, 36, 105, 142,
293-294, 420-436; YU 308,
919. See also Sredets
-Bŭlgarska akademiia na naukite
[Bulgarian Academy of
Sciences], MS. No. 15,
Serbian Gospels, YU 312
-Ilienski manastir [Monastery of
Ilentsi], BU 423
-Monastiro, church, BU 422
-Narodnata biblioteka (National
Library), No. 181, Serbian
Gospels, YU 308
-Sv. Georgi [St. George], church
of, BU 105, 424-433
-Sv. Petka [St. Paraskeve]
Samardzhiĭska [Samardjiska],
BU 434
-Sv. Sofiia [St. Sophia], BU 435-
436
Sokol [Soko], YU 1161-1162
Solin [Salona], YU 107, 1125,
1163-1164
Sopoćani, YU 71, 84, 116, 146,
169, 186, 188, 501, 532,
540, 564, 603, 1165-1180
Sopot, YU 824
Sozopol, BU 148, 437
Spain, YU 275, 391, 467
Spalato. See Split
Spasovitsa [Spasovica], BA 10;
BU 23, 437a
Split [Spalato], YU 99, 118,
257-258, 283, 292a-292b,
302, 369, 374, 380, 390,
469, 620, 626, 1181, 1188-
1191
-Cathedral, YU 1181-1187
-Cathedral treasury, YU 320
-Gospa od Zvonika [Our Lady of
the Belfry], YU 257, 283
Srbija. See Serbia
Srdj, painter, YU 724
Sredets, BU 421. See also Sofia
Sremski Karlovci, YU 1192
Sretenje, church, Ovčarsko-
Kablarska klisura, YU 1021.
See also Presentation in the
Temple

Srima, YU 1193
Stalać, YU 94, 1194-1195
Stanimaka [Asenovgrad/Stanimaca],
BU 63, 105, 438-439
Starac Isaija. See Isaija,
Starac
Stara Hercegovina, YU 130
Stara Pavlica, YU 77, 117, 1196-
1197
Stara Planina [mountain], BU 39-
40
Stara(ta) tsŭrkva, BU 319
Starčeva Gorica, scriptorium of,
YU 323
Stari Bar. See Bar
Stari Pustenik, YU 1198
Stari Trg, YU 1199
Stari zavet. See Old Testament
Staro Nagoričino, BU 123; YU 73,
79, 102, 166, 192, 404, 521,
527, 576-577, 1200-1202
Štava, YU 557
Stavronikita, YU 1178
Stavronikita Psalter, YU 1178
Stefan the Blind, Serbian Despot
(1458-1459), YU 430
Stefan Dečanski, Serbian King
(1321-1331), BU 437a; YU 183,
270, 299, 563, 673, 819, 1087
Stefan Dragutin. See Dragutin
Stefan Dušan. See Dušan
Stefan Lazarević, Serbian Despot
(1389-1427), YU 497, 685,
902, 905
Stefan Nemanja. See Nemanja,
Stefan
Stefan Prvoslav, Serbian Veliki
[Grand] Župan, YU 706
Stefan Prvovenčani, Serbian King
(1186-1228), YU 299, 448,
572, 1217
Stefan Uroš II Milutin. See
Milutin
Stevanac, YU 1195
Stična, YU 1203
Štip, YU 71, 1204-1205
Stjenik (Ježevica), YU 1206
Stjepan II Kotromanić, Bosnian
Ruler [Ban] (1324-1353),
YU 495